P9-BJV-437

ANDY GOLDSWORTHY

EPHEMERAL WORKS

2004 - 2014

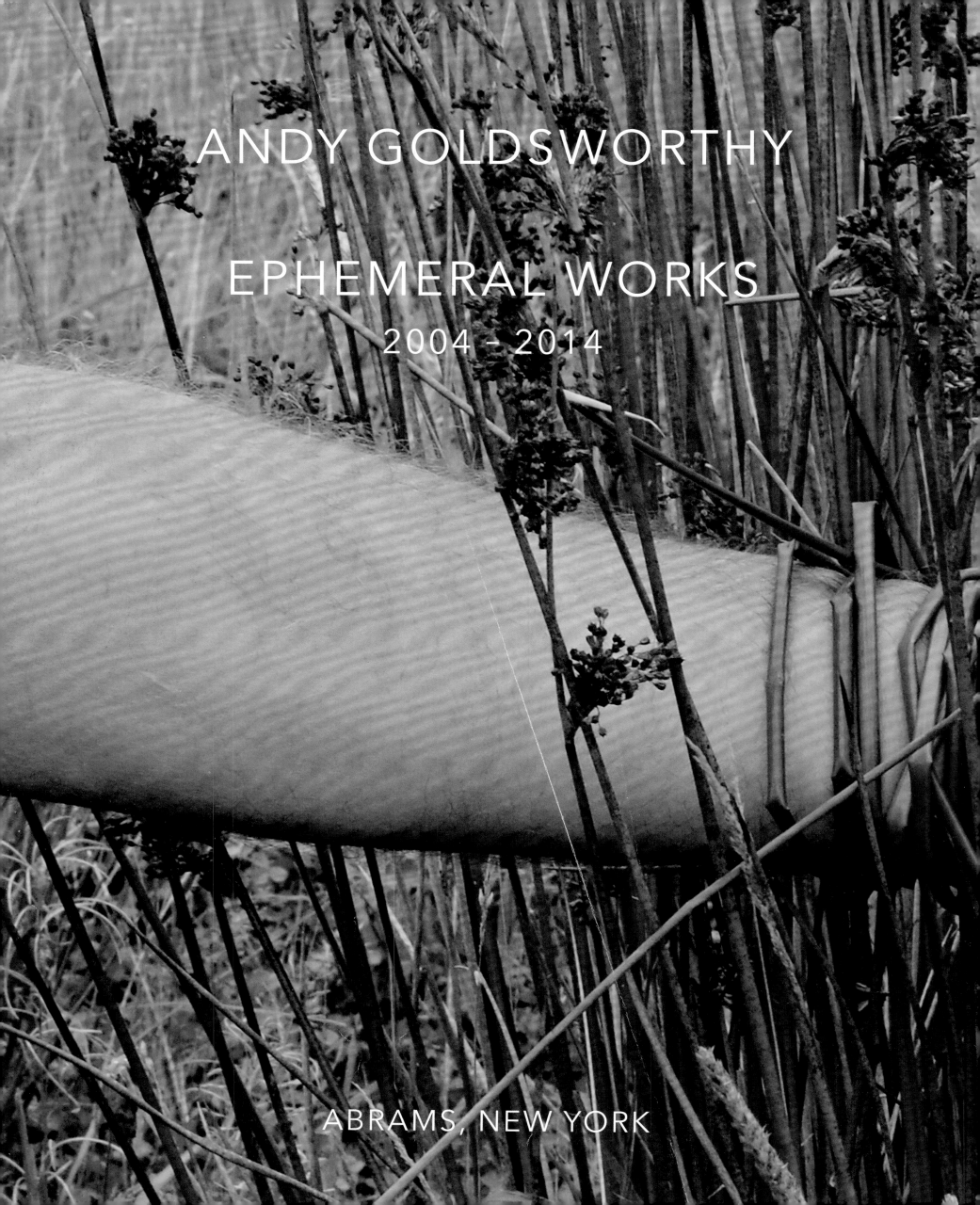

ANDY GOLDSWORTHY

EPHEMERAL WORKS

2004 – 2014

ABRAMS, NEW YORK

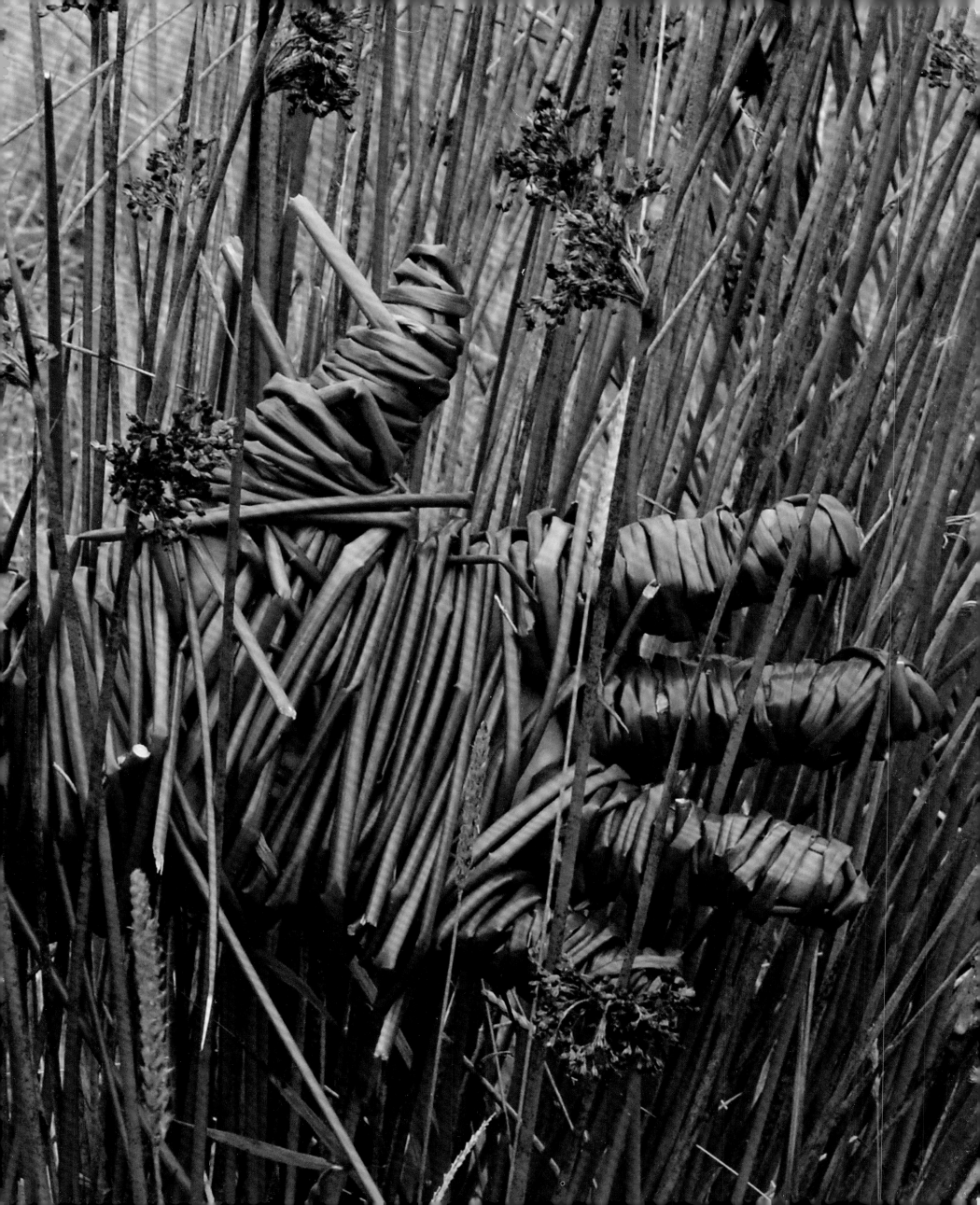

The works in this book have been selected from the period 2004 – 2014. They represent what I feel are my most significant unpublished ephemeral works produced during that time, with the majority being made since my last book in 2007. I have not included pieces made upon one particular dead elm tree, which I intend for a future publication of its own.

The works are presented in chronological order. As a result, ideas, places, forms, and materials occur with a similar randomness (or regularity) as they do outside.

This is the first book that I have created in my own studio. Working in the place where my photographs are stored, surrounded by the landscape in which many of the works were made, has made the process a far more tactile experience for me than my previous publications. I hope this is reflected in its pages.

Andy Goldsworthy

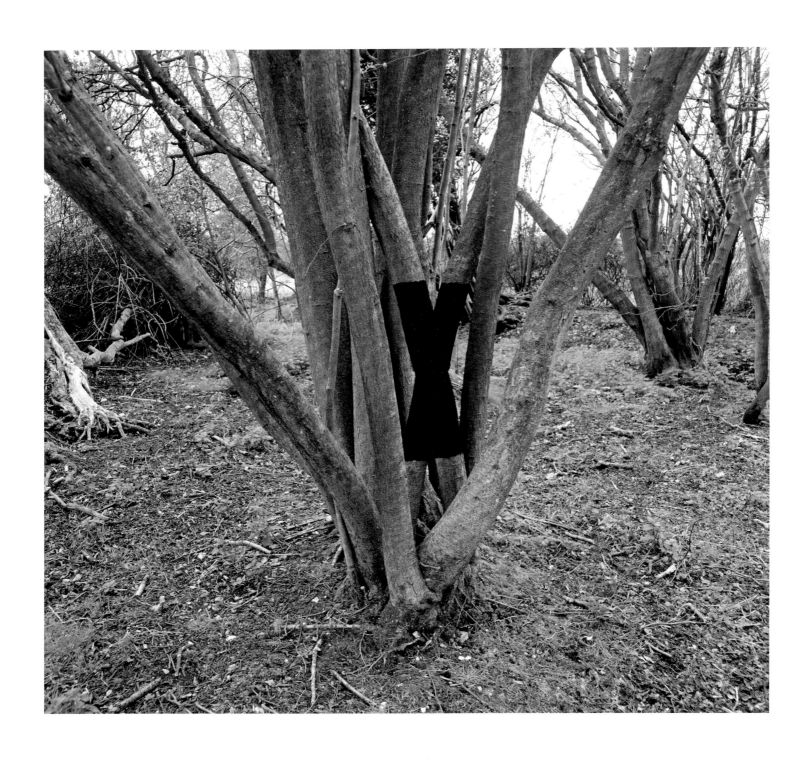

HAZEL TREE. SMEARED WITH BLACK EARTH. RUBBED WITH CHALK. BOTH FOUND NEXT TO THE TREE. BERE MILL, HAMPSHIRE. 13 APRIL, 13 JUNE 2004

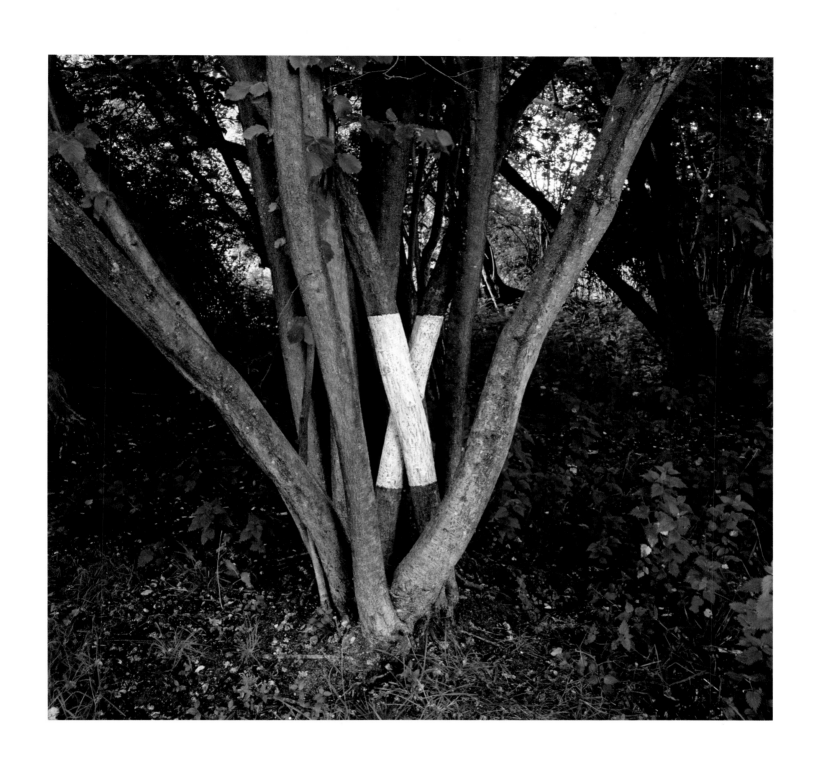

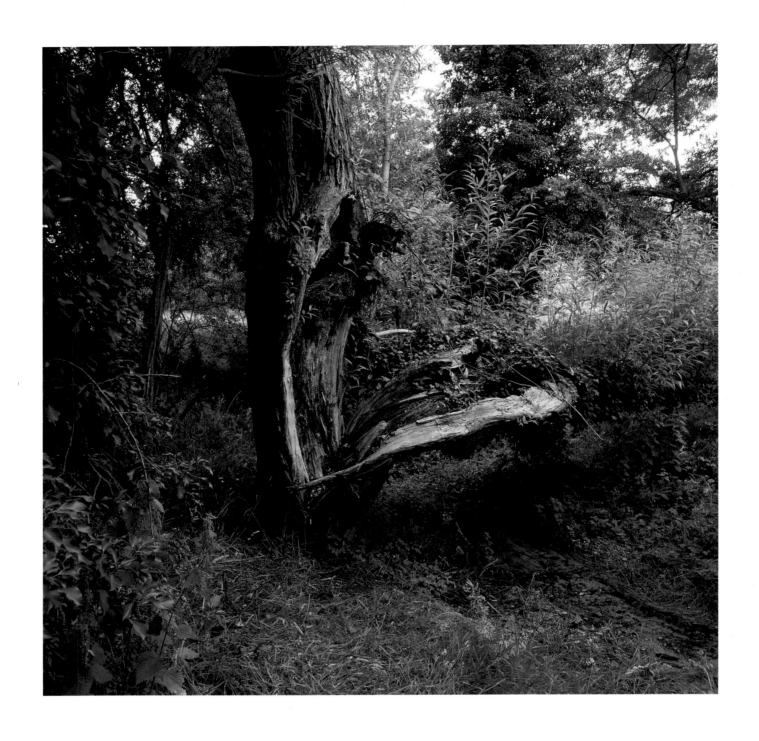

WET POPPY PETALS WRAPPED AROUND FRACTURED WILLOW. WOODPERRY, OXFORDSHIRE. 5 JULY 2004

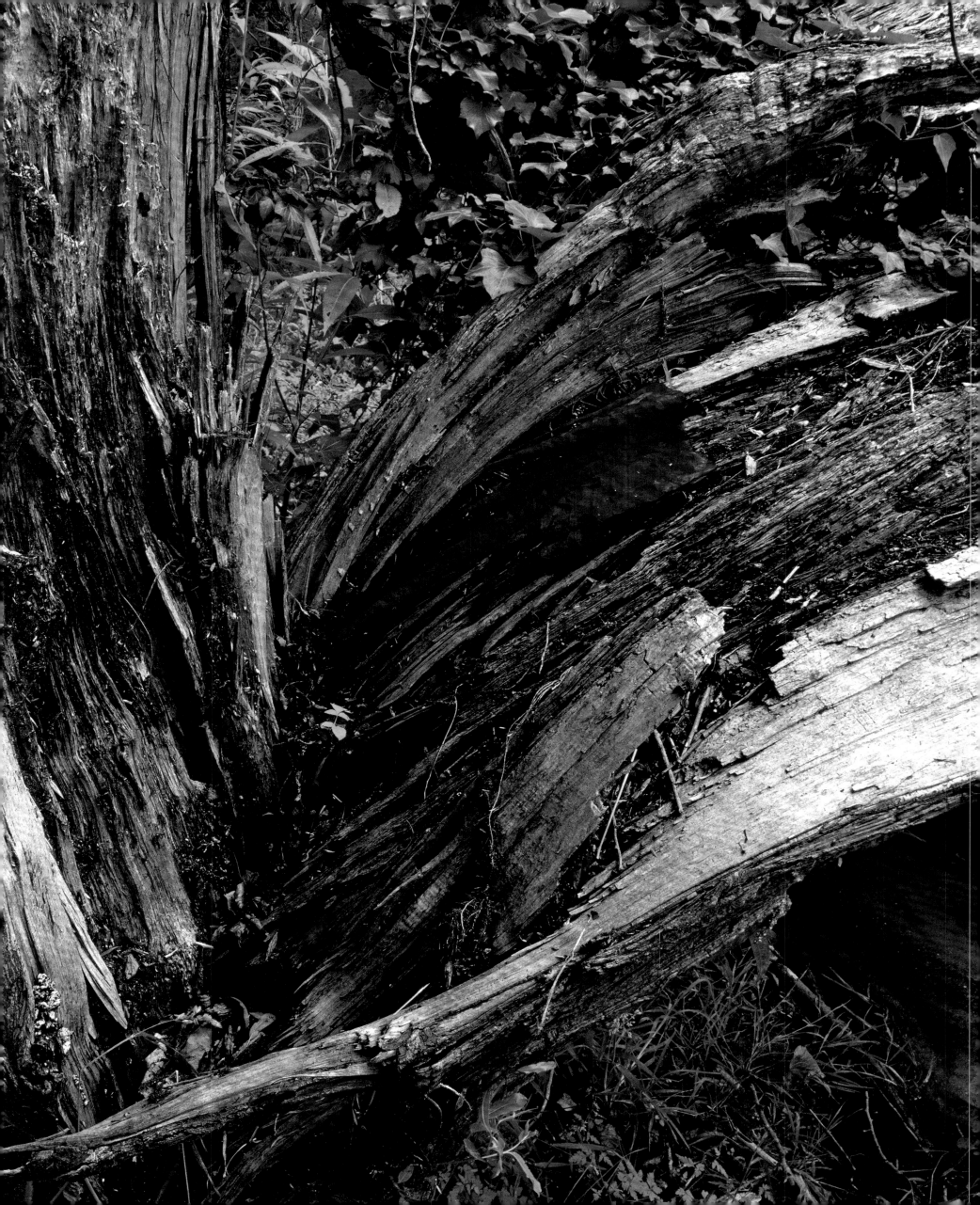

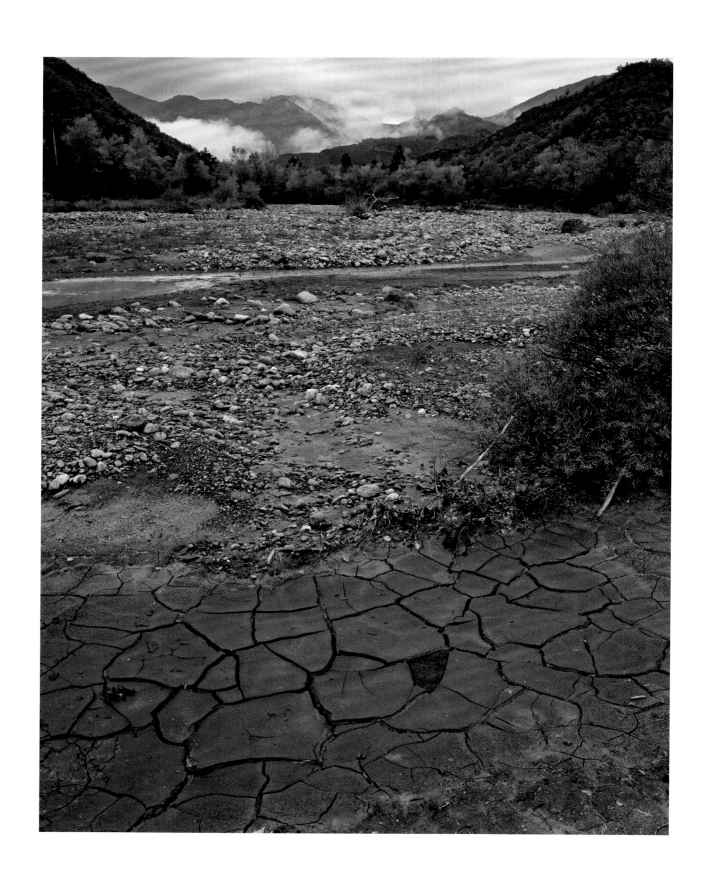

RED LEAVES. CRACKED RIVER CLAY. DIGNE-LES-BAINS, FRANCE. 13 OCTOBER 2004

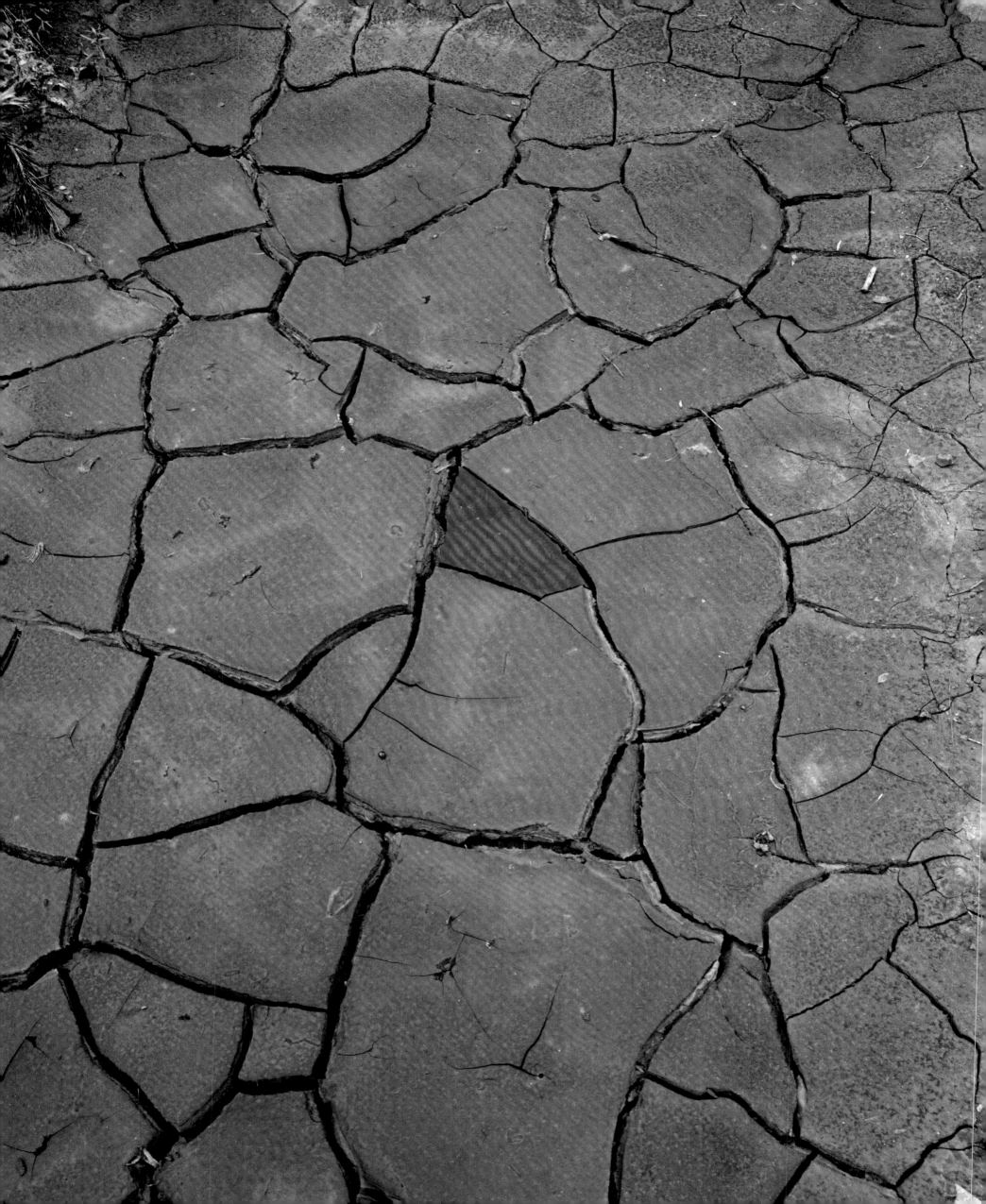

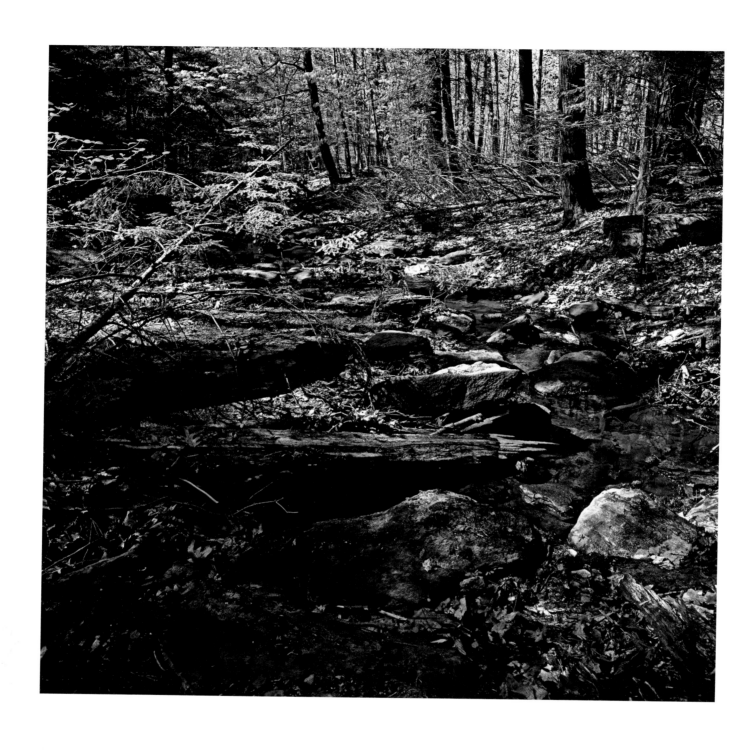

FRESH THIN BEECH LEAVES. WRAPPED AROUND THE SPLINTERED END OF A ROTTED TREE TRUNK. HELD WITH WATER. LENNOX, MASSACHUSETTS. 13 MAY 2005

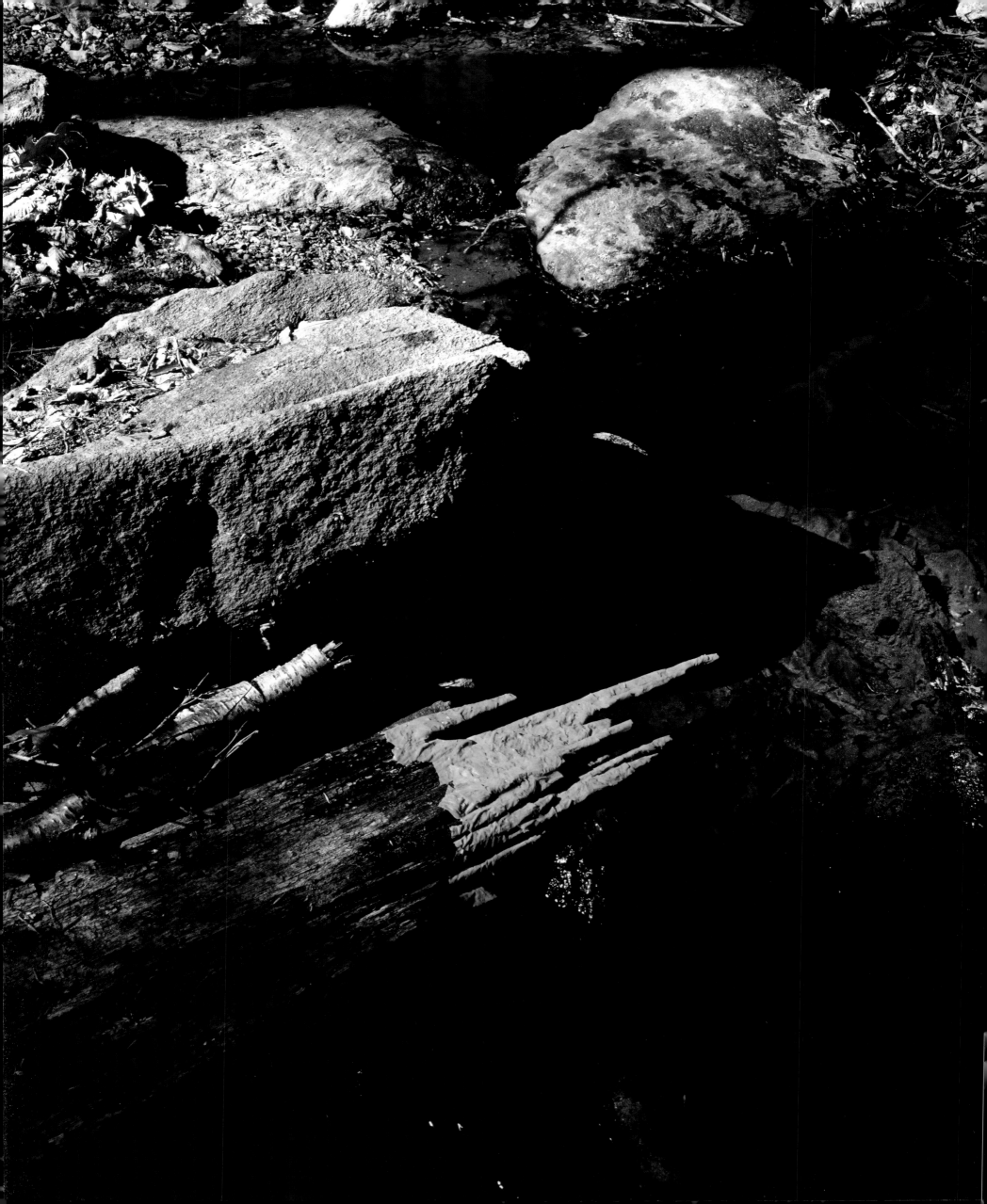

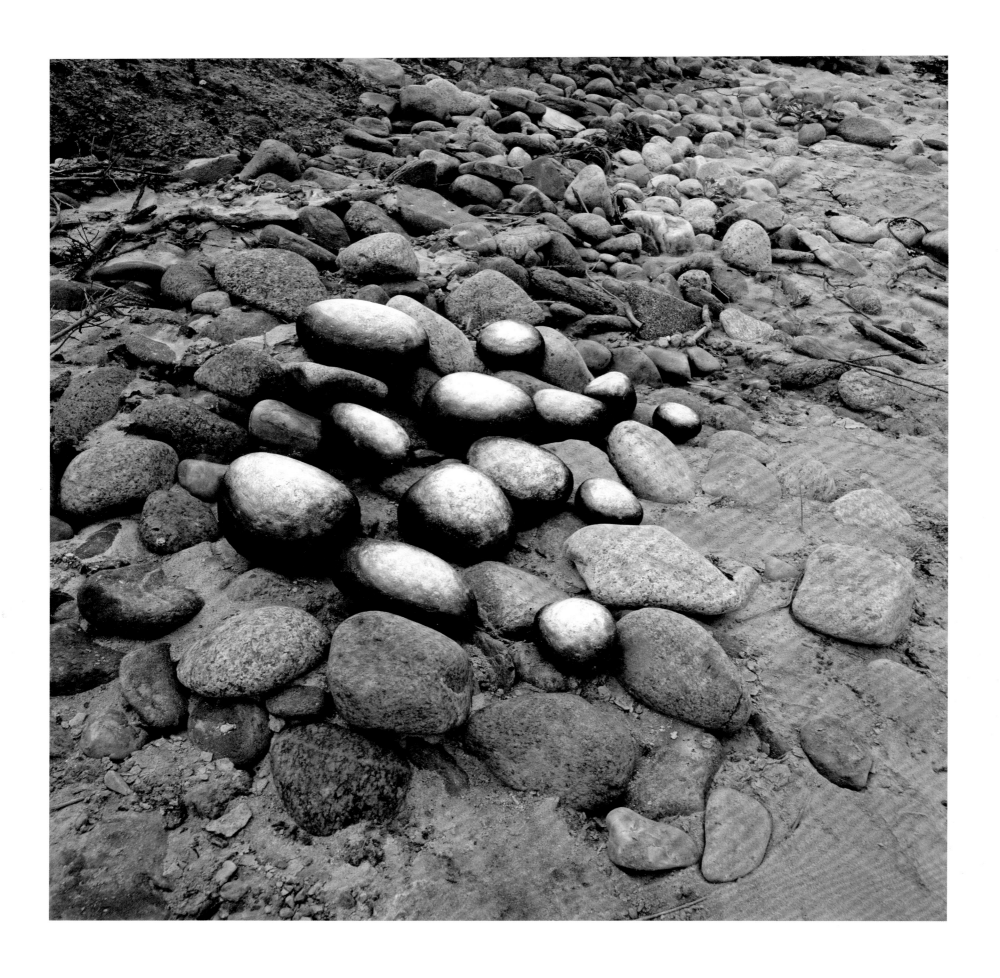

BLACK EARTH. WHITE CLAY. RUBBED INTO STONES. MARTHA'S VINEYARD, MASSACHUSETTS. JULY 2005

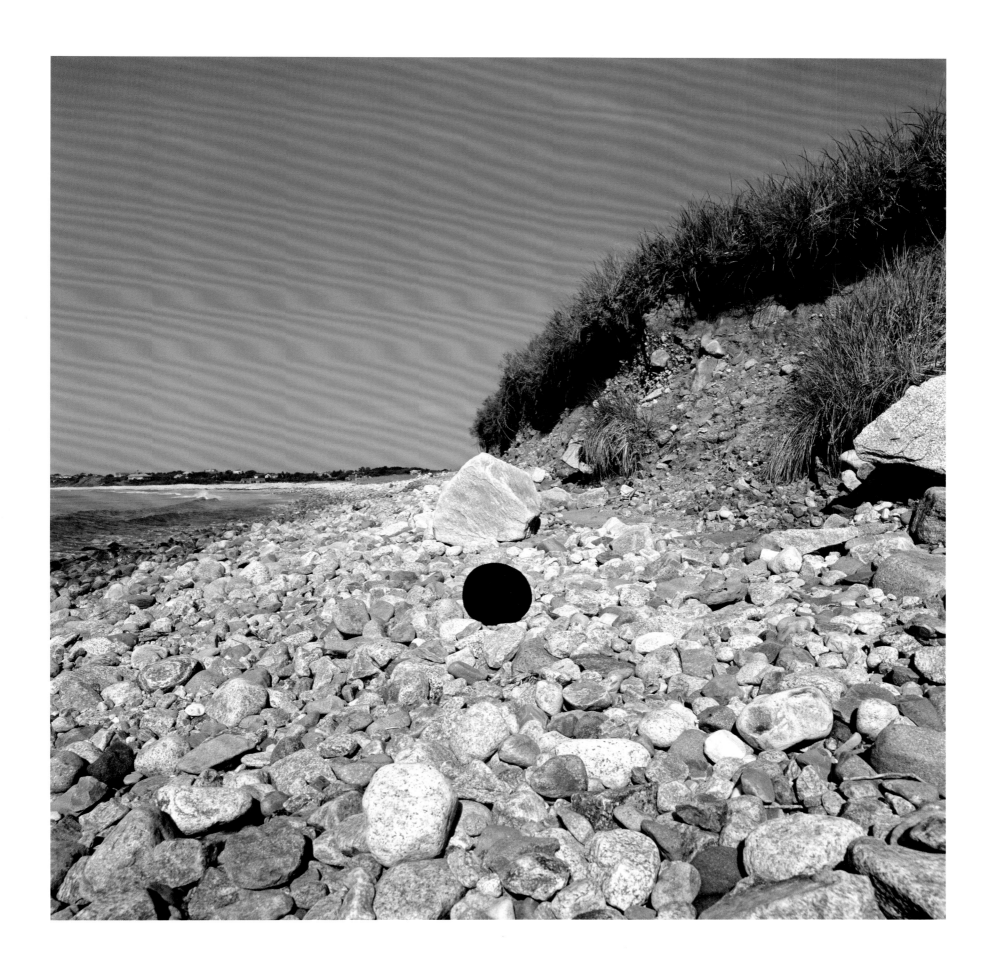

BLACK EARTH STONE. MARTHA'S VINEYARD, MASSACHUSETTS. JULY 2005

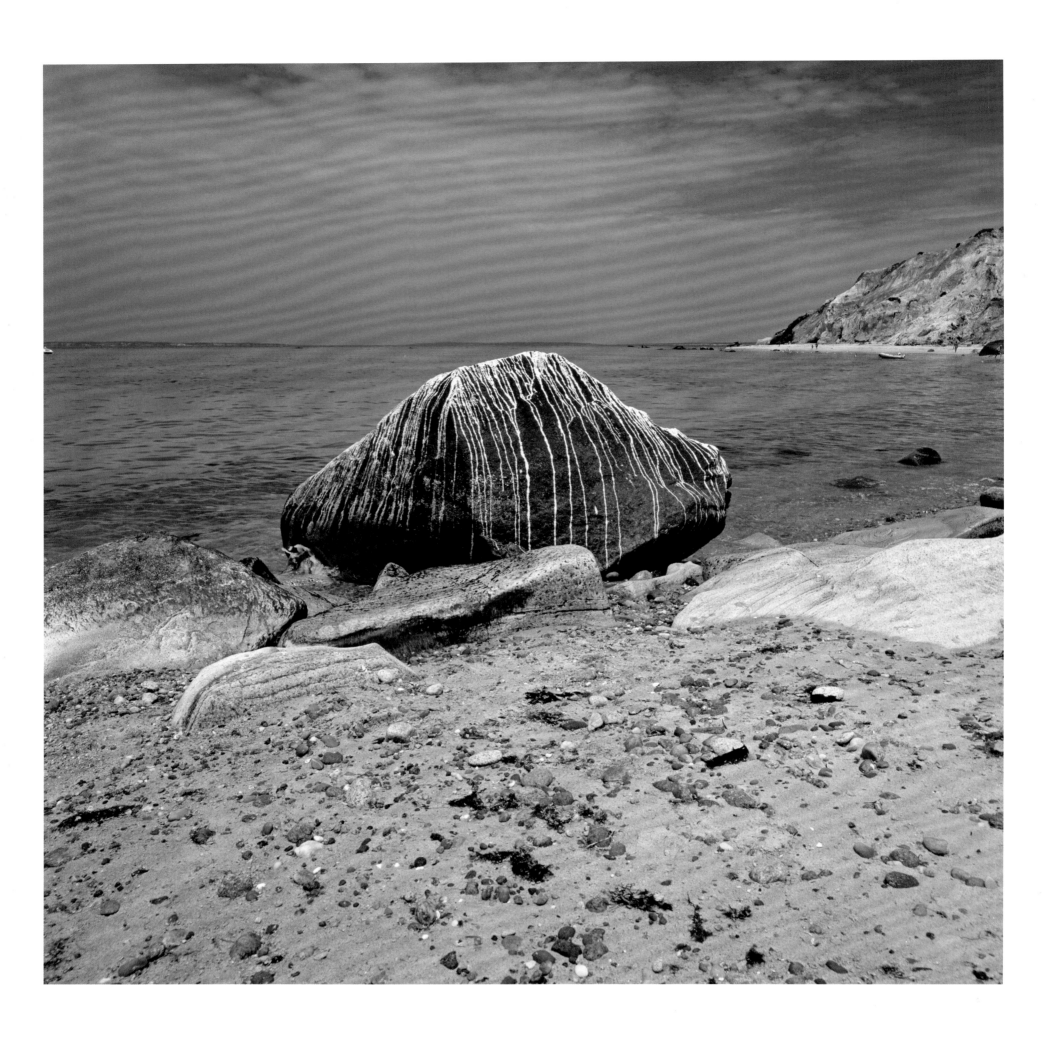

WHITE AND RED CLAY. SEA WATER. ROCK. MARTHA'S VINEYARD, MASSACHUSETTS. 2, 3 AUGUST 2005

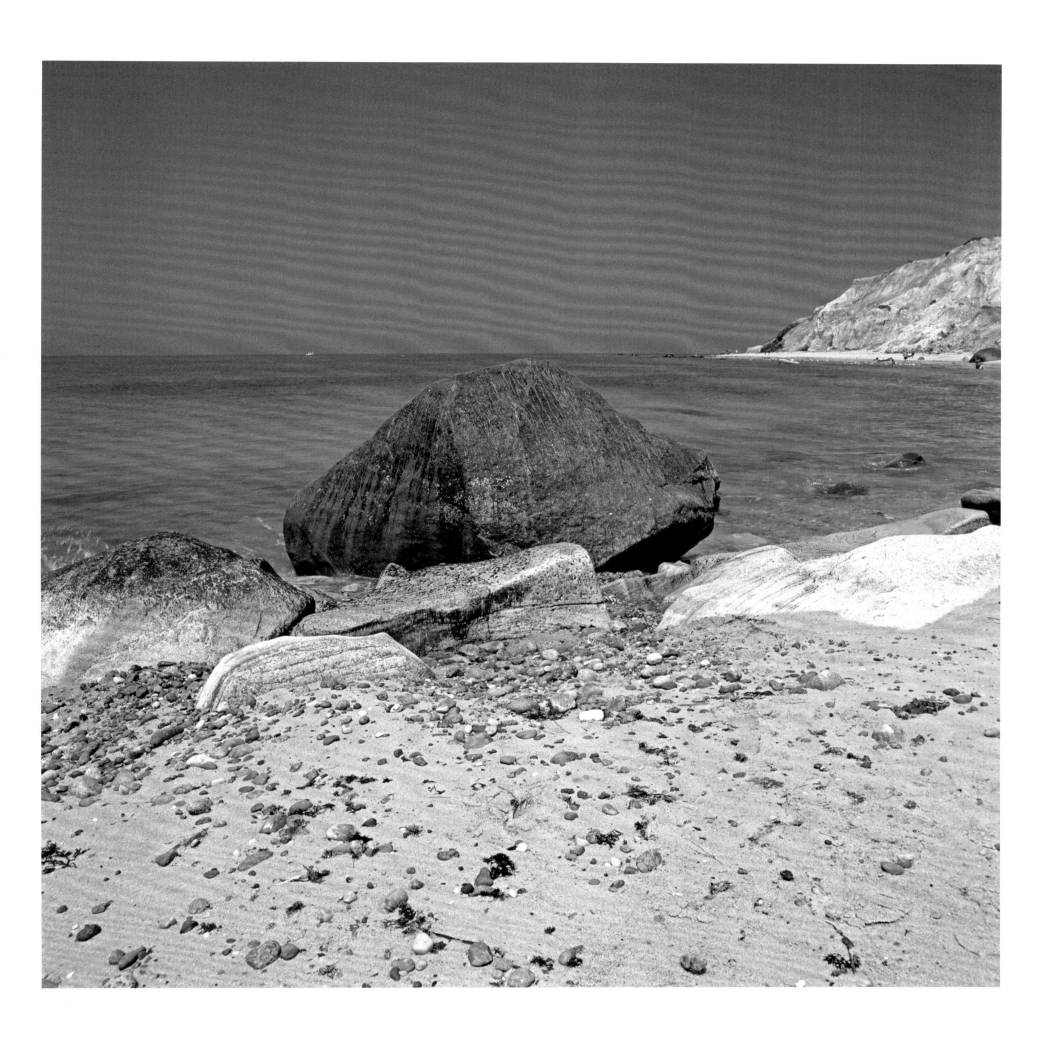

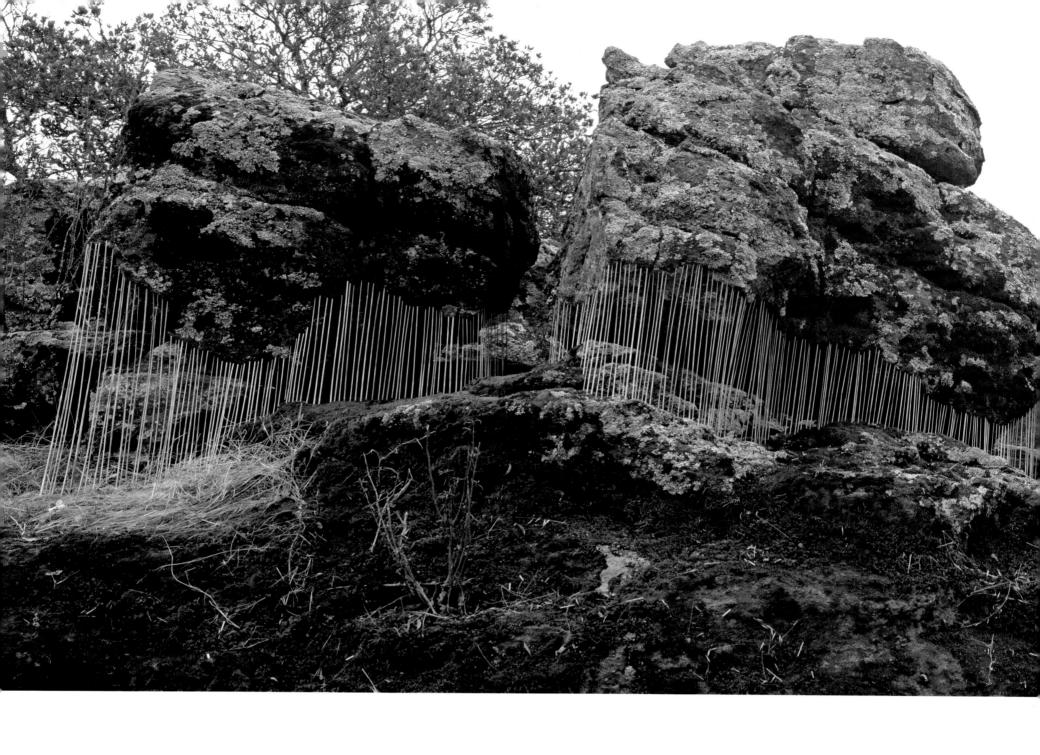

GRASS STALKS. WEDGED BETWEEN BOULDERS AND BEDROCK. NAPA, CALIFORNIA. 28 OCTOBER 2005

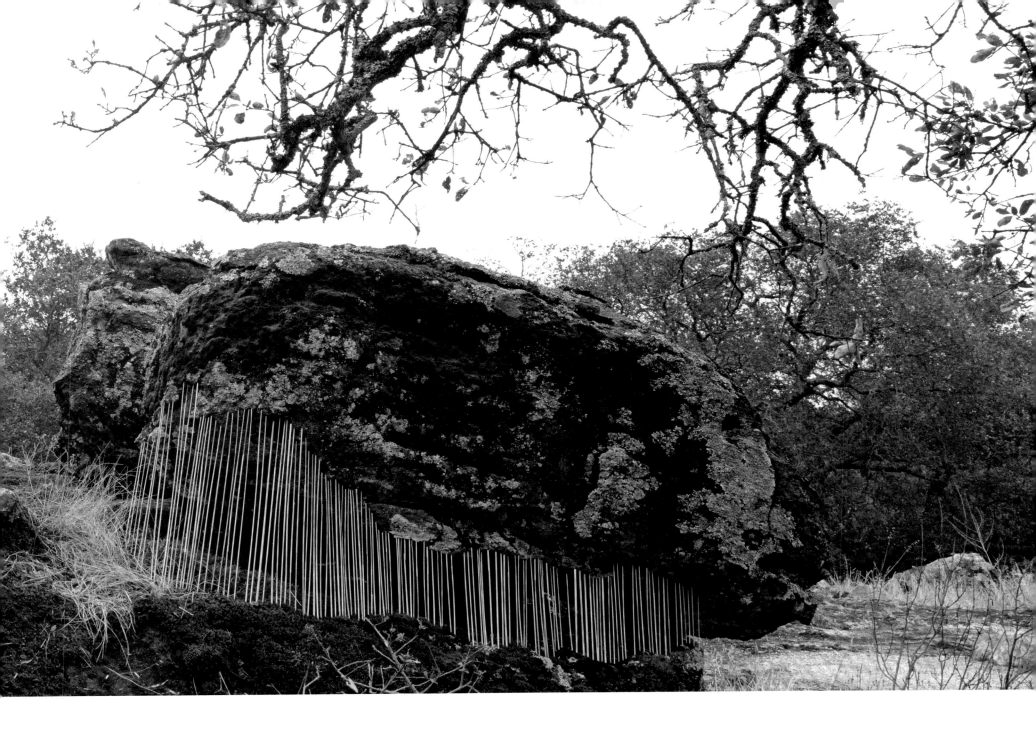

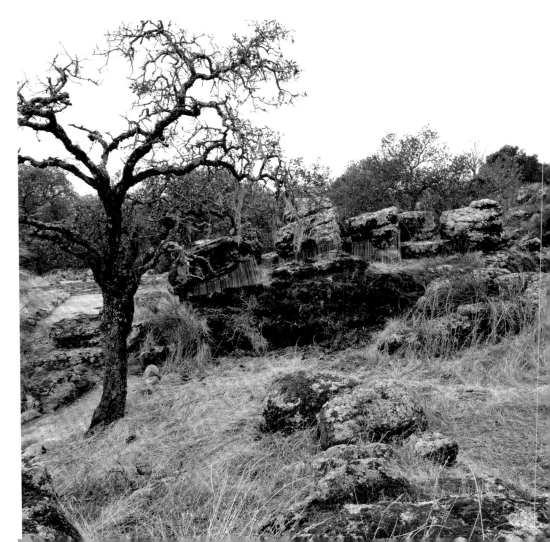

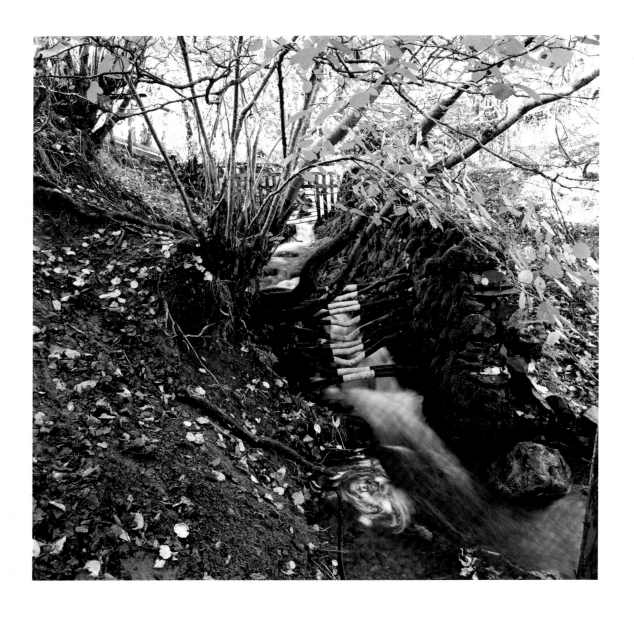

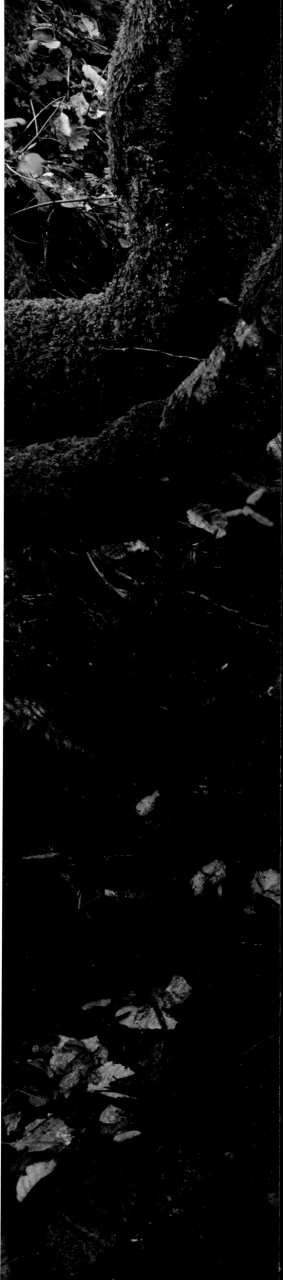

WET ELM LEAVES WRAPPED AROUND ELM BRANCHES. WEDGED BETWEEN WALL AND BANK. DUMFRIESSHIRE, SCOTLAND. 5 NOVEMBER 2005

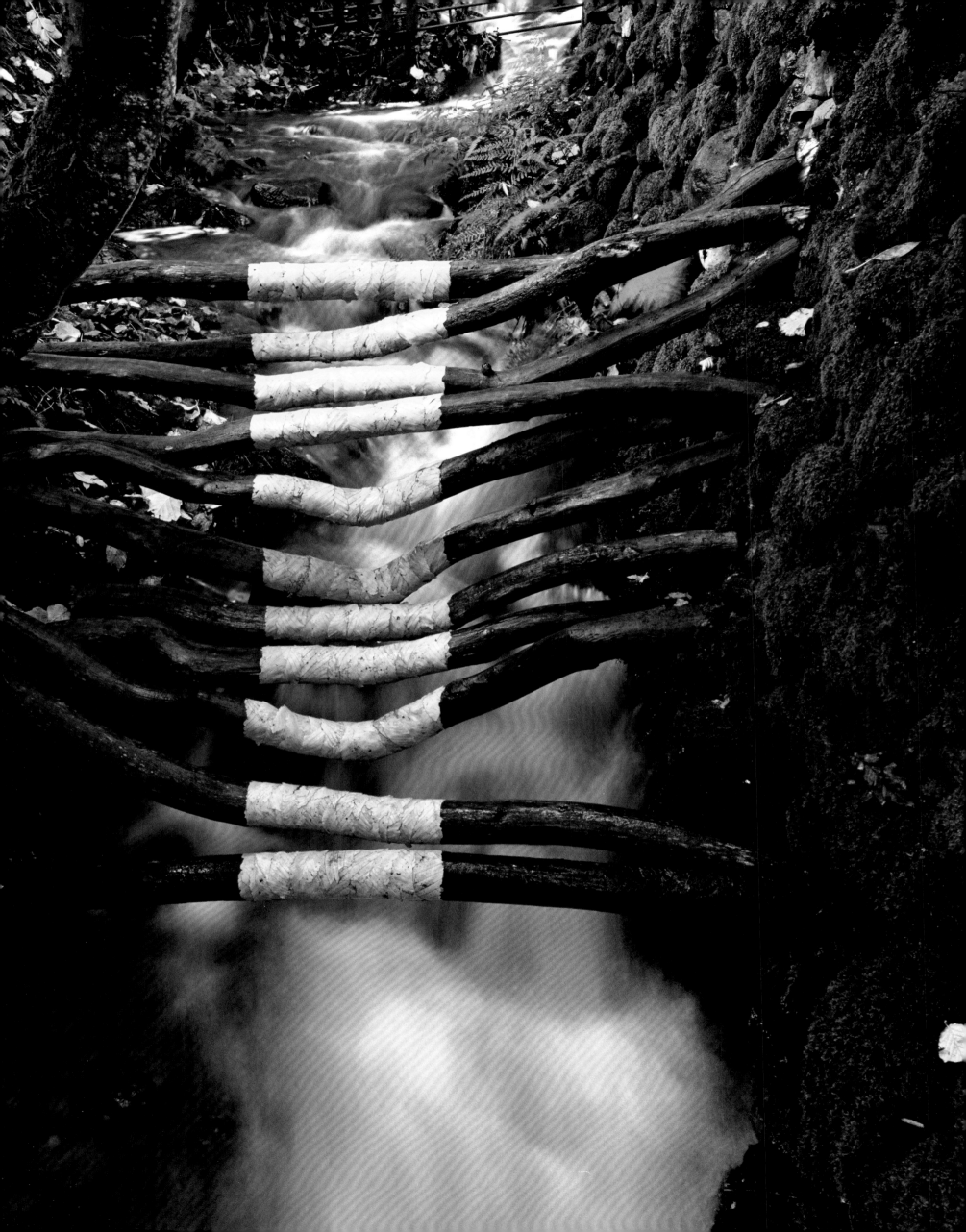

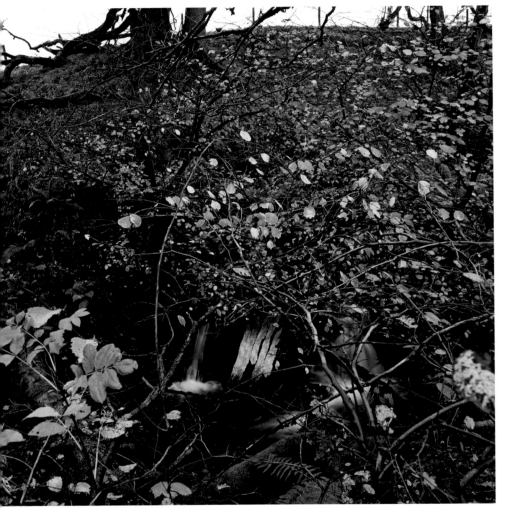 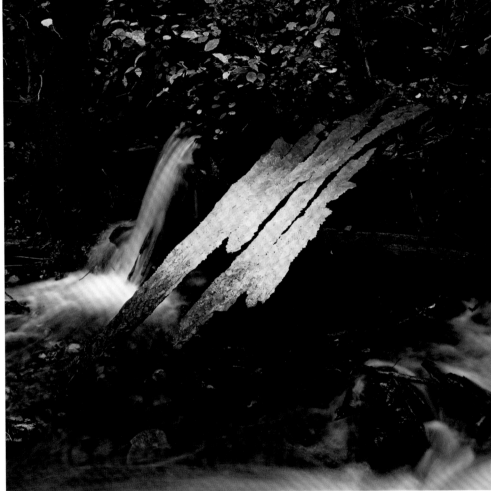

STRIPS OF BARK. PULLED OFF NEARBY DEAD ELM TREE. LAID ON FALLEN ELM BOUGH. WET ELM LEAVES PLACED ON THE DARK, WET, SMOOTH SIDE OF THE BARK THAT WAS ONCE ATTACHED TO THE TREE.
DUMFRIESSHIRE, SCOTLAND. 8, 9, 10 NOVEMBER 2005

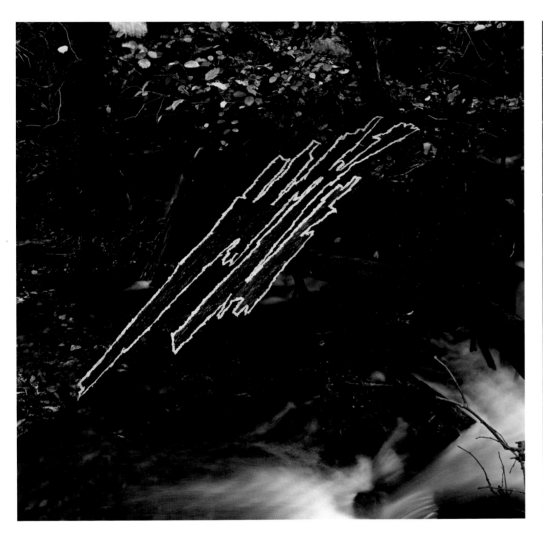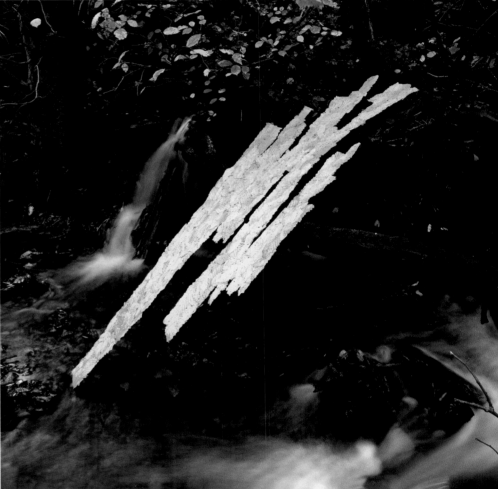

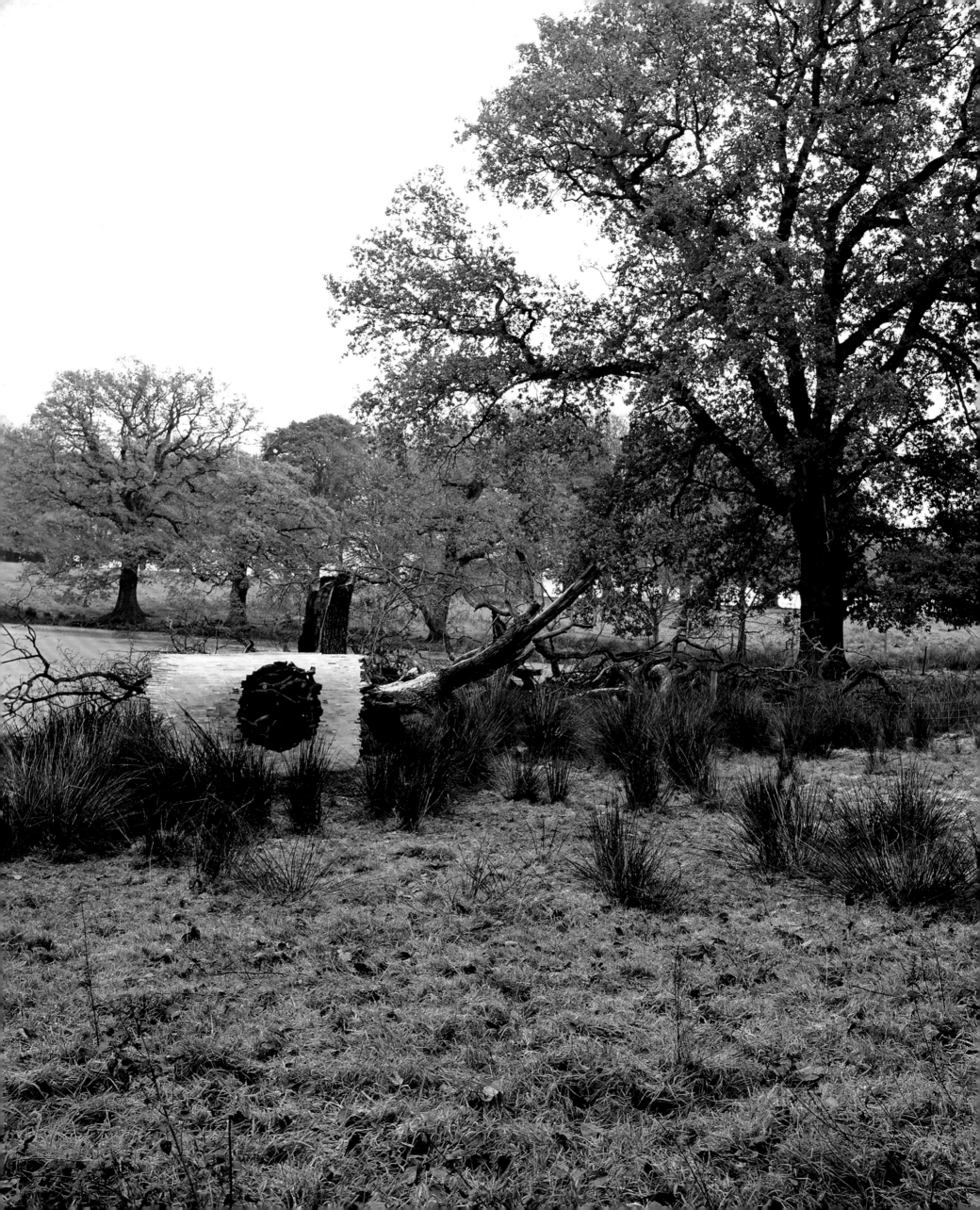

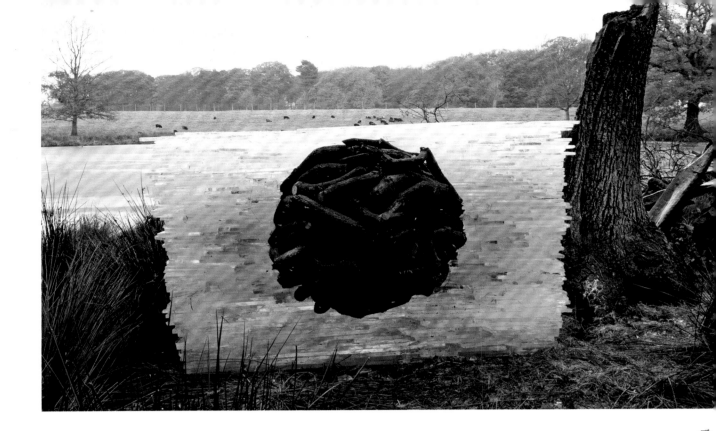

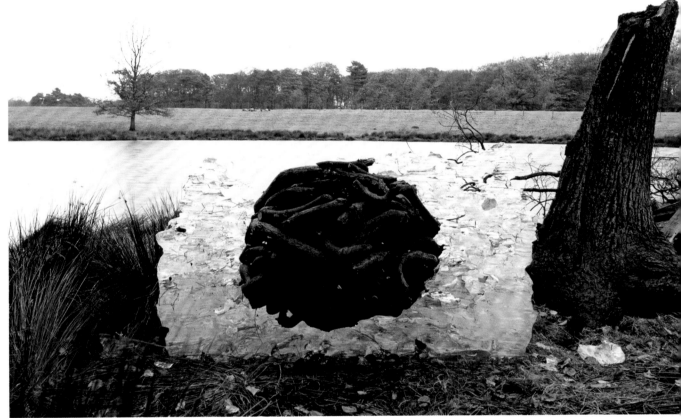

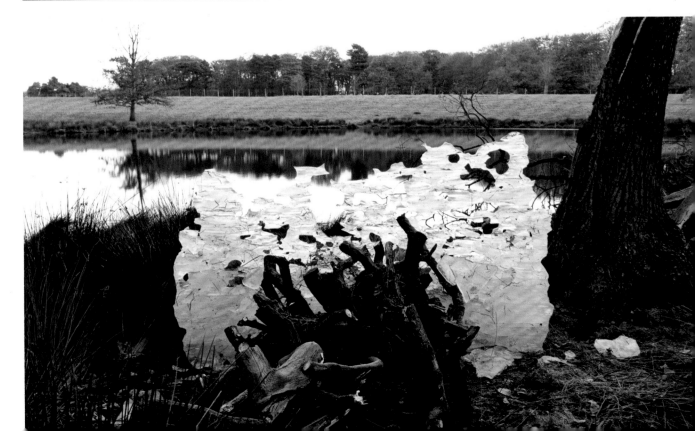

BRANCHES COLLECTED FROM NEARBY FALLEN OAK.
WORKED INTO A WALL OF LAKE ICE.
TATTON PARK, CHESHIRE. 20 NOVEMBER 2005

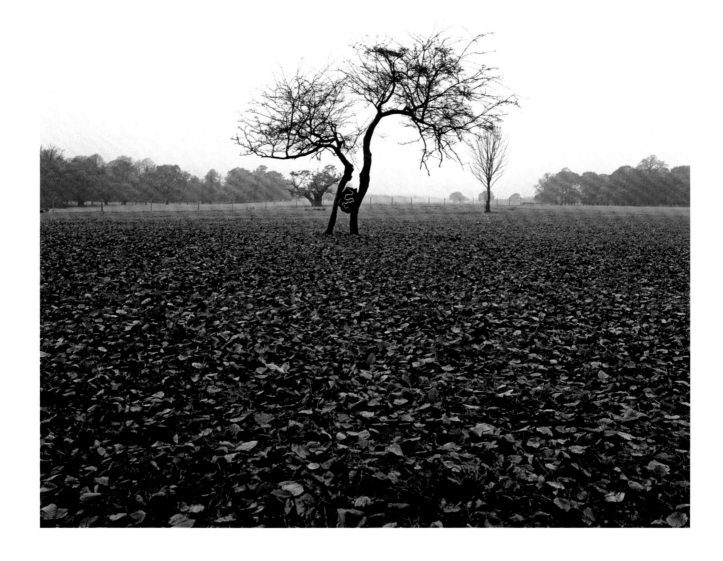

ICE HELD BETWEEN TWO TRUNKS OF A ONCE SINGLE HAWTHORN TREE THAT HAD BEEN SPLIT BY LIGHTNING. DARK, WET LEAVES. TORN LINE. TATTON PARK, CHESHIRE. 23 NOVEMBER 2005

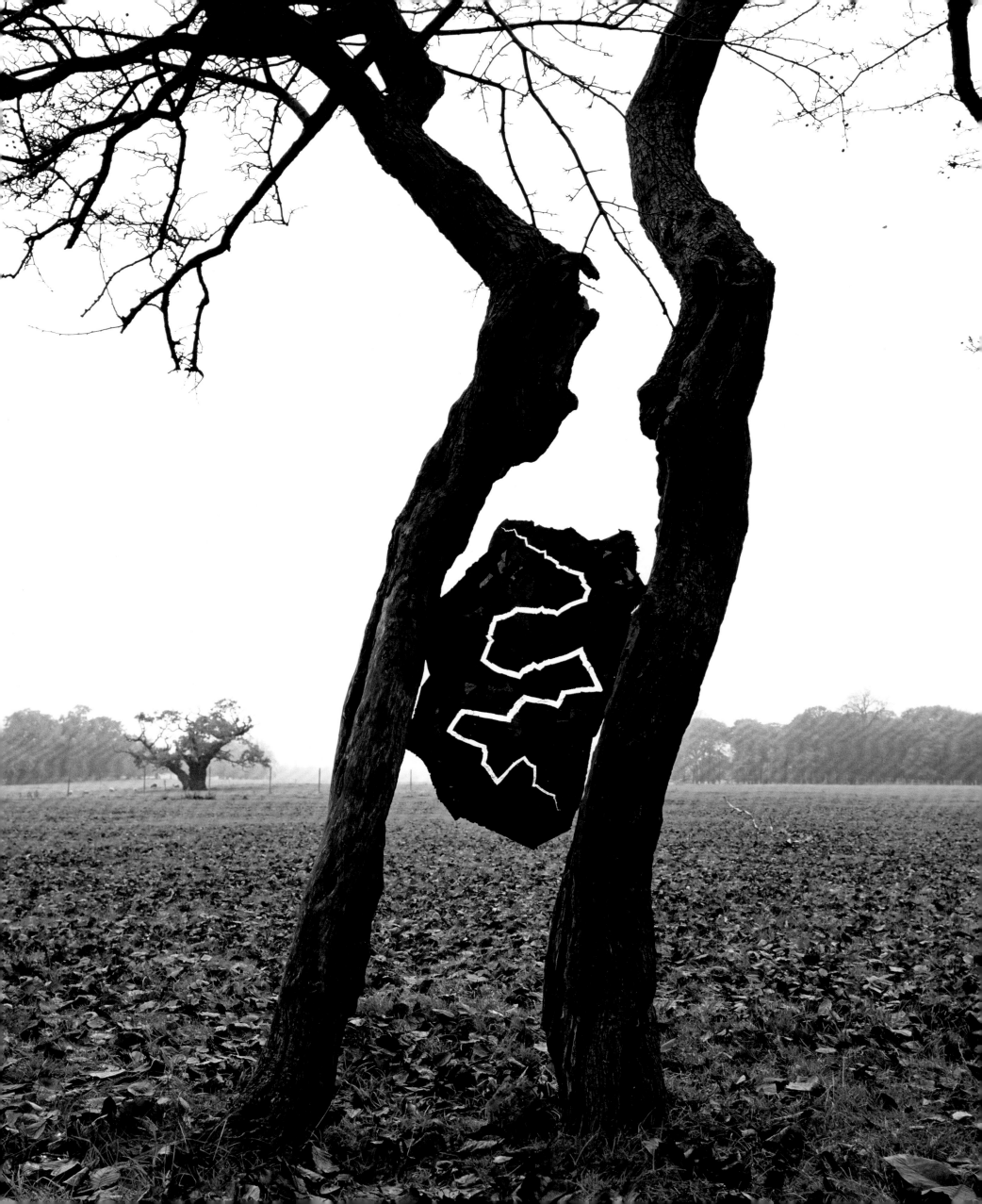

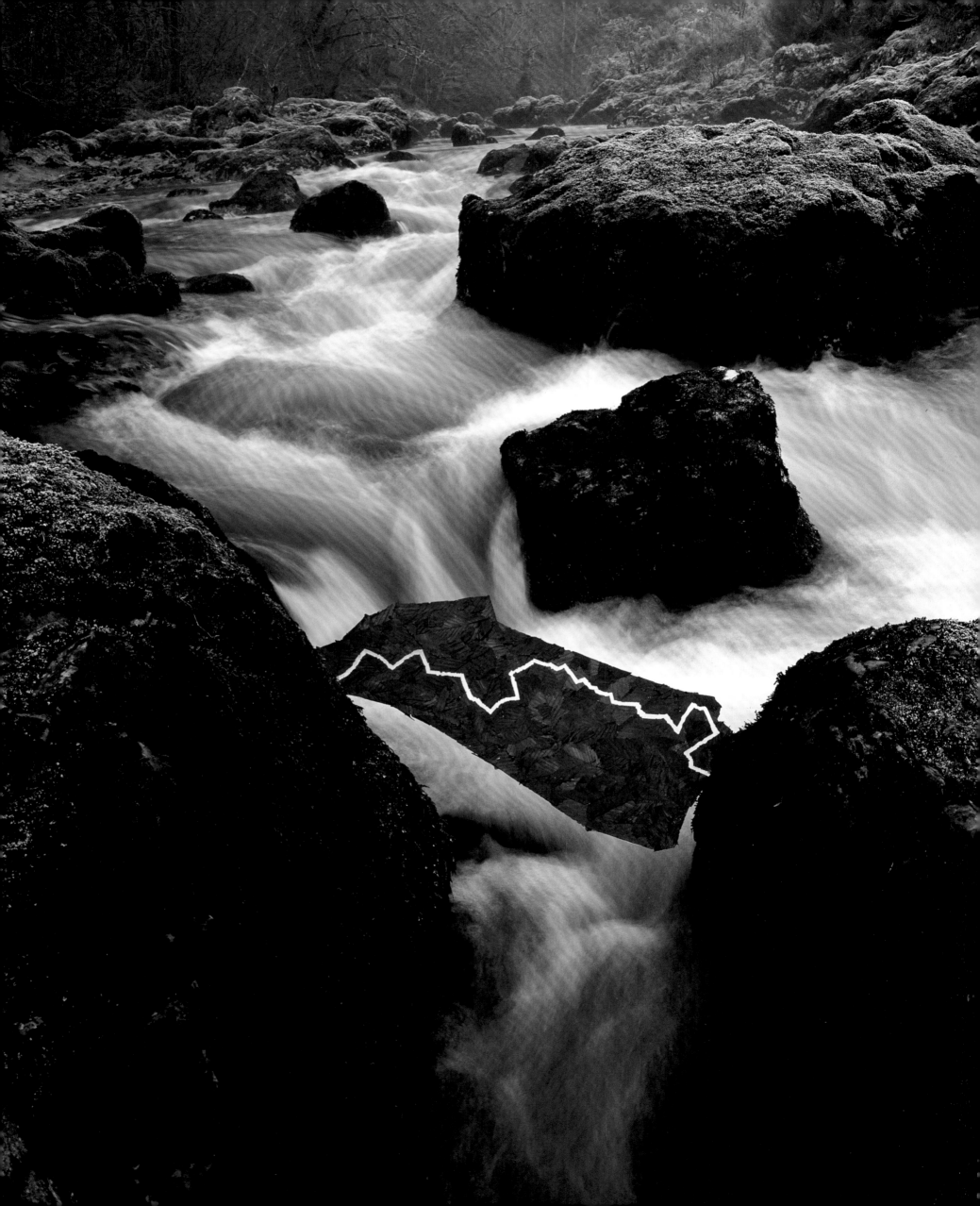

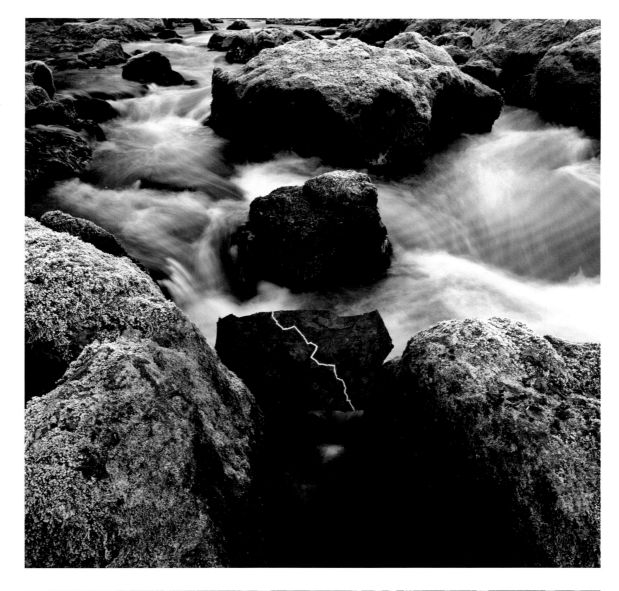

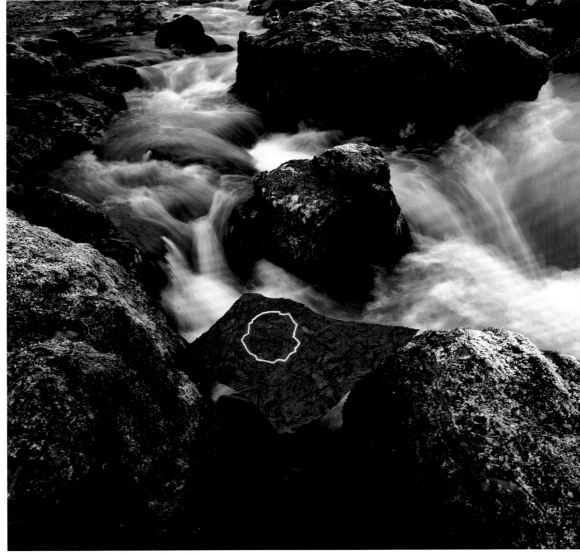

THIN SHEETS OF ICE. WEDGED BETWEEN RIVER ROCKS. DARK ELM LEAVES. TWO TORN LINES AND A CIRCLE. DUMFRIESSHIRE, SCOTLAND. DECEMBER 2005

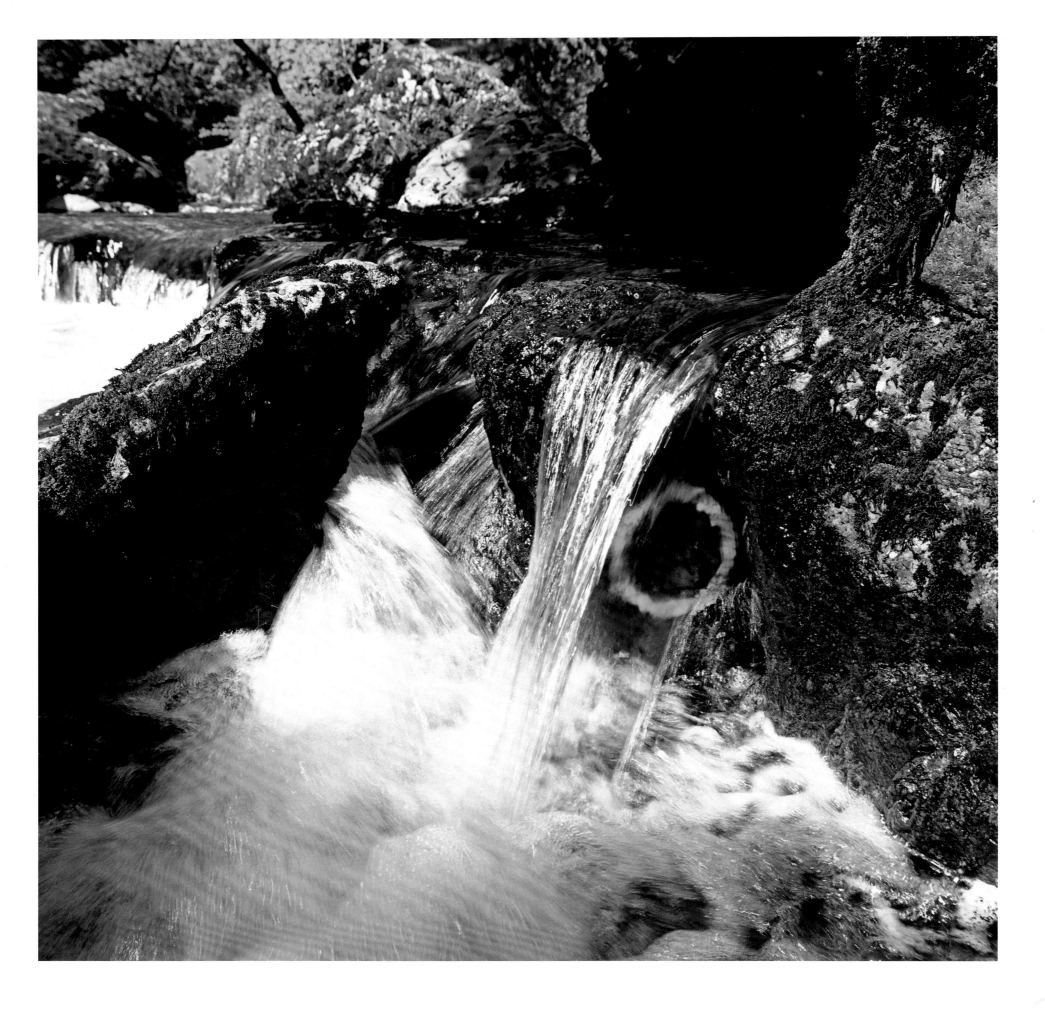

SYCAMORE LEAVES. LAID AGAINST THE WET STONE BEHIND A SMALL WATERFALL. SUNNY. DUMFRIESSHIRE, SCOTLAND. 1, 6 JUNE 2006

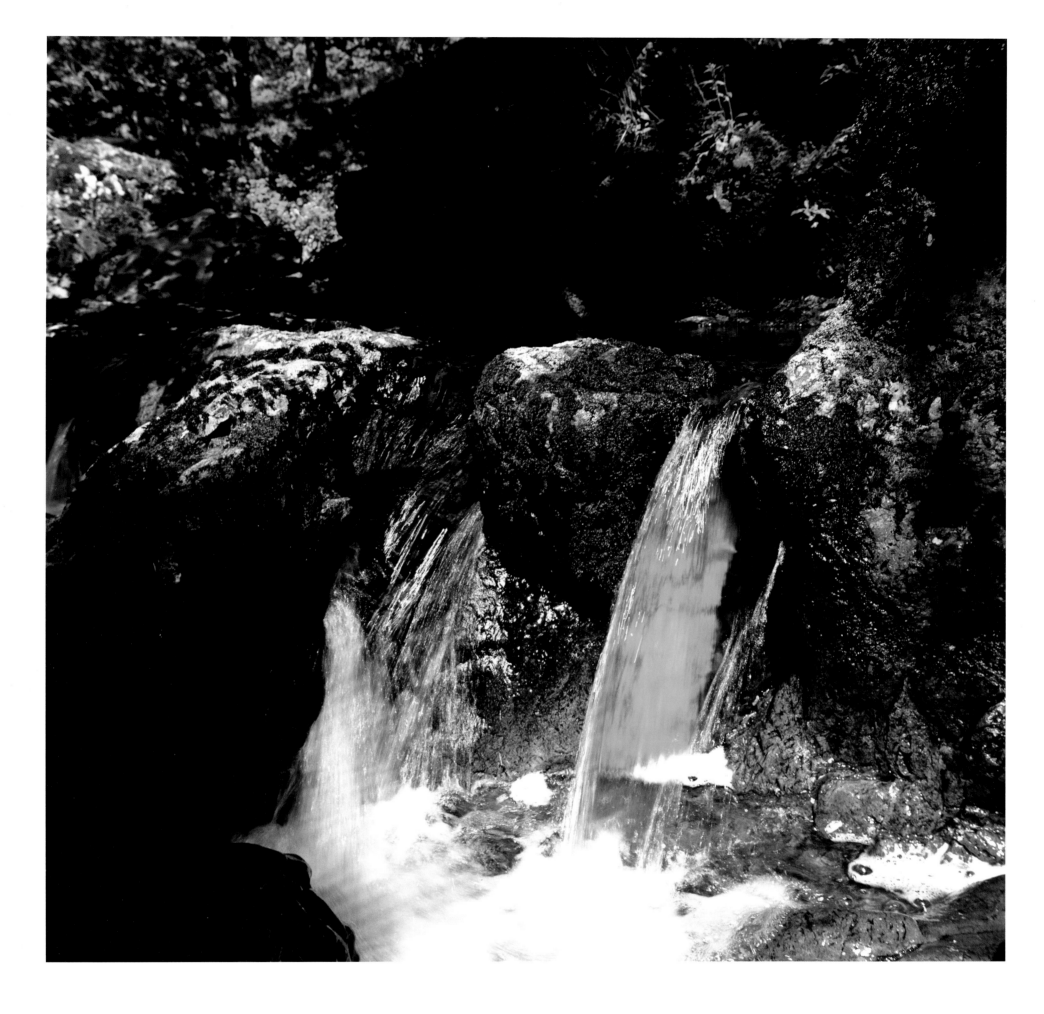

RIVER ROCK. WORKED TO A POINT WITH MUD. COVERED WITH WET SYCAMORE LEAVES. DUMFRIESSHIRE, SCOTLAND. 6 JUNE 2006

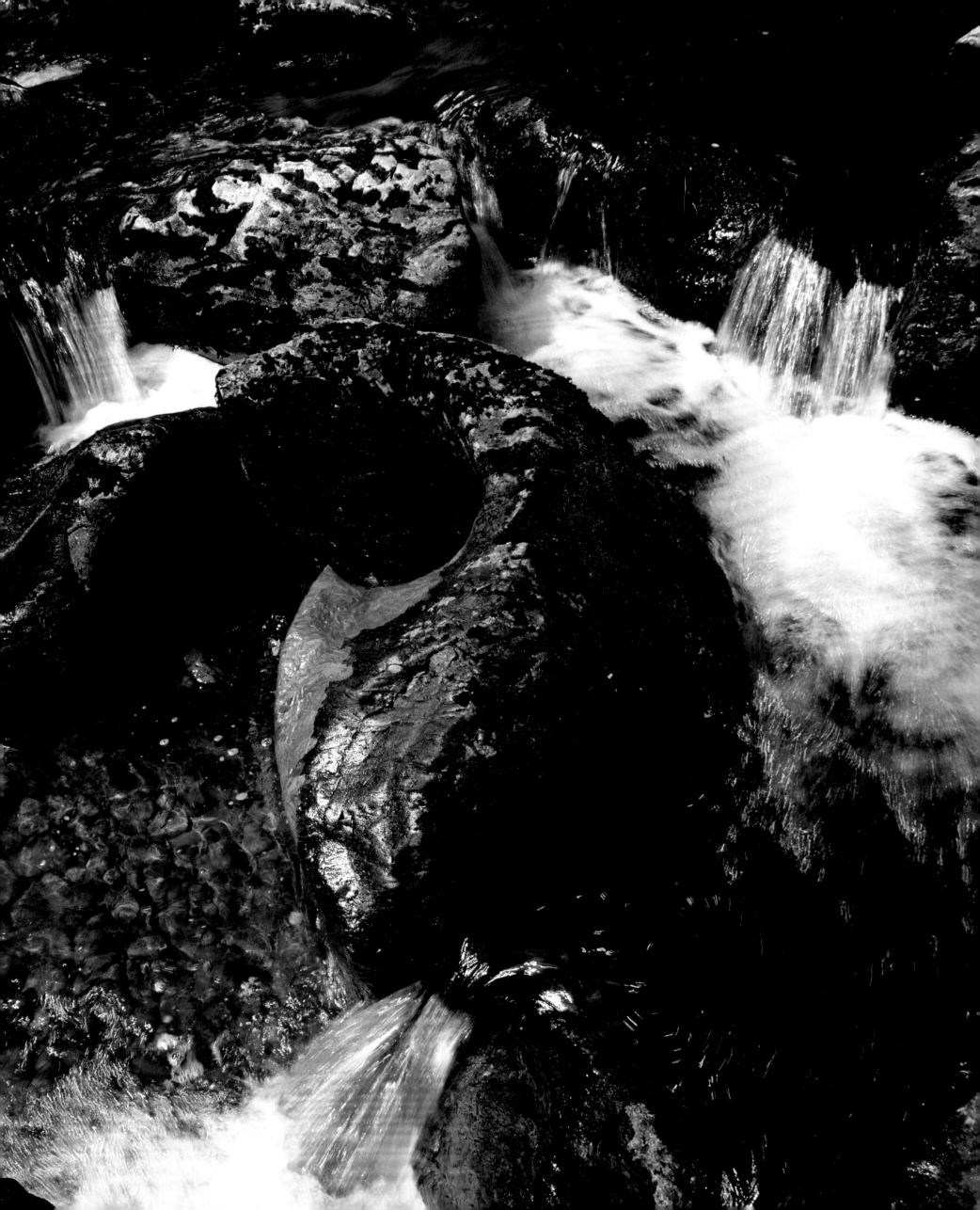

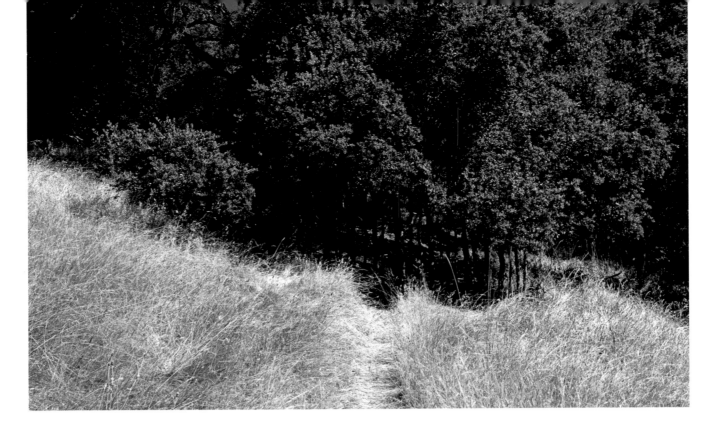

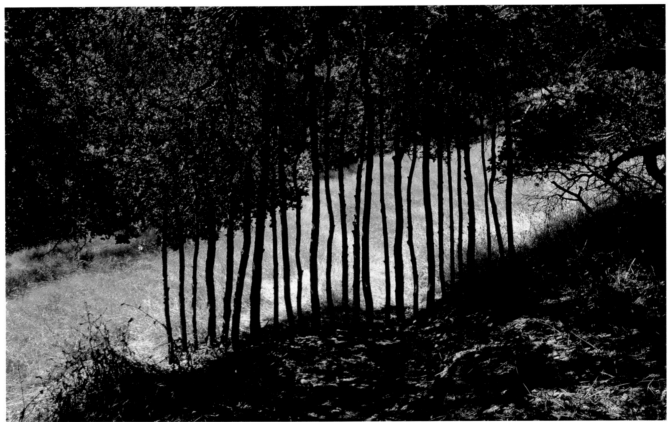

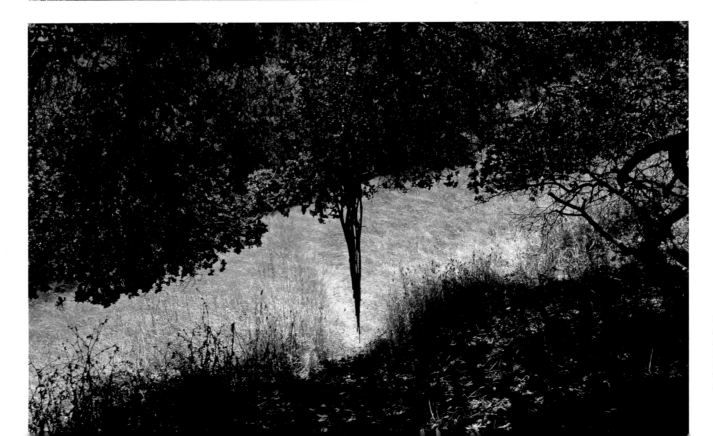

BRANCHES. AT THE EDGE OF
A CLEARING. BETWEEN TREE
AND GROUND, LIGHT AND
DARK, WOOD AND GRASS,
HEAT AND SHADE.
TRIPLE C RANCH,
CALIFORNIA. 26–29 JULY 2006

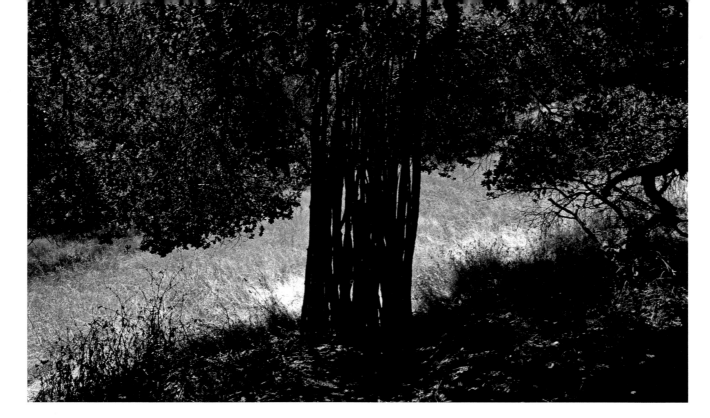

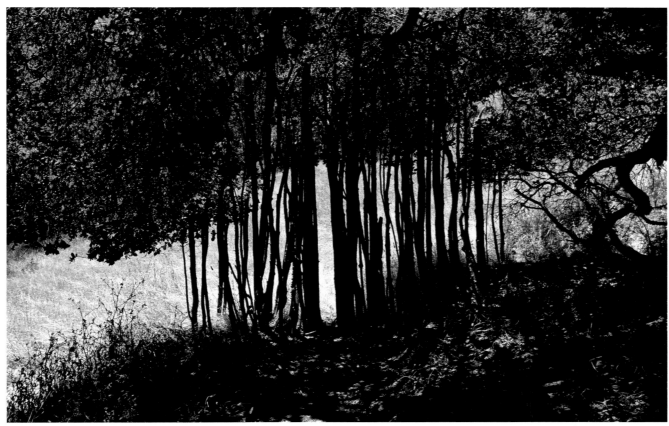

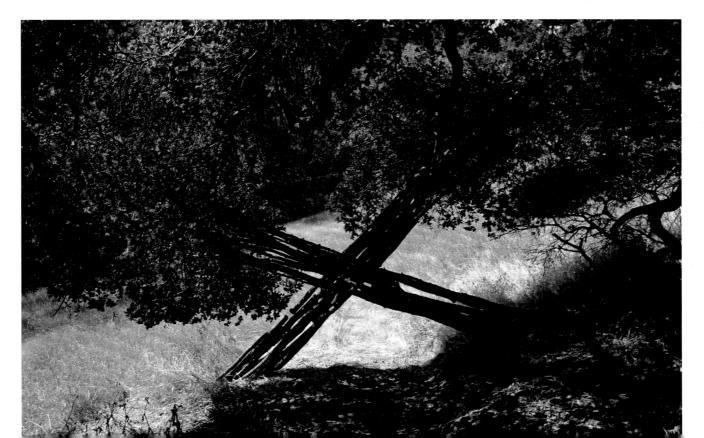

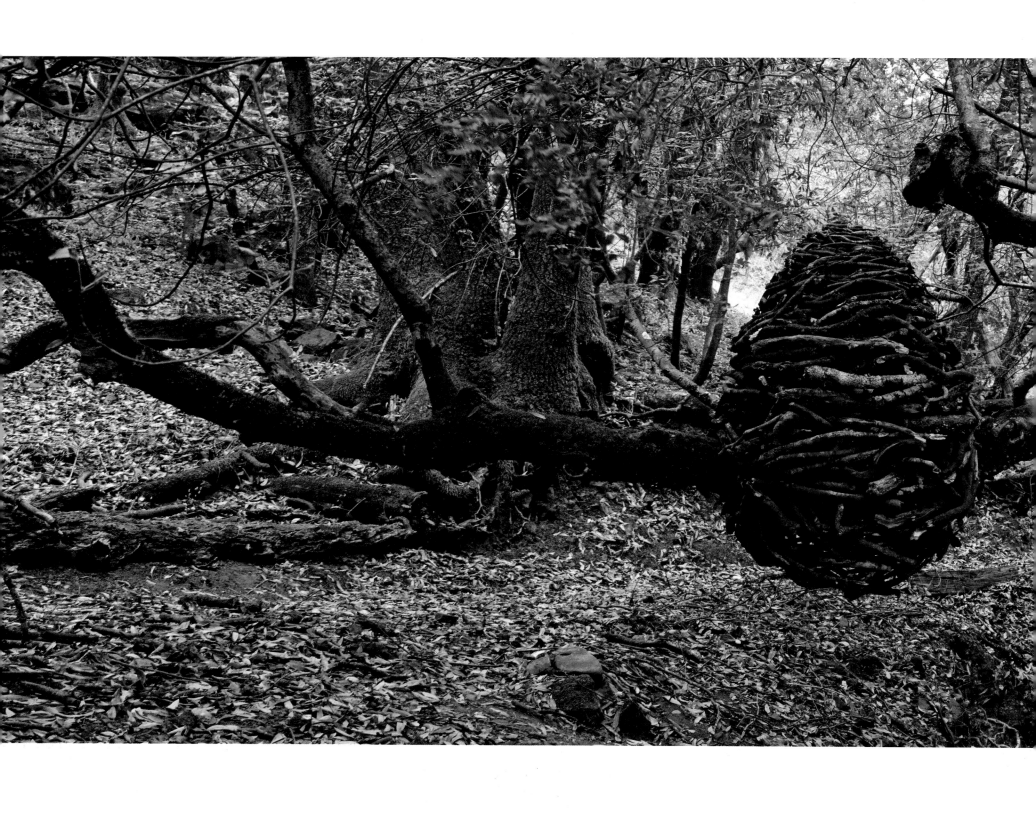

WINDFALLEN CURVED BRANCHES. WORKED AROUND THE HORIZONTAL TRUNK OF A GROWING TREE. TRIPLE C RANCH, CALIFORNIA. 27 JULY 2006

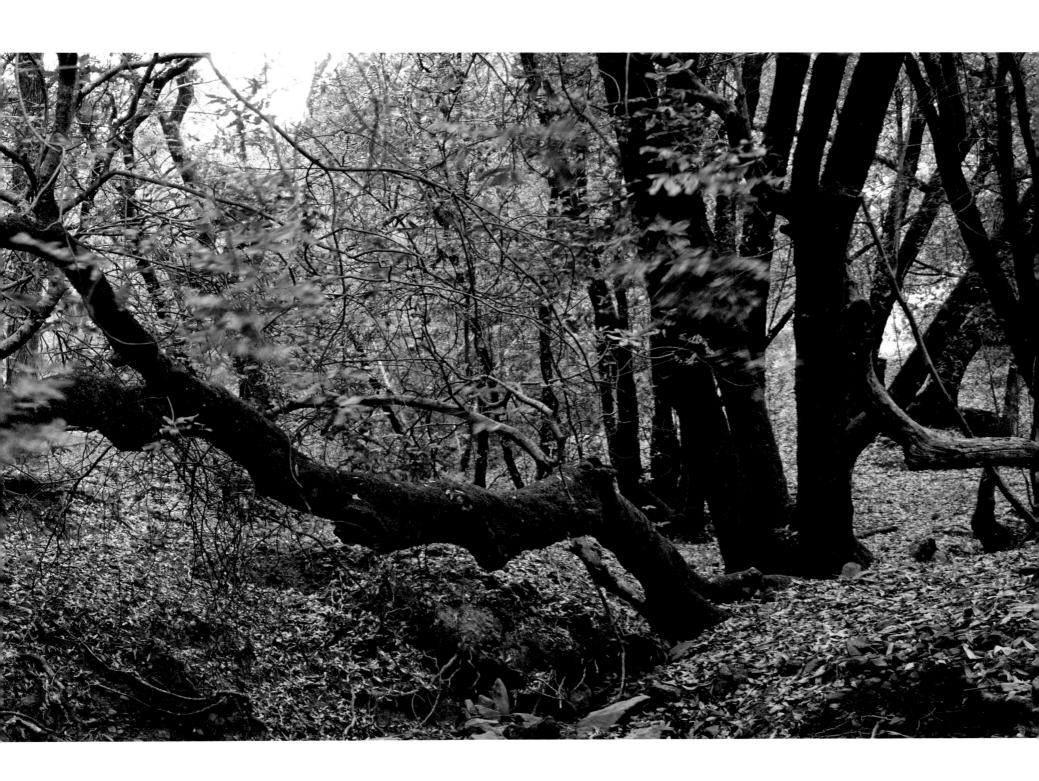

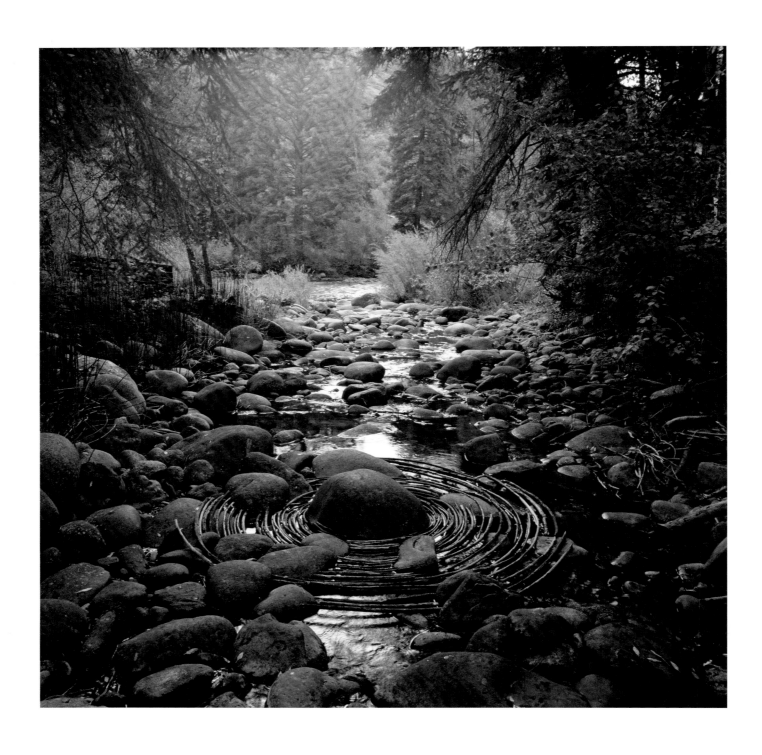

CURVED STICKS LAID AROUND A RIVER BOULDER. TOOK LONGER TO FIND THE STICKS THAN TO MAKE THE WORK. WOODY CREEK, COLORADO. 16 SEPTEMBER 2006

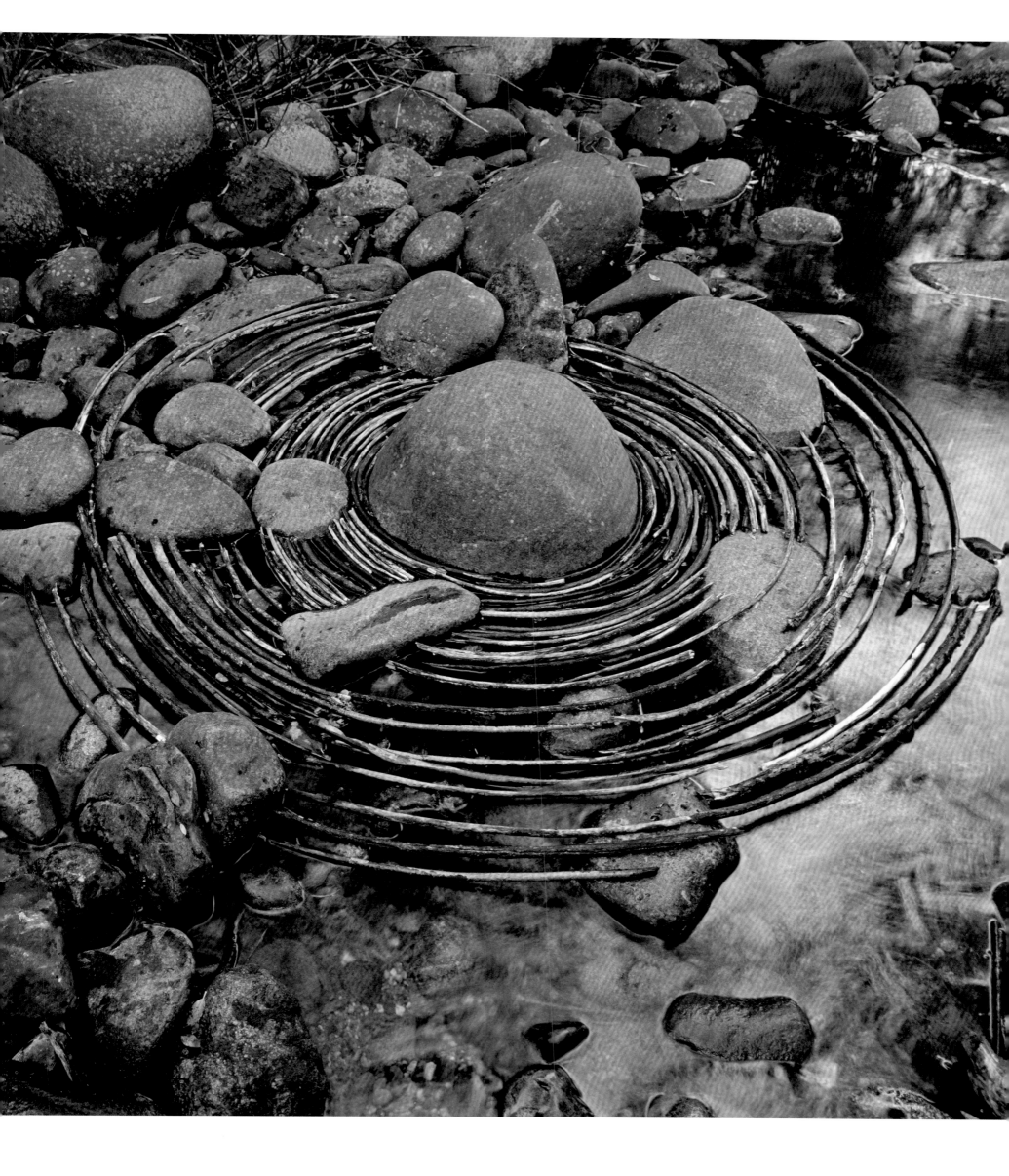

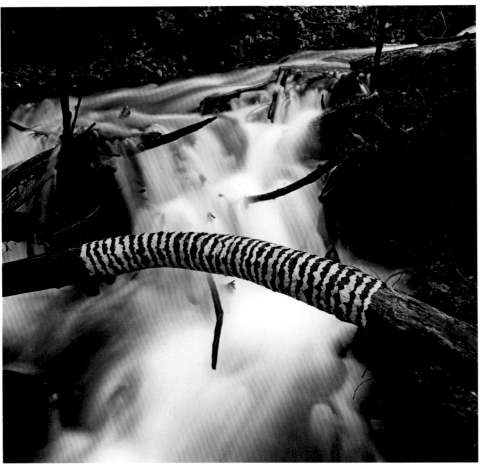

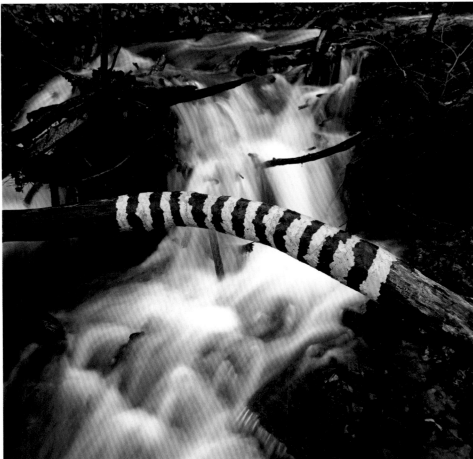

3 DECEMBER 2006

4 DECEMBER 2006

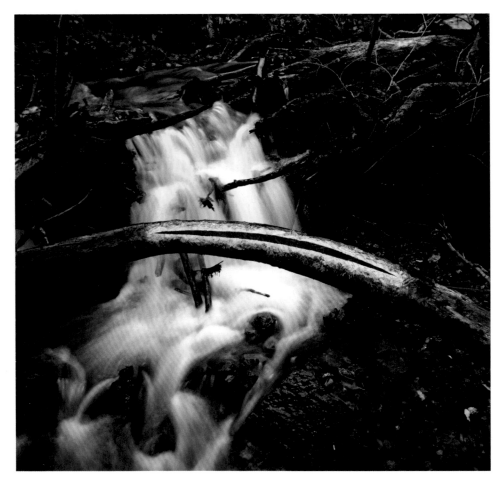

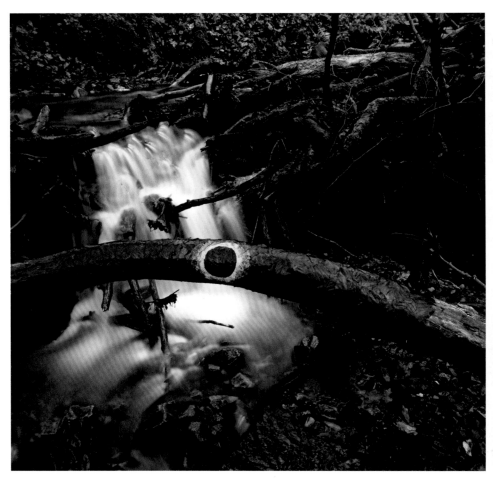

8 DECEMBER 2006

10 DECEMBER 2006

END OF A LONG AUTUMN. ONE ELM TREE STILL WITH LEAVES. LESS YELLOW TO WORK WITH EACH DAY. DUMFRIESSHIRE, SCOTLAND

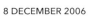
40

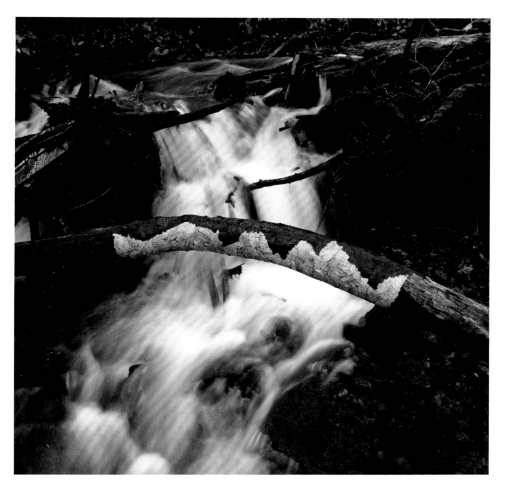

5 DECEMBER 2006

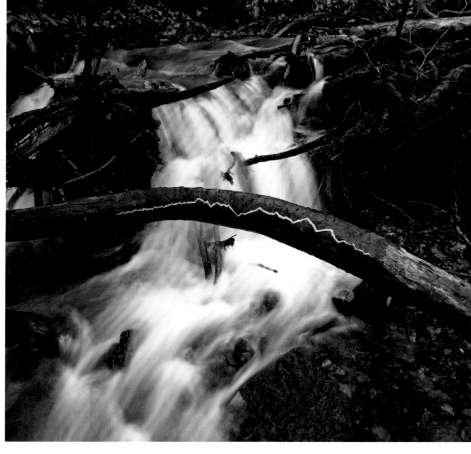

6 DECEMBER 2006

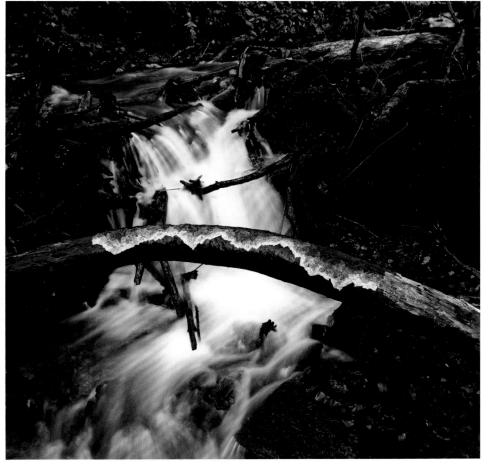

16 DECEMBER 2006

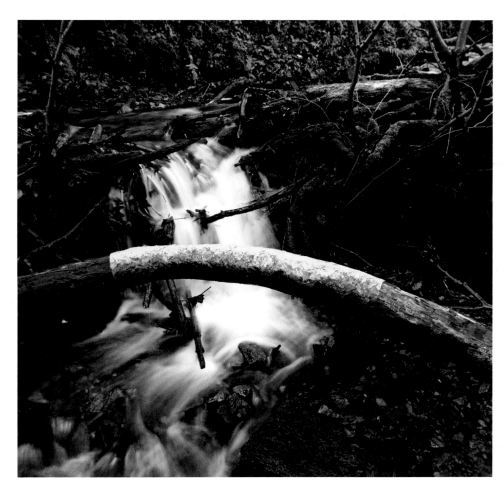

17 DECEMBER 2006

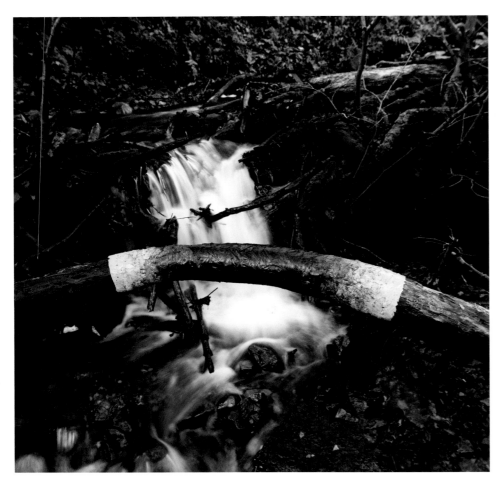

19 DECEMBER 2006

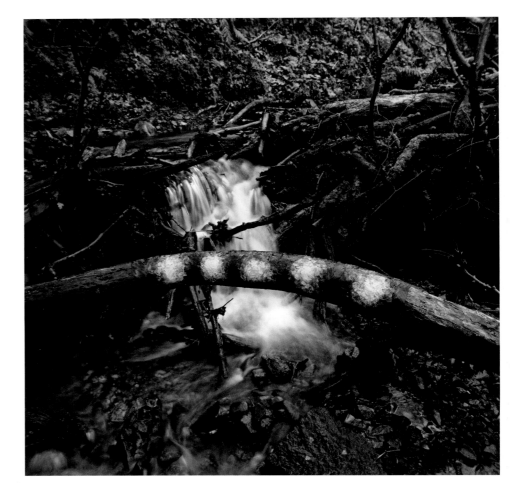

20 DECEMBER 2006

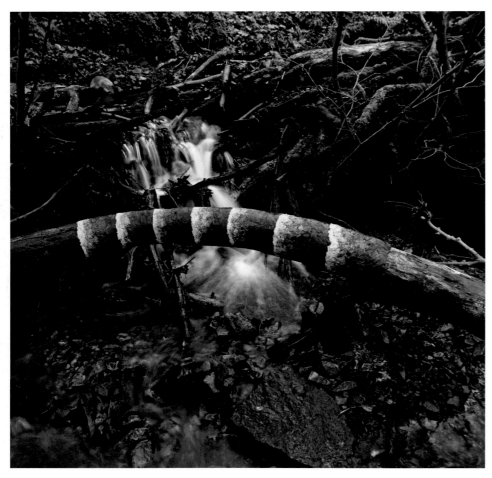

23 DECEMBER 2006

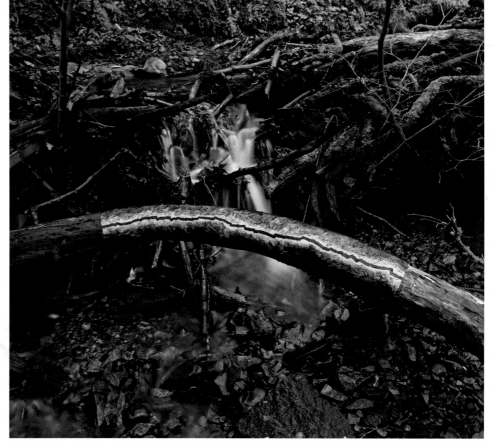

25 DECEMBER 2006

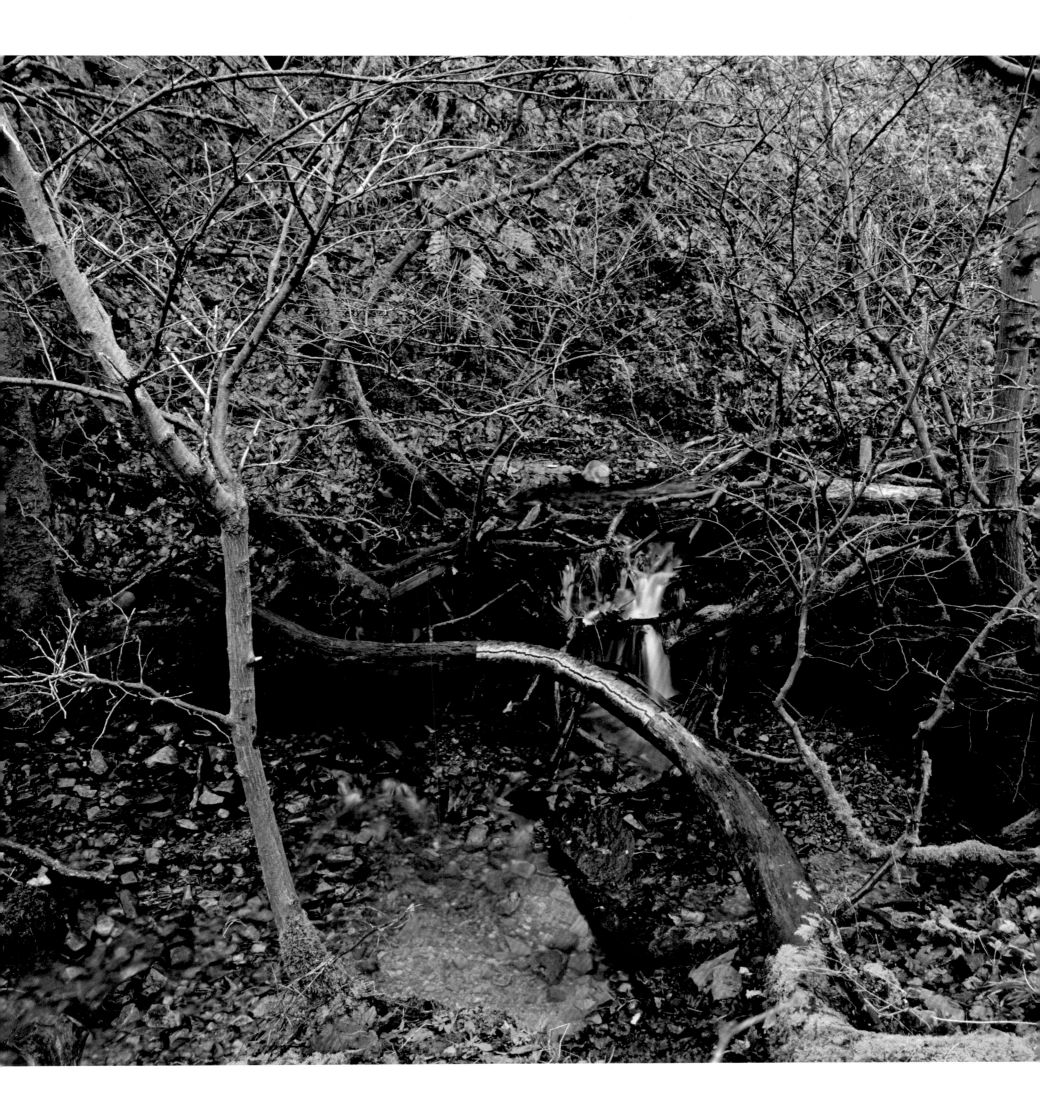

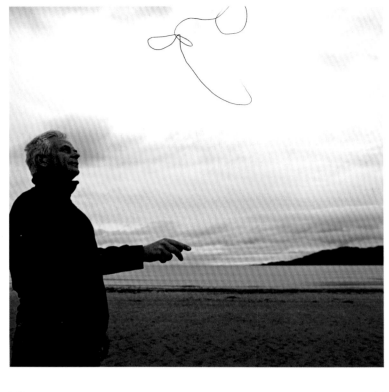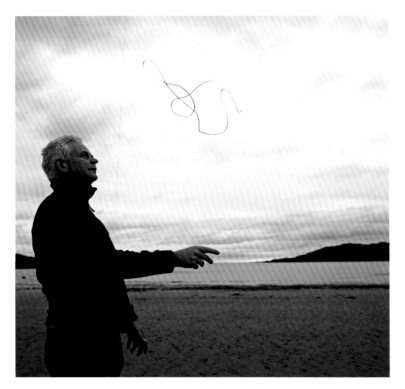

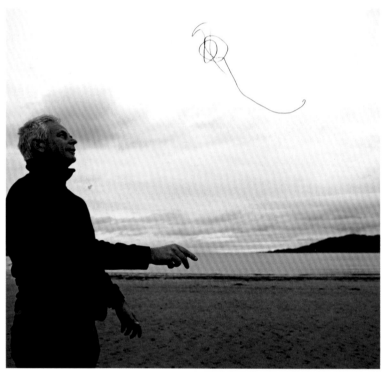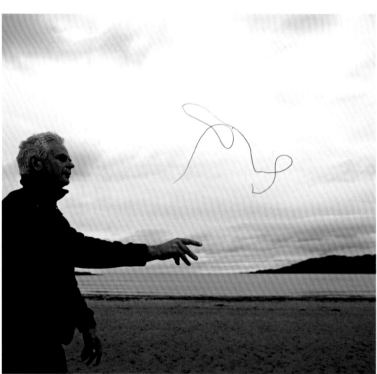

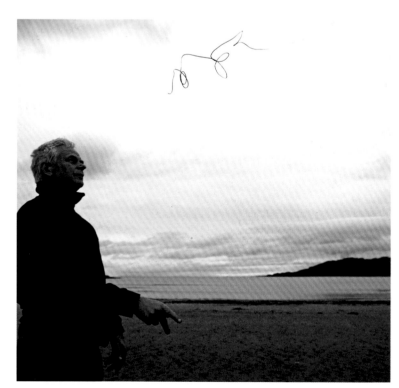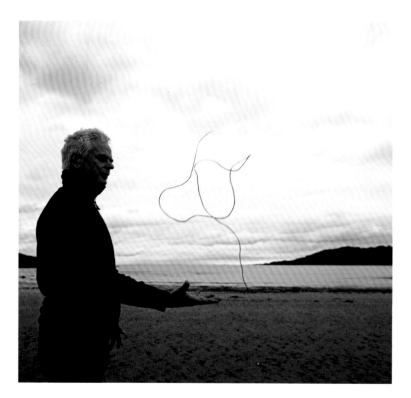

SEAWEED THROWS. DUMFRIESSHIRE, SCOTLAND. 19 AUGUST 2007

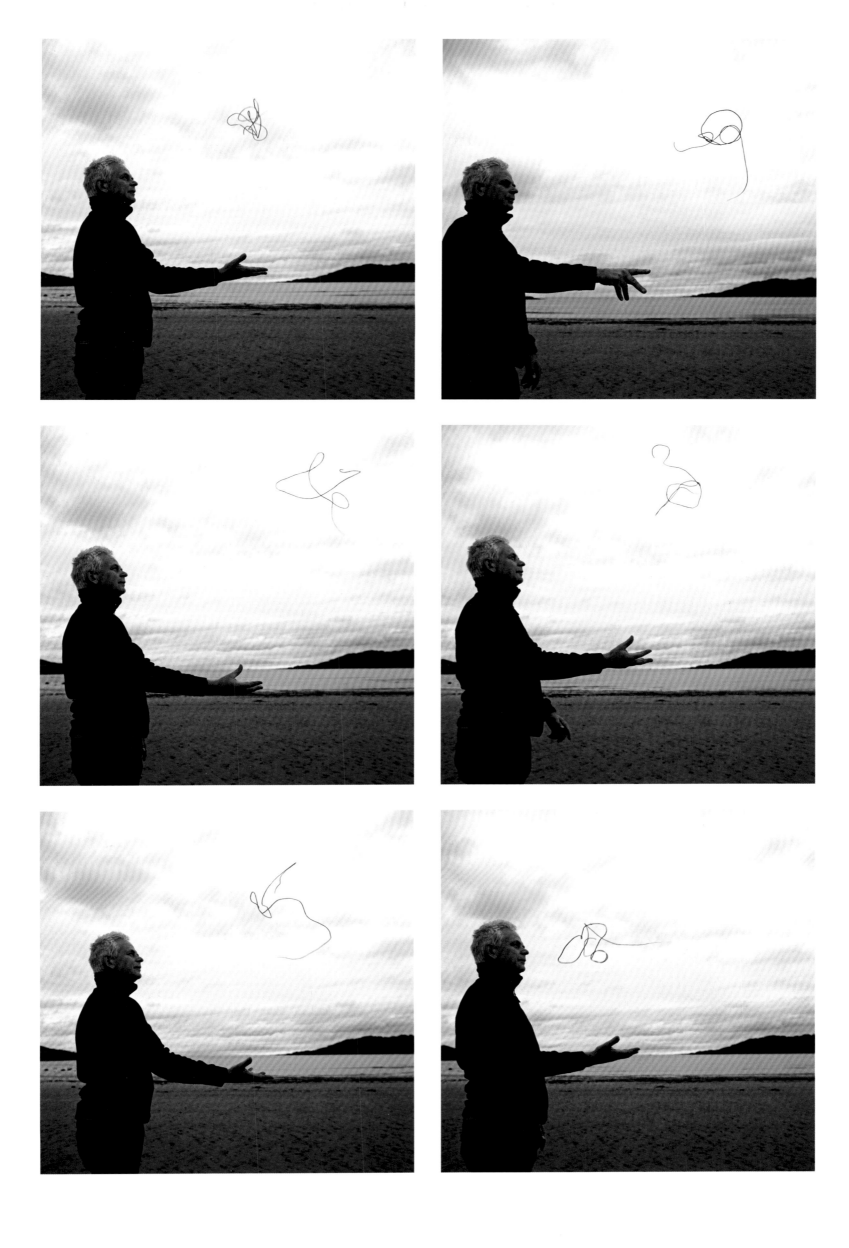

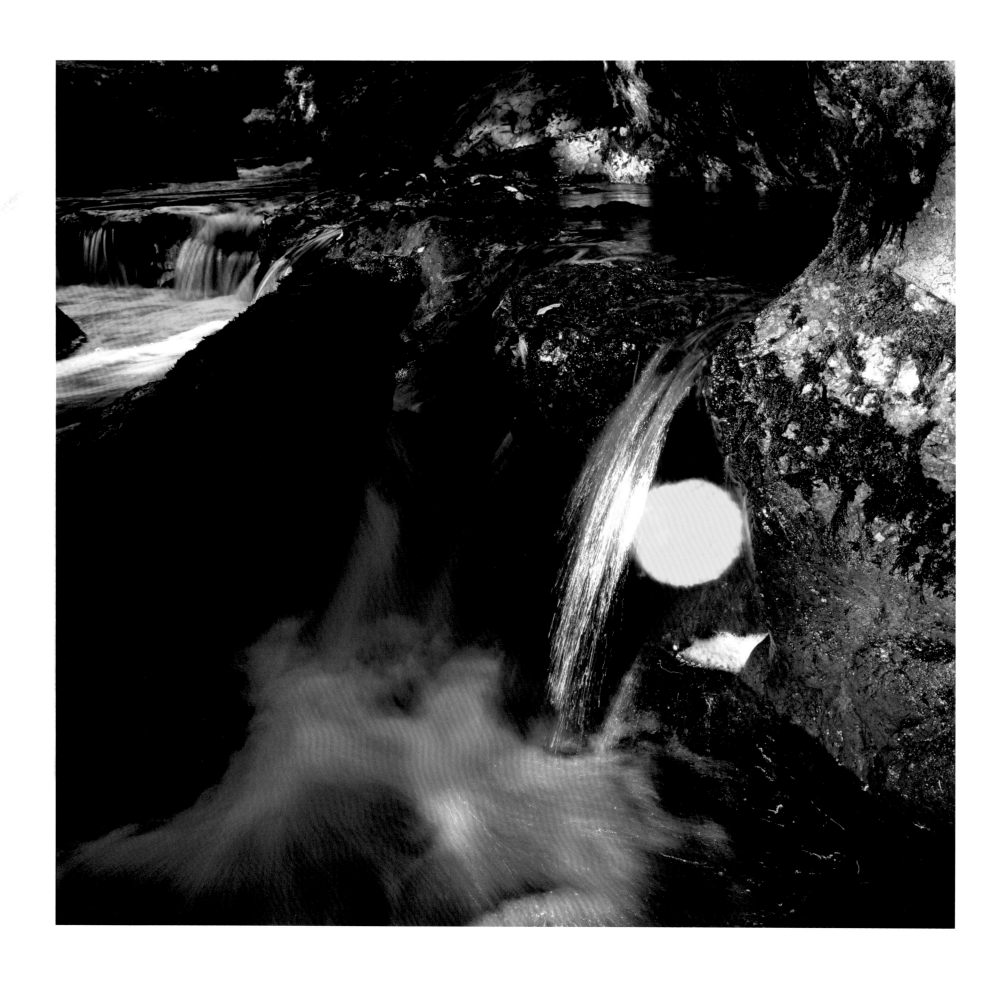

YELLOW ELM LEAVES. LAID ON WET ROCK BEHIND A SMALL, THINLY FLOWING WATERFALL. DUMFRIESSHIRE, SCOTLAND. 18, 19 OCTOBER 2007

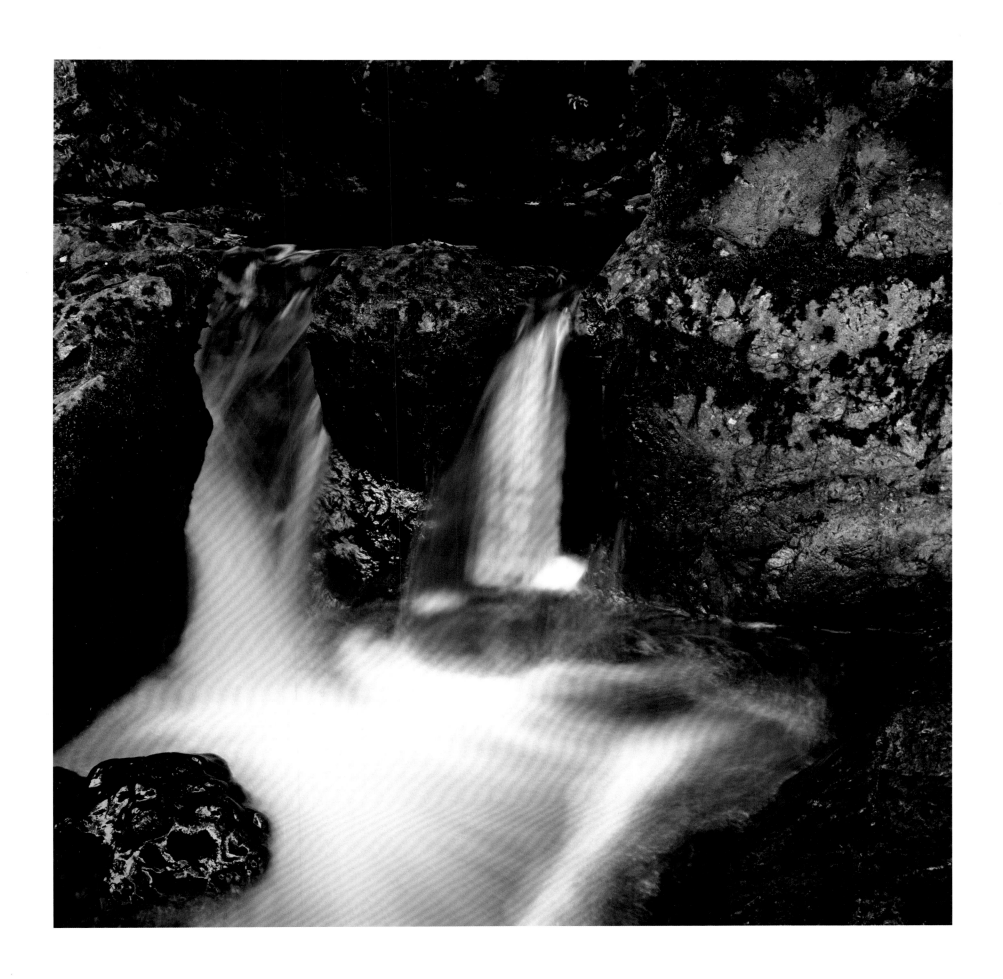

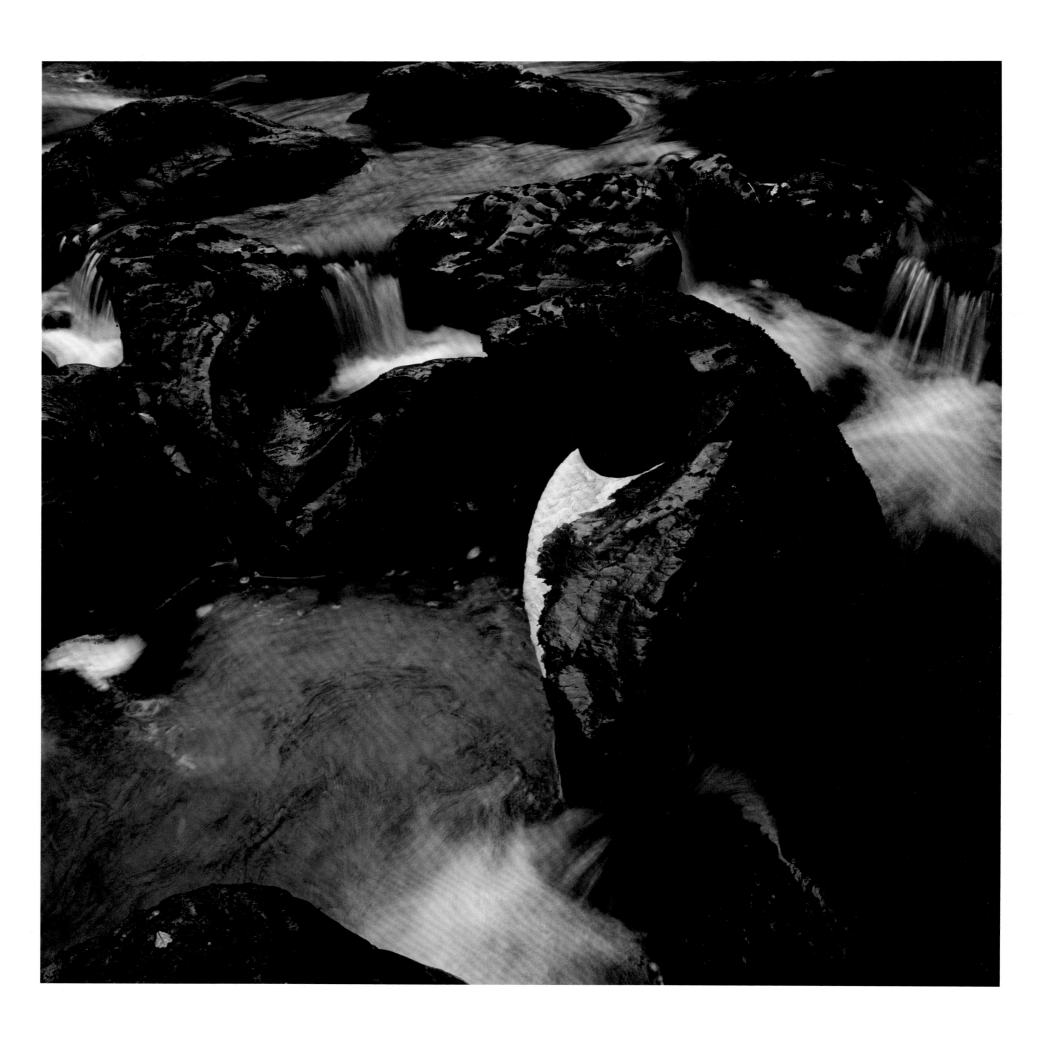

RIVER ROCK WORKED TO A POINT WITH MUD. COVERED WITH ELM LEAVES. DUMFRIESSHIRE, SCOTLAND. 20, 21 OCTOBER 2007

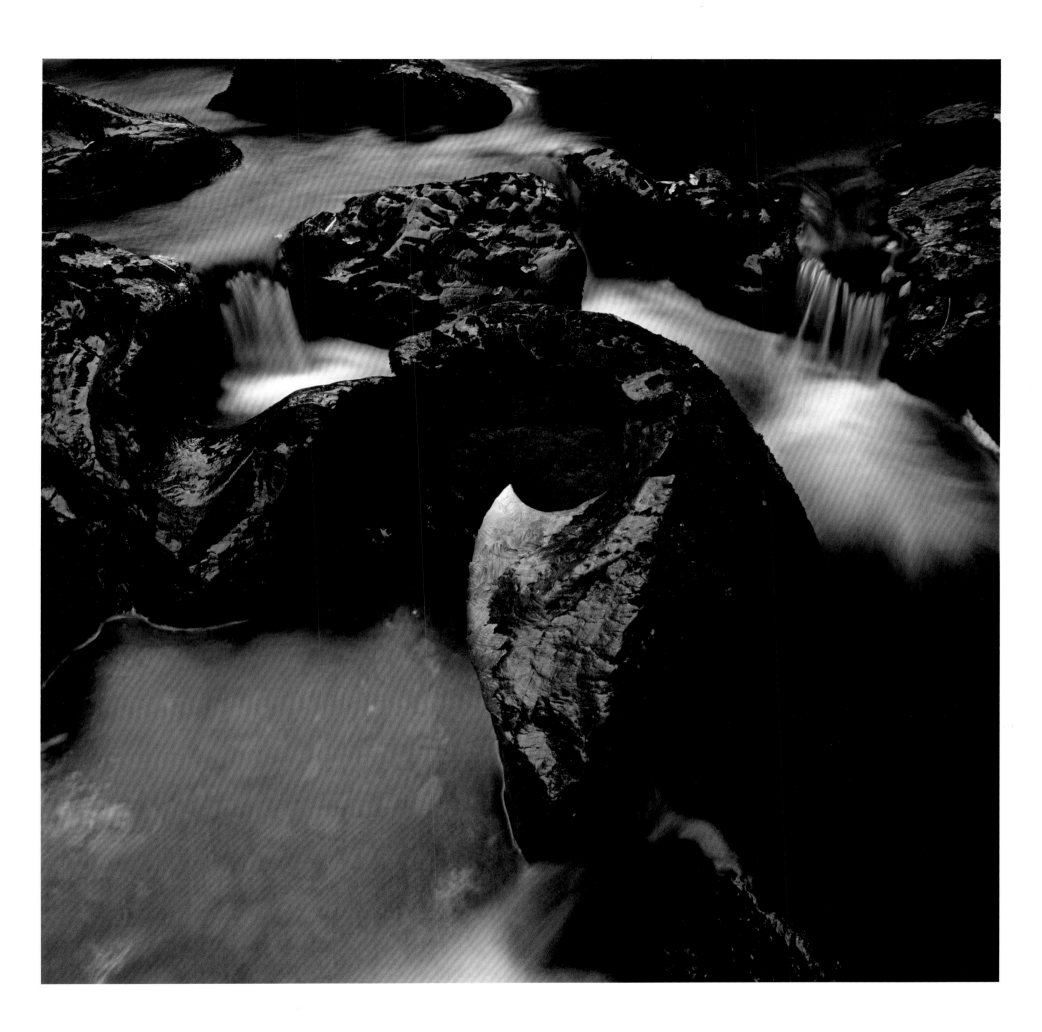

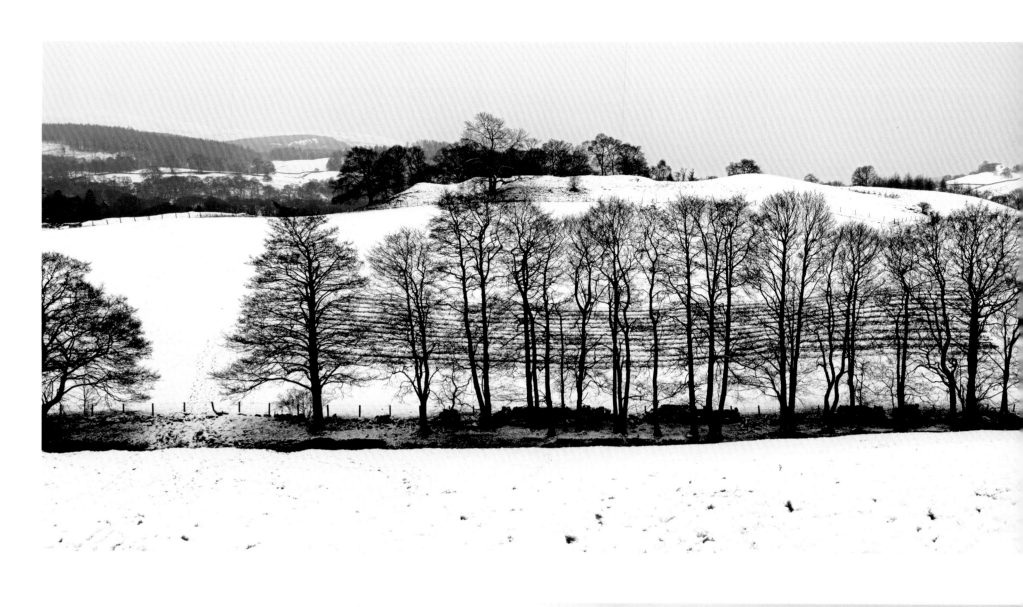

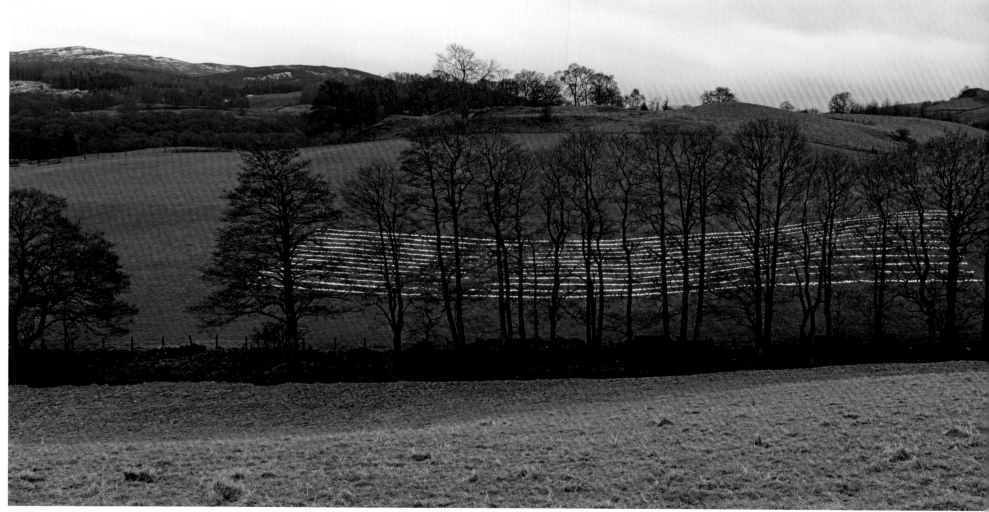

HEAVY, WET, FRESH FALLEN SNOW. SCRAPED INTO LINES WITH A SHOVEL. MADE IN ANTICIPATION THAT THE SNOW WOULD MELT. LEAVING LINES. DUMFRIESSHIRE, SCOTLAND. 4, 5 JANUARY 2008

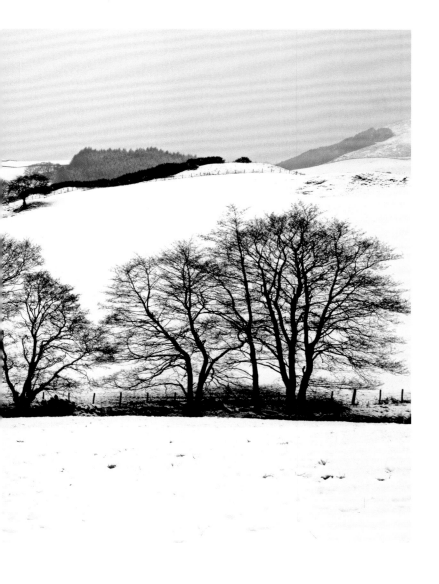
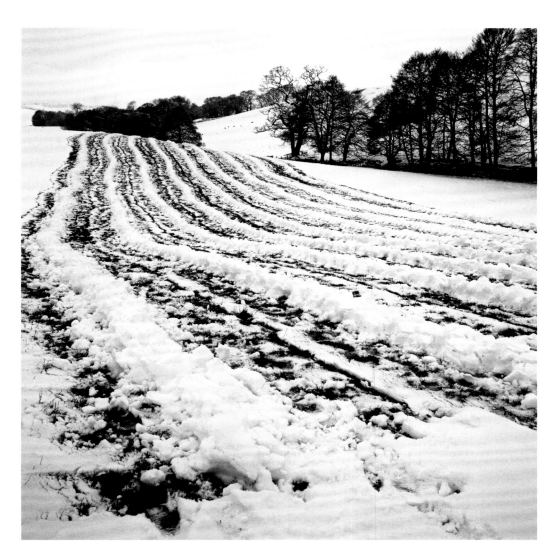
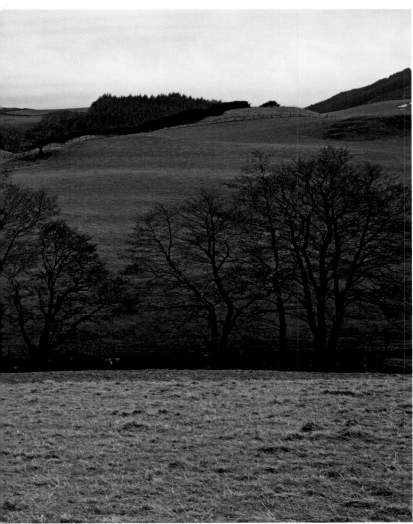
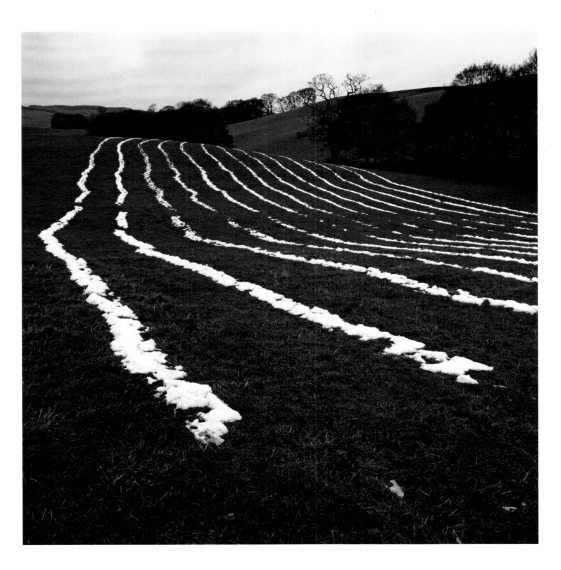

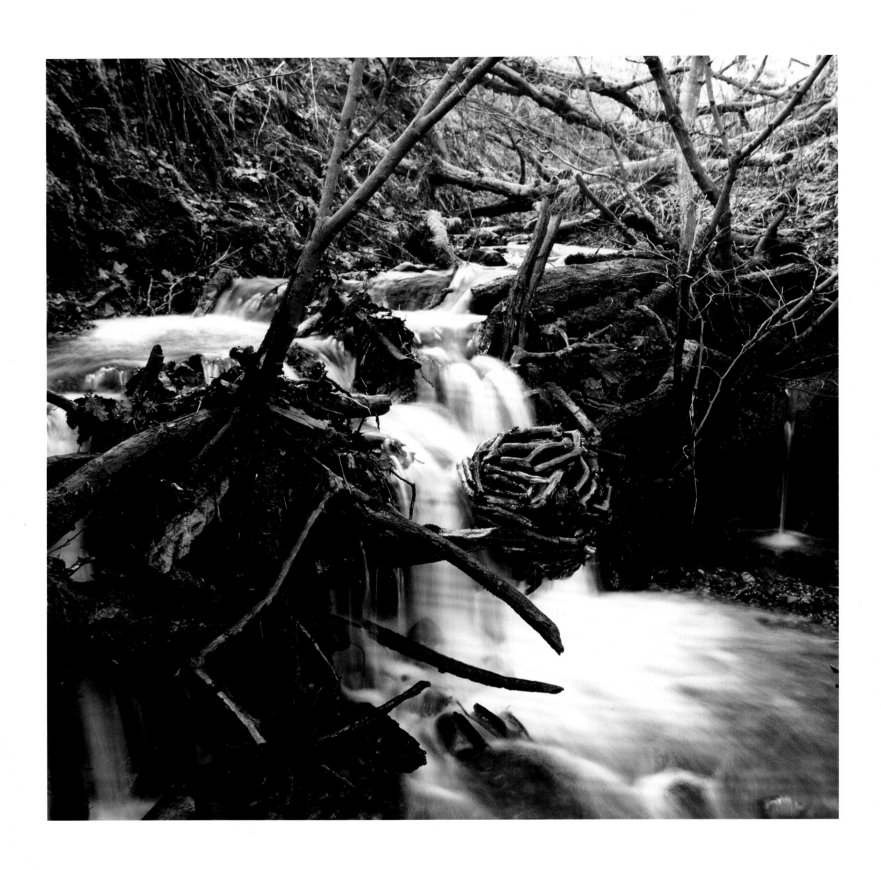

ELM STACK. WORKED AROUND BRANCHES PUSHED INTO THE MATTED DEADWOOD OF A SMALL WATERFALL. DUMFRIESSHIRE, SCOTLAND. JANUARY 2008

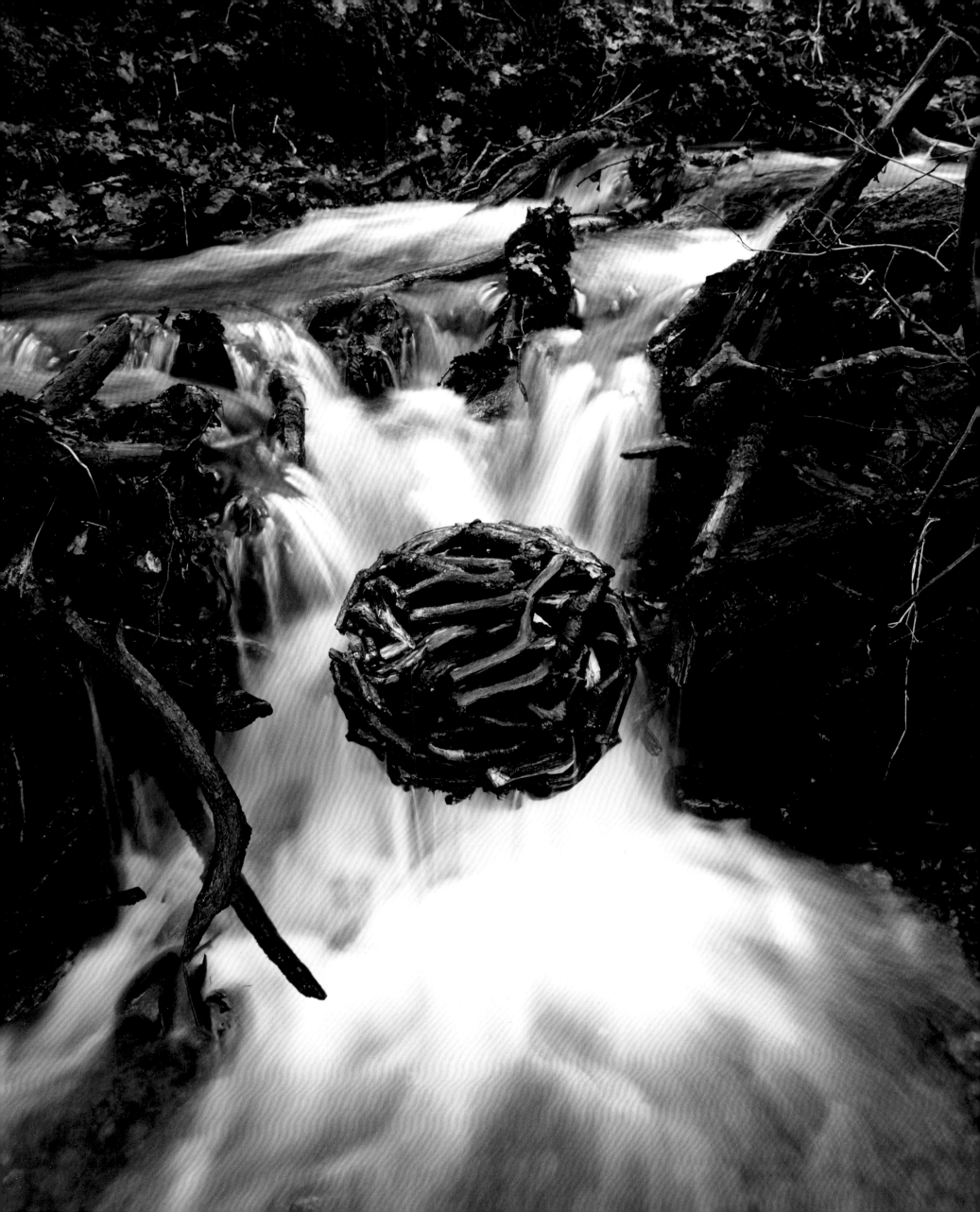

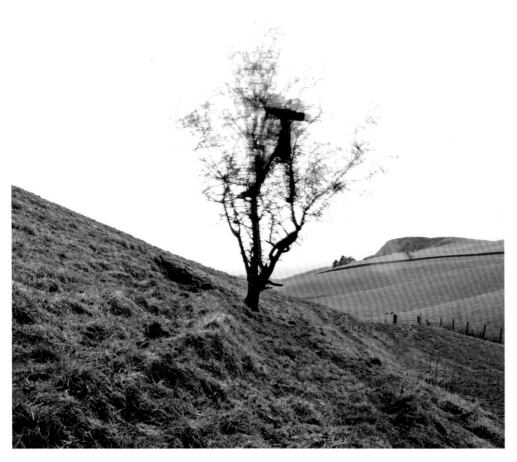
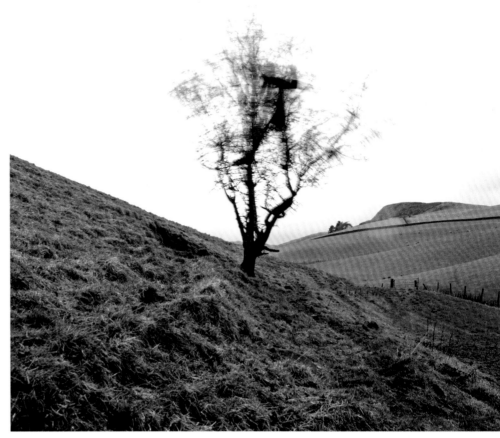
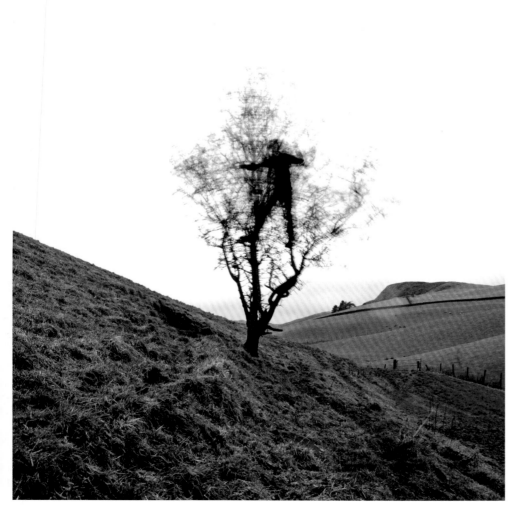
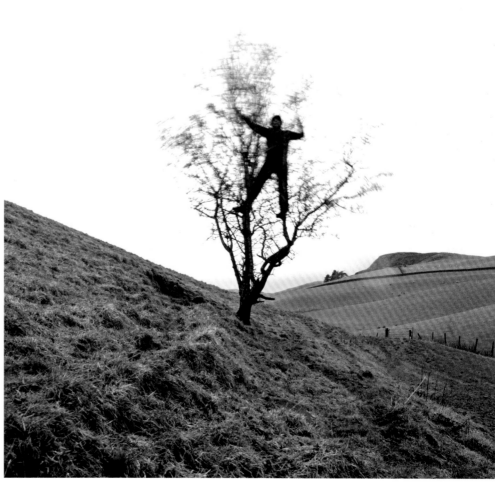

HAWTHORN TREE SHAKE. DUMFRIESSHIRE, SCOTLAND. FEBRUARY 2008

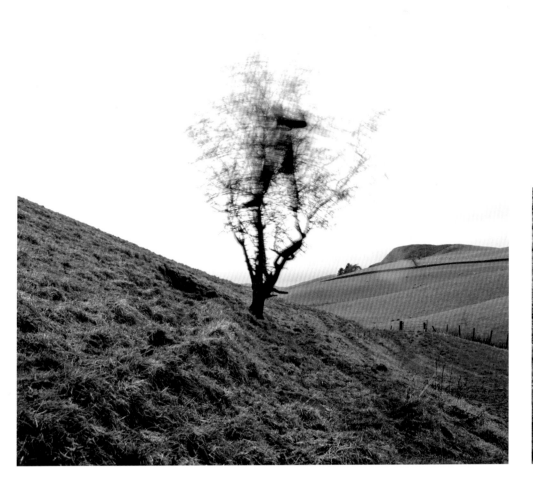
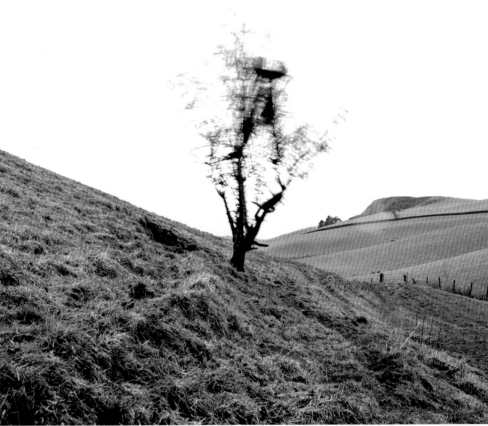
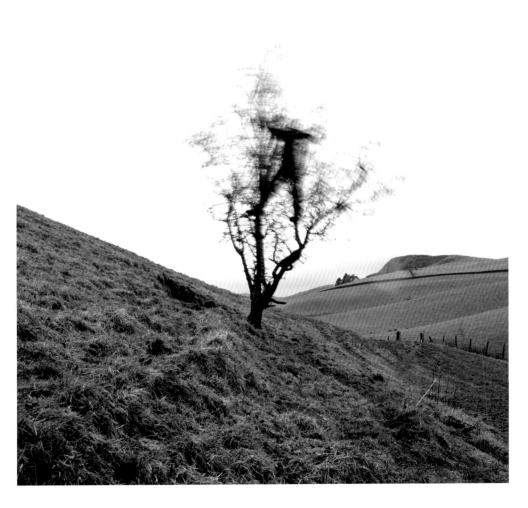
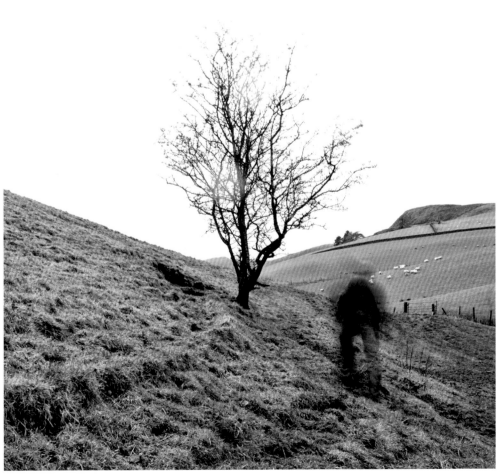

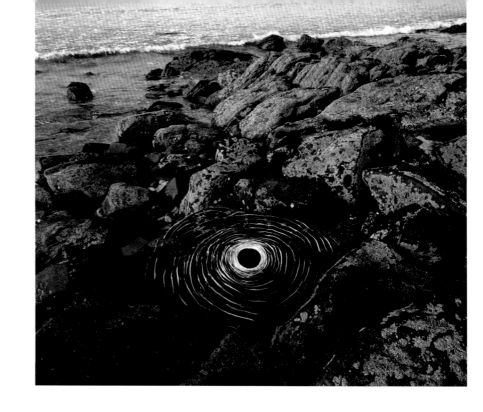

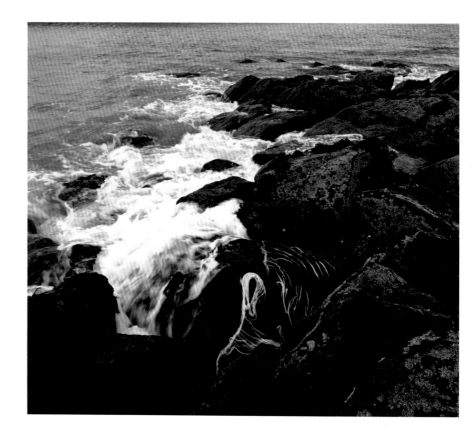

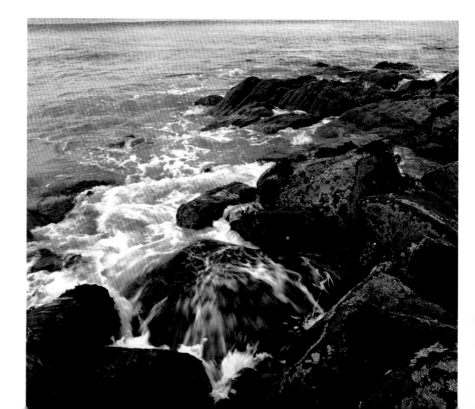

WET WOOL. HOLE. TIDE. NORTH UIST, SCOTLAND. 15 MARCH 2008

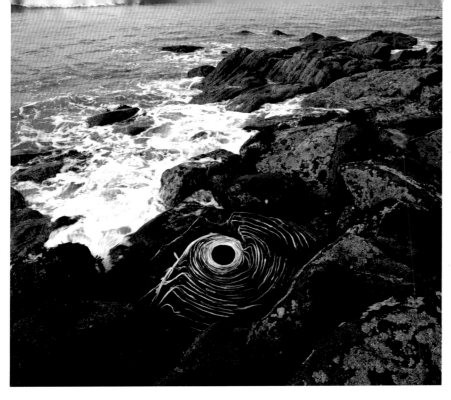 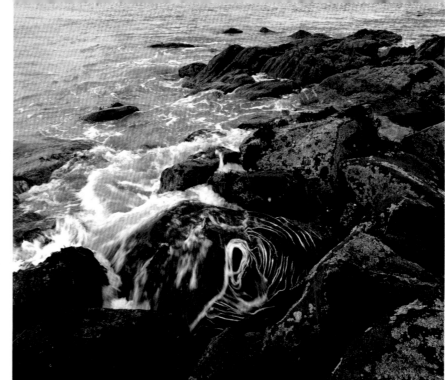

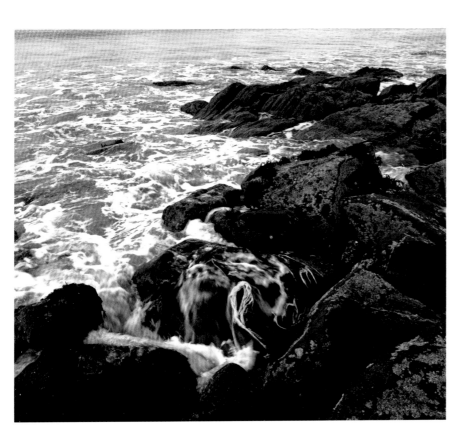 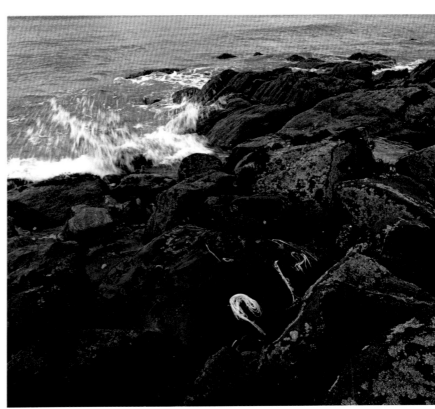

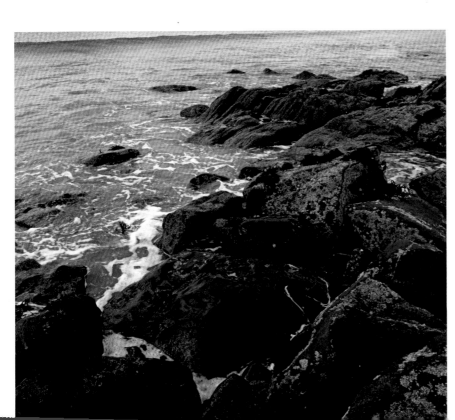 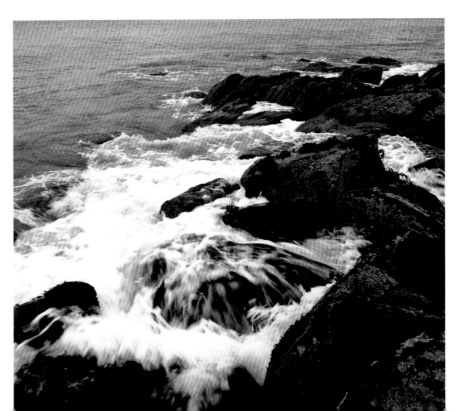

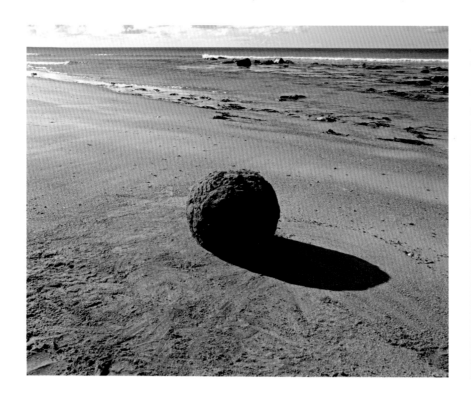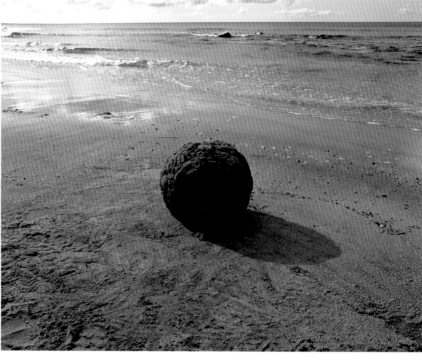
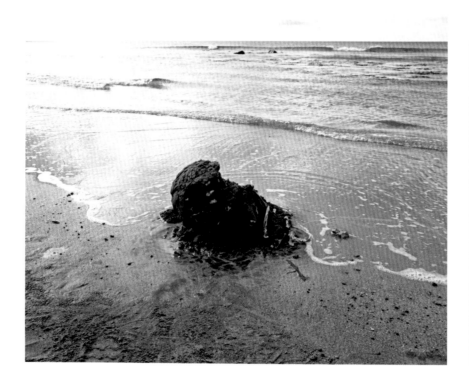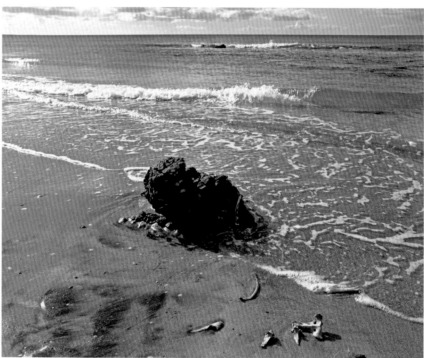
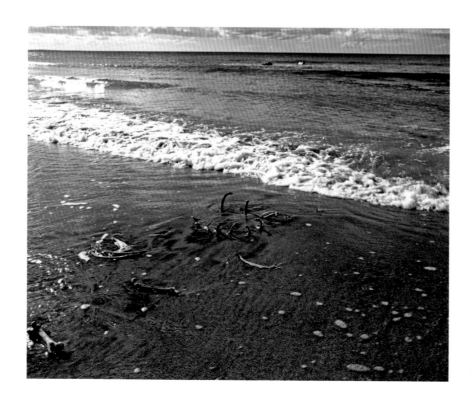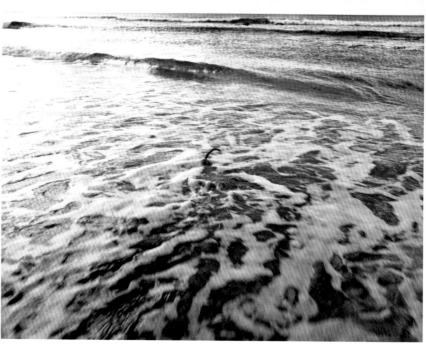

SHEEP BONES. FROM DEAD HOLE IN DUNES. EXPOSED BY THE SEA. REBURIED IN A BOULDER OF SAND. AHEAD OF AN INCOMING TIDE. NORTH UIST, SCOTLAND. 16 MARCH 2008

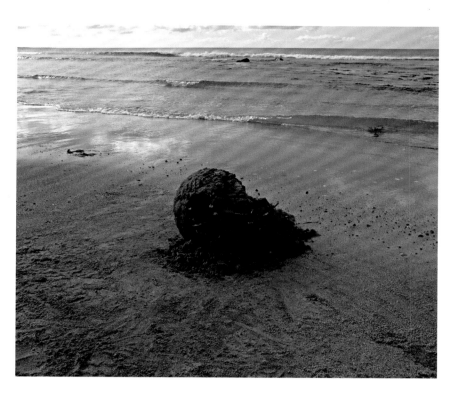
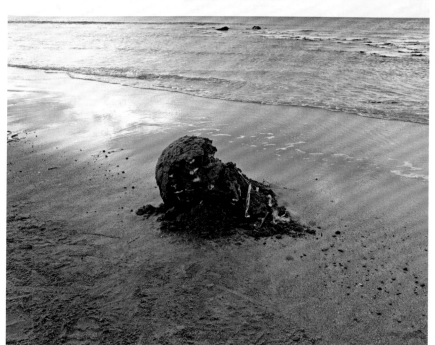
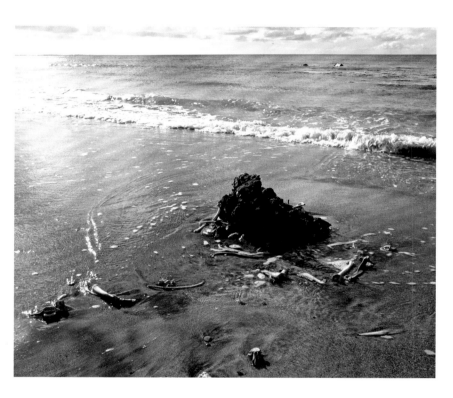
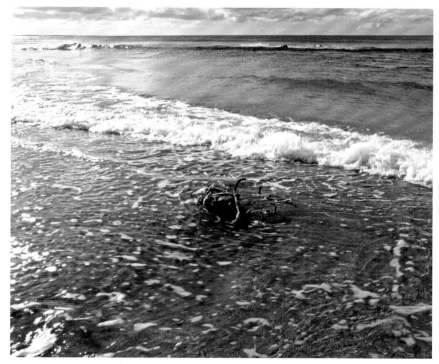
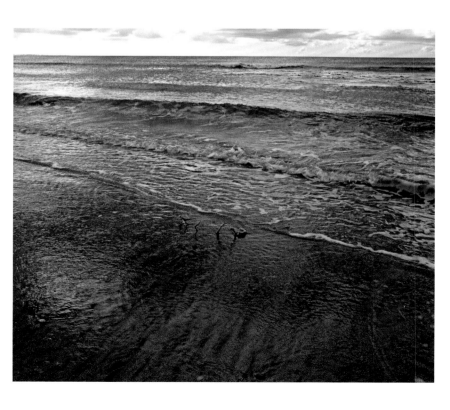
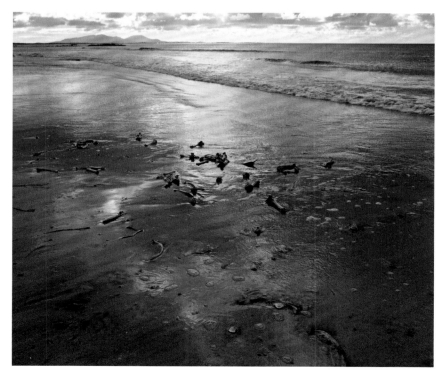

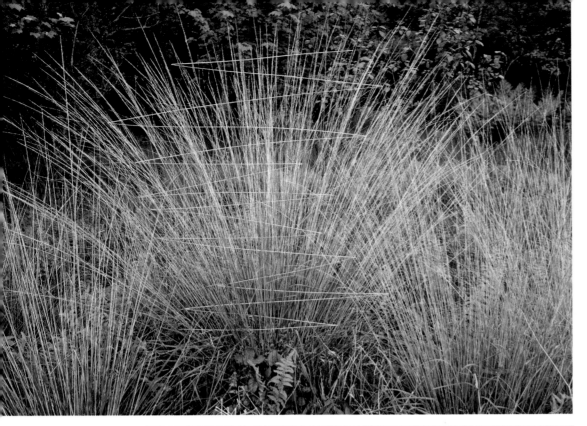

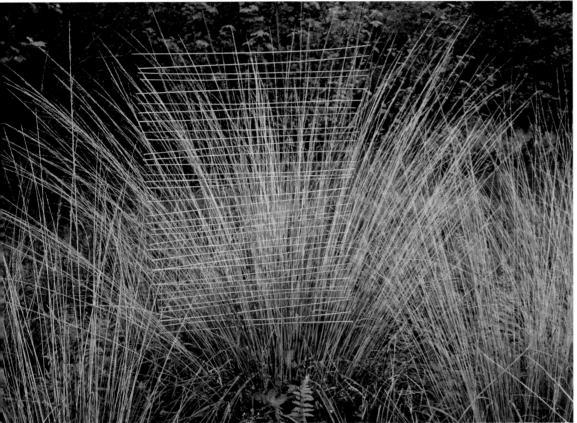

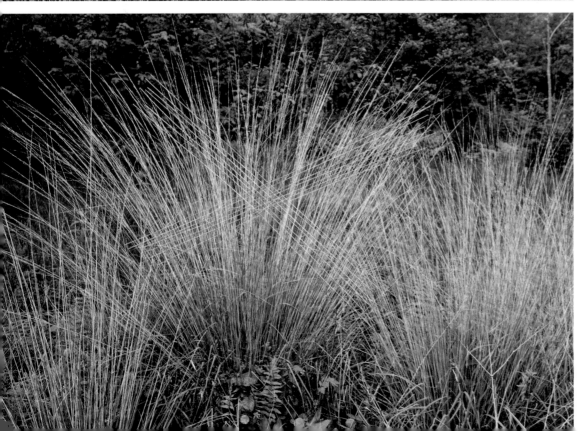

GRASS STALK LINE DRAWINGS. BIARRITZ, FRANCE. 19, 20, 22 MAY 2008

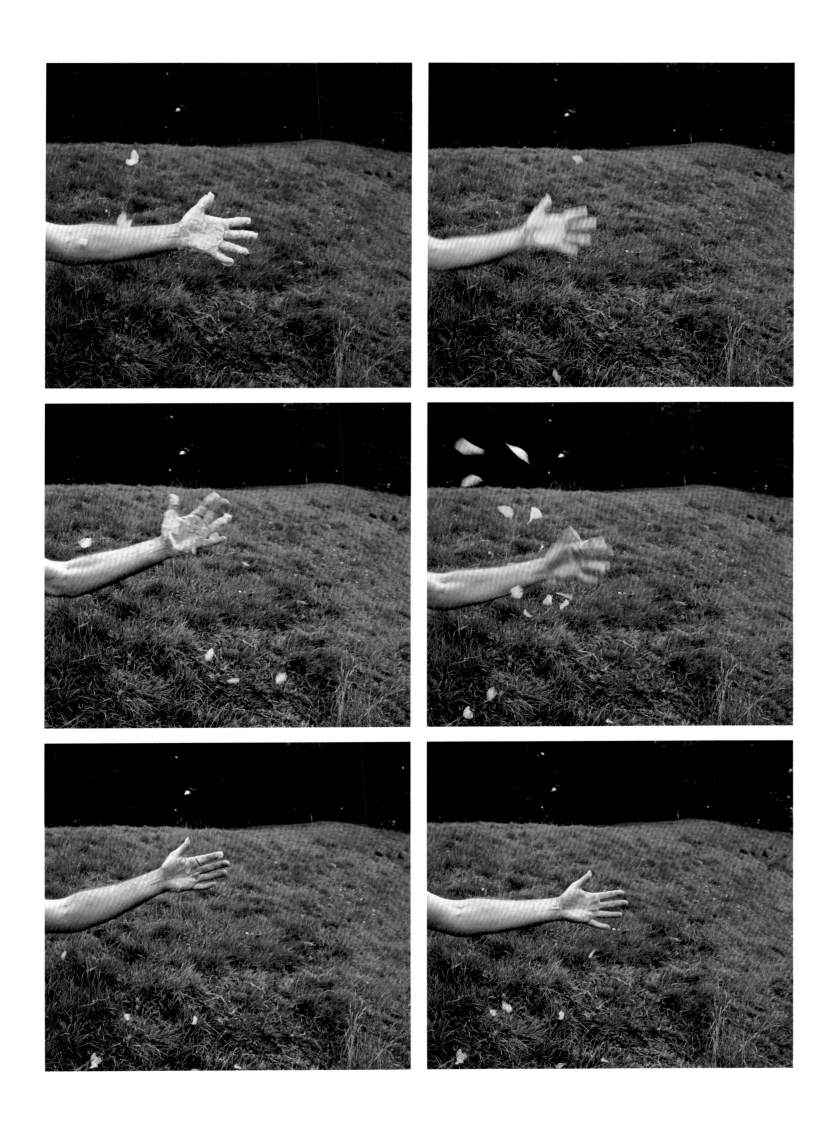

IRIS PETALS. HELD TO MY HAND WITH SPIT. SHOOK OFF. DUMFRIESSHIRE, SCOTLAND. JUNE 2008

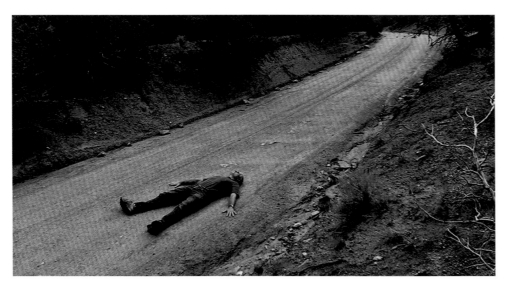 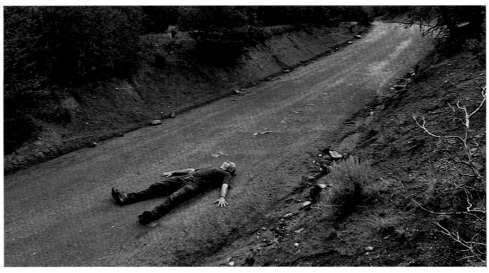

 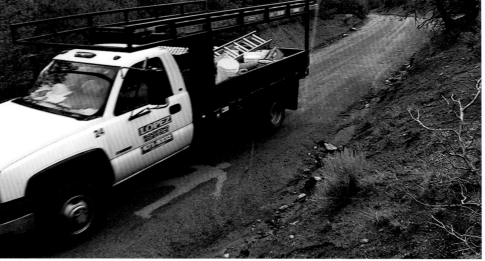

 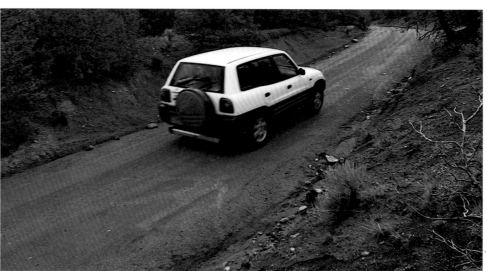

RAIN SHADOW. MADE BETWEEN PASSING TRUCKS. SANTA FE, NEW MEXICO. 12 AUGUST 2008

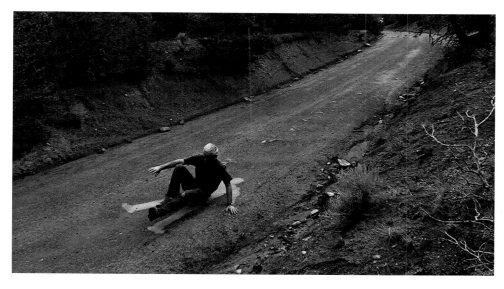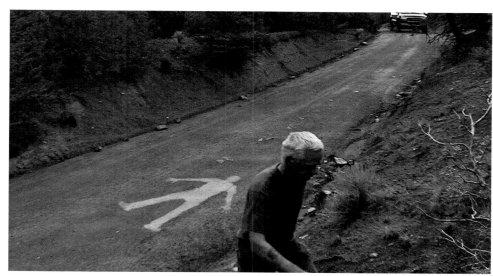
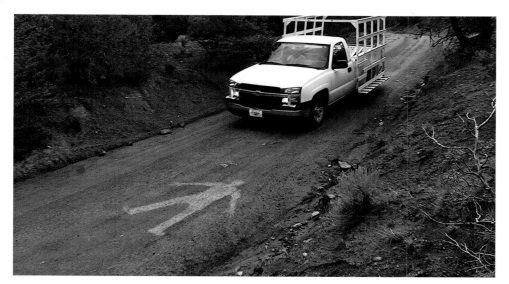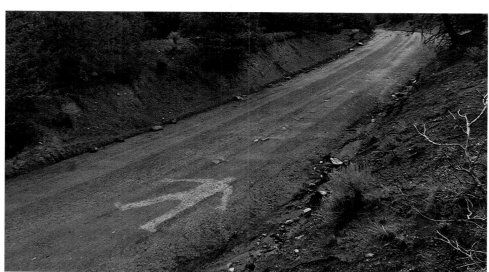
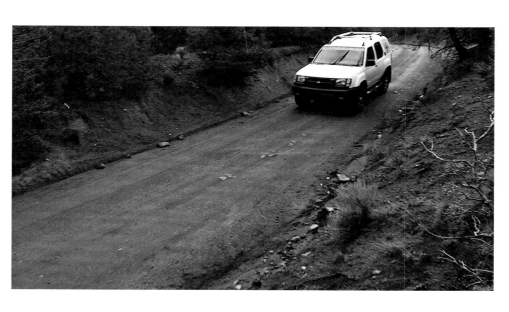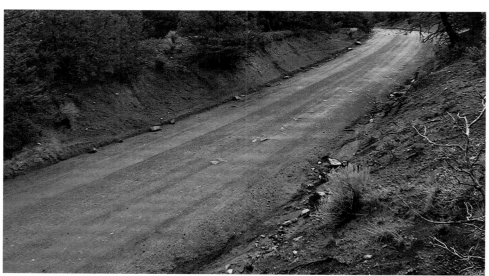

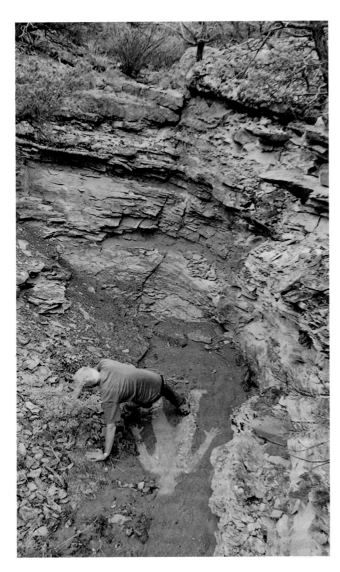
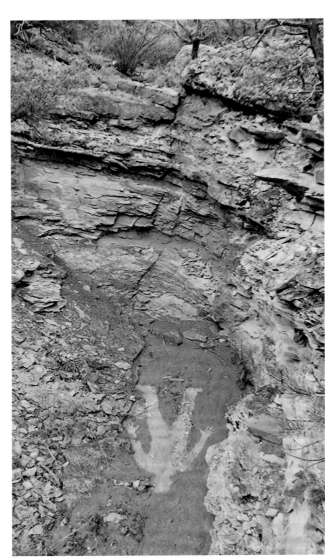
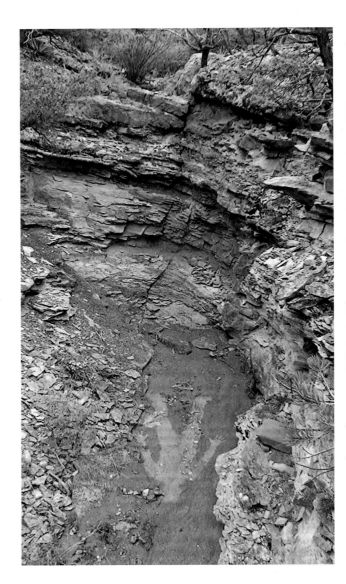

LAY DOWN. STOPPED RAINING. GOT UP. SHADOW SLOWLY DRYING OUT. SANTA FE, NEW MEXICO. 16 AUGUST 2008

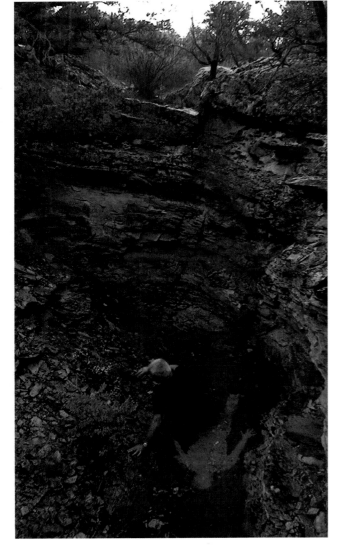
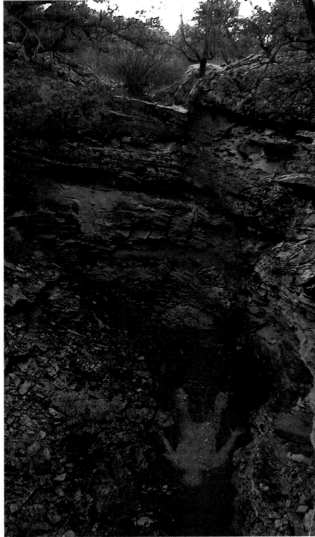
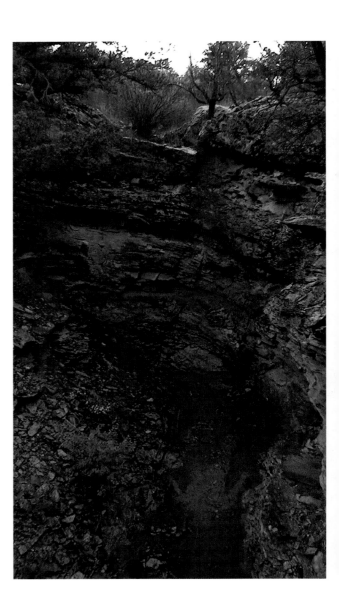

LAID DOWN THE FOLLOWING DAY. THUNDER, LIGHTNING, HEAVY RAIN AND HAIL. SHADOW QUICKLY OBLITERATED AS THE CREEK BECAME A FAST-FLOWING TORRENT. SANTA FE, NEW MEXICO. 17 AUGUST 2008

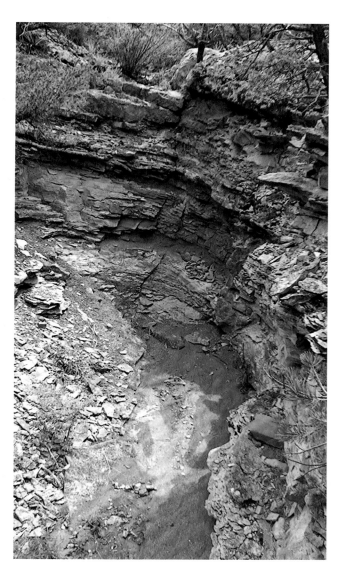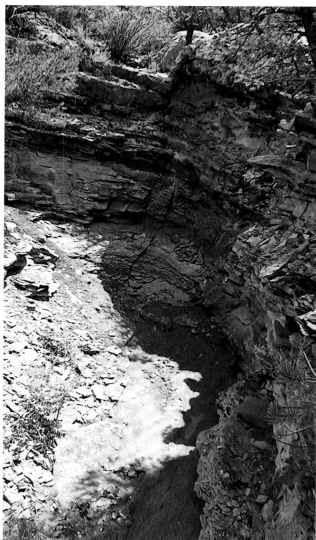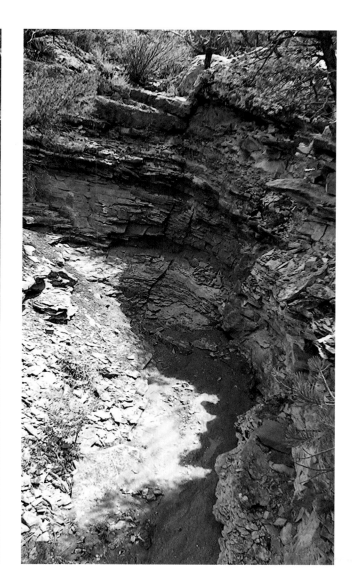
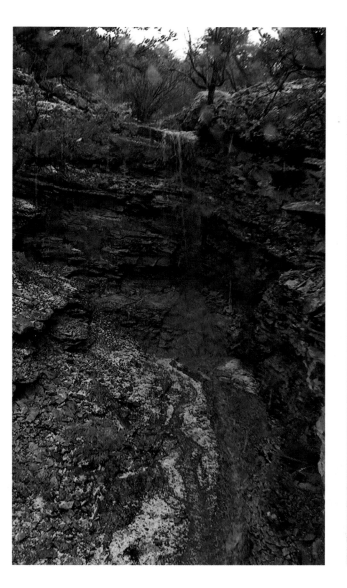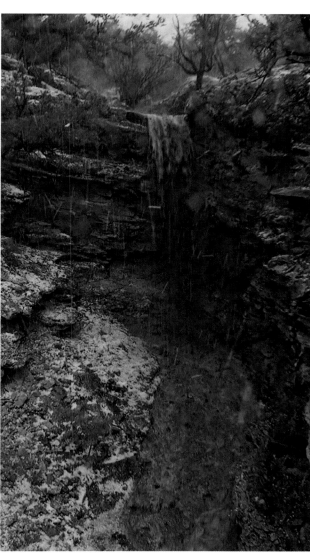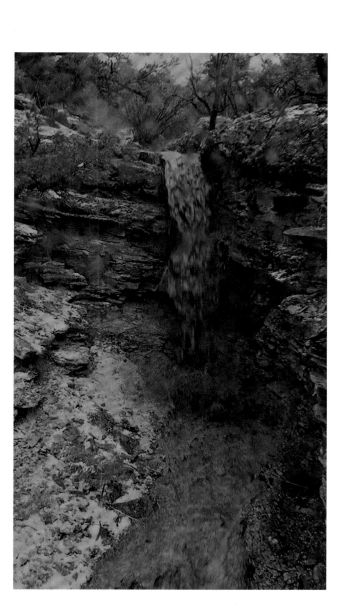

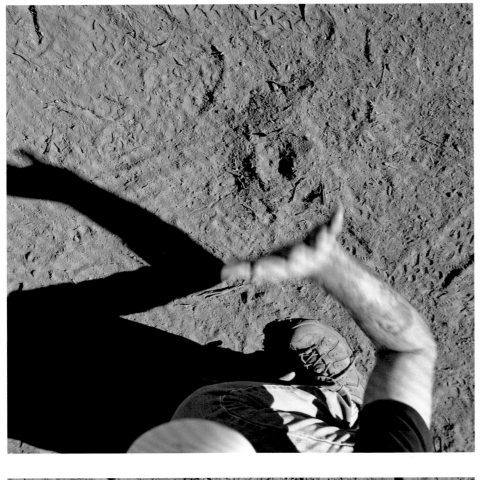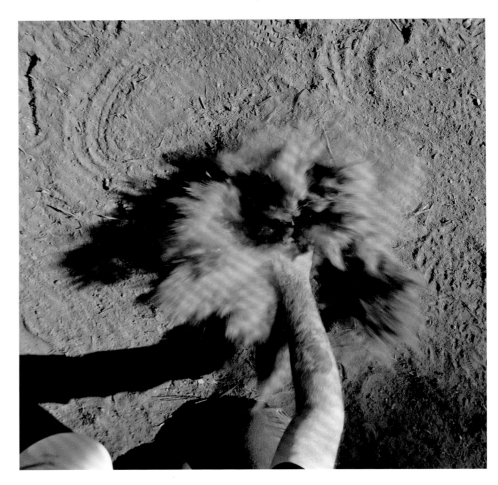
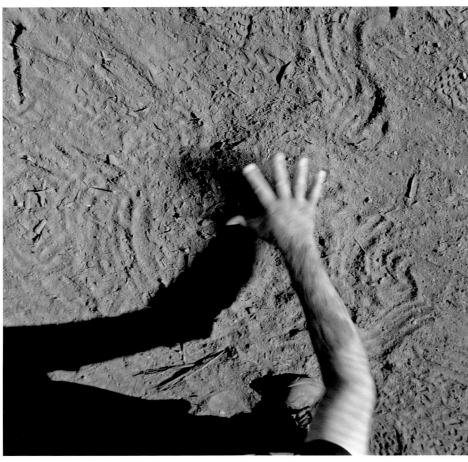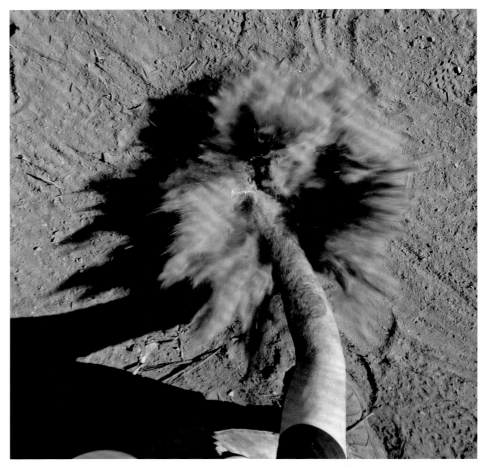

HAND. HIT. CONSTRUCTION DUST. PRESIDIO, CALIFORNIA. OCTOBER 2008

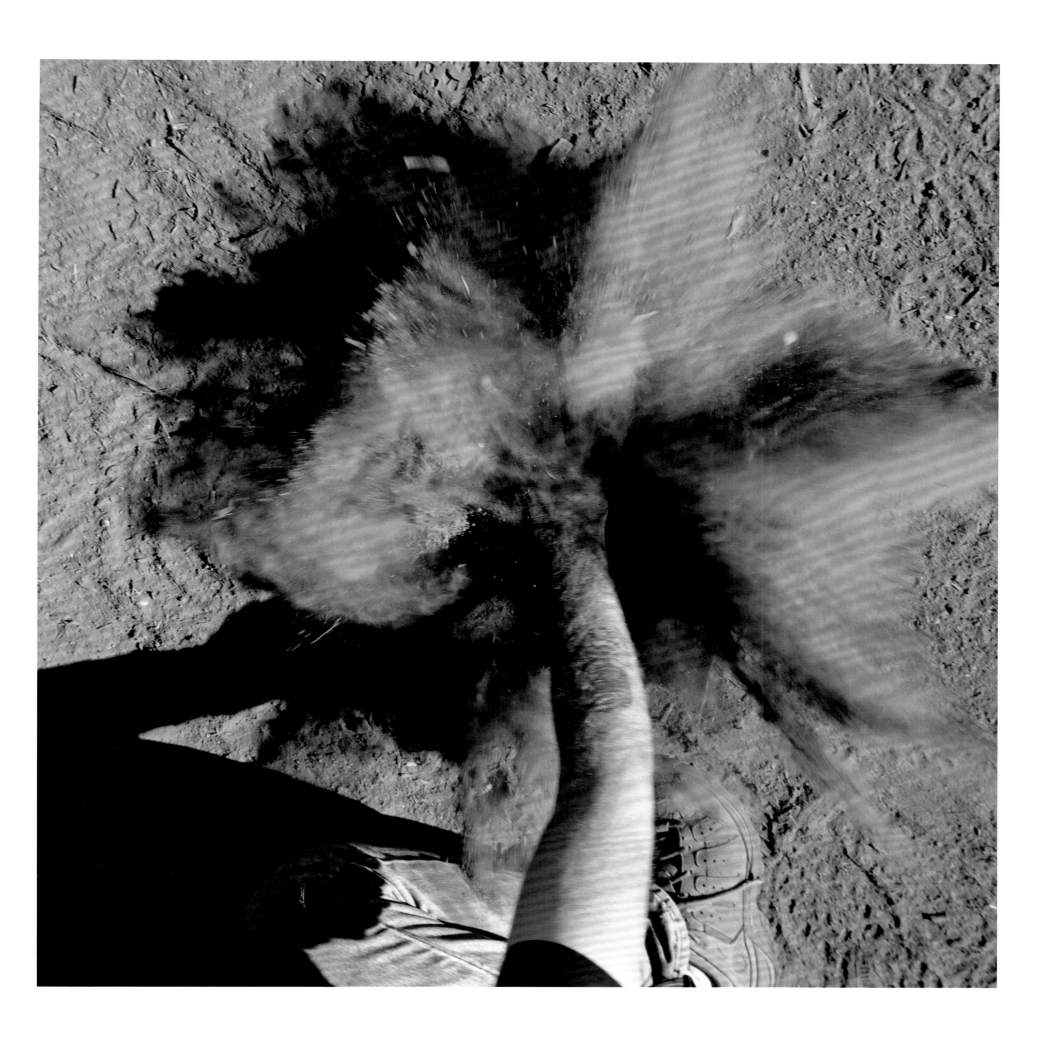

HAZEL STICKS. LAID AT THE BOTTOM OF A SMALL WATERFALL. FOR JUDITH DYKES. DUMFRIESSHIRE, SCOTLAND. 26 DECEMBER 2008

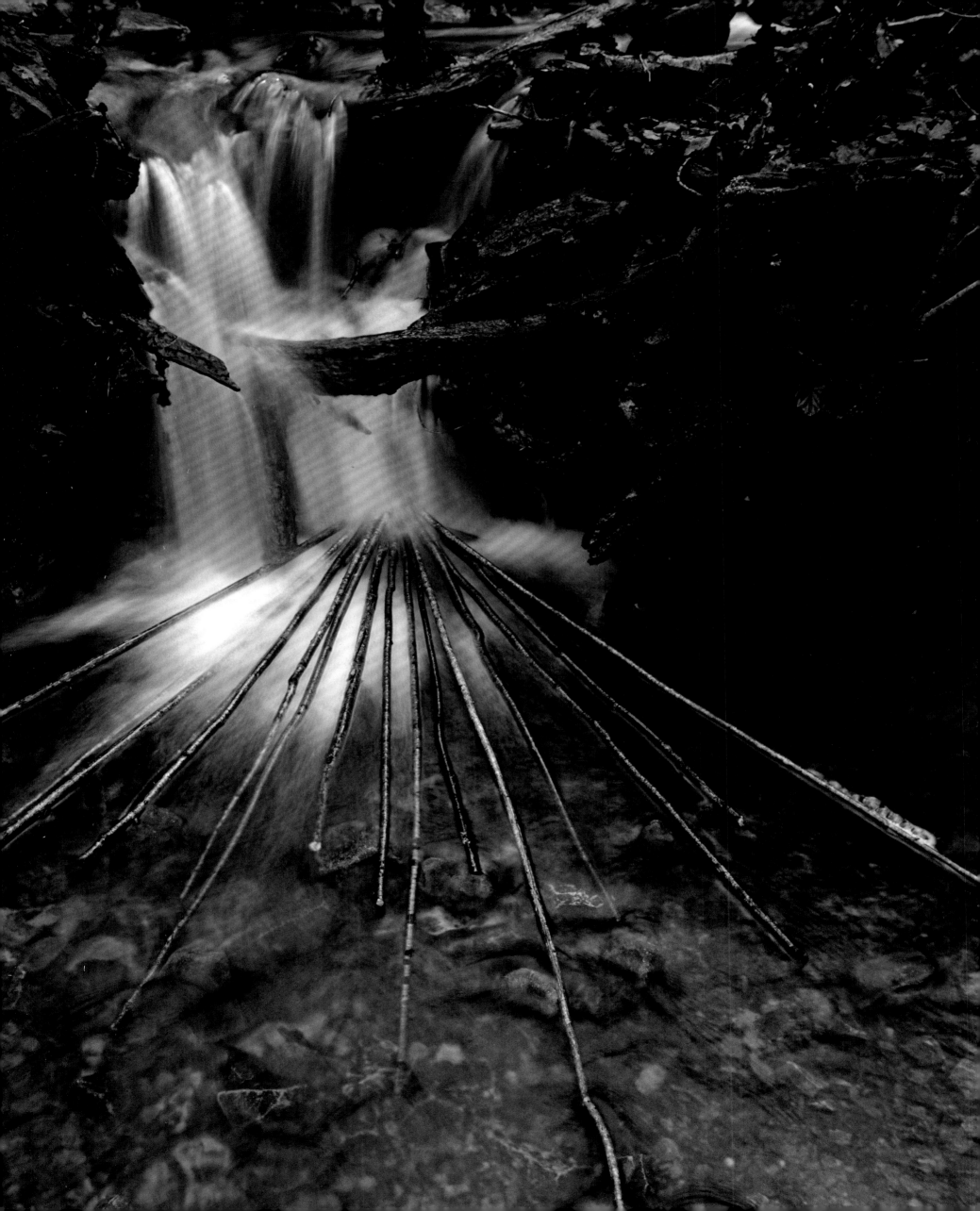

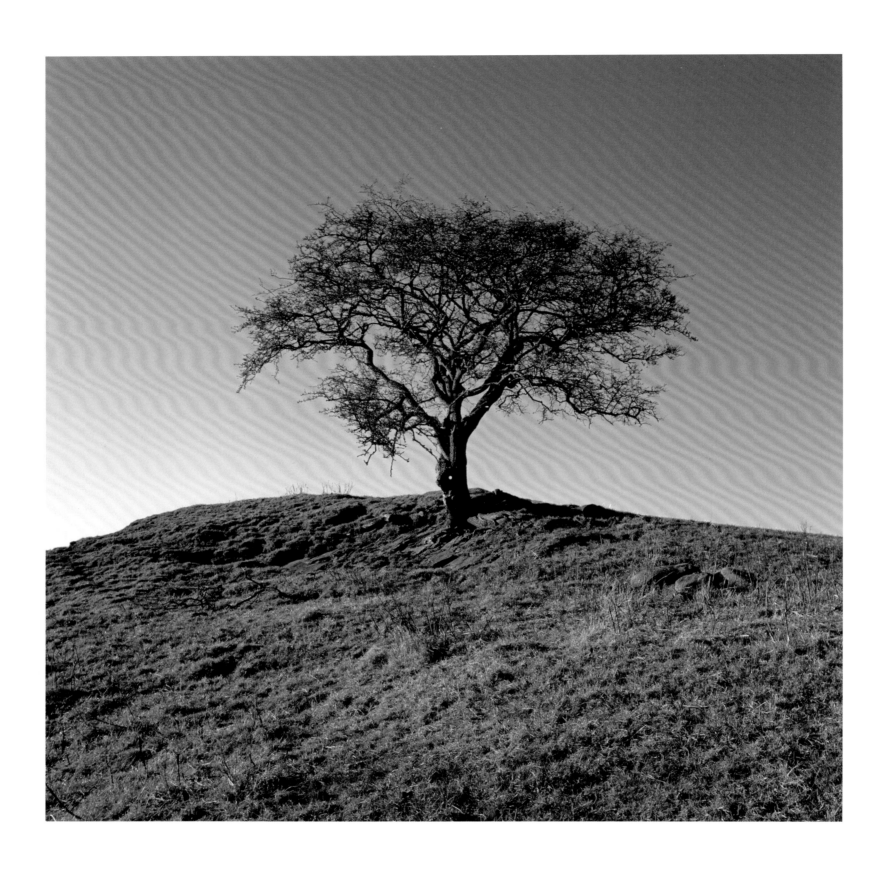

MUD. HOLE. WORKED INTO SPILT HAWTHORN. DUMFRIESSHIRE, SCOTLAND. DECEMBER 2008

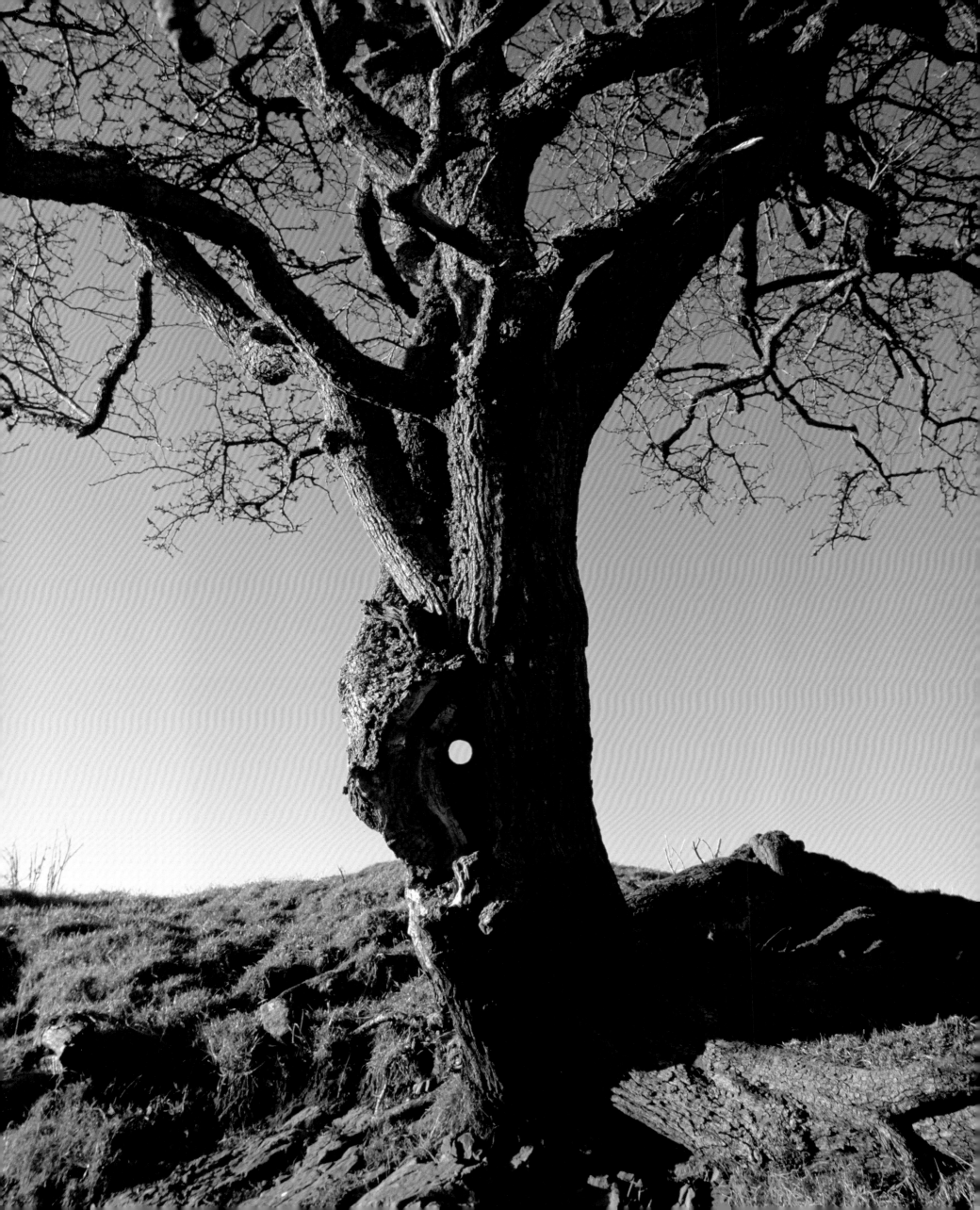

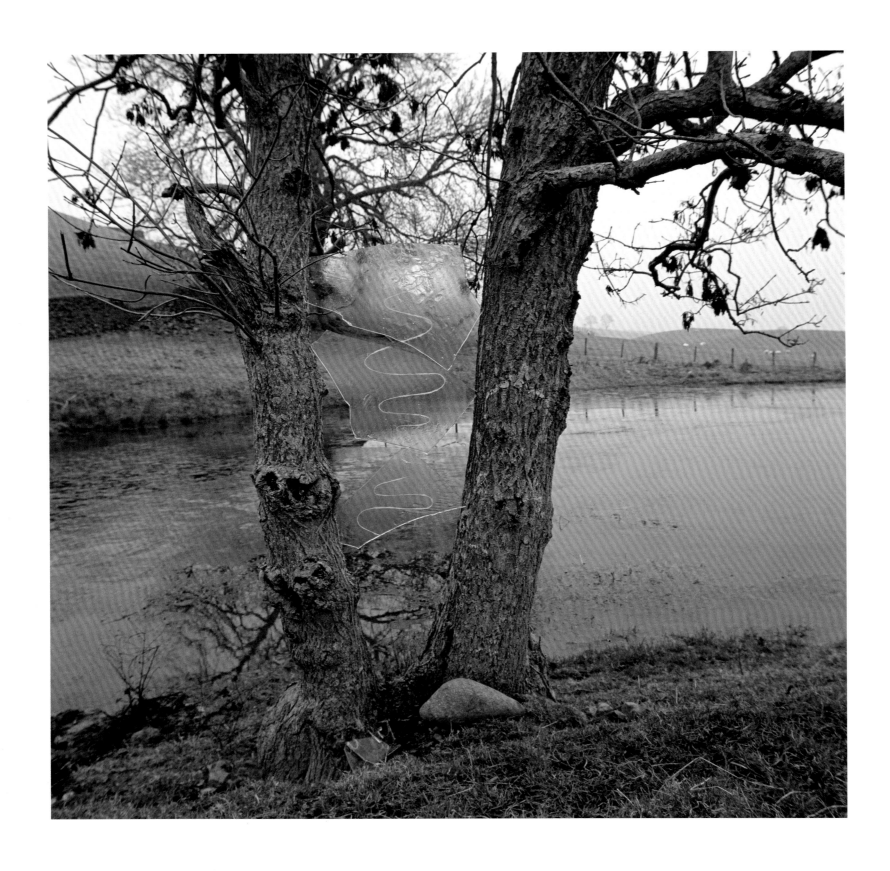

ICE WEDGED BETWEEN TWO TRUNKS OF AN ASH TREE. THIN STRANDS OF SHEEP WOOL. DIPPED IN WATER. LAID ON ICE. QUICKLY FREEZING AND BECOMING UNWORKABLE.
DUMFRIESSHIRE, SCOTLAND. DECEMBER 2008

(OVERLEAF) GRASS STALKS. THIN END OF ONE INSERTED INTO THE WIDER HOLLOW END OF ANOTHER TO MAKE A LINE. HELD IN MUD-FILLED CRACKS AND CREVICES. NO WIND.
DUMFRIESSHIRE, SCOTLAND. 3 JANUARY 2009

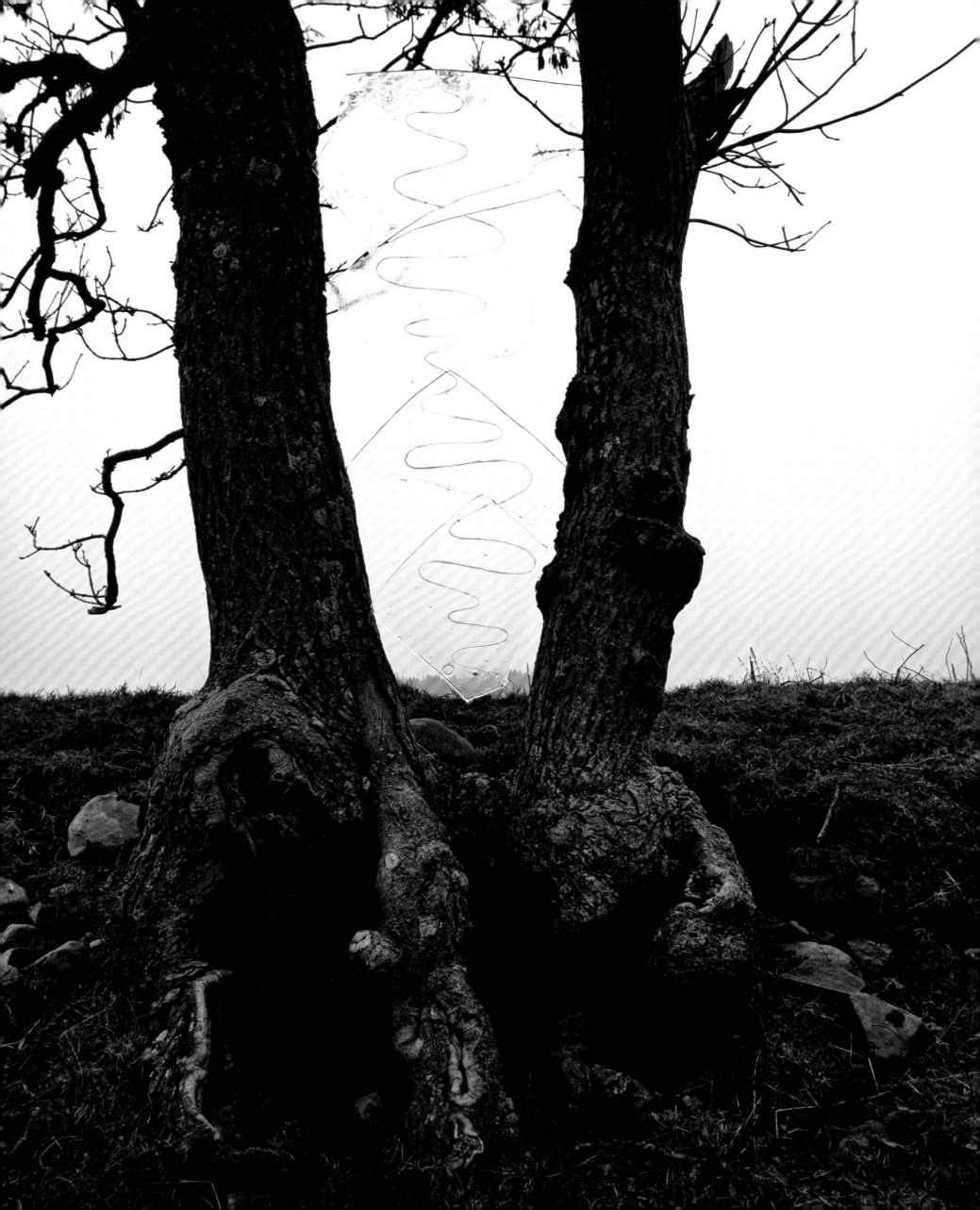

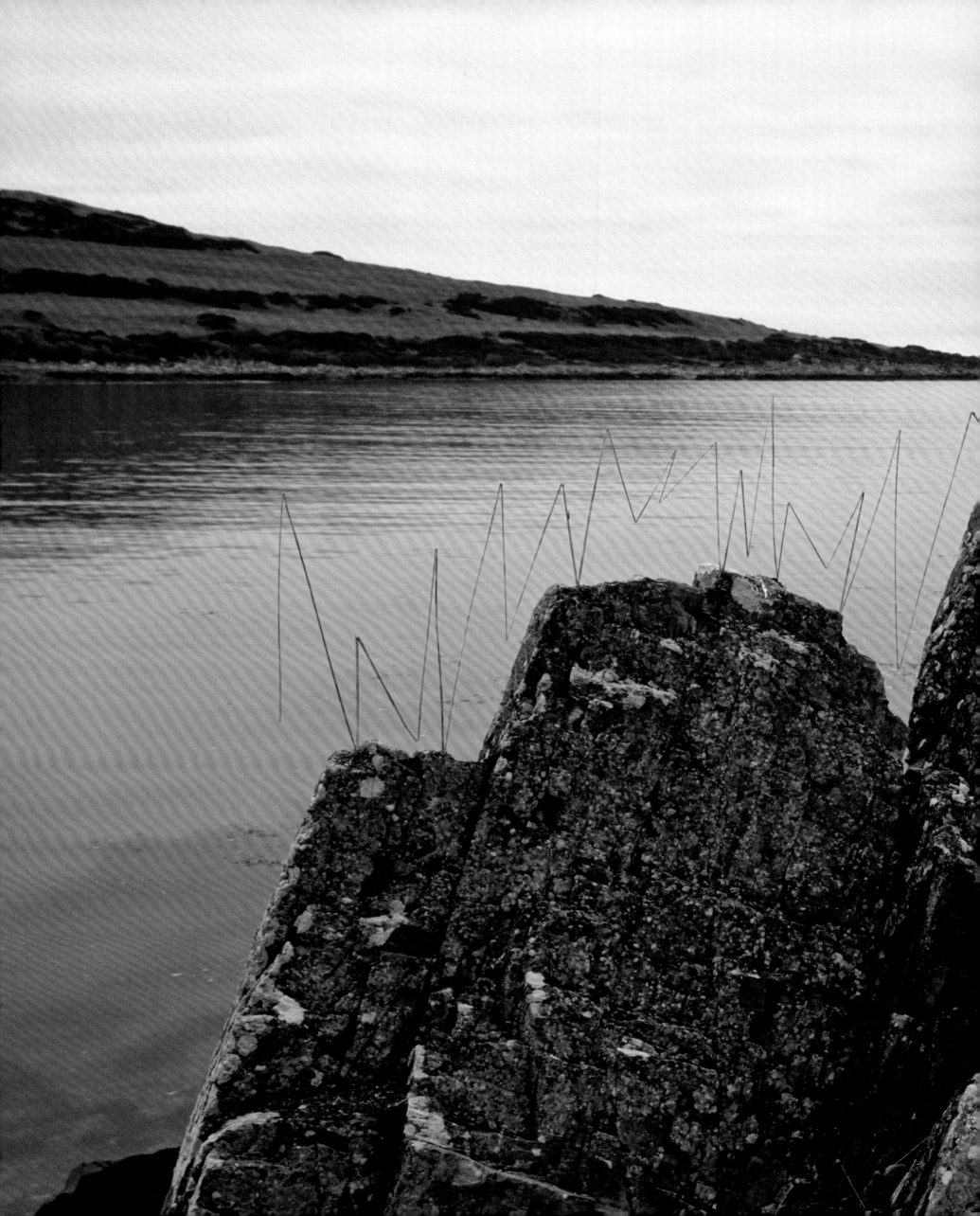

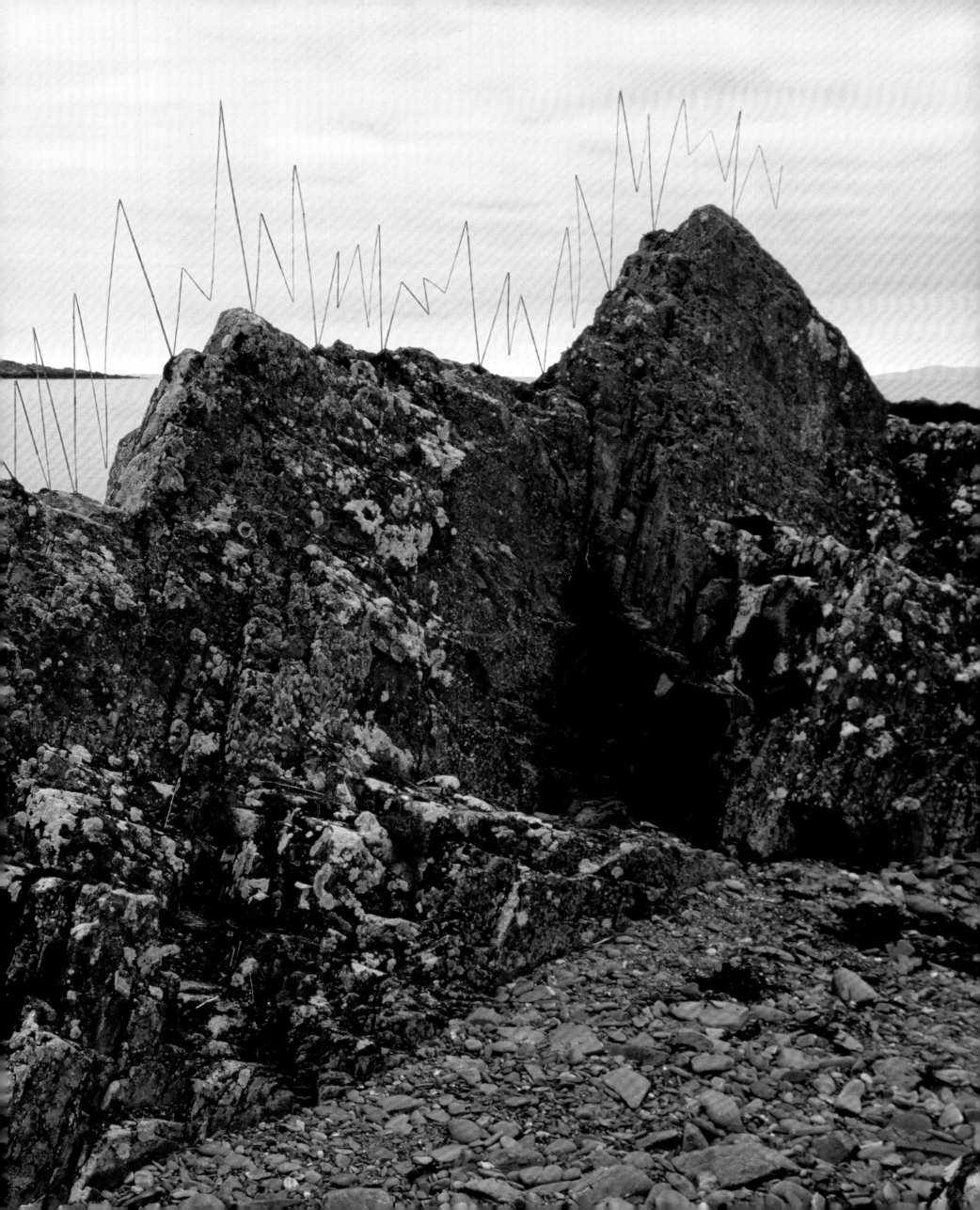

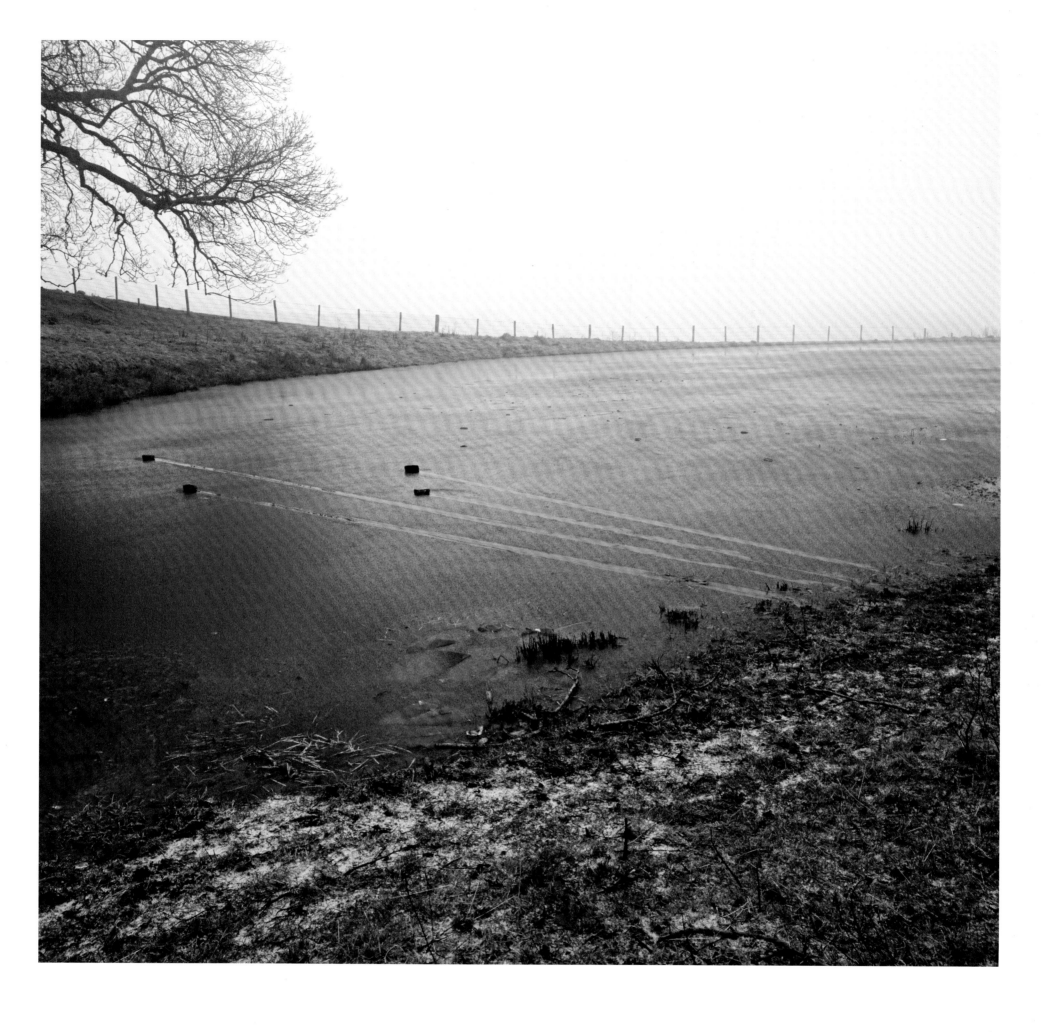

FOUR FLAT-BOTTOMED STONES. SLID ACROSS SLUSH-COVERED ICE. DUMFRIESSHIRE, SCOTLAND. JANUARY 2009

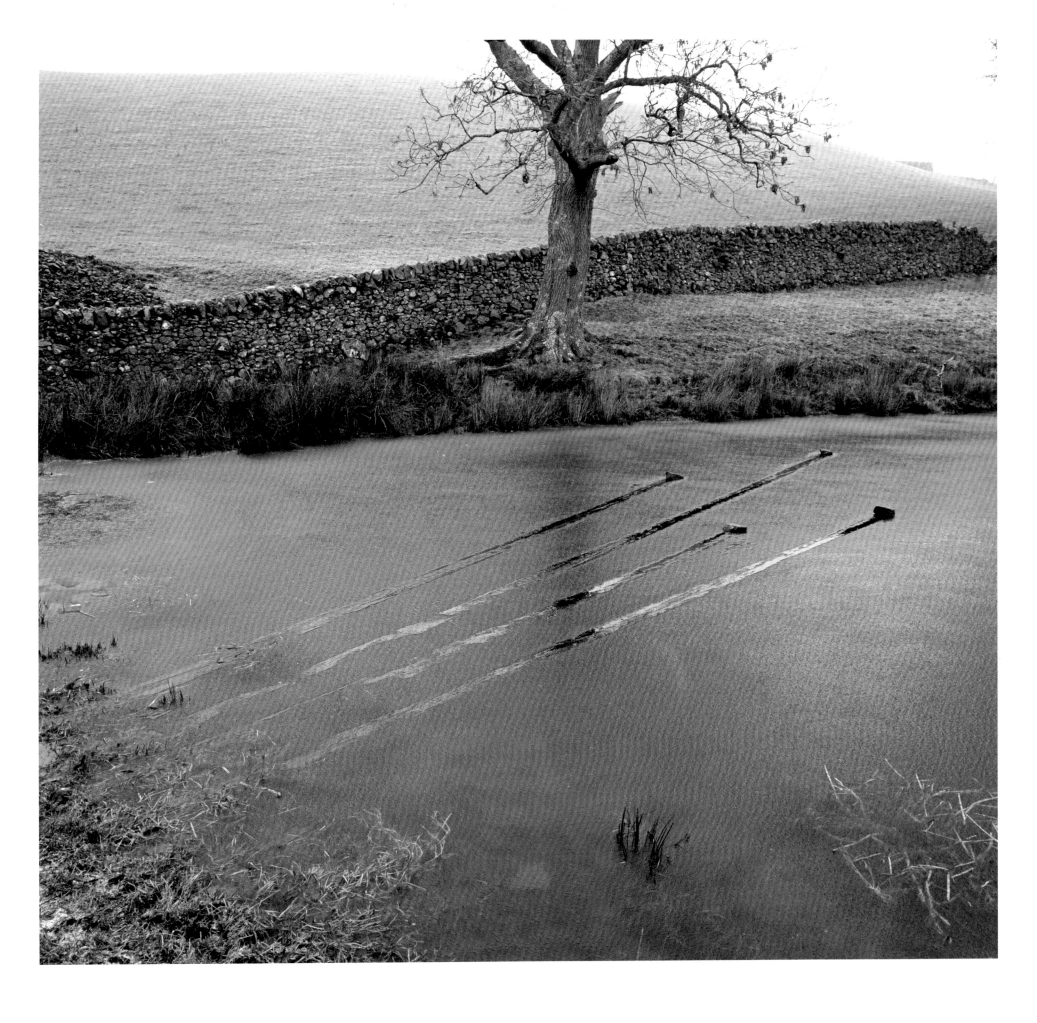

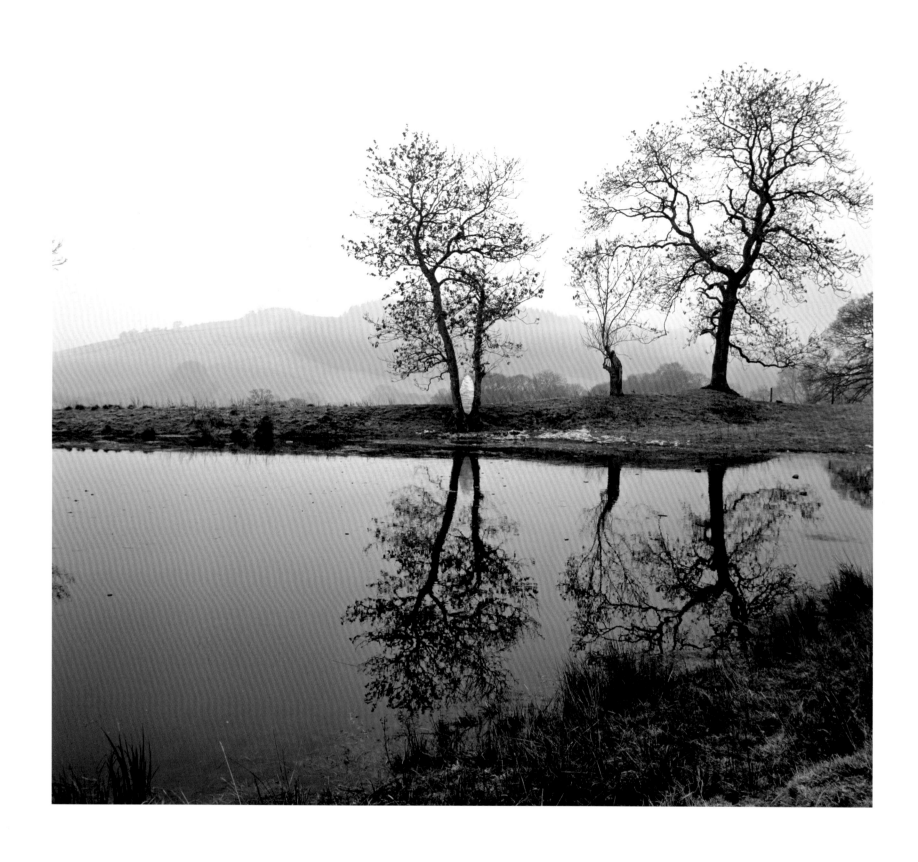

ICE STACKED BETWEEN TWO TRUNKS OF AN ASH TREE. DUMFRIESSHIRE, SCOTLAND. 13 JANUARY 2009

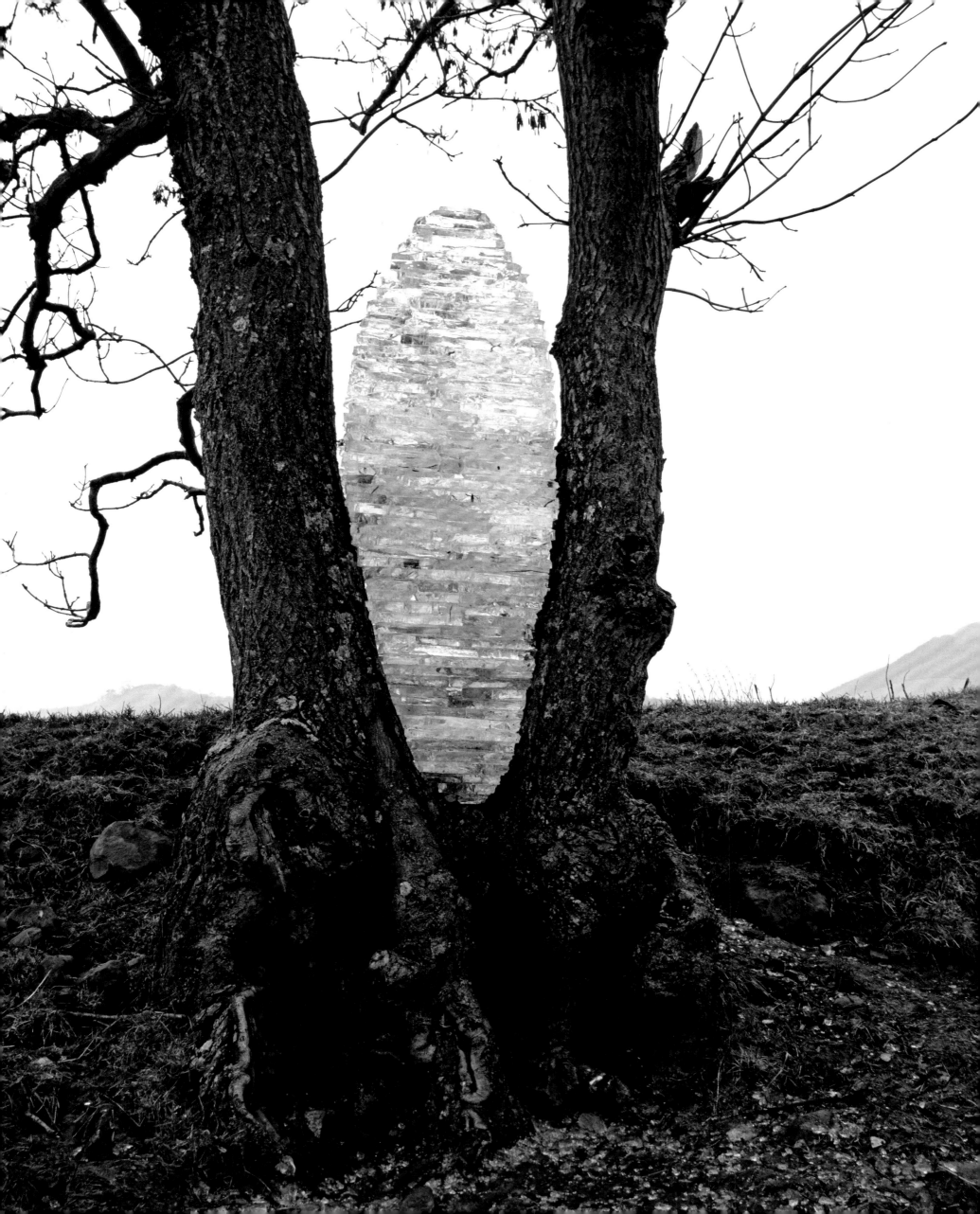

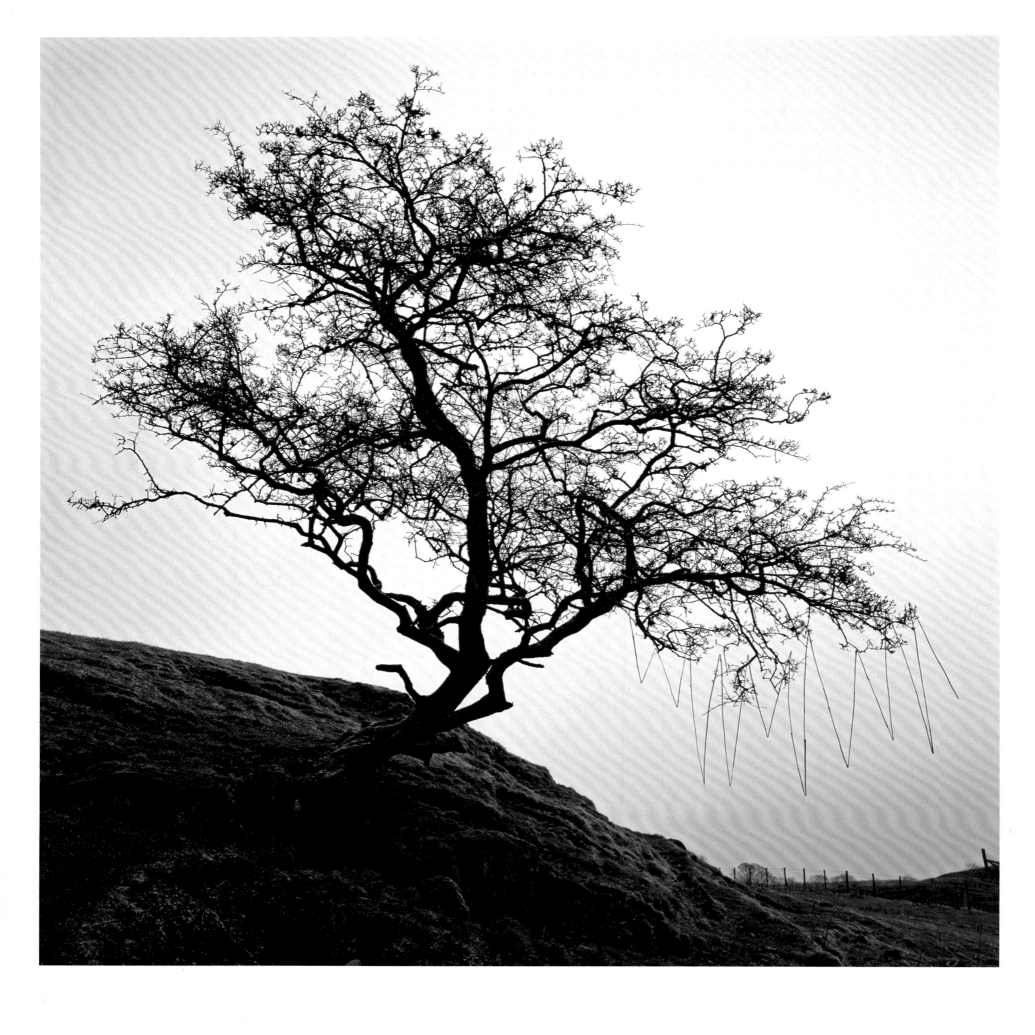

NETTLE STALKS. ATTACHED TO THE THORNS OF HAWTHORN TREES. CALM, OVERCAST. DUMFRIESSHIRE, SCOTLAND. MARCH 2009

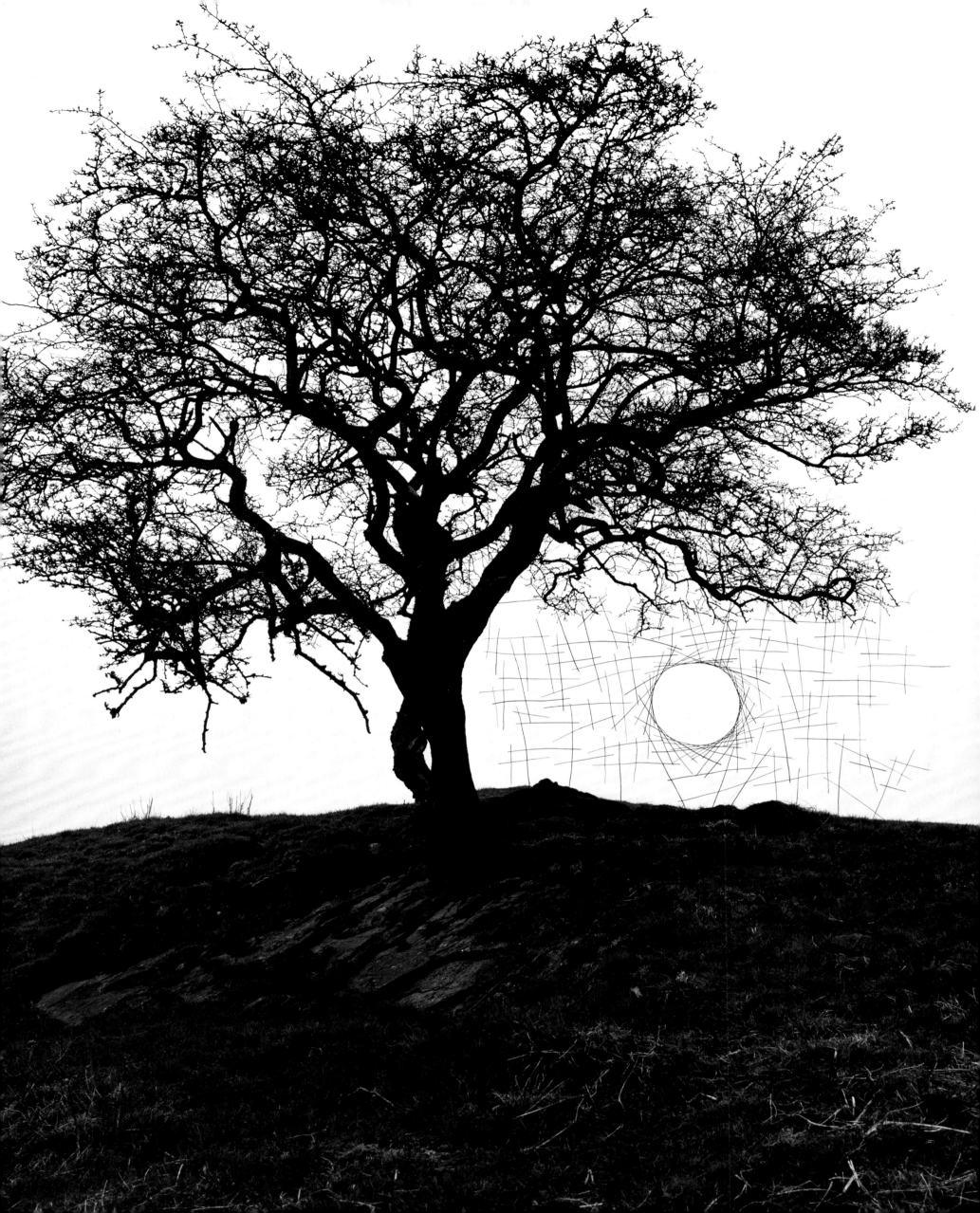

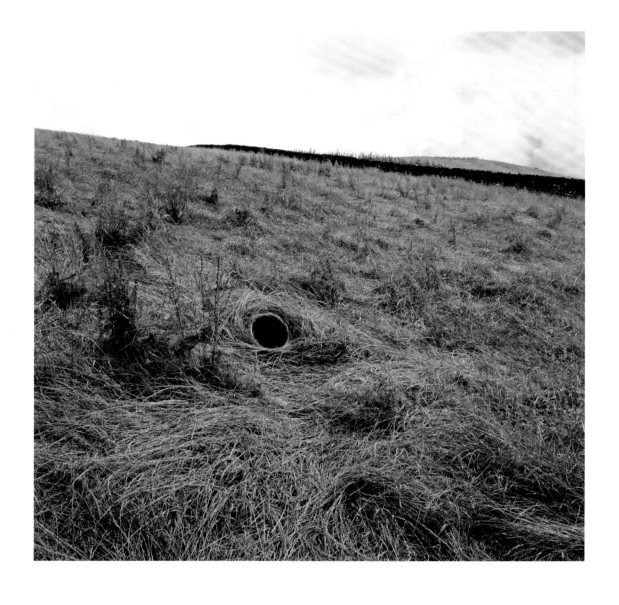

HAY FIELD. FLATTENED BY WIND AND RAIN. GRASS. HUMMOCK. HOLE. DUMFRIESSHIRE, SCOTLAND. MARCH 2009

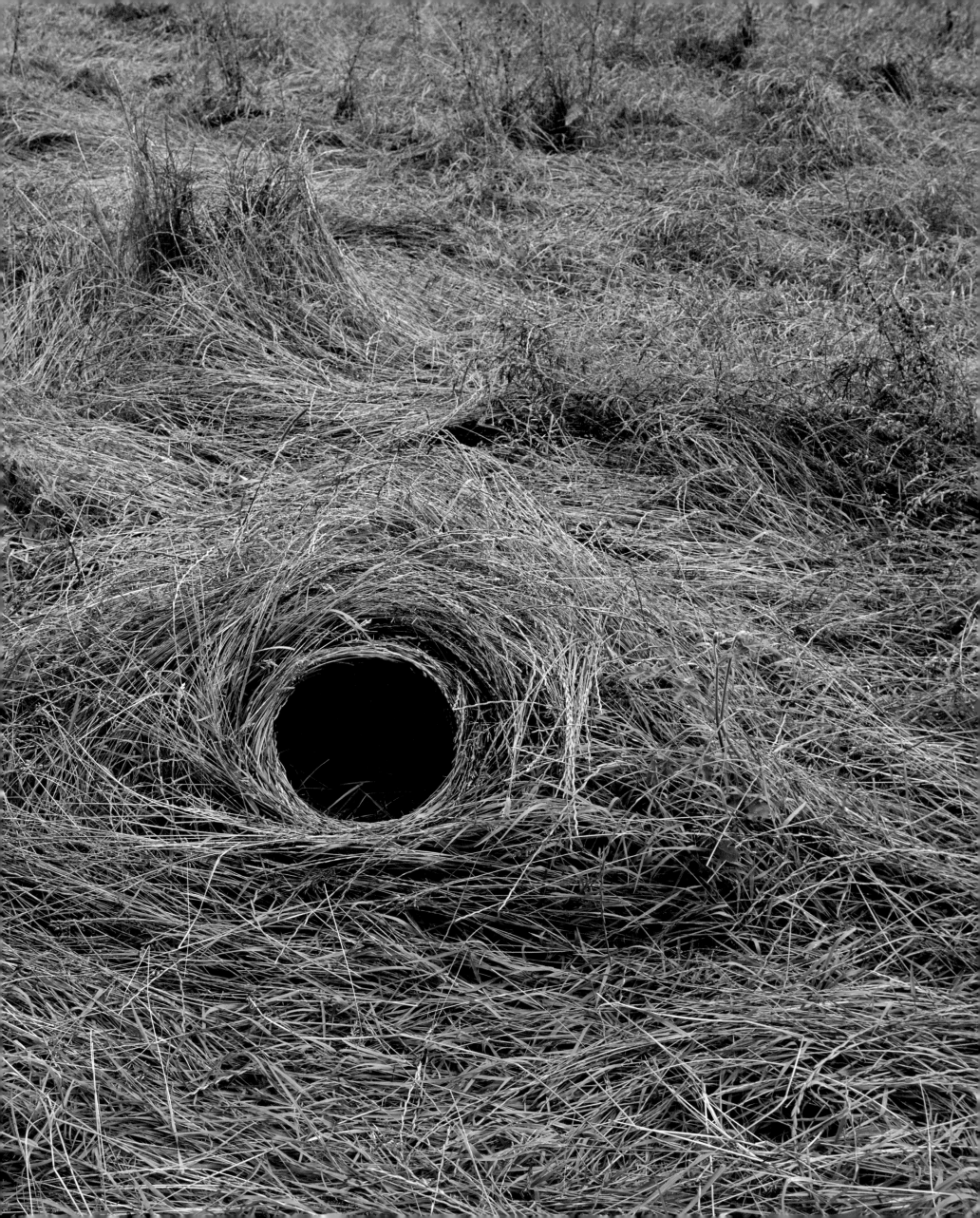

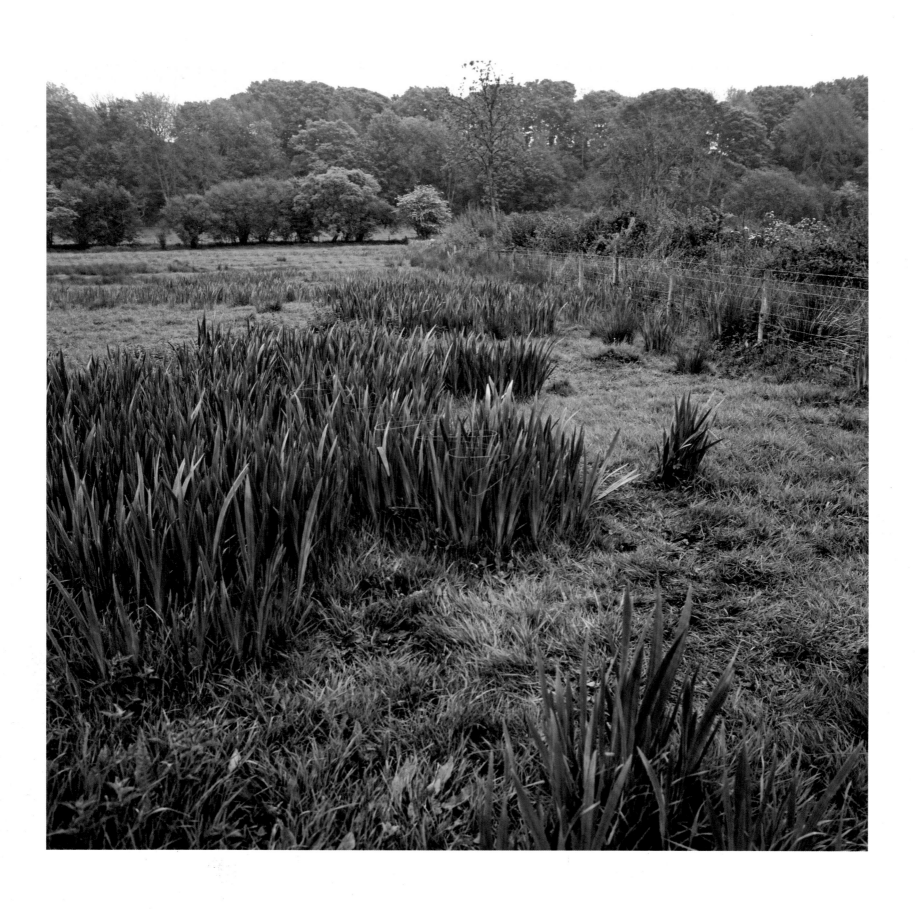

RUSH LINE. DRAWN THROUGH IRIS BLADES. BERE MILL, HAMPSHIRE. MAY 2009

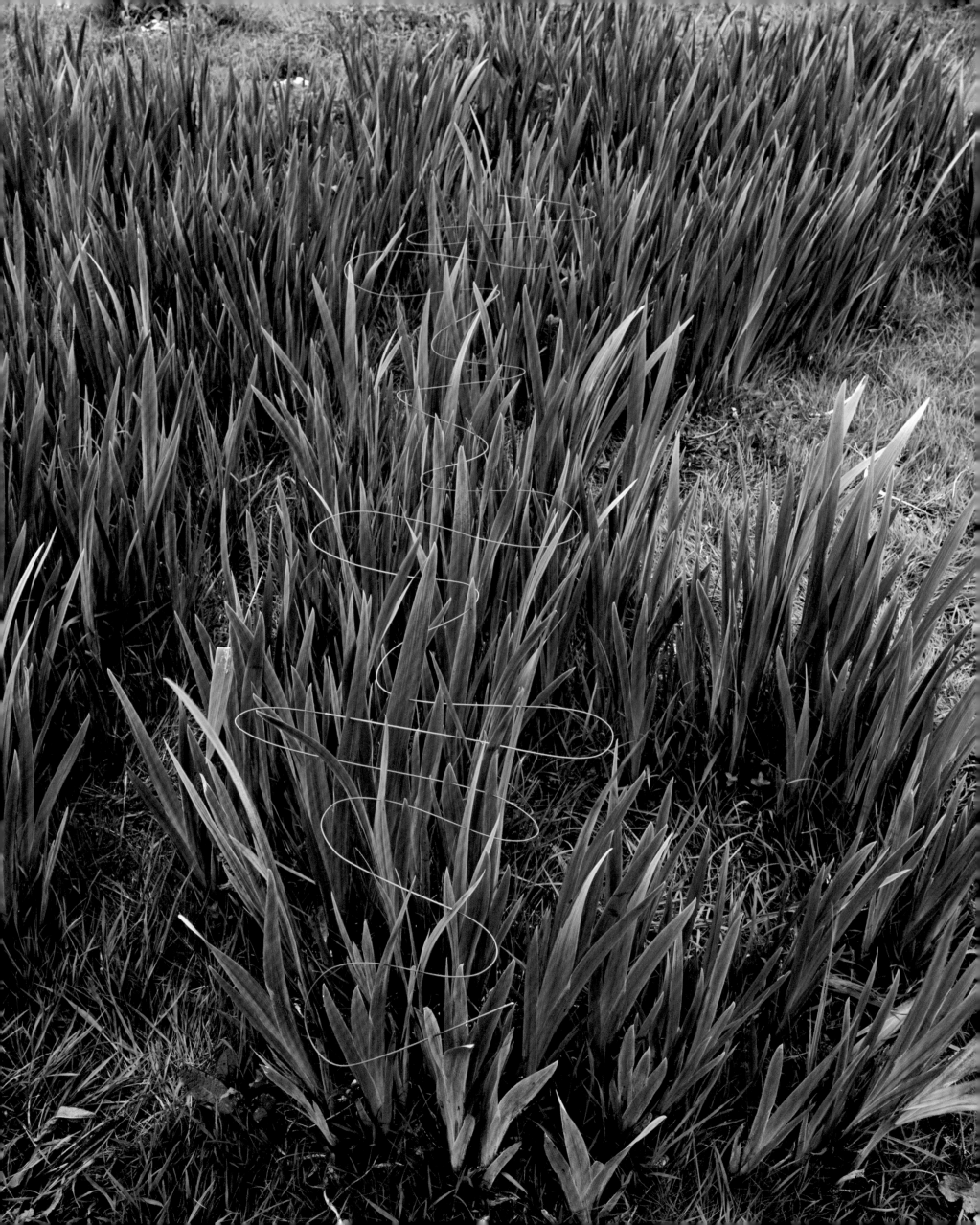

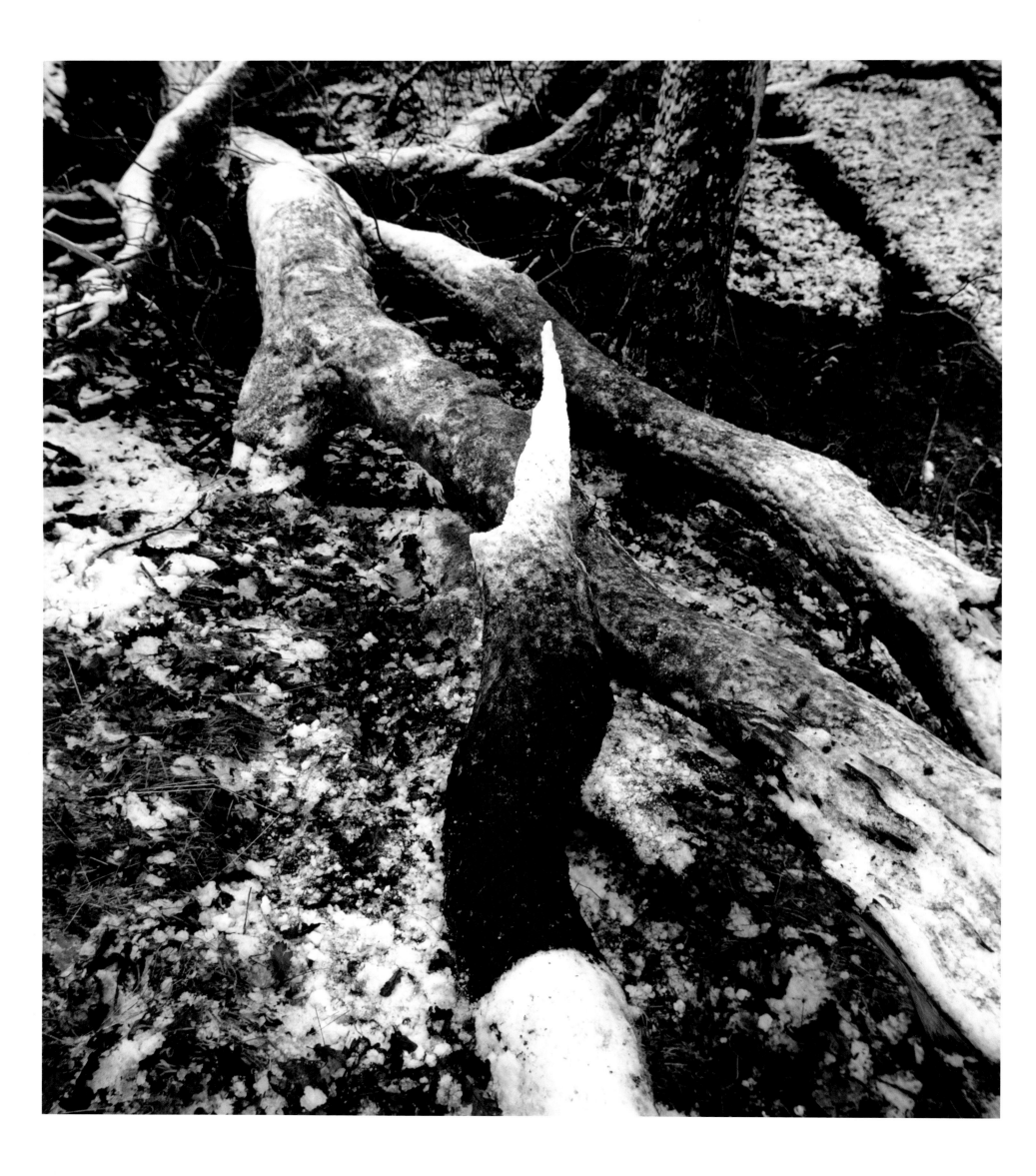

BLACK MUD. WHITE SNOW. BROKEN ASH. DUMFRIESSHIRE, SCOTLAND. 21, 22 DECEMBER 2009

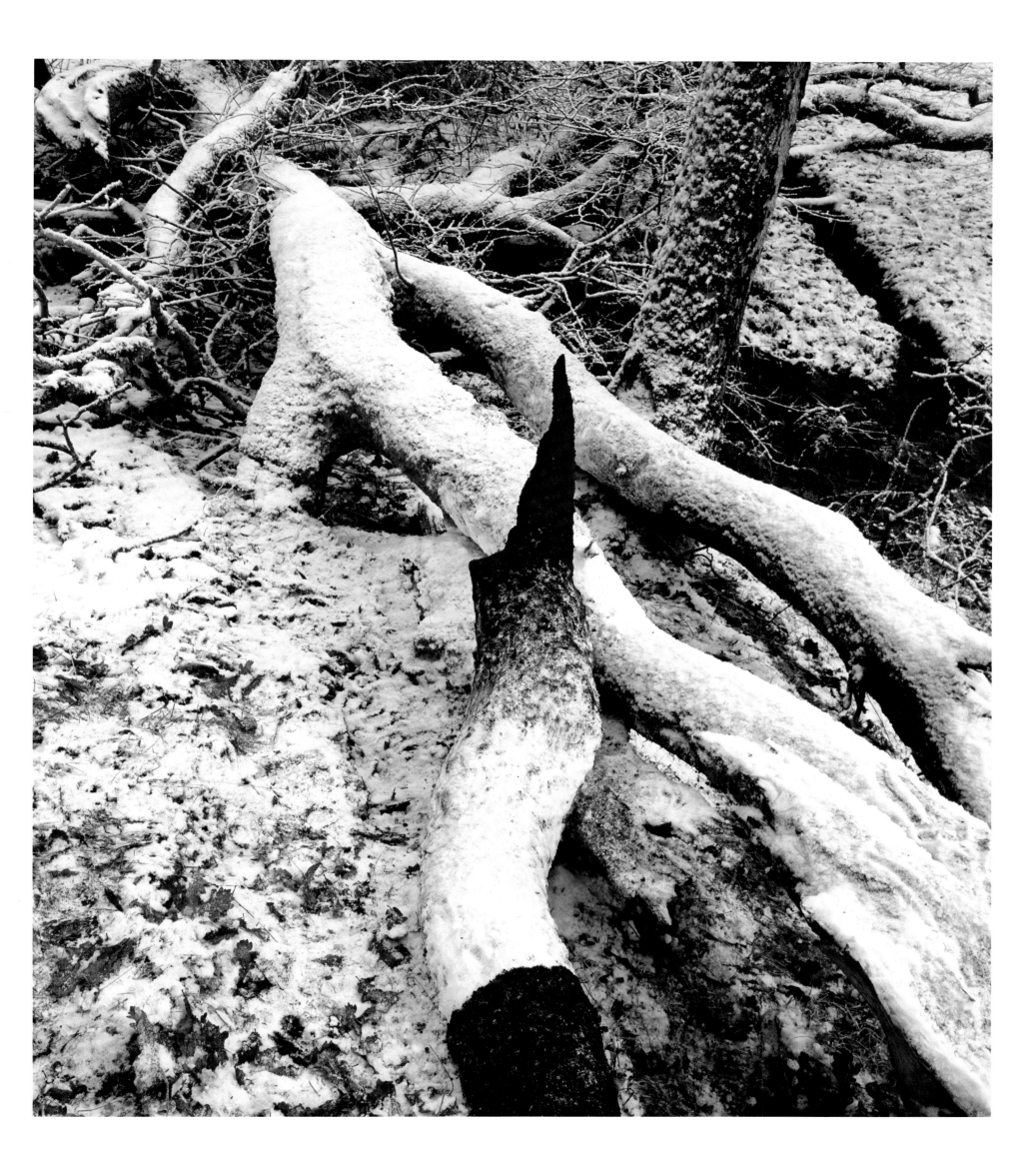

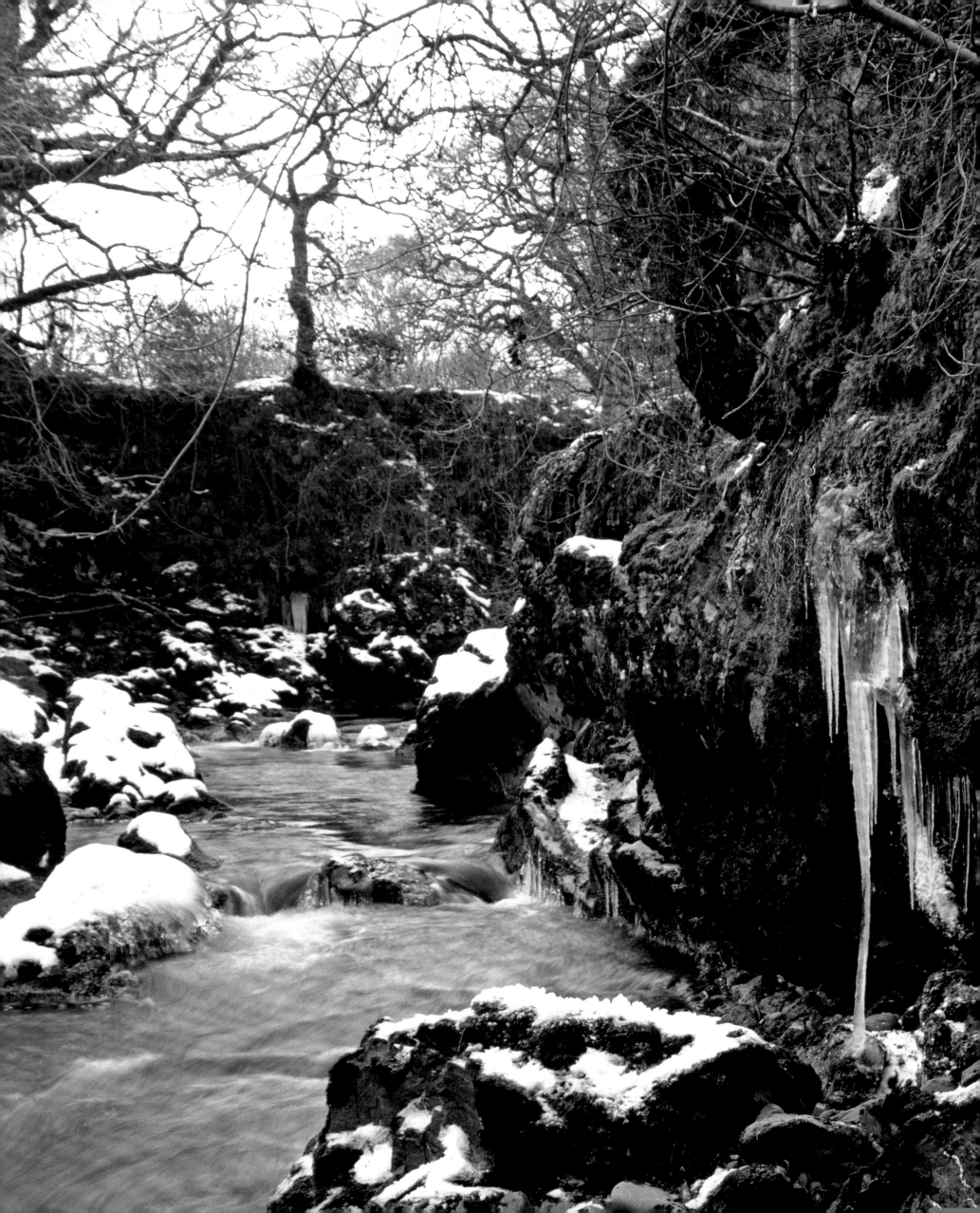

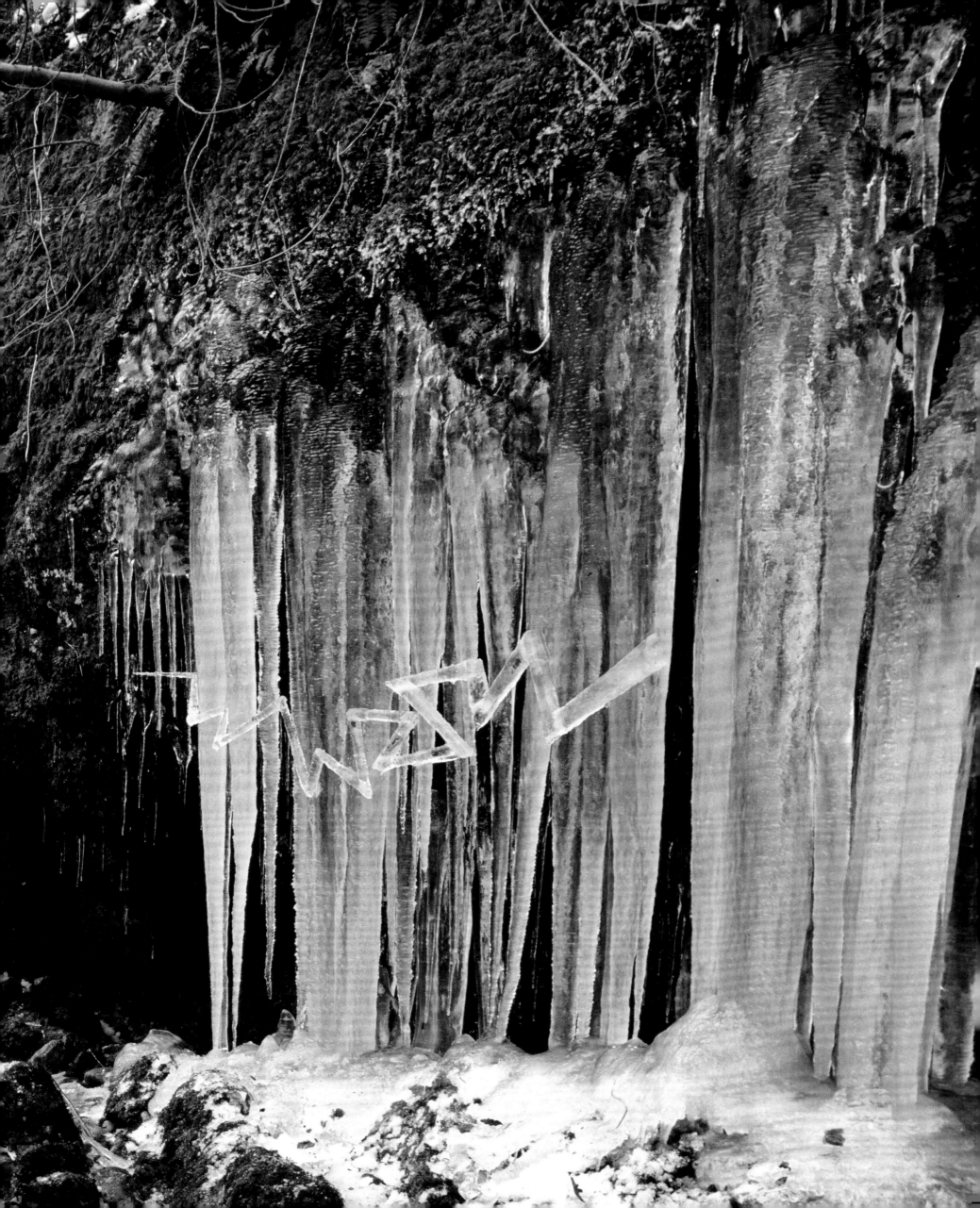

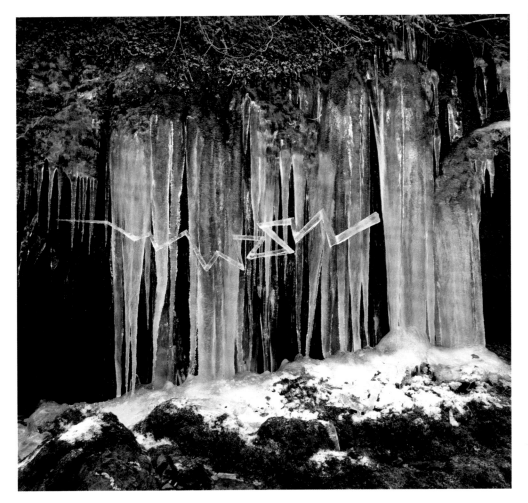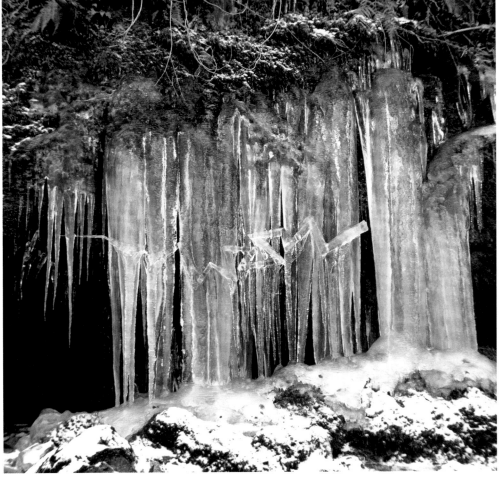

BROKEN ICICLES RECONNECTED. FROZEN TO ICE WALL. DRIPPING. CONTINUING TO FLOW AND FREEZE. COVERING THE WORK. DUMFRIESSHIRE, SCOTLAND. 4 JANUARY 2010

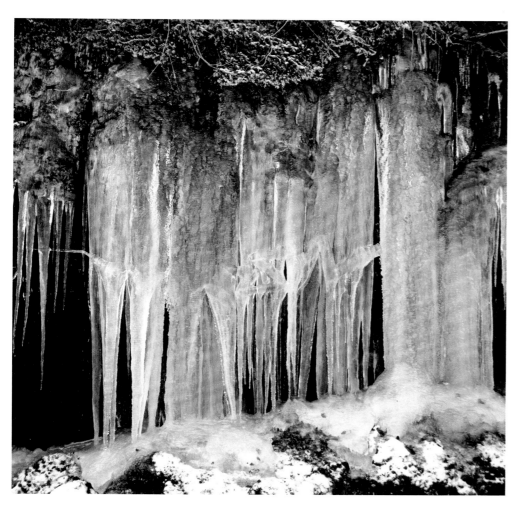 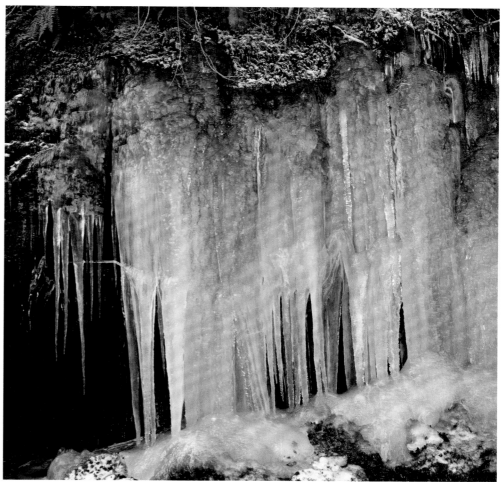

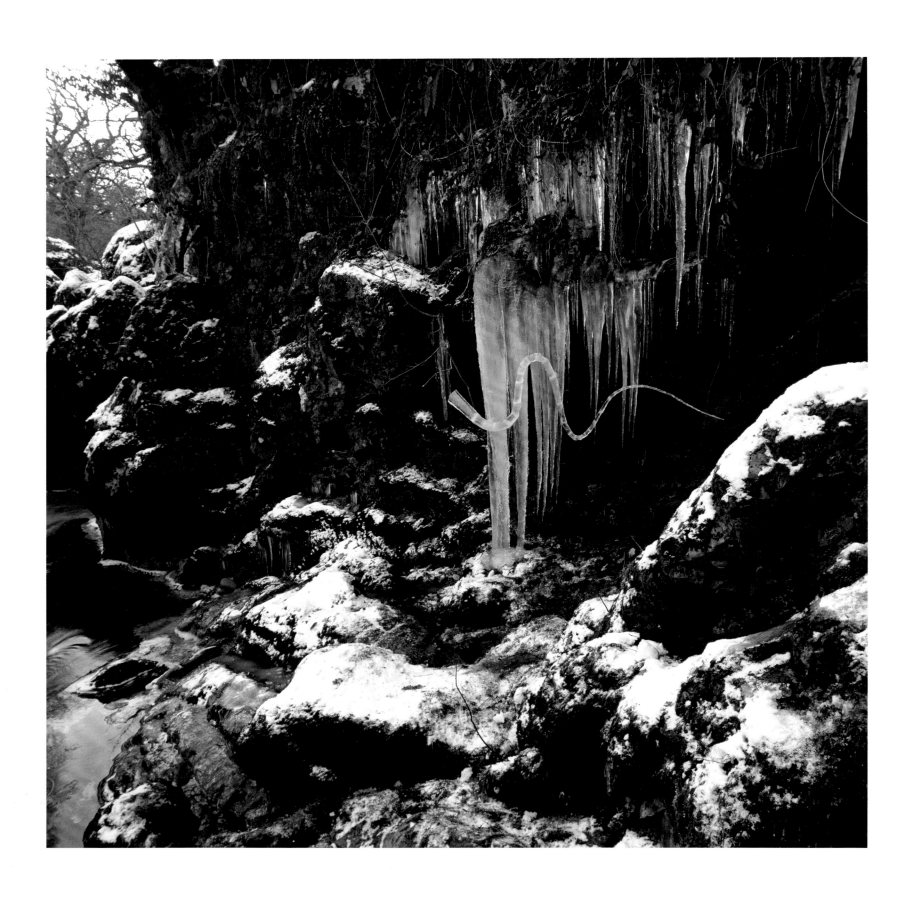

RECONSTRUCTED ICICLES. BROKEN AND FROZEN. DUMFRIESSHIRE, SCOTLAND. 7 JANUARY 2010

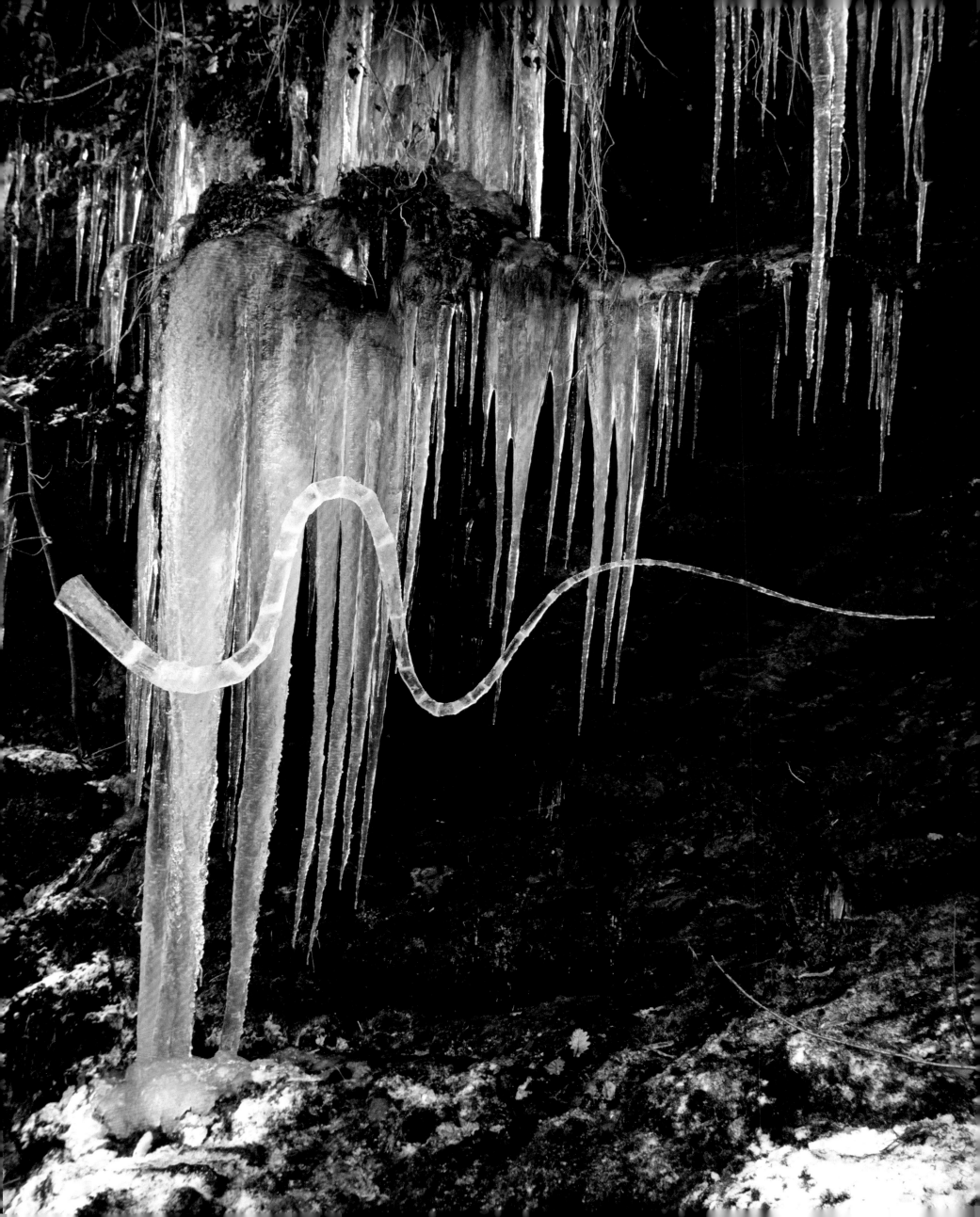

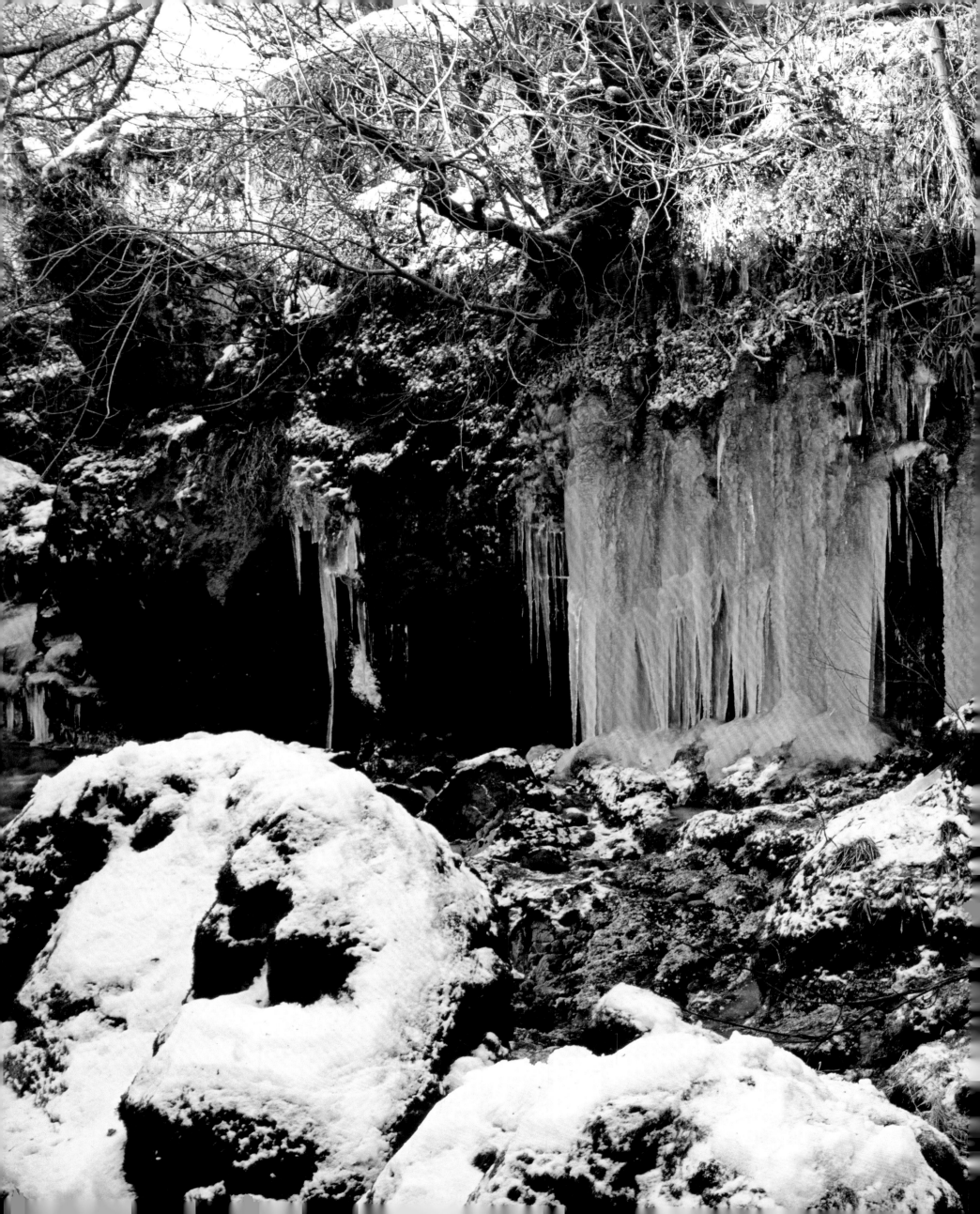

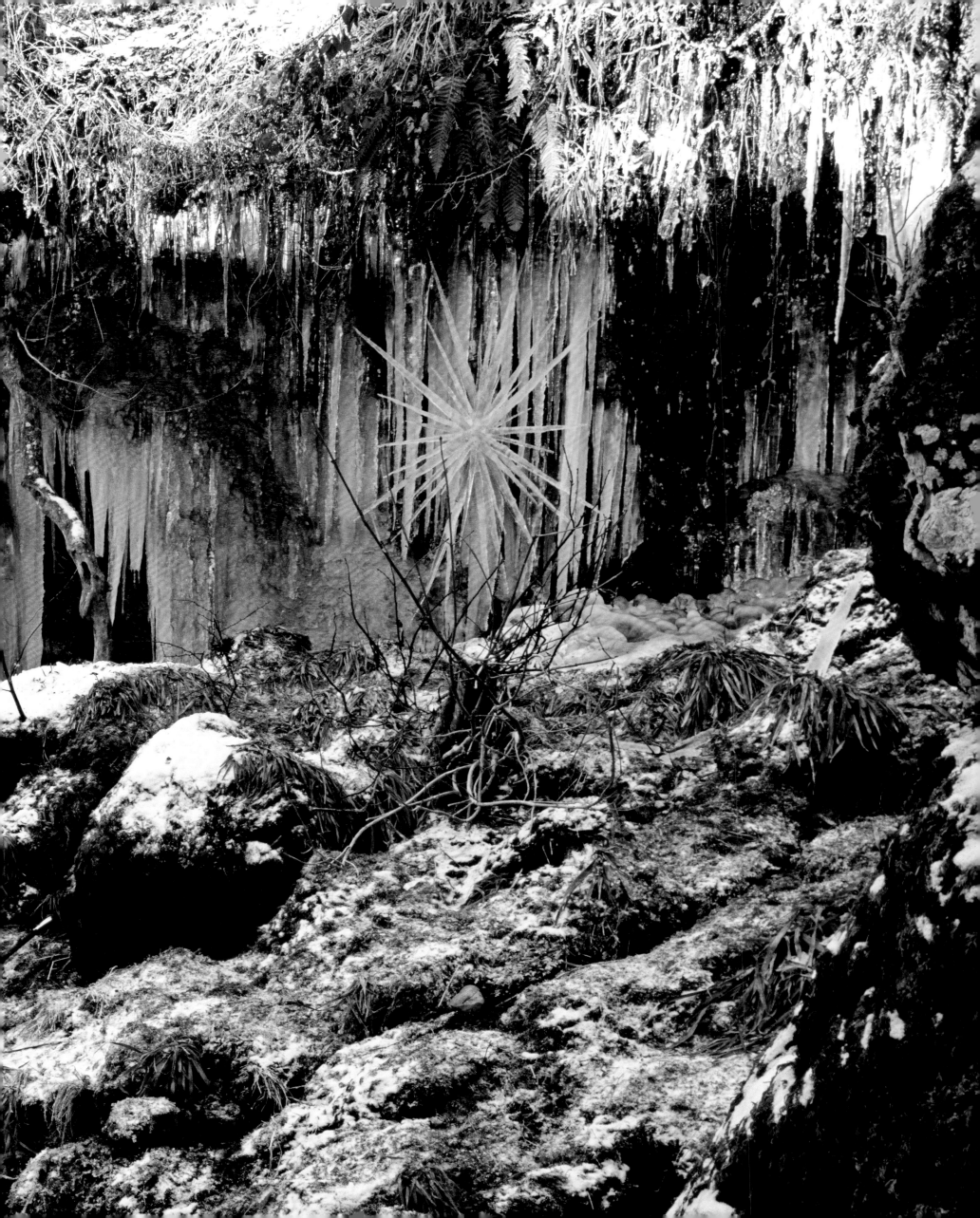

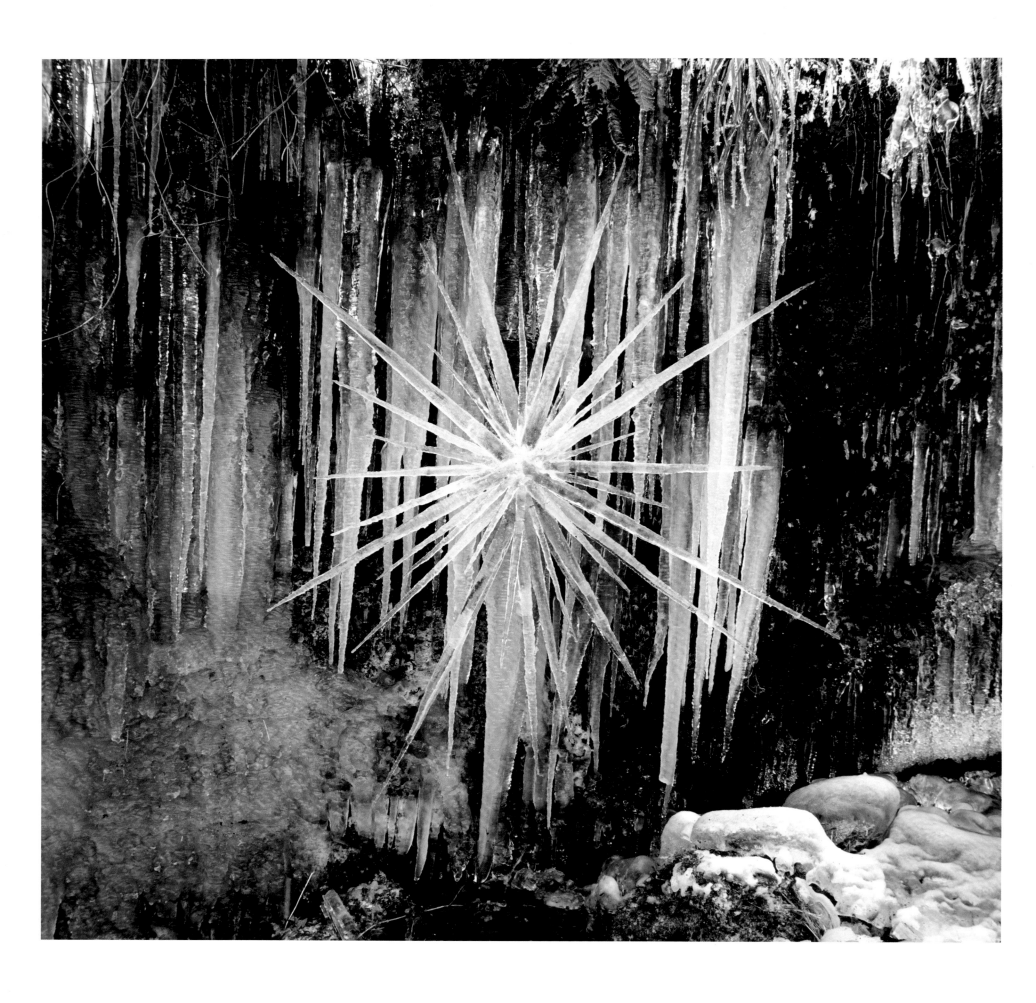

ICICLES FROZEN TO ICICLES. MIDDAY SUN WARMING THE BANK ABOVE WHERE I WORKED. CAUSING SOME ICE TO MELT AND FALL. CONTINUED TO FREEZE IN THE SHADOWS. COLD OVERNIGHT. STILL INTACT THE FOLLOWING DAY. COLLAPSED TWO DAYS LATER. DUMFRIESSHIRE, SCOTLAND. 8 JANUARY 2010

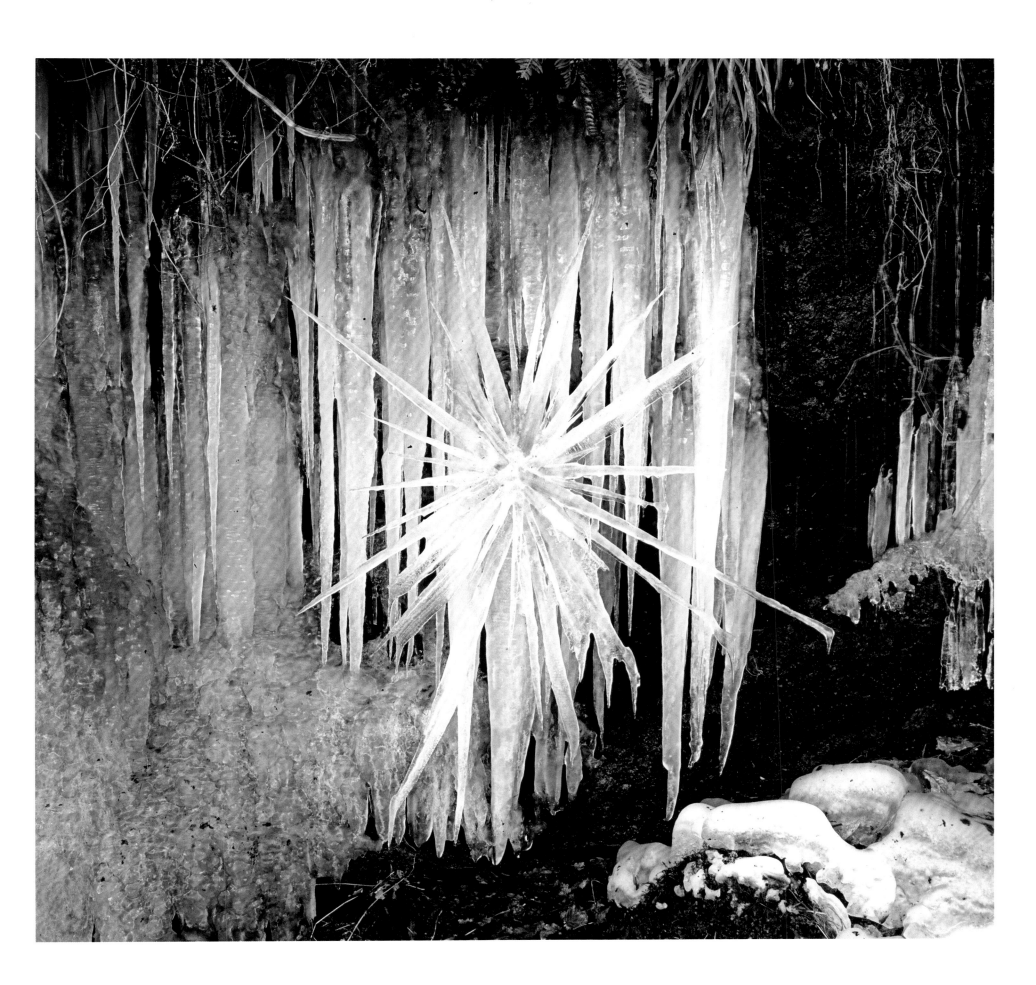

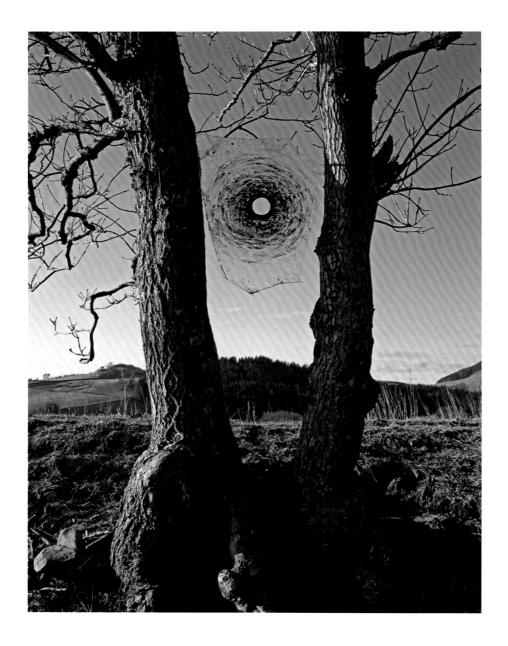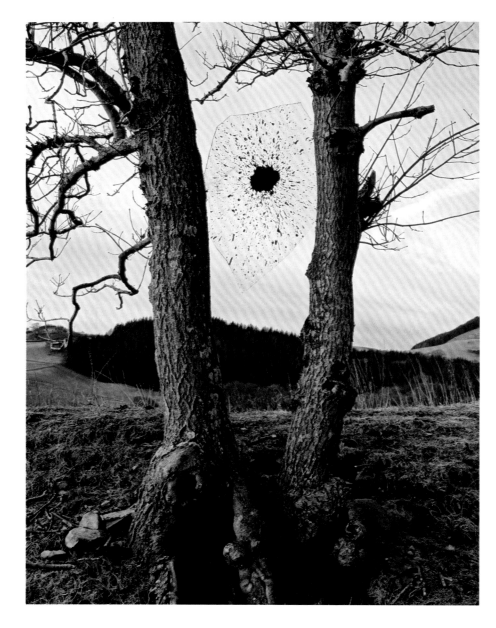

MUD. FROZEN ON ICE. DUMFRIESSHIRE, SCOTLAND. 23 FEBRUARY 2010

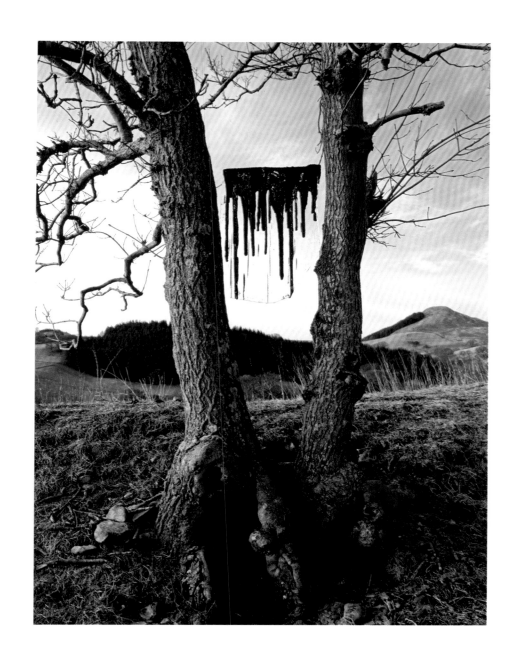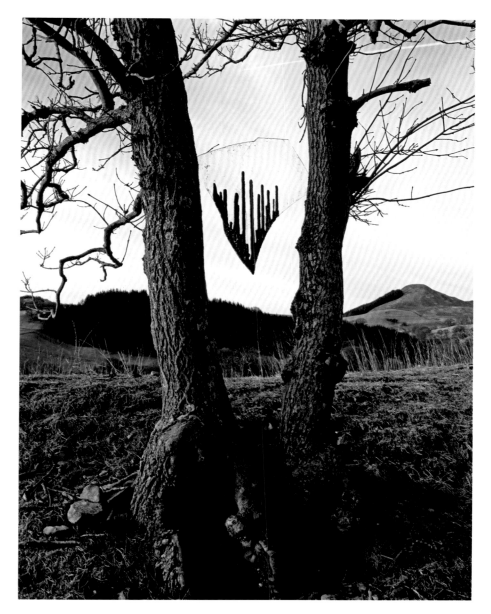

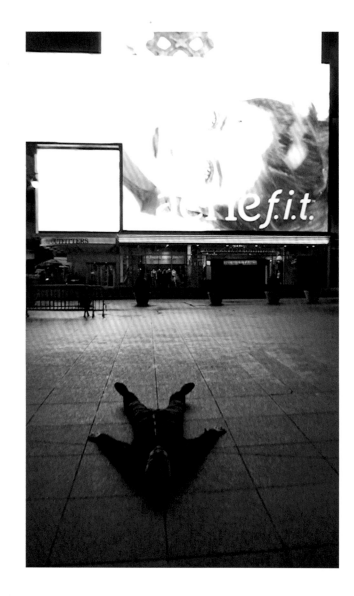
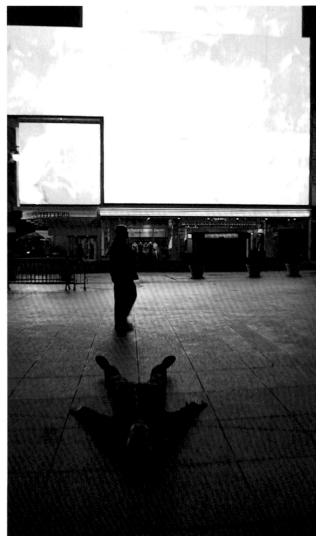
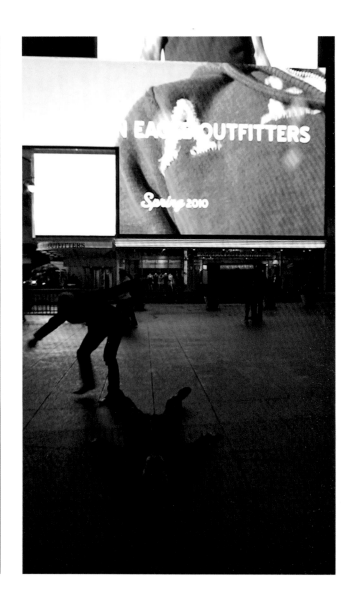
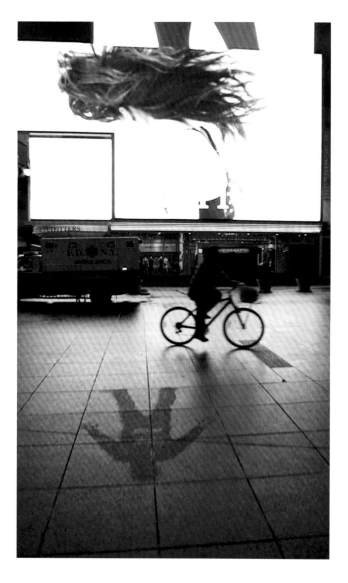
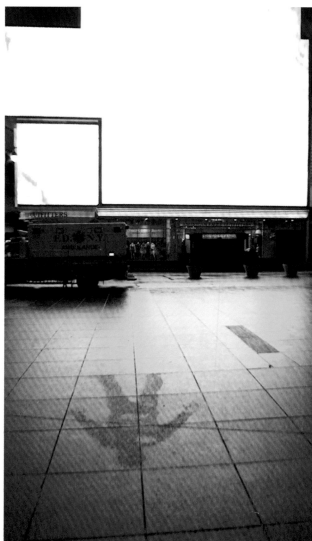
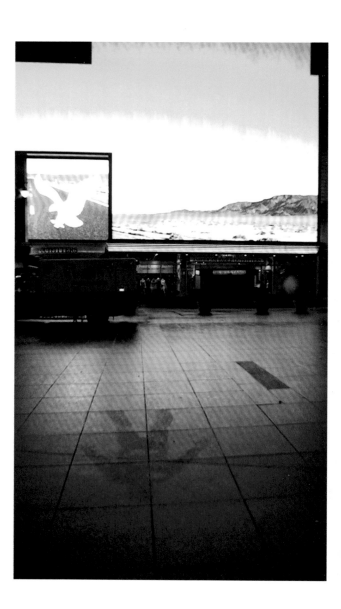

LATE NIGHT RAIN SHADOW. TIMES SQUARE, NEW YORK. 3 MARCH 2010

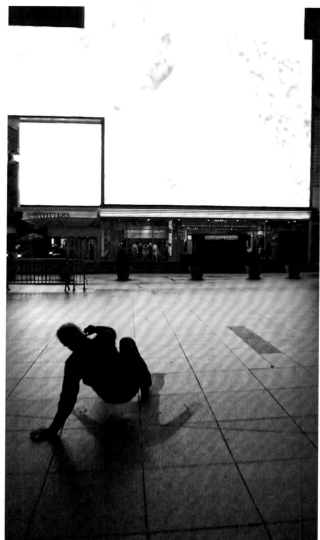

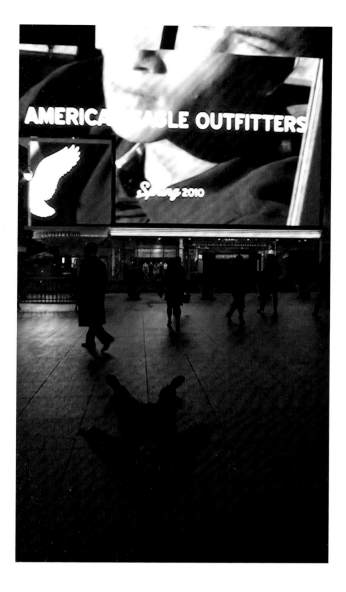

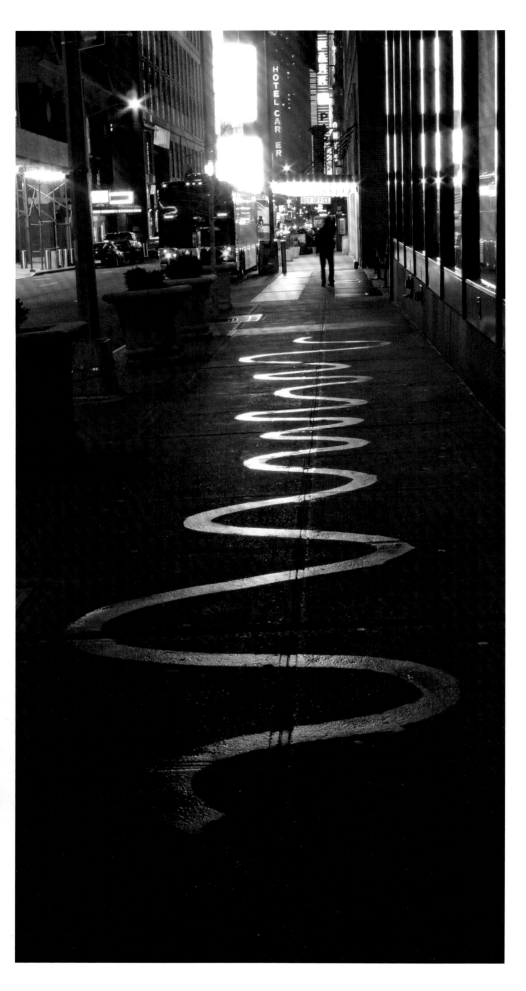
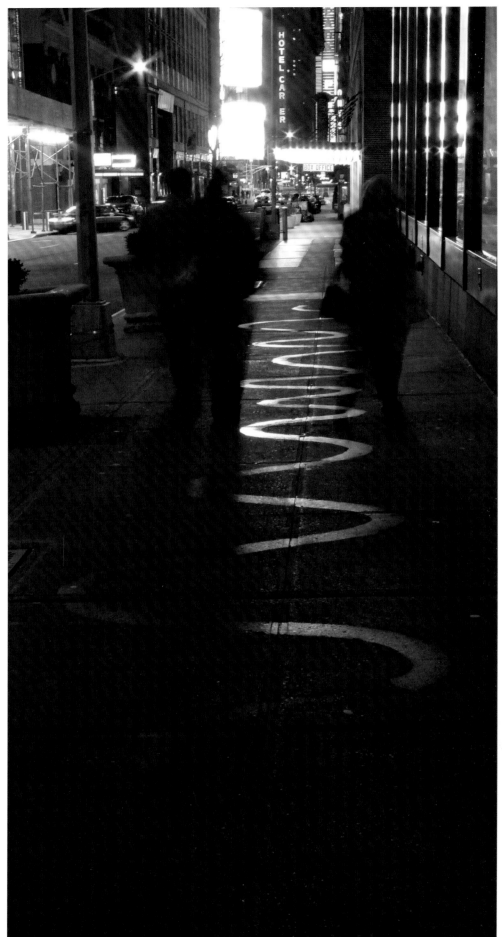

PAVEMENT DRAWING. GUTTER WATER, BOWL AND SPONGE. WEST 43RD STREET BETWEEN 6TH AND 7TH AVENUES, NEW YORK. 5 MARCH 2010

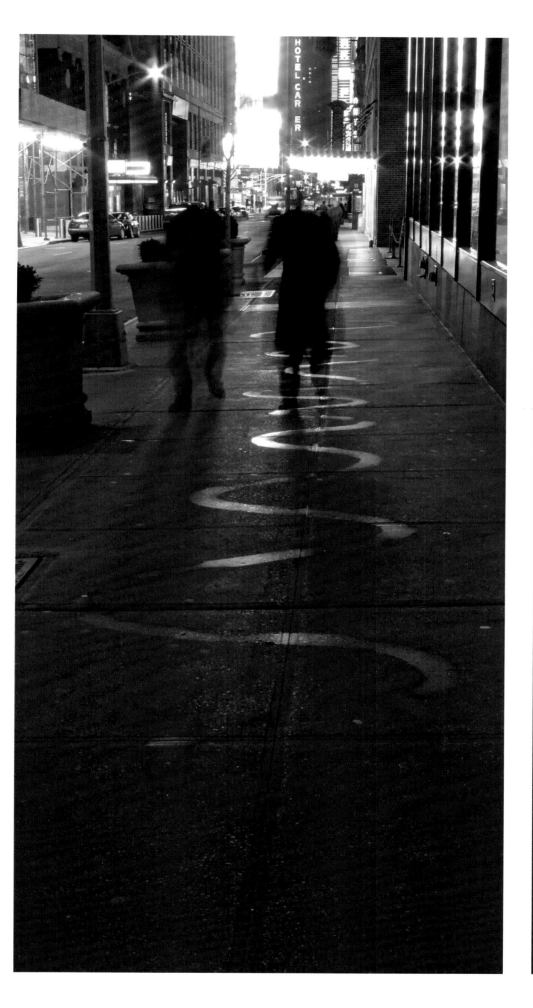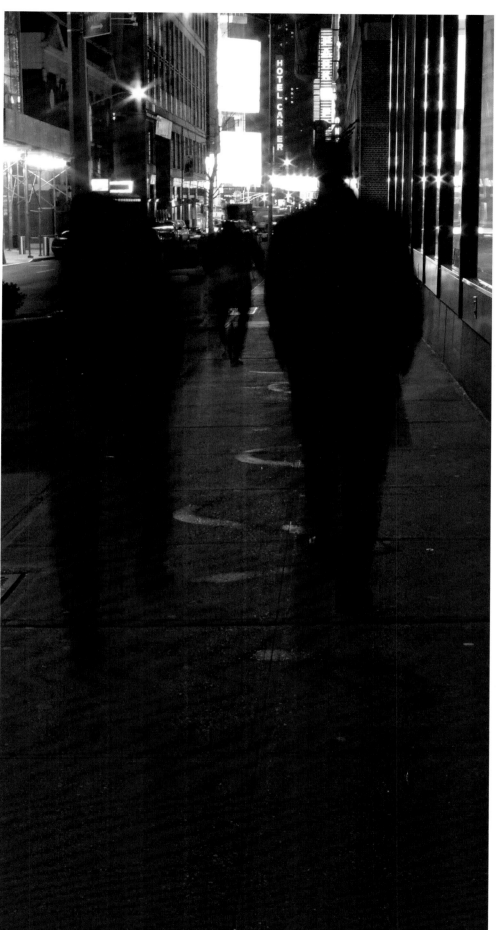

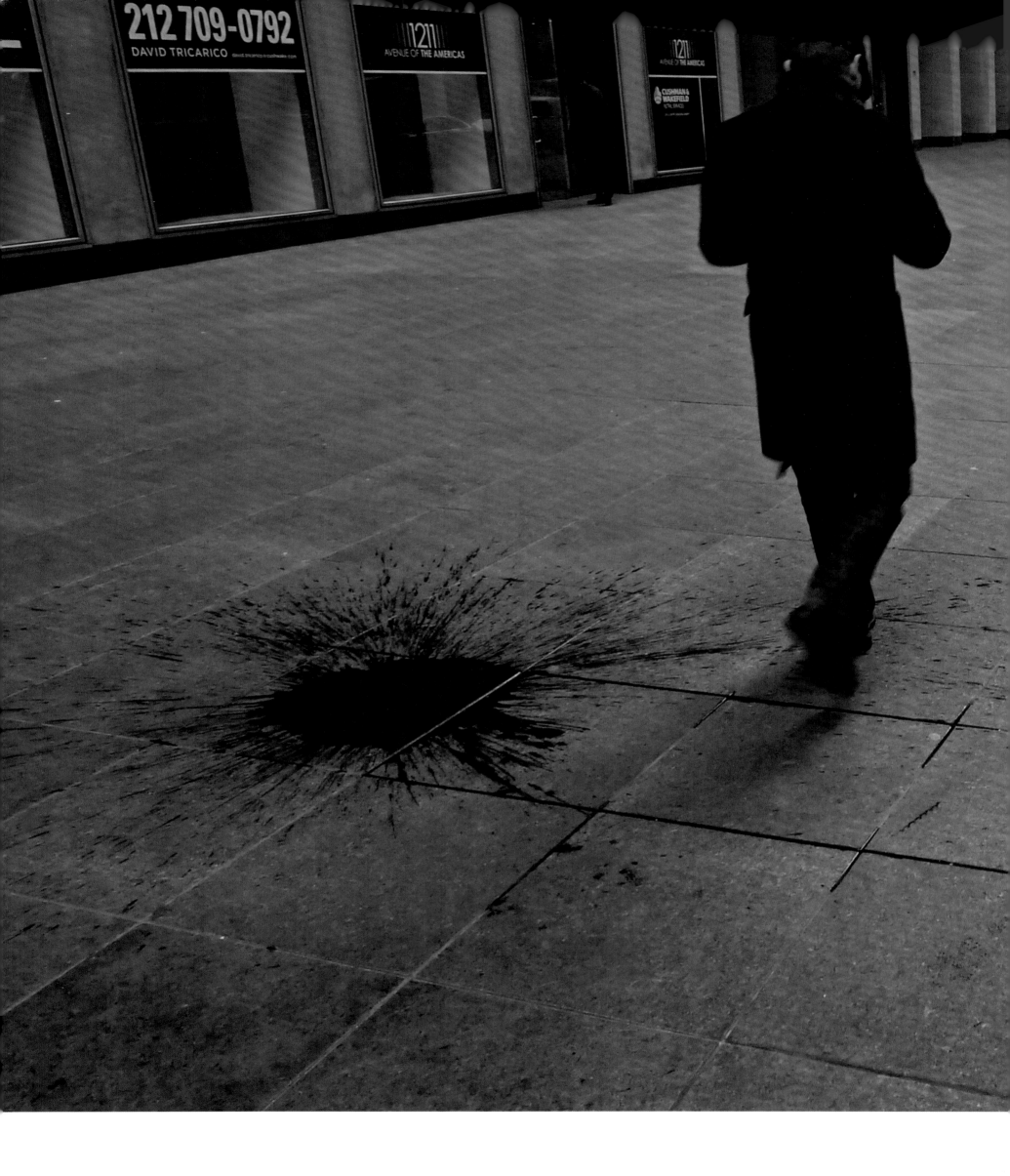

TWO CUPS OF GUTTER WATER. POURED ONTO PAVEMENT. ONE REFLECTING BUILDINGS. THE OTHER REFLECTING SKY. WEST 47TH STREET BETWEEN 6TH AND 7TH AVENUES, NEW YORK. 5 MARCH 2010

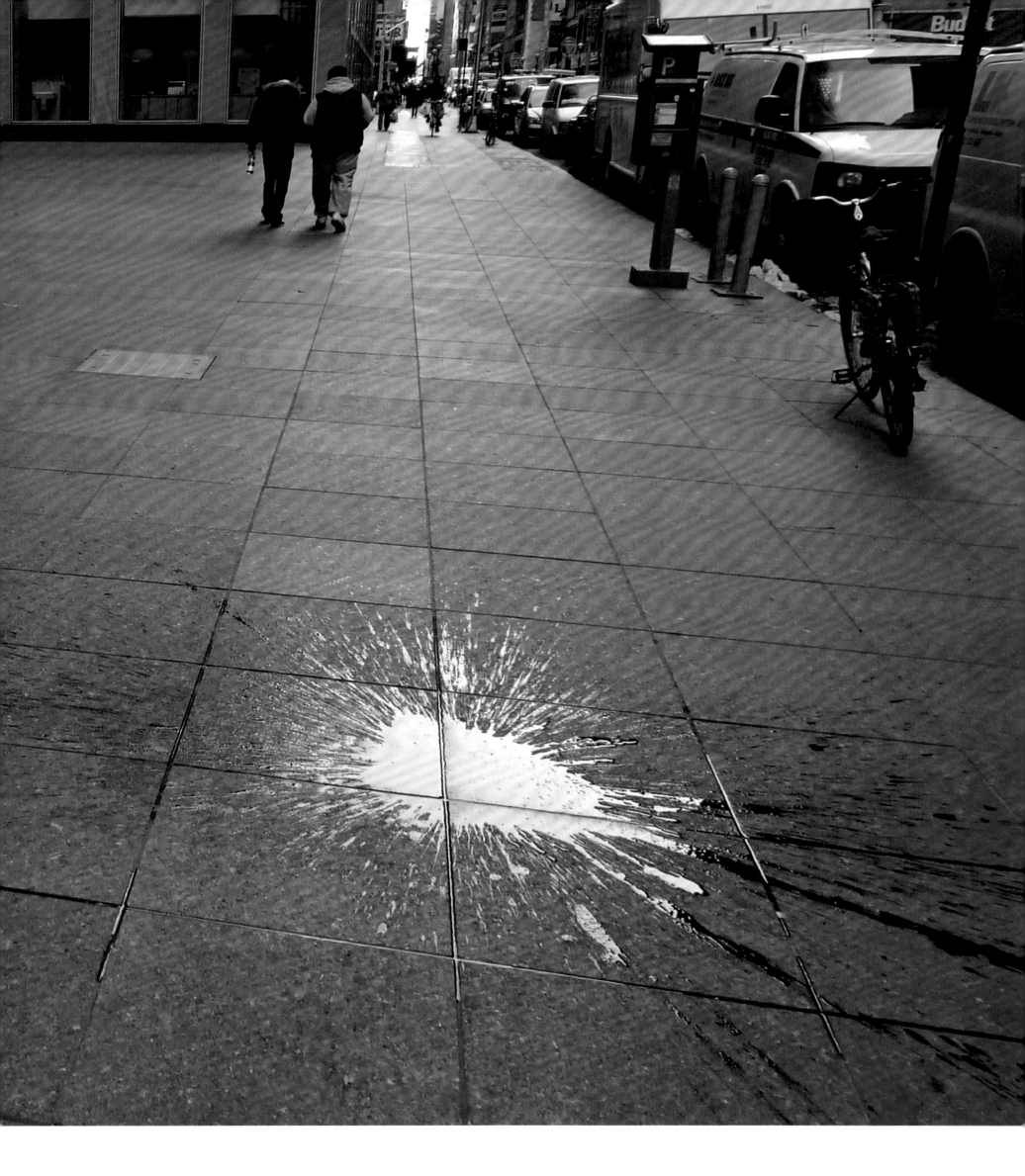

CUP OF GUTTER WATER. POURED ON THE PAVEMENT. REFLECTING RED. TIMES SQUARE, NEW YORK. 6 MARCH 2010

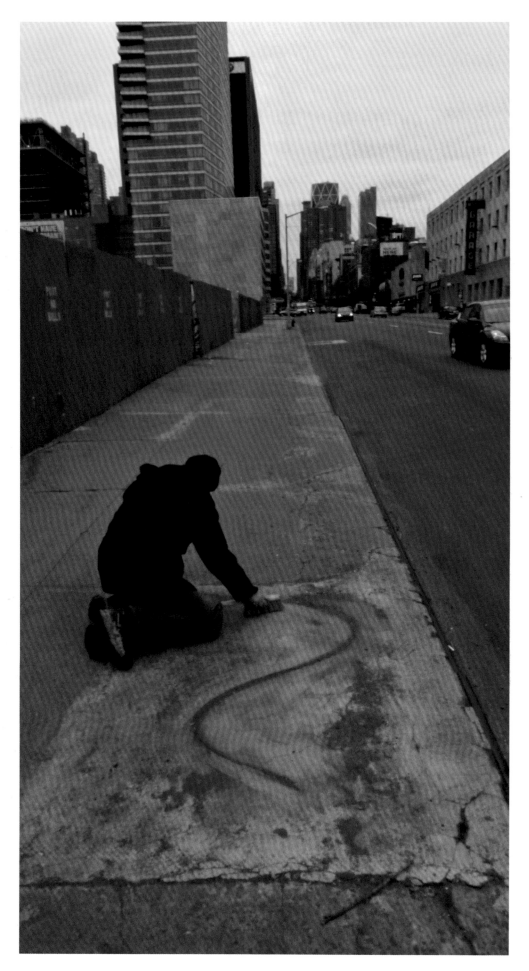
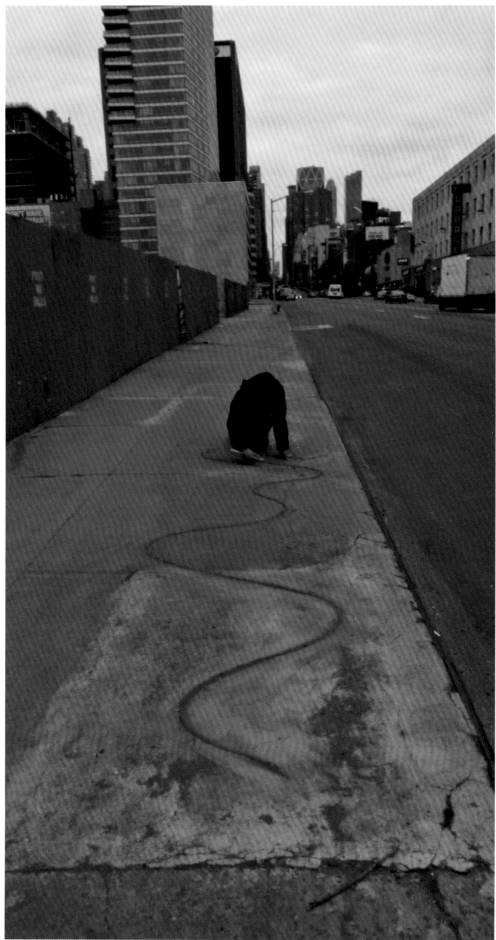

SWEPT UP STREET DIRT. AFTERNOON. WEST 57TH BETWEEN 11TH AND 12TH AVENUES, NEW YORK. 11 MARCH 2010

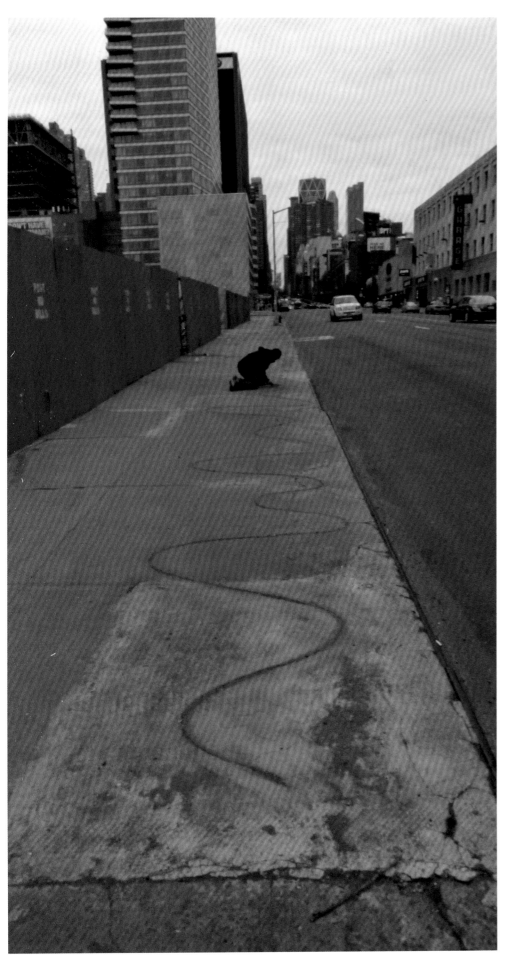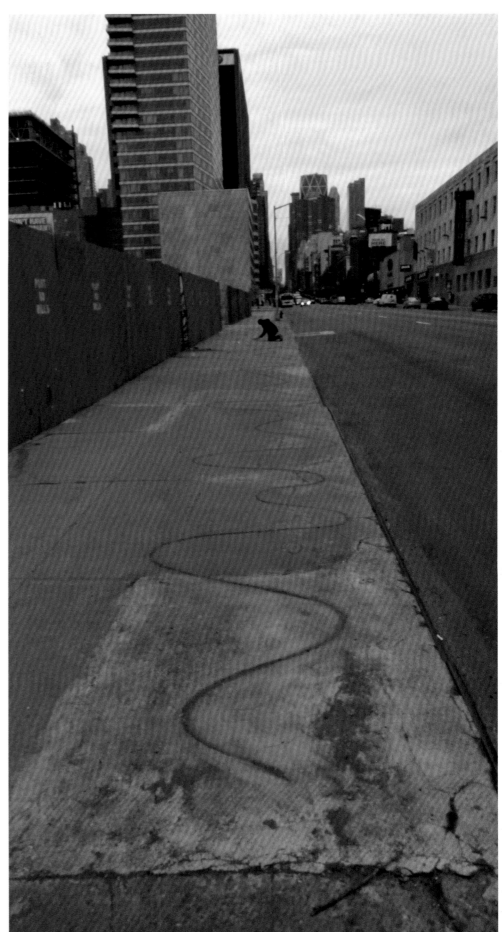

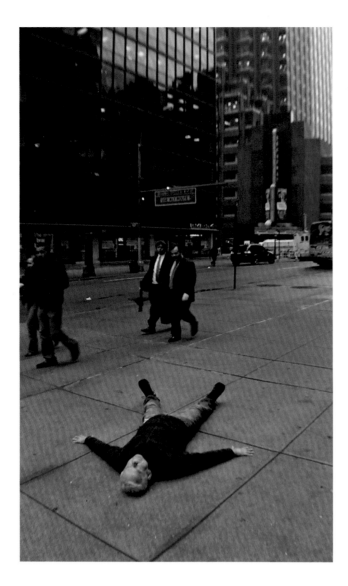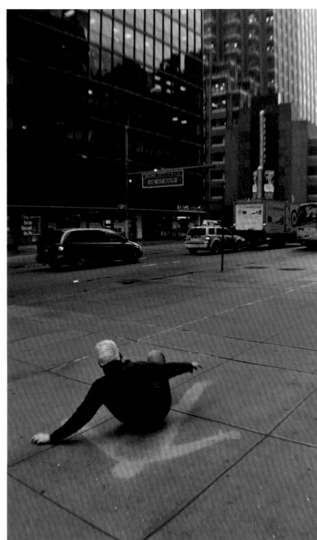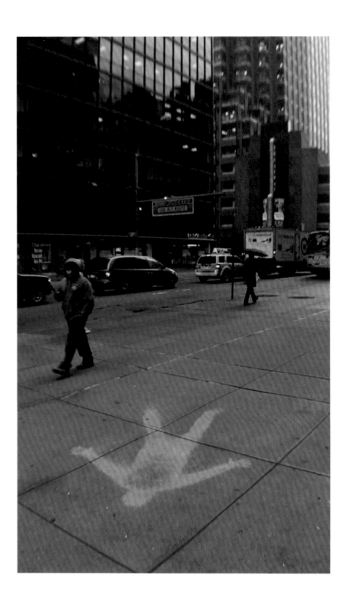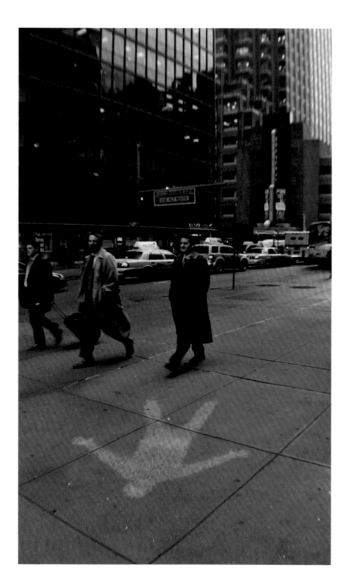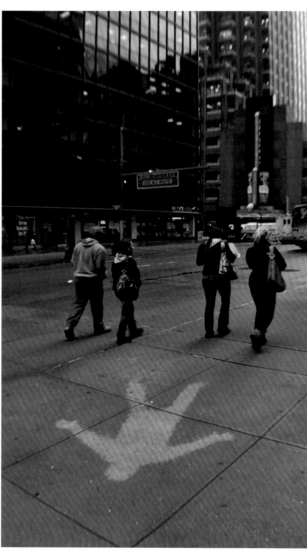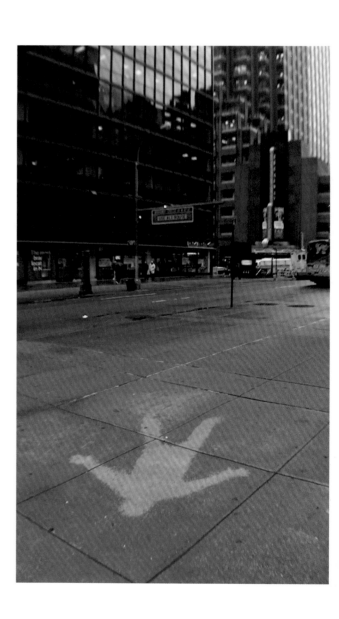

RAIN SHADOW. CORNER OF 53RD STREET AND 7TH AVENUE, NEW YORK. 12 MARCH 2010

 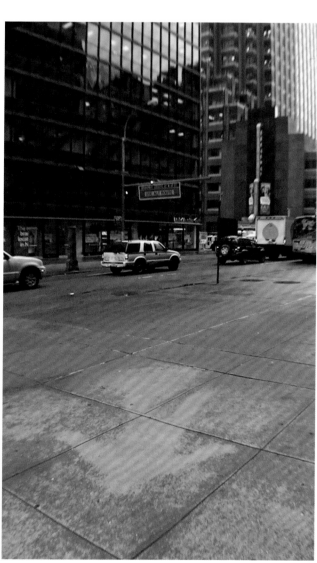 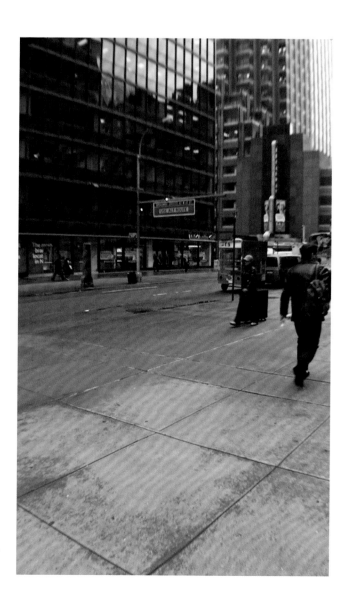

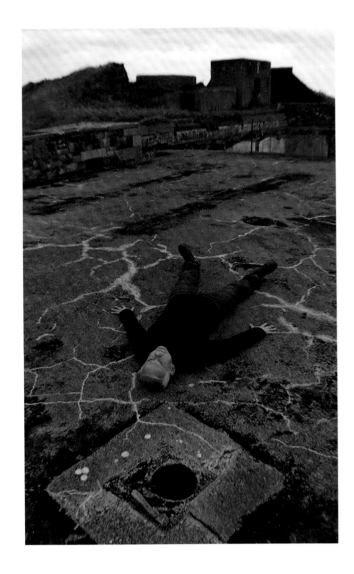
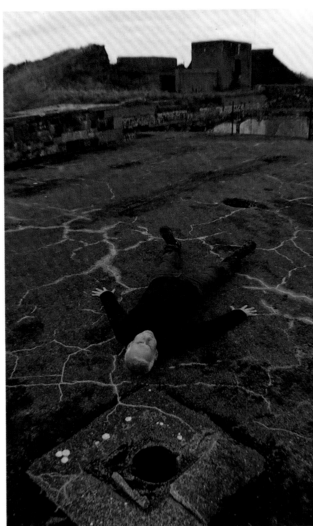
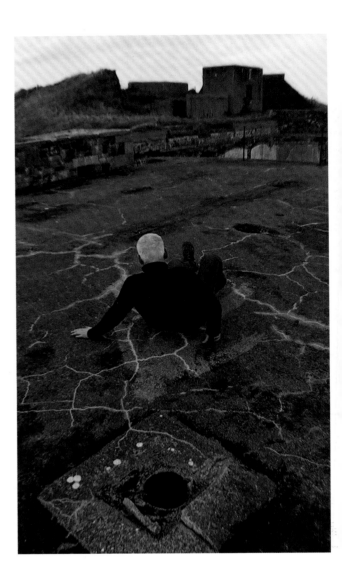
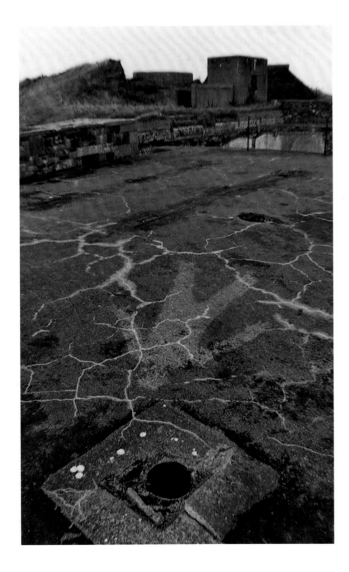
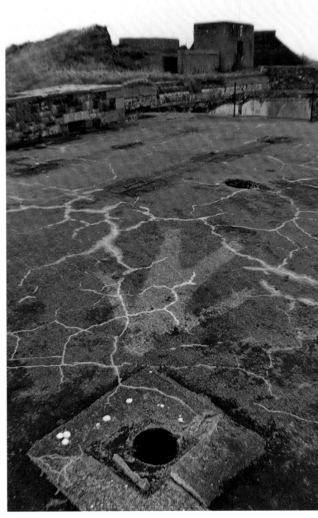
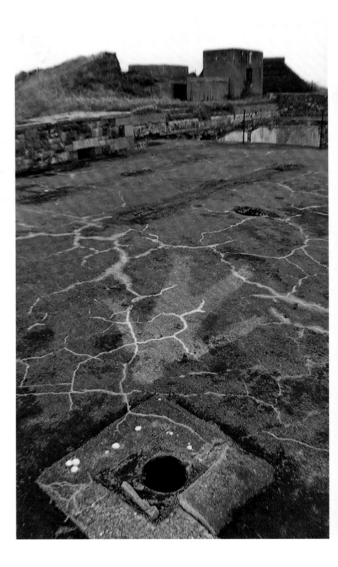

RAIN SHADOW. FORT ALBERT, ALDERNEY. 24 MARCH 2010

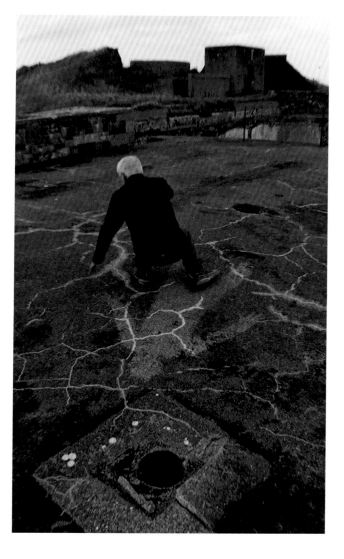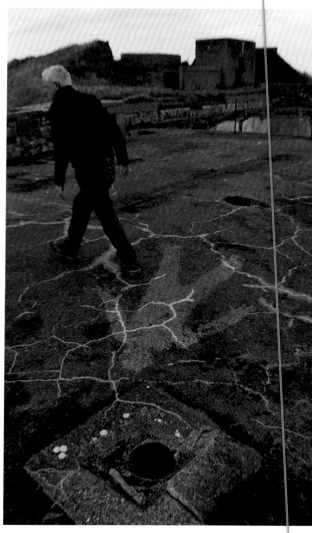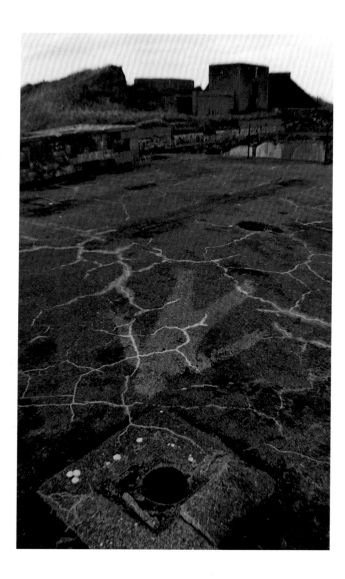
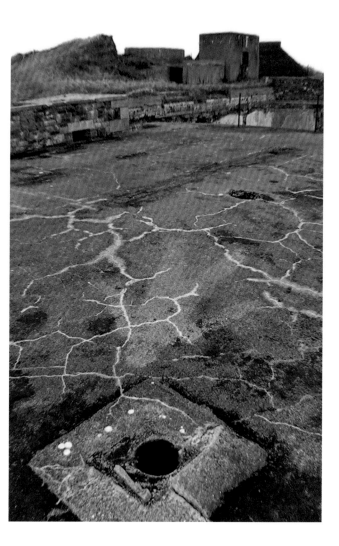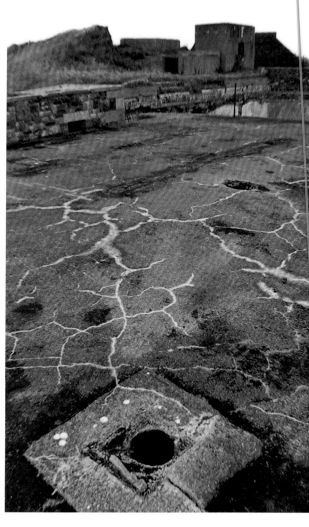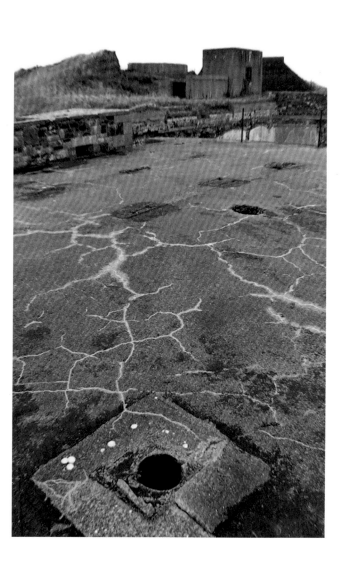

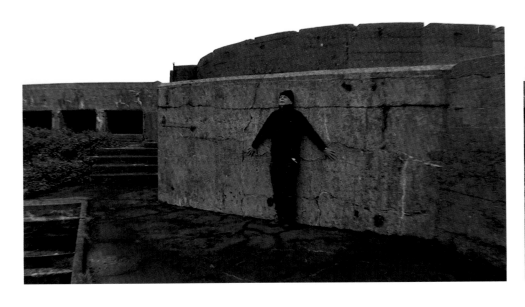
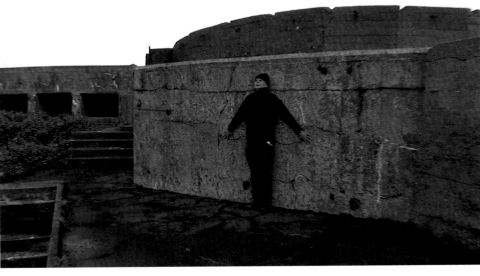
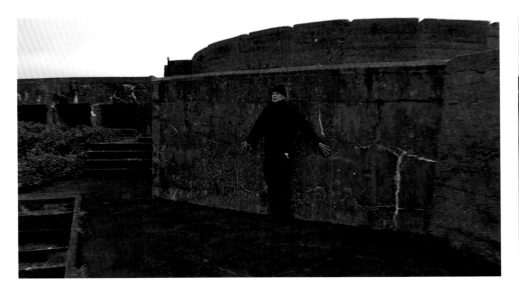
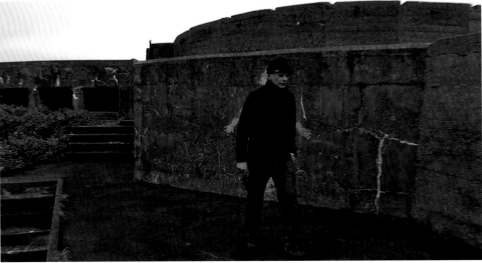
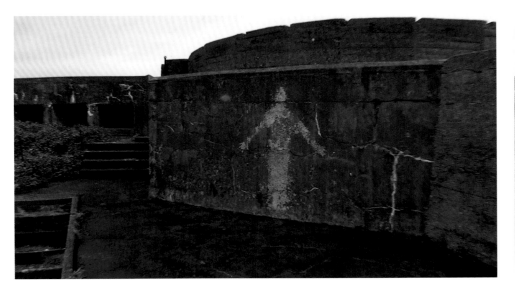
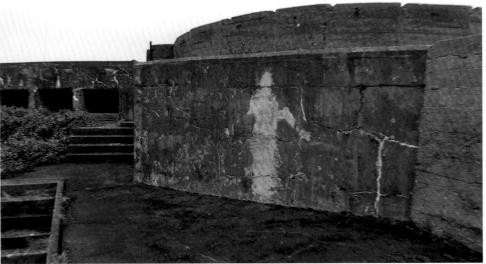

STRONG WIND AND DRIVING RAIN. FORT ALBERT, ALDERNEY. 30 MARCH 2010

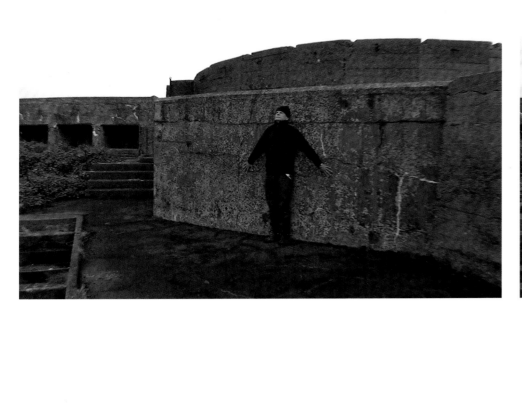
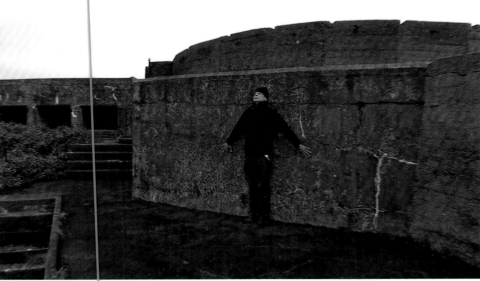
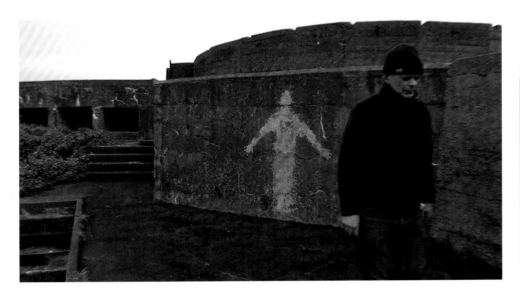
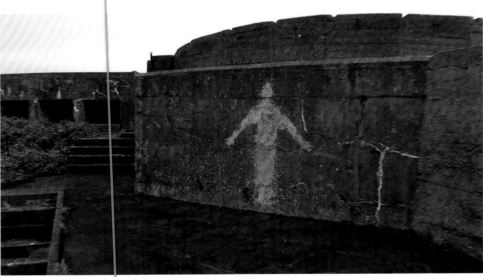
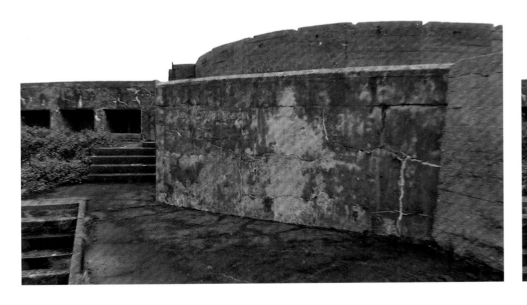
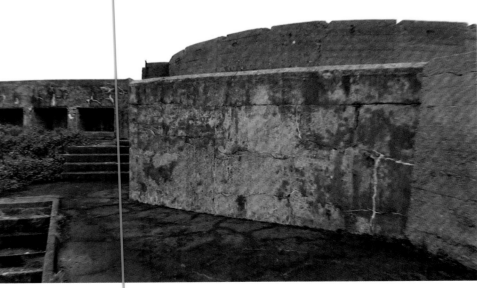

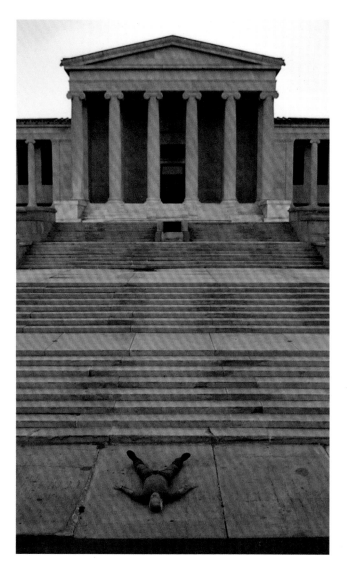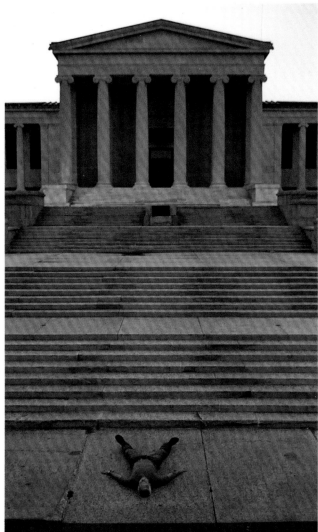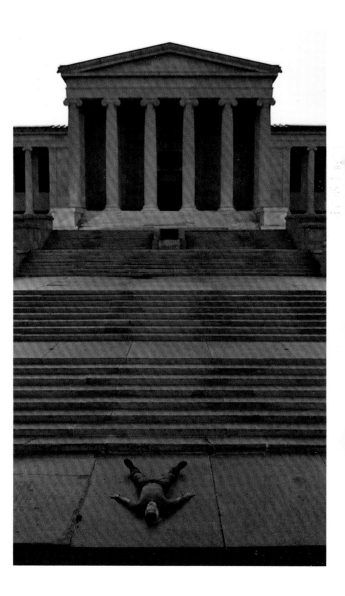

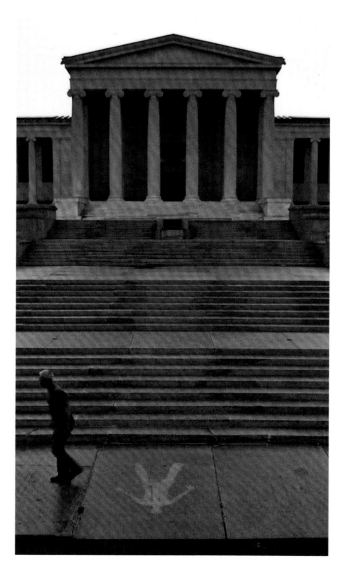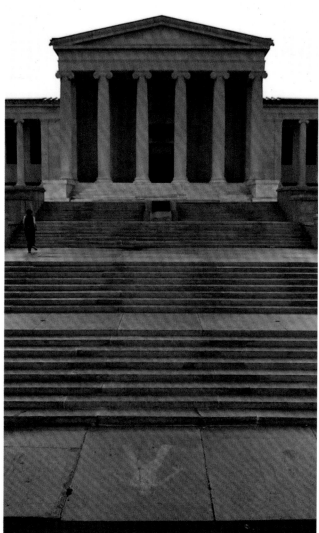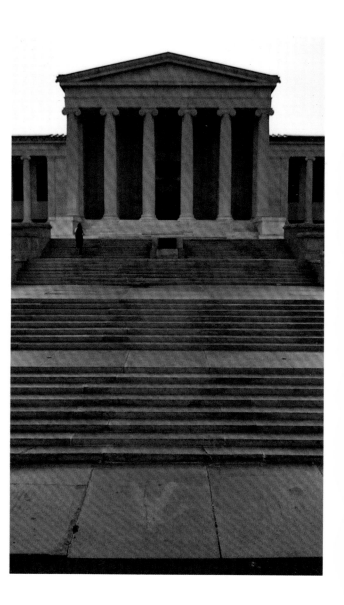

RAIN SHADOW. ALBRIGHT-KNOX ART GALLERY, BUFFALO, NEW YORK. 2 JUNE 2010

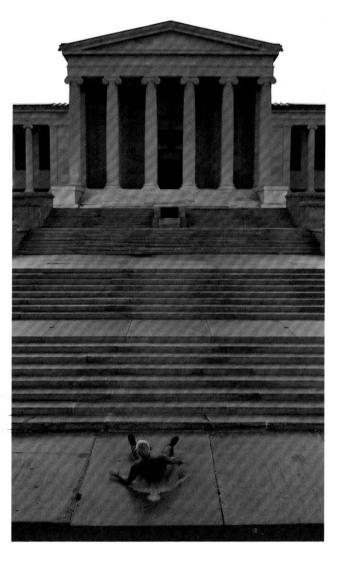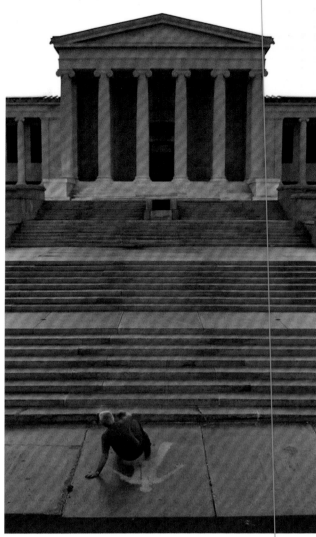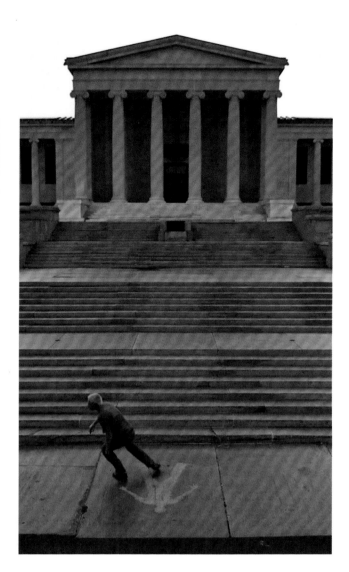
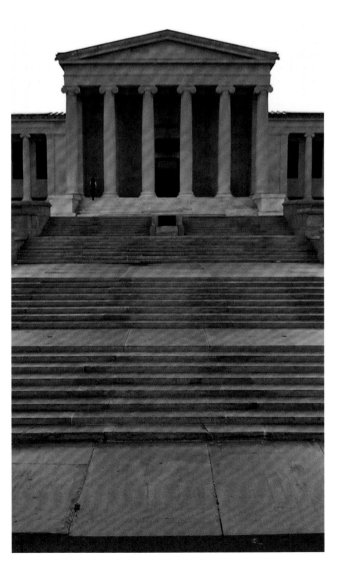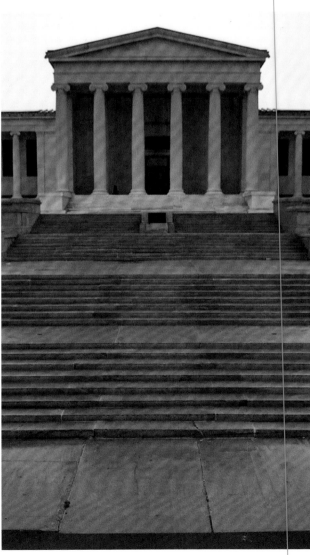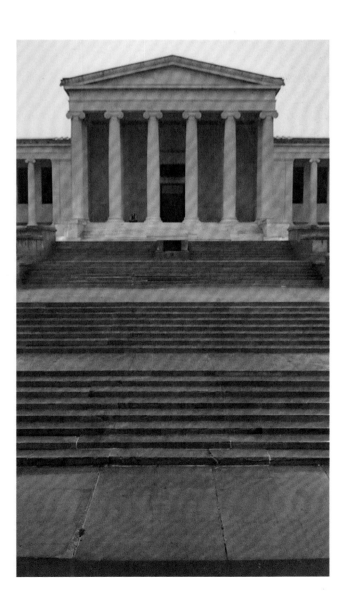

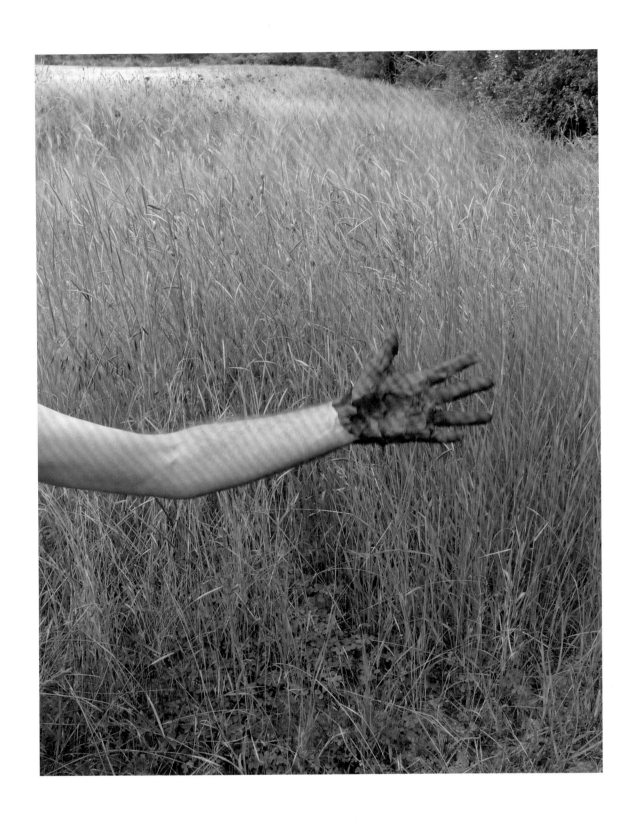

POPPIES HELD WITH WATER. SHOOK OFF. DIGNE-LES-BAINS, FRANCE. 11 JUNE 2010

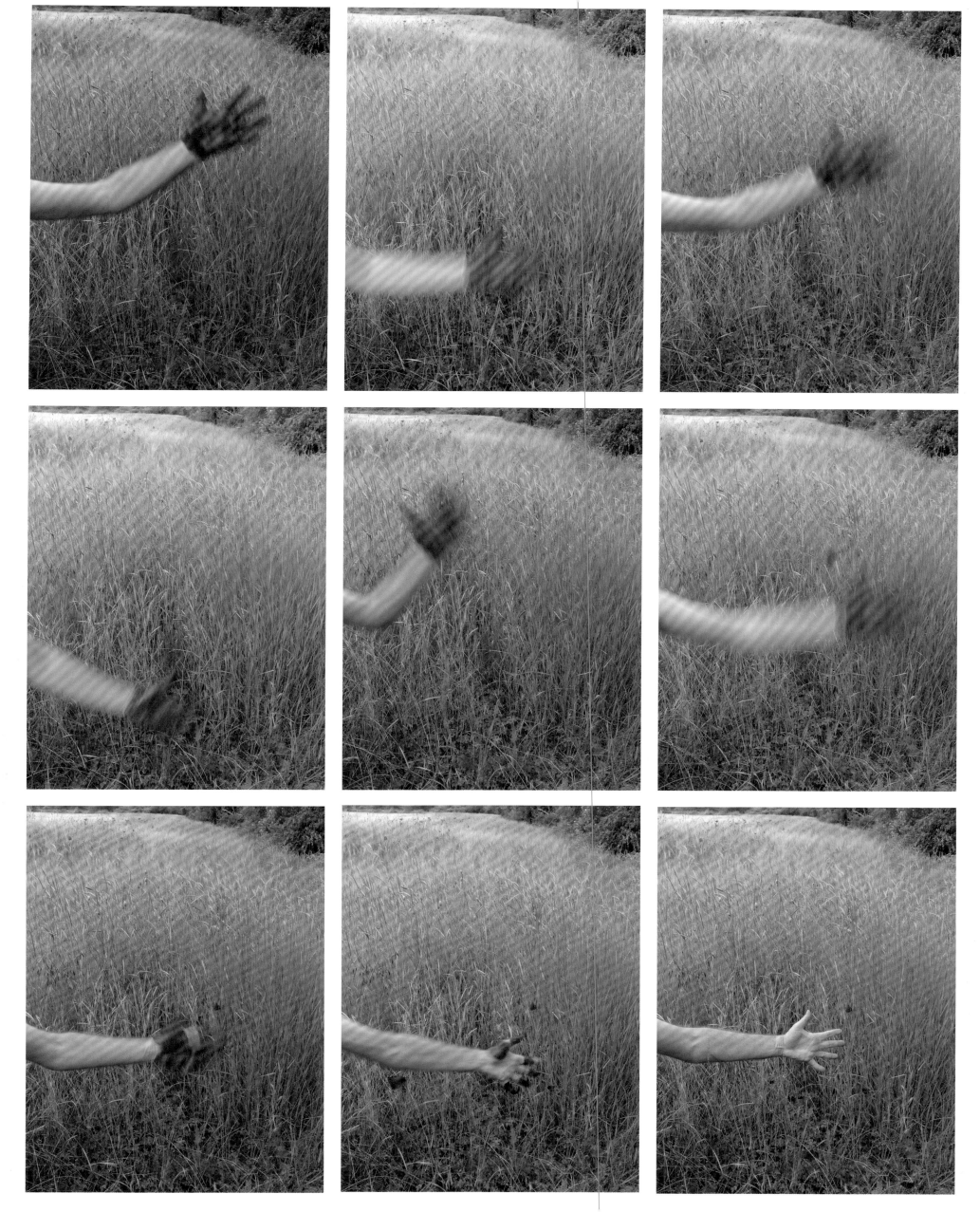

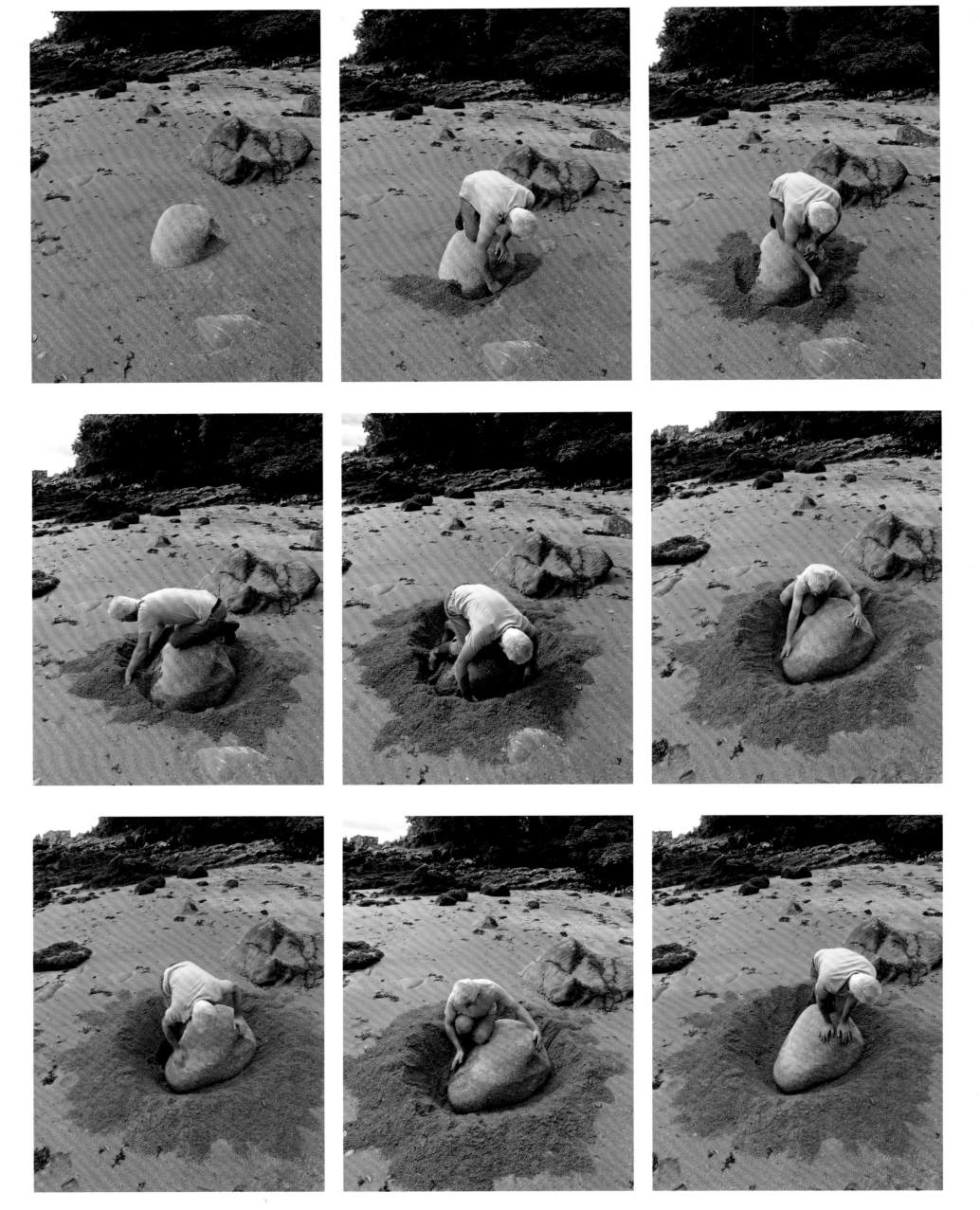

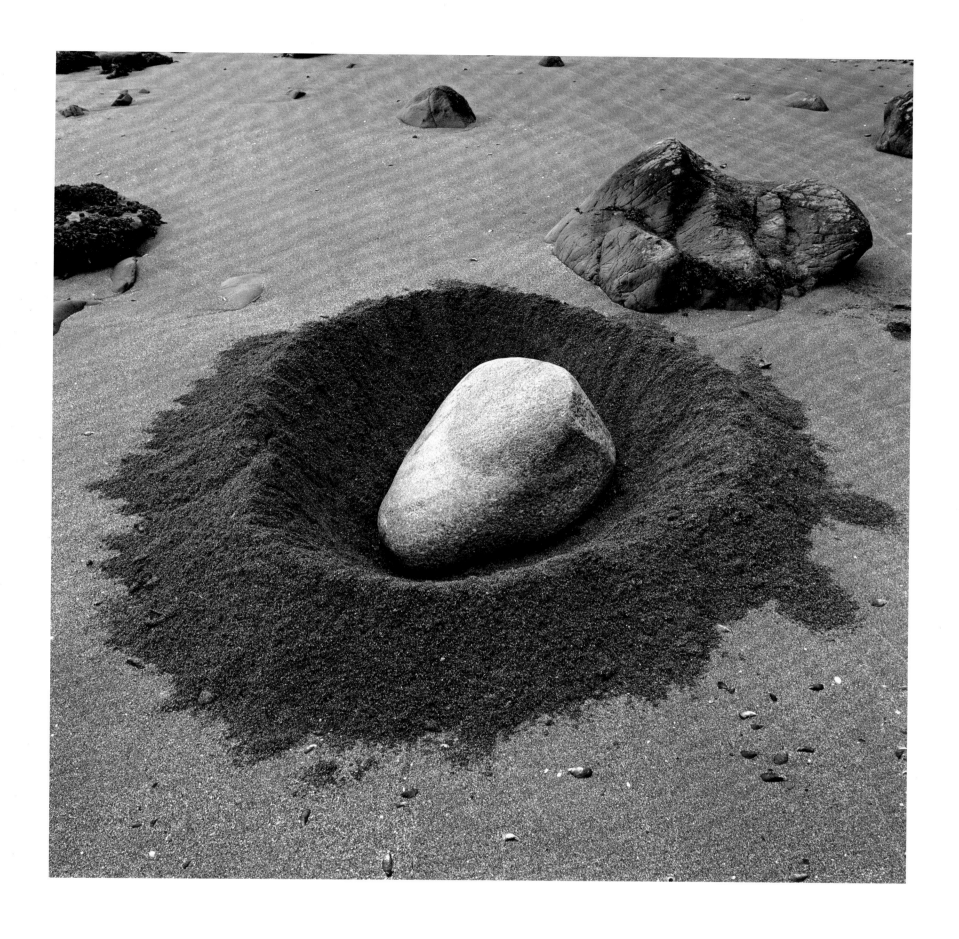

BEACH BOULDER. UNEARTHED. BETWEEN TIDES. DUMFRIESSHIRE, SCOTLAND. 18, 19 JULY 2010

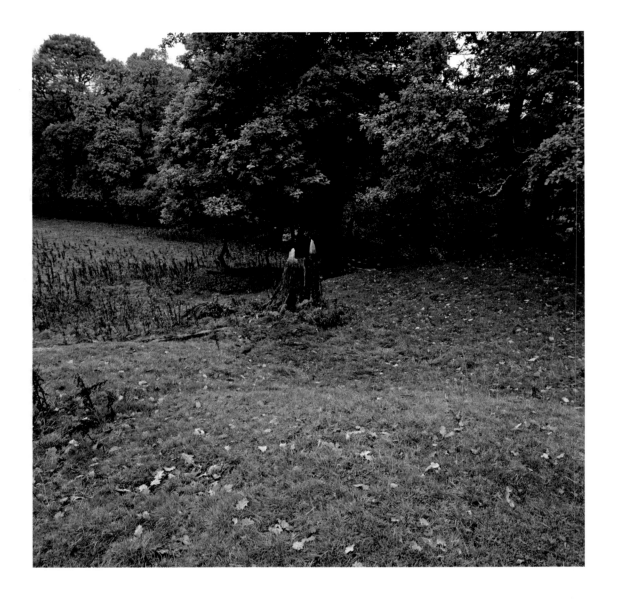

ELM LEAVES WRAPPED AROUND THE ROTTED REMAINS OF AN OAK TREE. DUMFRIESSHIRE, SCOTLAND. OCTOBER 2010

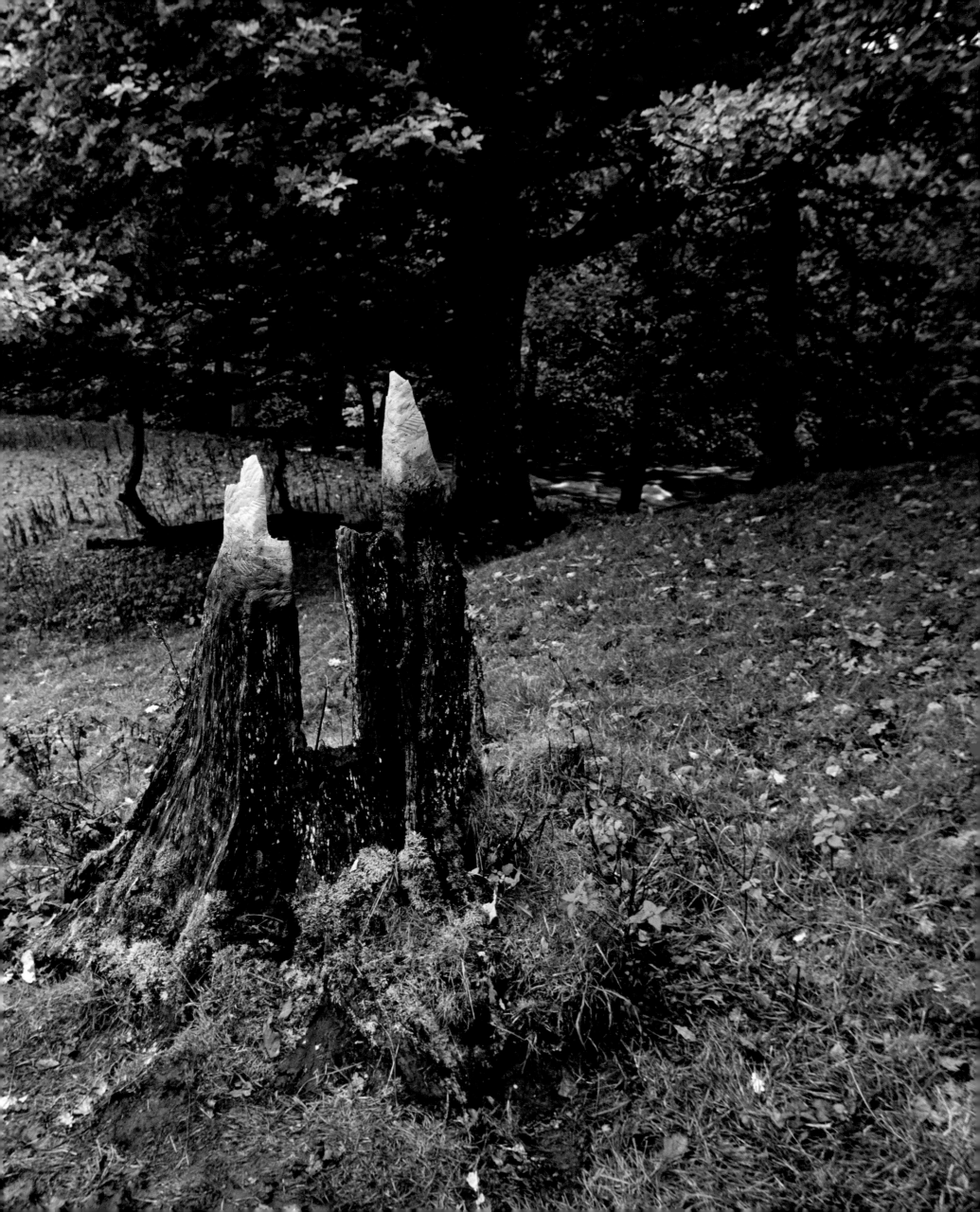

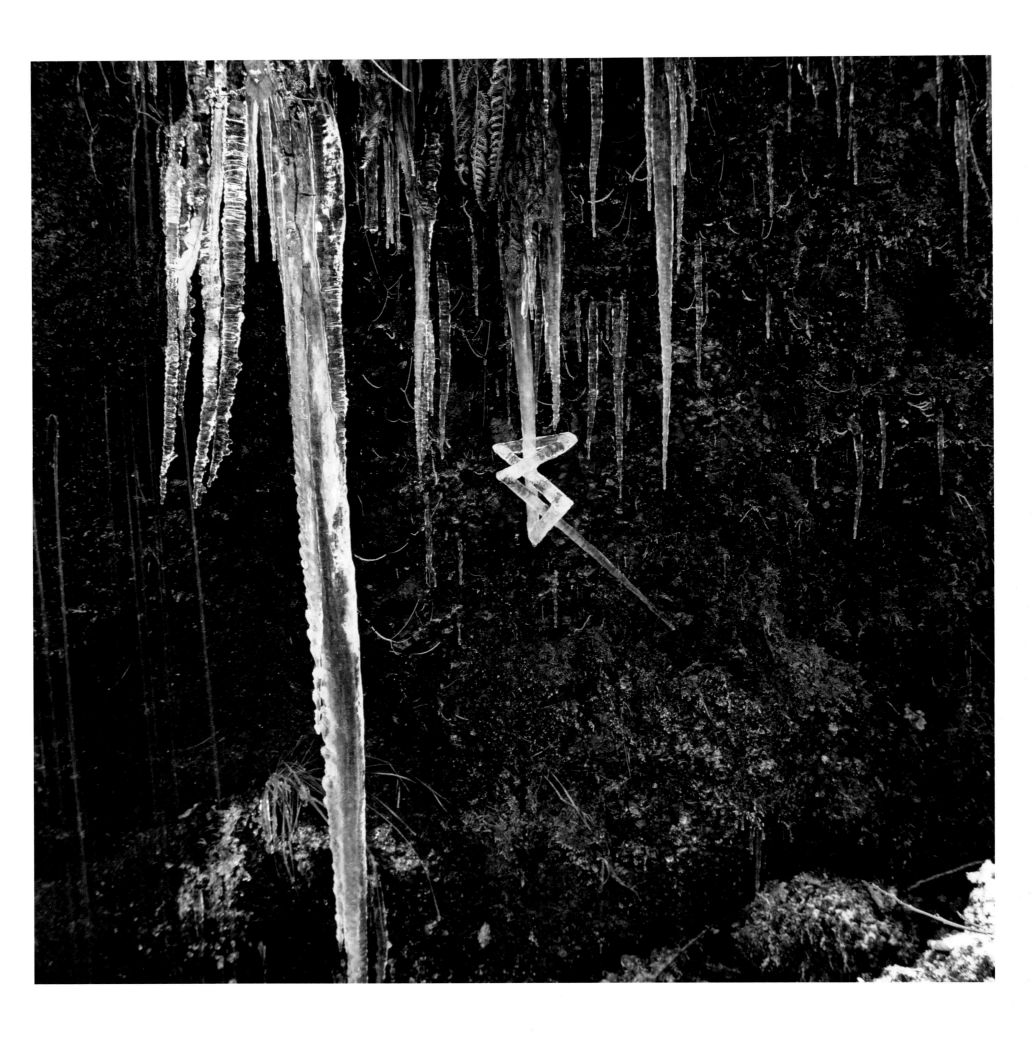

ICICLE WORKED INTO A KNOT. CONTINUED TO DRIP AND FREEZE FOR SEVERAL DAYS. DUMFRIESSHIRE, SCOTLAND. 3 DECEMBER 2010

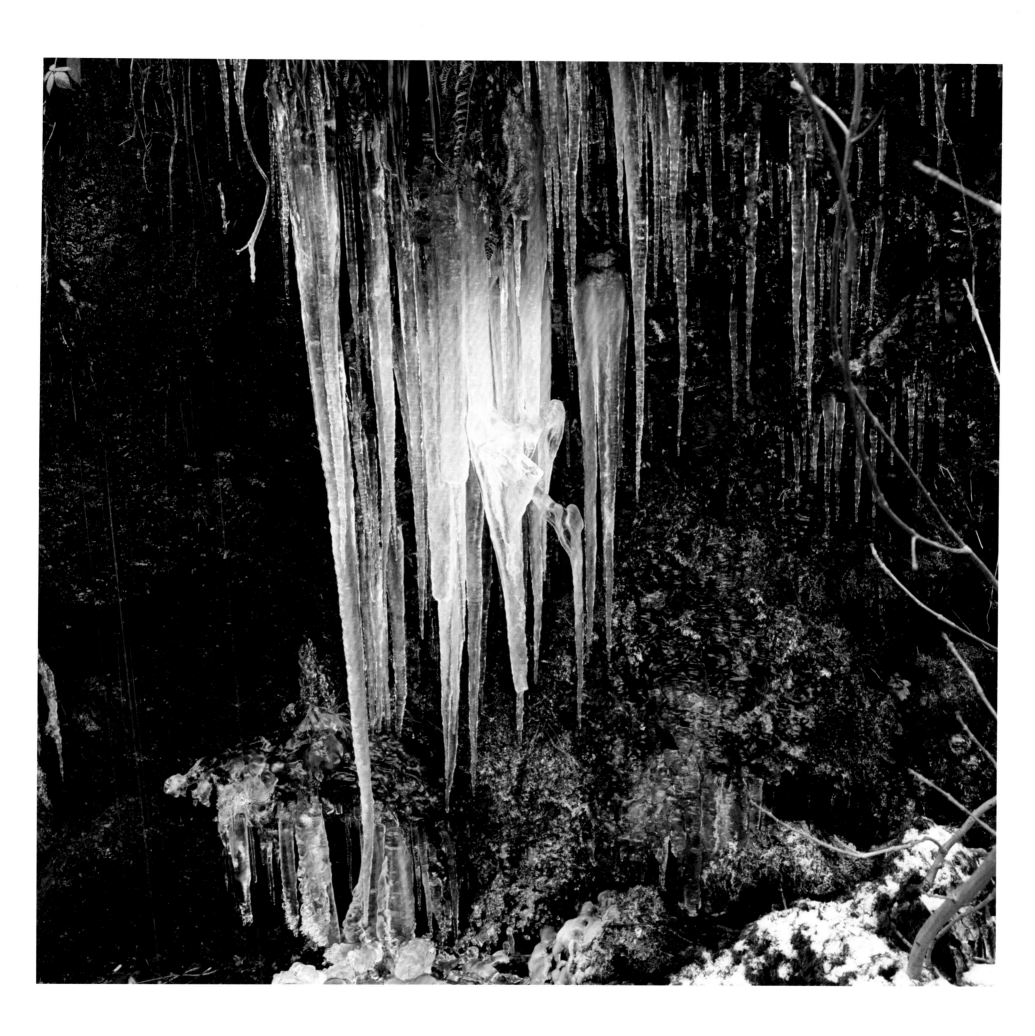

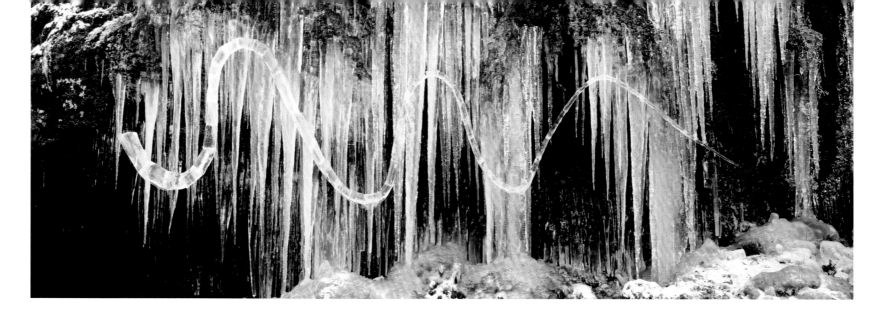

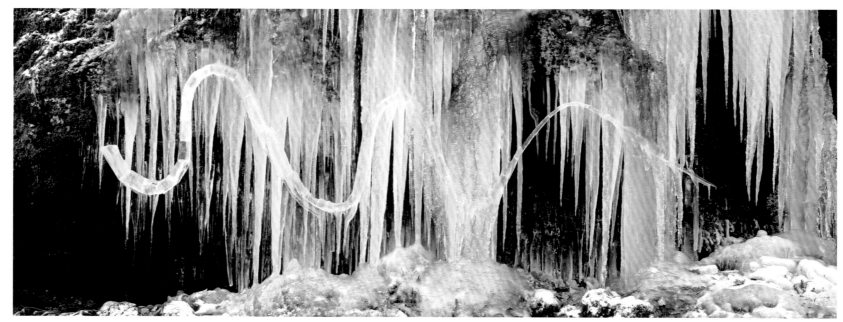

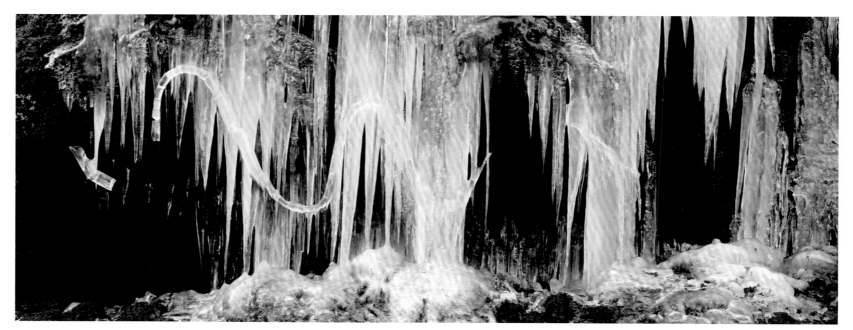

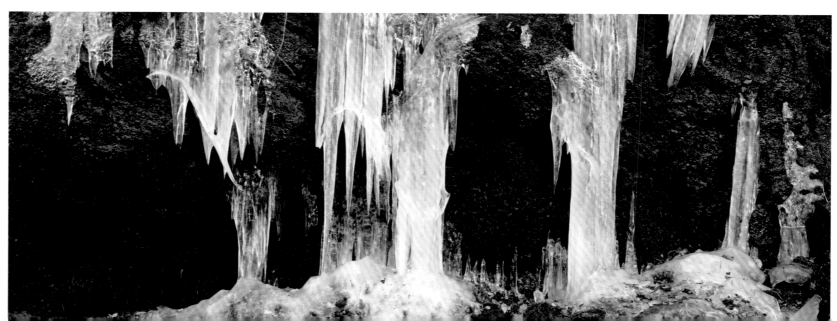

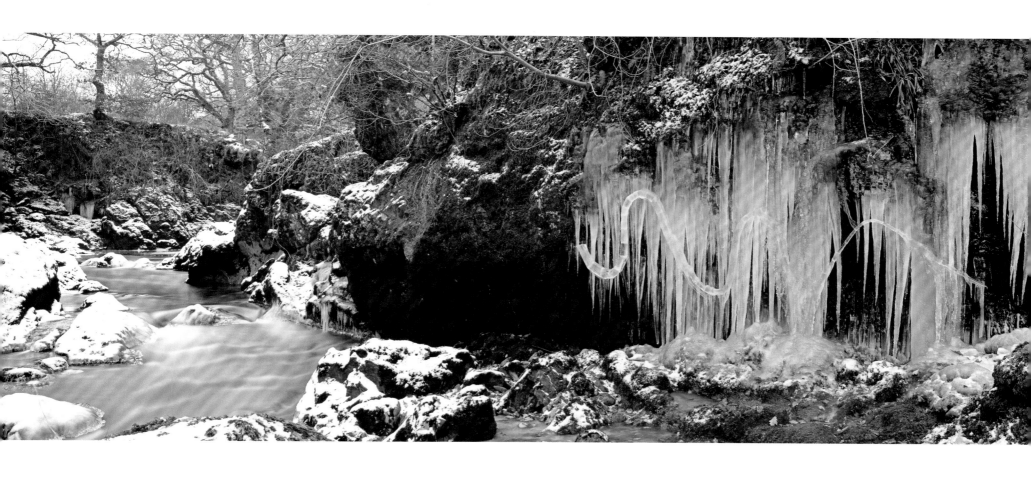

RECONSTRUCTED ICICLES. BEGAN AT DAWN. GOOD PROGRESS AT FIRST. BECOMING PAINFULLY SLOW AS THE DAY WARMED UP. ALMOST AS MANY ICICLES FALLING OFF AS STAYING ON. NEARLY GAVE UP. BUT TEMPERATURE DROPPED AS IT BEGAN TO TURN DARK. JUST COLD ENOUGH TO FREEZE THE LAST FEW PIECES IN PLACE. DUMFRIESSHIRE, SCOTLAND. 5 DECEMBER 2010

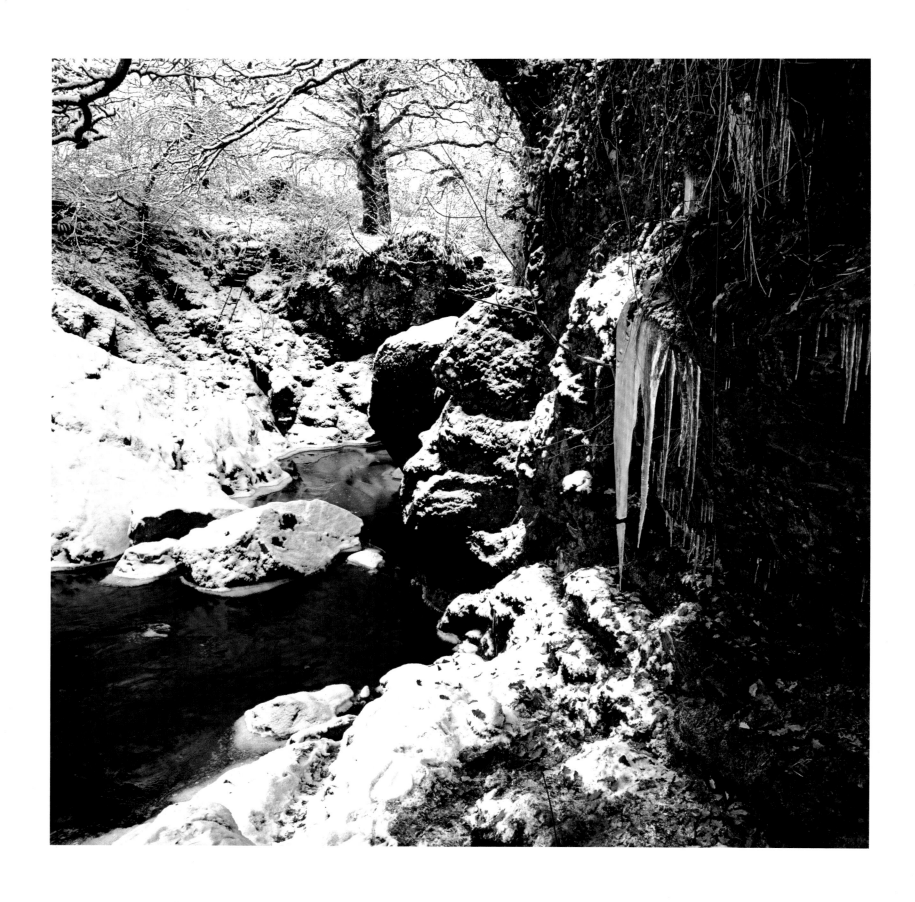

ICICLE. CUT IN TWO. CONNECTED BY STRANDS OF HAIR. FROZEN ACROSS THE GAP. DUMFRIESSHIRE, SCOTLAND. 19 DECEMBER 2010

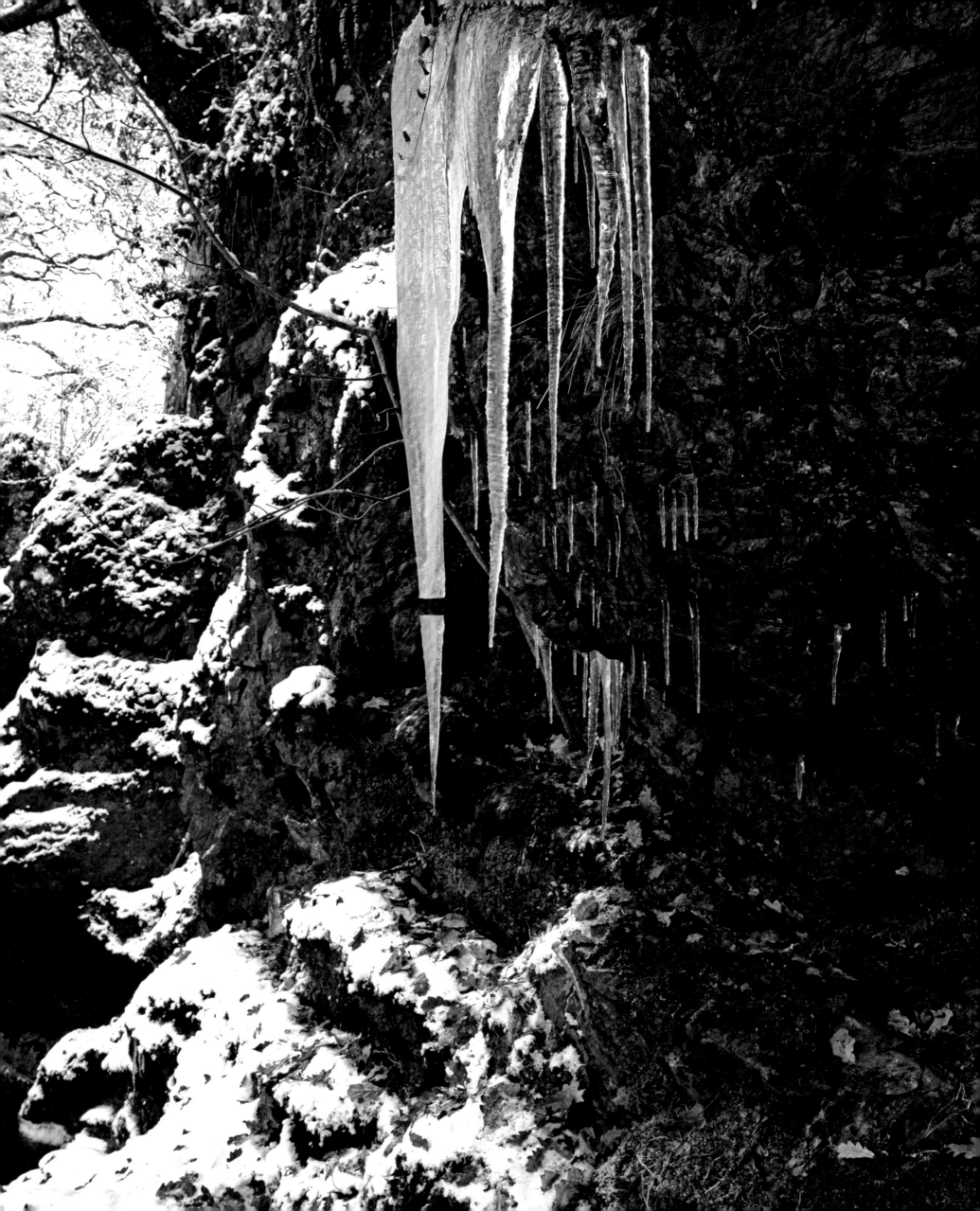

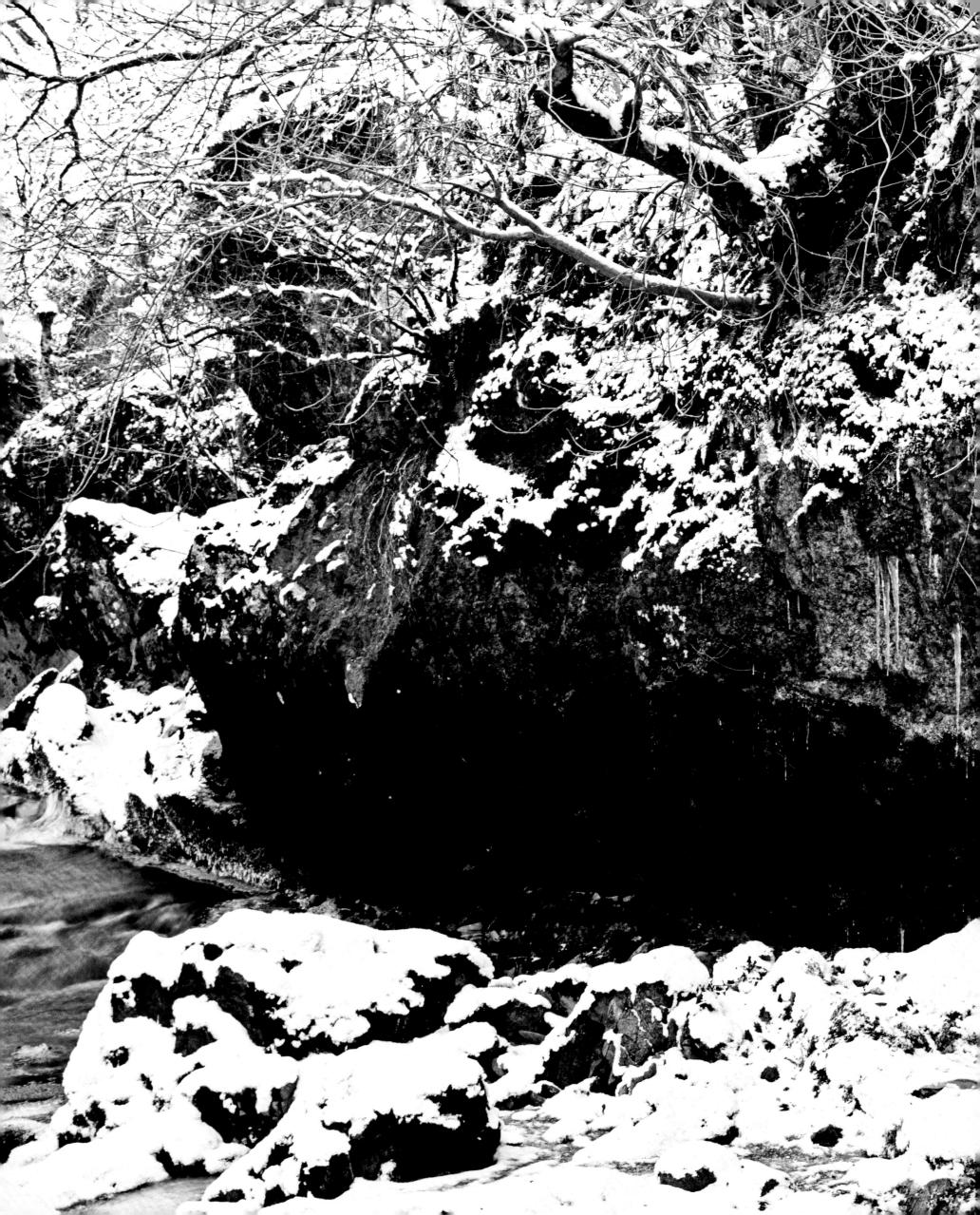

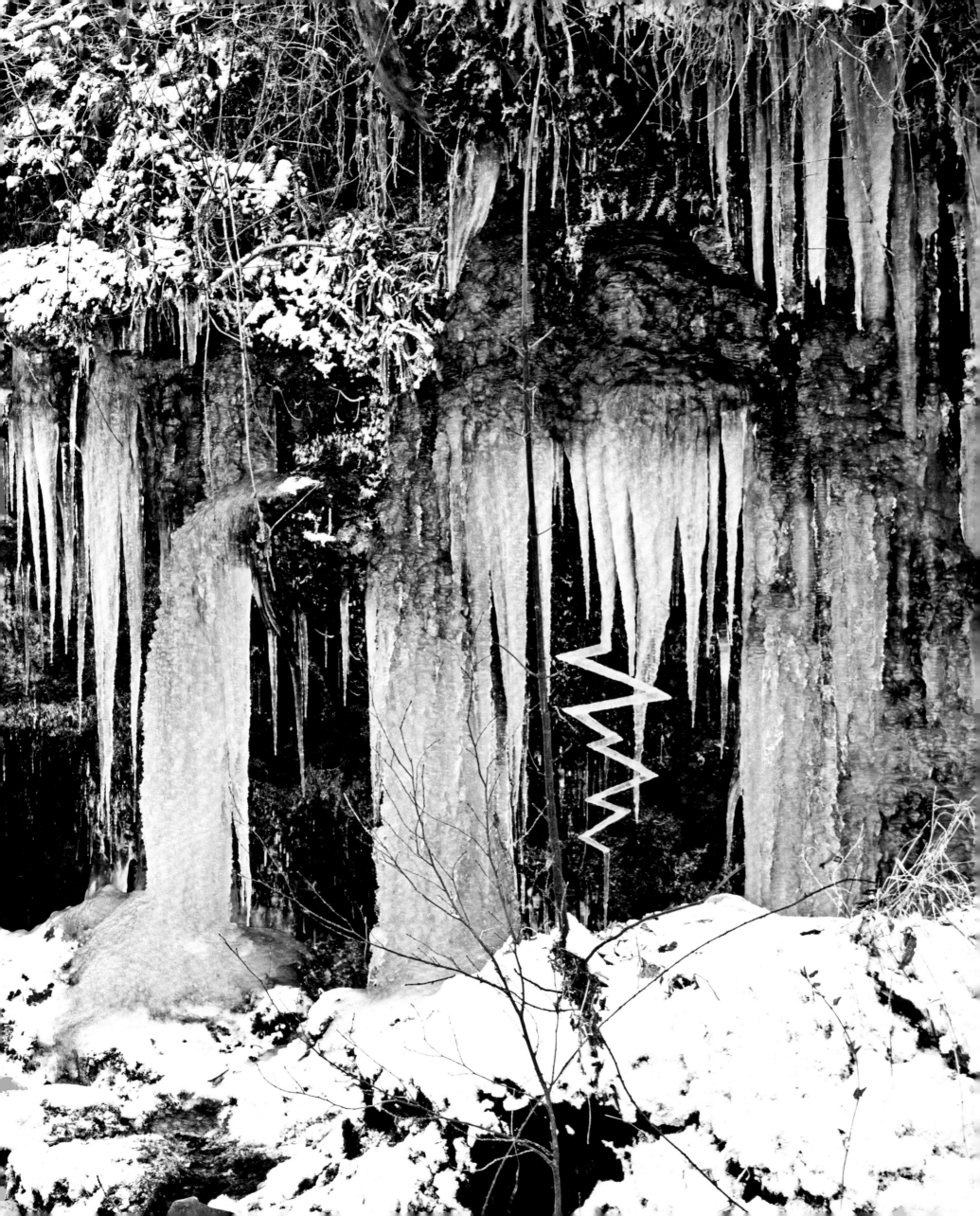

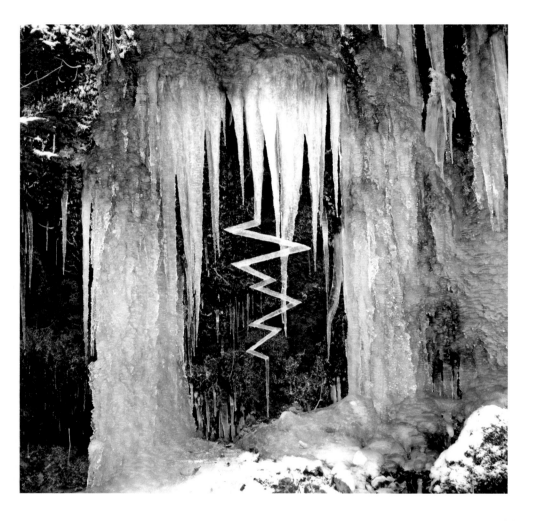
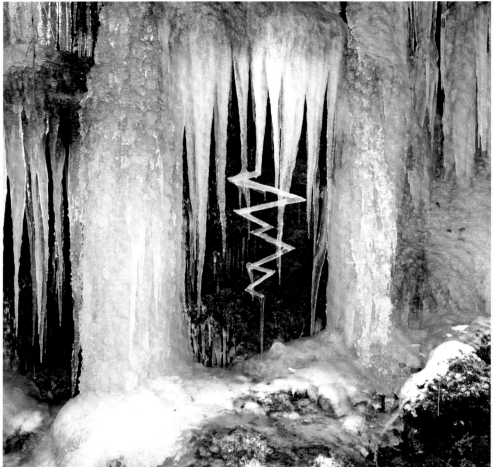

RECONSTRUCTED ICICLES. JOINTS CUT FLAT WITH A KNIFE. DUMFRIESSHIRE, SCOTLAND. 21 DECEMBER 2010

(OVERLEAF) ICE. ROLLED AND ROUNDED BY THE RIVER. WASHED UP ALONG THE BANK. GATHERED. MADE INTO A WALL. DUMFRIESSHIRE, SCOTLAND. 9 JANUARY 2011

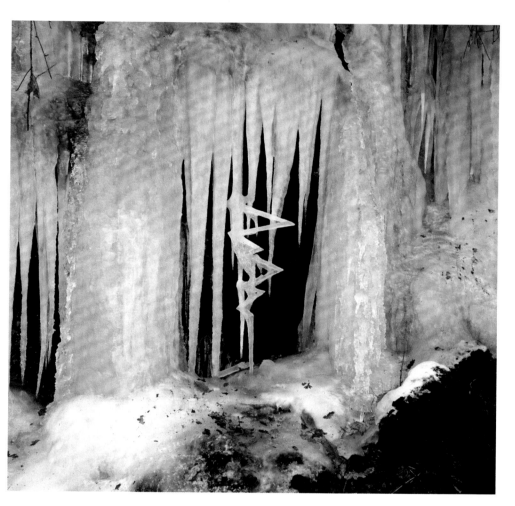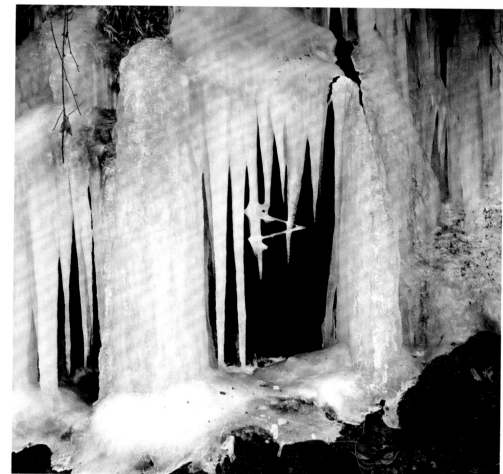

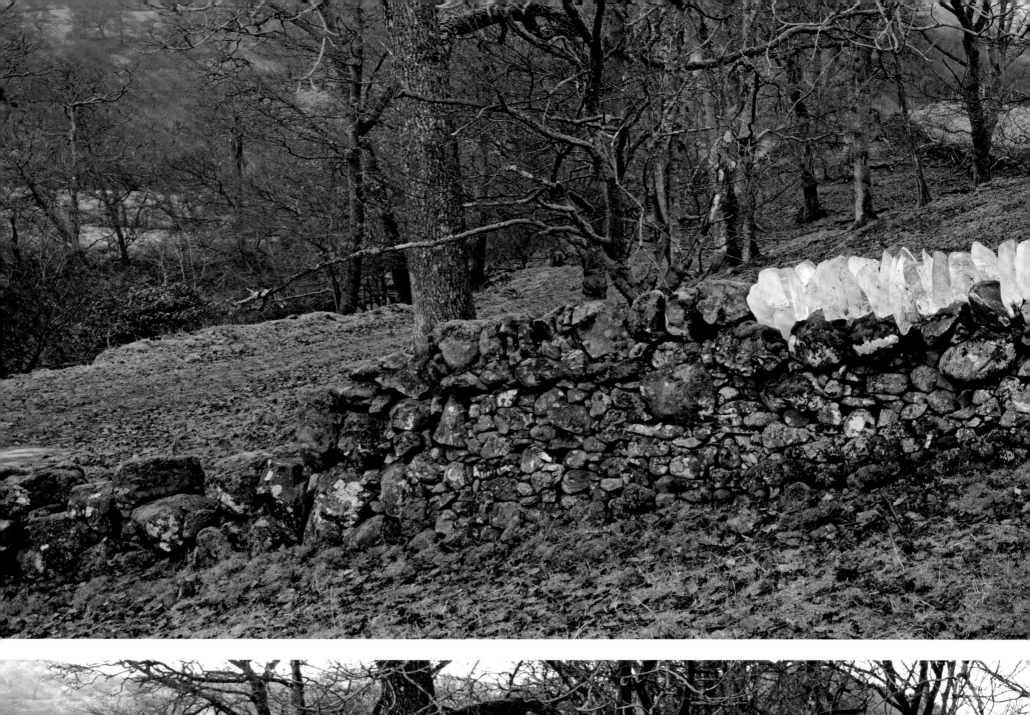
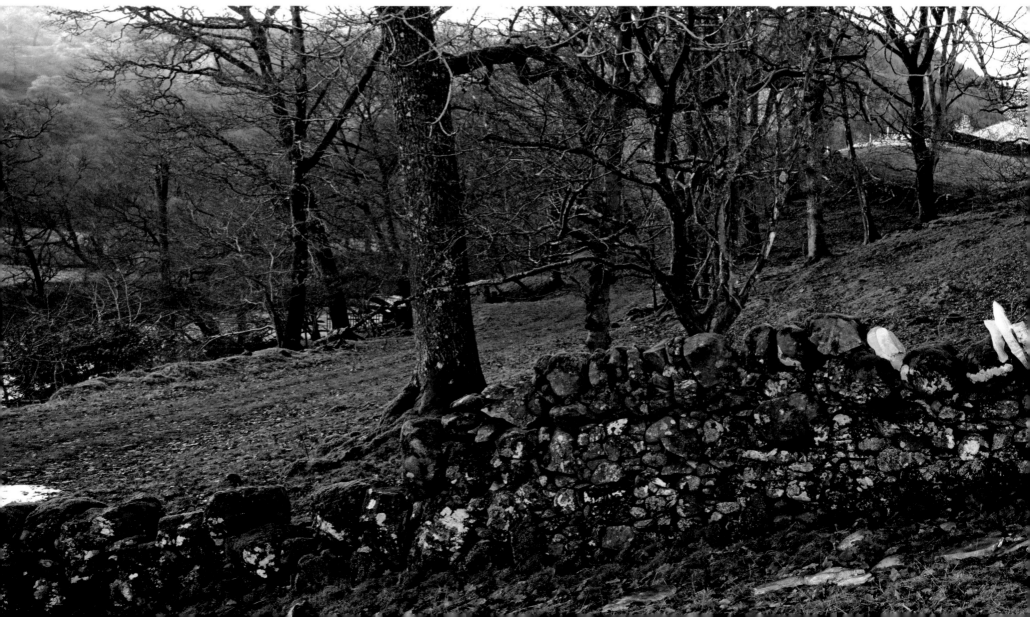

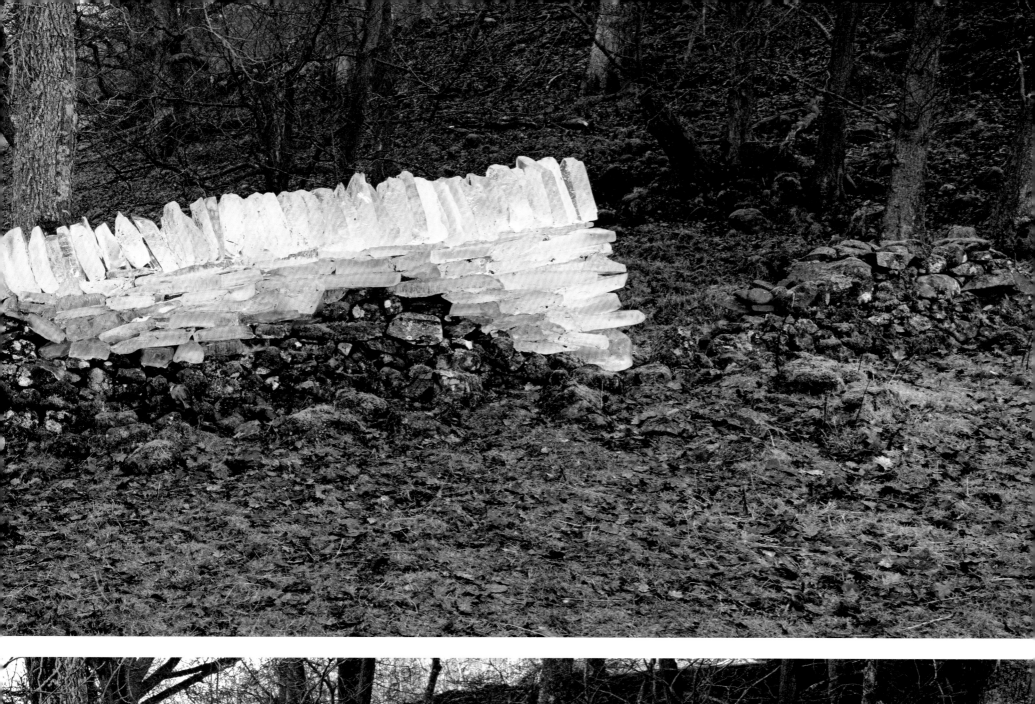
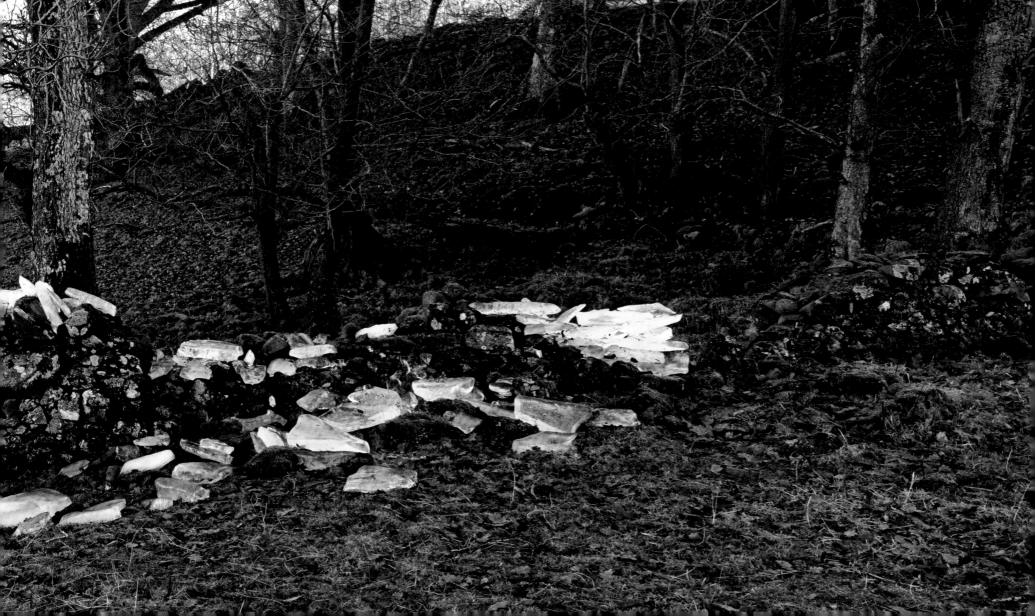

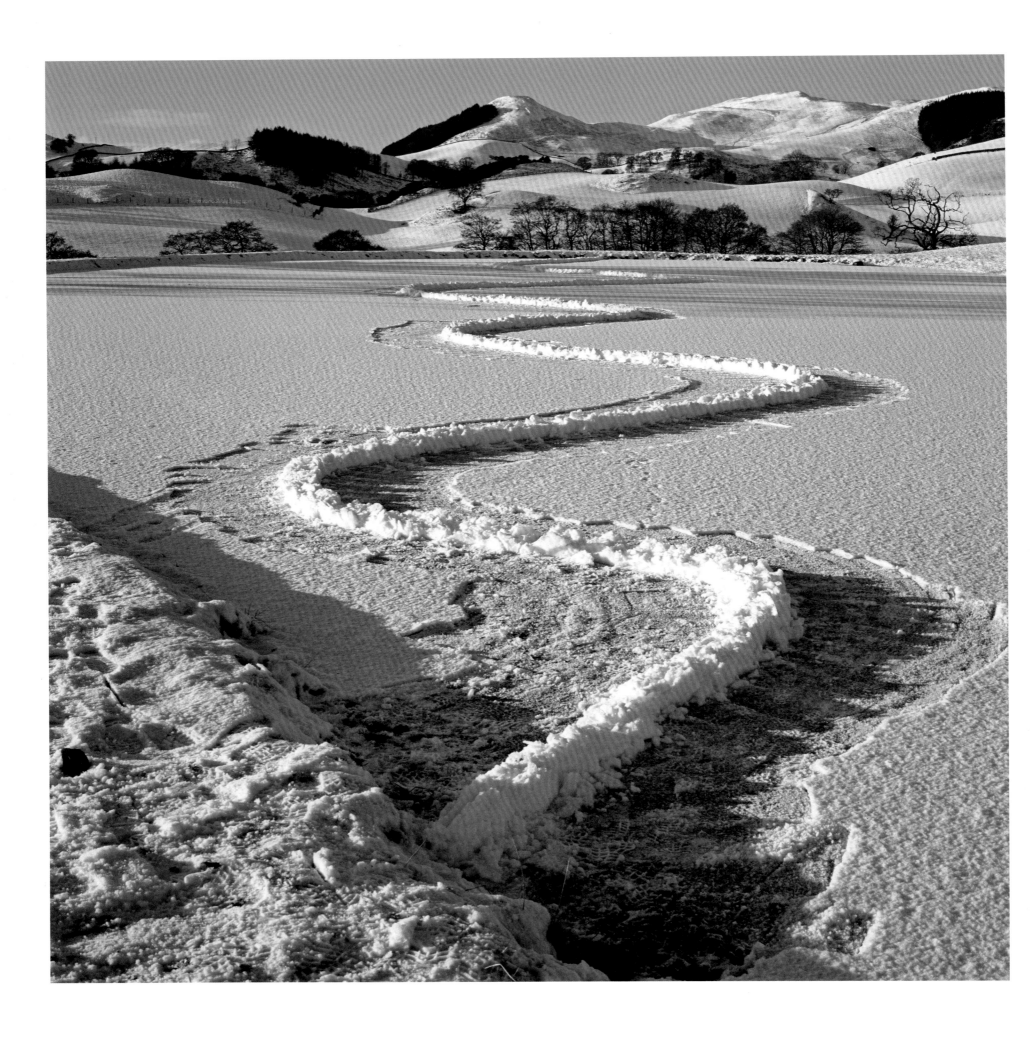

LAKE ICE. THICK ENOUGH TO WALK ON. FRESH-FALLEN POWDER SNOW. SCRAPED INTO A LINE WITH MY FEET. THAWING AND FREEZING OVER SEVERAL DAYS. EVENTUALLY BECOMING A DETACHED PIECE OF ICE THAT FLOATED AROUND THE LAKE BEFORE MELTING COMPLETELY. DUMFRIESSHIRE, SCOTLAND. JANUARY 2011

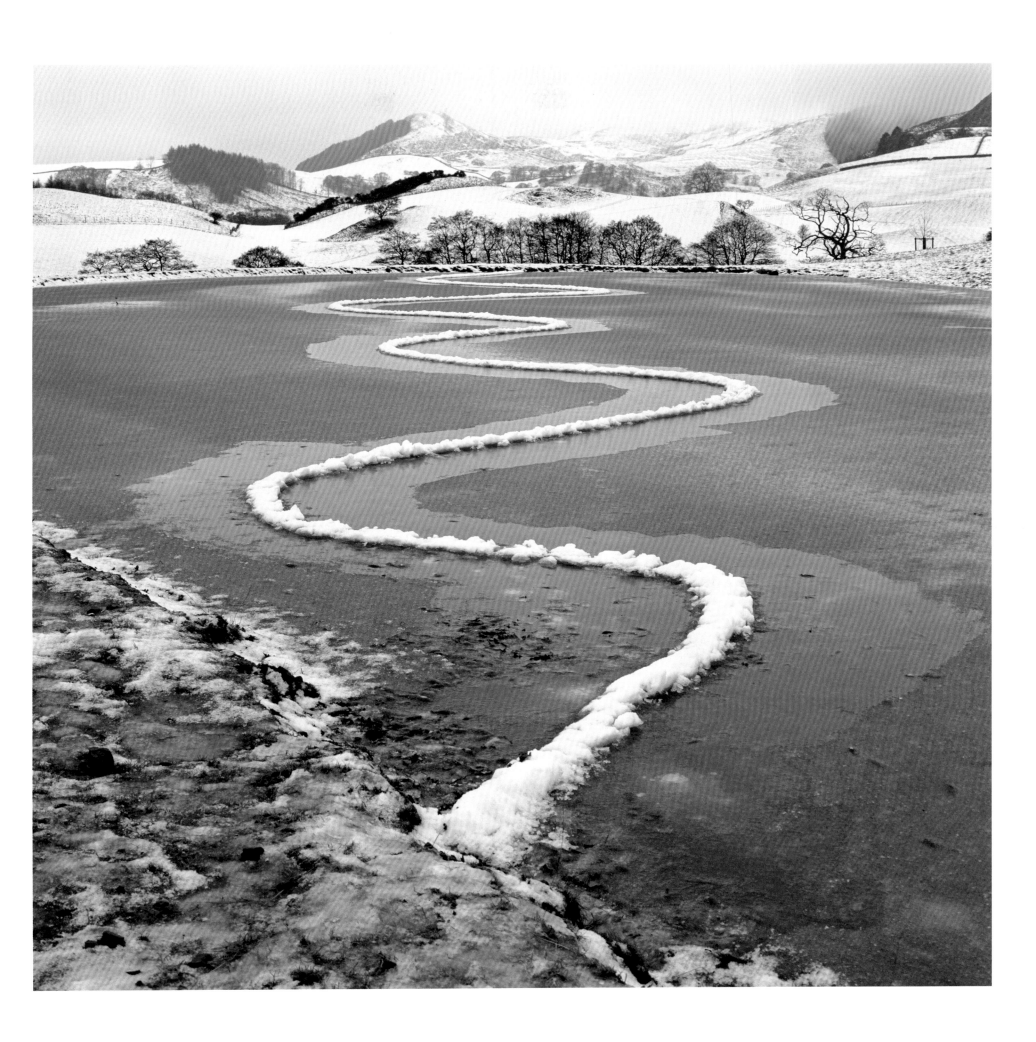

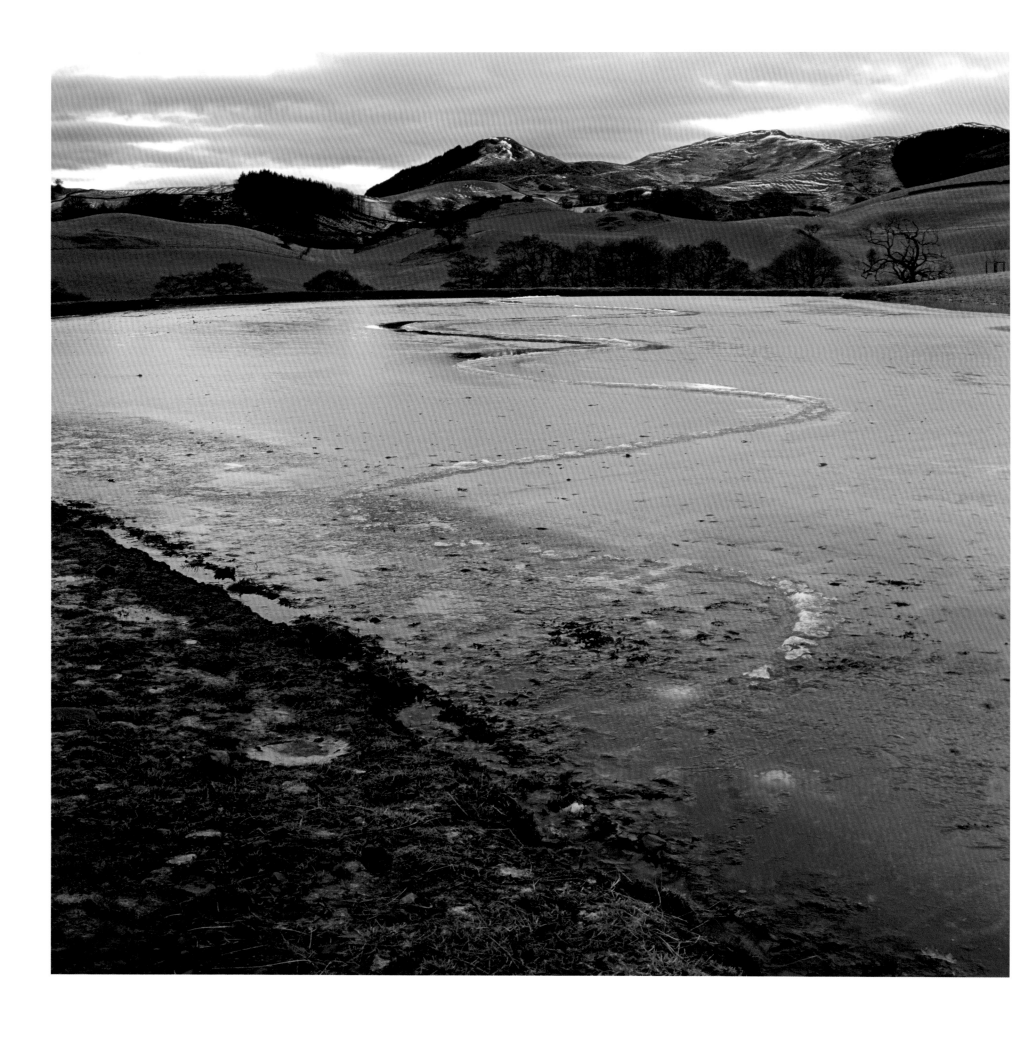

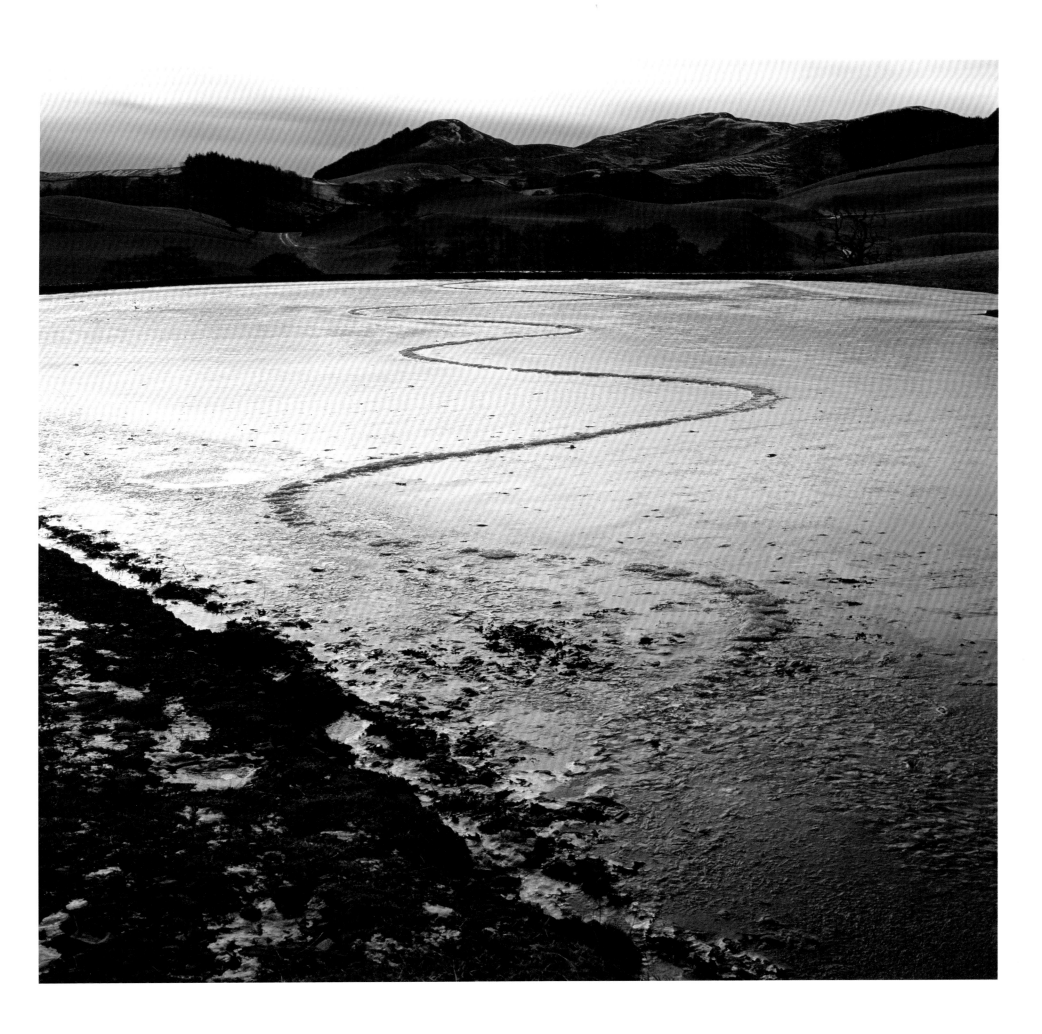

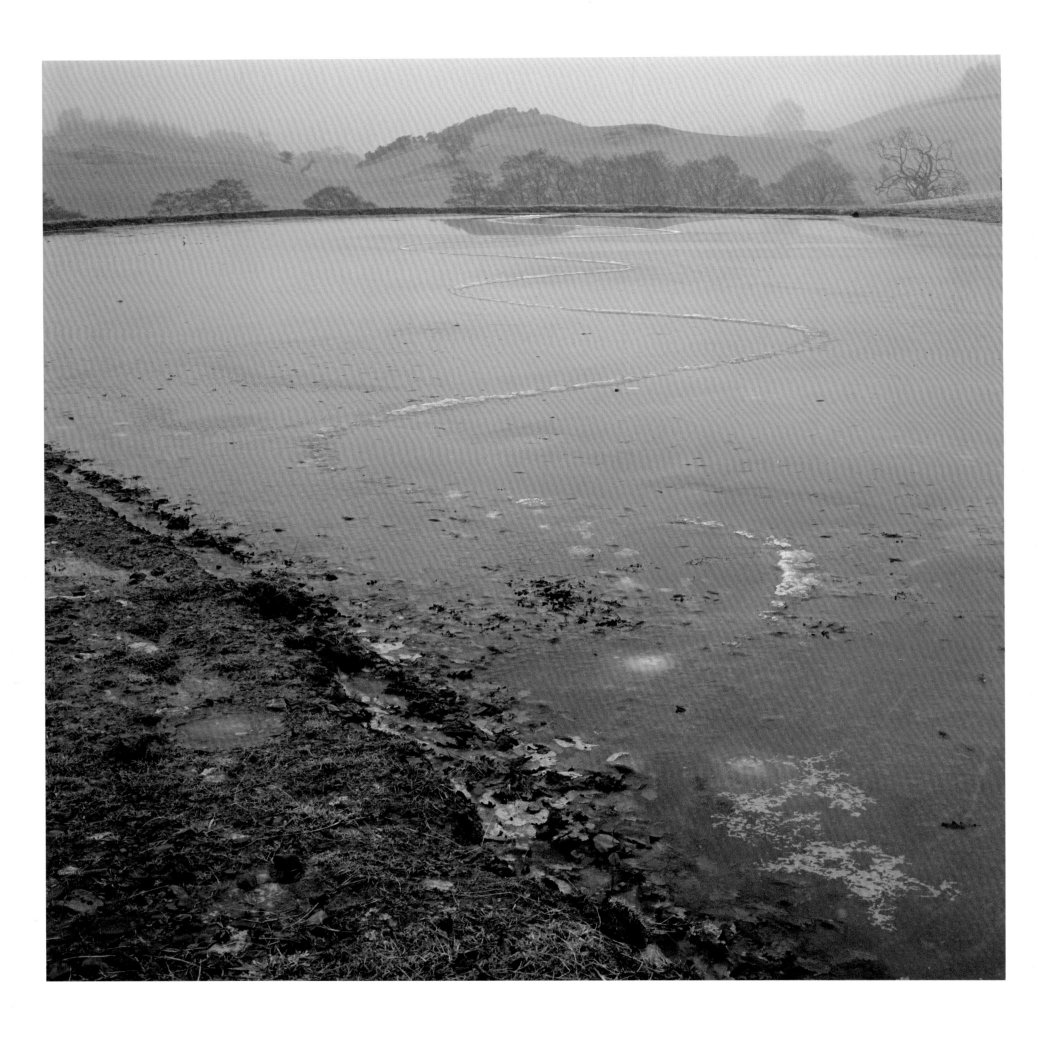

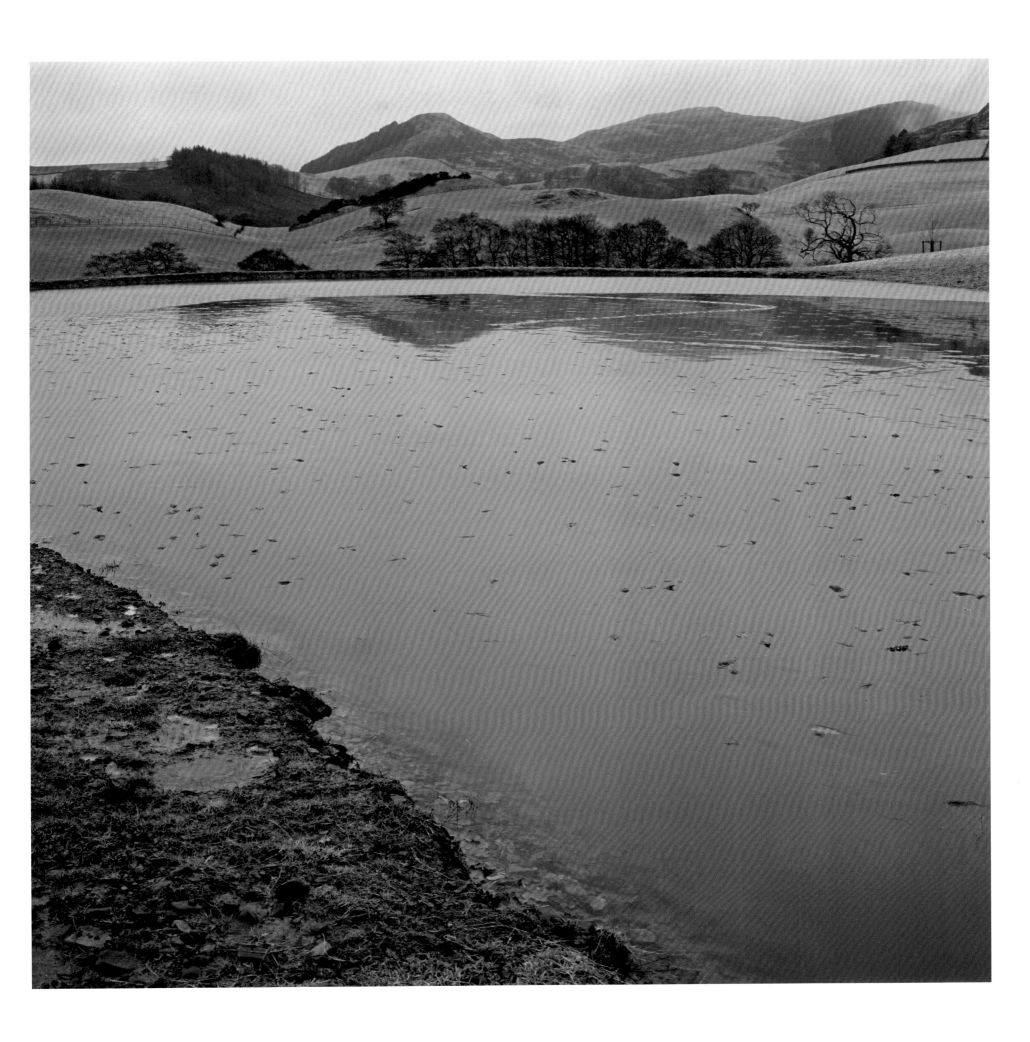

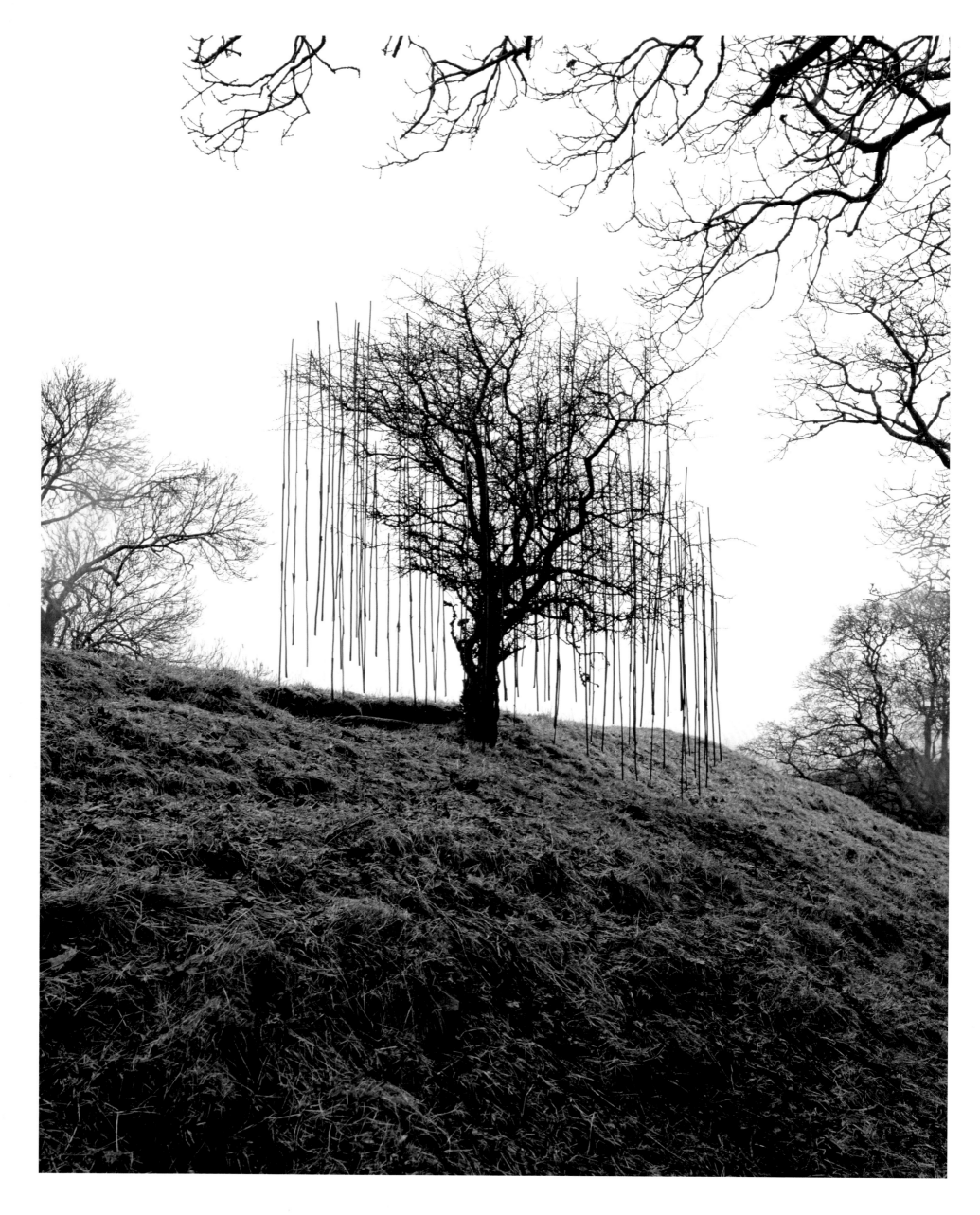

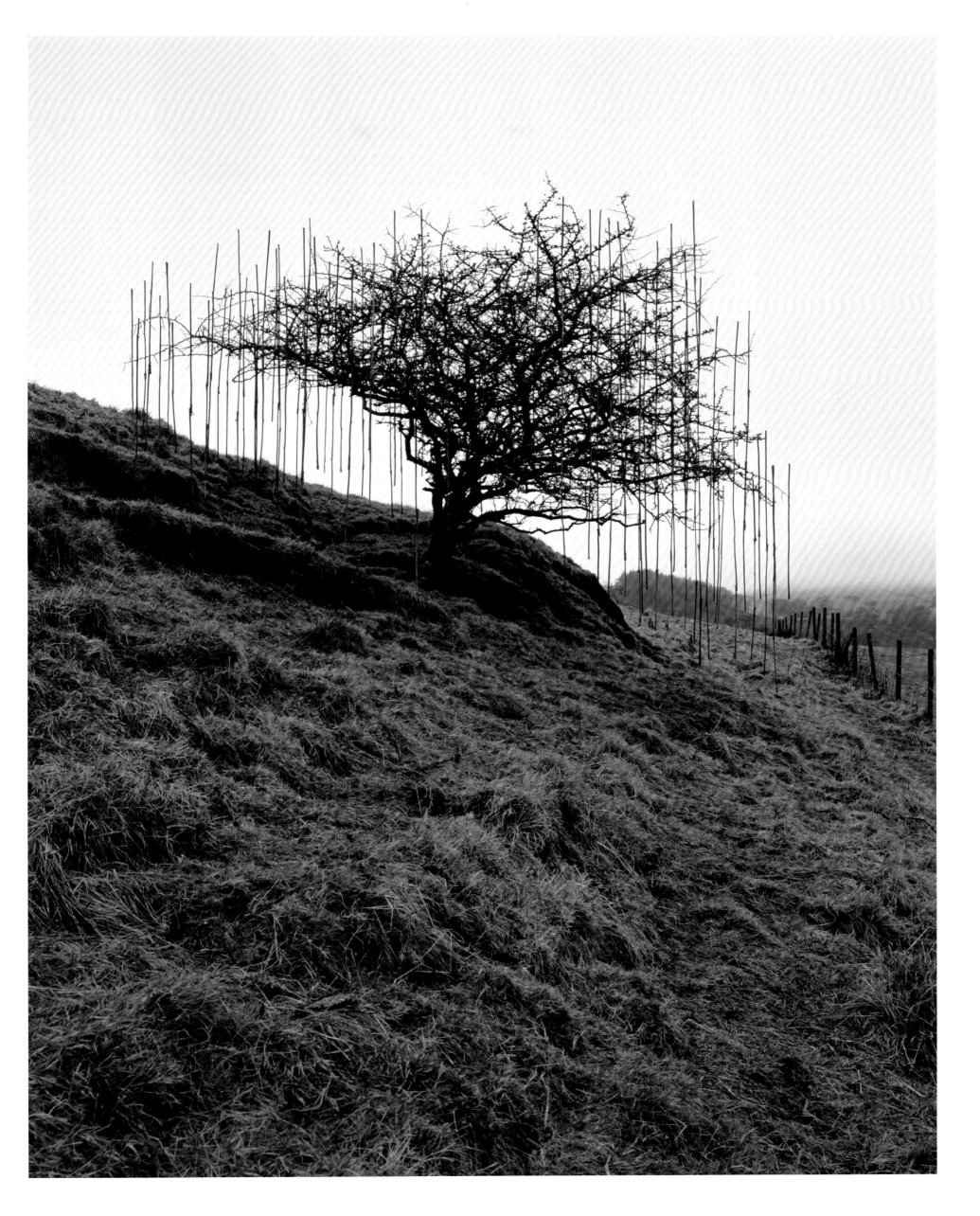

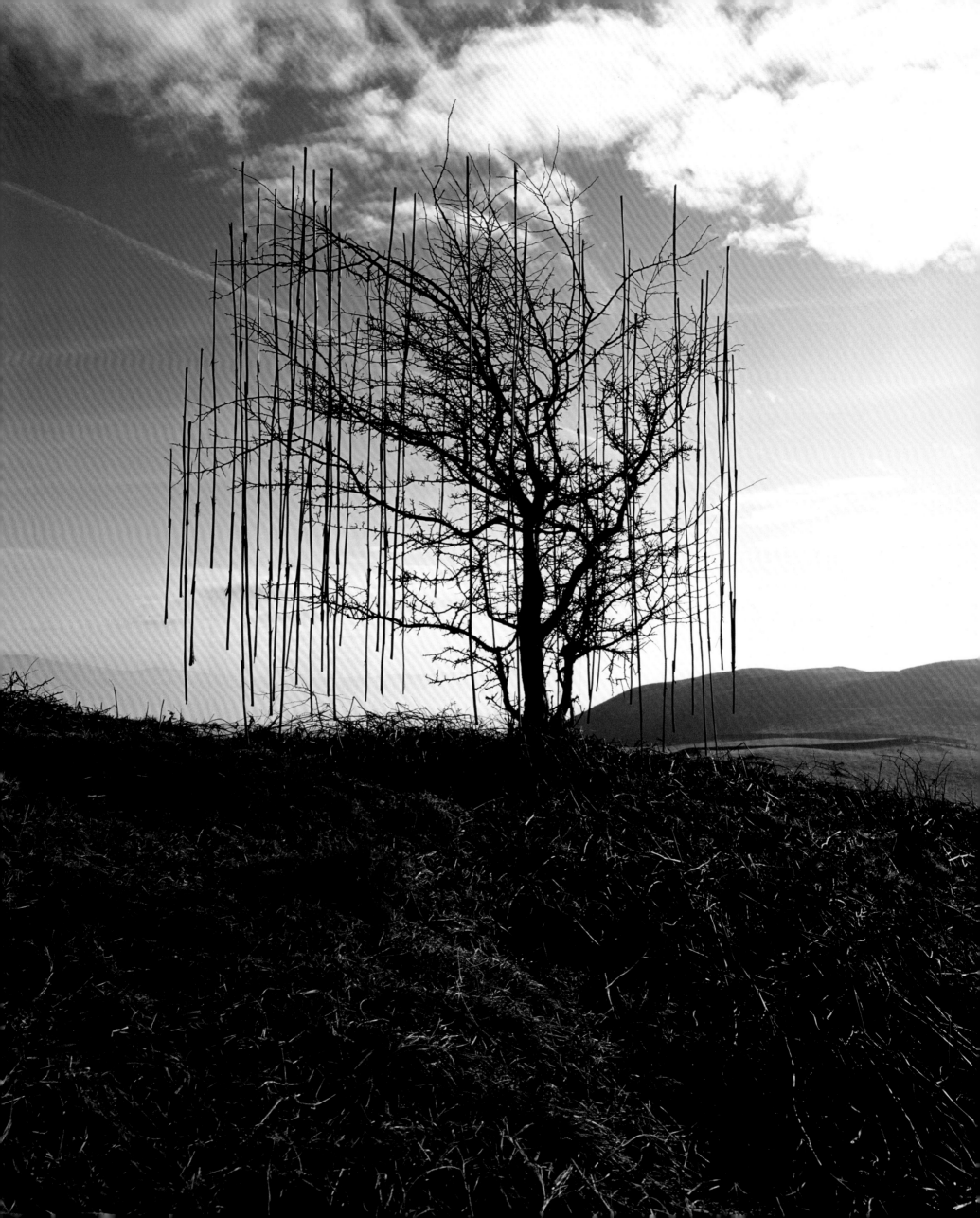

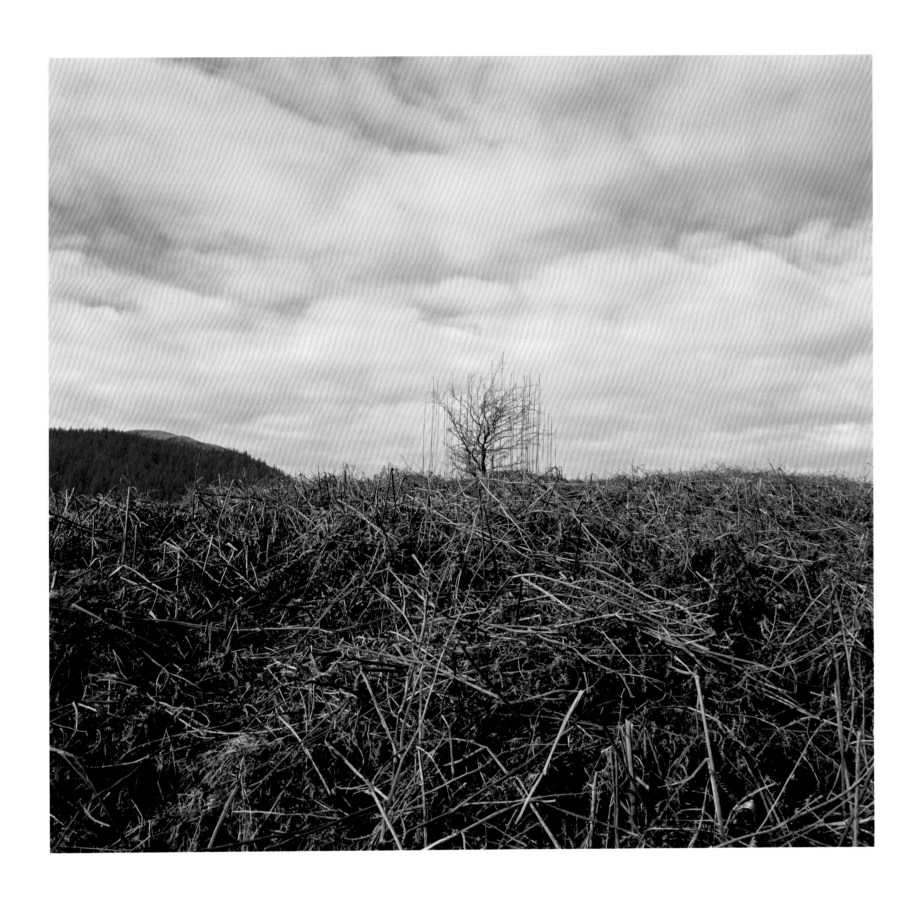

BRACKEN. EACH STALK PUSHED INTO ANOTHER TO MAKE LINES. ATTACHED TO THE THORNS OF HAWTHORN TREES. THREE WORKS MADE OVER THREE INTENSELY CALM DAYS.
DUMFRIESSHIRE, SCOTLAND. 6, 11 FEBRUARY, 3 MARCH 2011

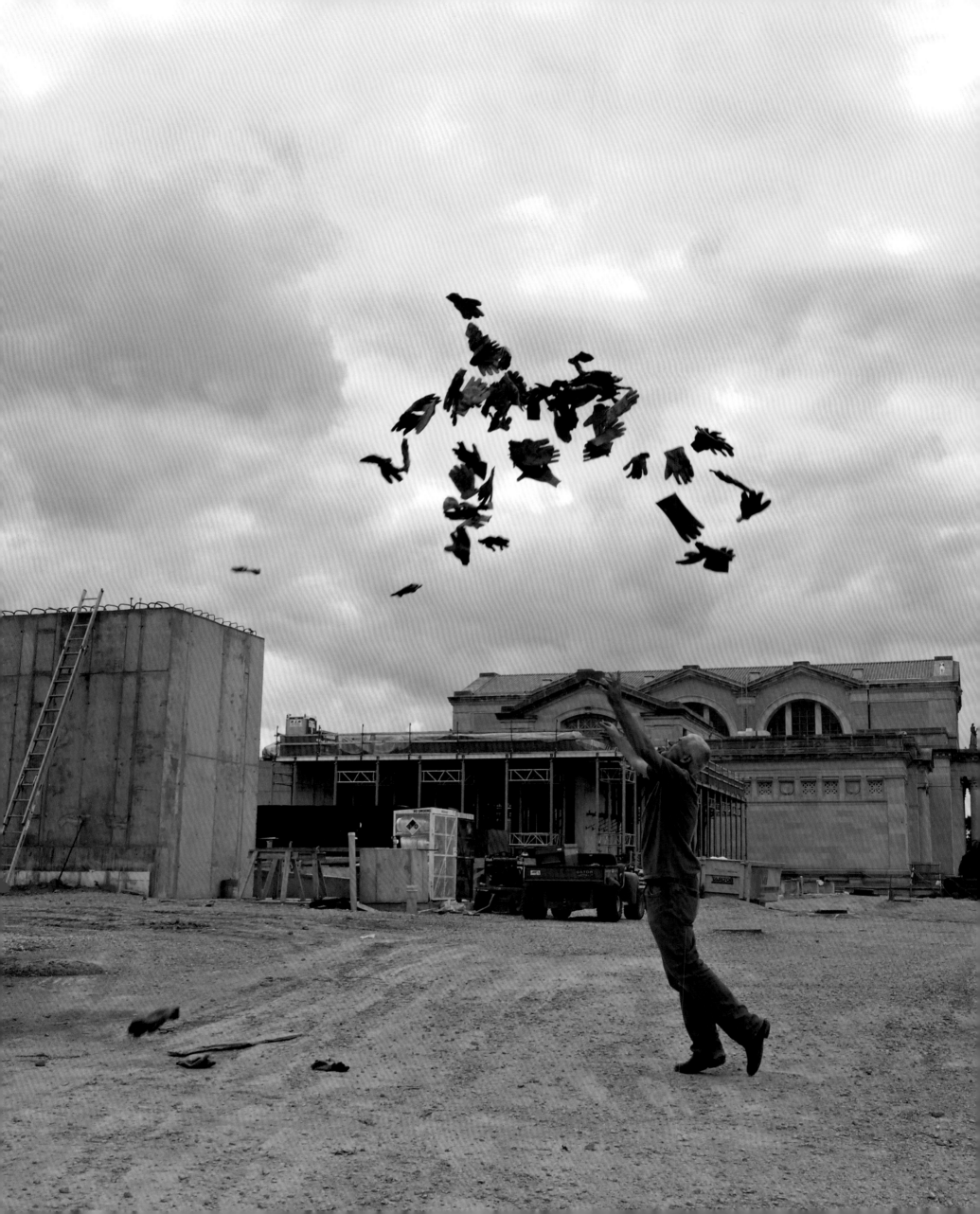

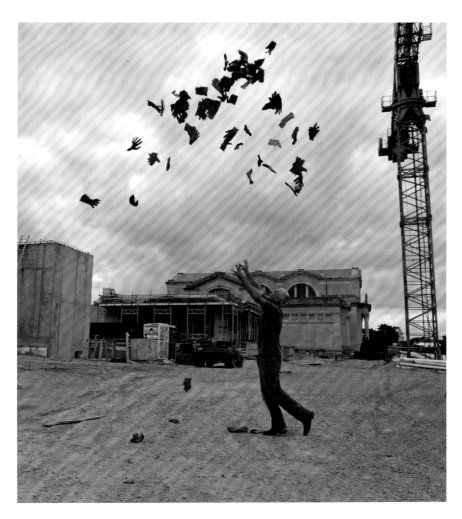
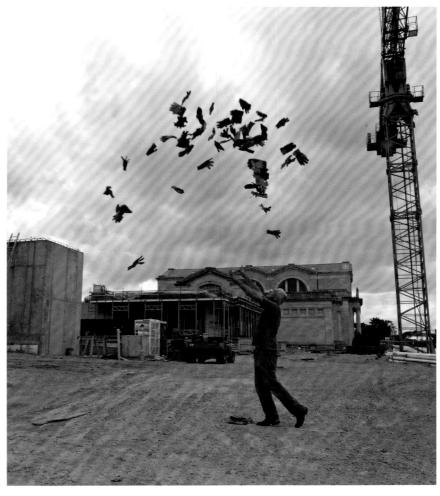
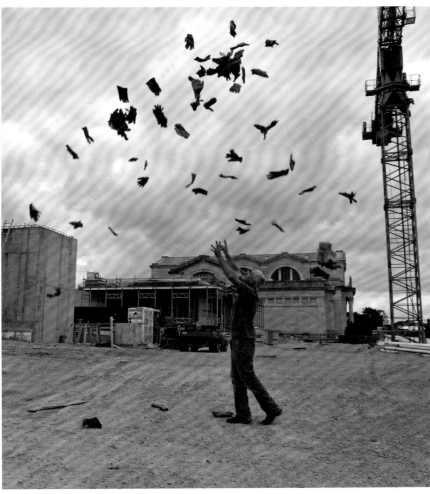
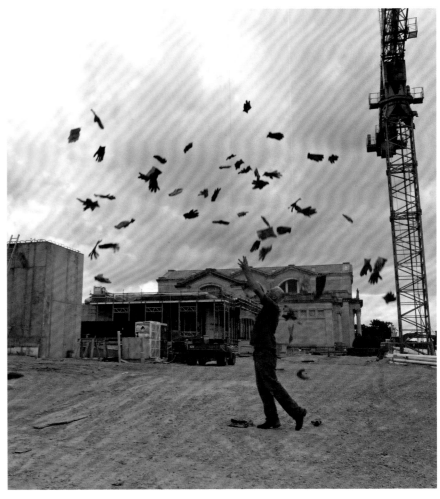

DISCARDED GLOVES. COLLECTED FROM THE CONSTRUCTION SITE OF THE NEW WING AT SAINT LOUIS ART MUSEUM. THROWN. SAINT LOUIS, MISSOURI. 24 JUNE 2011

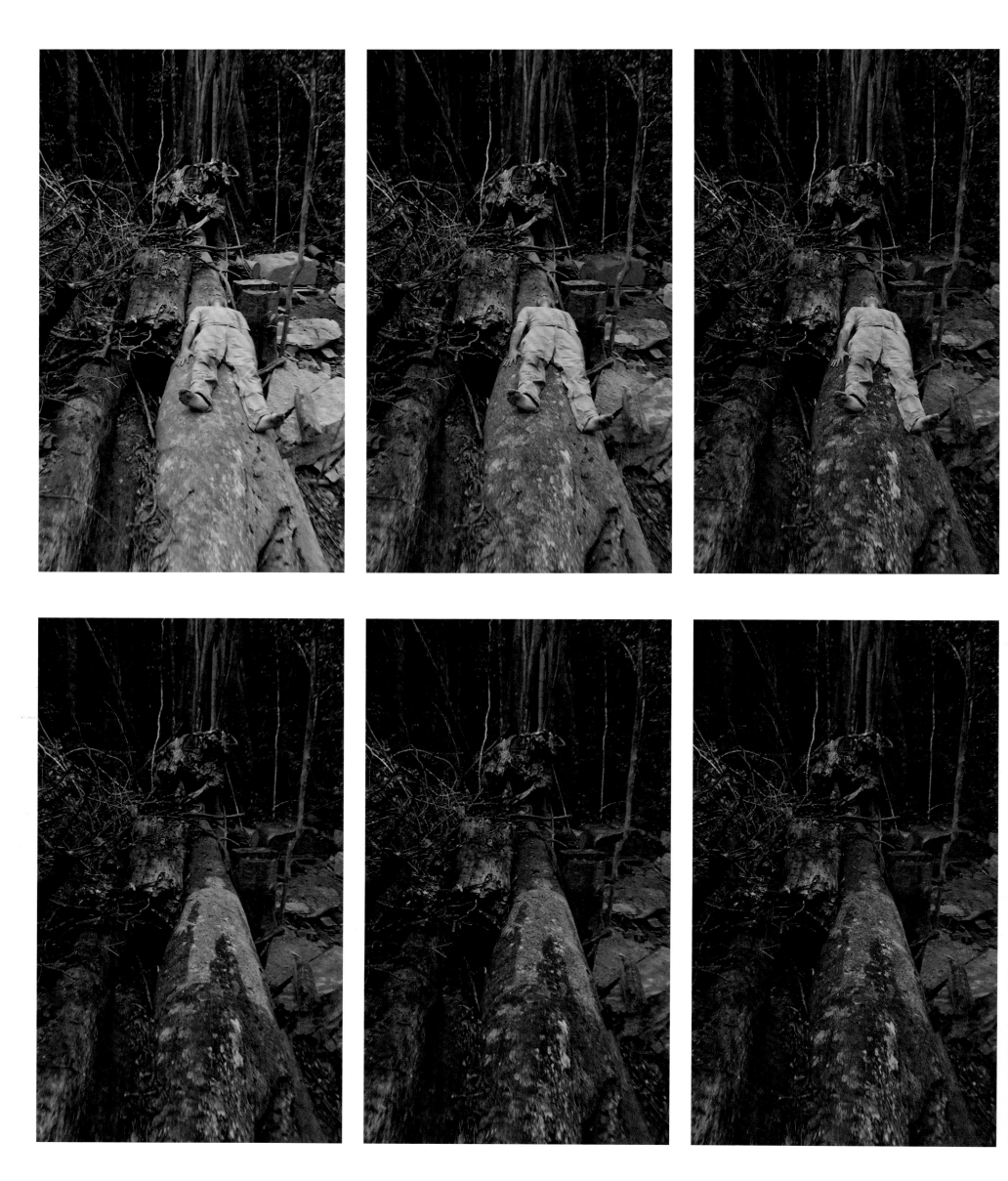

RAIN SHADOW ON A RECENTLY FALLEN STRANGLER FIG TREE. CONONDALE NATIONAL PARK, QUEENSLAND. 21 AUGUST 2011

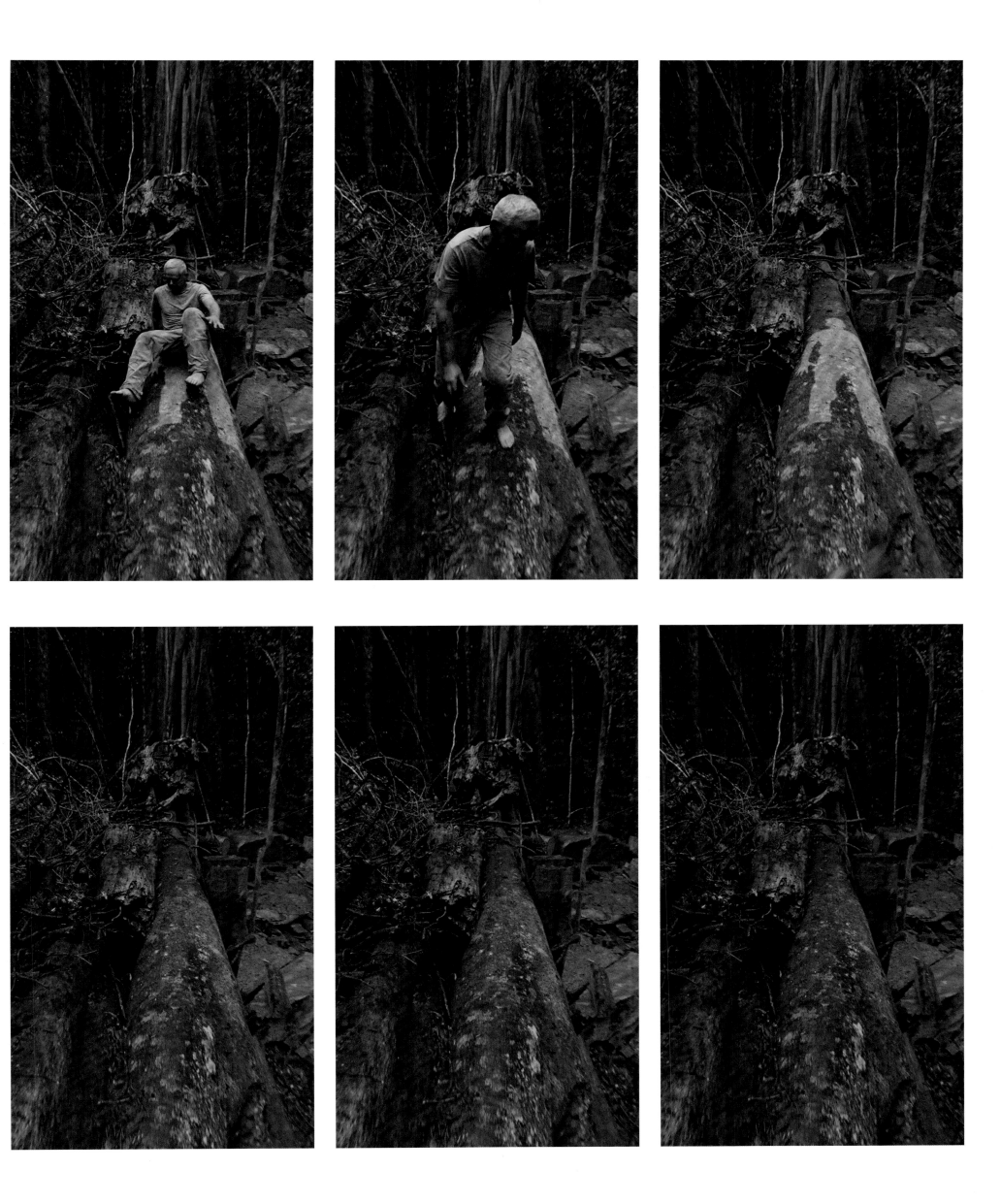

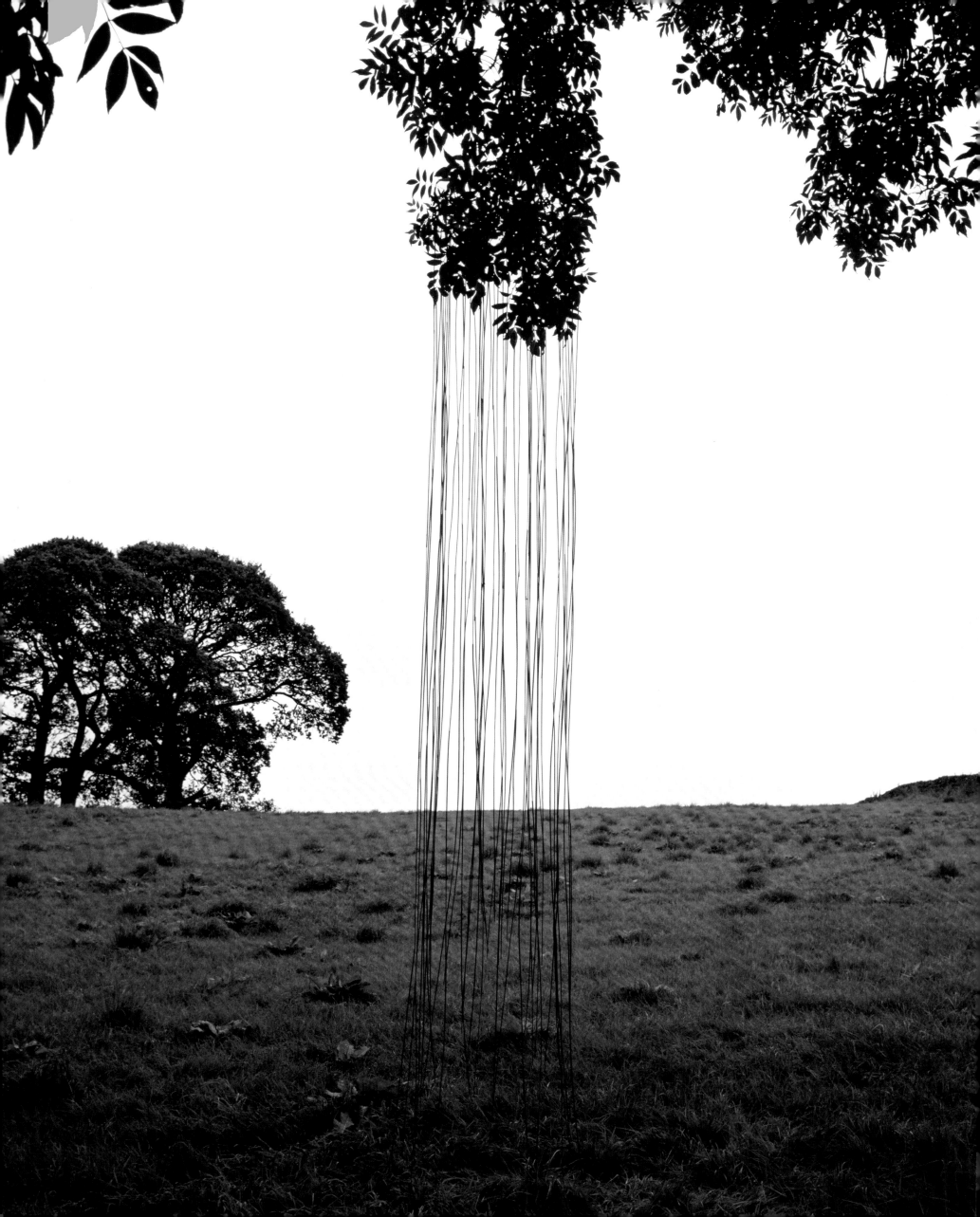

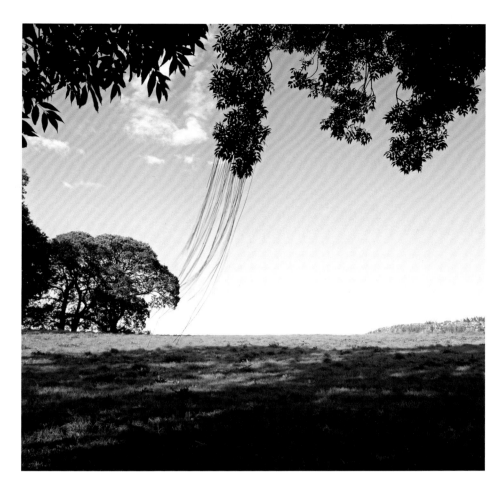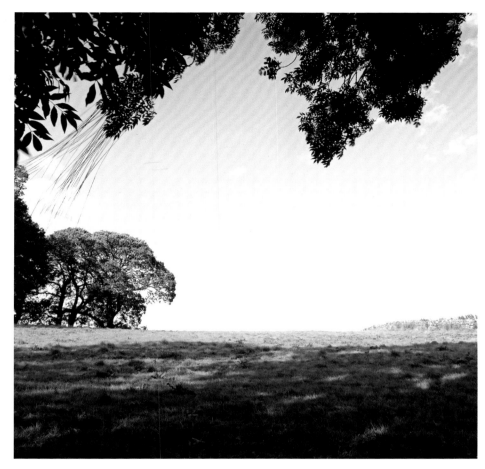
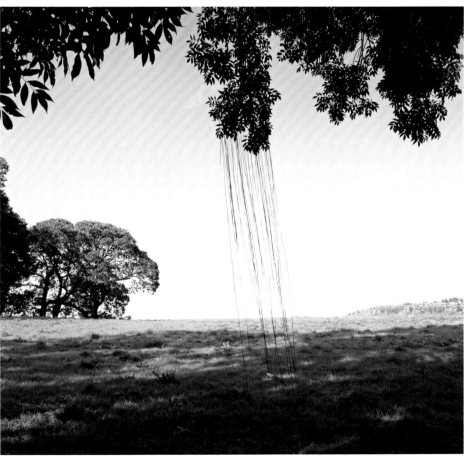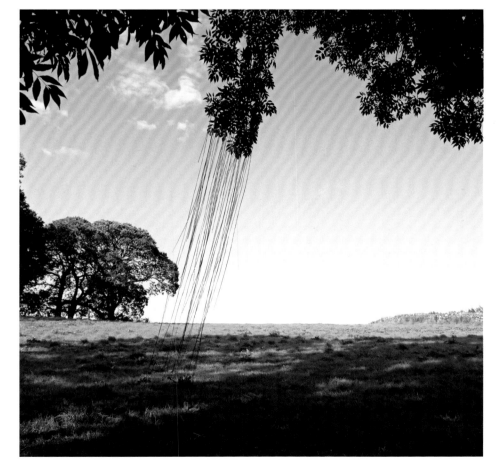

RUSHES. SHARP, POINTED END OF ONE PUSHED INTO THE WIDER END OF ANOTHER TO MAKE LINES ATTACHED TO AN OVERHANGING ASH BRANCH. REACHED WITH A LADDER. CALM AND OVERCAST. FINISHED AHEAD OF A STRENGTHENING WIND AND A CLEARING SKY. DUMFRIESSHIRE, SCOTLAND. 11 SEPTEMBER 2011

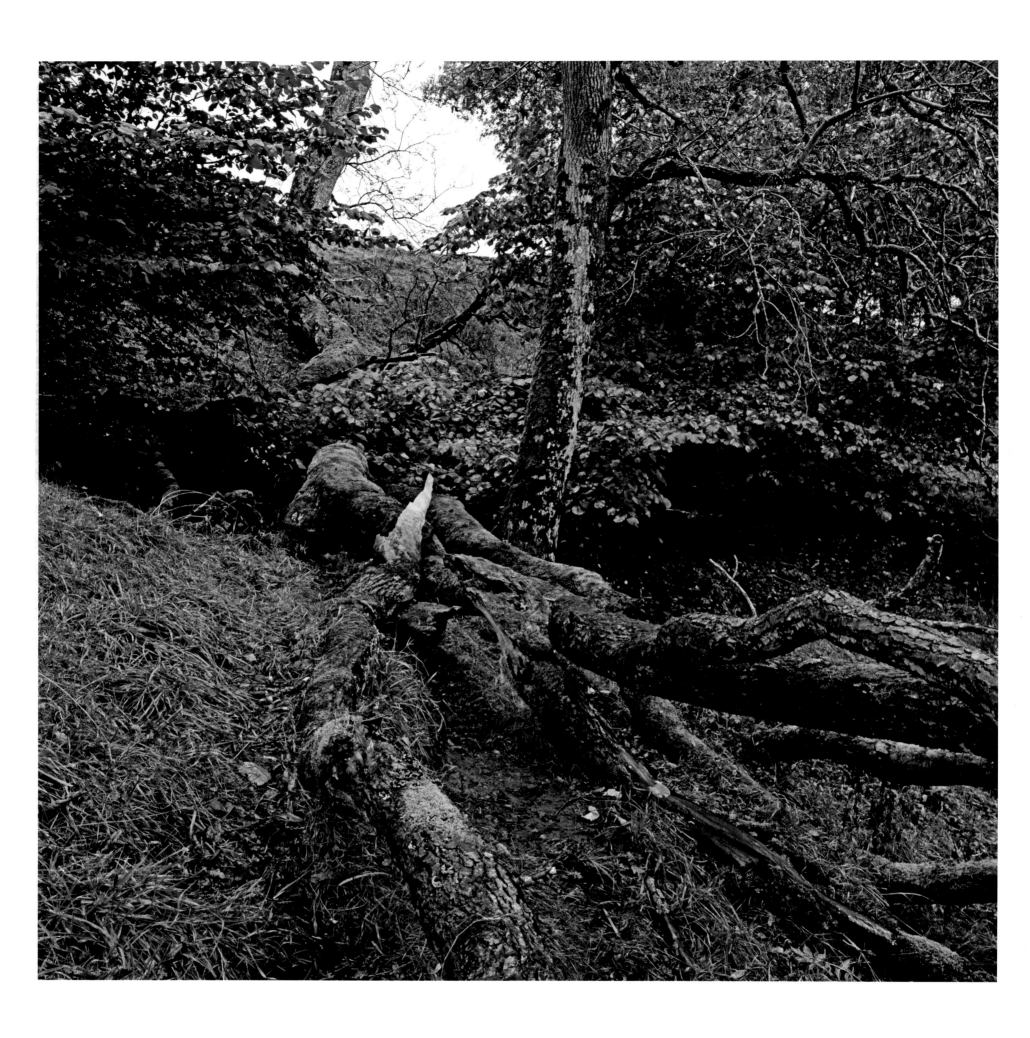

WET ELM LEAVES WRAPPED AROUND THE SPLINTERED TIP OF A FALLEN ASH BOUGH. DUMFRIESSHIRE, SCOTLAND. 26 OCTOBER 2011

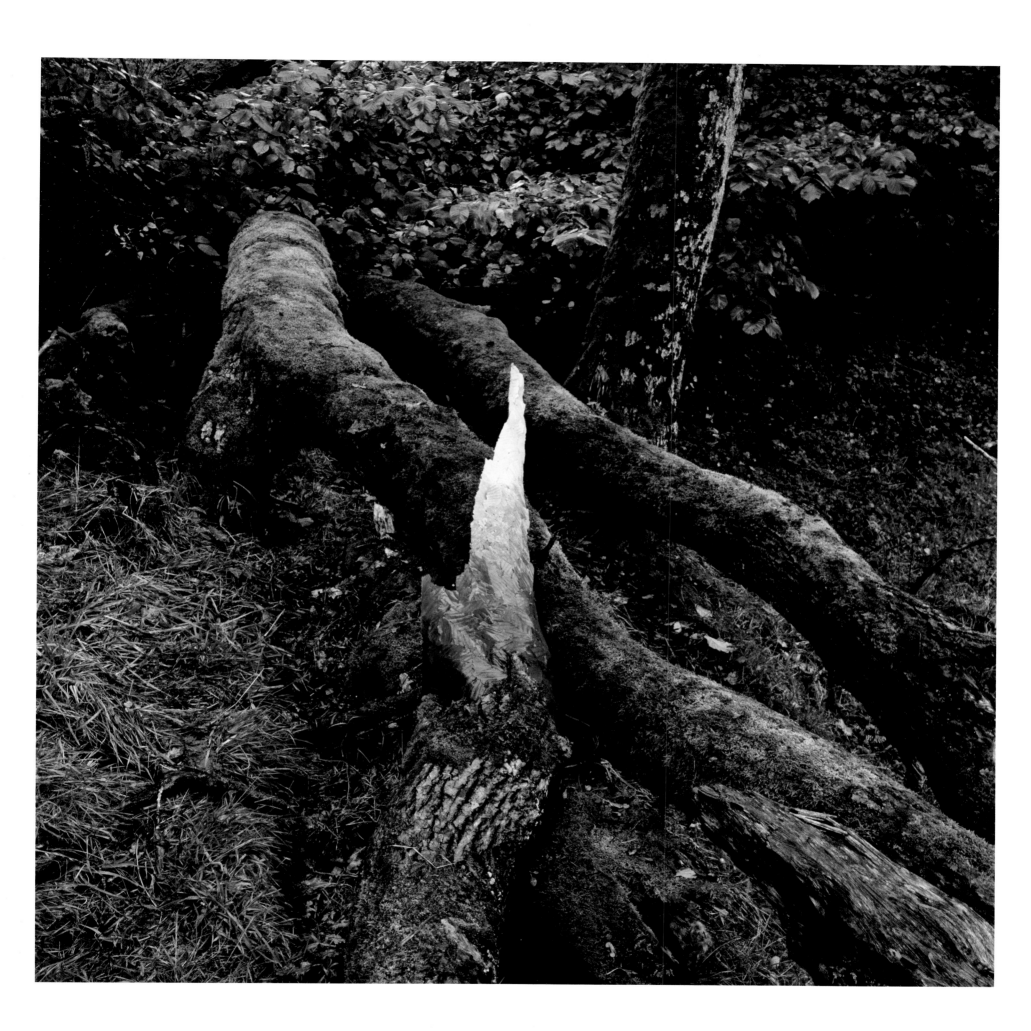

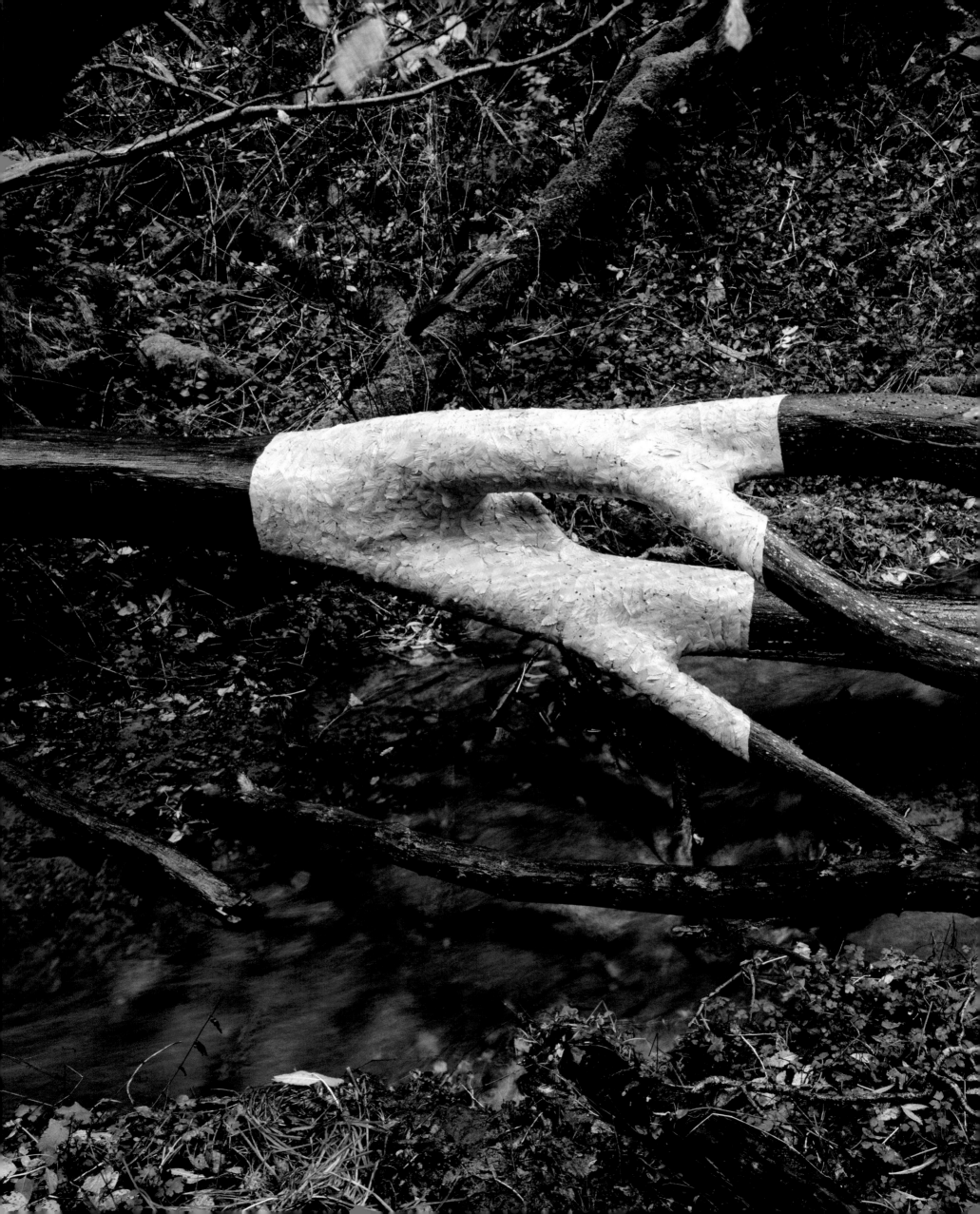

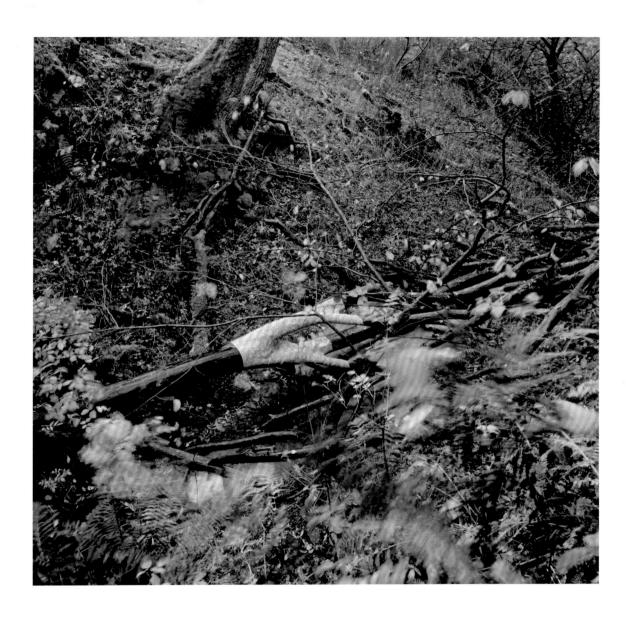

WET, YELLOW ELM LEAVES. LAID AROUND A SMOOTH, BARKLESS, DARK, WET, FALLEN ELM TREE. DUMFRIESSHIRE, SCOTLAND. NOVEMBER 2011

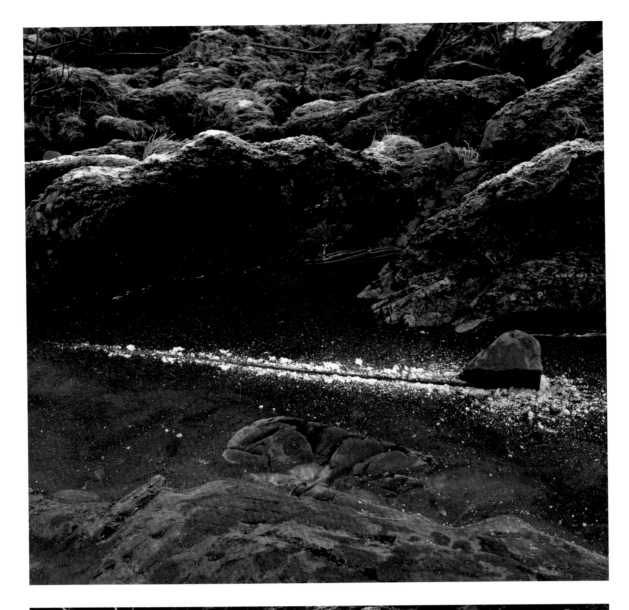

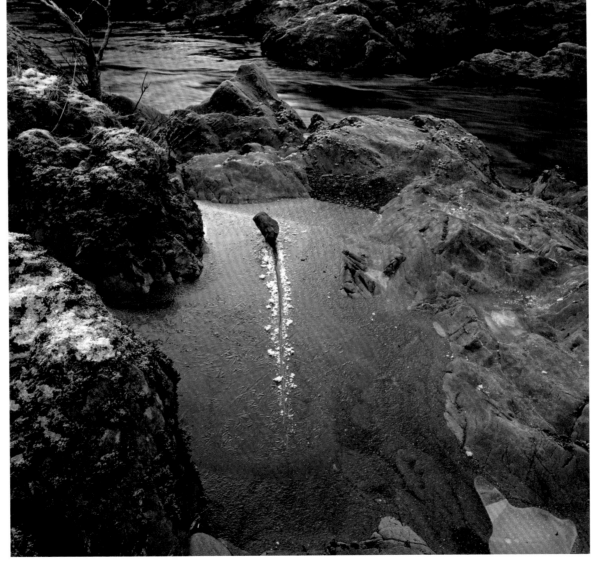

ICE SCORED WITH A STONE. FLAT STONE SLID DOWN A SODDEN HILL. DUMFRIESSHIRE, SCOTLAND. 18, 31 DECEMBER 2011

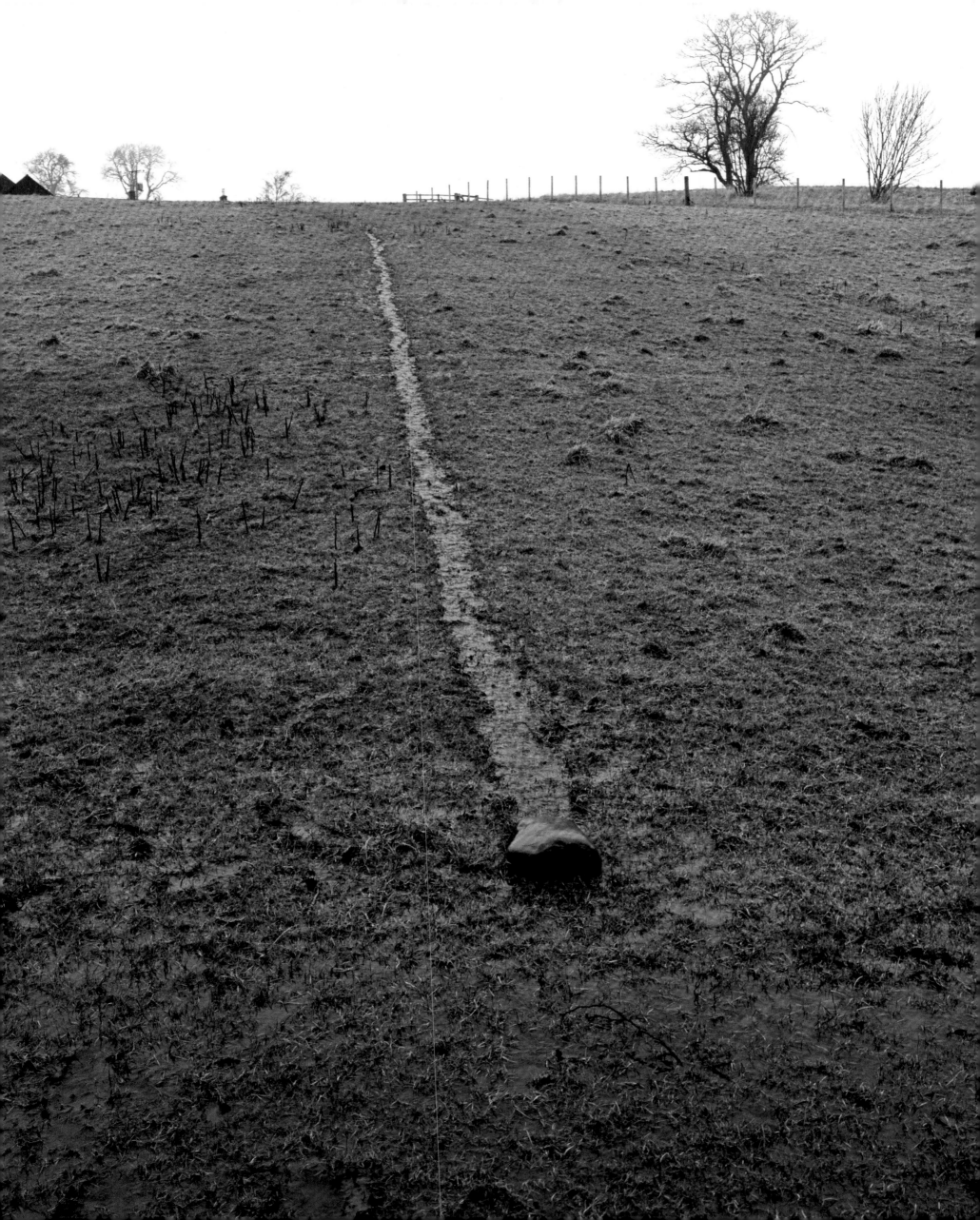

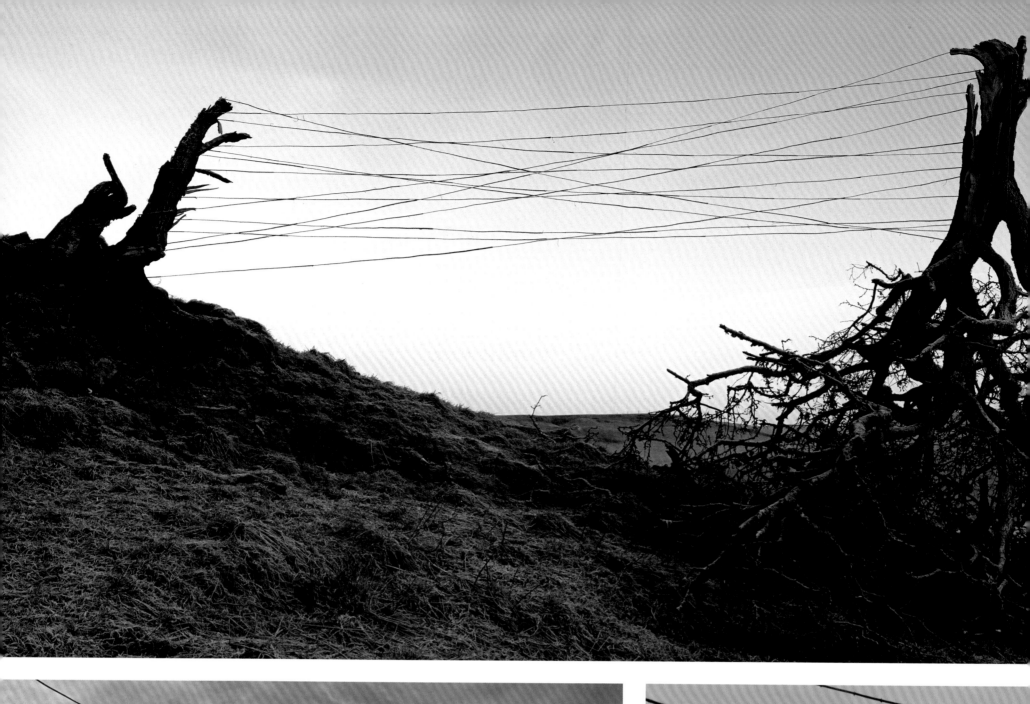

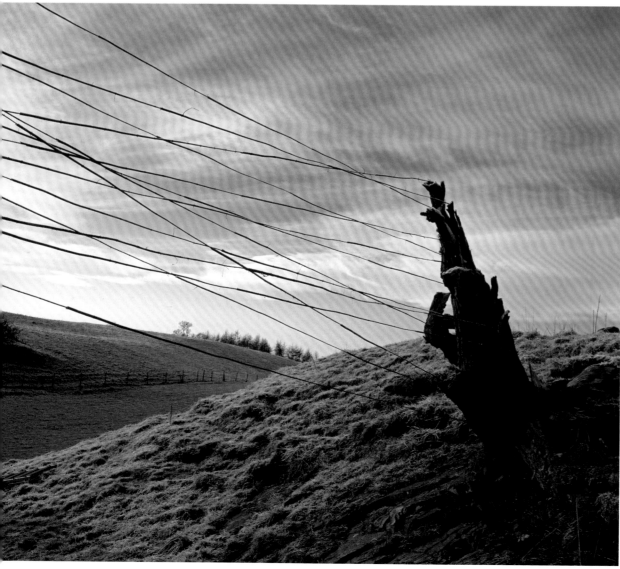

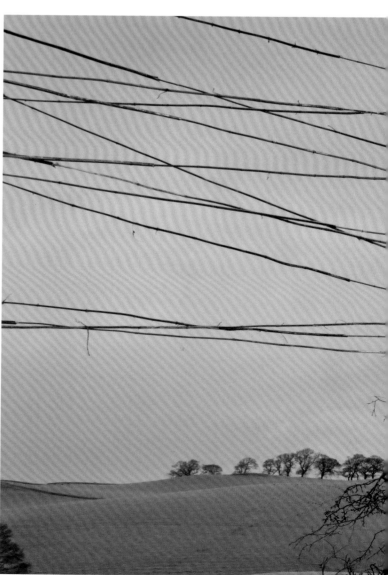

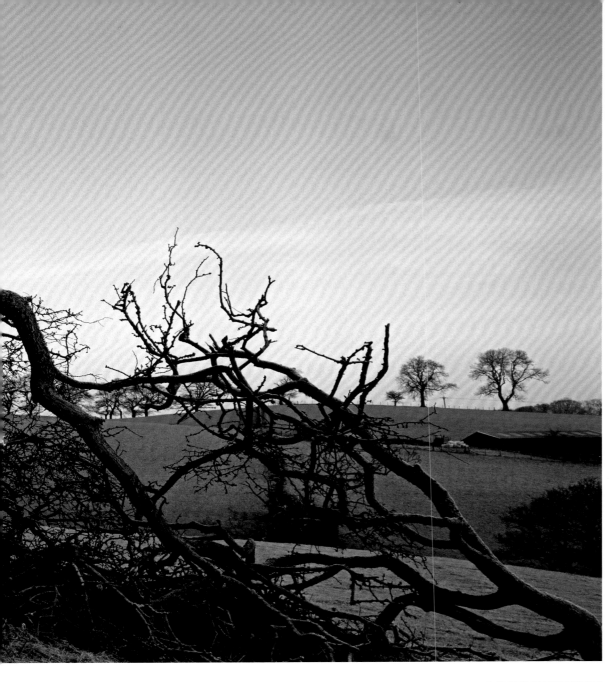

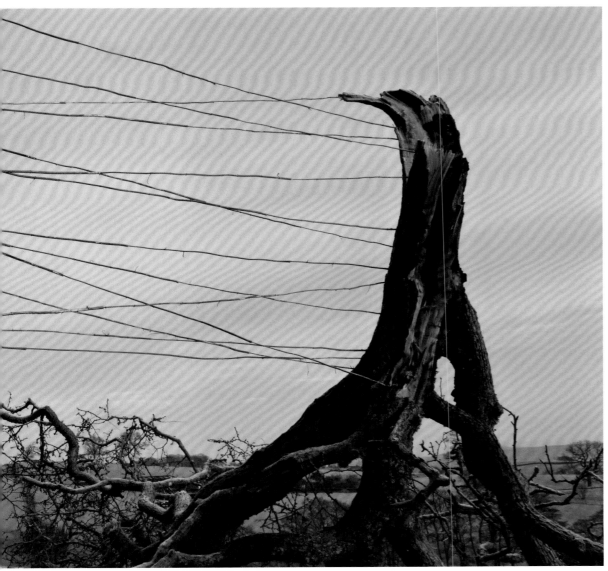

HAWTHORN TREE. SNAPPED IN TWO BY STRONG WINDS. RECONNECTED WITH
NETTLE STALKS. THE THIN END OF ONE STALK PUSHED TIGHTLY INTO THE HOLLOW,
WIDER END OF ANOTHER TO MAKE LONG LINES. HELD TO THE TREE WITH THORNS.
MADE OVER SEVERAL UNUSUALLY CALM DAYS.
DUMFRIESSHIRE, SCOTLAND. 14 - 17 JANUARY 2012

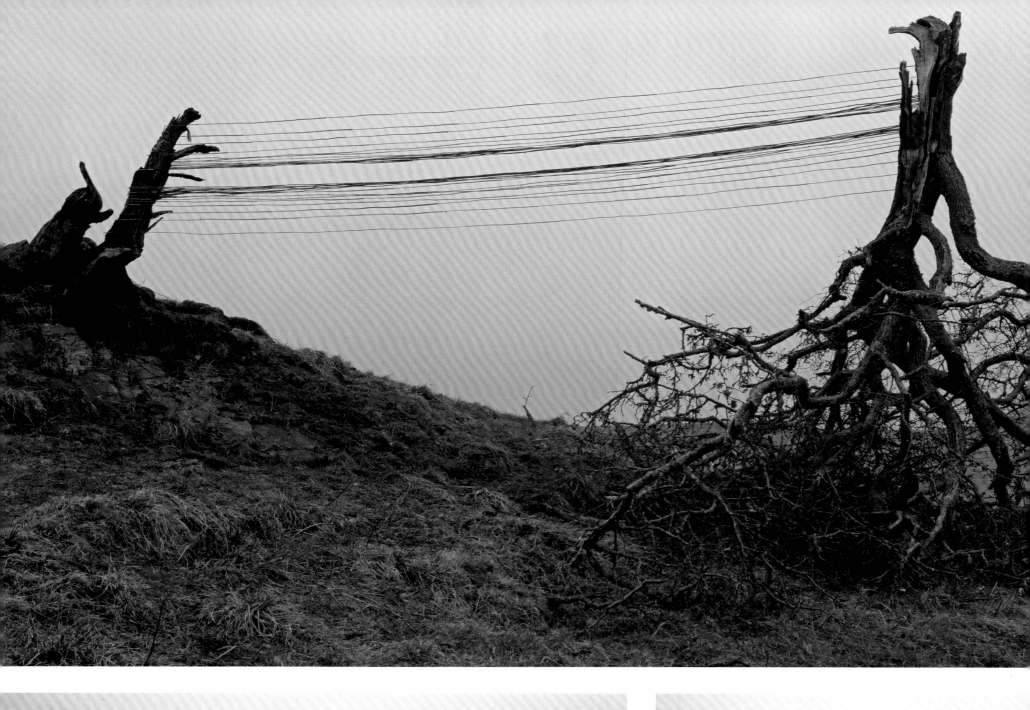

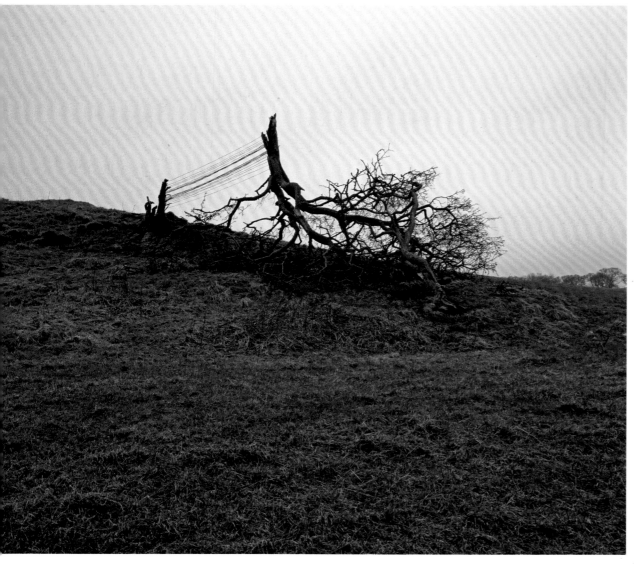

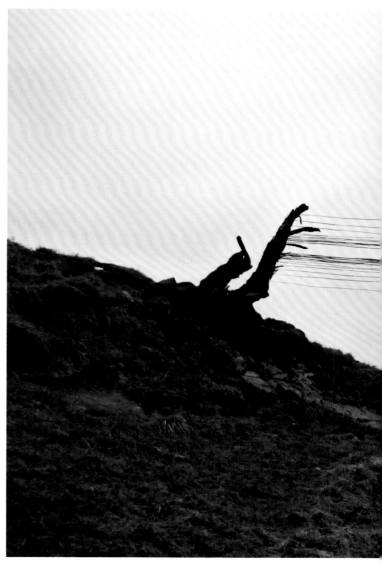

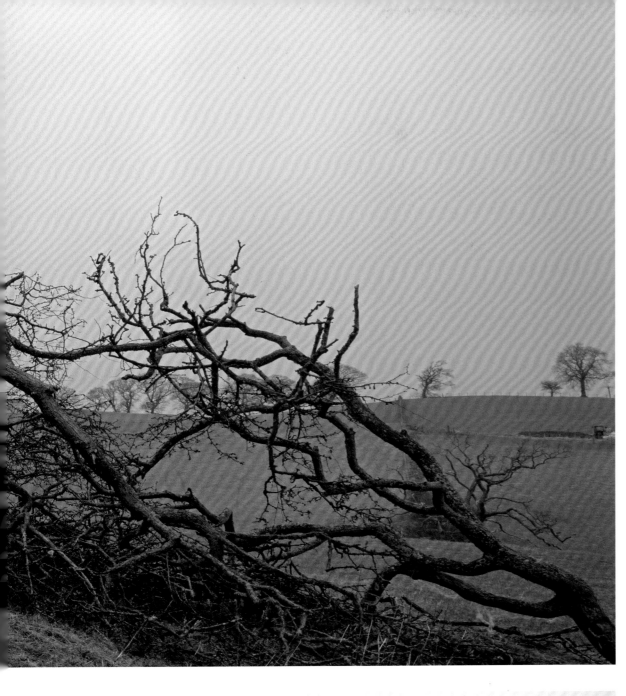

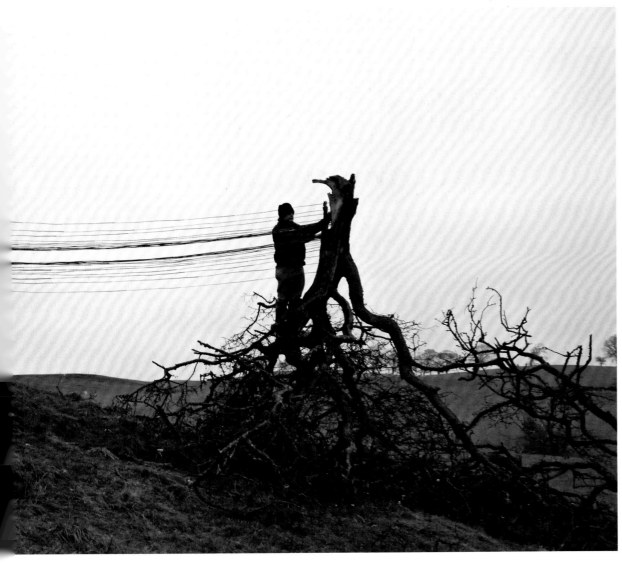

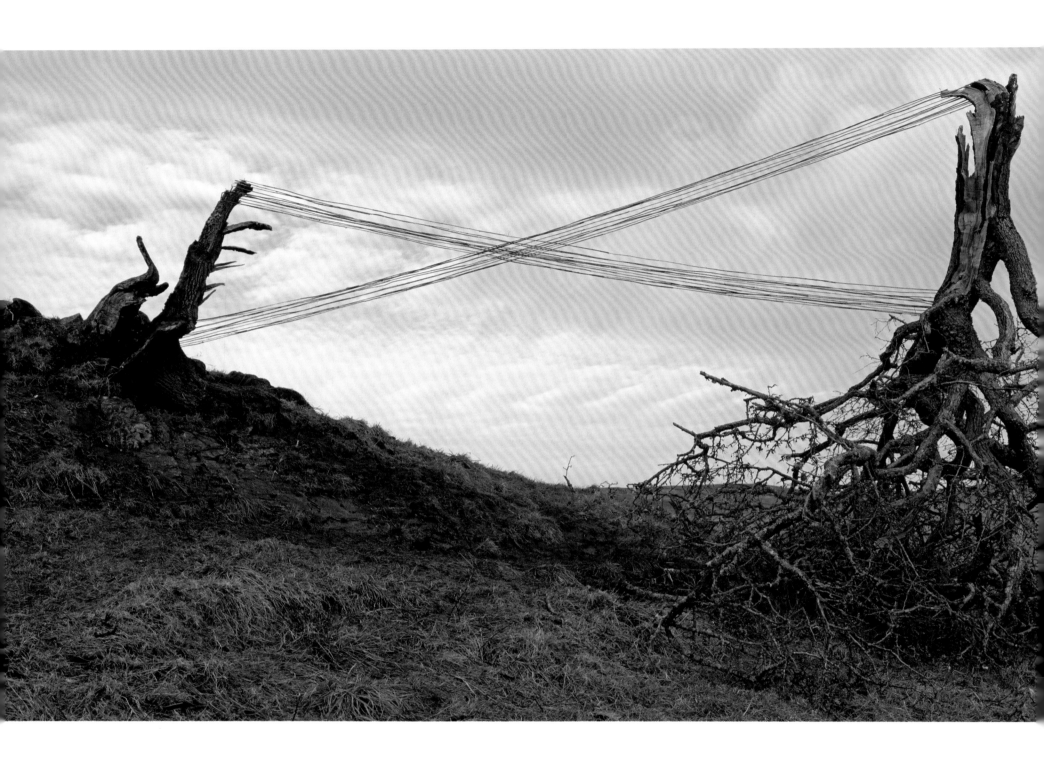

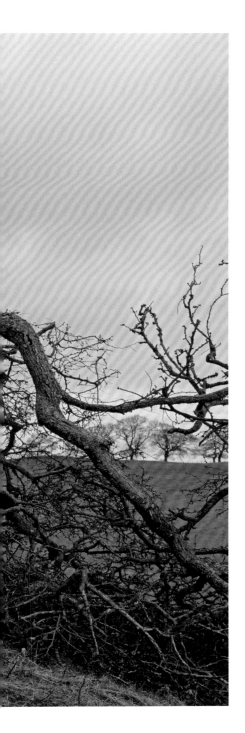
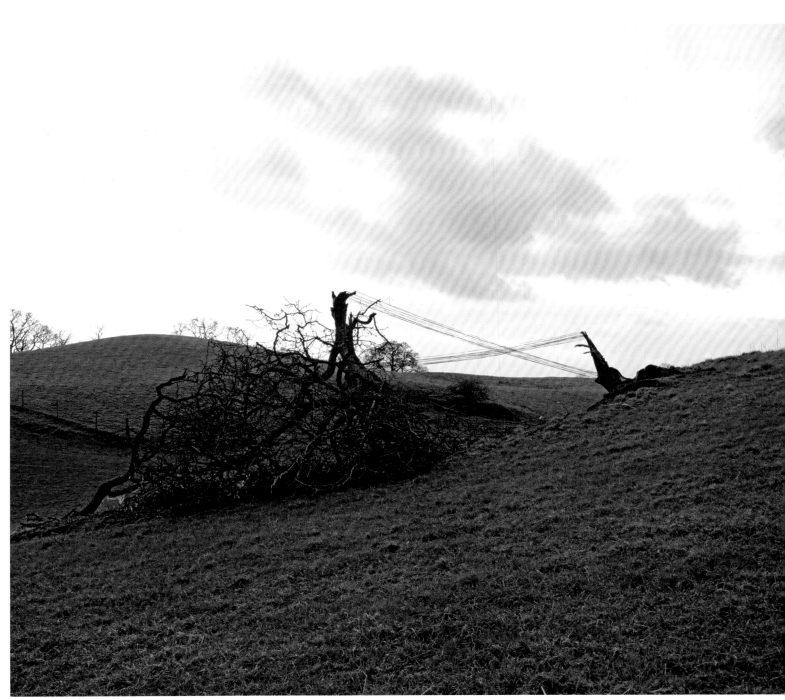

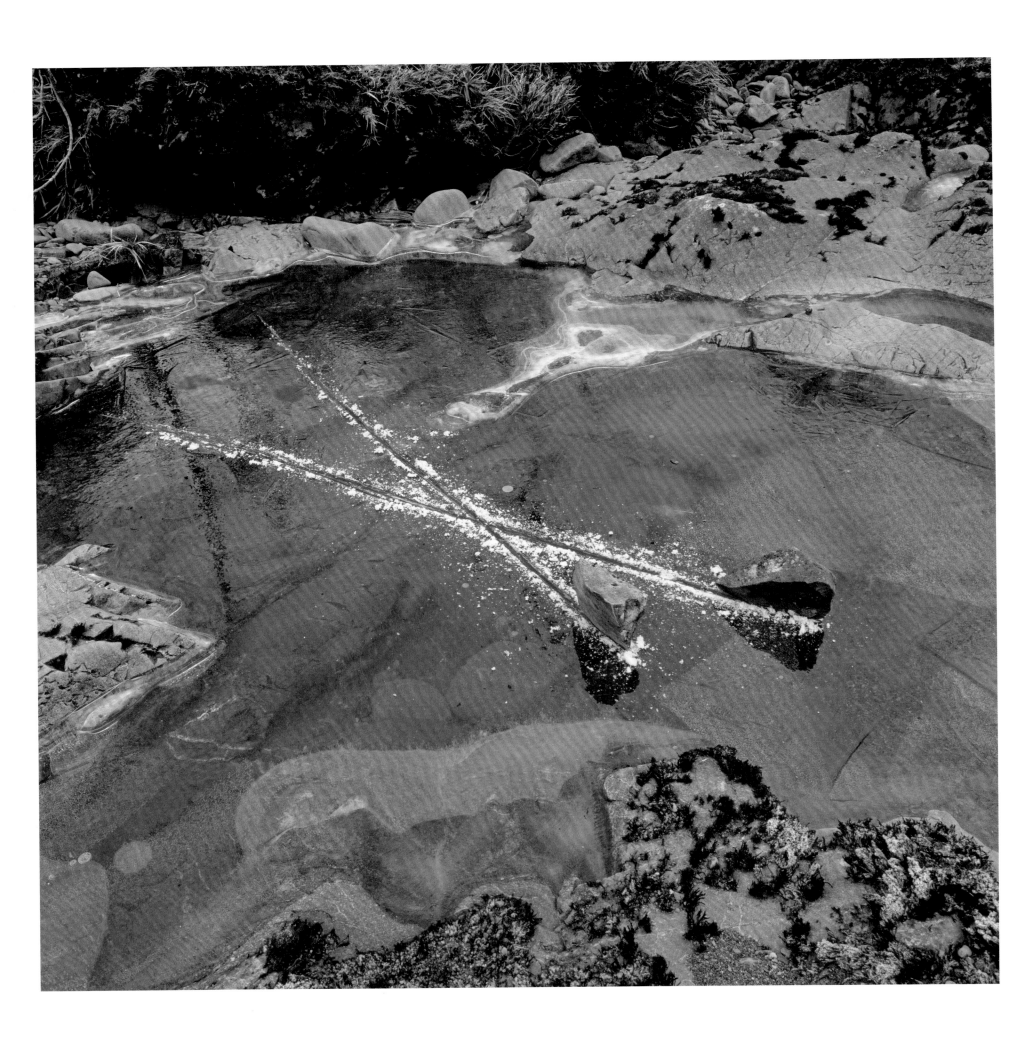

ICE SCORED WITH TWO STONES. THAWING AND FREEZING. DUMFRIESSHIRE, SCOTLAND. FEBRUARY 2012

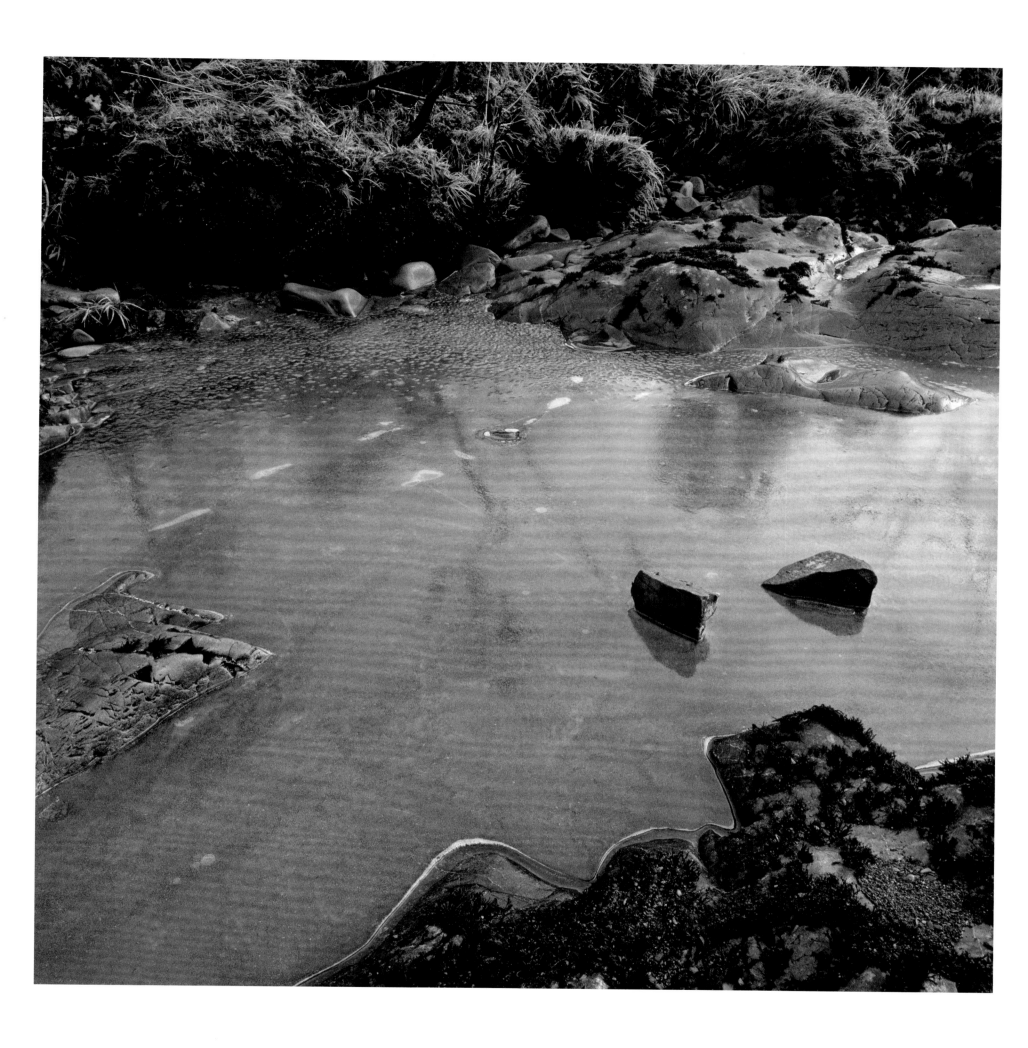

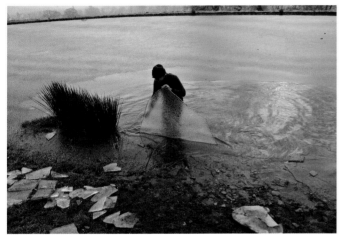 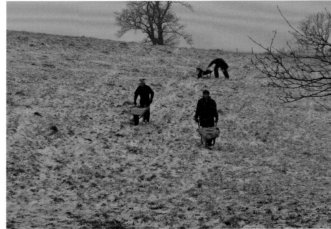 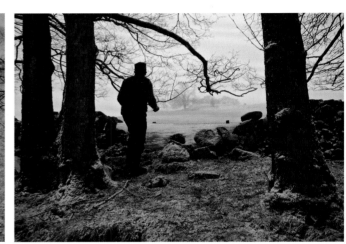

ICE LIFTED OFF NEARBY LAKE. CARRIED CAREFULLY BY WHEELBARROWS. WORKED INTO THE GAP OF A BROKEN WALL. JUST COLD ENOUGH TO FREEZE ICE TO ICE. DUMFRIESSHIRE, SCOTLAND. 4, 5 FEBRUARY 2012

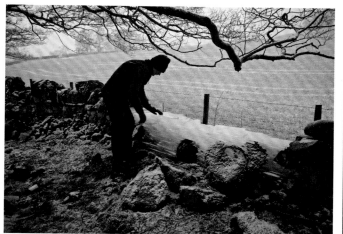 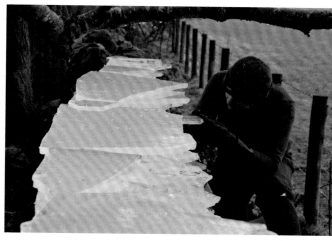 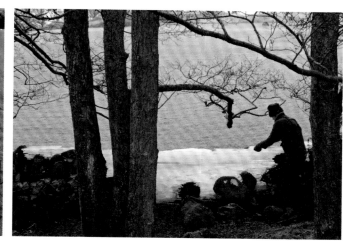

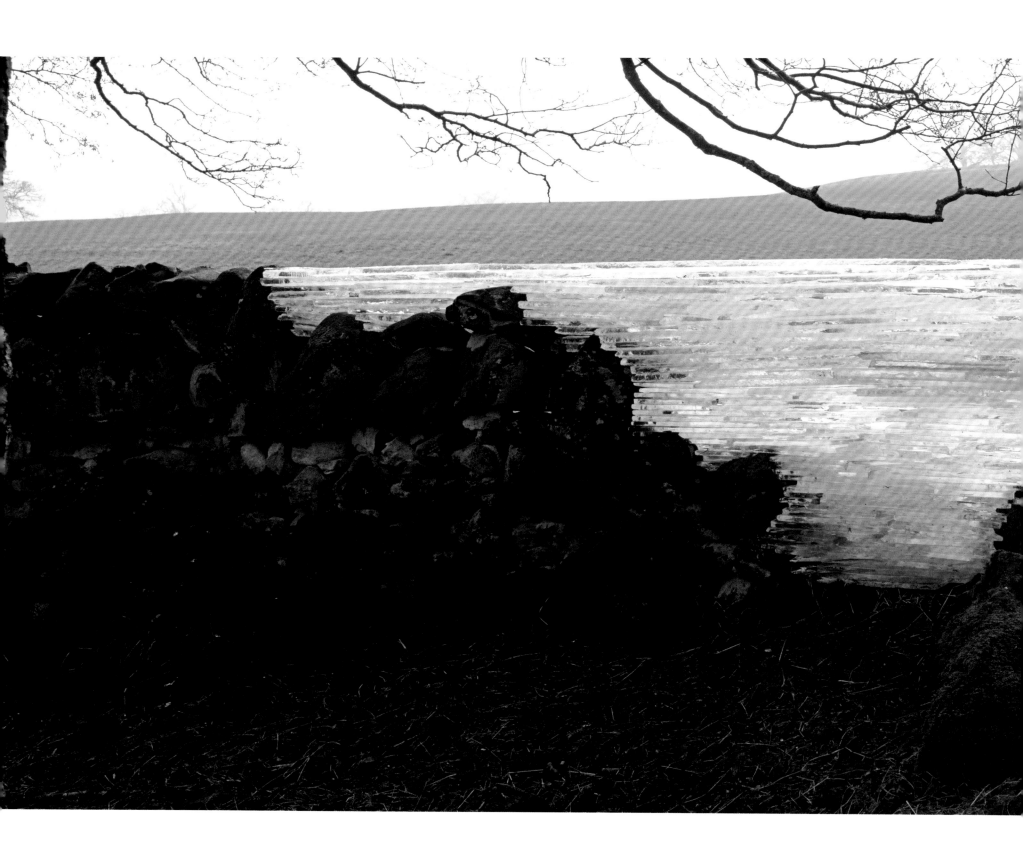

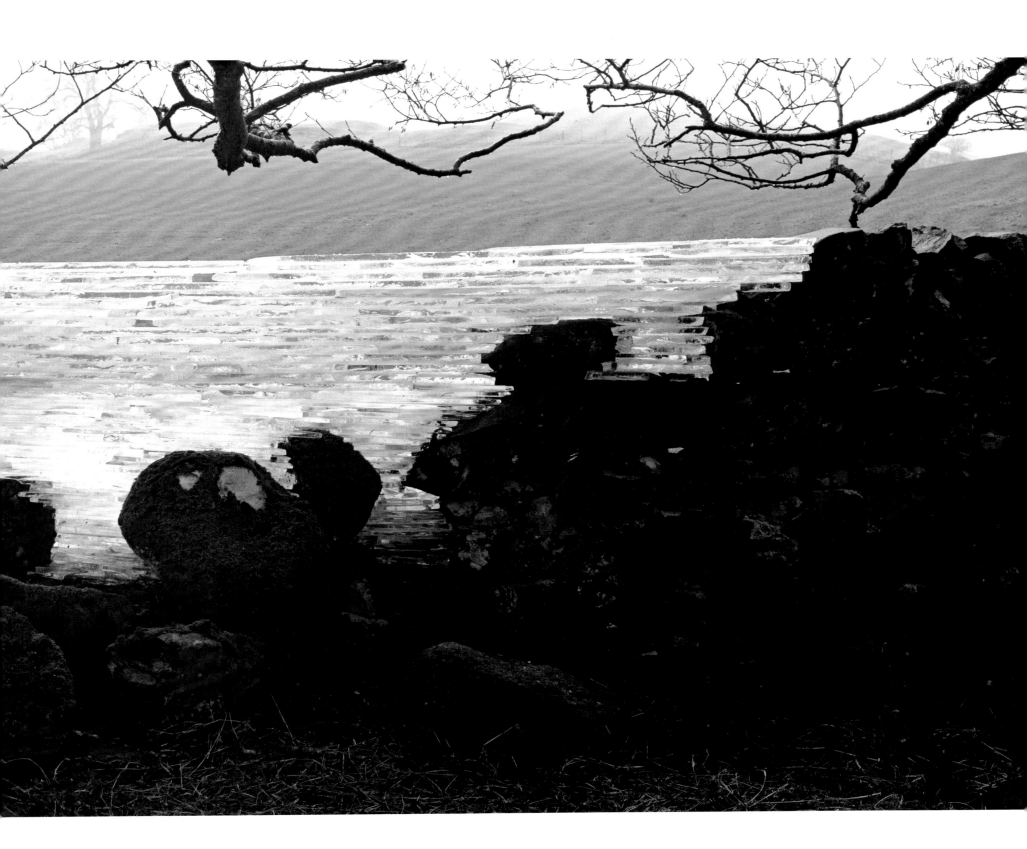

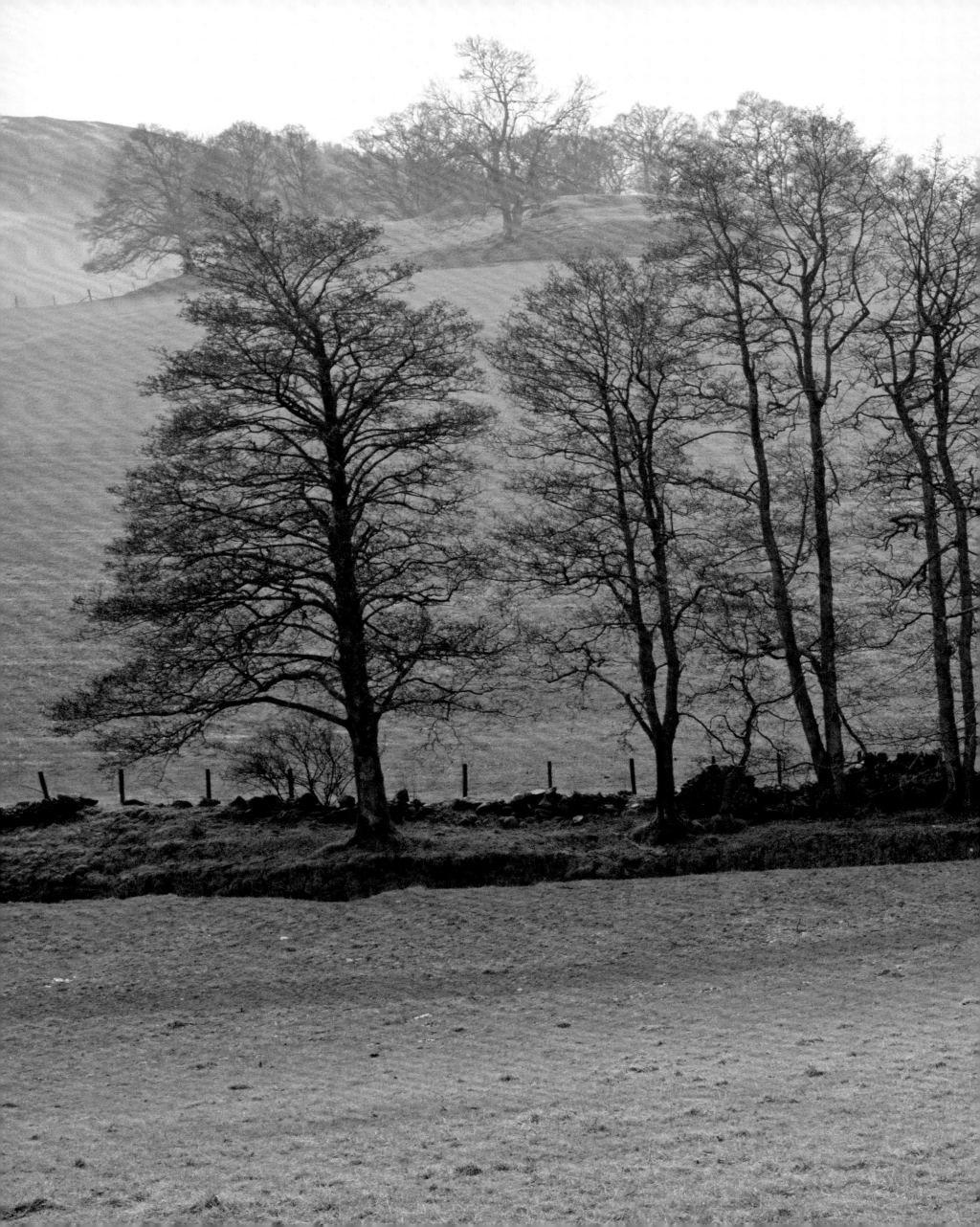

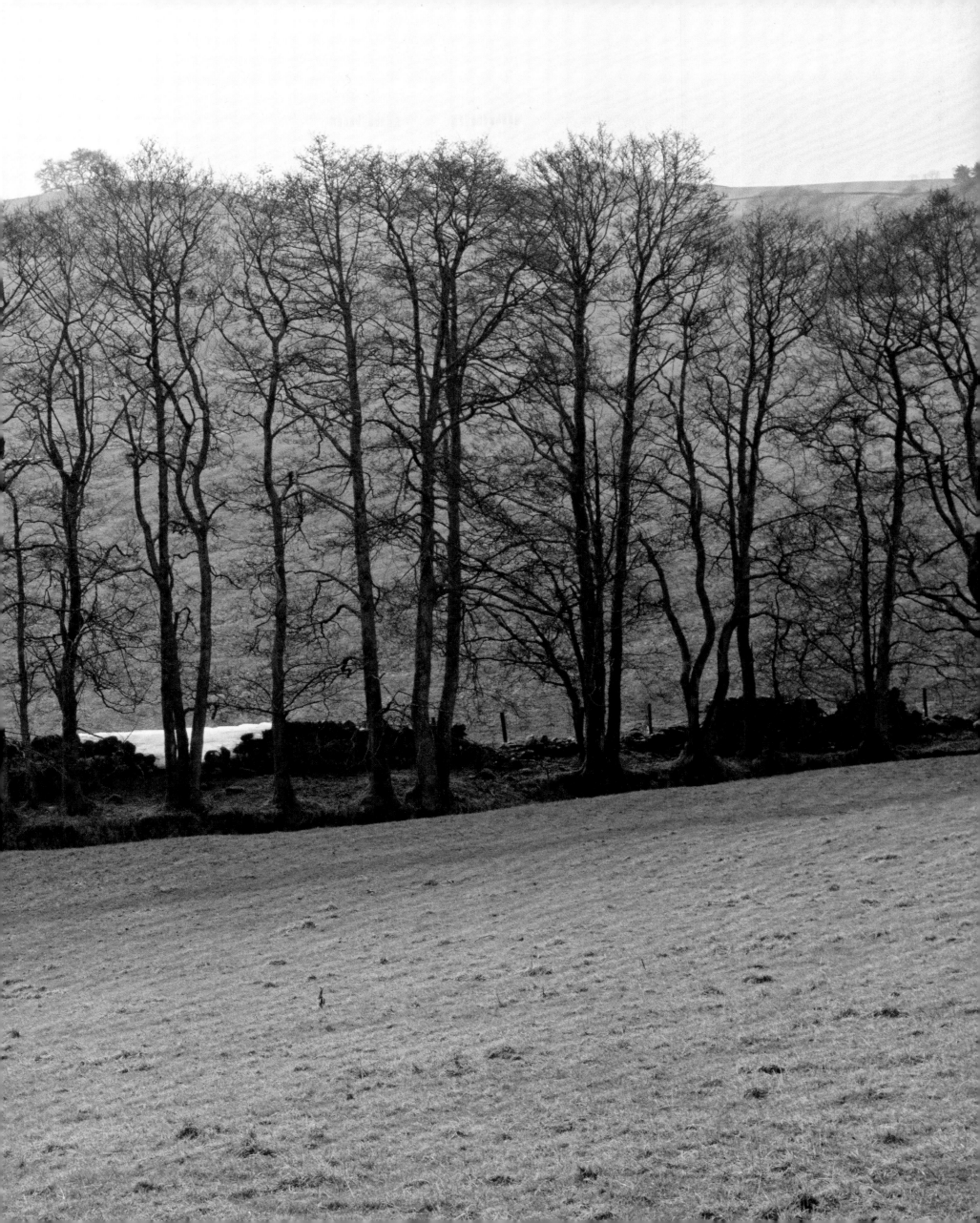

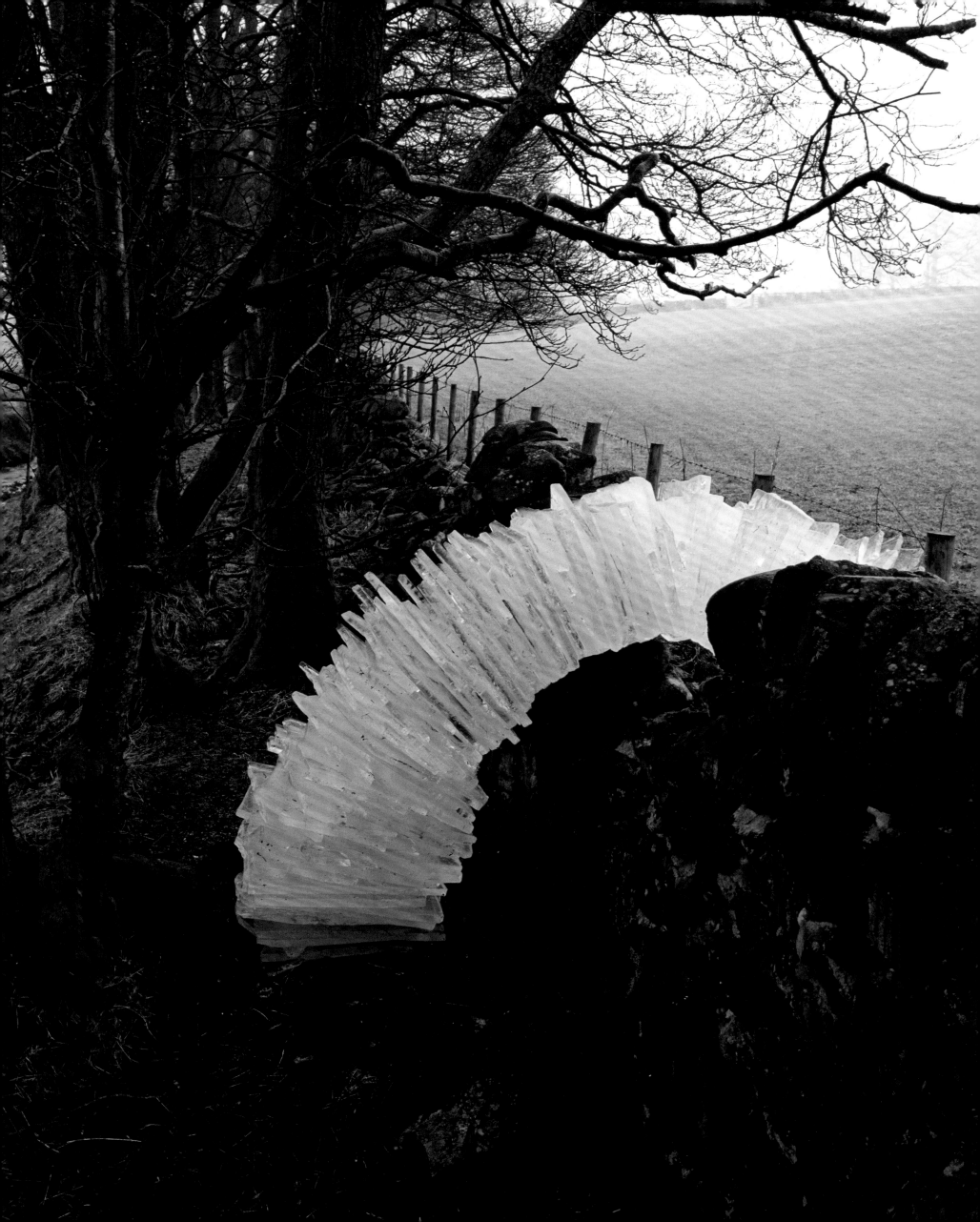

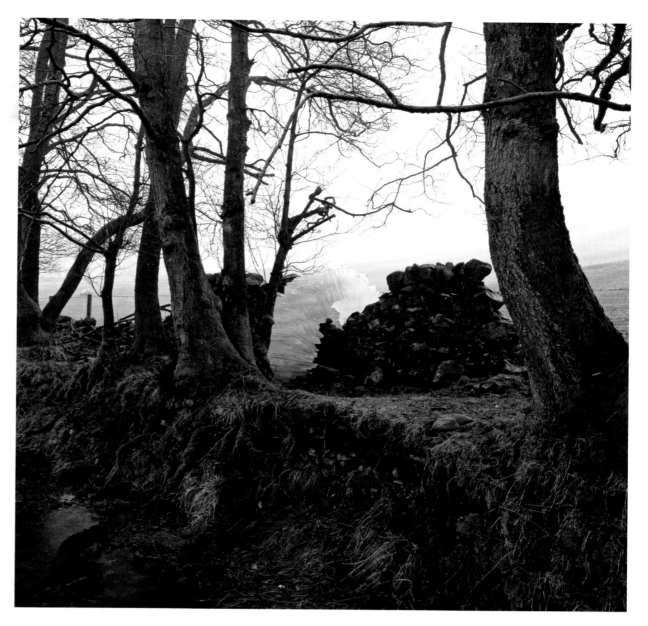

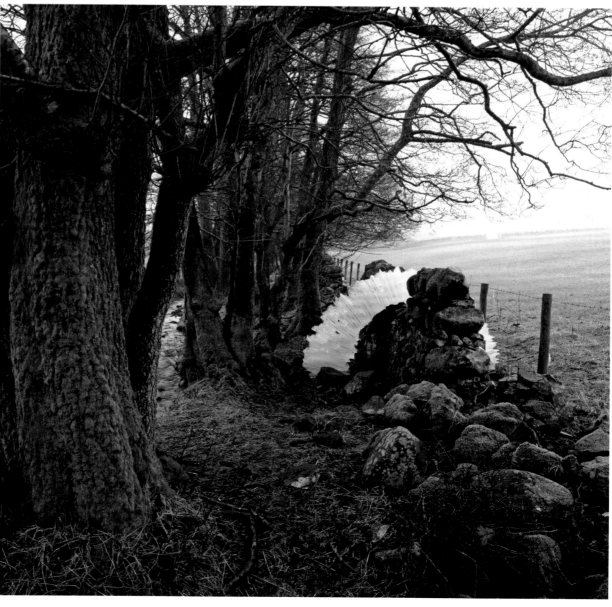

ICE ARCH. SUPPORTED WITH LOGS AND BRANCHES.
LEFT OVERNIGHT TO FREEZE. REMOVED LOGS THE FOLLOWING DAY.
THAWING AND FREEZING FOR SEVERAL DAYS BEFORE COLLAPSING.
DUMFRIESSHIRE, SCOTLAND. 8, 9 FEBRUARY 2012

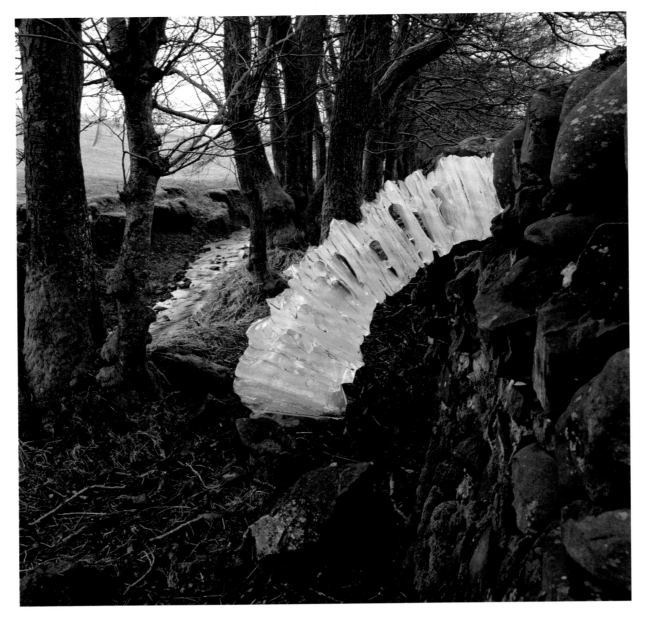
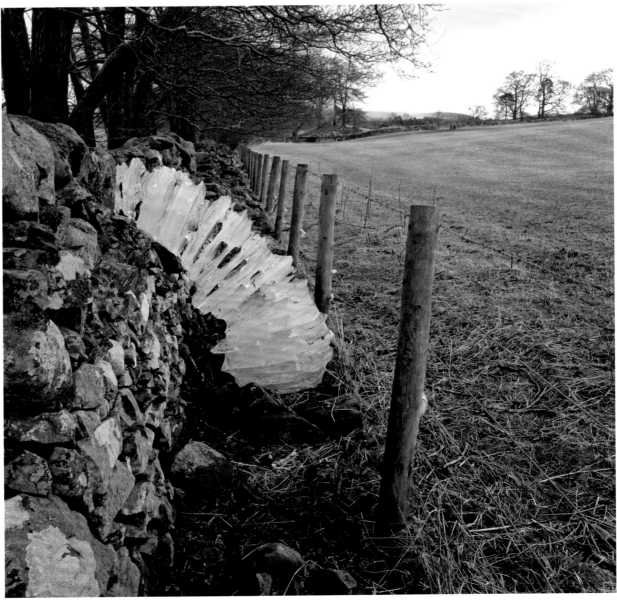

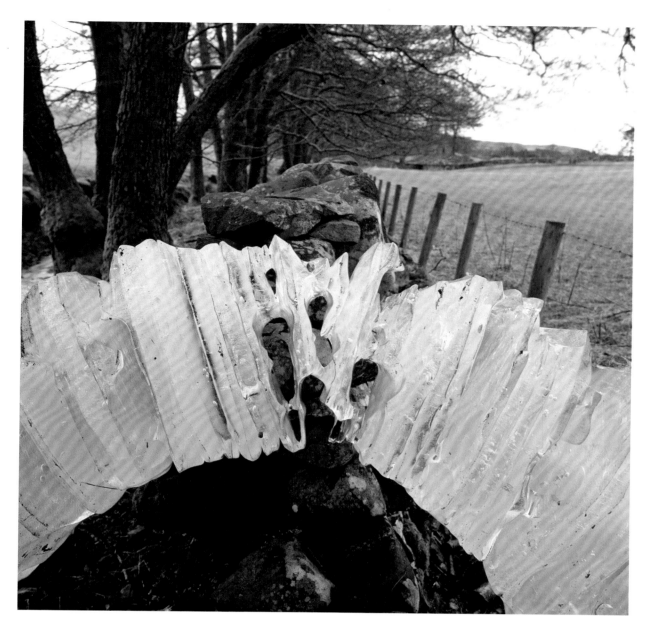

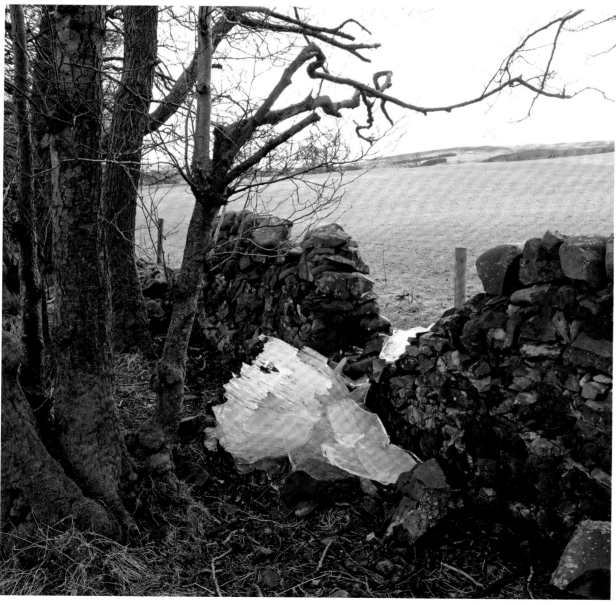

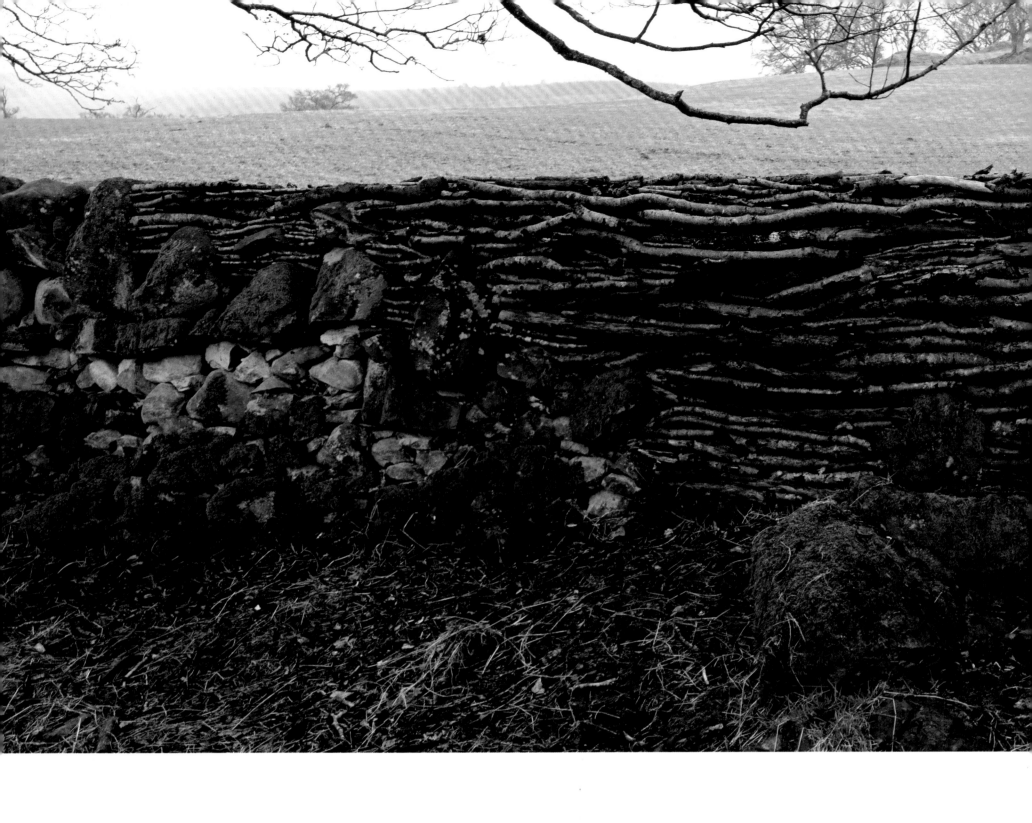

WINDFALLEN ALDER BRANCHES. FILLING GAP IN WALL. DUMFRIESSHIRE, SCOTLAND. 2 MARCH 2012

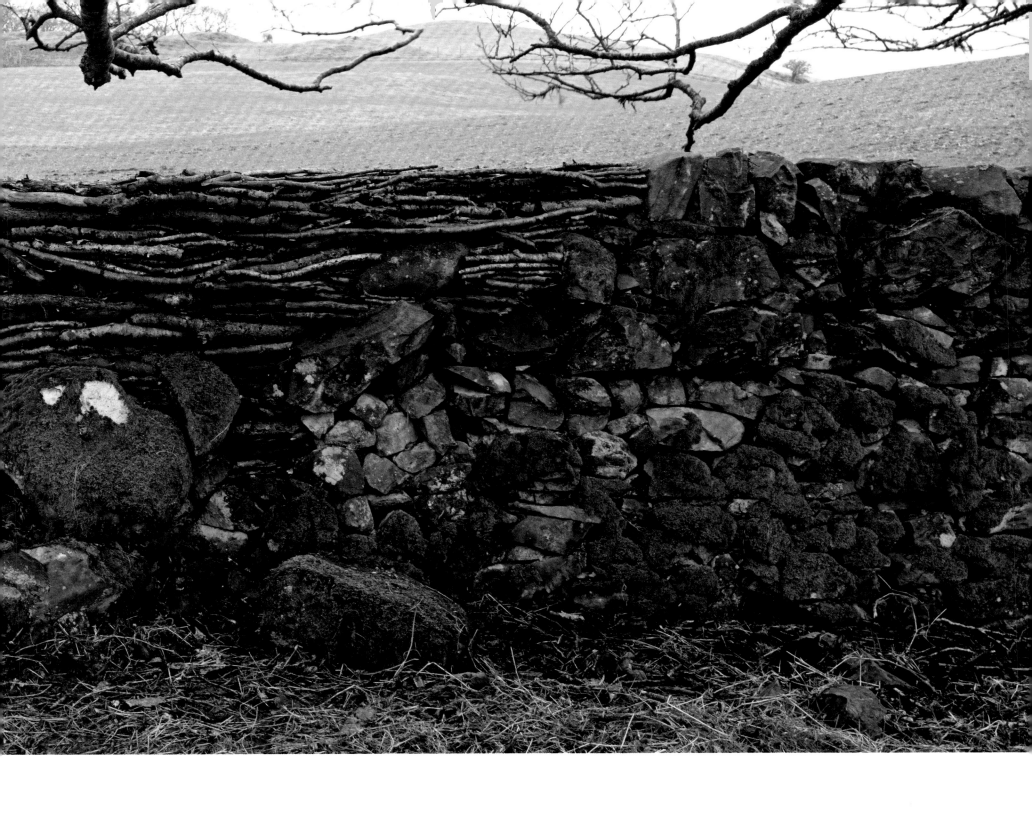

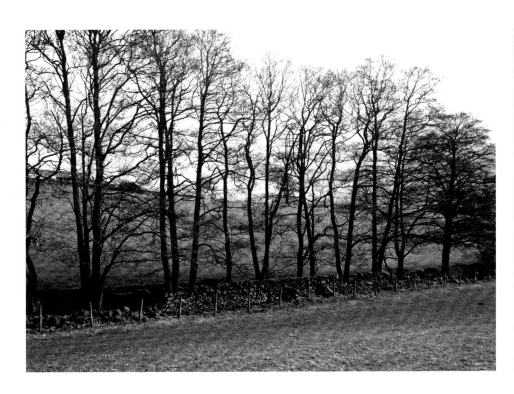

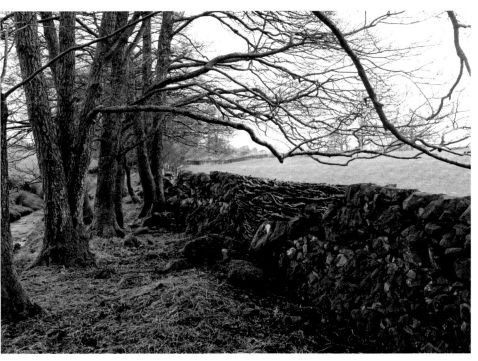

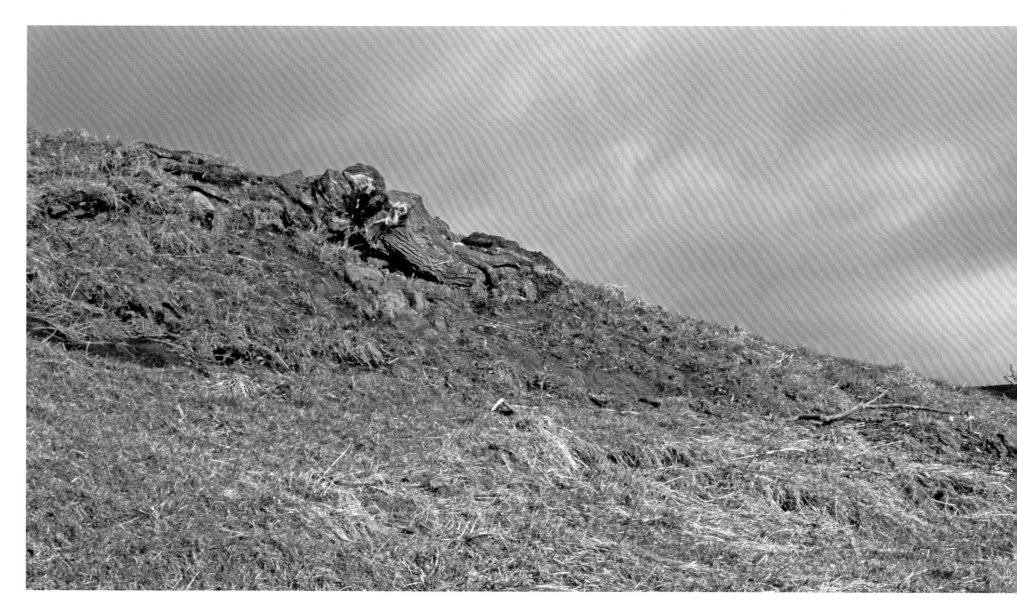

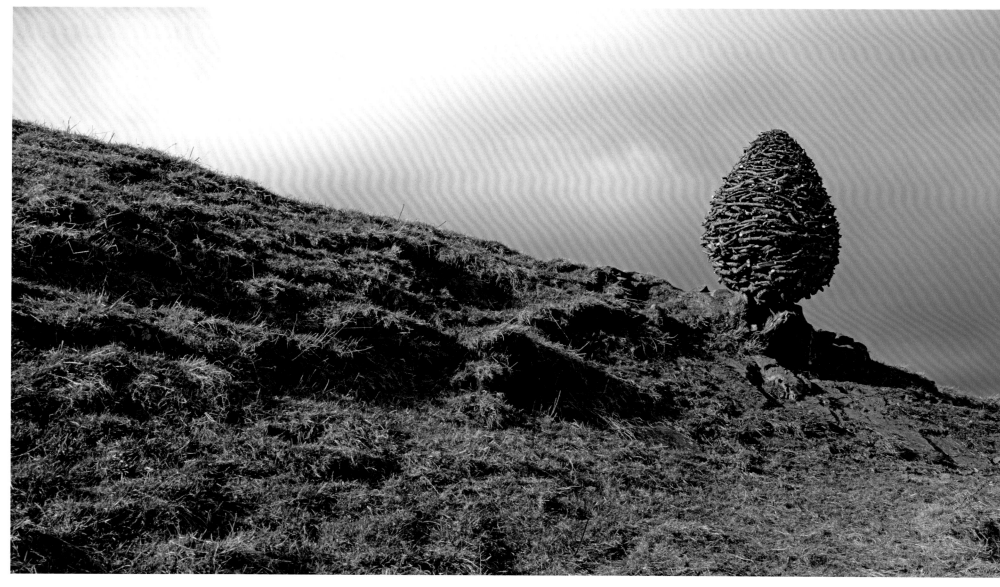

REMNANTS OF WINDFALLEN HAWTHORN. LEFT AFTER BEING CUT UP BY FARMER. WORKED INTO A CAIRN ON THE STUMP WHERE THE TREE ONCE GREW. DUMFRIESSHIRE, SCOTLAND. 11 MARCH 2012

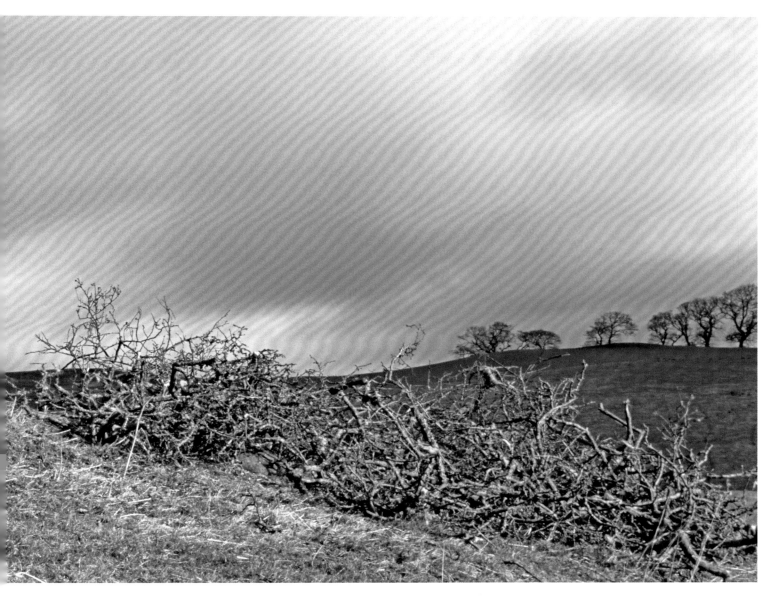

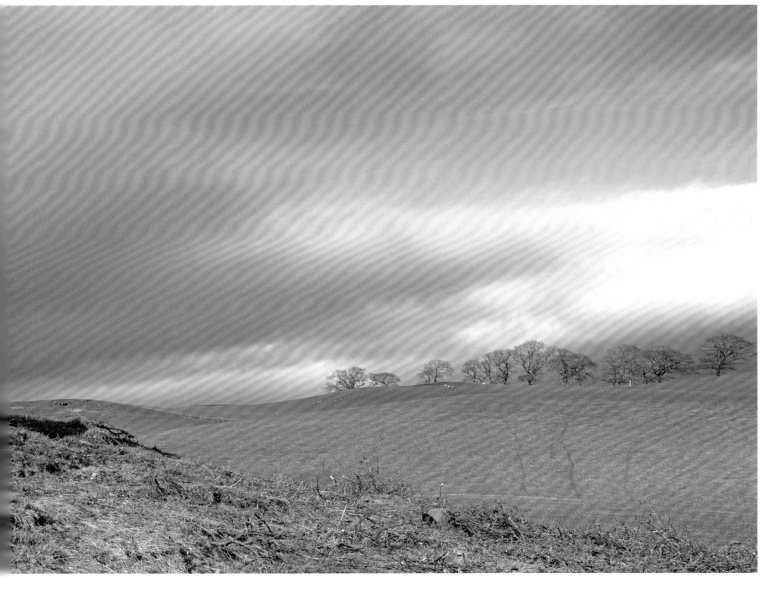

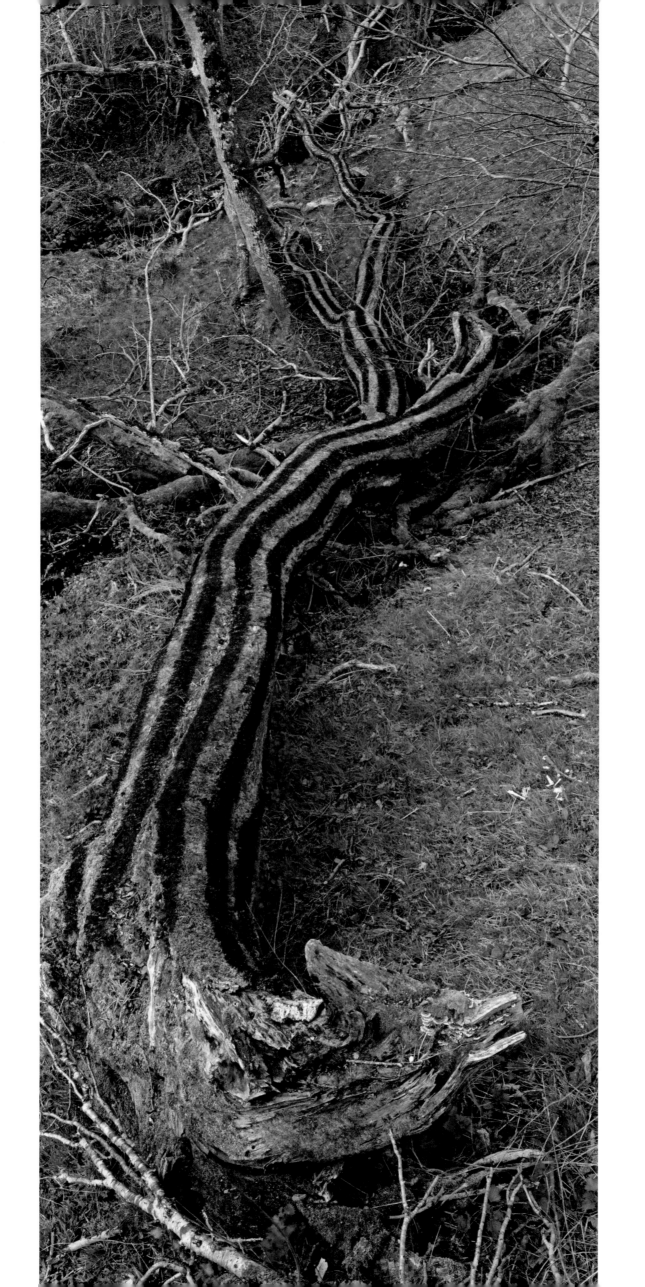

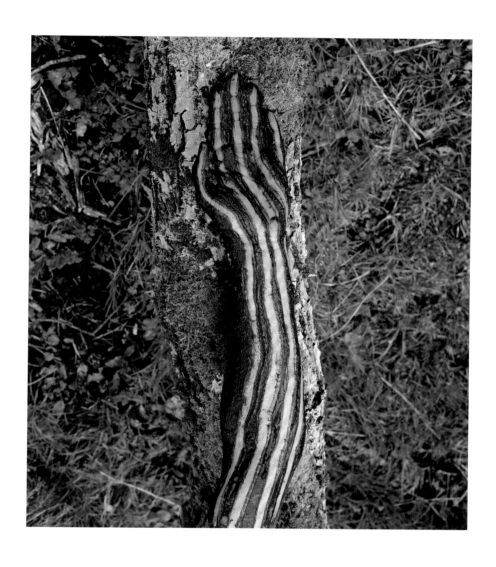

FALLEN ASH TREE. MY ARM. BLACK MUD. MADE IN THE SAME PLACE. DUMFRIESSHIRE, SCOTLAND. APRIL 2012

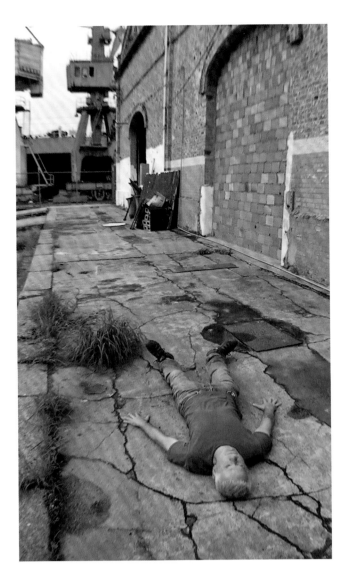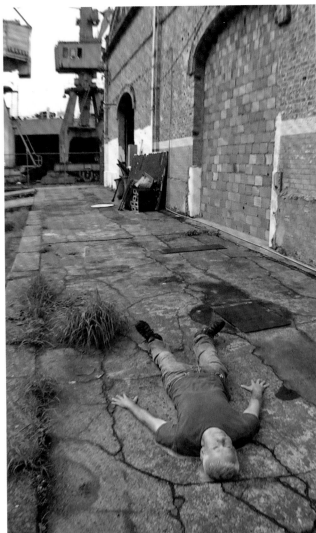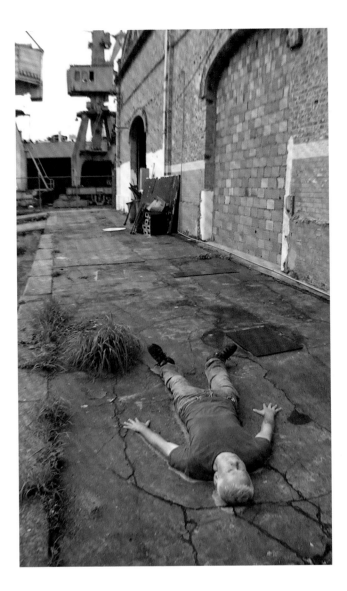
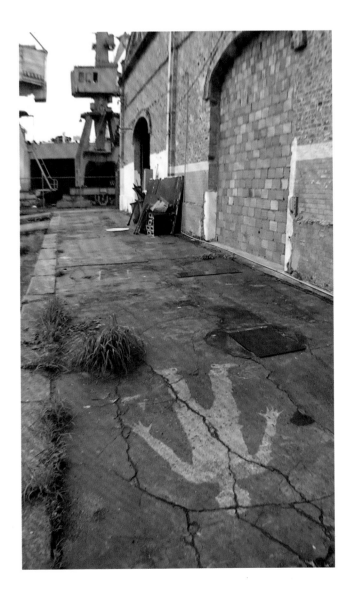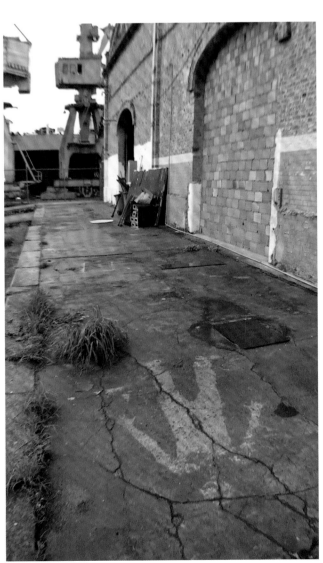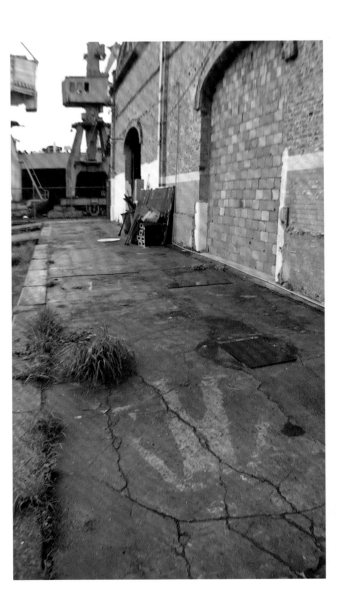

RAIN SHADOW. RIO DE JANEIRO, BRAZIL. 23 APRIL 2012

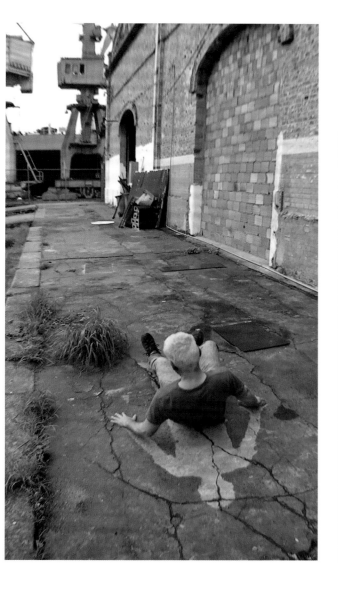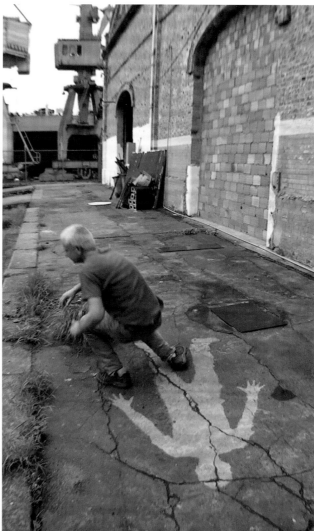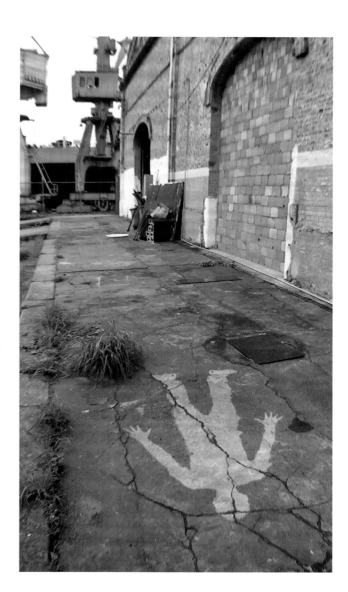

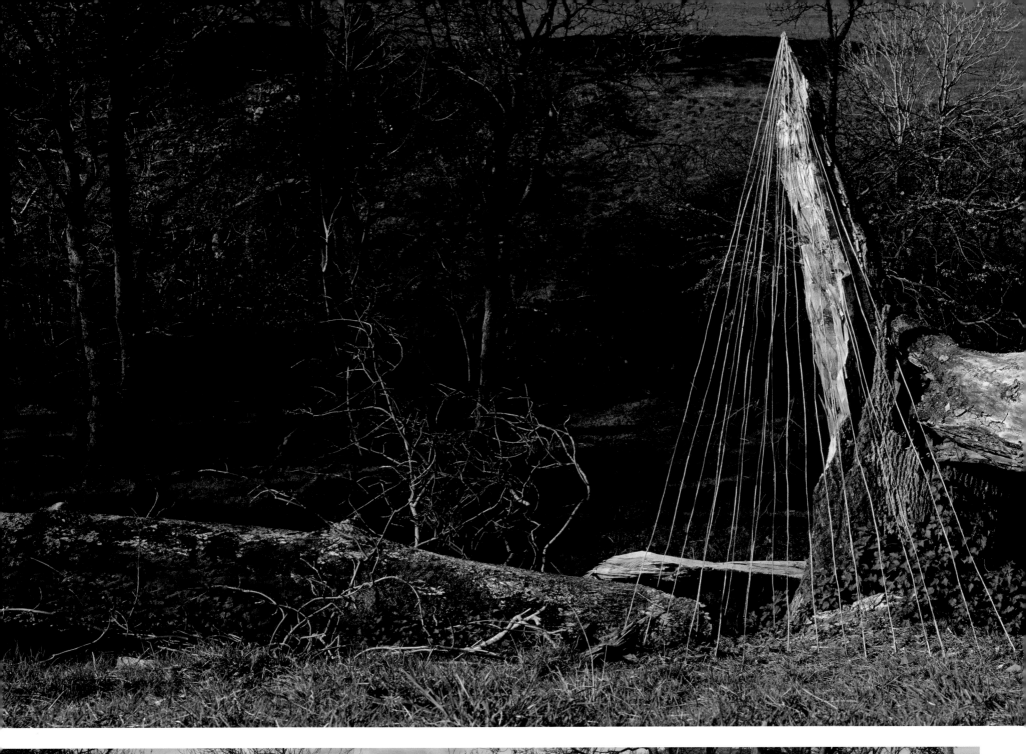
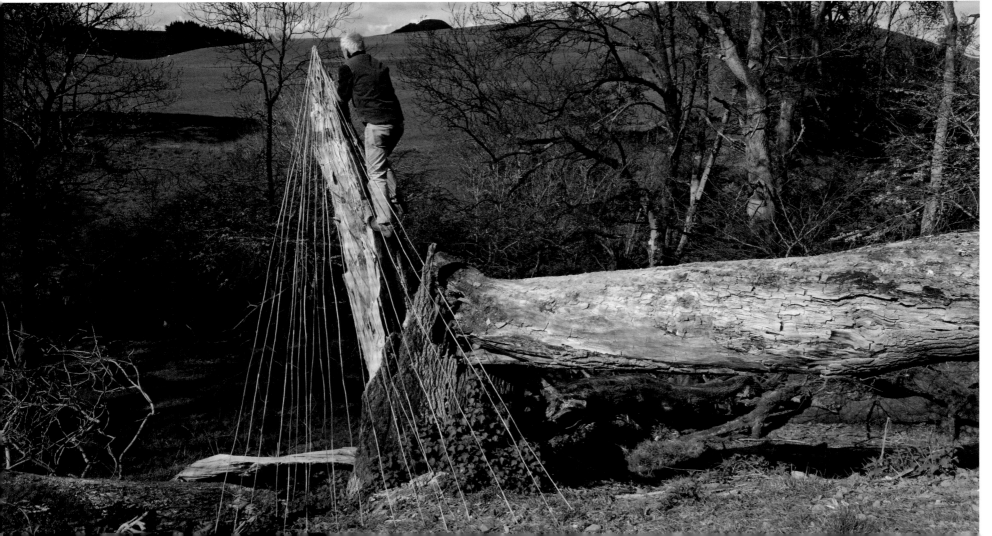

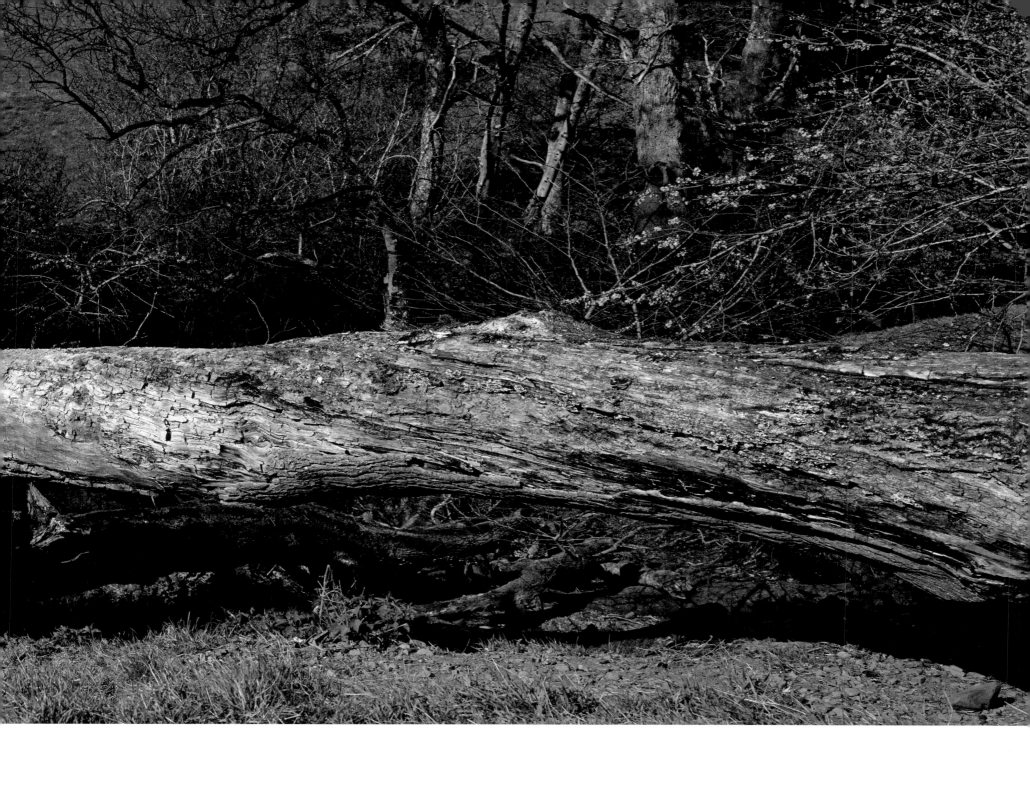

PALE, DRY, LIGHT, DEAD NETTLE STALKS. JOINED TO MAKE LINES. HELD AT EACH END WITH THORNS. CALM. DUMFRIESSHIRE, SCOTLAND. 5 MAY 2012

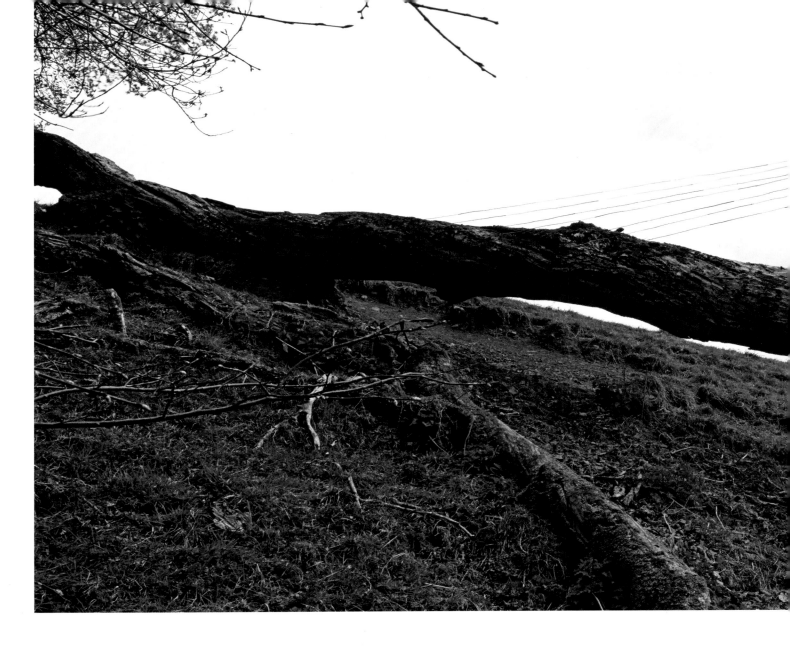

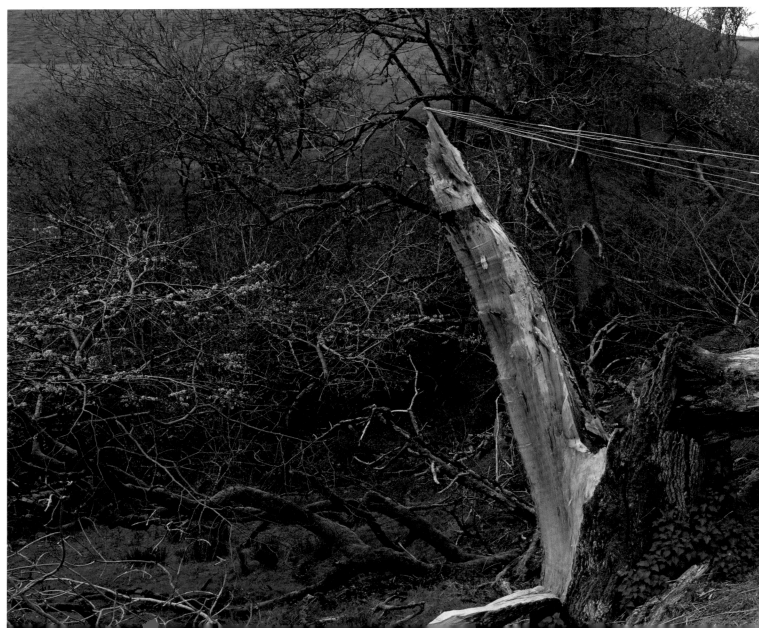

REWORKED NETTLE STALKS.
DUMFRIESSHIRE, SCOTLAND. 7 MAY 2012

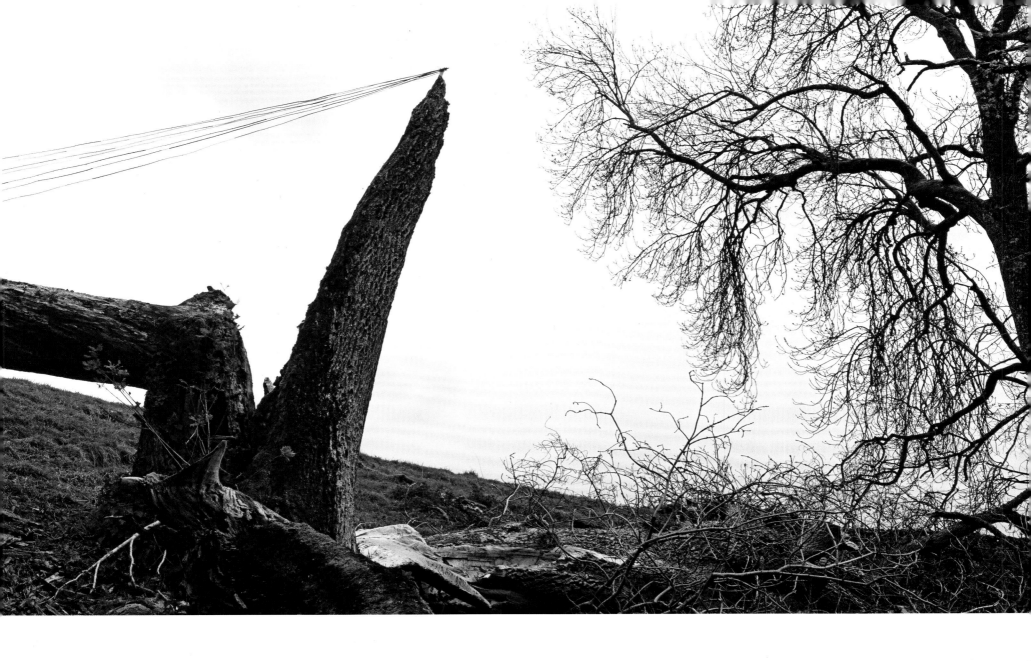

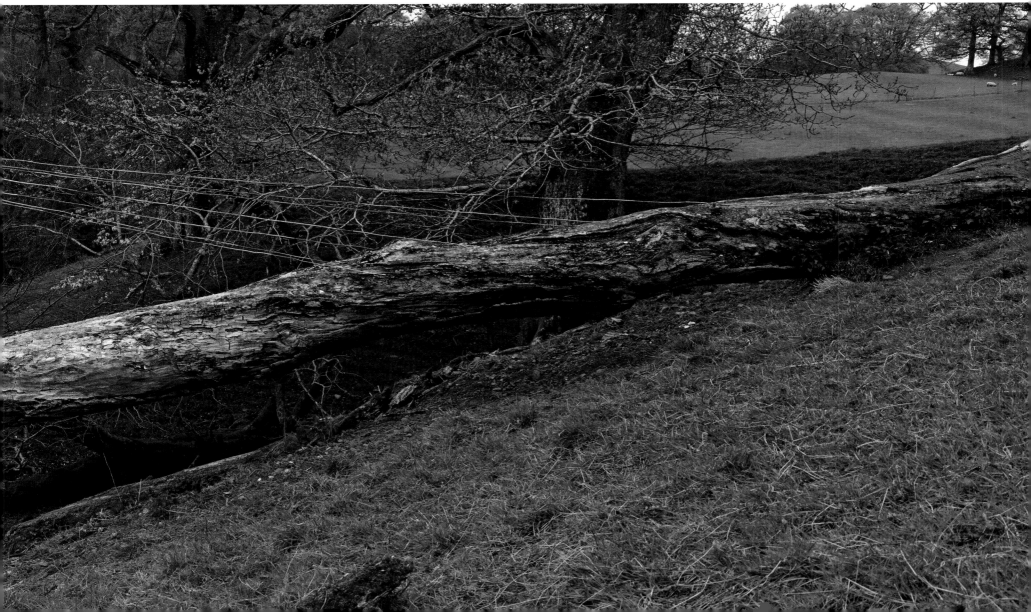

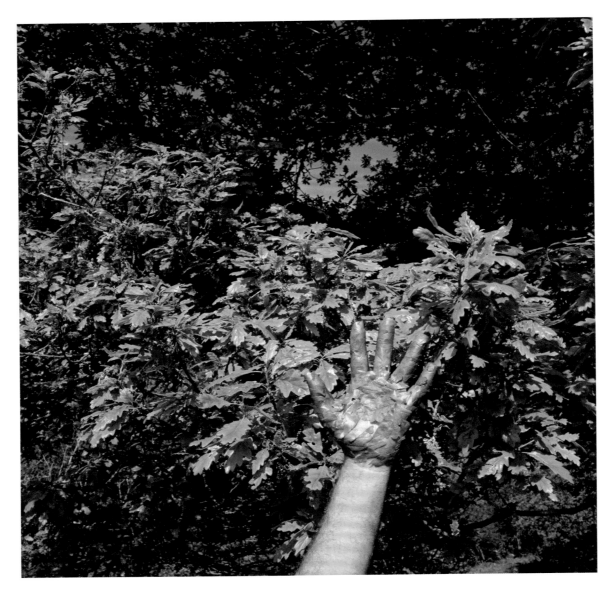

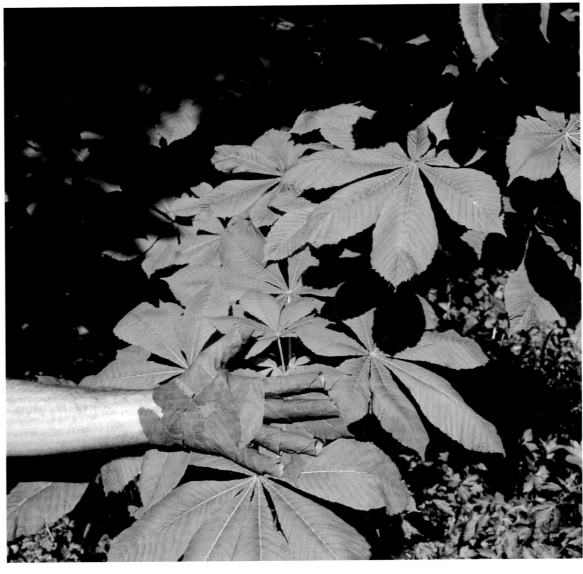

SUPPLE, SPRING-GREEN LEAVES. WRAPPED AROUND MY HAND. HELD WITH WATER. OAK. HORSE CHESTNUT. LIME. SYCAMORE. DUMFRIESSHIRE, SCOTLAND. MAY 2012

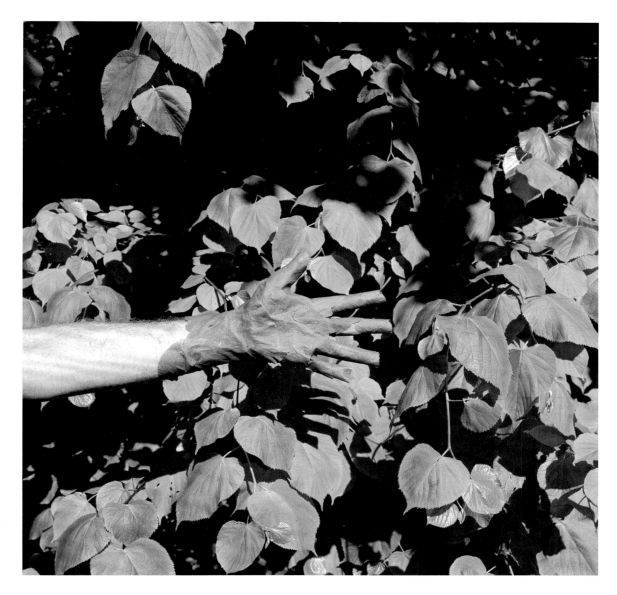
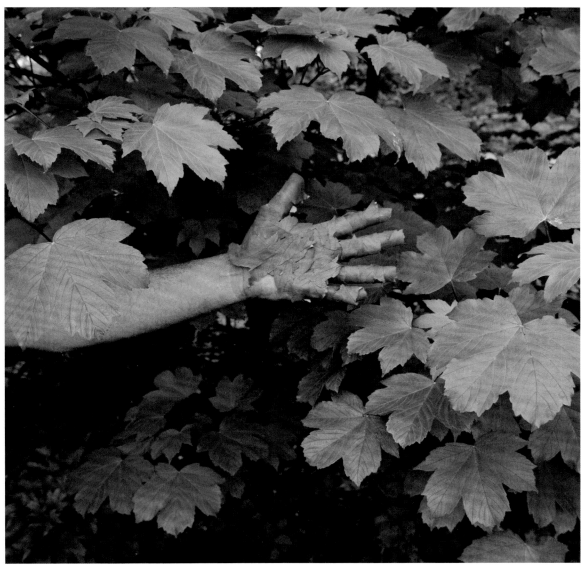

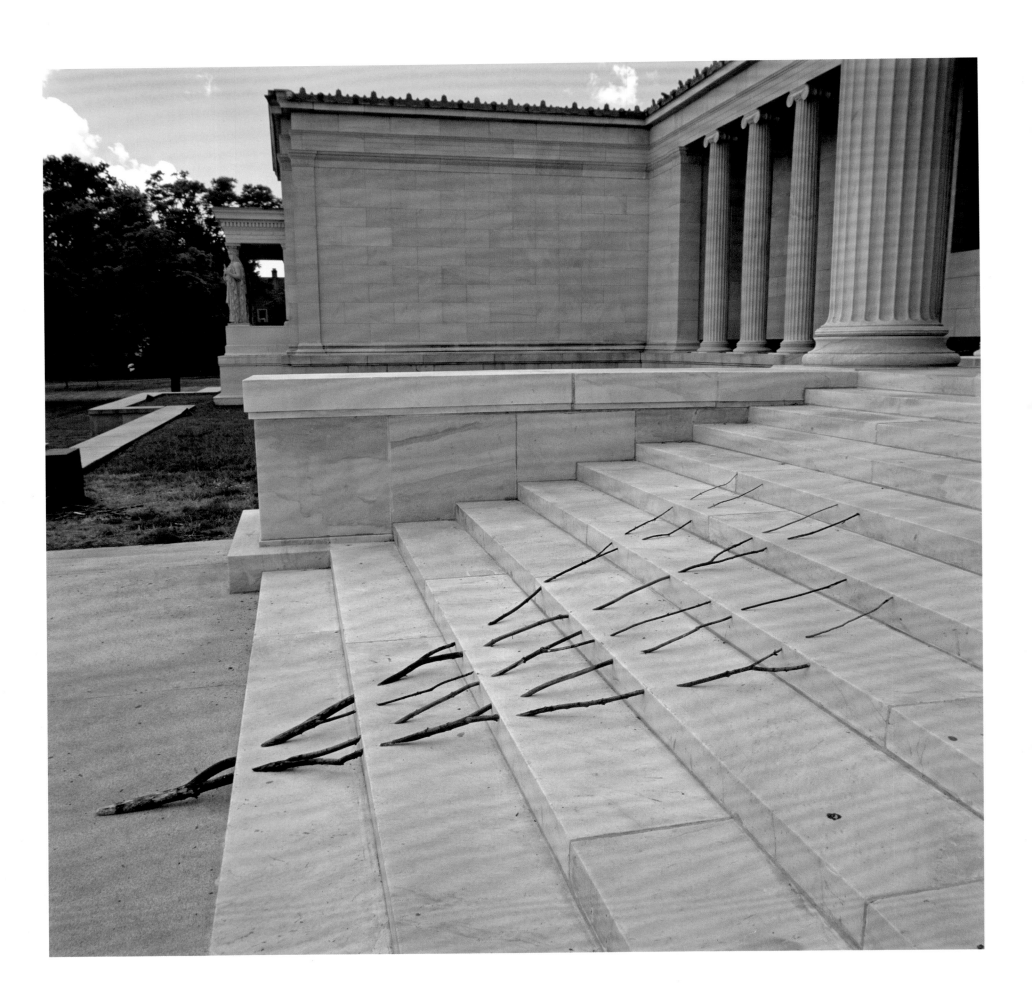

WINDFALLEN BRANCHES. SAWN. WORKED INTO THE STONE STEPS OF THE ALBRIGHT-KNOX ART GALLERY. BUFFALO, NEW YORK. 10 JULY 2012

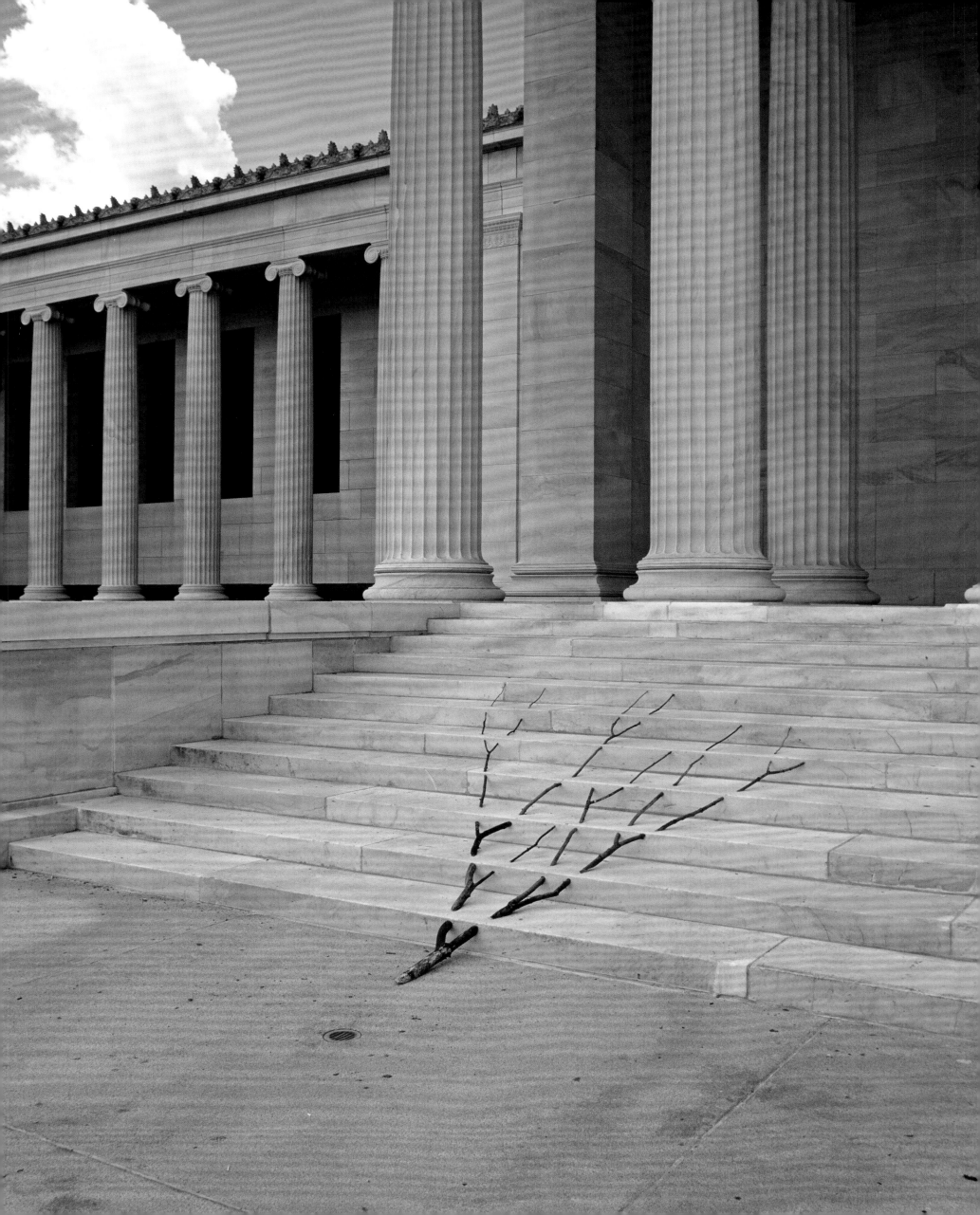

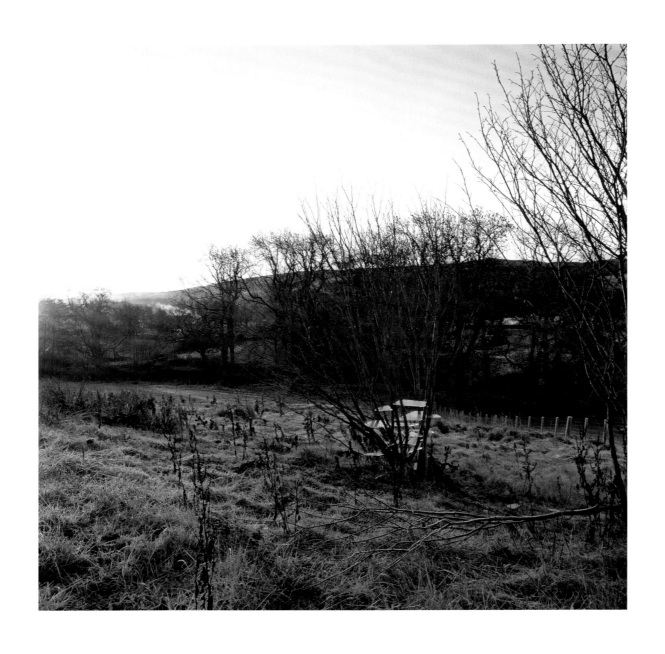

ICE. WEDGED BETWEEN BRANCHES OF A HAZEL TREE. MADE BETWEEN DAWN AND SUNRISE. DUMFRIESSHIRE, SCOTLAND. 2 DECEMBER 2012

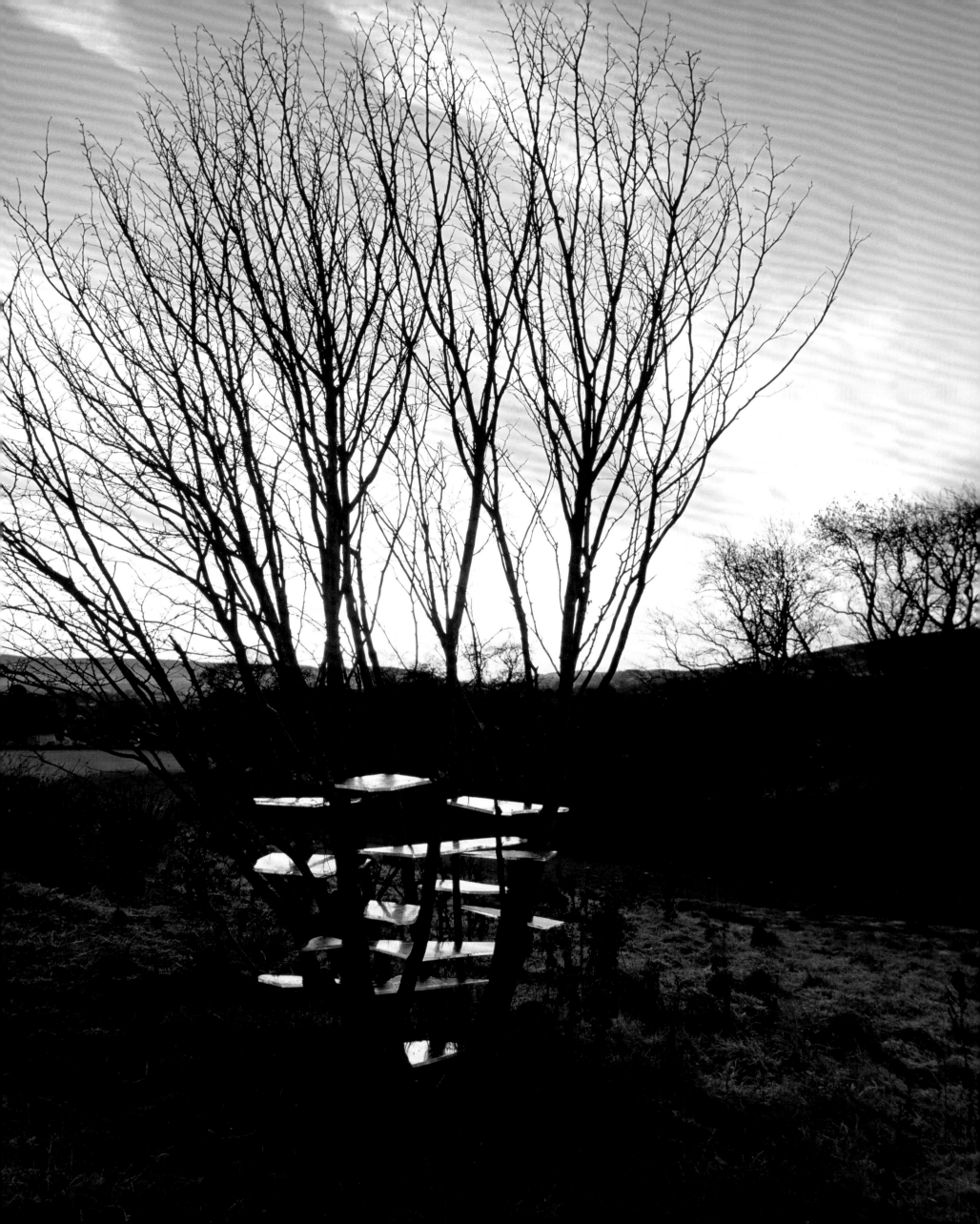

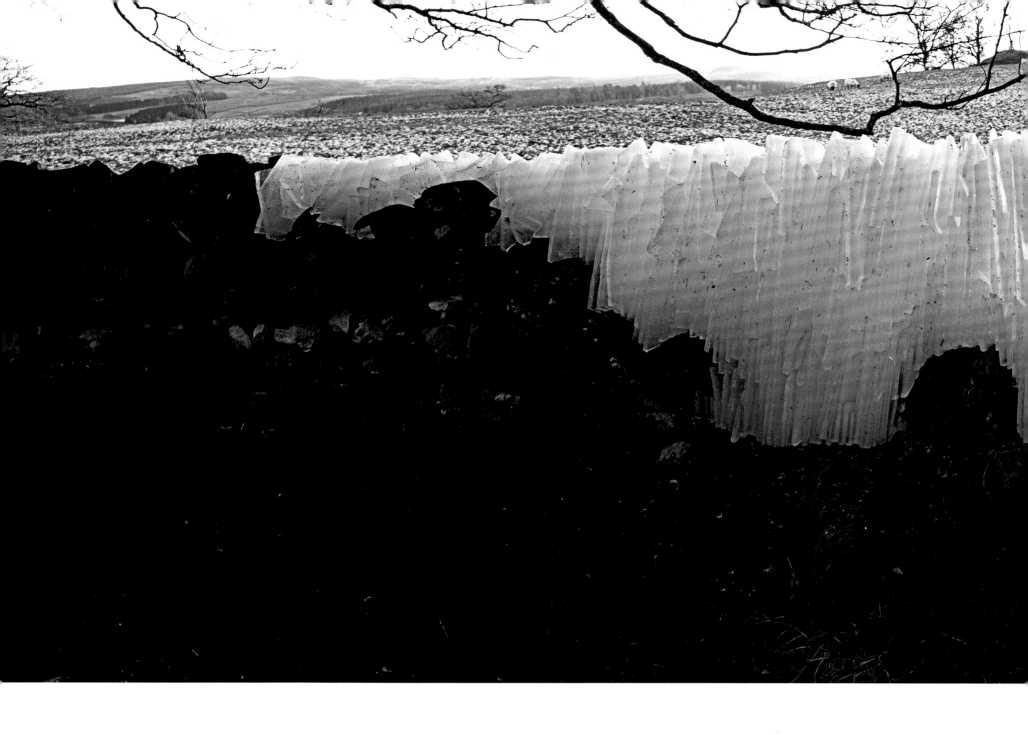

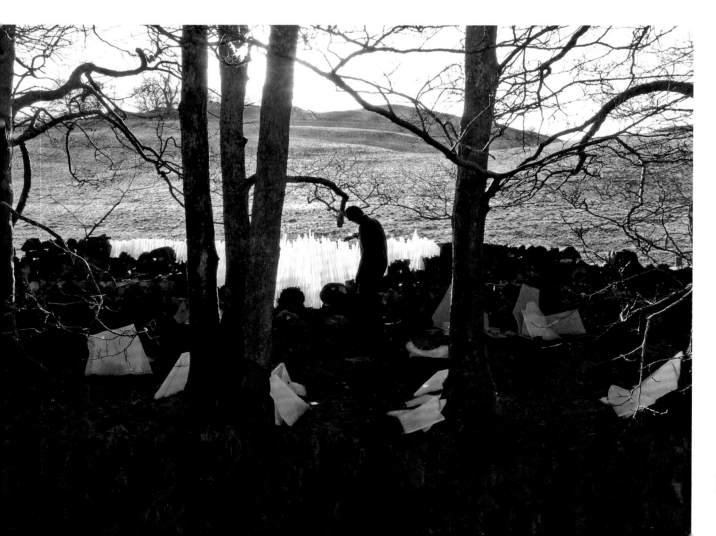

ICE. STOOD ON END. FILLING GAP IN WALL.
DUMFRIESSHIRE, SCOTLAND. 5 DECEMBER 2012

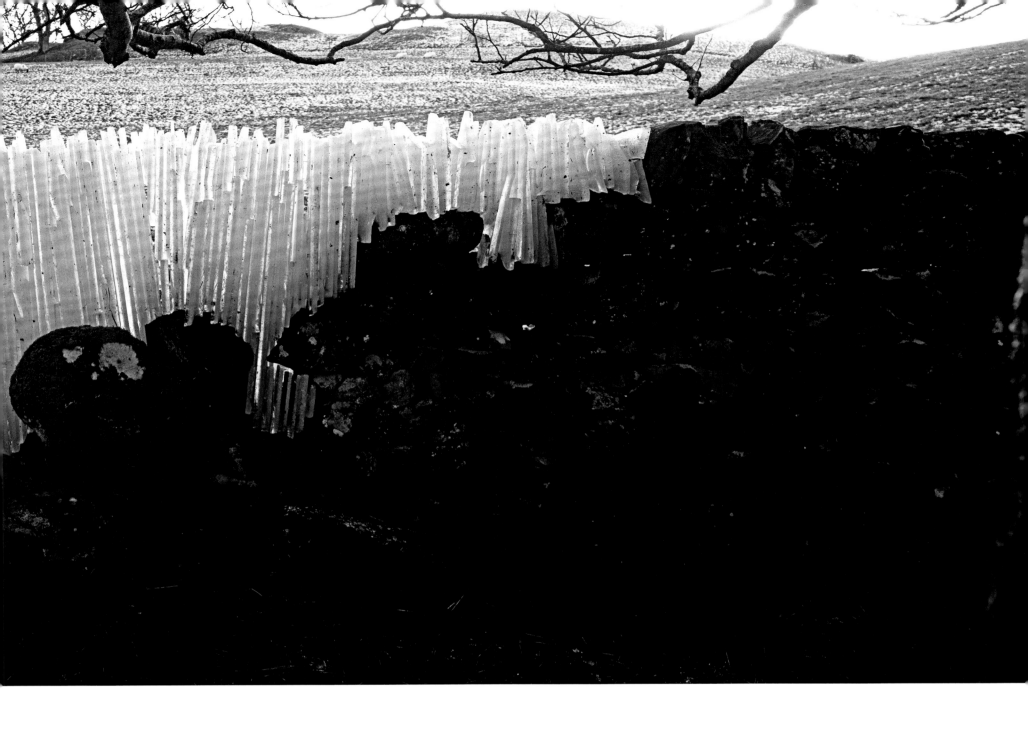

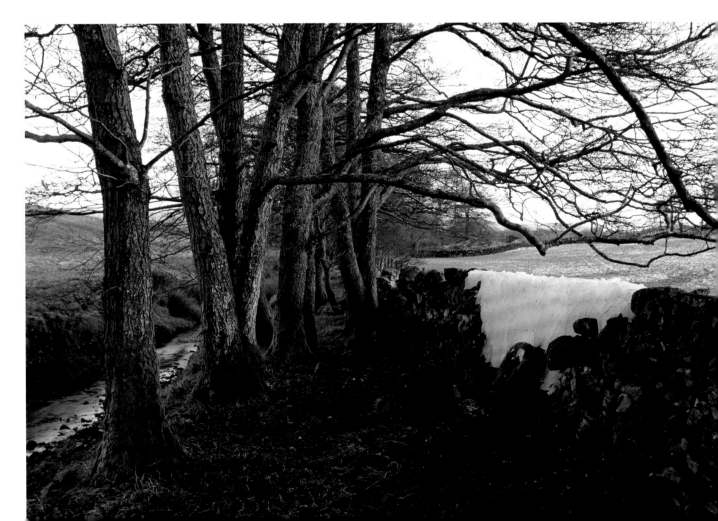

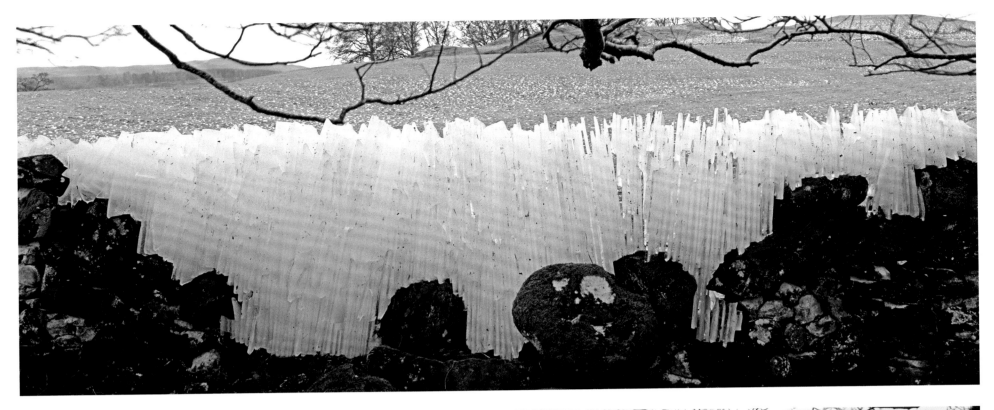

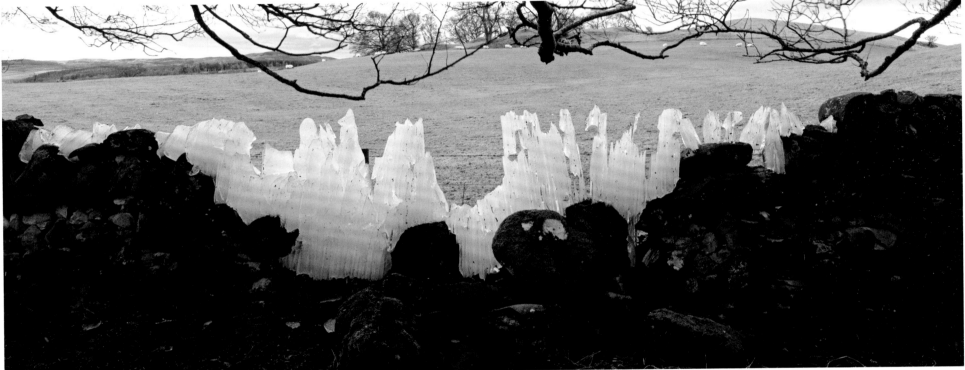

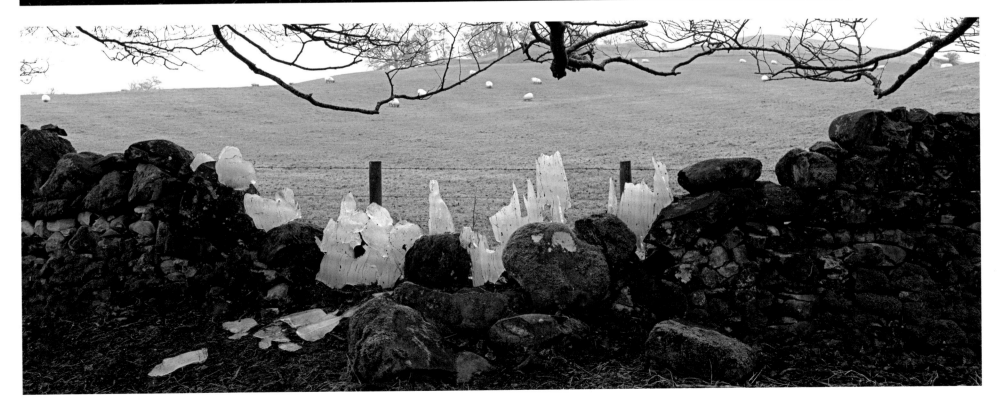

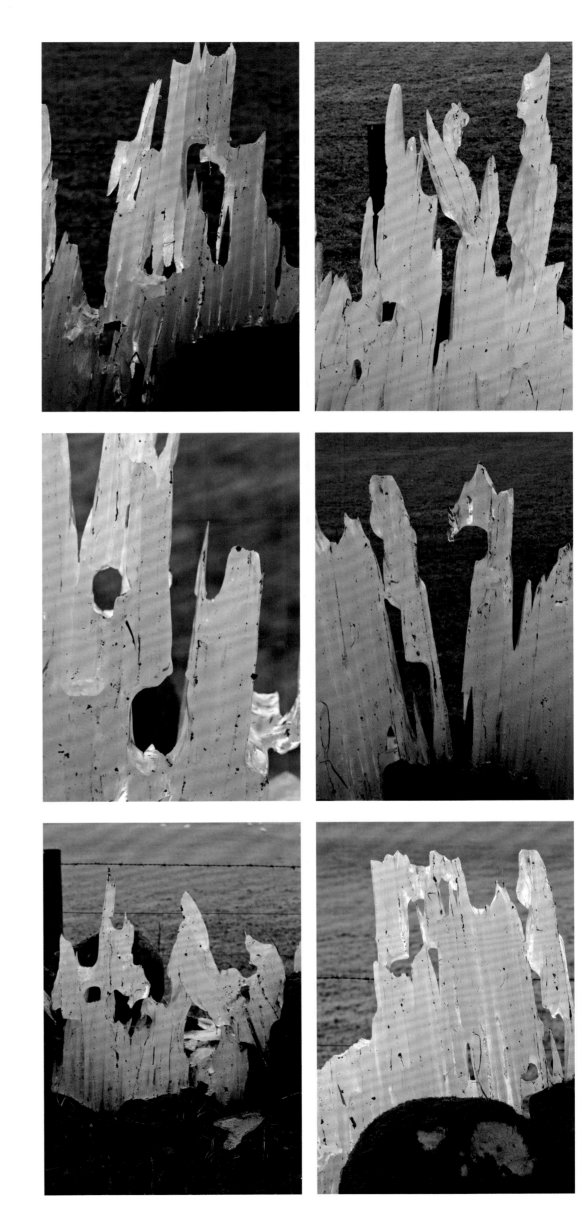

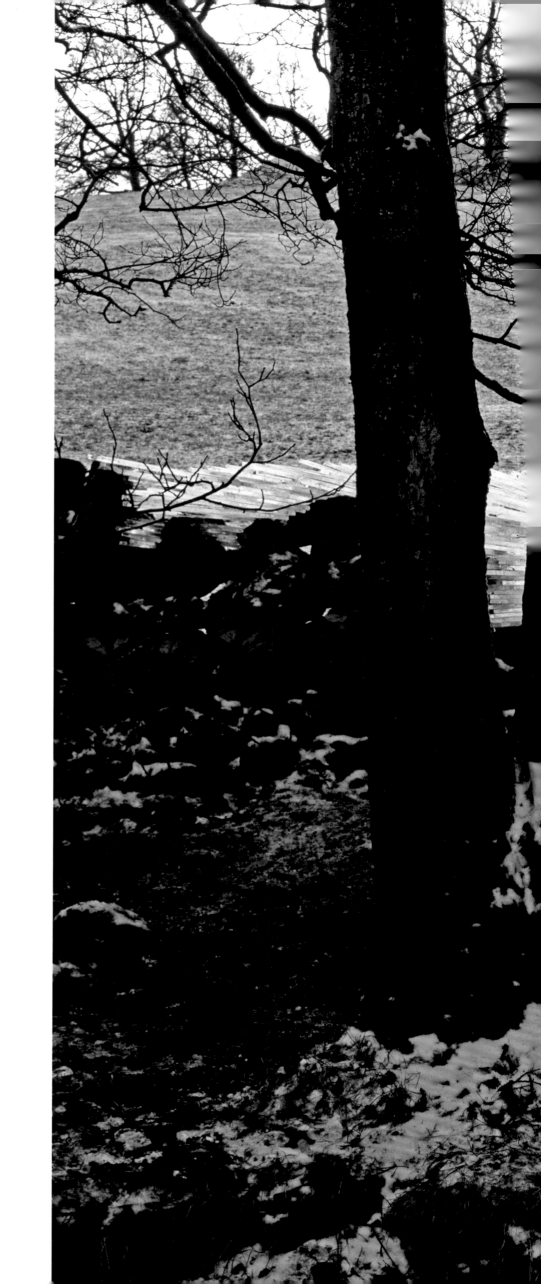

ICE WALL. MADE OVER TWO DAYS. OCCASIONALLY BECOMING WARMER. AT TIMES, UNABLE TO FREEZE
ICE TO ICE. ALMOST FAILED. DUMFRIESSHIRE, SCOTLAND. 12 DECEMBER 2012

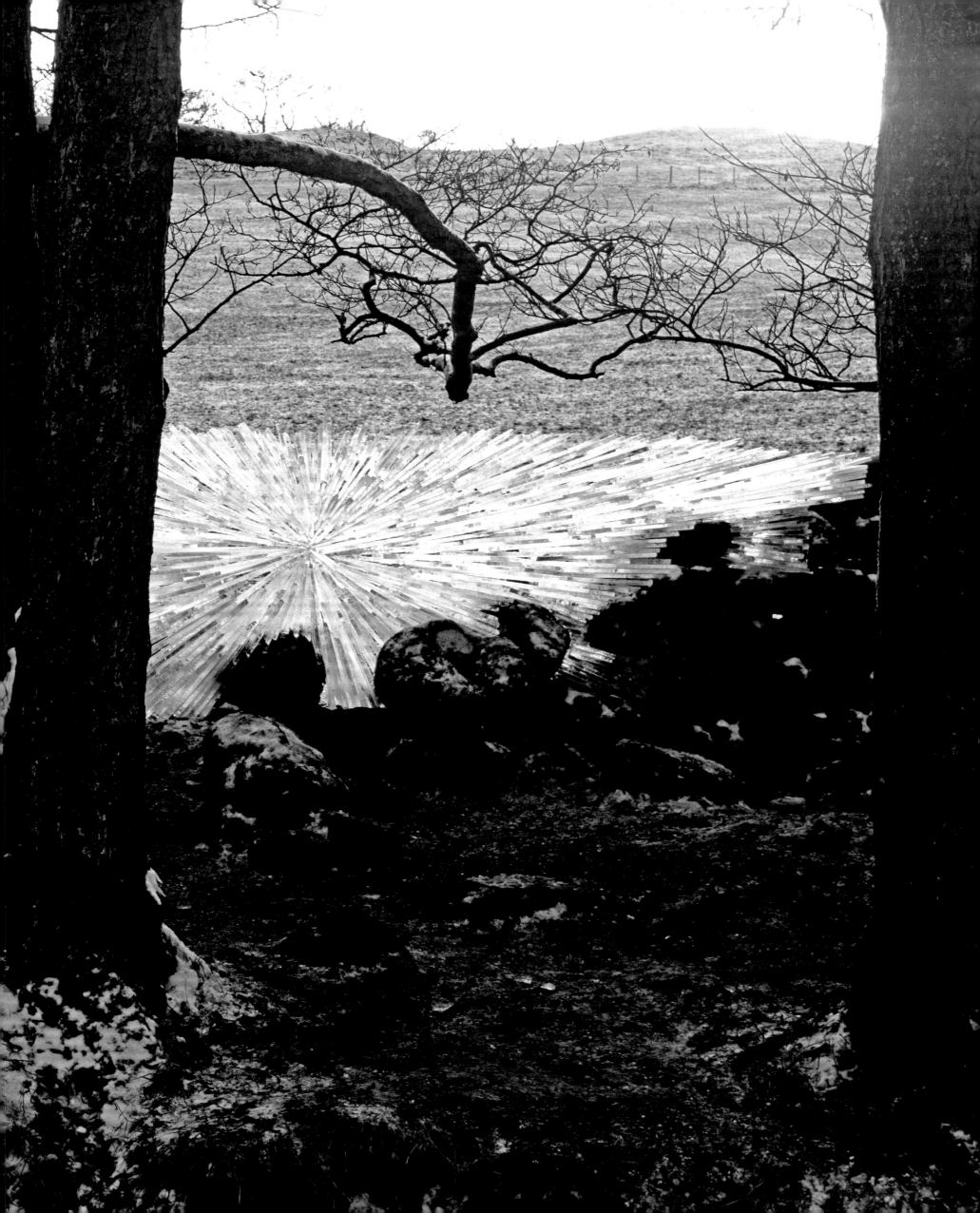

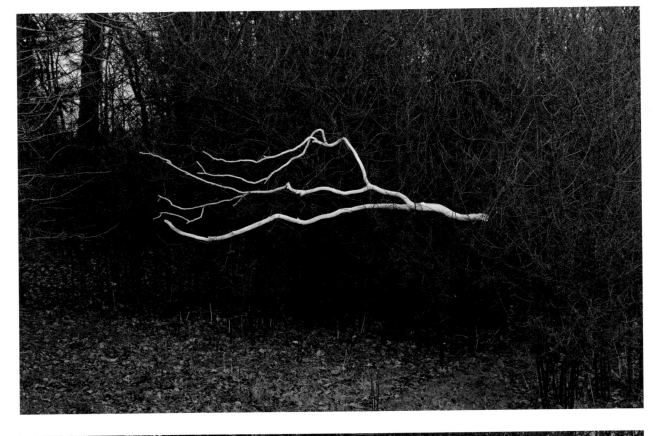

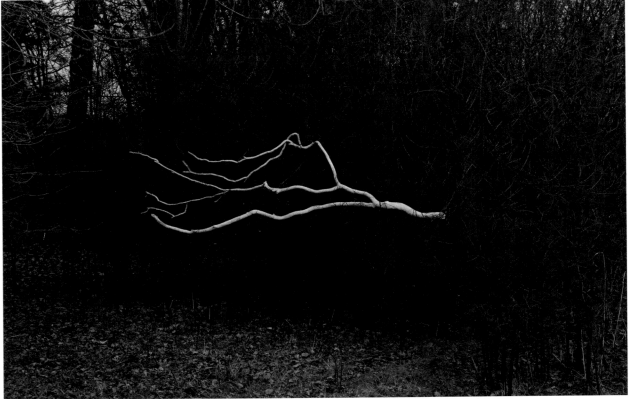

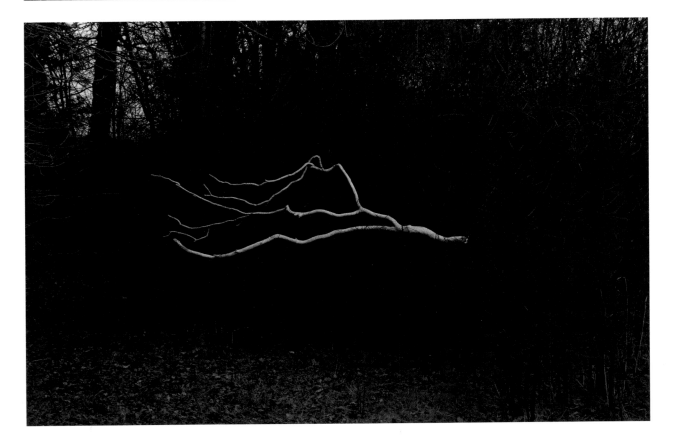

WINDFALLEN BEECH BRANCH. SCRAPED OFF BARK.
RUBBED WITH CHALK COLLECTED FROM NEARBY
BADGER SETT. PLACED IN A BLACKTHORN THICKET.
FROM DUSK TO DARK. BERRYDOWN FOUNDATION,
HAMPSHIRE. 5 FEBRUARY 2013

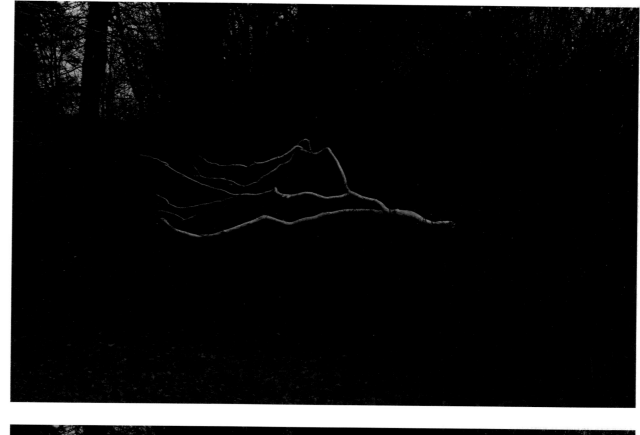

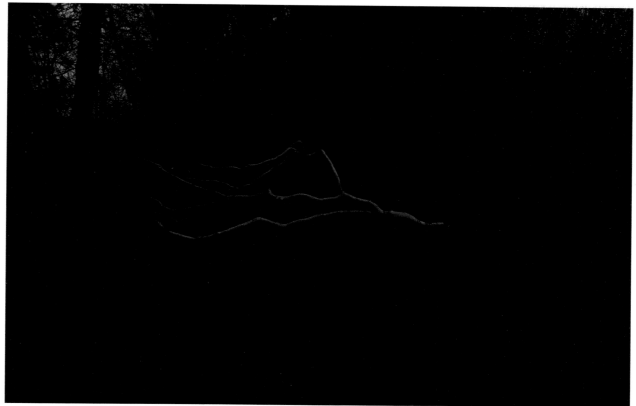

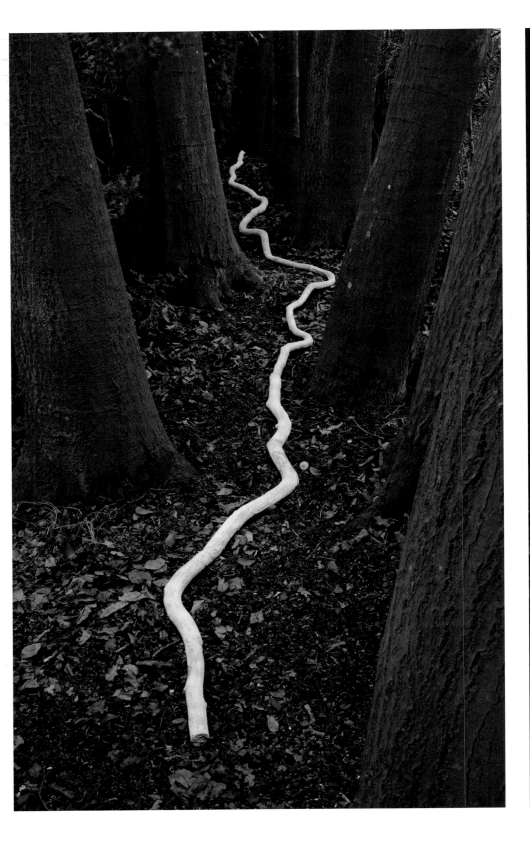
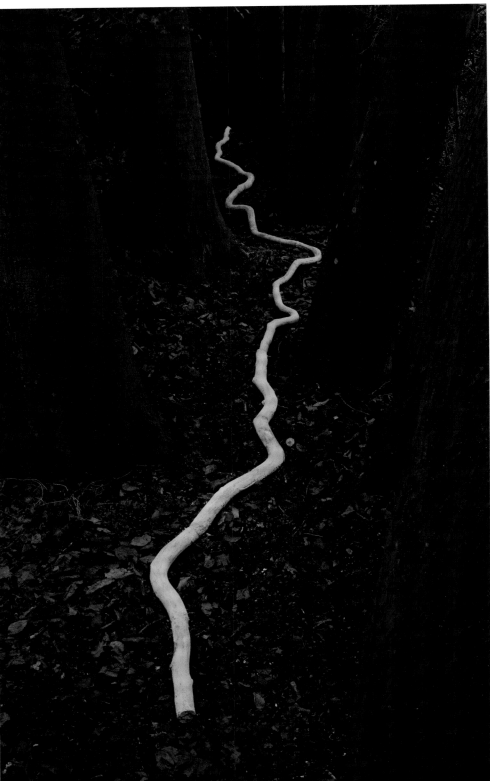

BEECH BRANCHES. RUBBED WITH CHALK. LAID END TO END. JOINTS FILLED WITH CRUSHED CHALK TO MAKE LINE BETWEEN BEECH TREES. NIGHTFALL. BERRYDOWN FOUNDATION, HAMPSHIRE. 7 FEBRUARY 2013

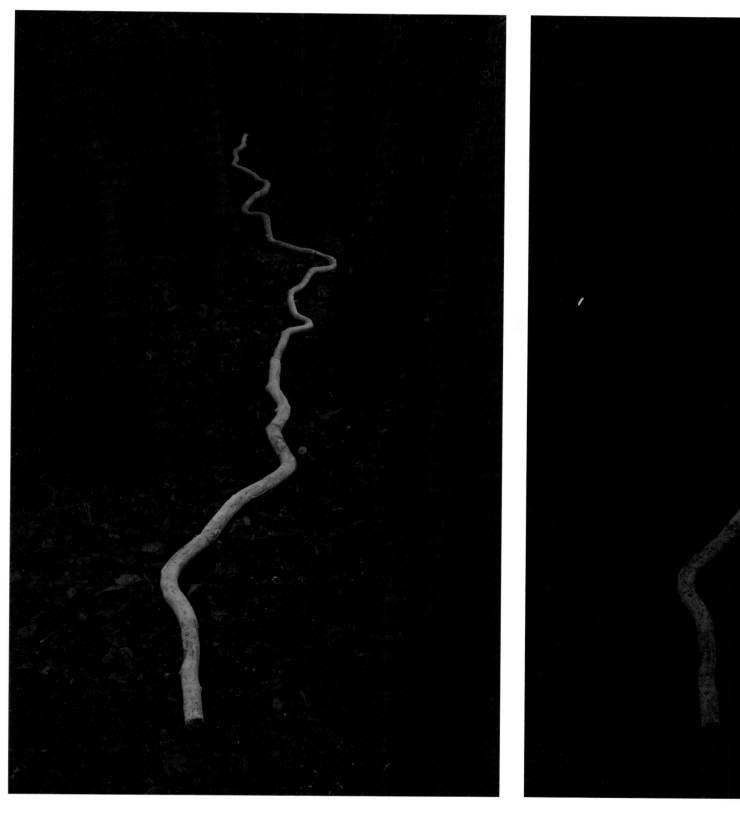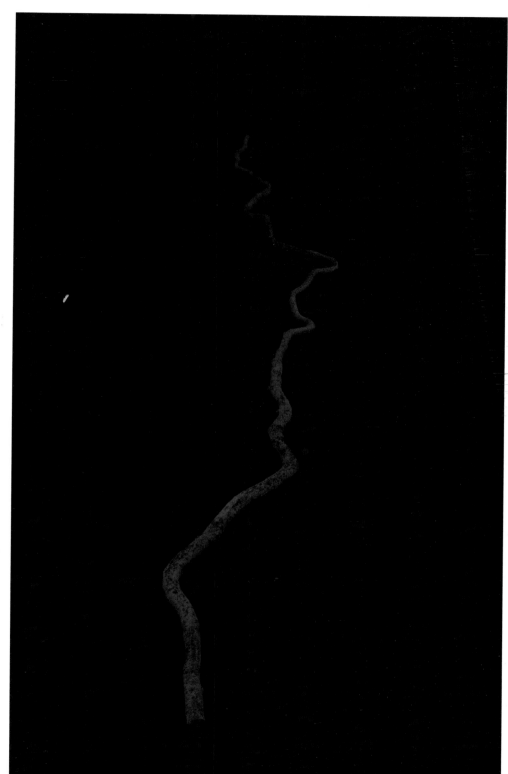

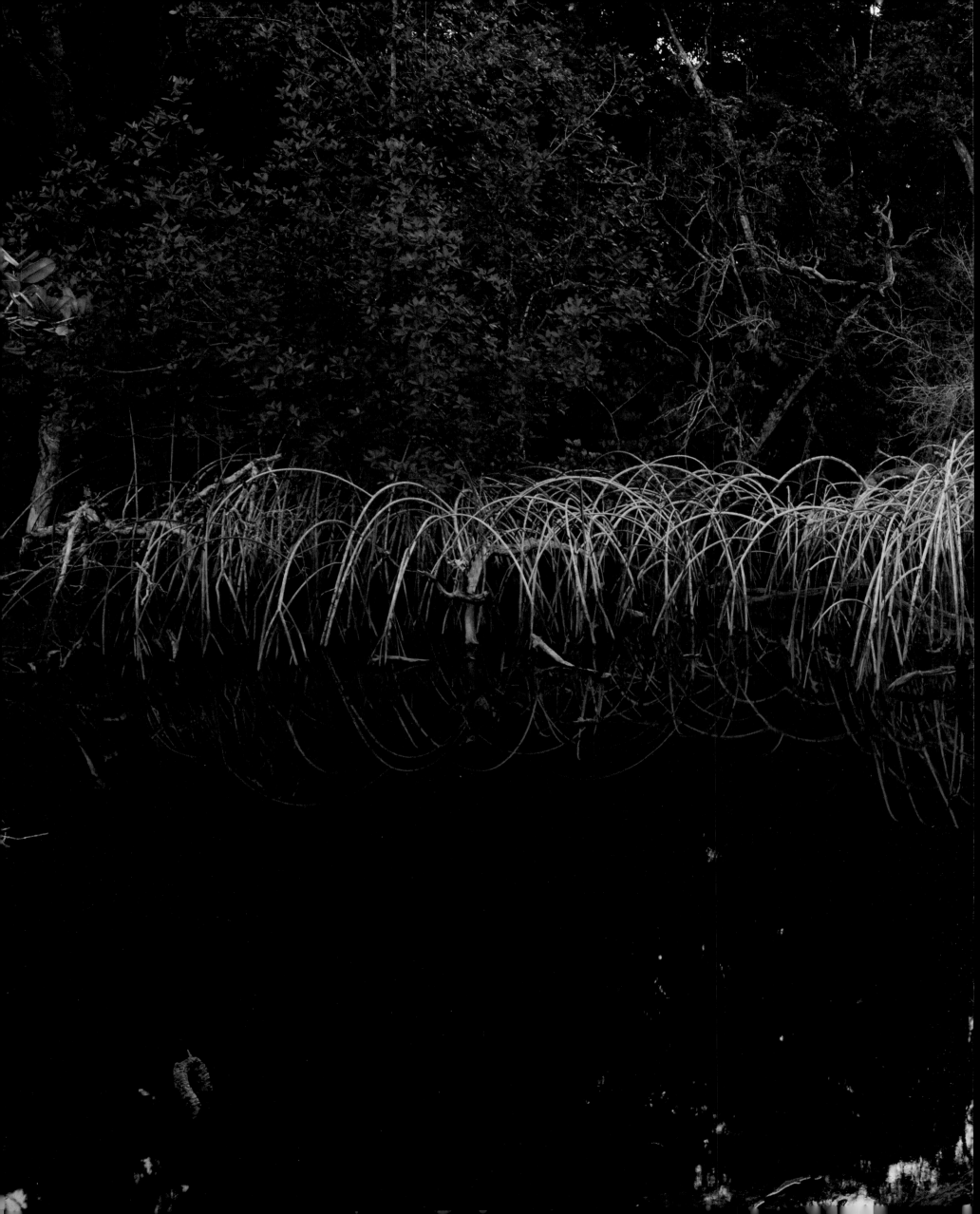

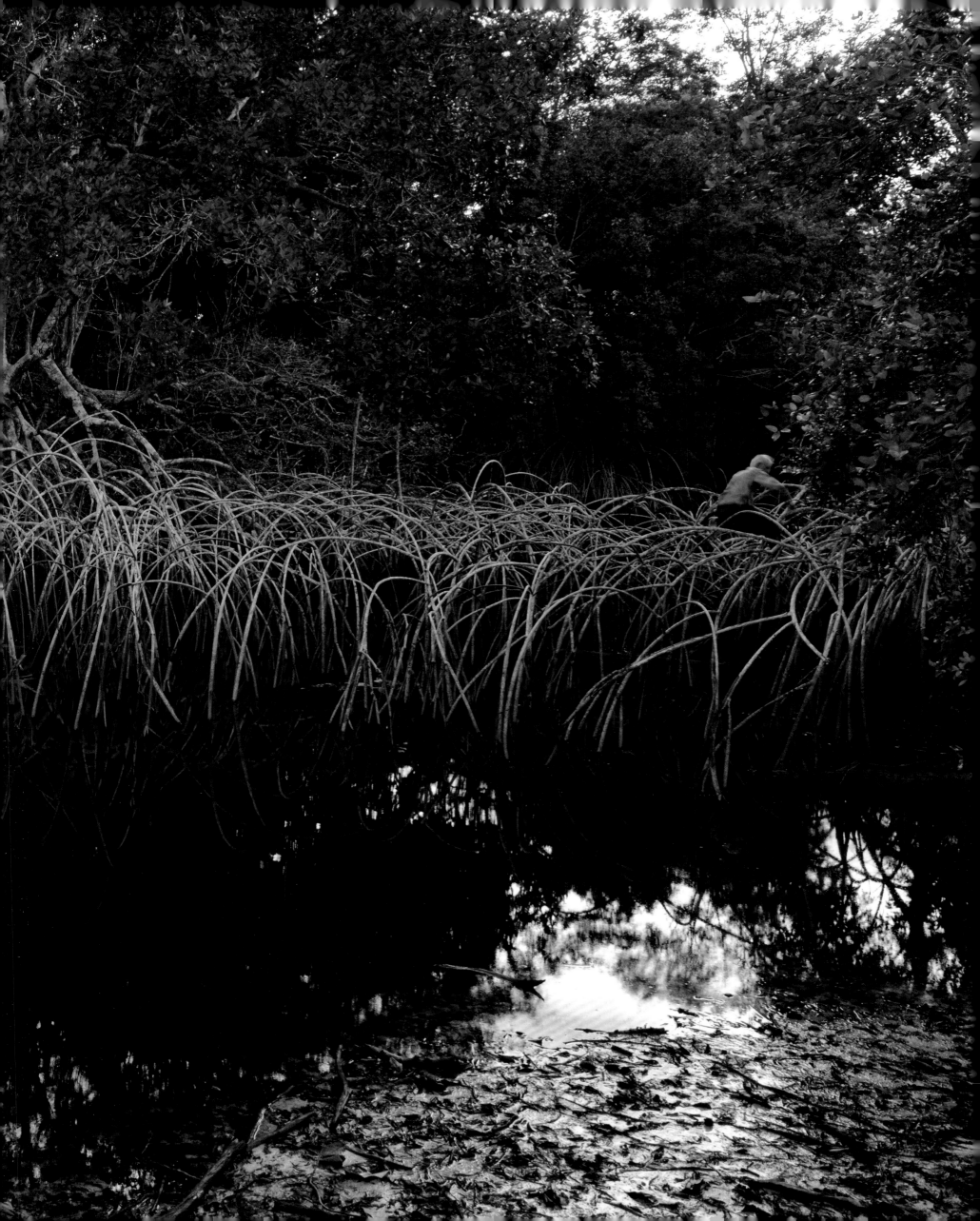

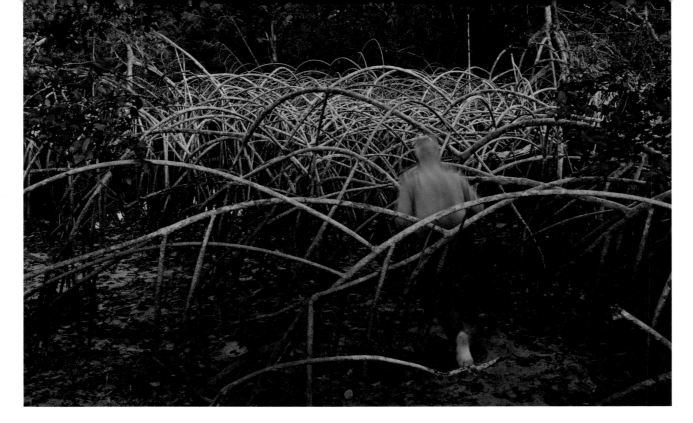

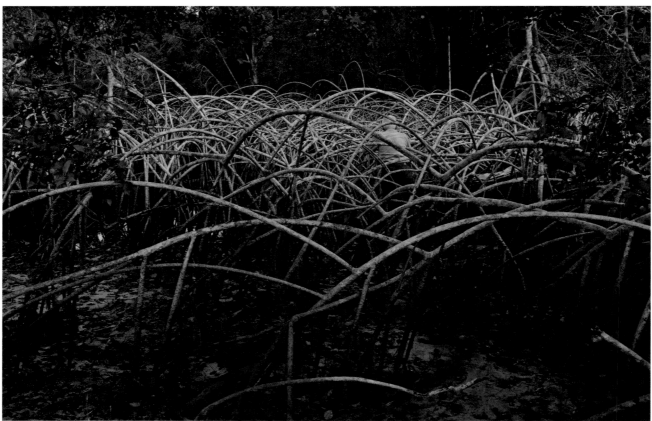

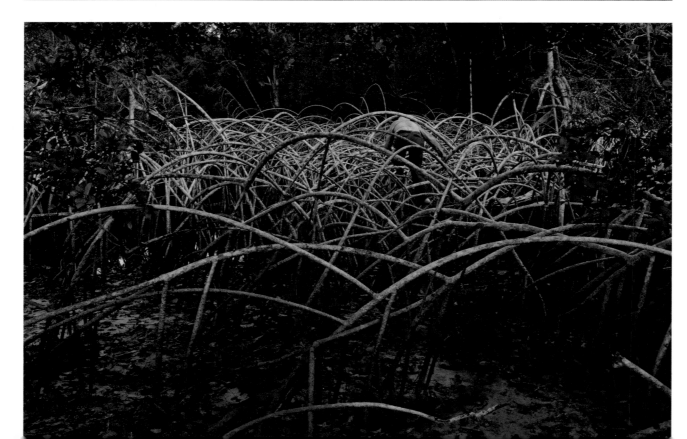

MANGROVE WALK.
PONGARA NATIONAL PARK, GABON.
16 APRIL 2013

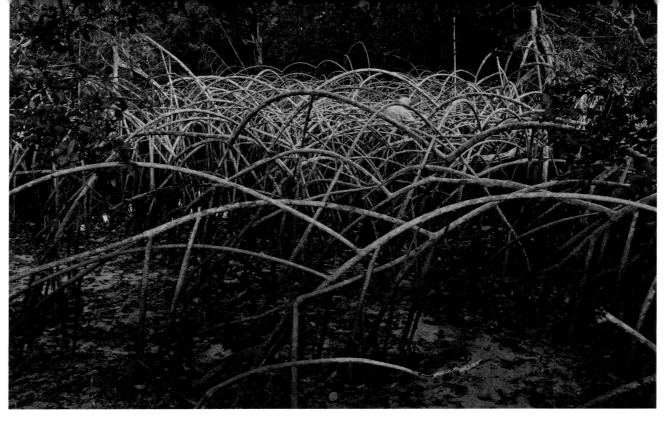

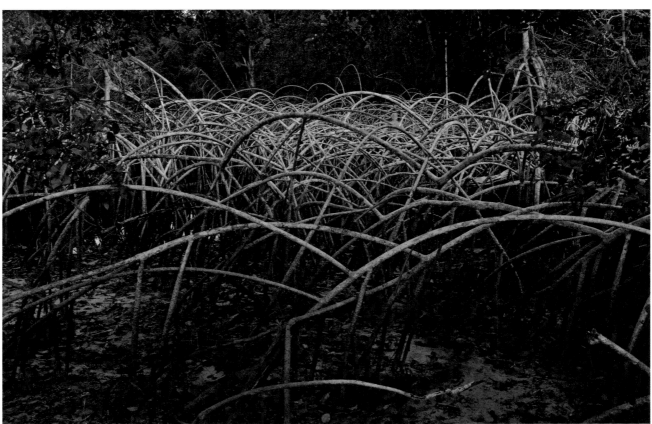

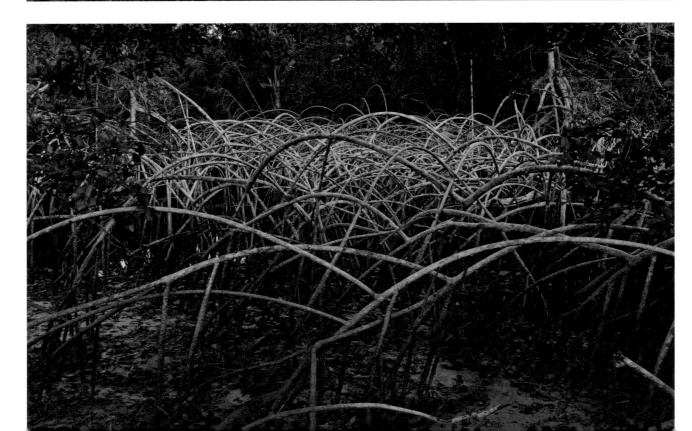

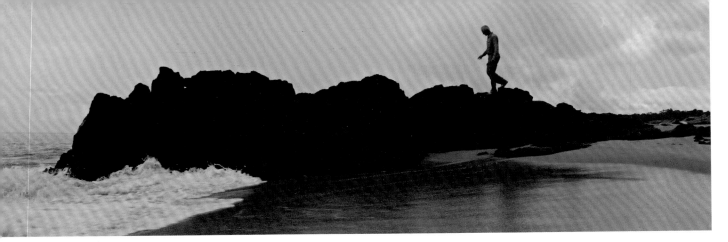

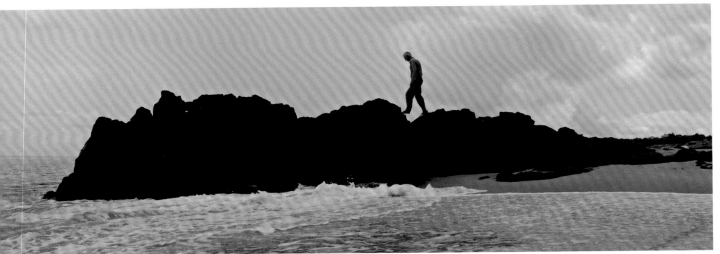

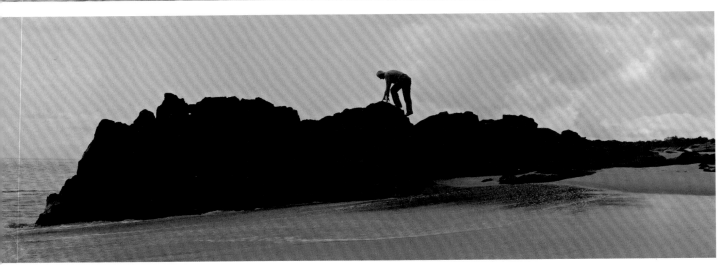

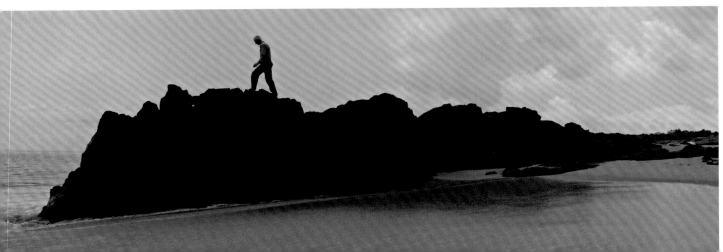

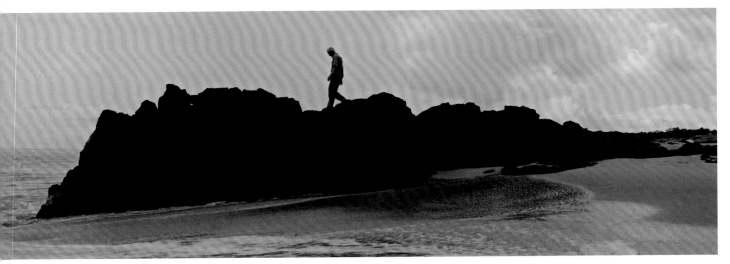

RIDGE LINE. PONGARA NATIONAL PARK, GABON.
17 APRIL 2013

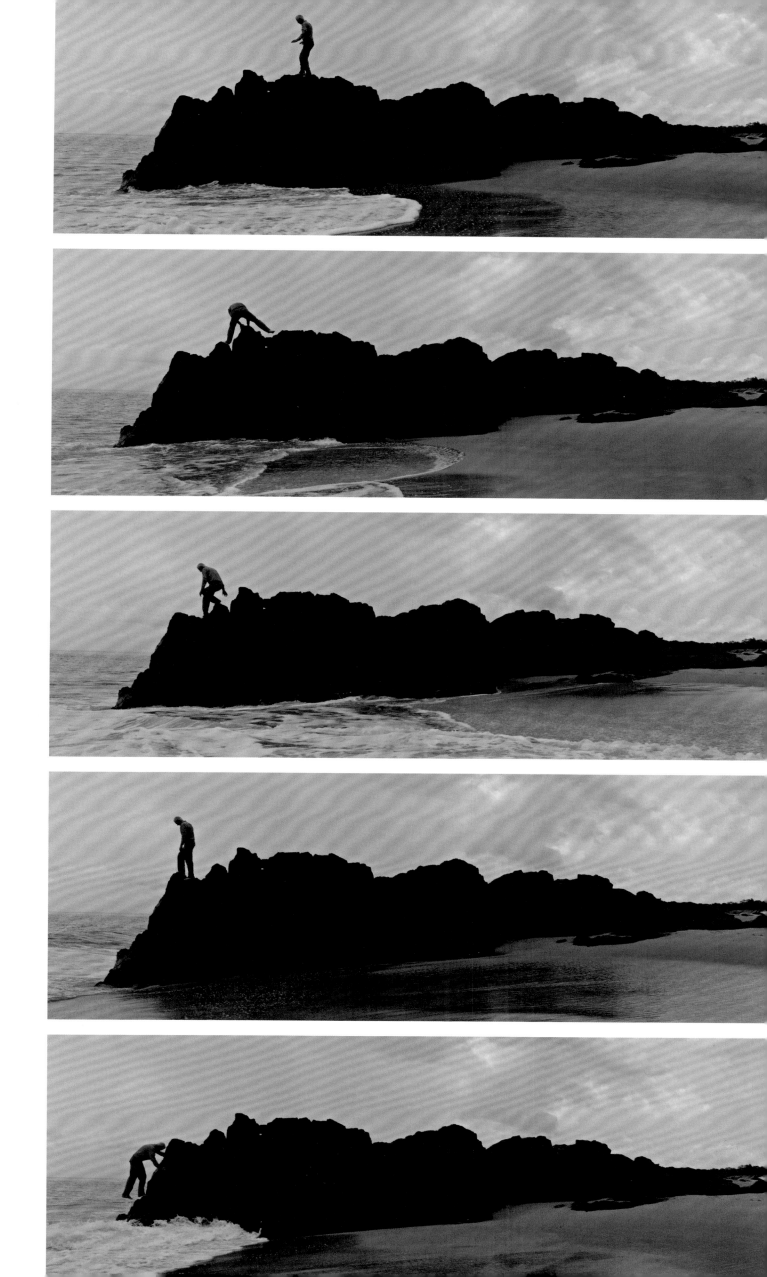

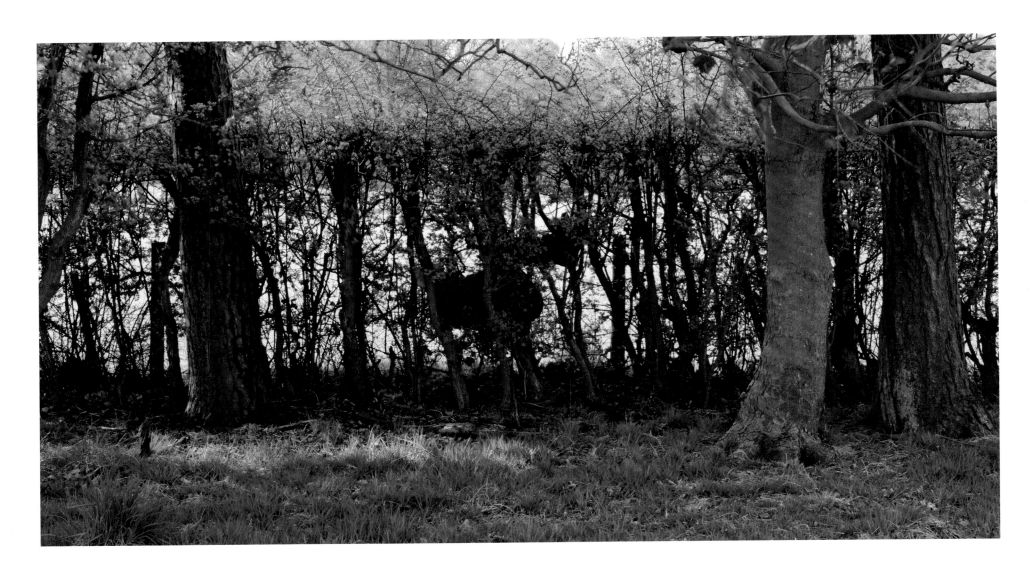

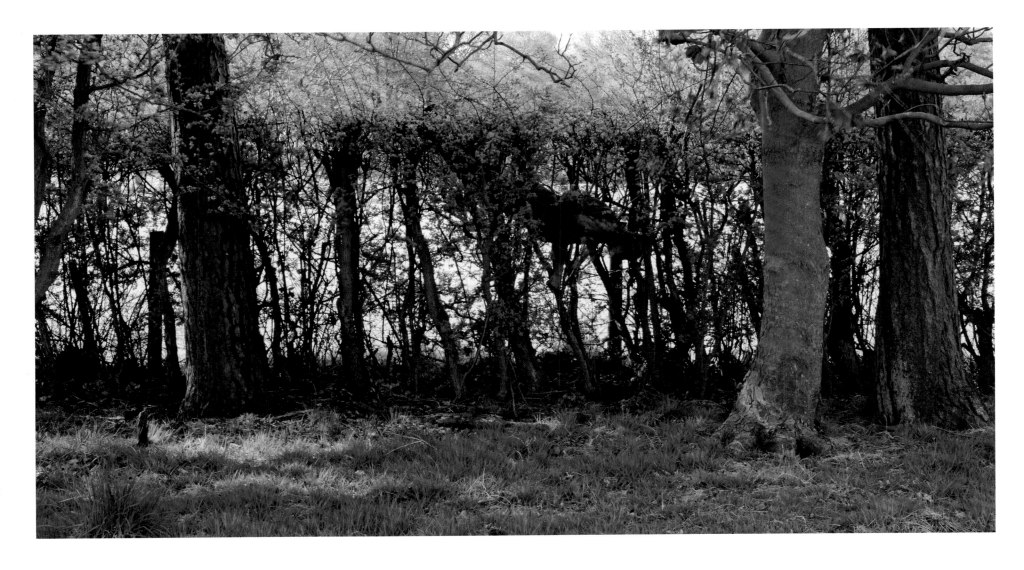

TURNING IN A HEDGE. BERRYDOWN FOUNDATION, HAMPSHIRE. 30 APRIL 2013

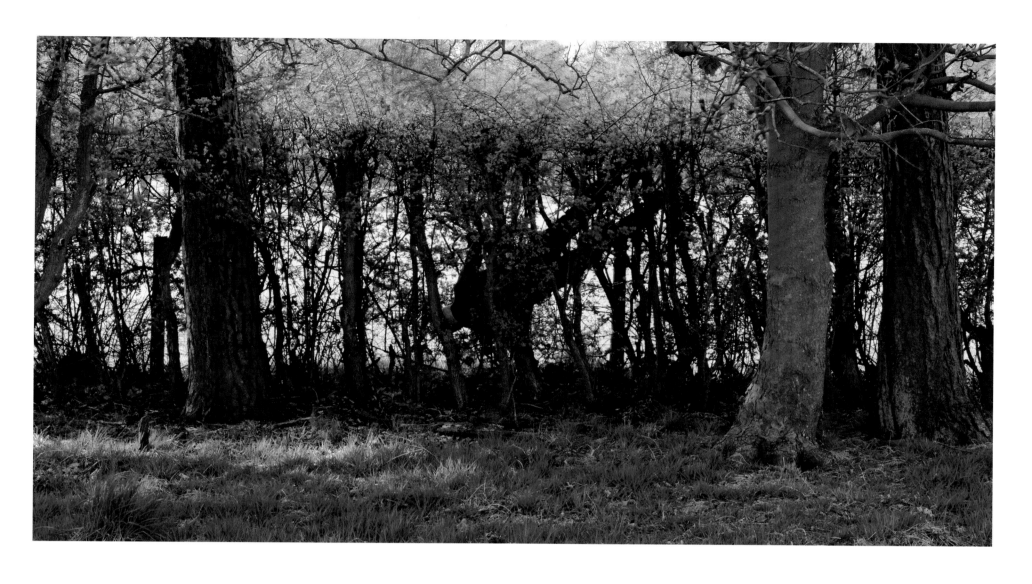

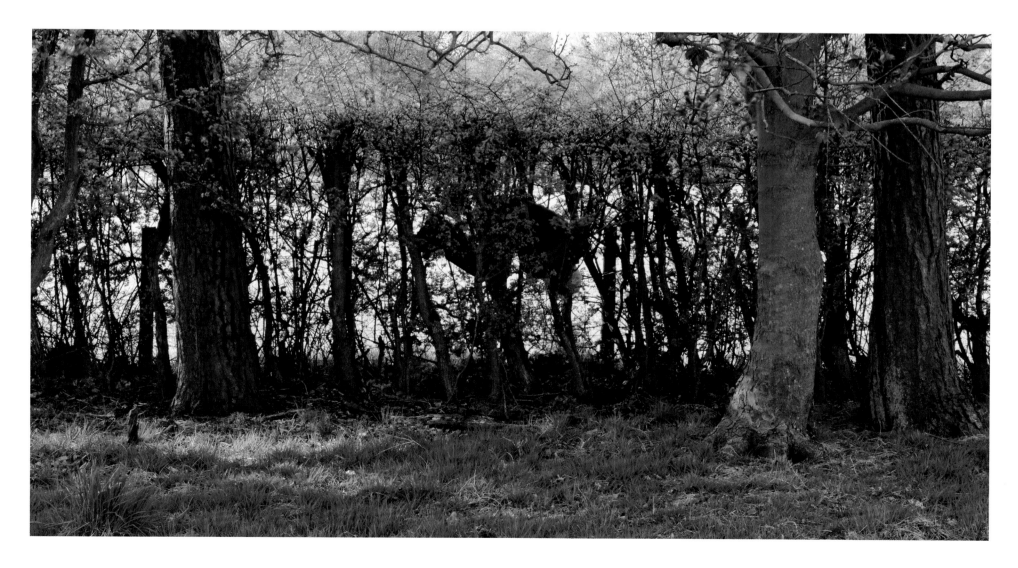

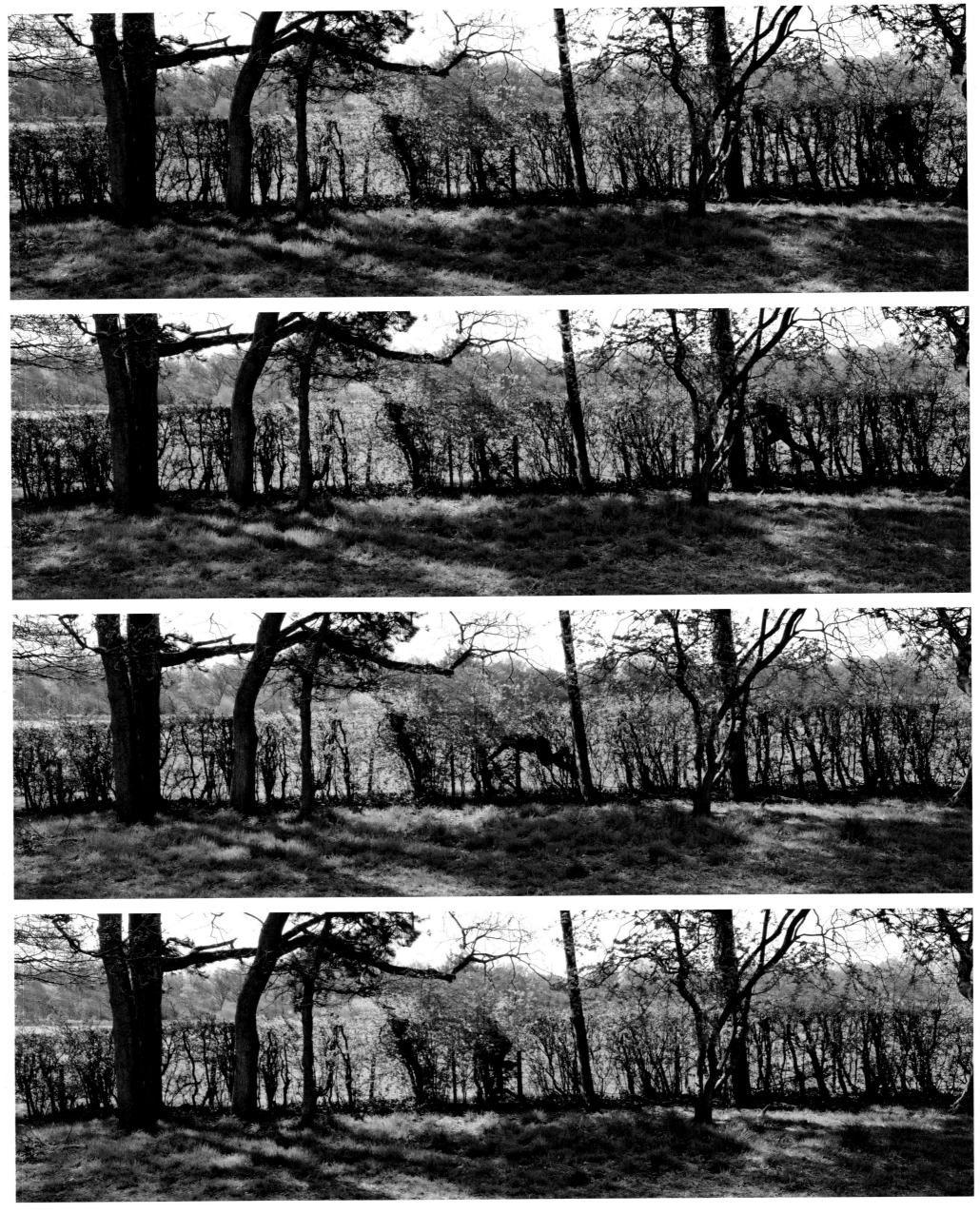

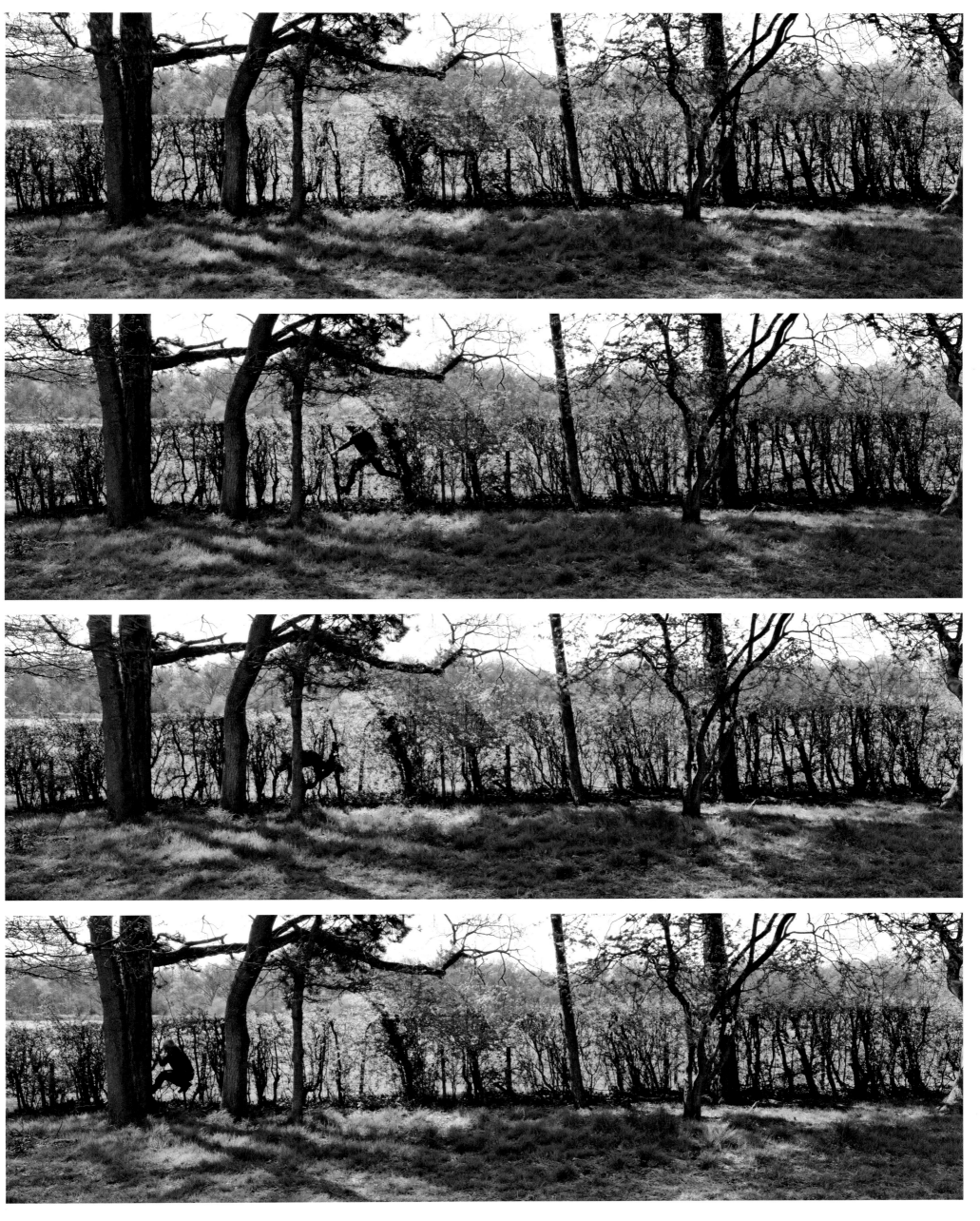

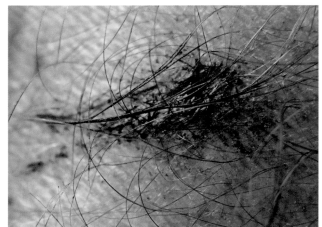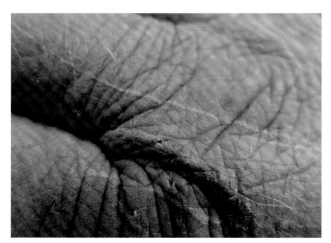

WALKING THROUGH A HAWTHORN HEDGE. BERRYDOWN FOUNDATION, HAMPSHIRE. 30 APRIL 2013

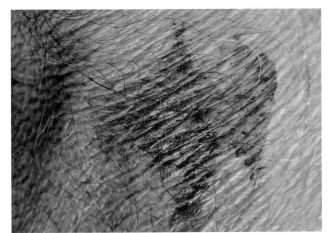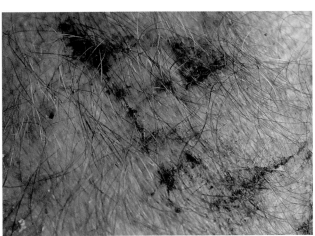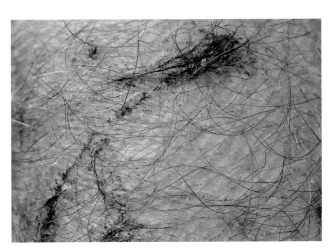

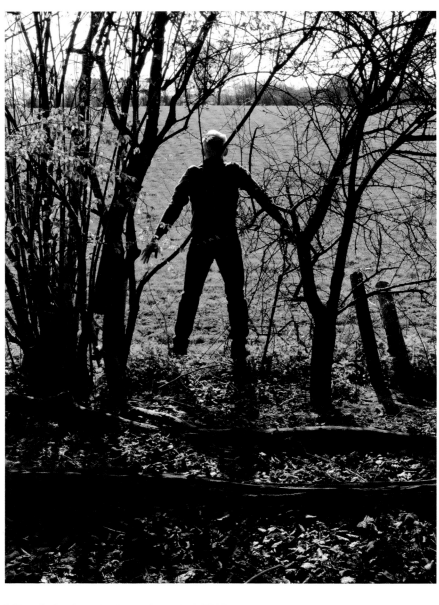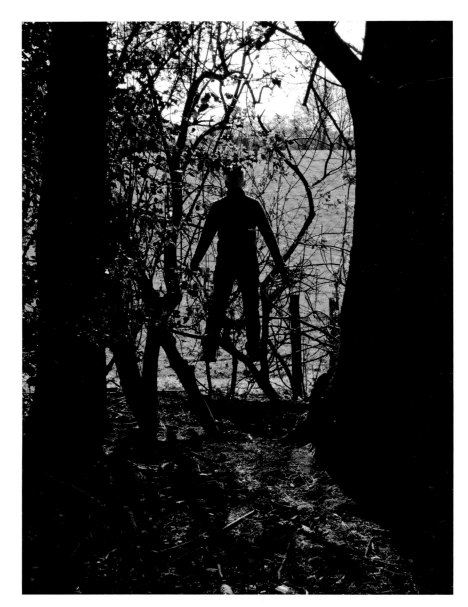

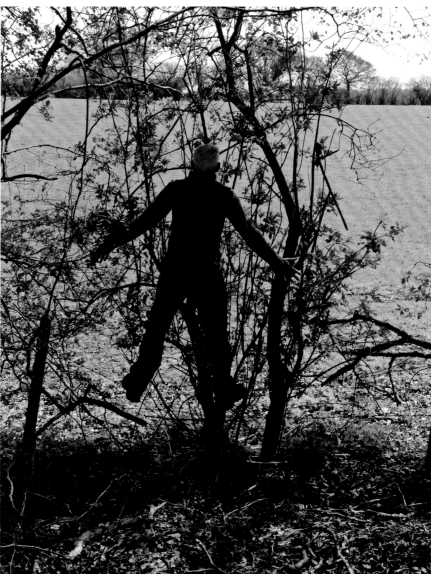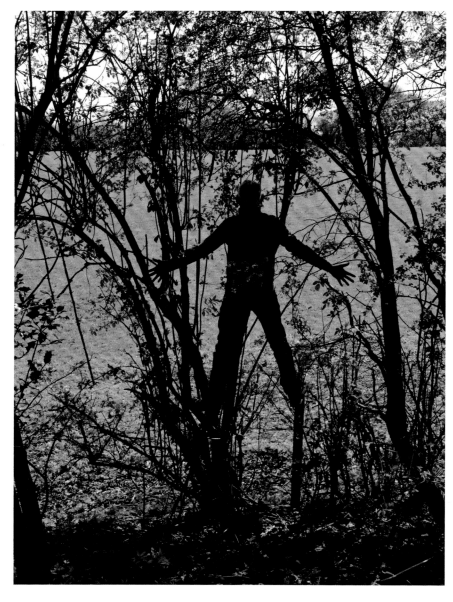

STOOD ASTRIDE BARBED WIRE AND BRANCHES ON BOUNDARY BETWEEN TWO PROPERTIES. BERRYDOWN FOUNDATION, HAMPSHIRE. 2 MAY 2013

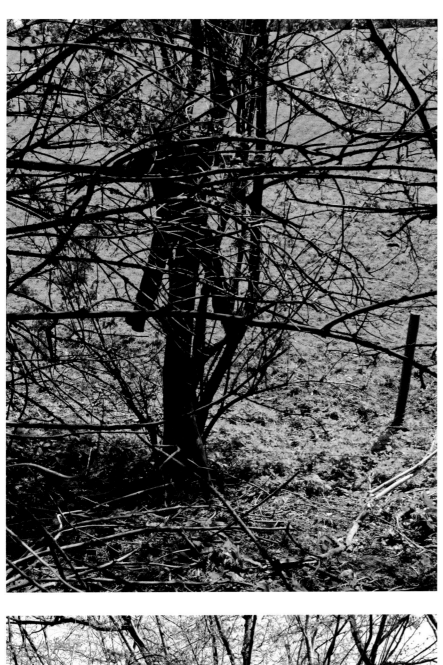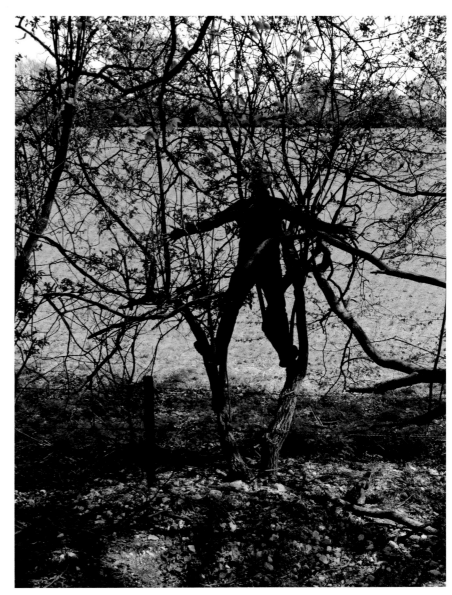
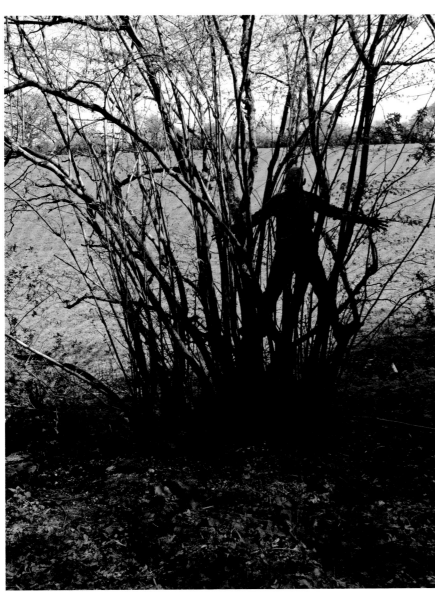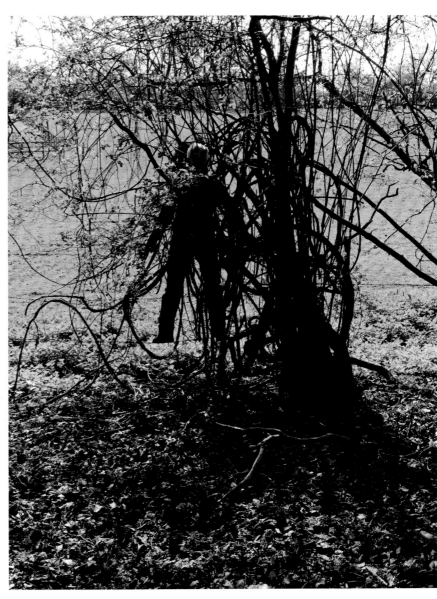

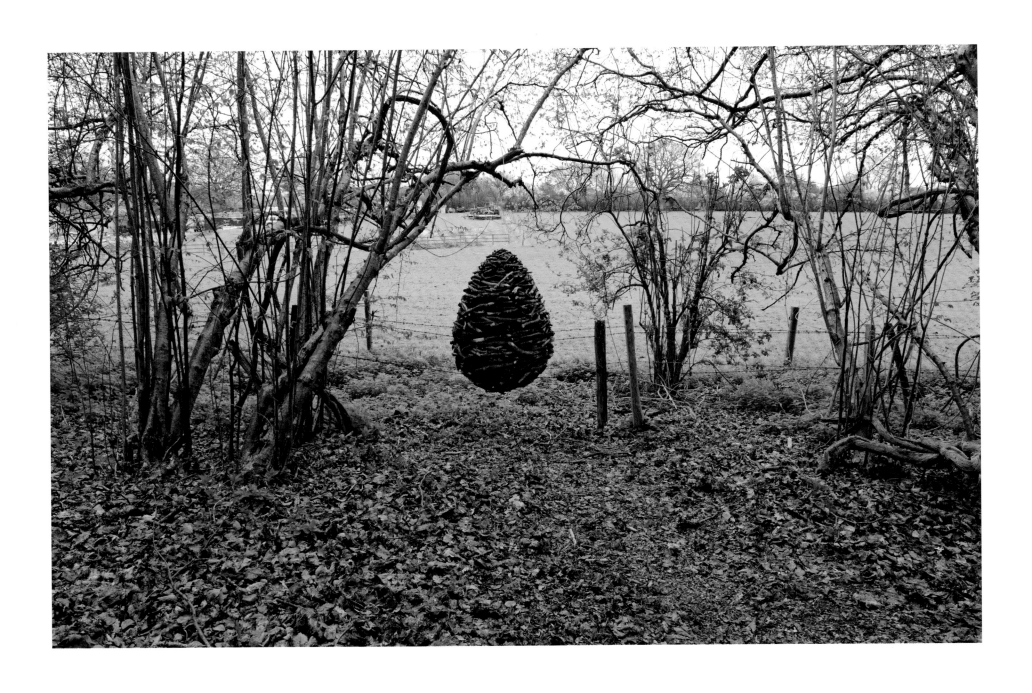

BRANCHES WRAPPED AND STACKED AROUND STRANDS OF A BARBED WIRE FENCE. LASTING ONLY A FEW MINUTES BEFORE TOPPLING OVER. BERRYDOWN FOUNDATION, HAMPSHIRE. 4 MAY 2013

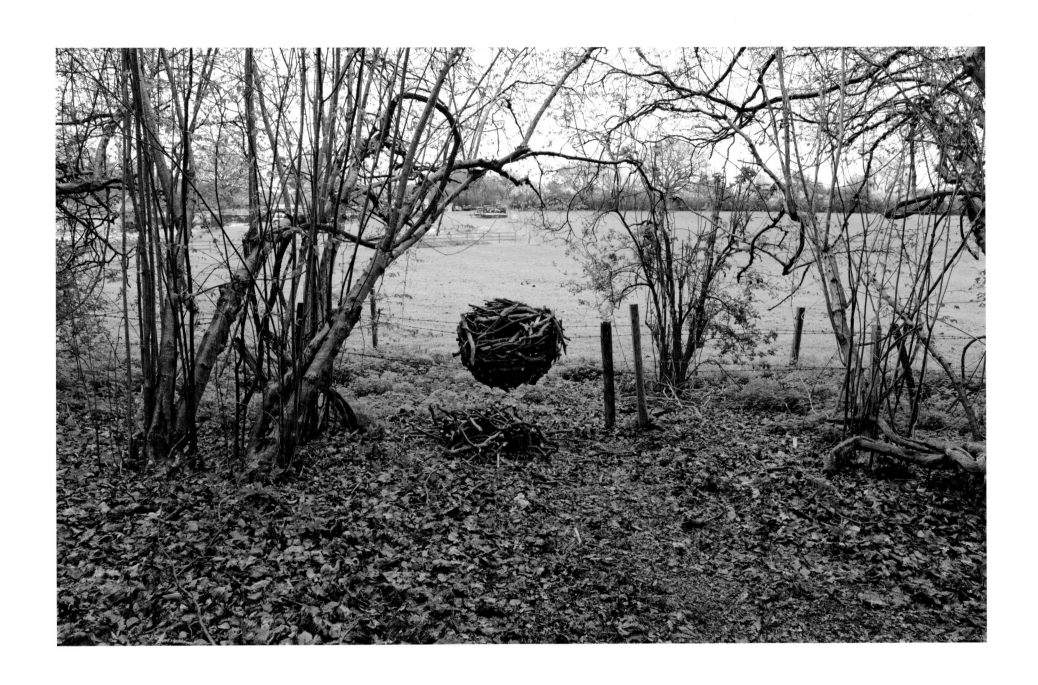

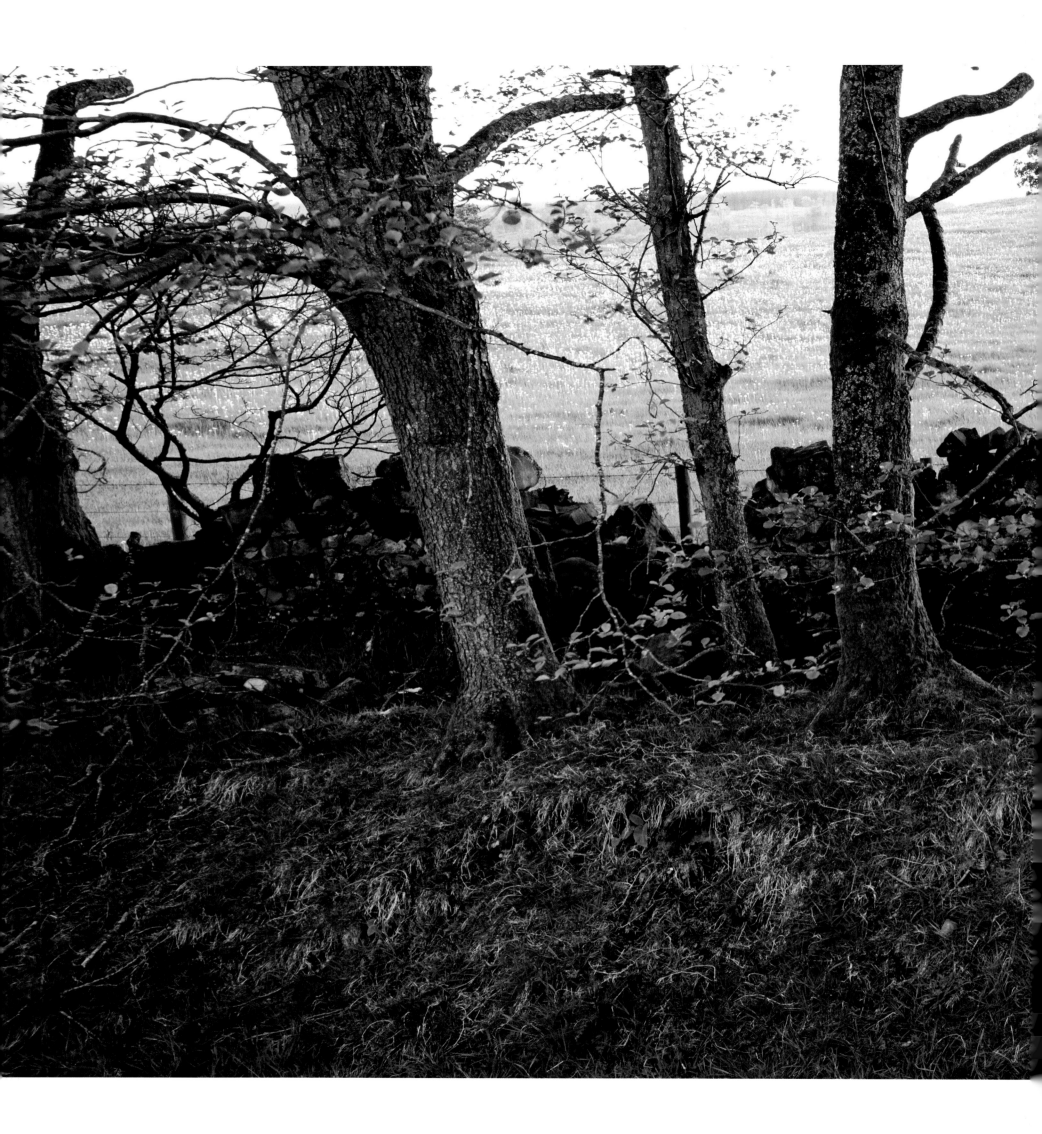

BROKEN SECTION OF WALL. FILLED WITH ALDER BRANCHES. LEAVING A SAWN GAP. DUMFRIESSHIRE, SCOTLAND. 6 JUNE 2013

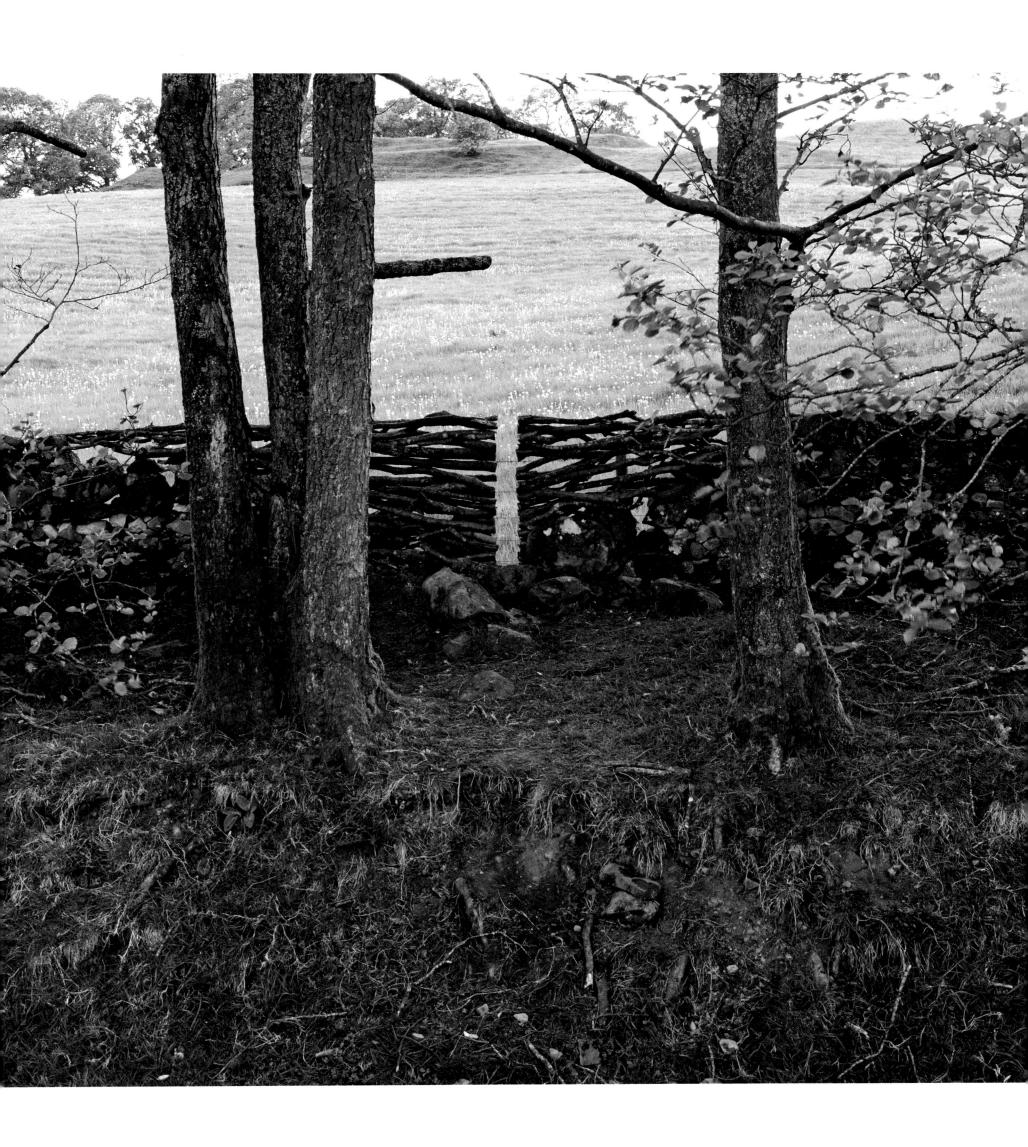

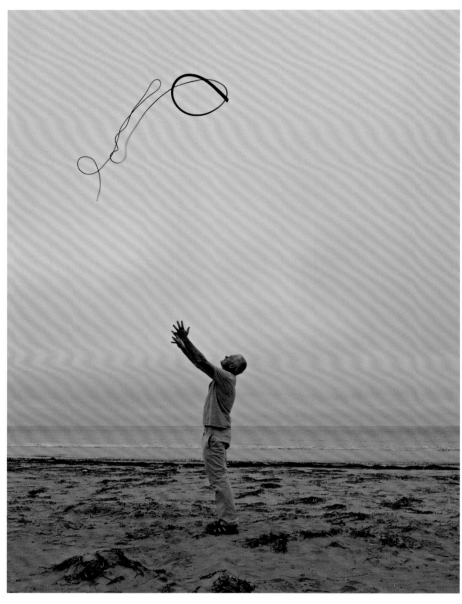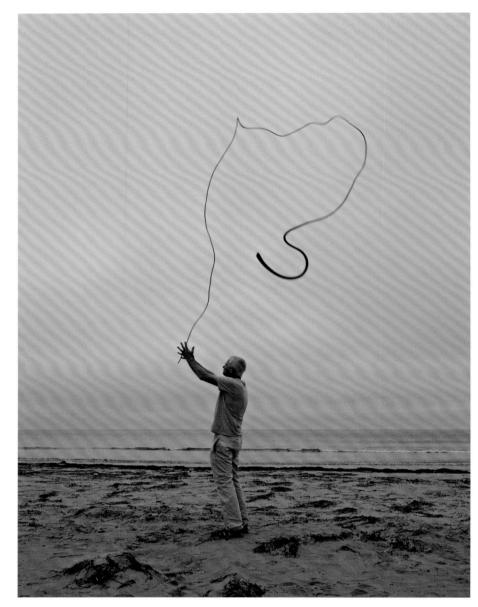
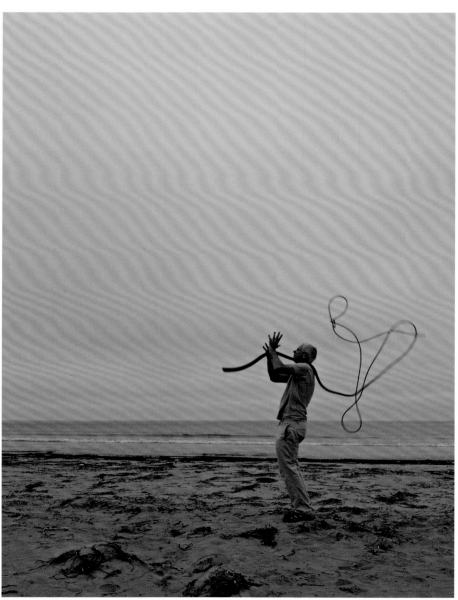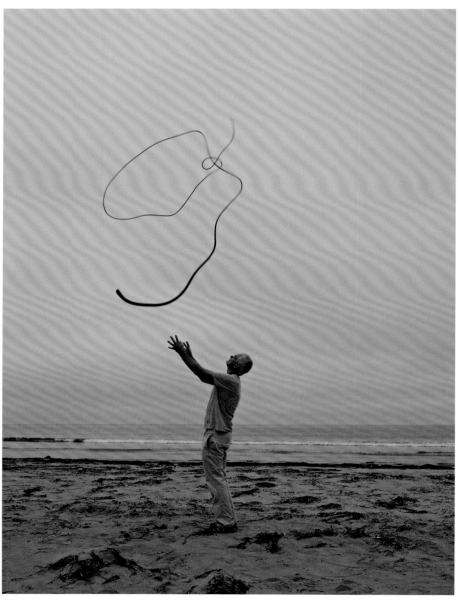

KELP THROWN INTO A GREY, OVERCAST SKY. DRAKES BEACH, CALIFORNIA. 14 JULY 2013

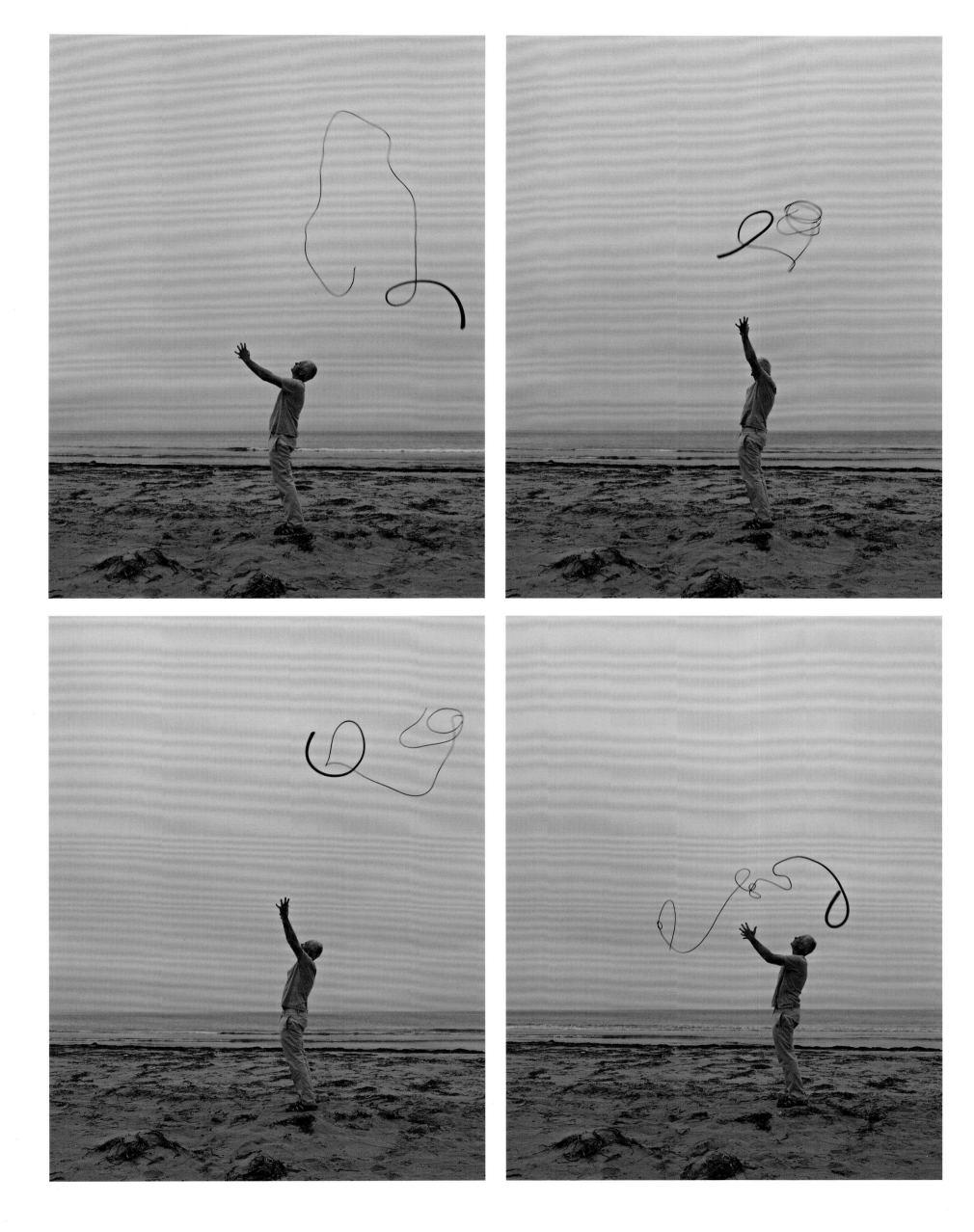

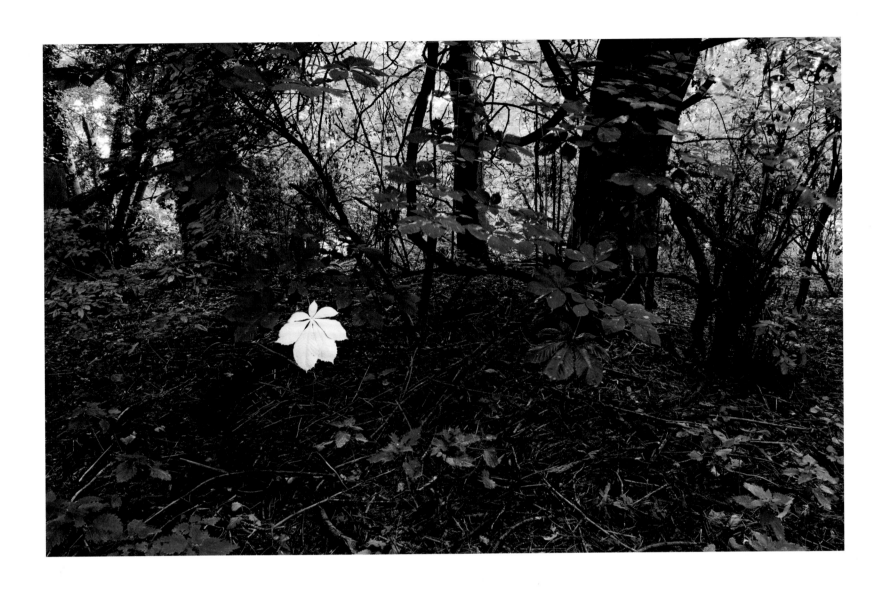

CHALK. DUSTED ON LEAF. DRAWN ON DEAD TREE. BERRYDOWN FOUNDATION, HAMPSHIRE. 29, 31 AUGUST 2013

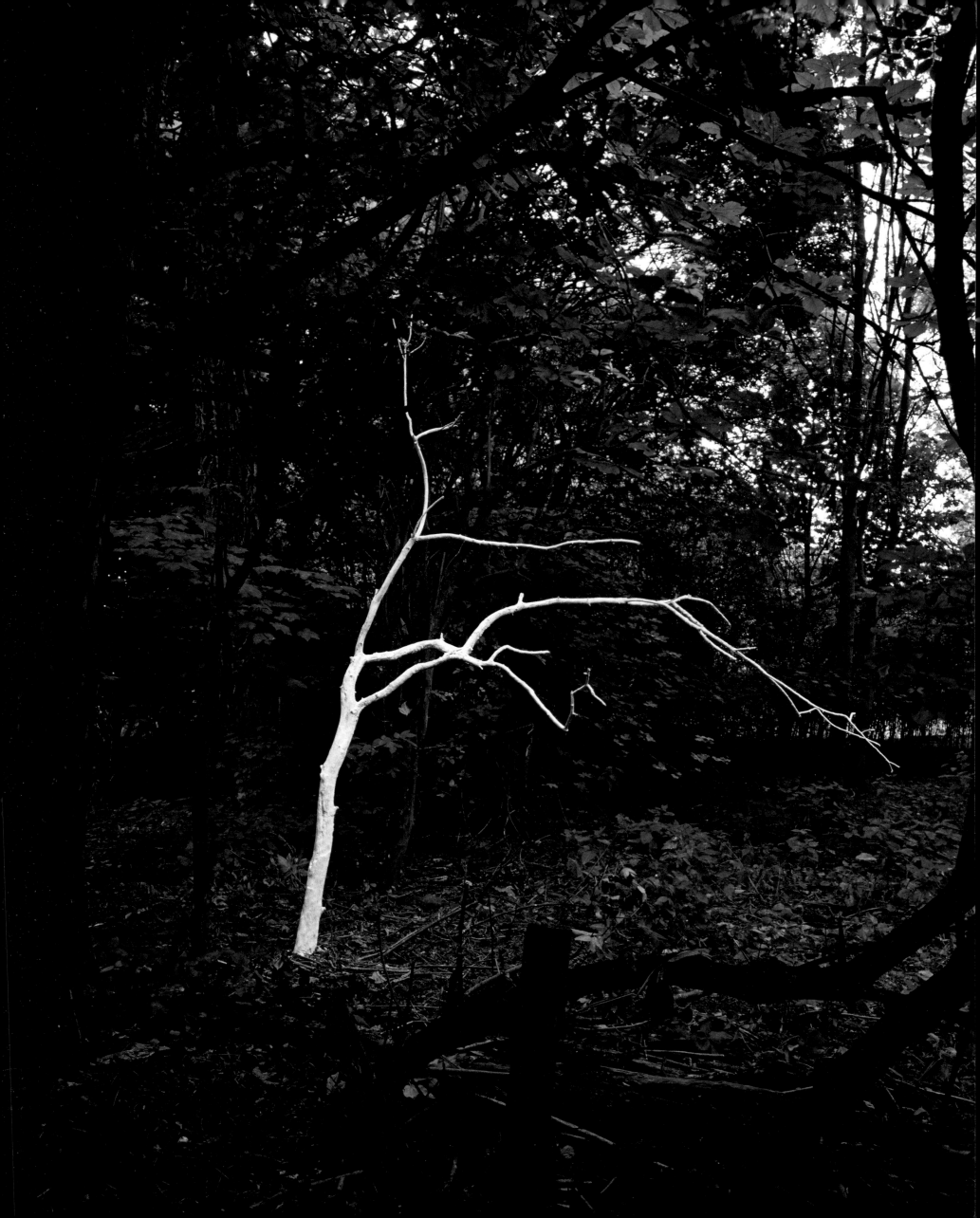

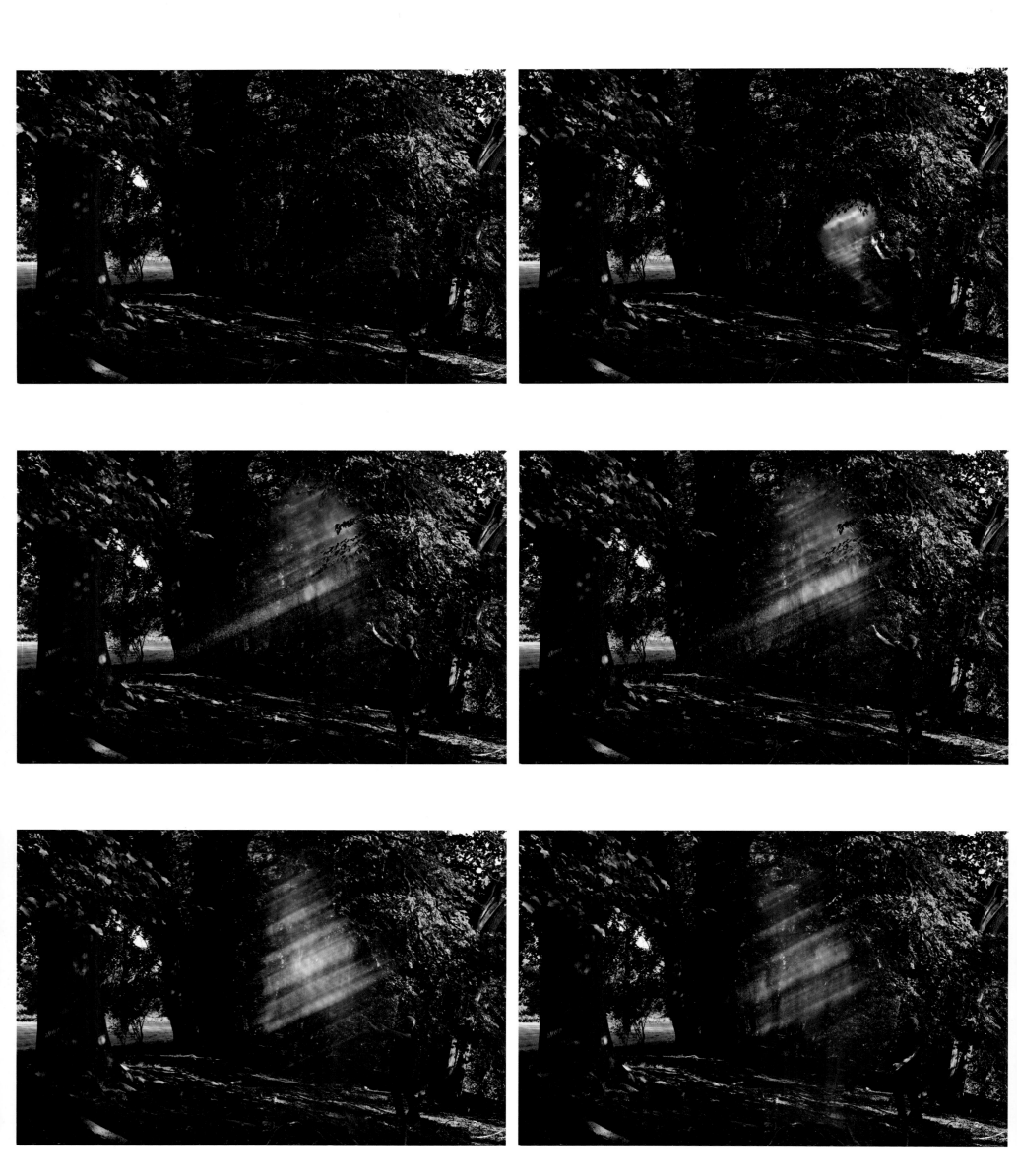

CHALKSTONE. CRUSHED INTO POWDER. THROWN INSIDE THE WOOD TO REVEAL SHAFTS OF LIGHT. BERRYDOWN FOUNDATION, HAMPSHIRE. 31 AUGUST 2013

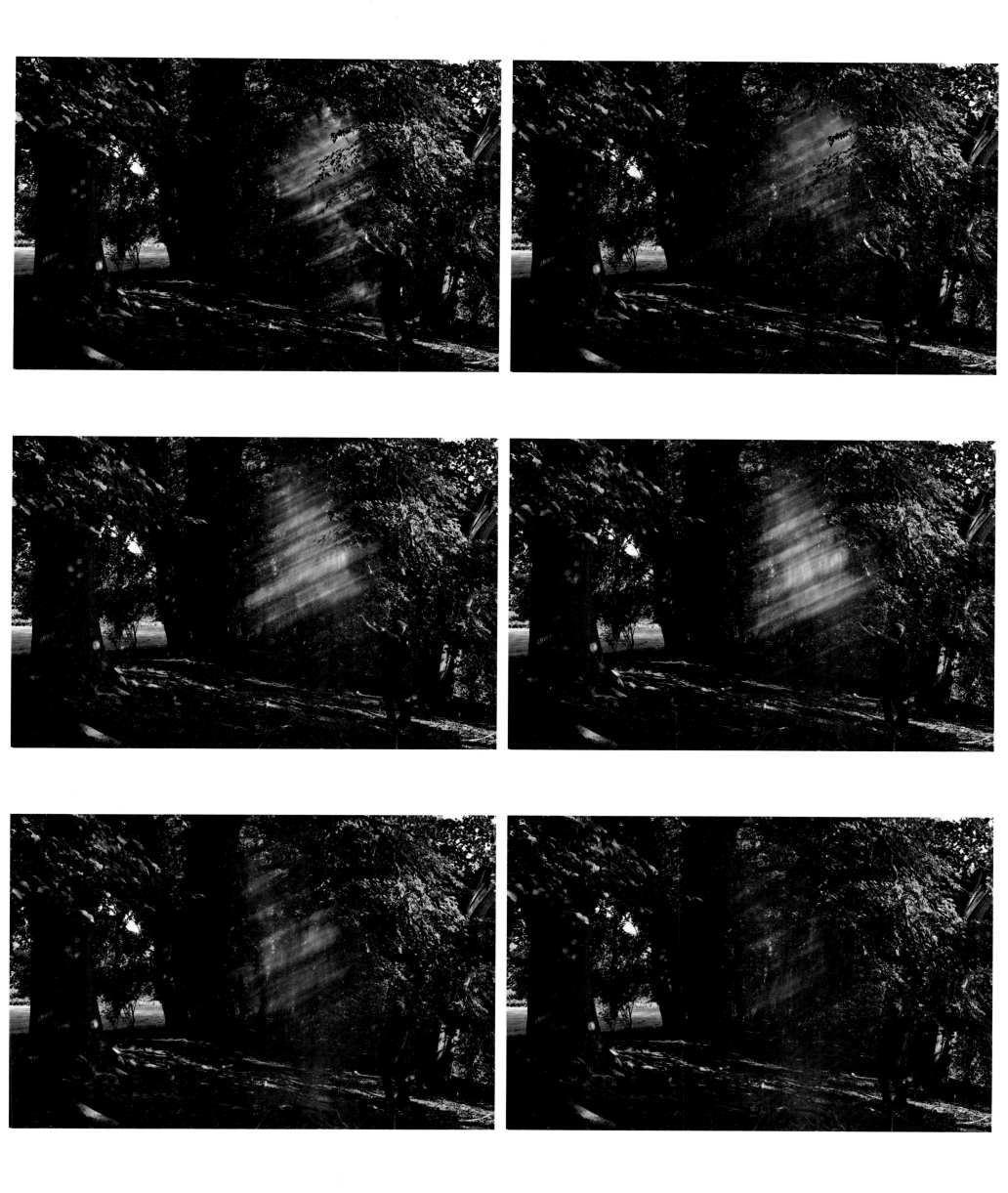

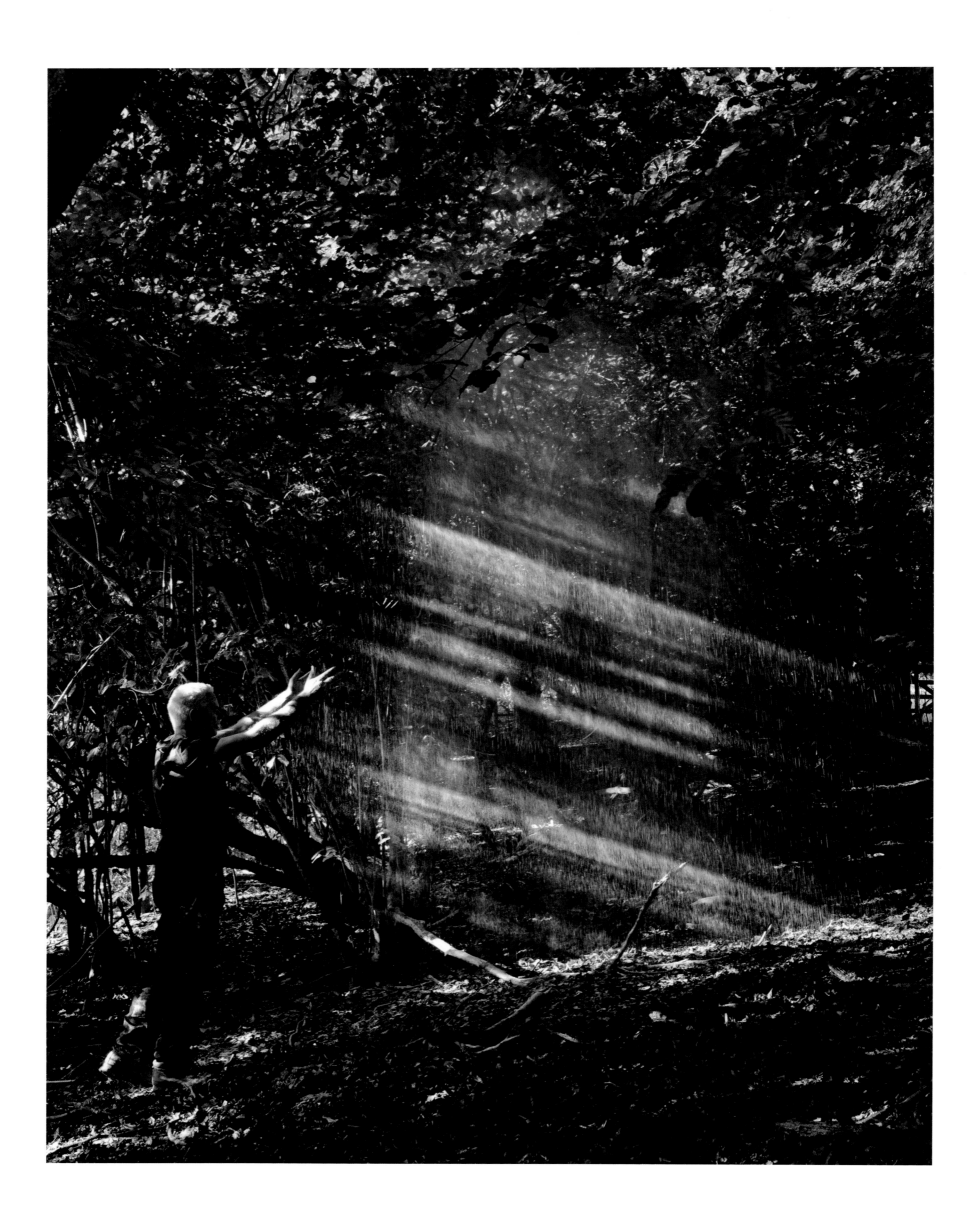

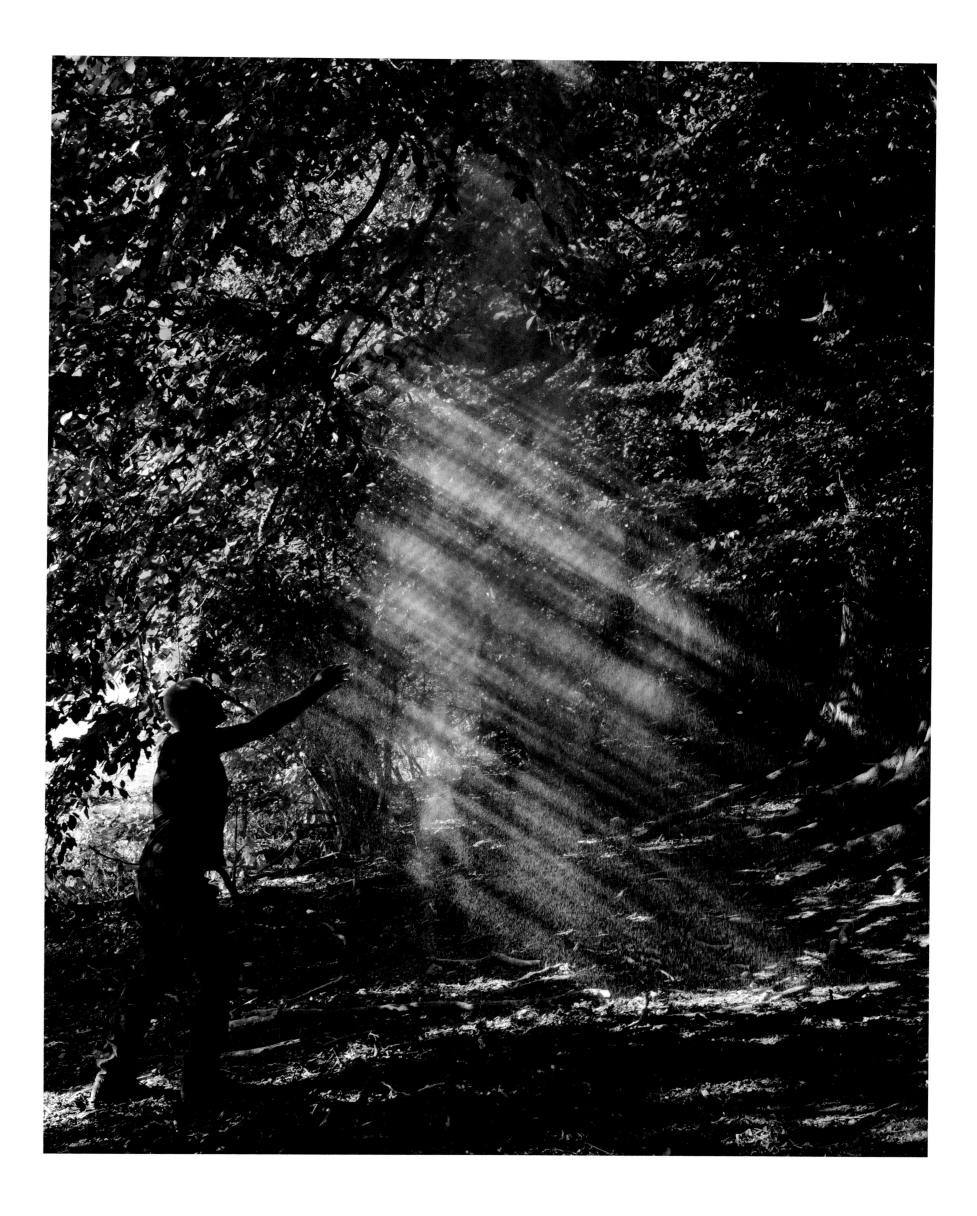

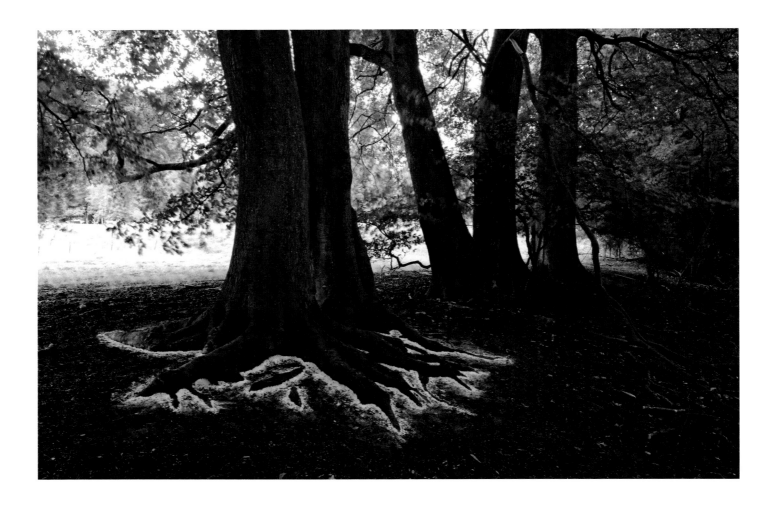

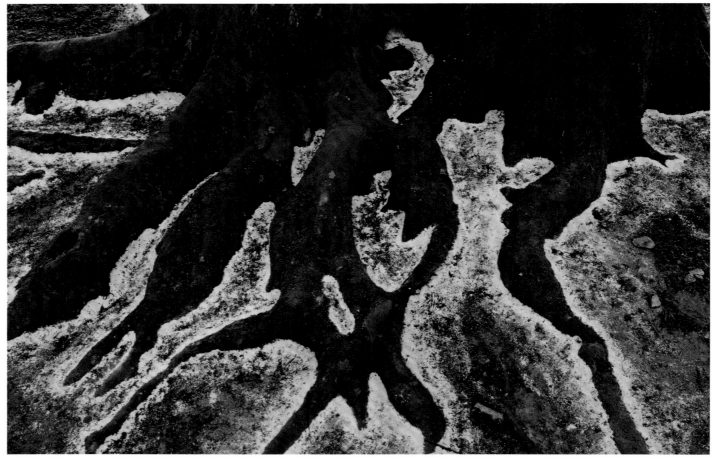

SOFT LUMPS OF UNEARTHED CHALK. SCRAPED WITH A SHARD OF FLINT TO MAKE WHITE DUST AROUND THE ROOTS OF TWO BEECH TREES. BERRYDOWN FOUNDATION, HAMPSHIRE. 1, 2 SEPTEMBER 2013

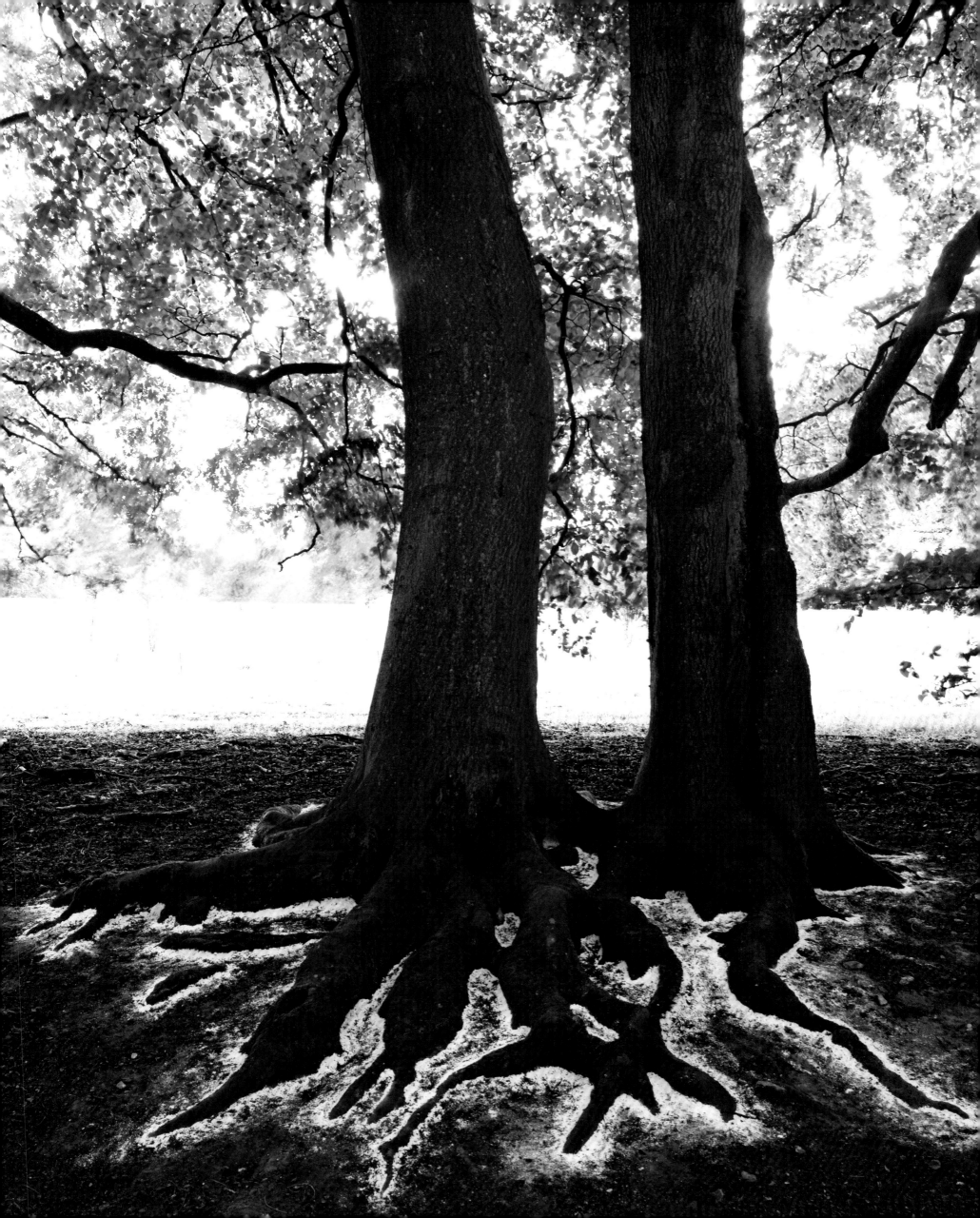

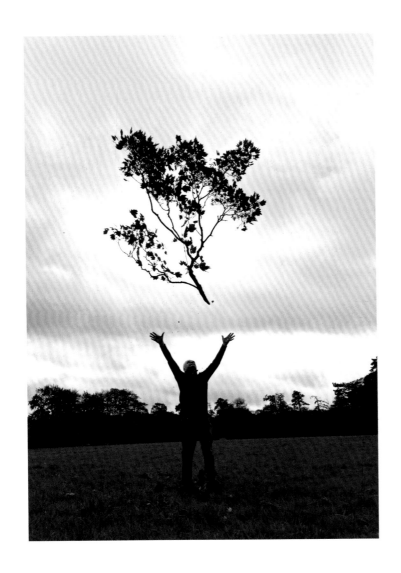
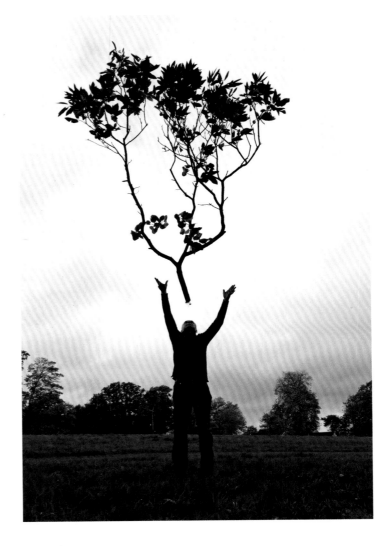
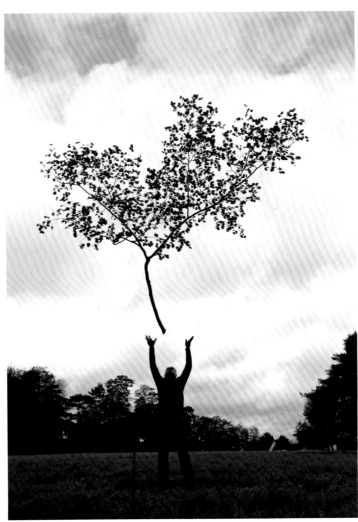
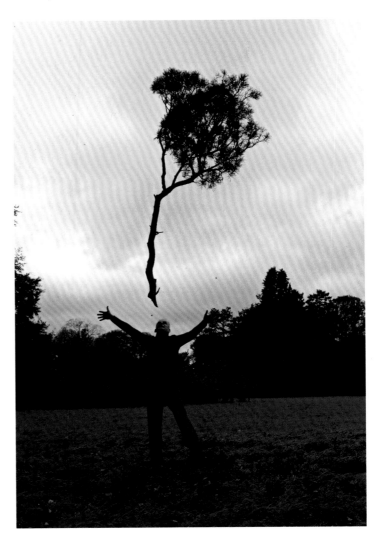

FIVE STORM-DAMAGED BRANCH THROWS. SYCAMORE. CHESTNUT. BEECH. SCOTS PINE. OAK. BERRYDOWN FOUNDATION, HAMPSHIRE. 28 OCTOBER 2013

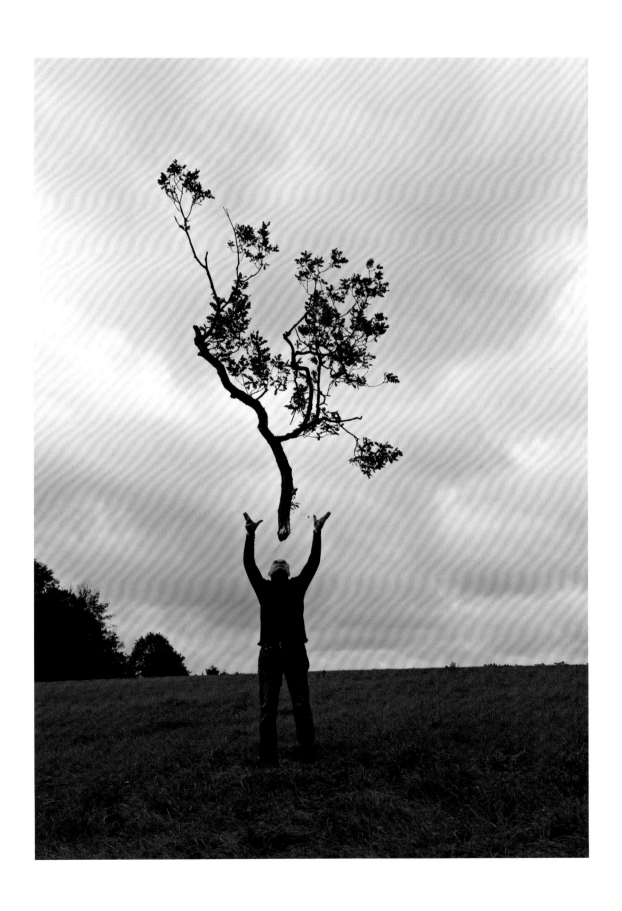

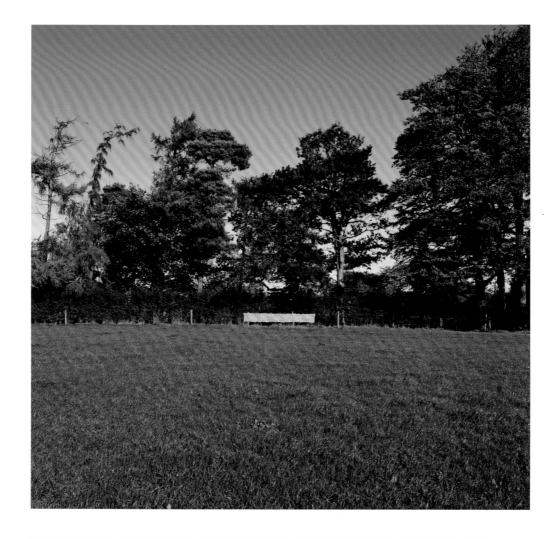

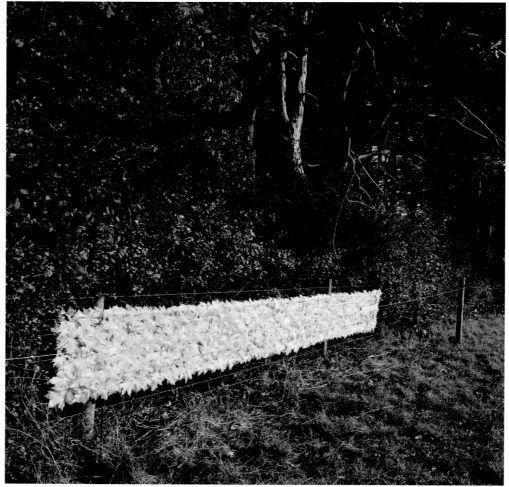

SYCAMORE LEAVES. STITCHED TOGETHER AND ATTACHED TO SHEEP NETTING WITH GRASS STALKS. SUNNY. MID-MORNING. BERRYDOWN FOUNDATION, HAMPSHIRE. 30 OCTOBER 2013

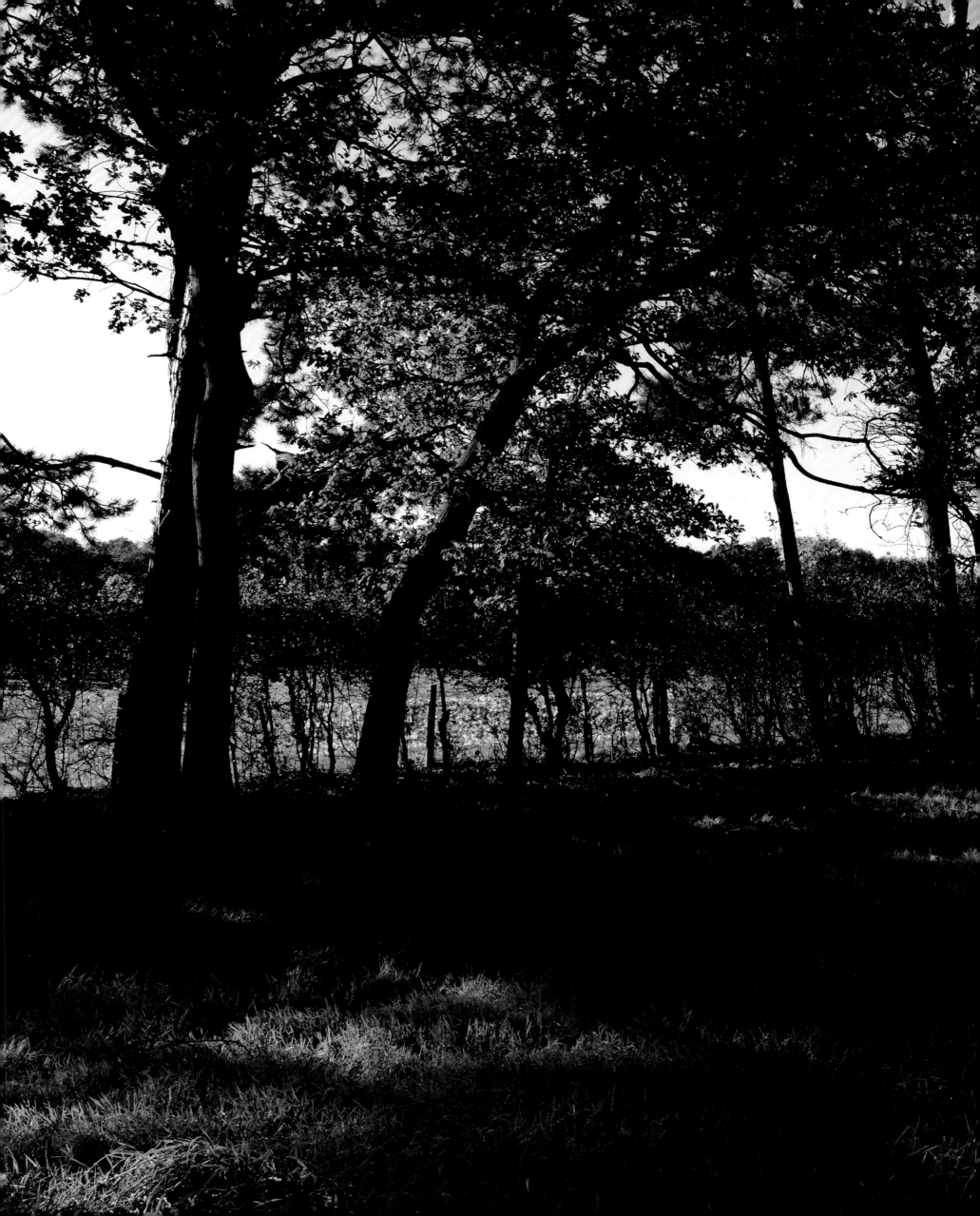

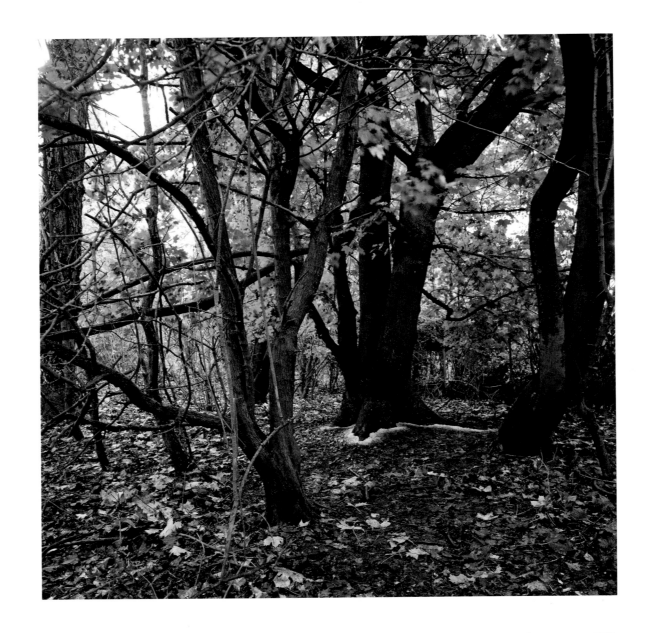

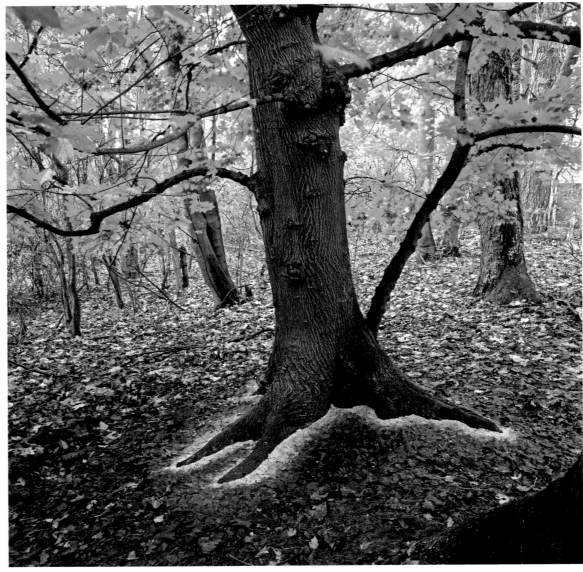

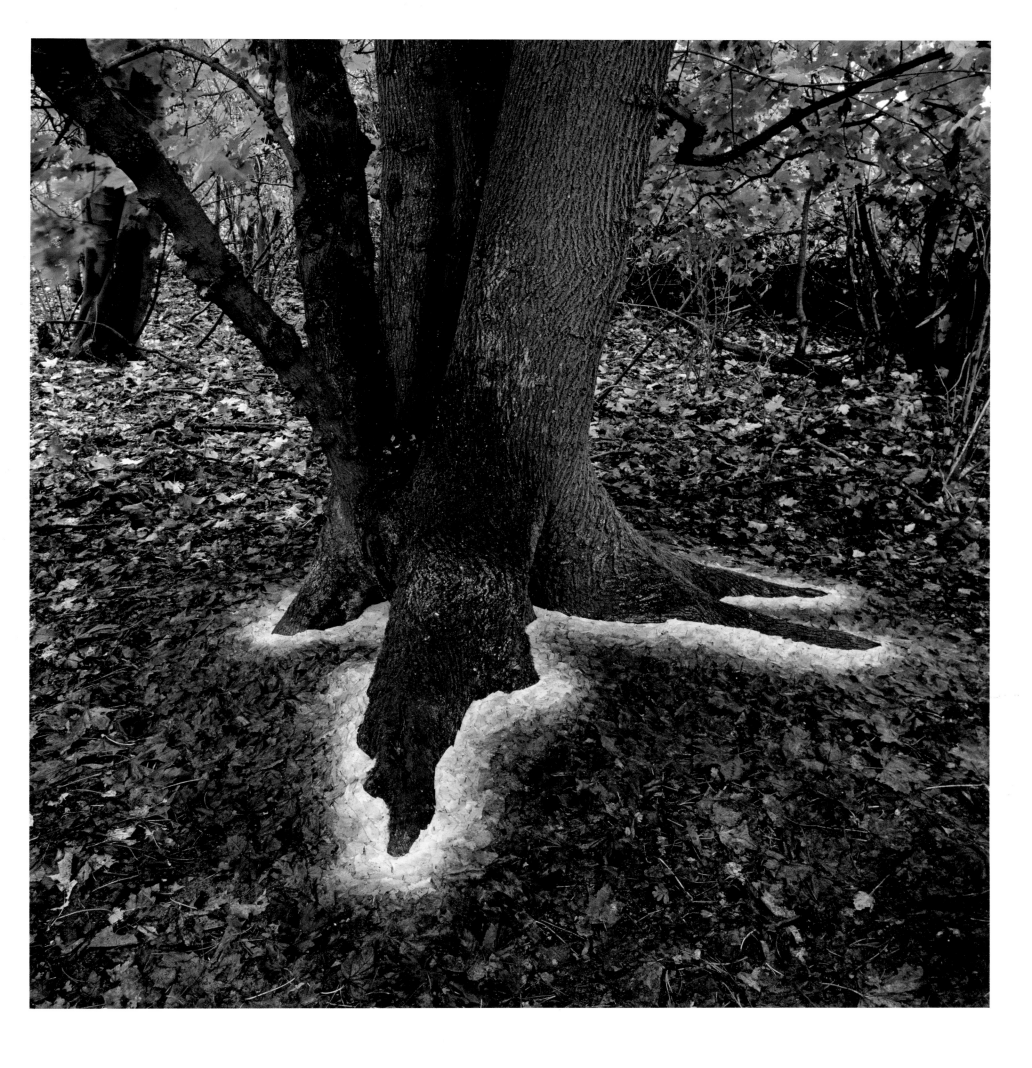

SYCAMORE LEAVES EDGING THE ROOTS OF A SYCAMORE TREE. BERRYDOWN FOUNDATION, HAMPSHIRE. 1 NOVEMBER 2013

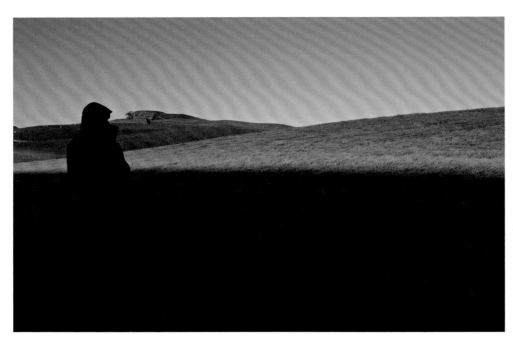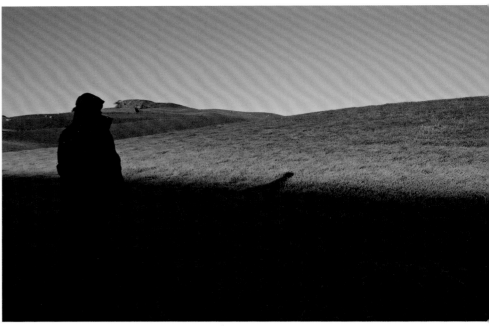
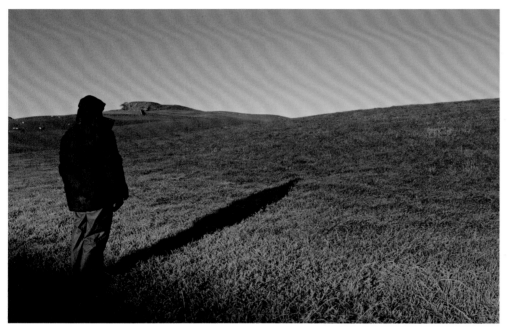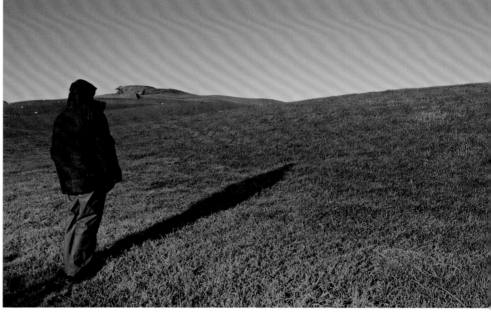
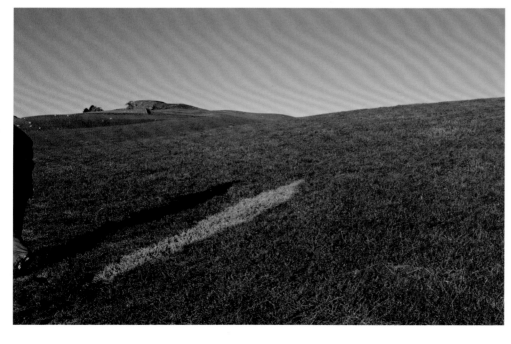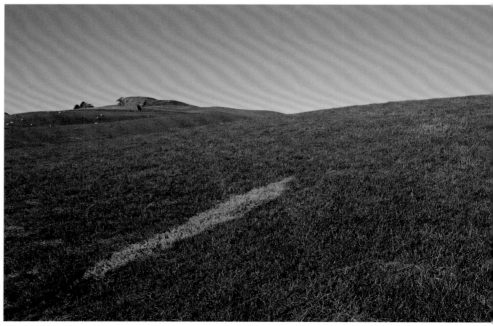

FROST SHADOW. DUMFRIESSHIRE, SCOTLAND. 4 NOVEMBER 2013

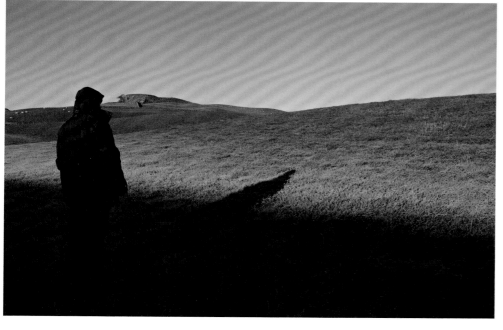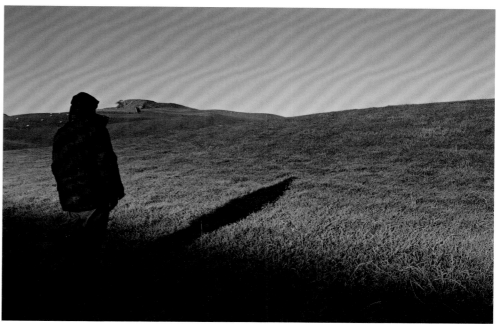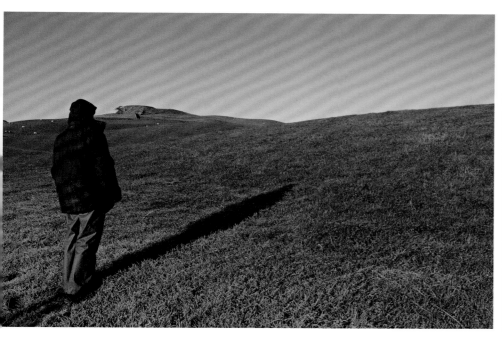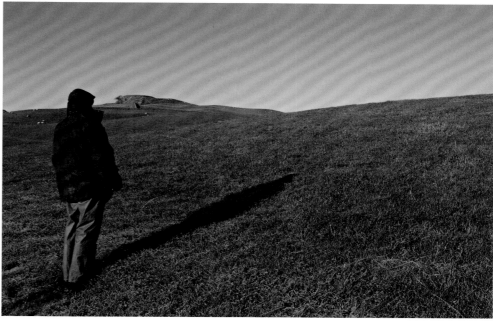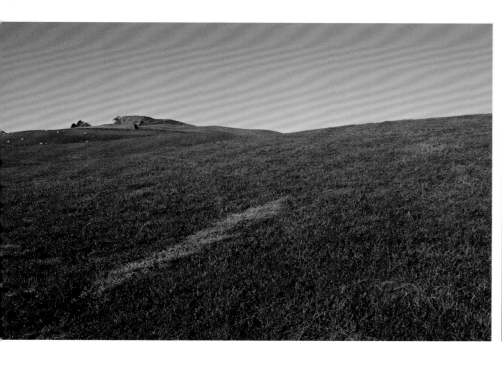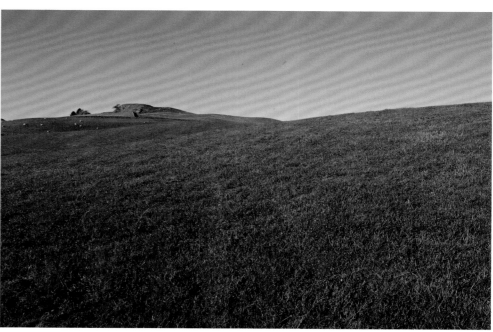

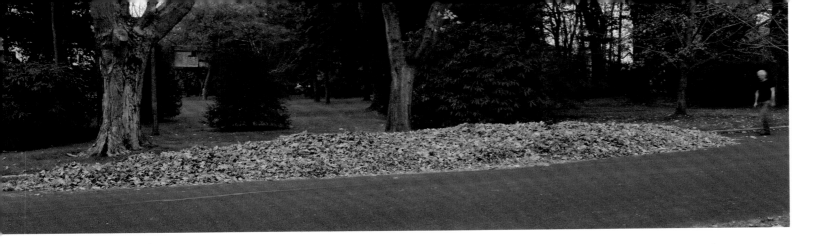

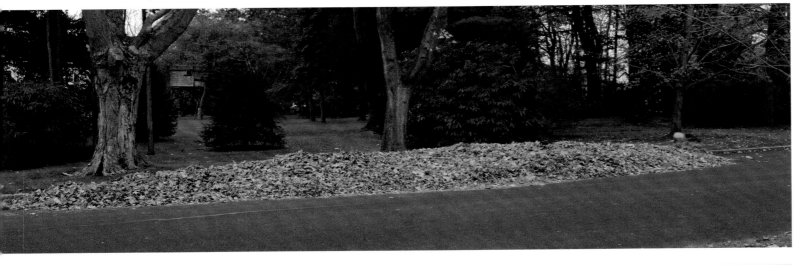

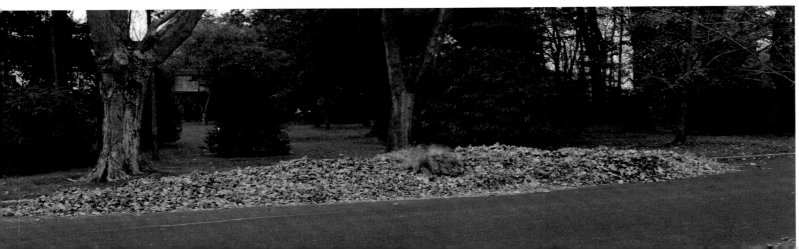

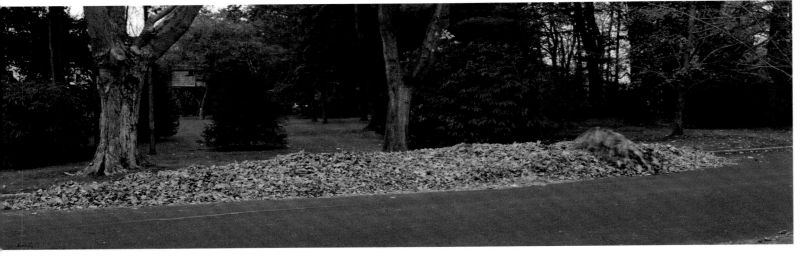

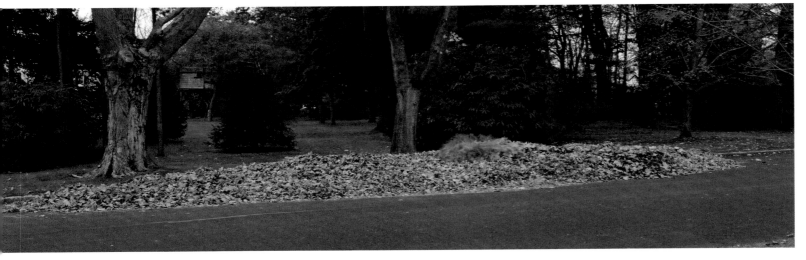

BURROWING THROUGH A PILE OF LEAVES.
GREENWICH, CONNECTICUT.
15 NOVEMBER 2013

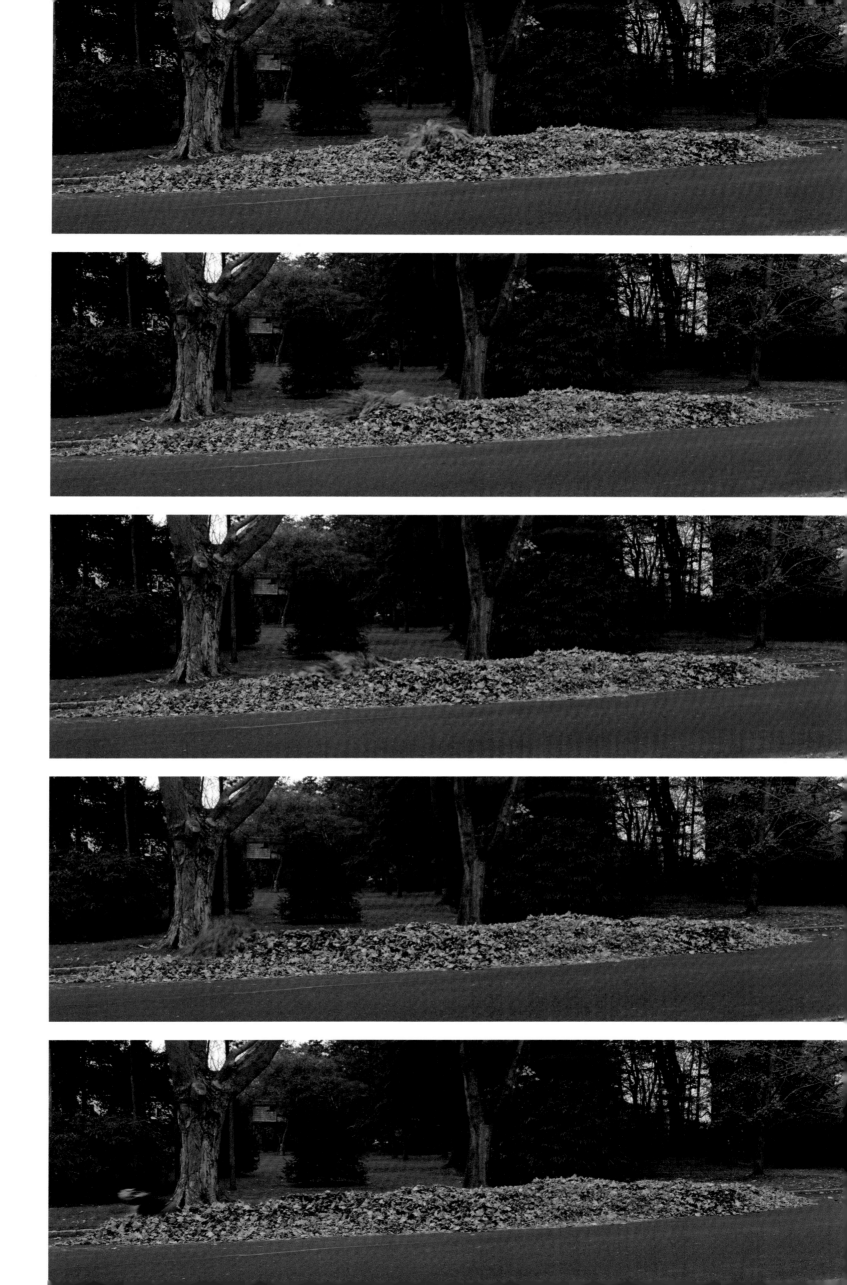

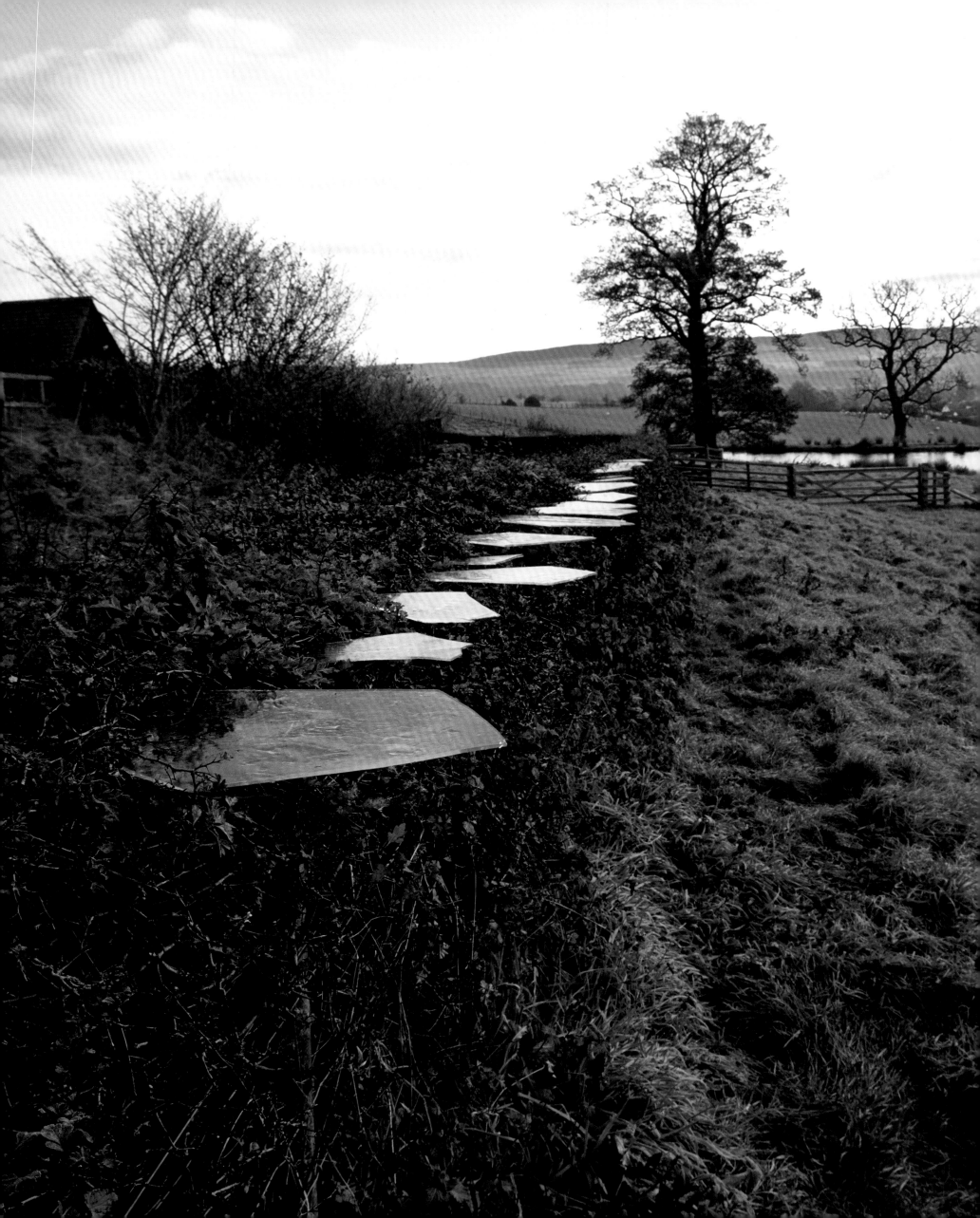

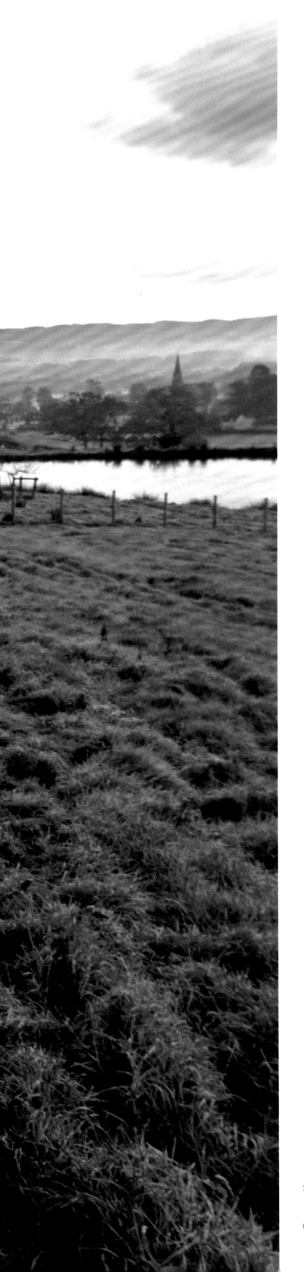

SHEETS OF ICE IN HEDGE. FOR EMMA HARKNESS. DUMFRIESSHIRE, SCOTLAND. 25 NOVEMBER 2013

(OVERLEAF) ICE PLACED IN FENCE NETTING AND WIRE. DUMFRIESSHIRE, SCOTLAND. 17 DECEMBER 2013

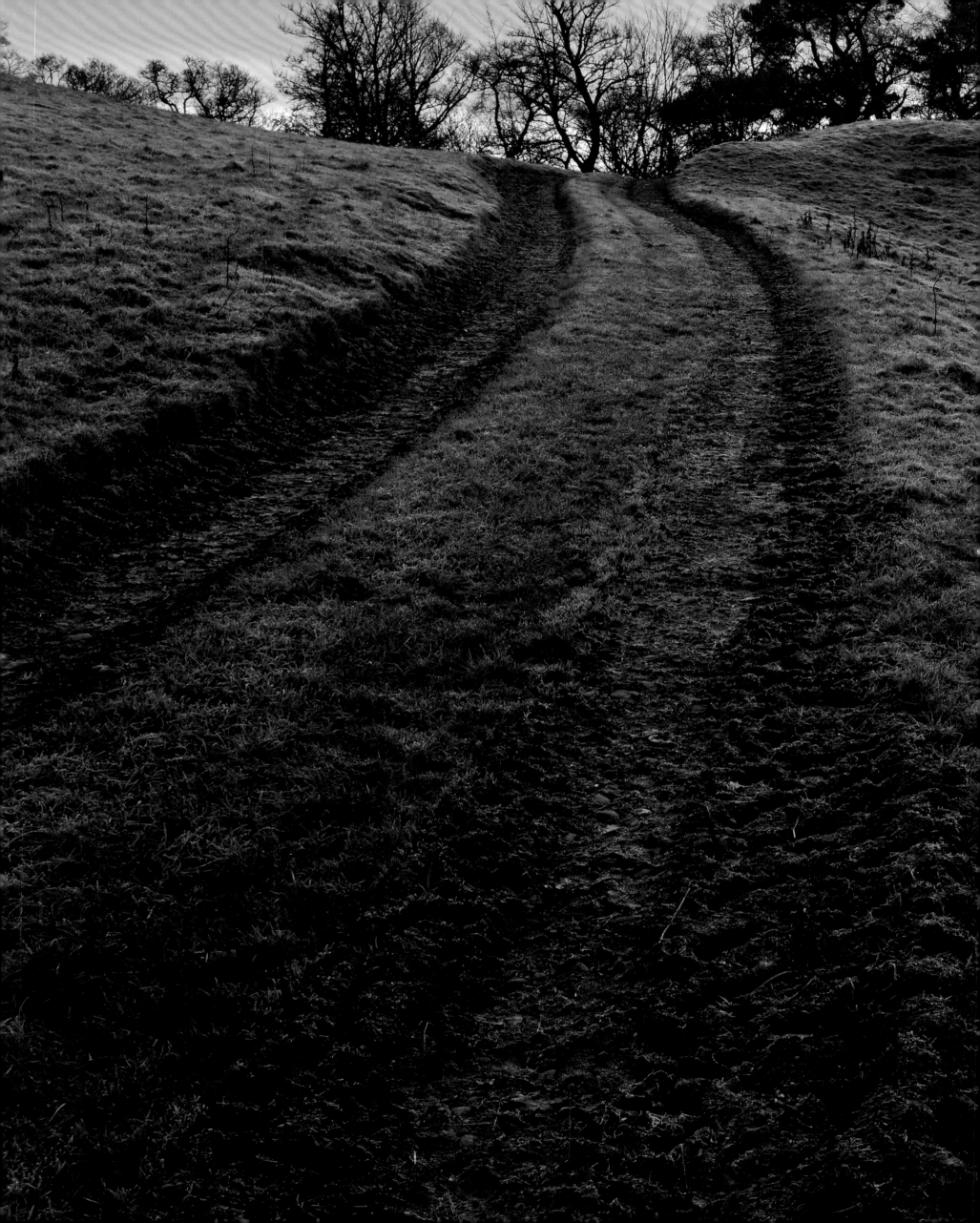

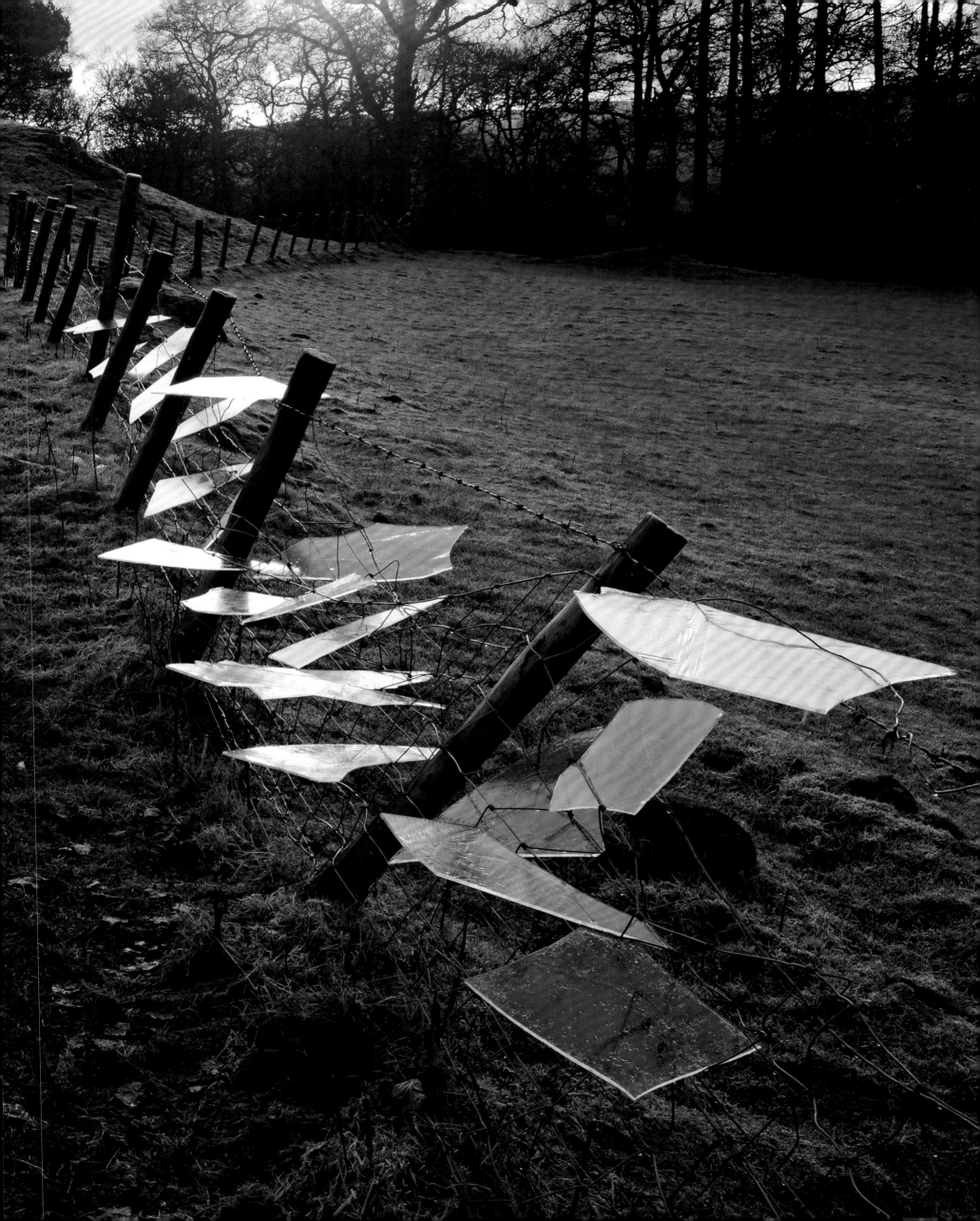

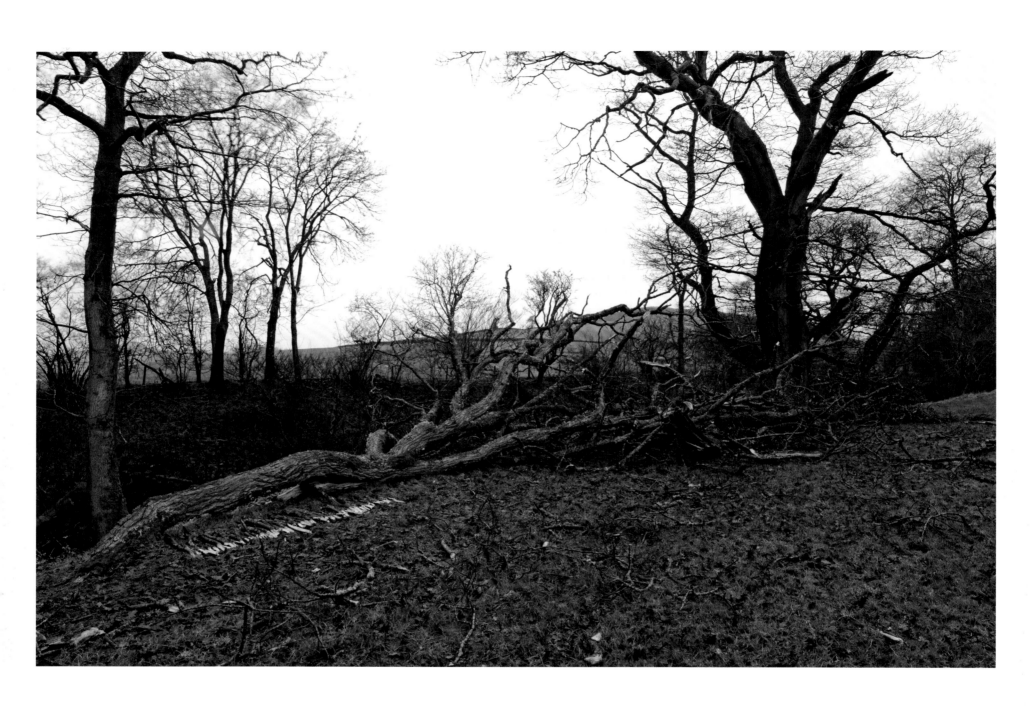

BRANCHES. TORN FROM RECENTLY FALLEN OAK BOUGH. DUMFRIESSHIRE, SCOTLAND. 22 DECEMBER 2013

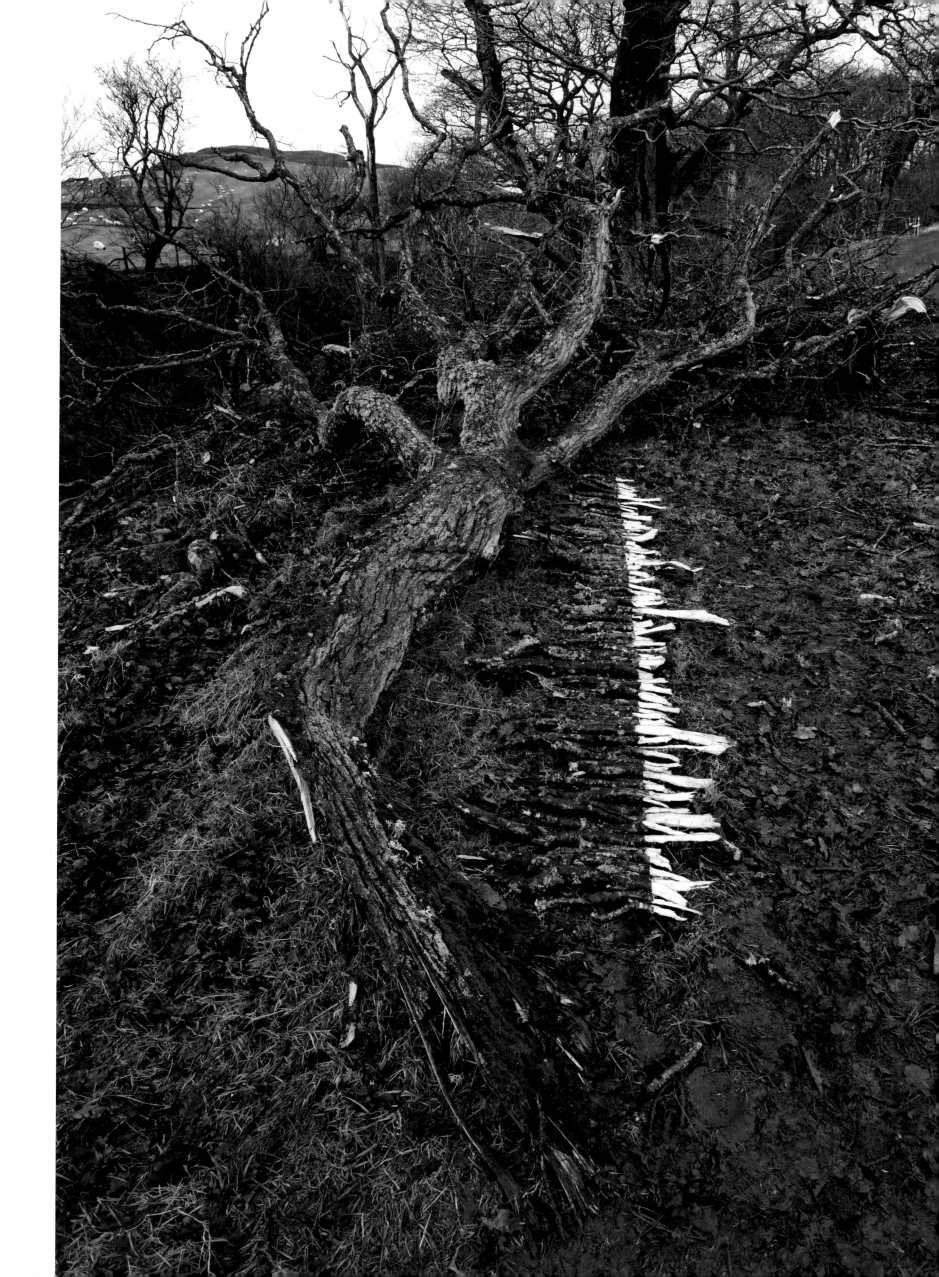

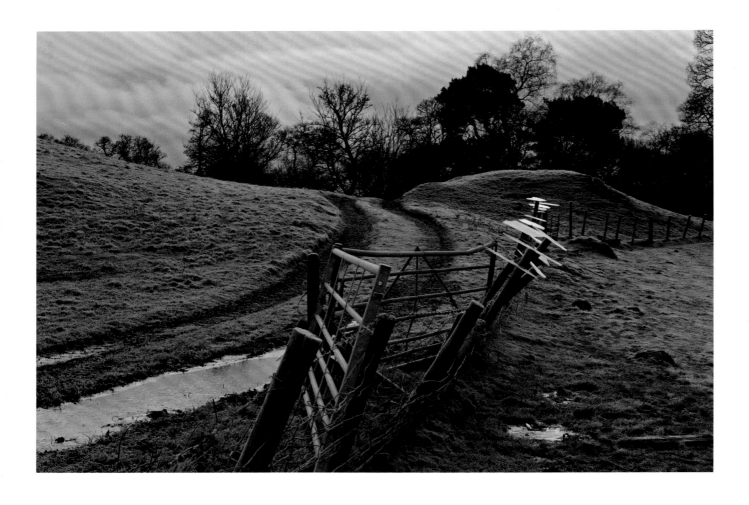

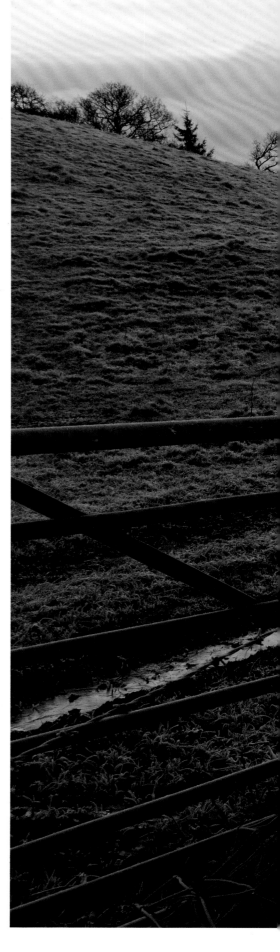

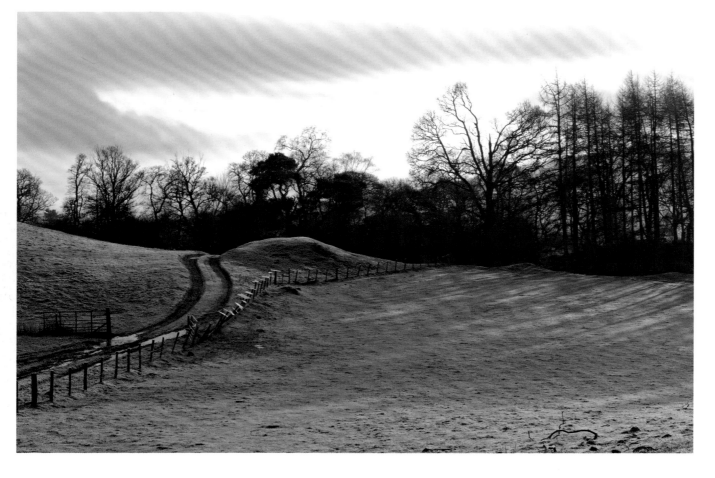

ICE. FROZEN TO THE FLAT, FROSTED TOPS OF FENCE POSTS. DUMFRIESSHIRE, SCOTLAND. 26 DECEMBER 2013

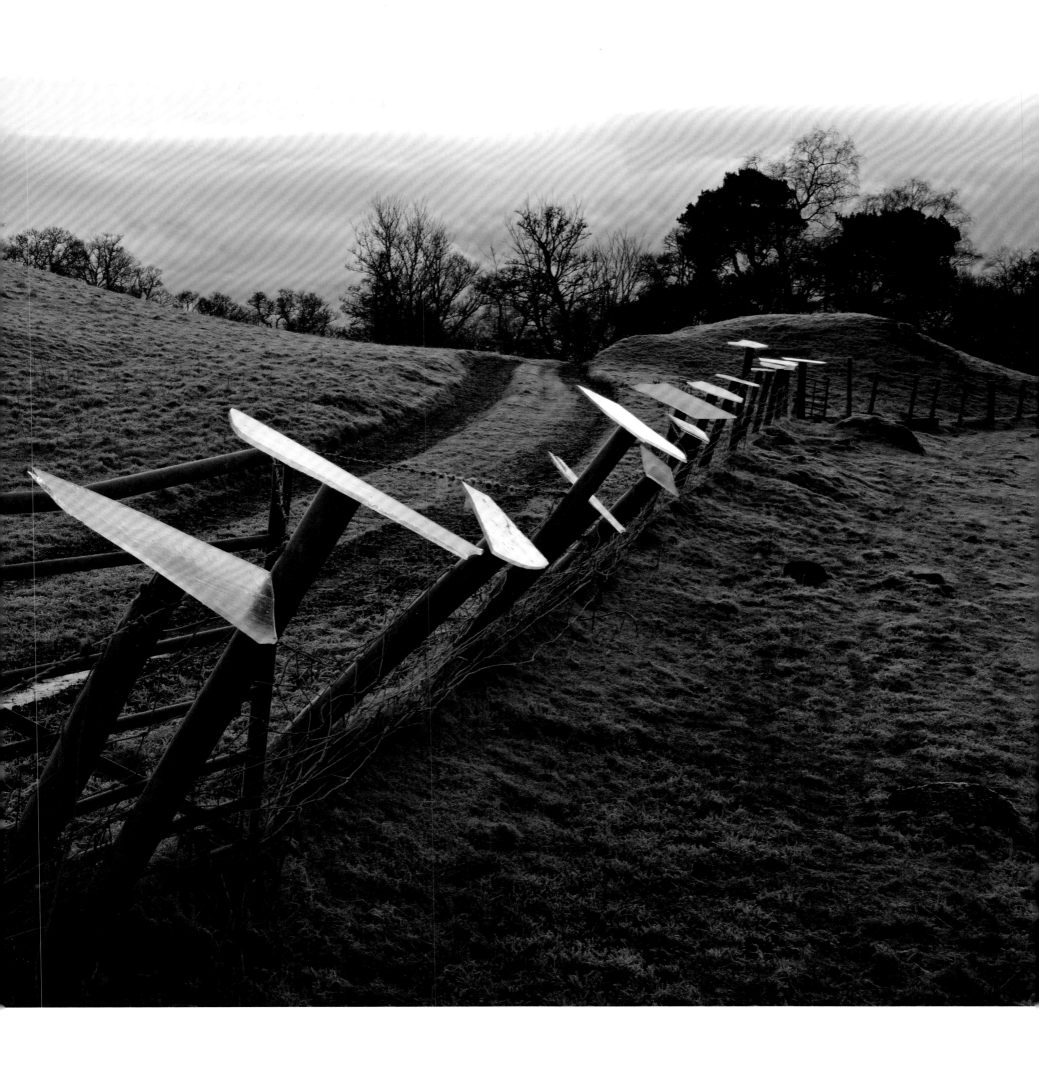

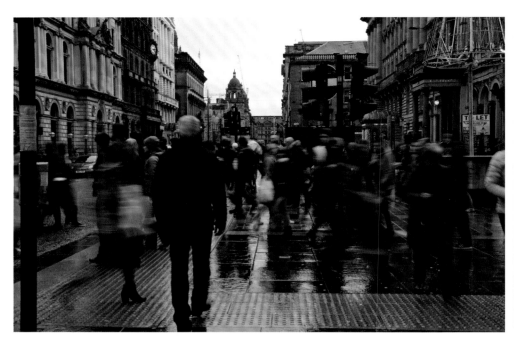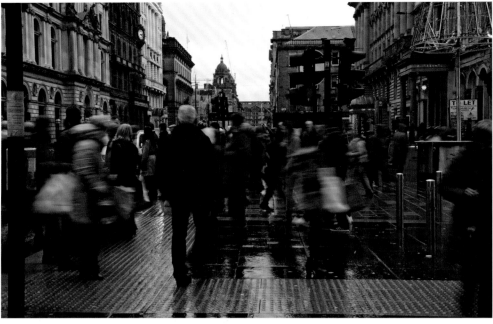
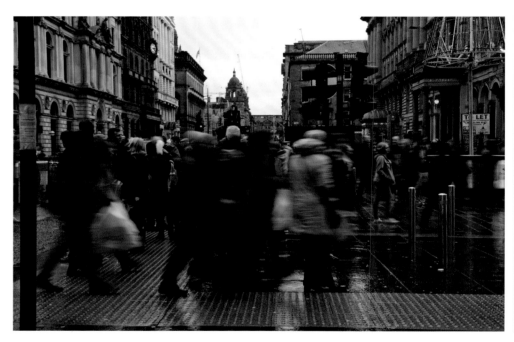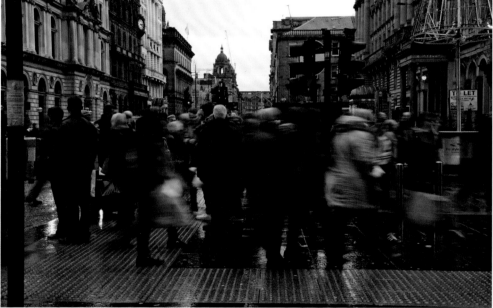
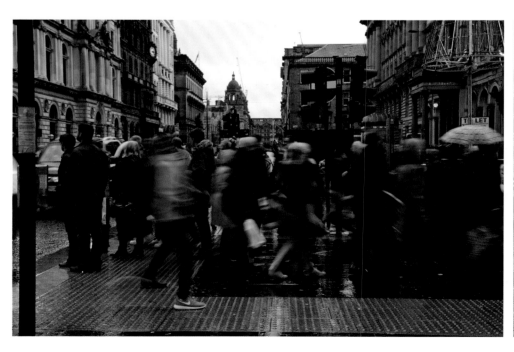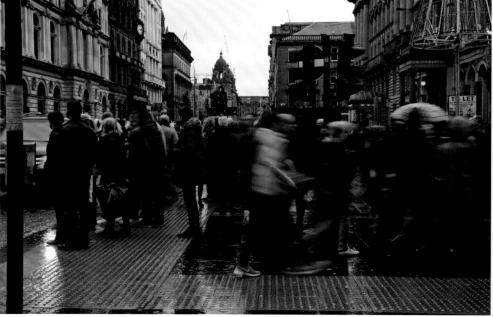

STREET WALK. GLASGOW, SCOTLAND. 28 DECEMBER 2013

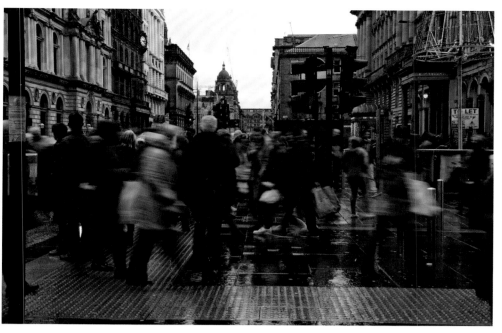

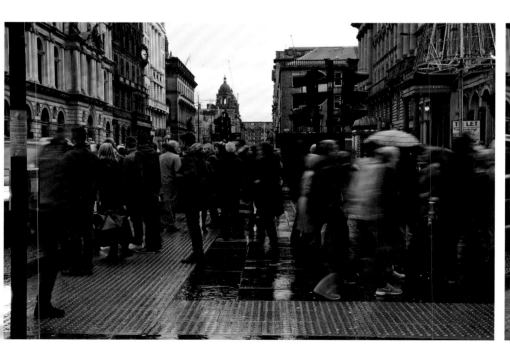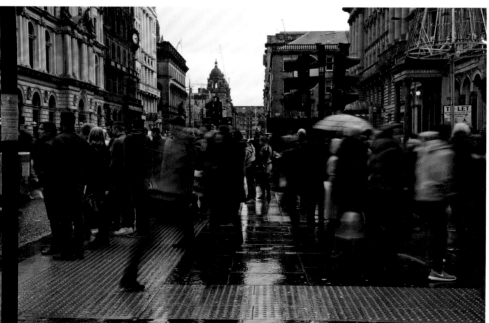

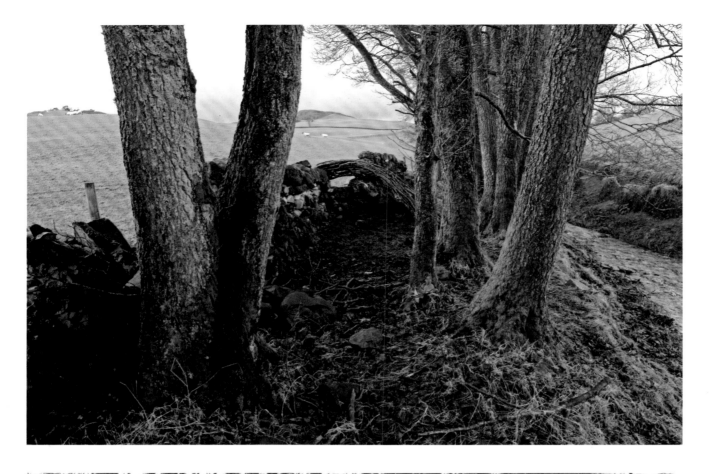

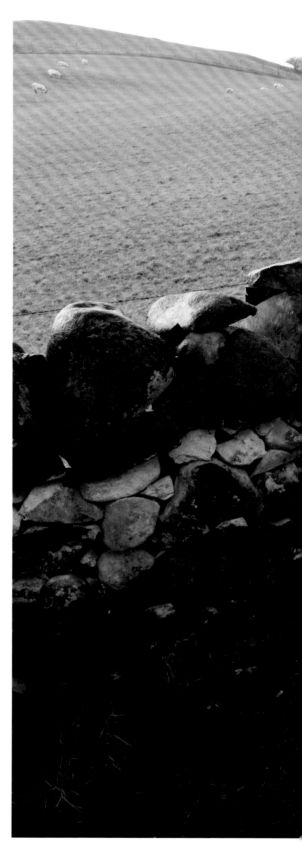

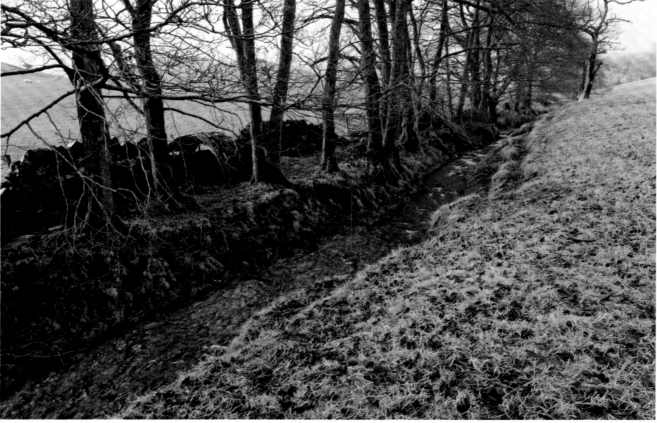

BRANCHES. PRUNED BY NEIGHBOURING FARMER. LEFT IN PILES ALONGSIDE THE WALL. COLLECTED, STACKED AND WOVEN INTO AN ARCH. DUMFRIESSHIRE, SCOTLAND. 1, 2 JANUARY 2014

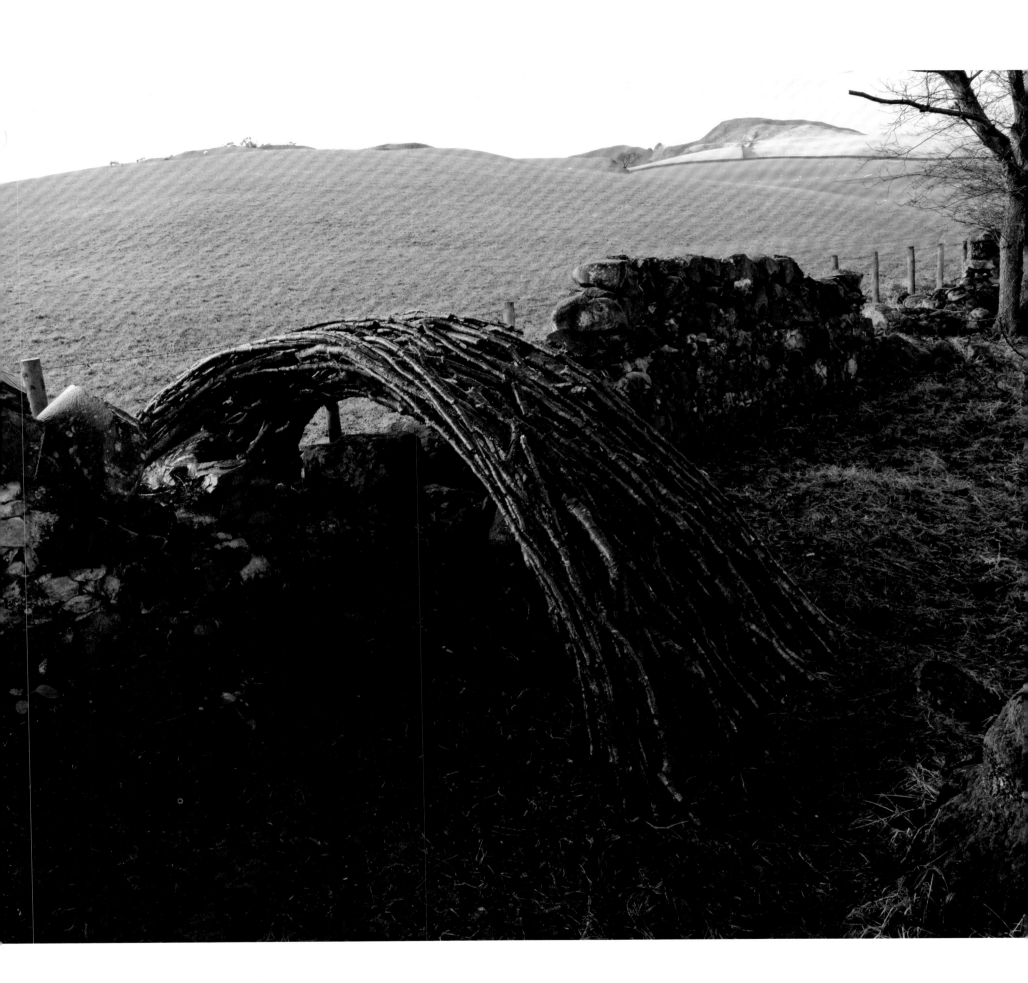

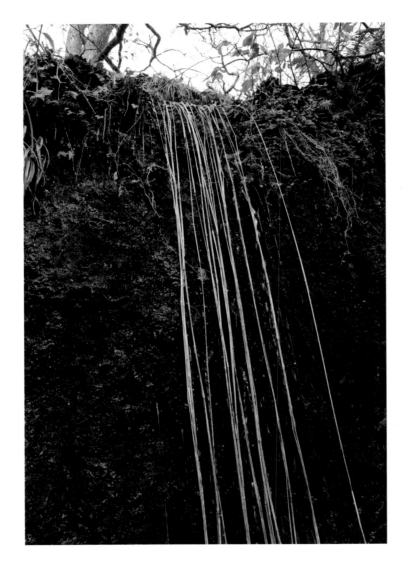

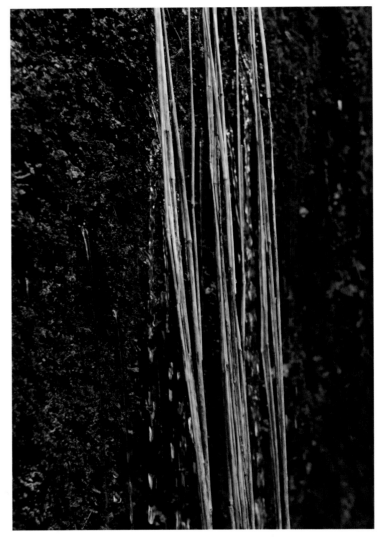

GRASS STALKS. THIN END OF ONE PUSHED INTO THE WIDER HOLLOW END OF ANOTHER TO MAKE LINES. DRAWING A WATERFALL. DUMFRIESSHIRE, SCOTLAND. 8 JANUARY 2014

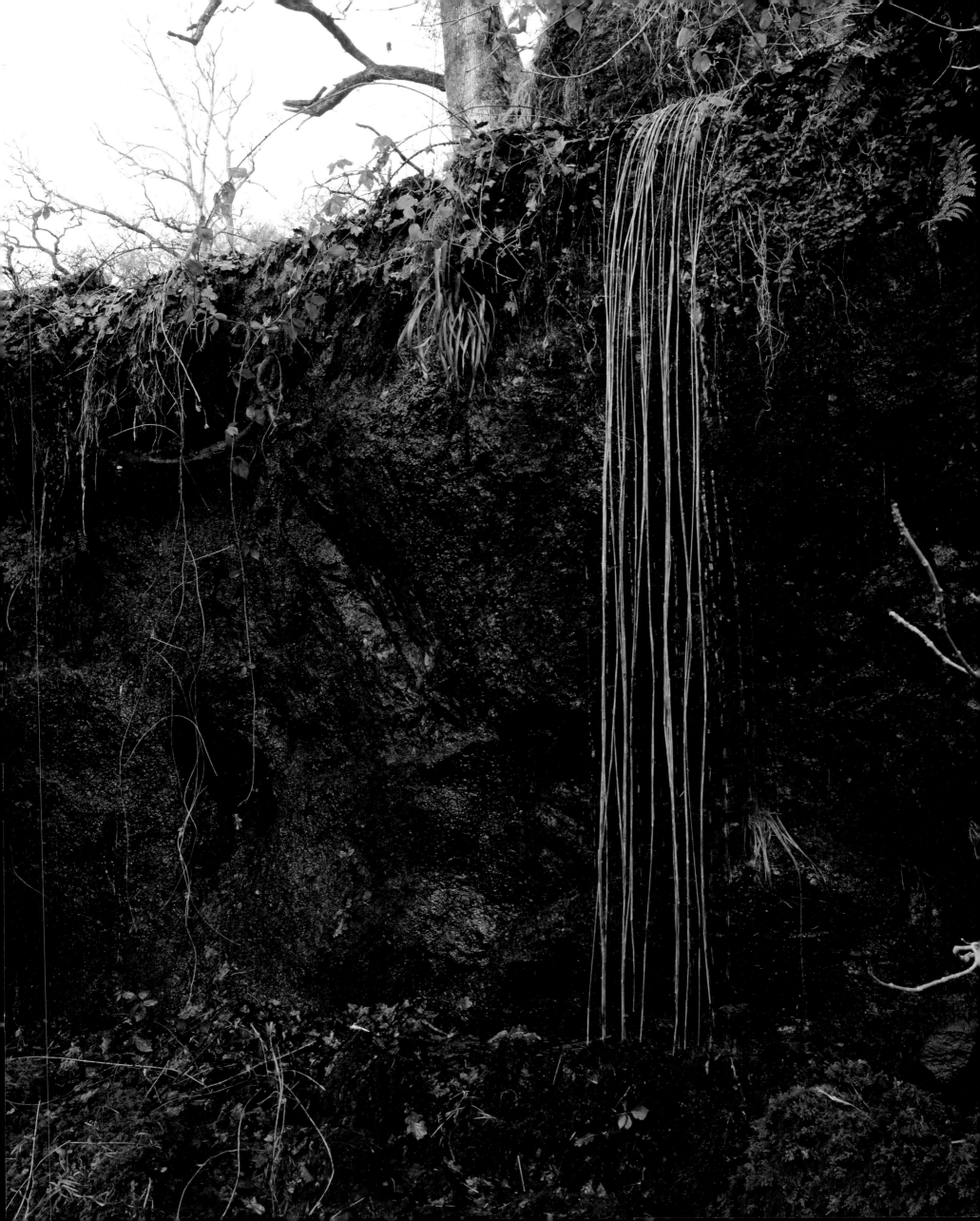

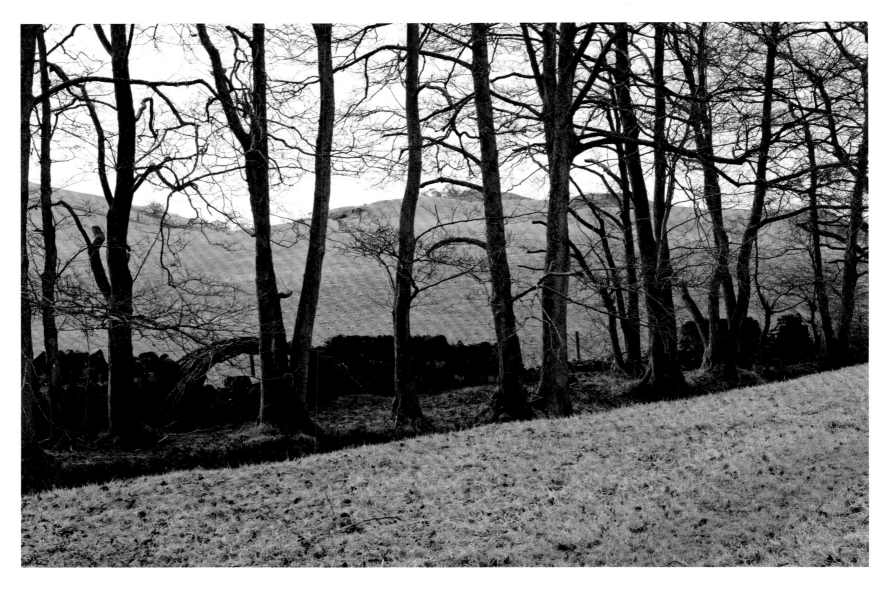

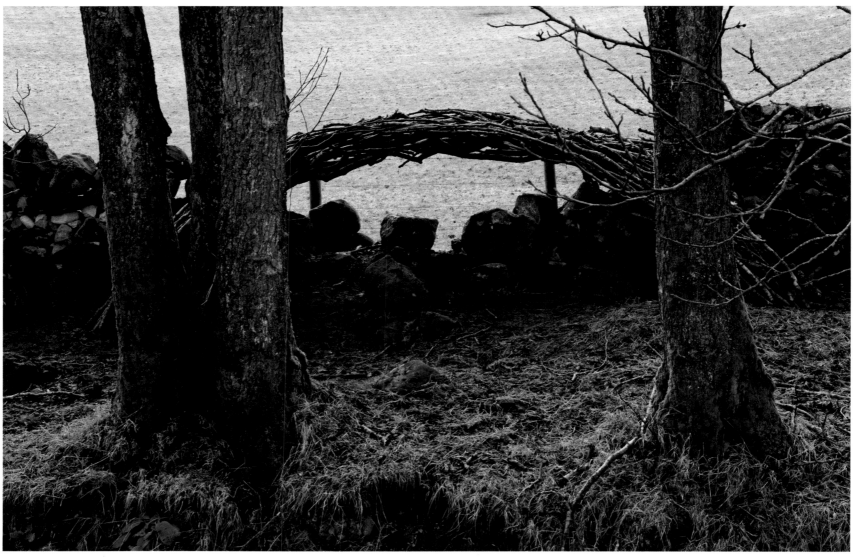

ALDER BRANCHES. REWORKED ALONG THE WALL. DUMFRIESSHIRE, SCOTLAND. 13 JANUARY 2014

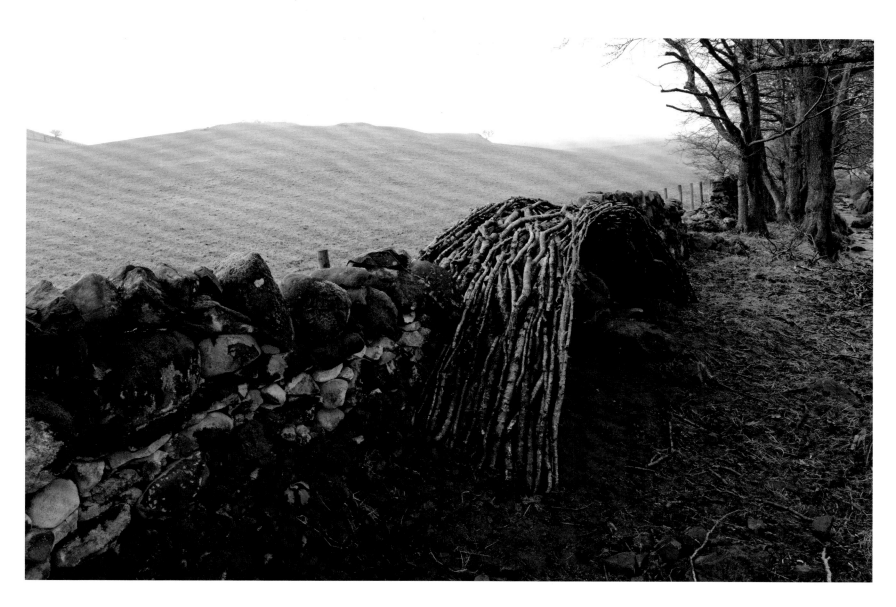
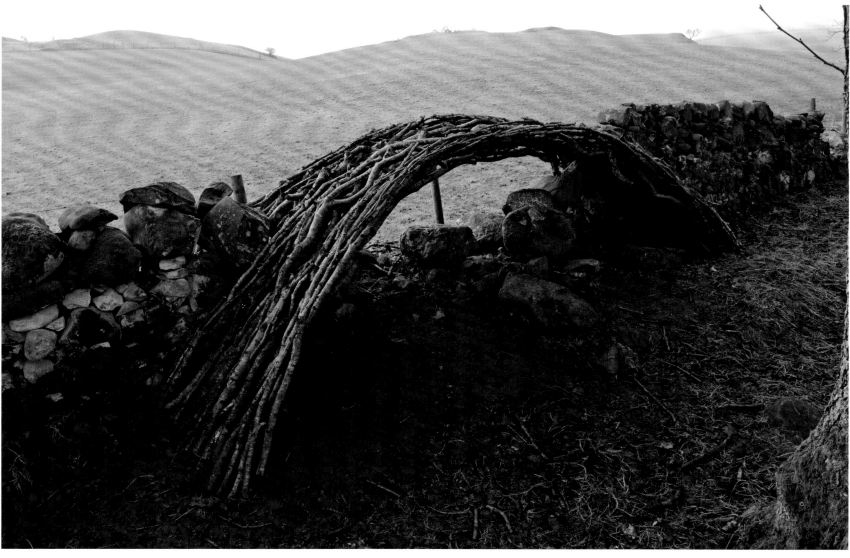

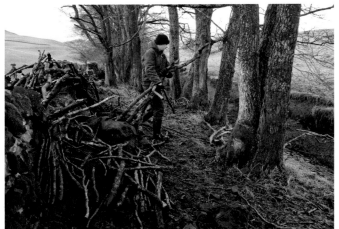

ALDER BRANCHES REWORKED OVER THE BURN. DUMFRIESSHIRE, SCOTLAND. 14 JANUARY 2014

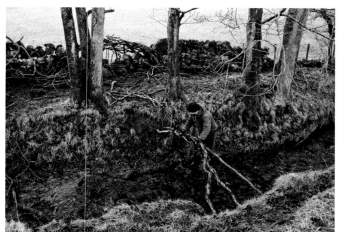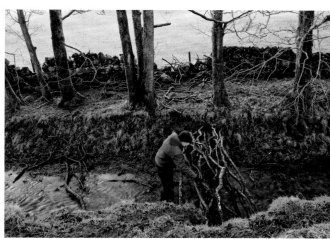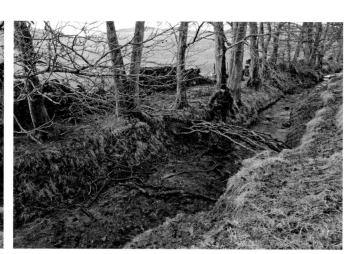

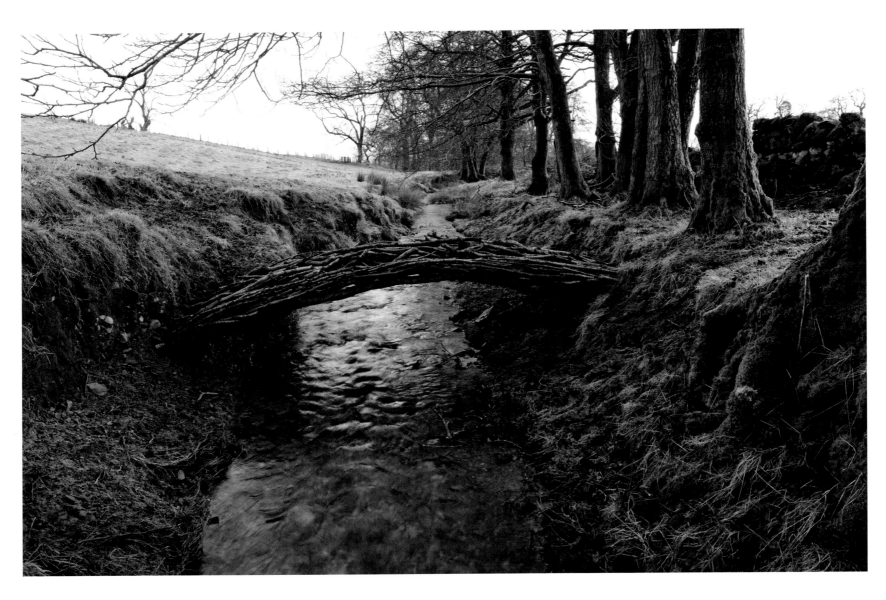

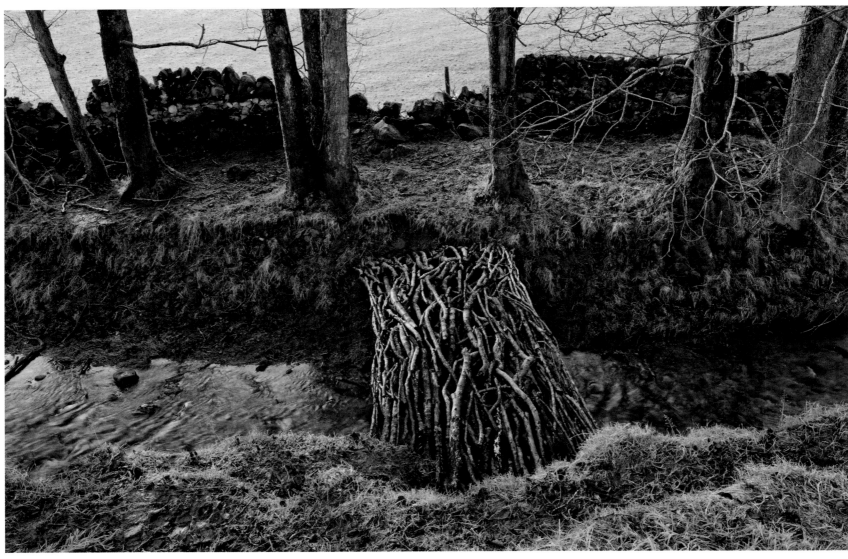

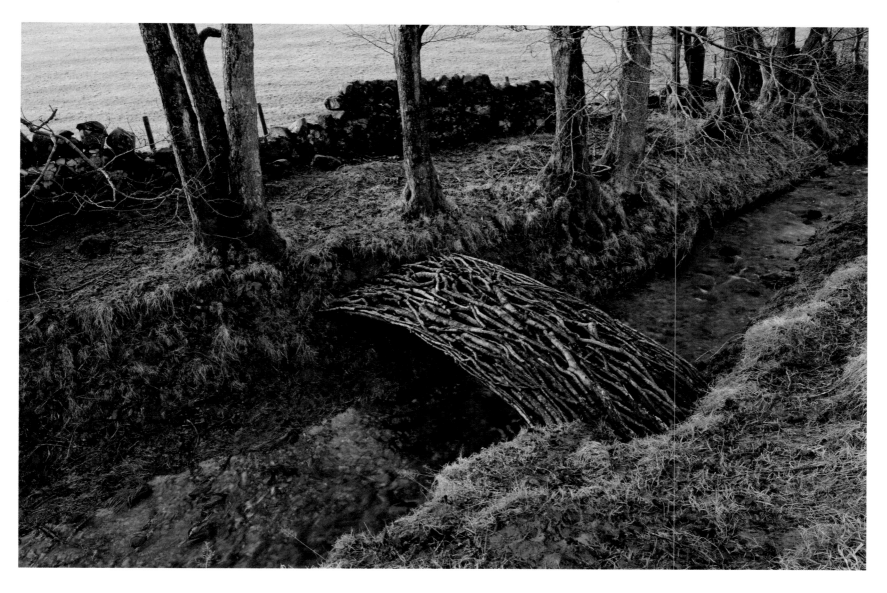

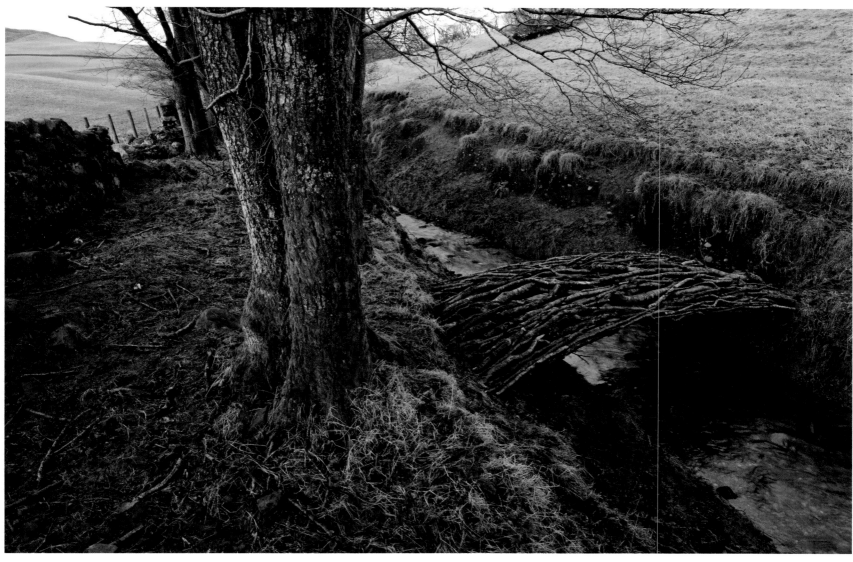

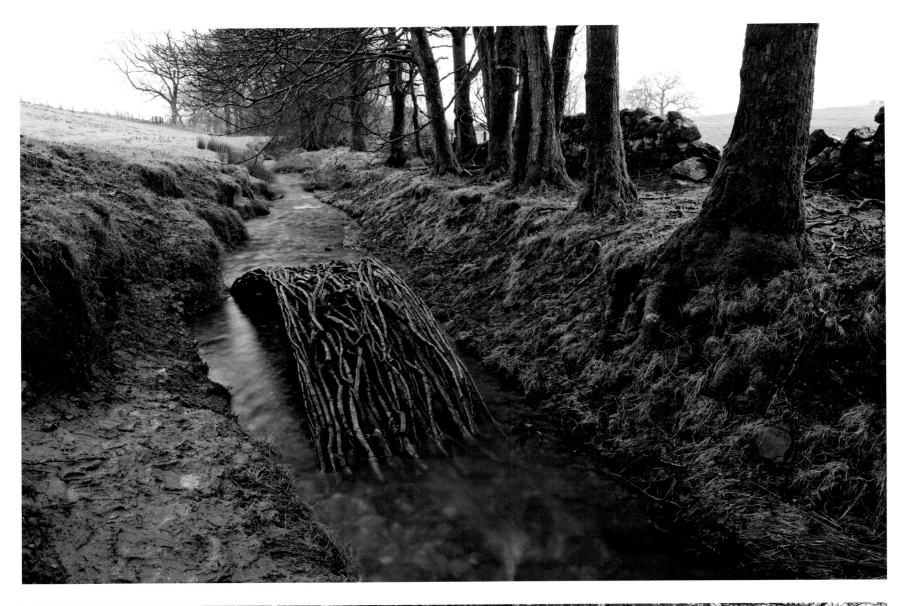

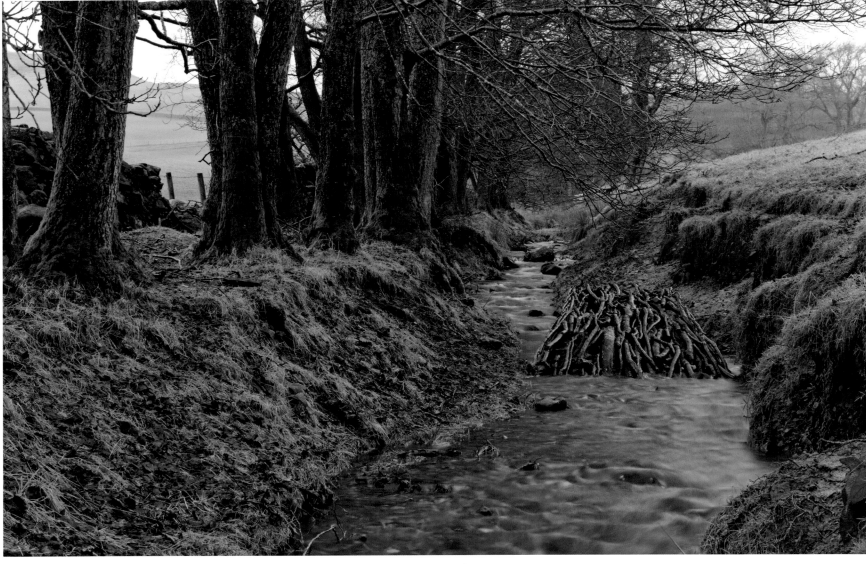

ALDER BRANCHES REWORKED ALONG THE BURN. DUMFRIESSHIRE, SCOTLAND. 17 JANUARY 2014

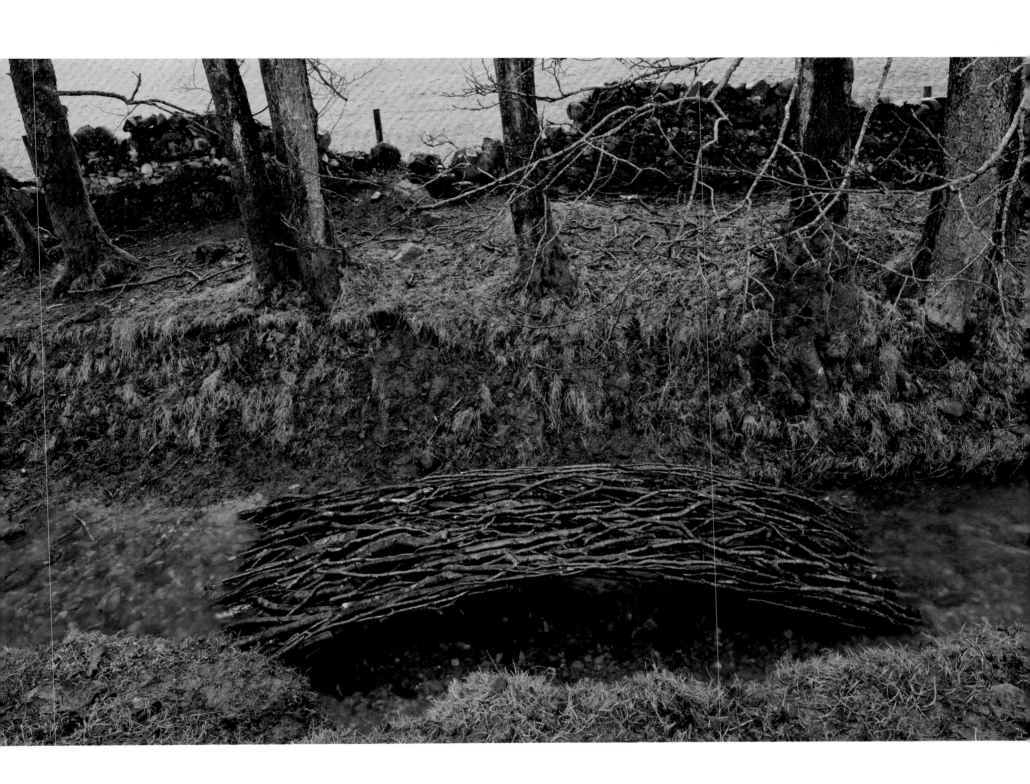

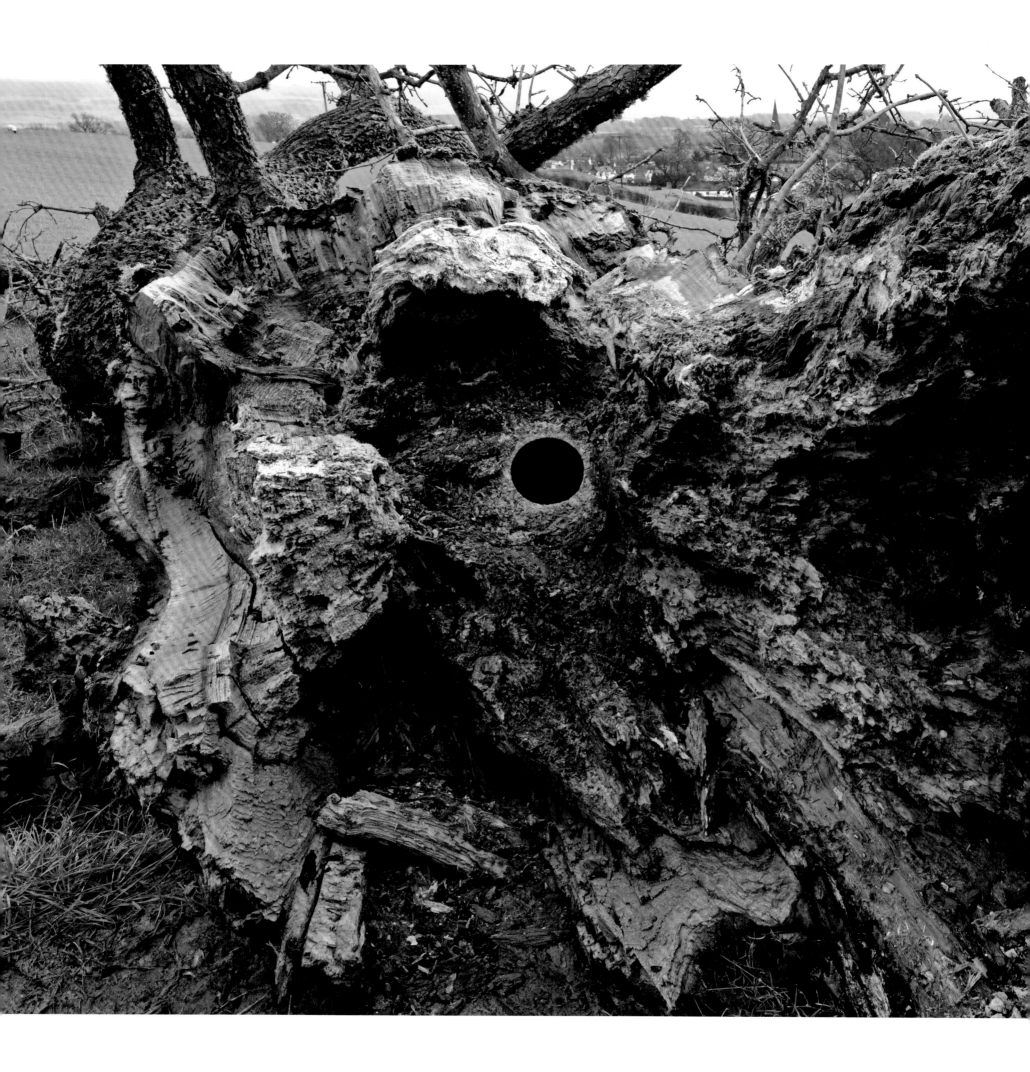

HOLE. DUG AND MOULDED OUT OF THE ROTTED HEART WOOD OF A FALLEN ASH. DUMFRIESSHIRE, SCOTLAND. 20 JANUARY 2014

(OVERLEAF) BRANCHES TORN FROM A RECENTLY FALLEN OAK TREE. PUSHED INTO A SMASHED THICKET THAT WAS ONCE THE TREE'S CANOPY.
THE HEELS OF FRESH WHITE WOOD (WHERE EACH BRANCH WAS ONCE ATTACHED TO THE TREE) POINTING OUTWARD. DUMFRIESSHIRE, SCOTLAND. 22 JANUARY 2014

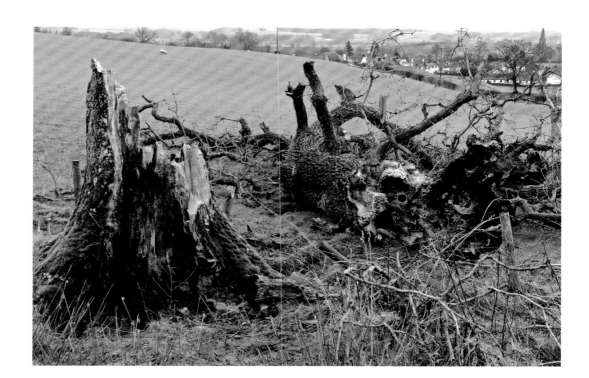
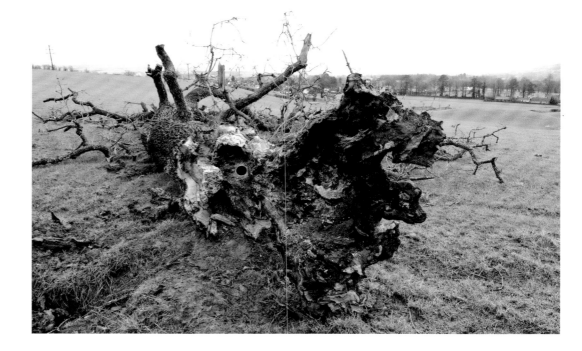

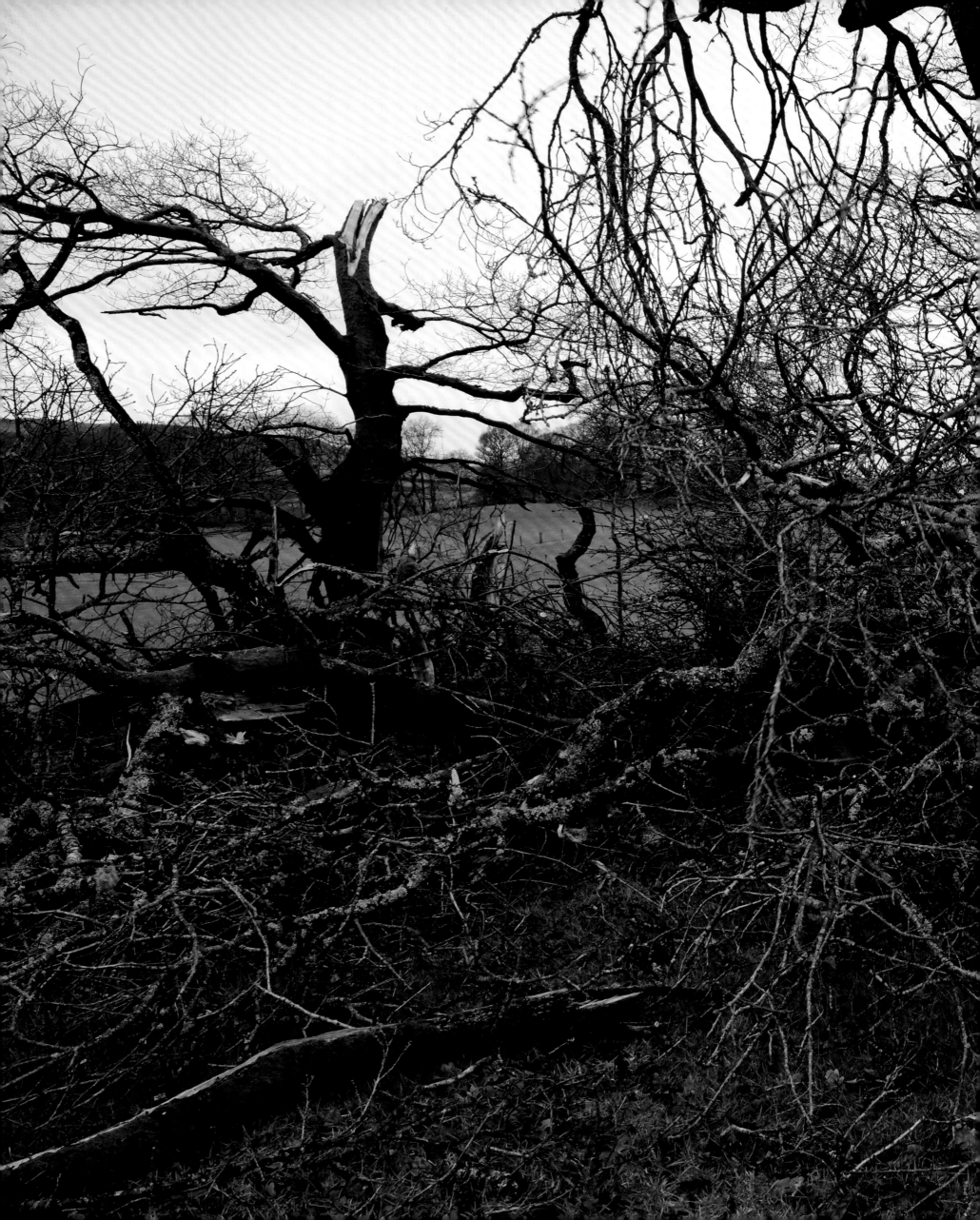

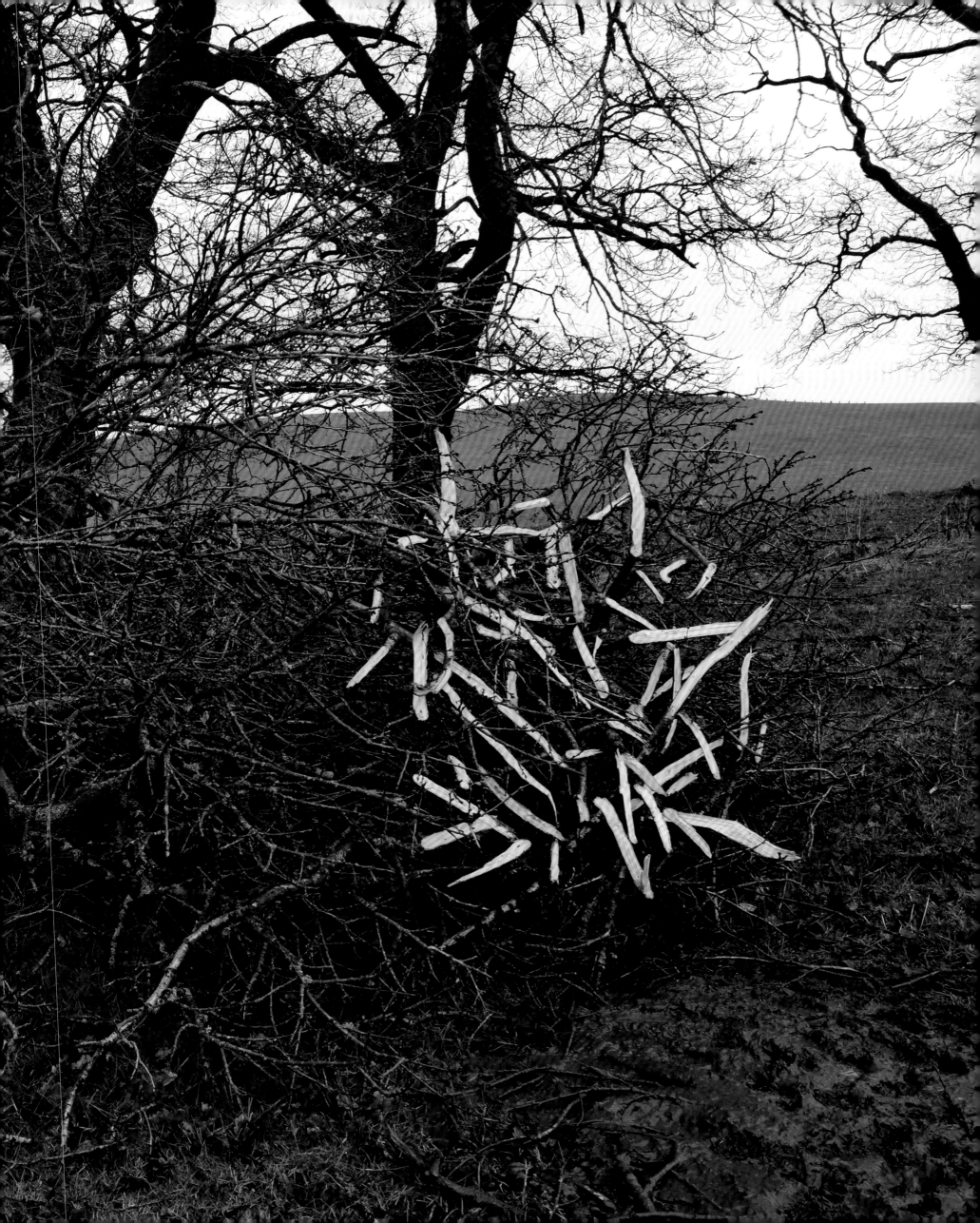

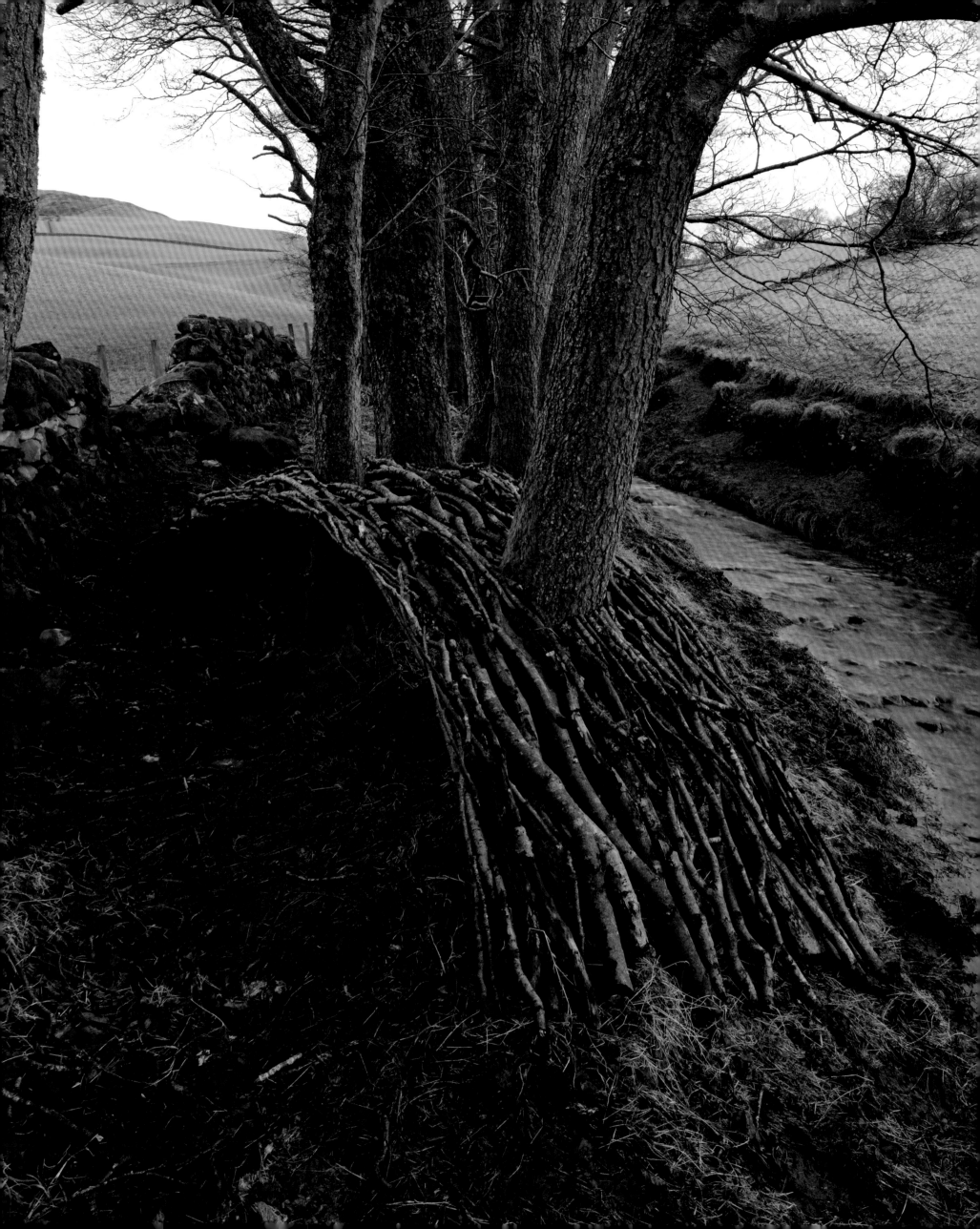

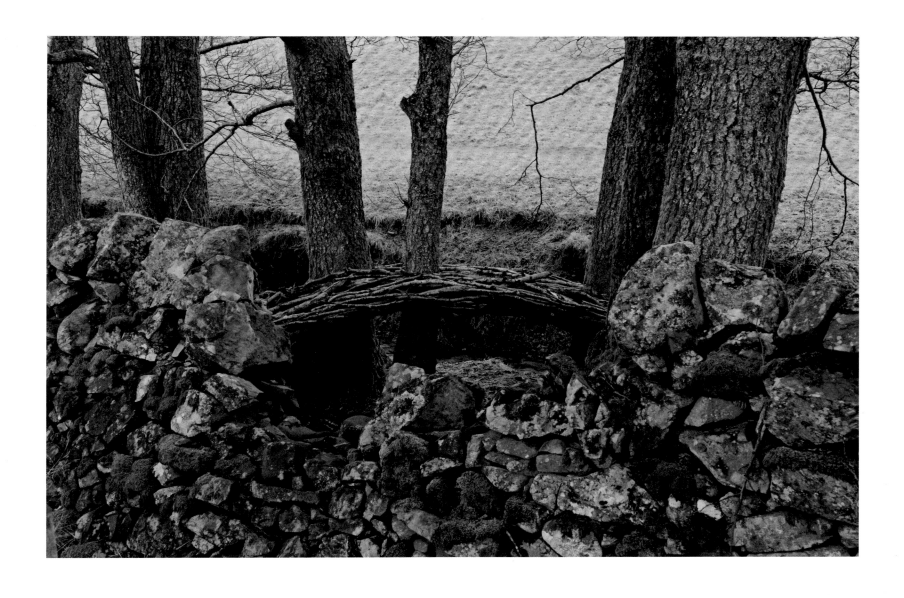

ALDER BRANCHES REWORKED AROUND ALDER TREES. DUMFRIESSHIRE SCOTLAND. 29 JANUARY 2014

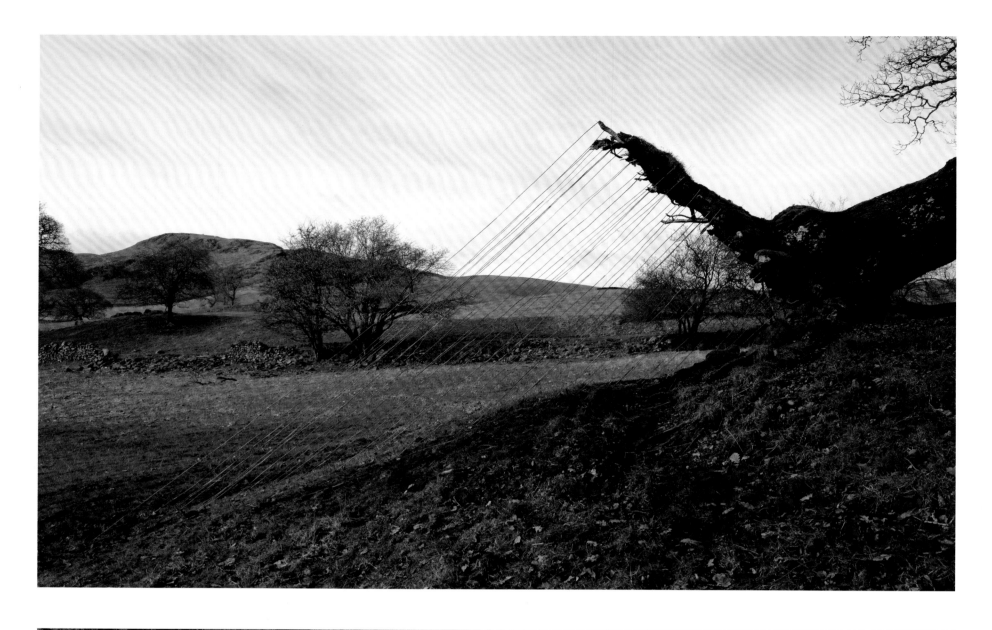

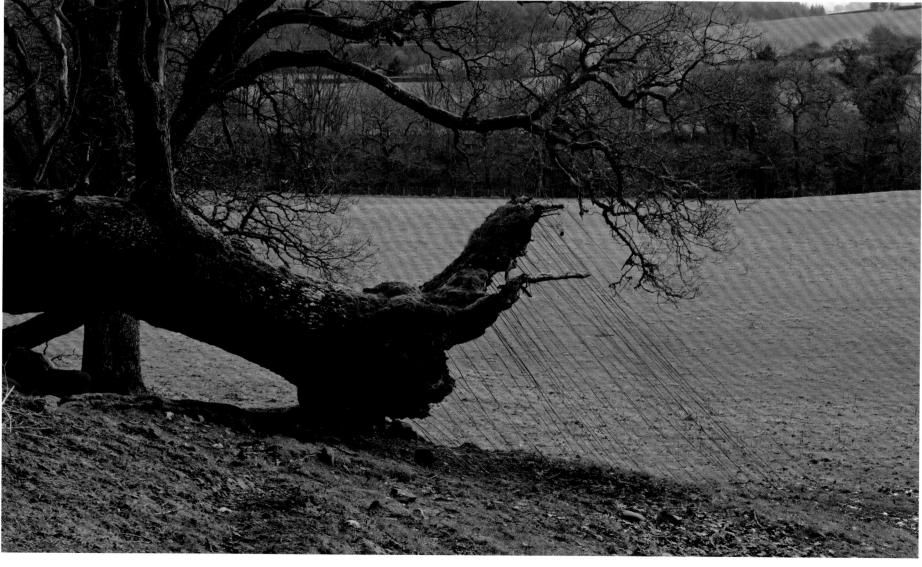

NETTLE STALKS. JOINED TO MAKE LINES. DRAWING THE SPACE BETWEEN UPROOTED OAK TREE AND THE FIELD FROM WHICH IT GREW. CALM TO BEGIN WITH BUT STRENGTHENING WIND BROUGHT WORK TO AN EARLY CONCLUSION. DUMFRIESSHIRE, SCOTLAND. 10 FEBRUARY 2014

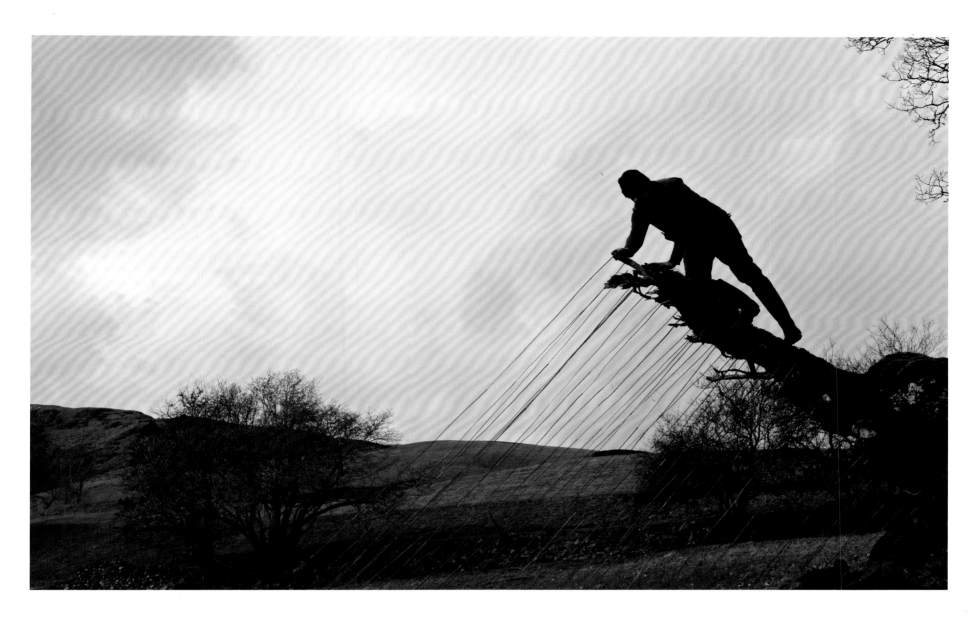

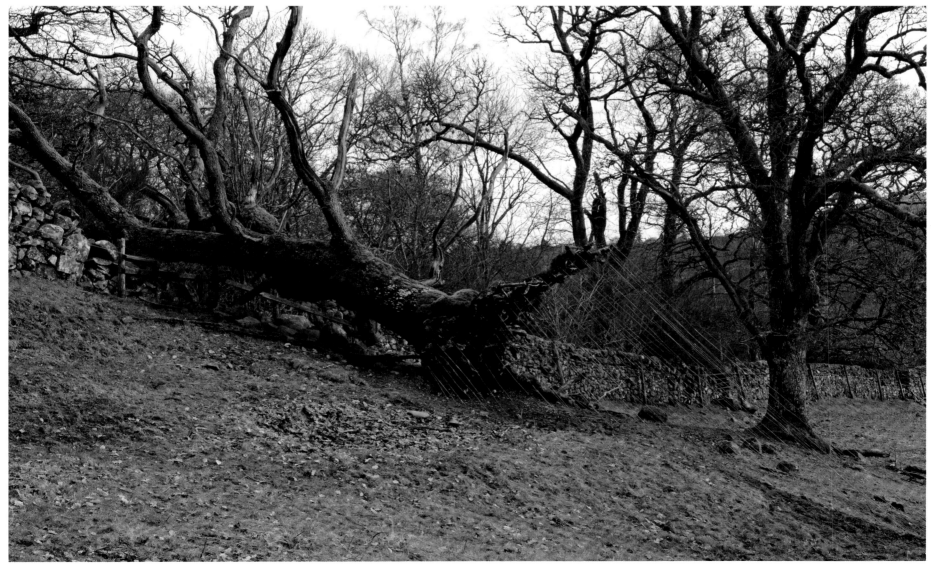

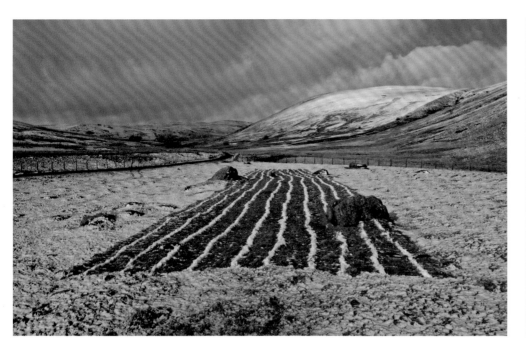

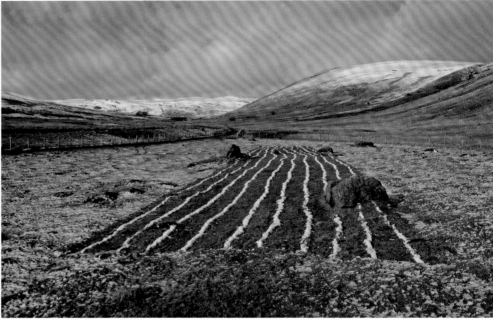

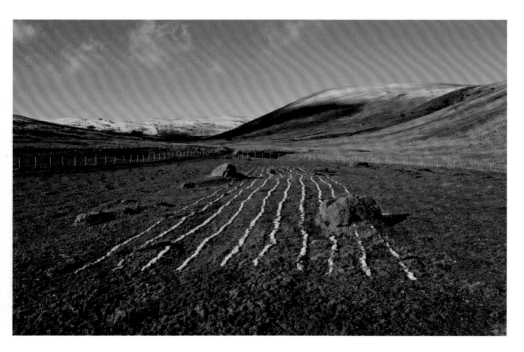

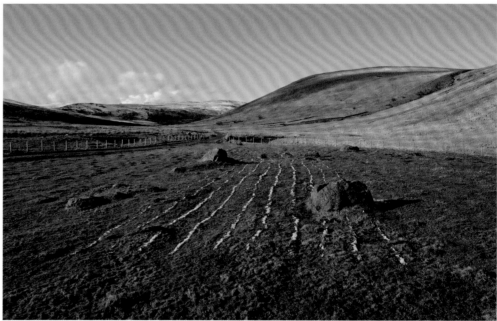

OVERNIGHT SNOW. GATHERED INTO LINES. MELTING QUICKLY. DUMFRIESSHIRE, SCOTLAND. 11 FEBRUARY 2014

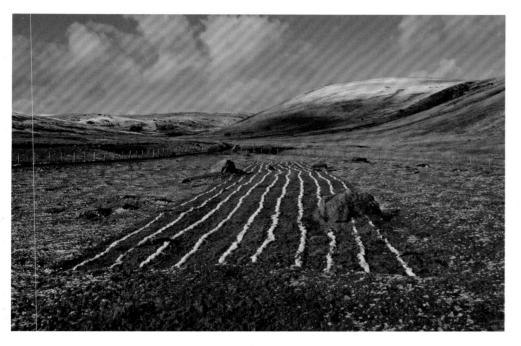
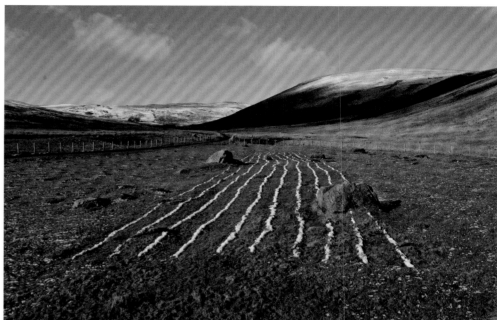
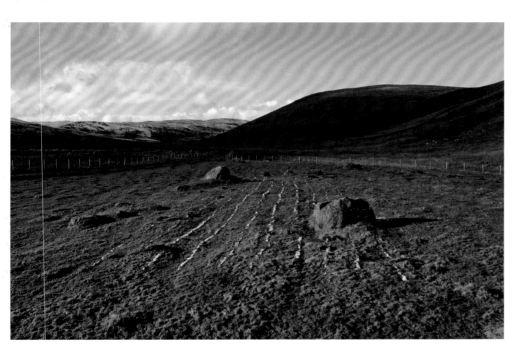
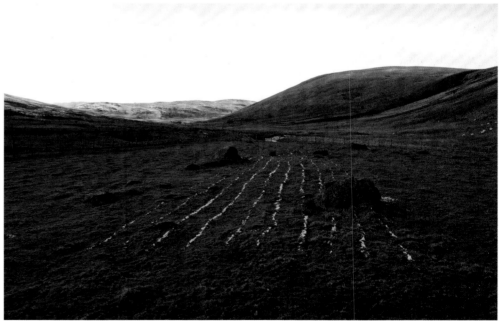

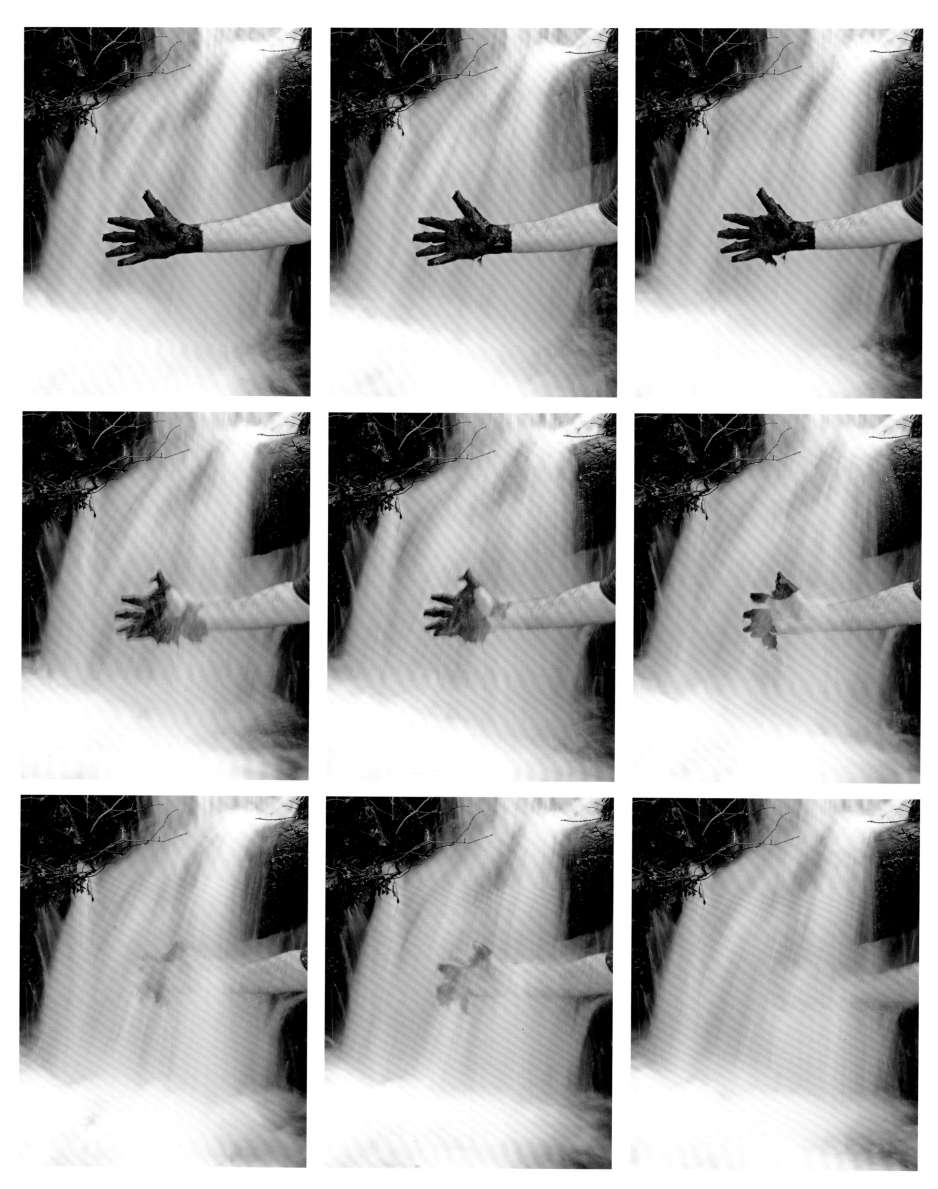

ELM LEAVES (ABOVE). MUD (OPPOSITE). DUMFRIESSHIRE, SCOTLAND. 13 FEBRUARY 2014.

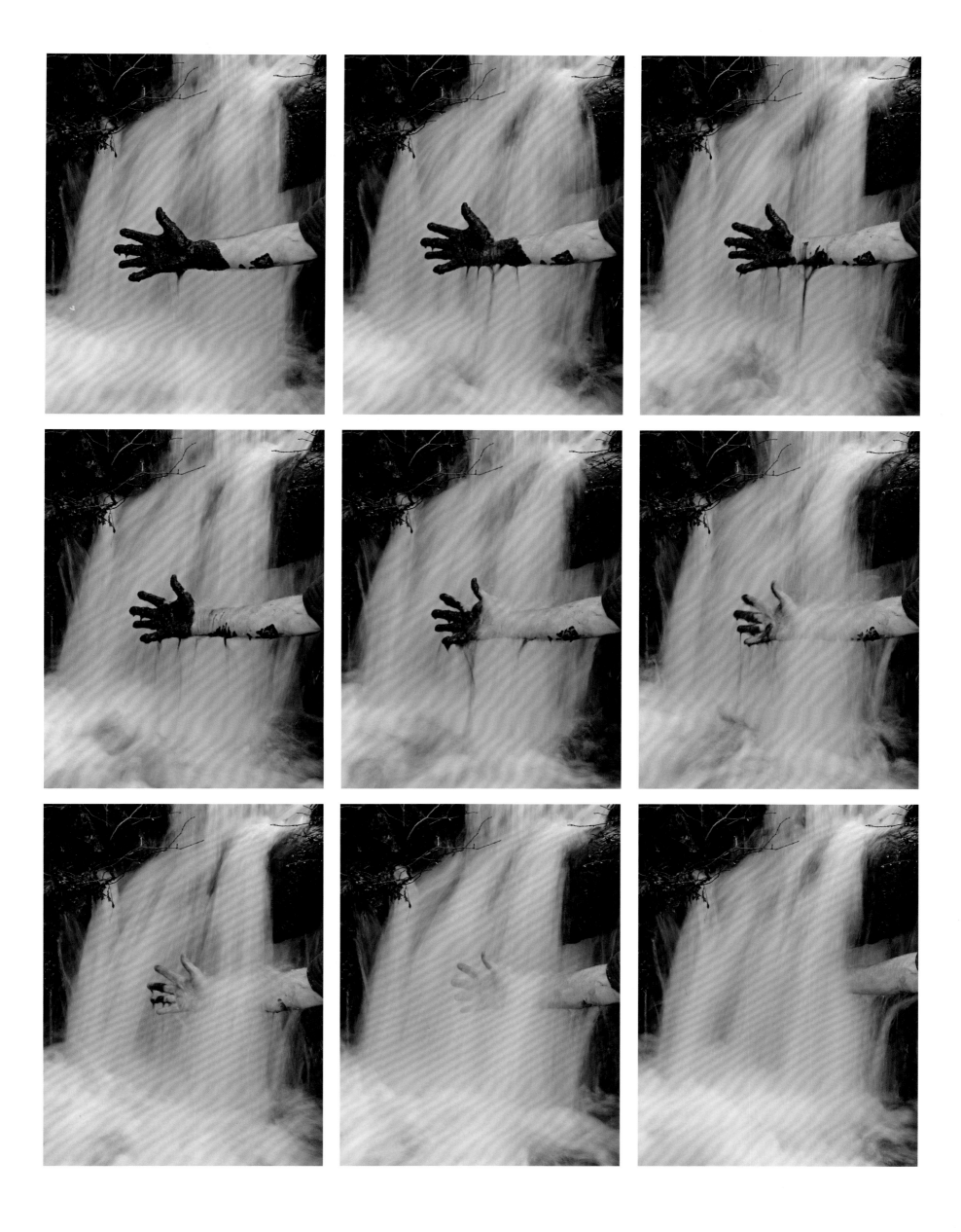

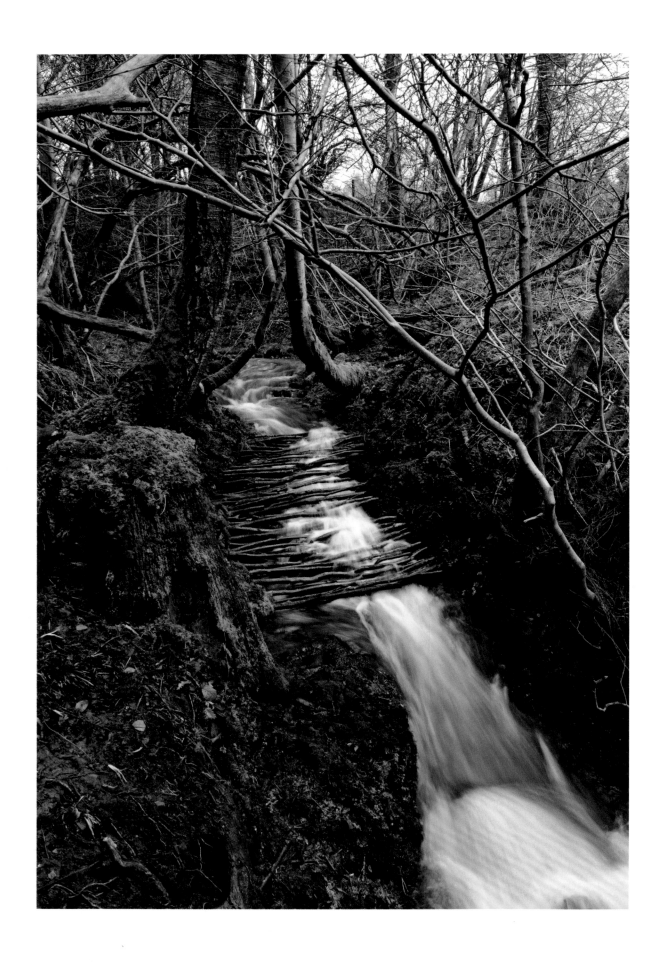

BRANCHES LAID OVER A WATERFALL. DUMFRIESSHIRE, SCOTLAND. 25 FEBRUARY 2014

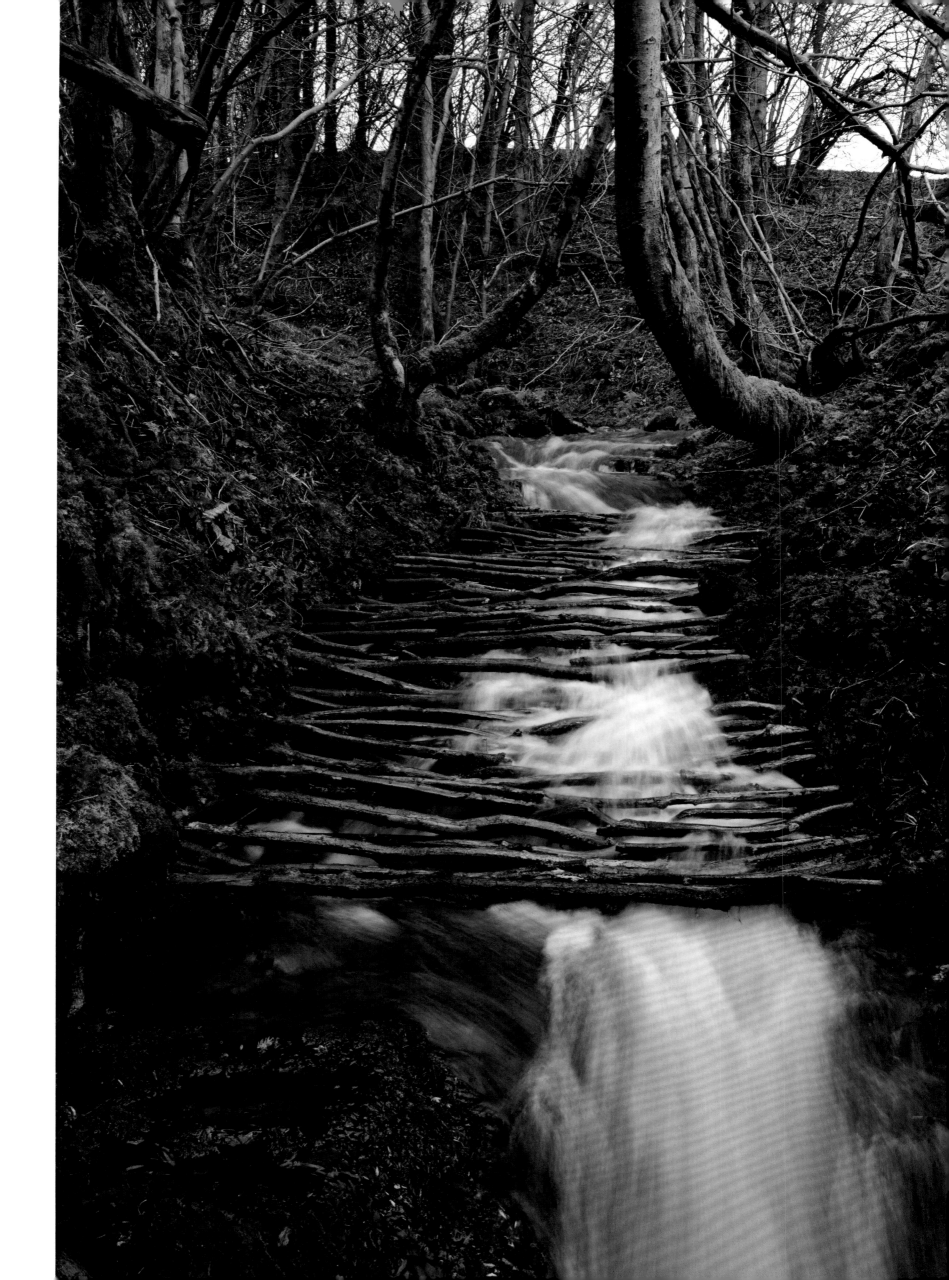

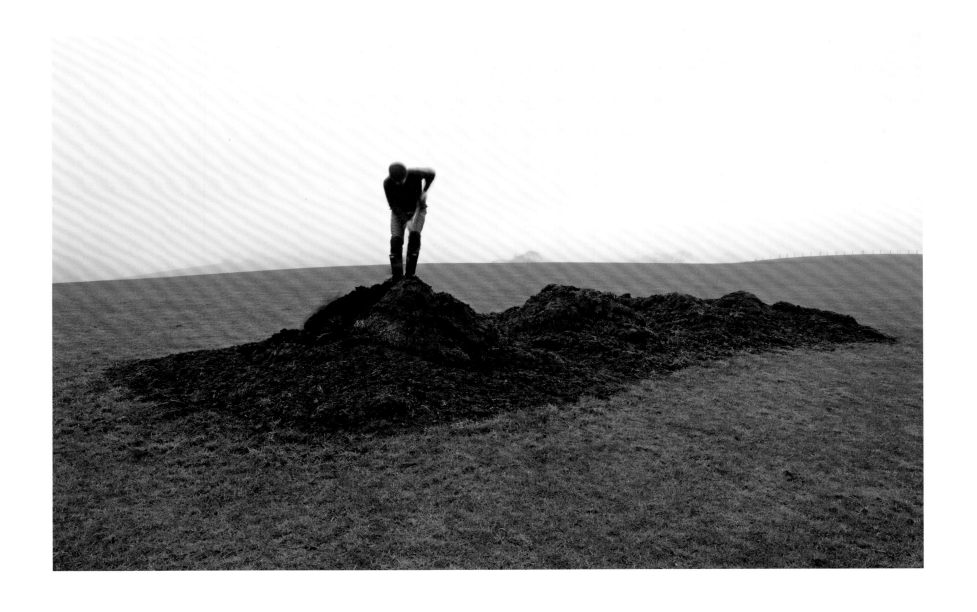

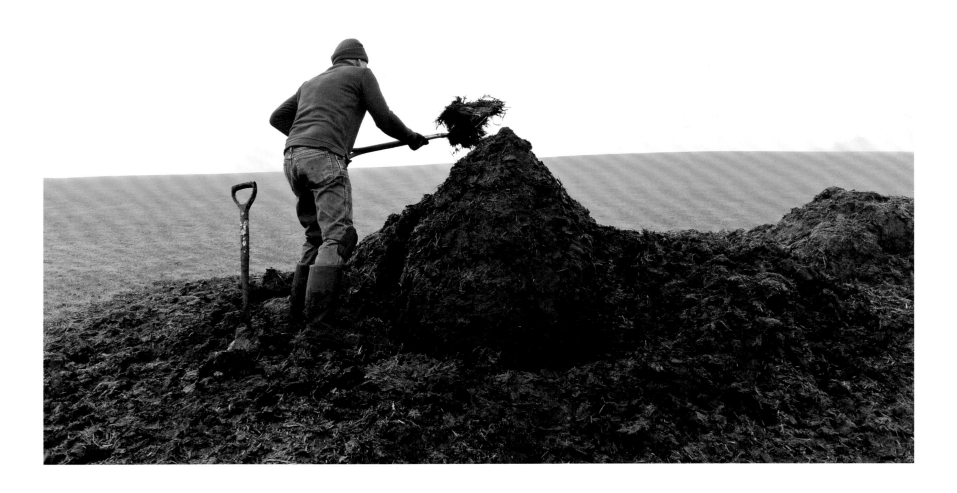

CAIRN. DUG, CUT, CARVED AND COMPACTED OUT OF A WELL-ROTTED MUCK HEAP. DUMFRIESSHIRE, SCOTLAND. 28 FEBRUARY 2014.

(OVERLEAF AND FOLLOWING SPREAD) HEDGE CRAWL AND WALK. DAWN. FROST. COLD HANDS. SINDERBY, ENGLAND. 4 MARCH 2014

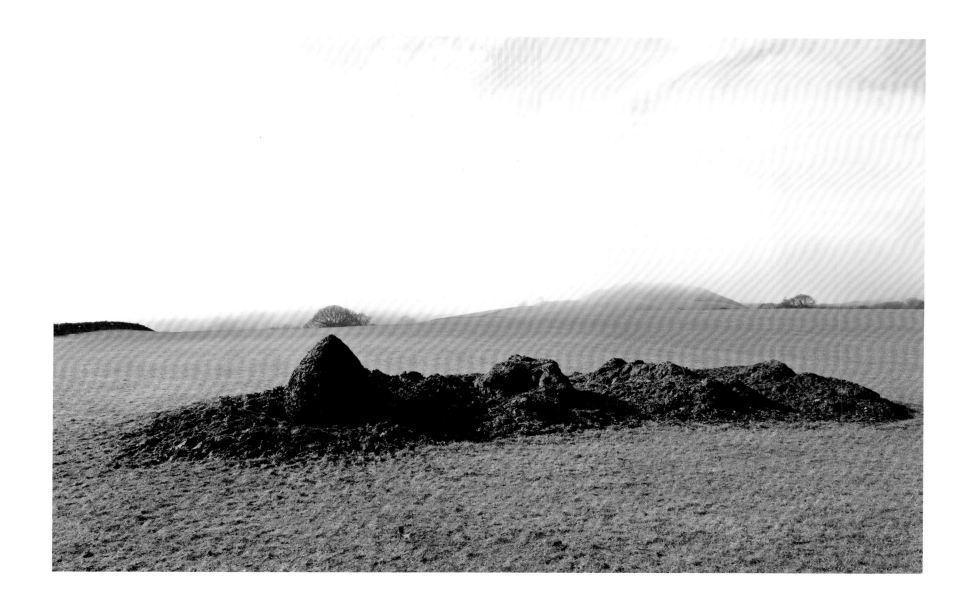

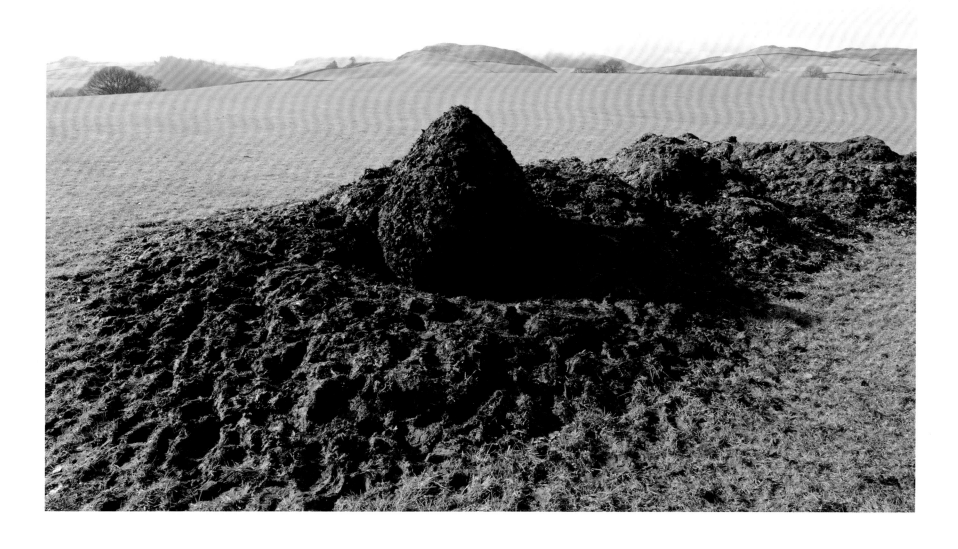

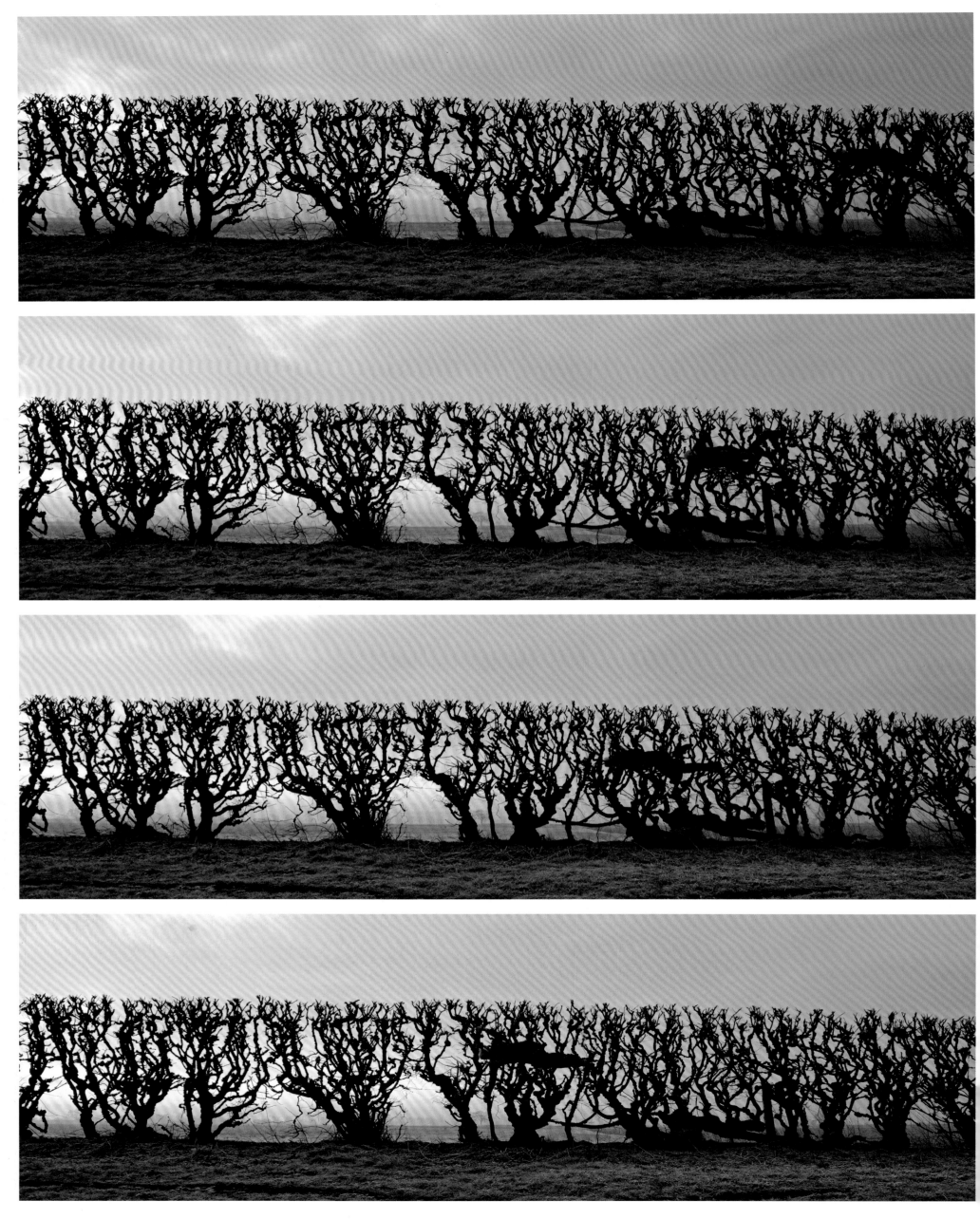

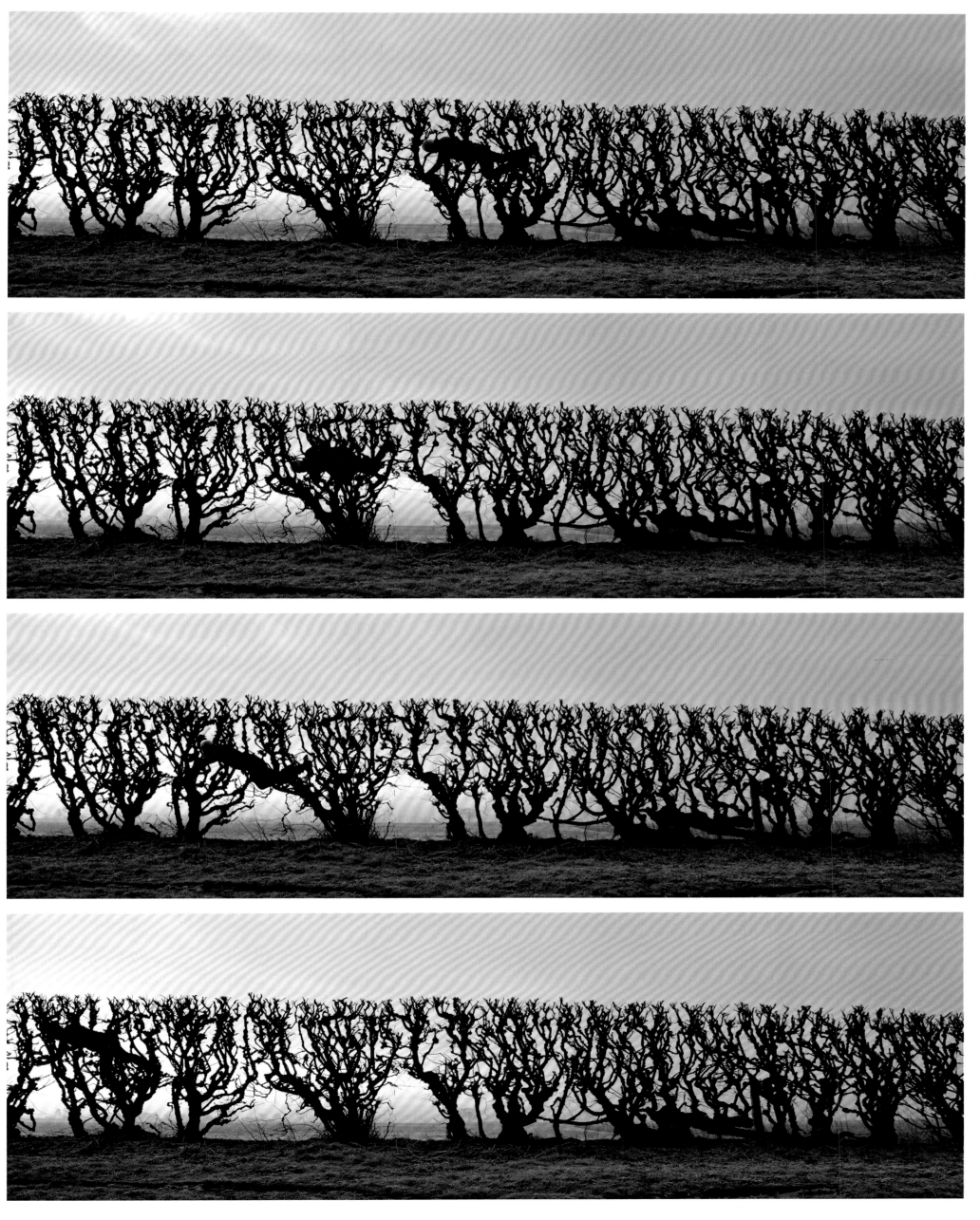

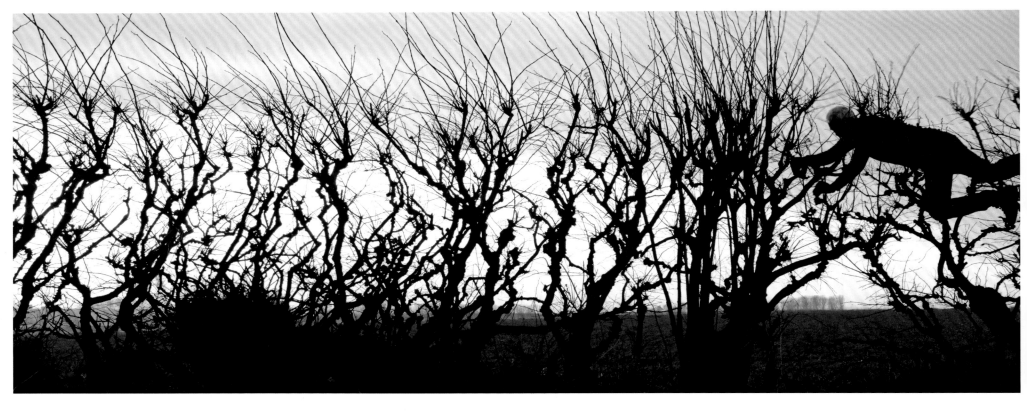

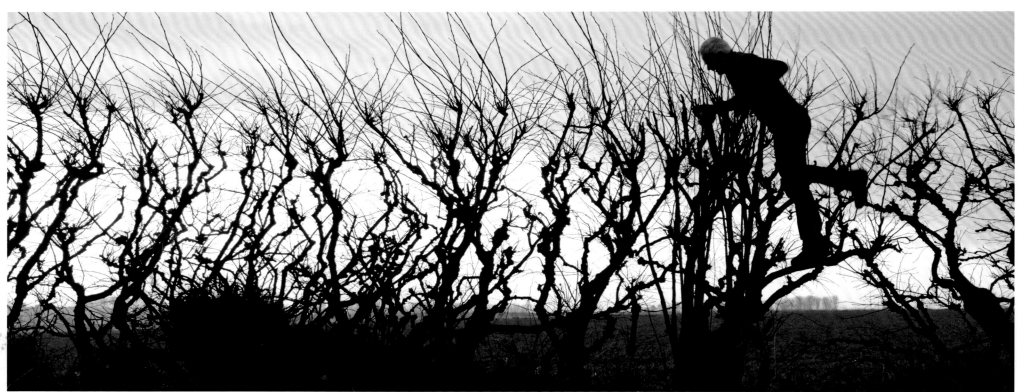

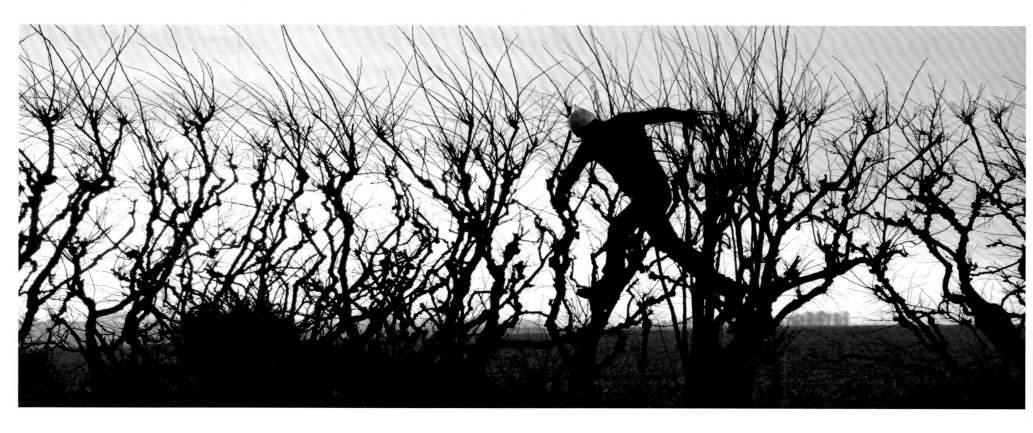

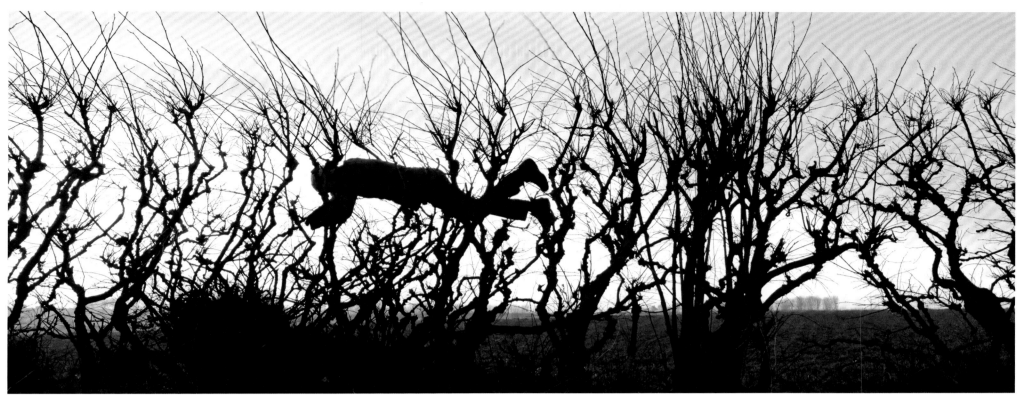

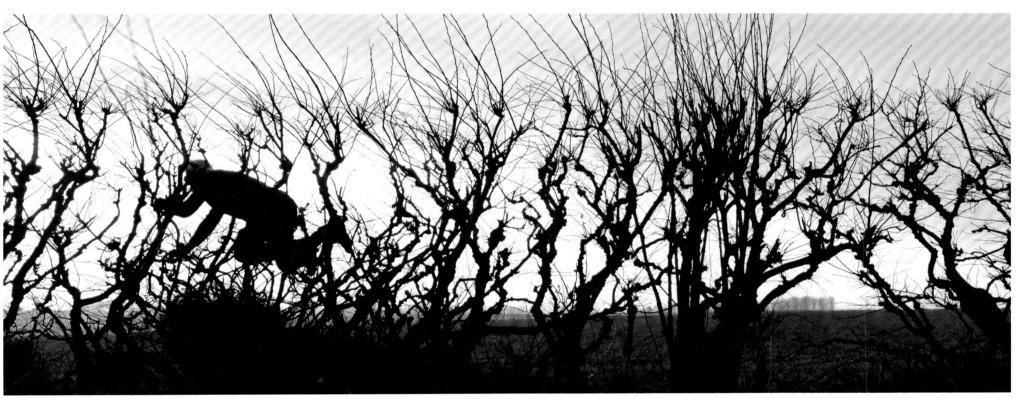

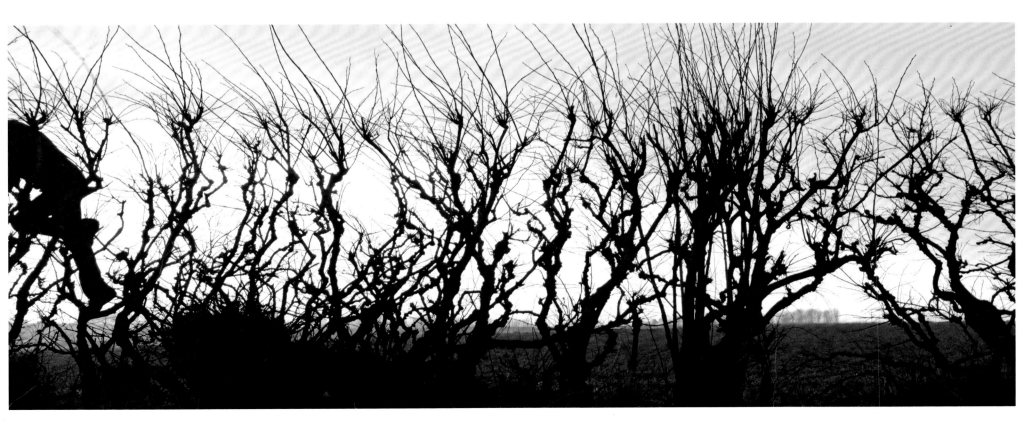

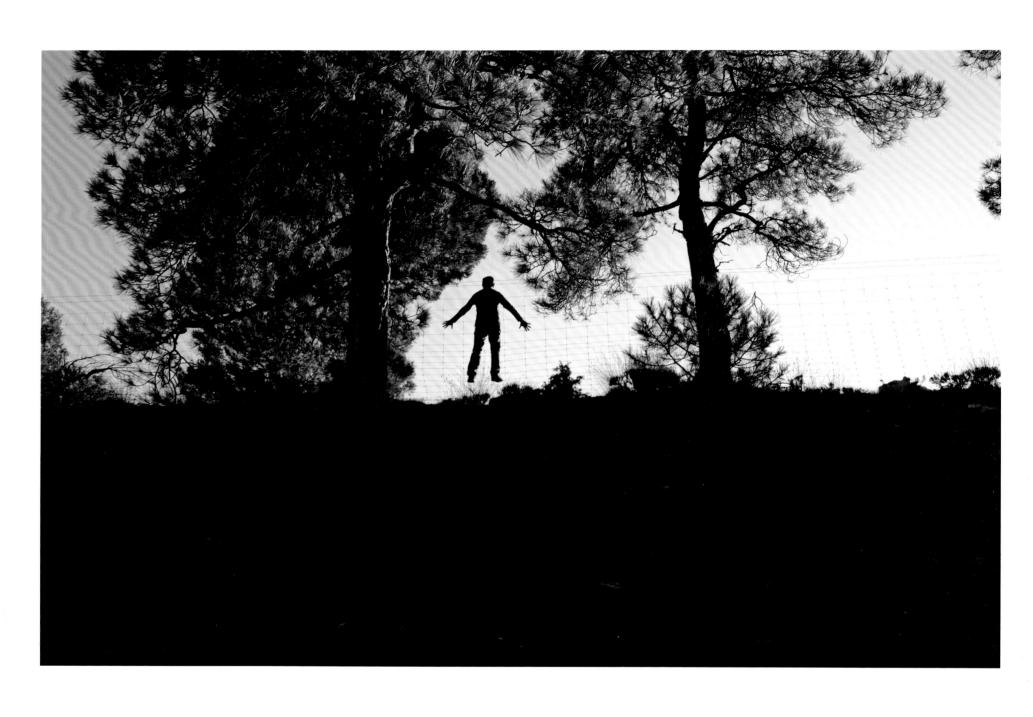

HOLDING STILL ON A FENCE. CUENCA, SPAIN. 9 MARCH 2014

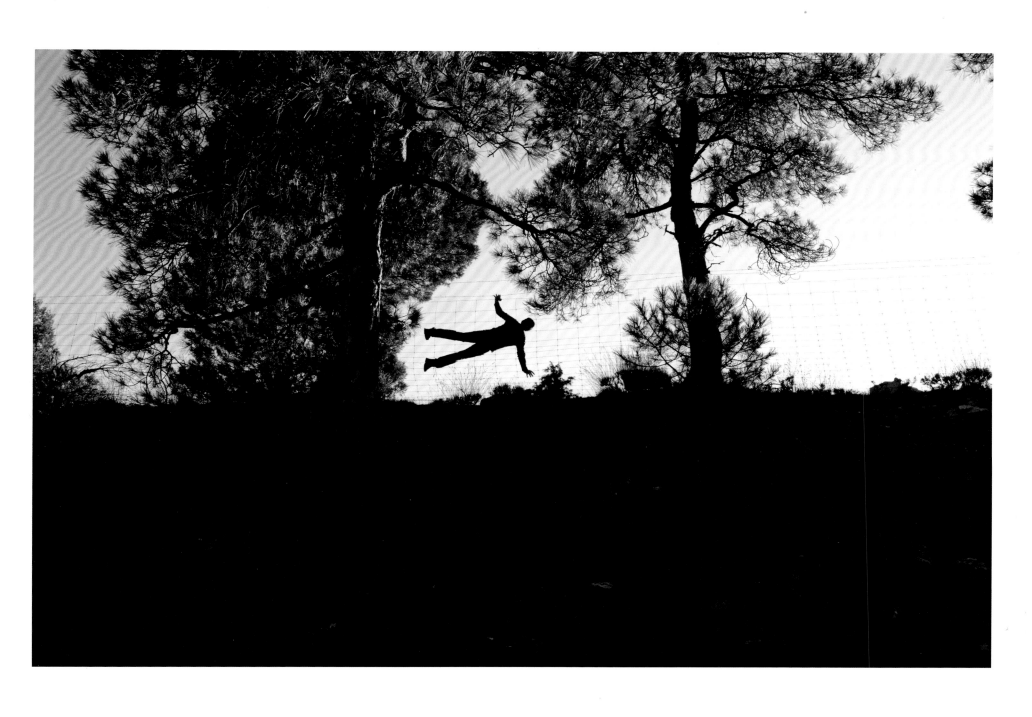

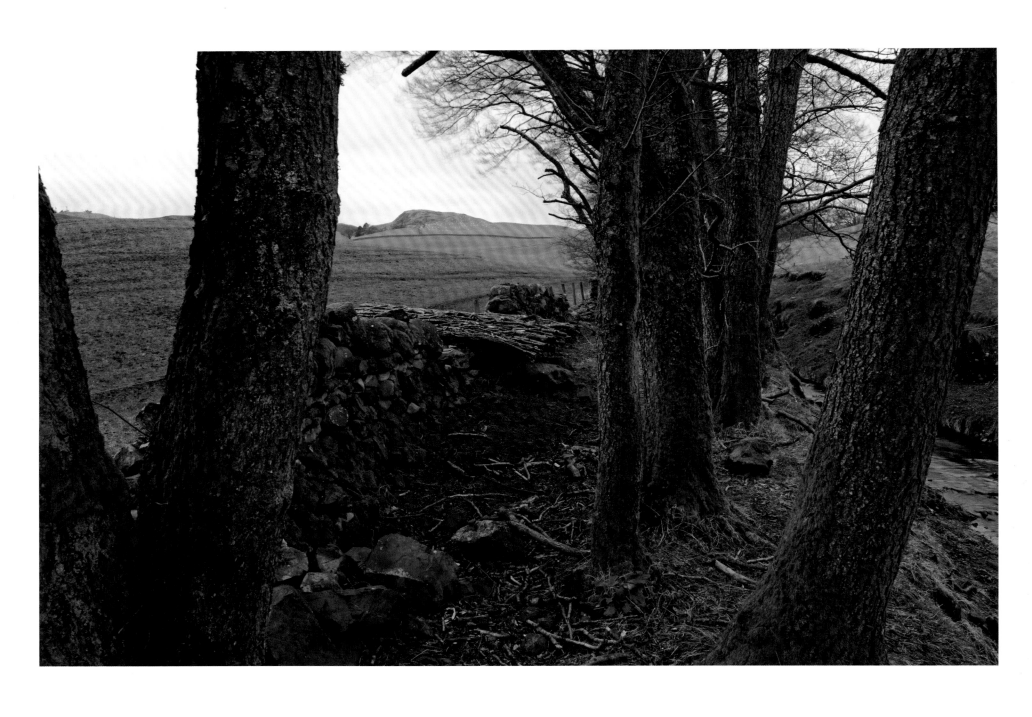

BRANCHES. SUSPENDED BETWEEN WIRE FENCE AND STONE WALL. DUMFRIESSHIRE, SCOTLAND. 14 MARCH 2014

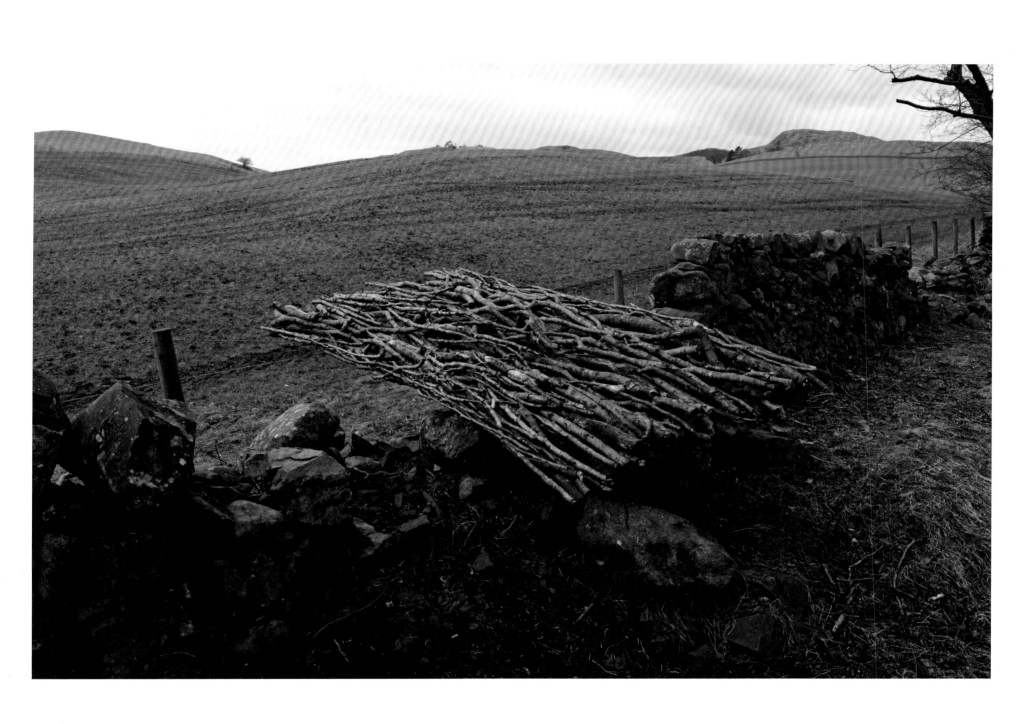

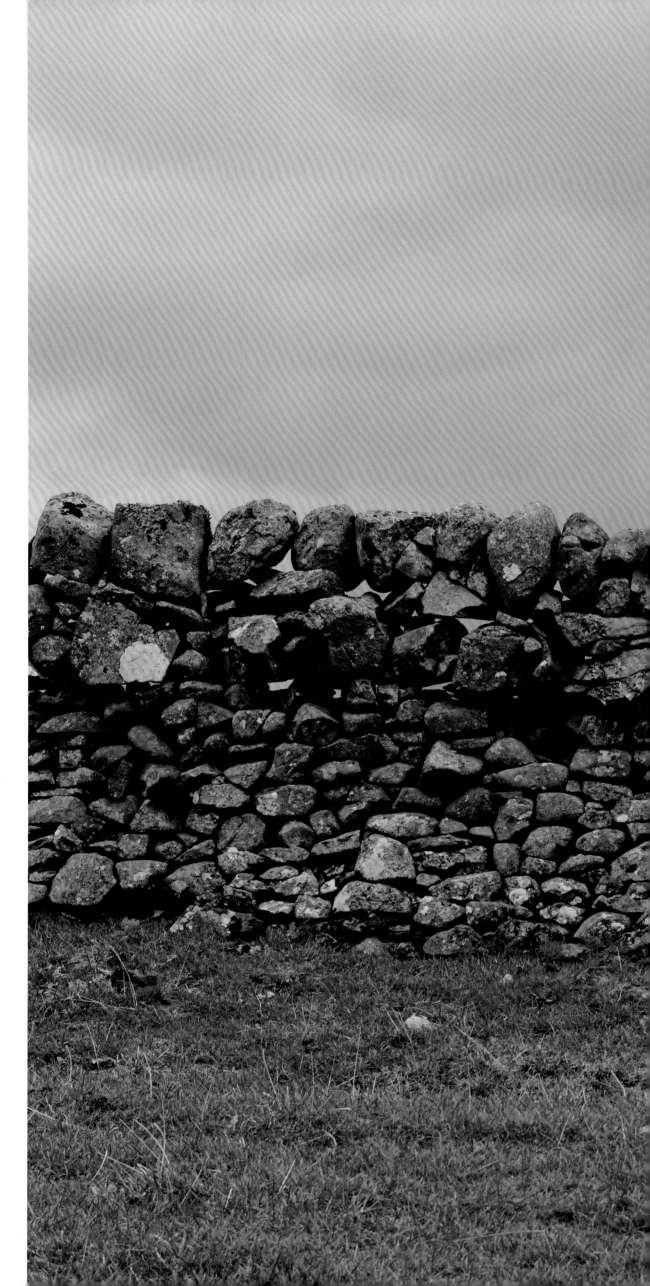

HOLE IN WALL. FORMED WITH MUD. DUMFRIESSHIRE, SCOTLAND. 17 MARCH 2014

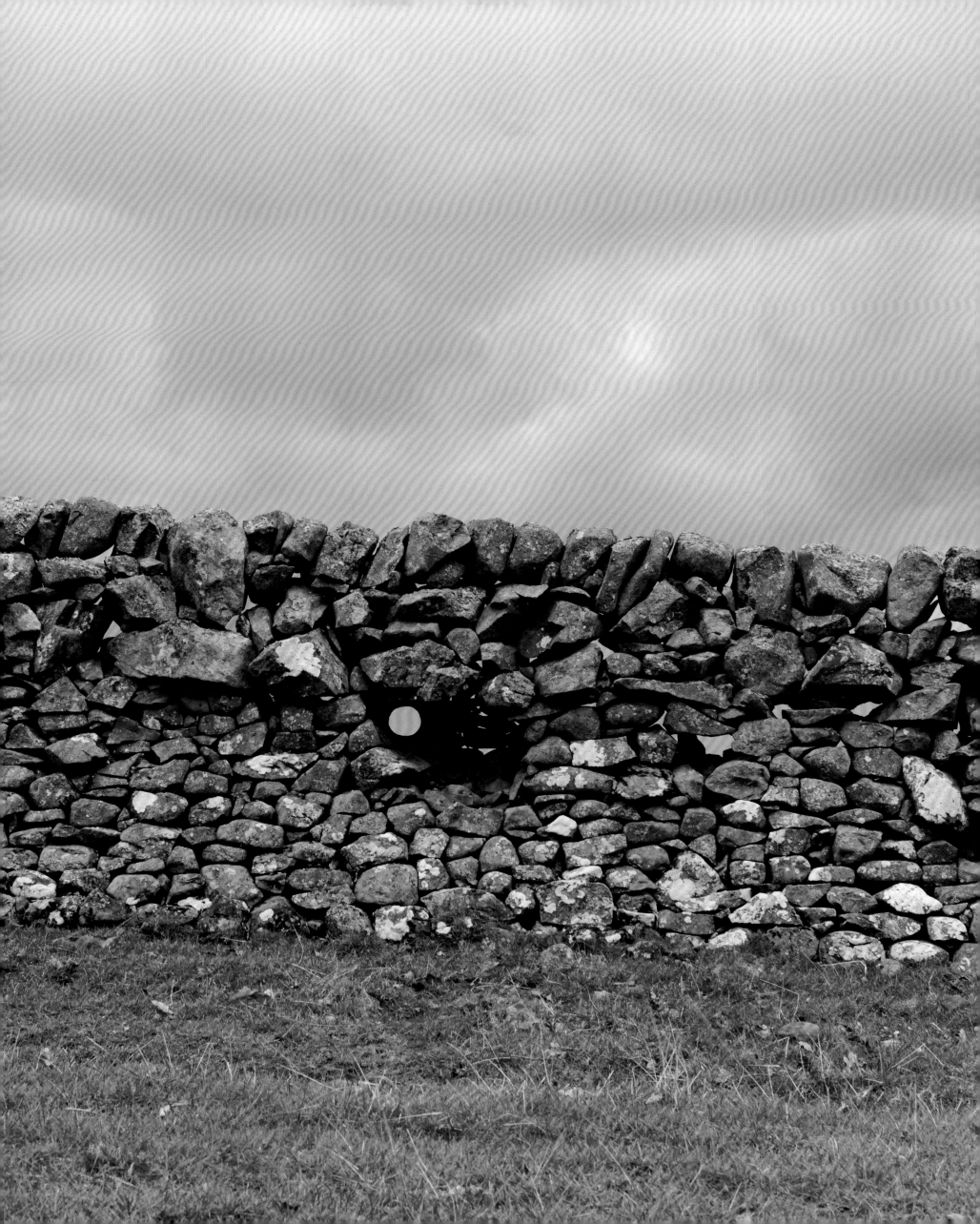

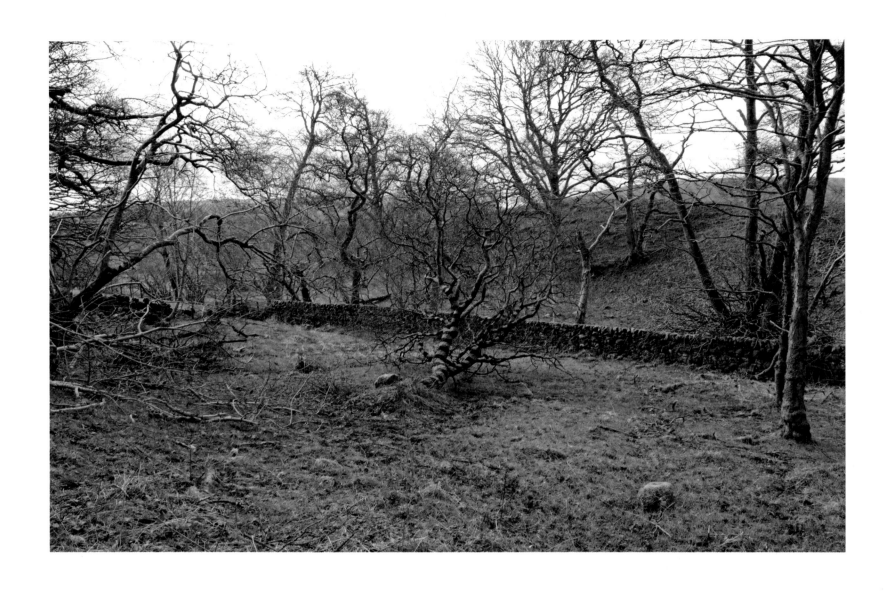

TREE PAINTED WITH BLACK MUD. COLLECTED FROM NEARBY BOG. DUMFRIESSHIRE, SCOTLAND. 21 MARCH 2014

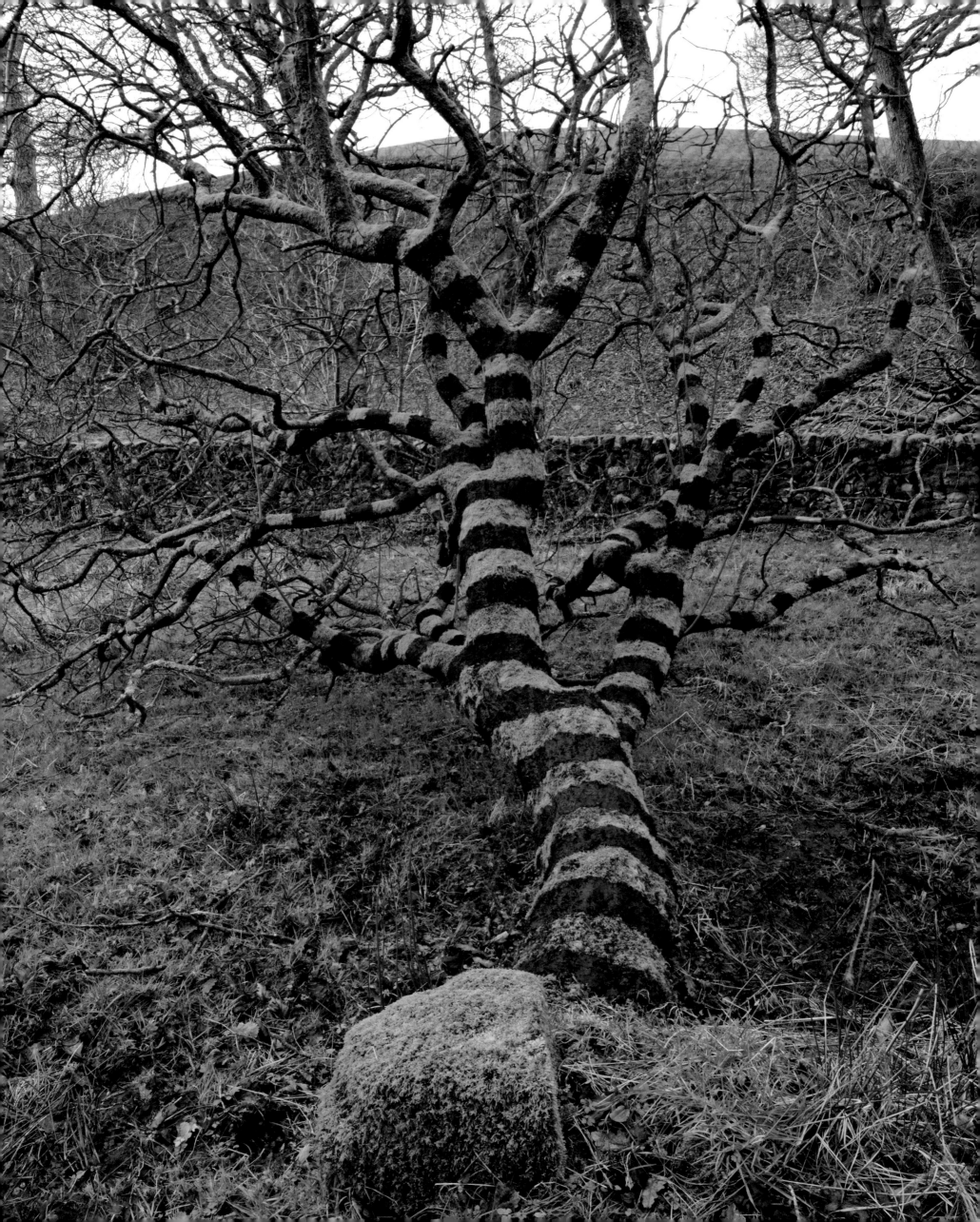

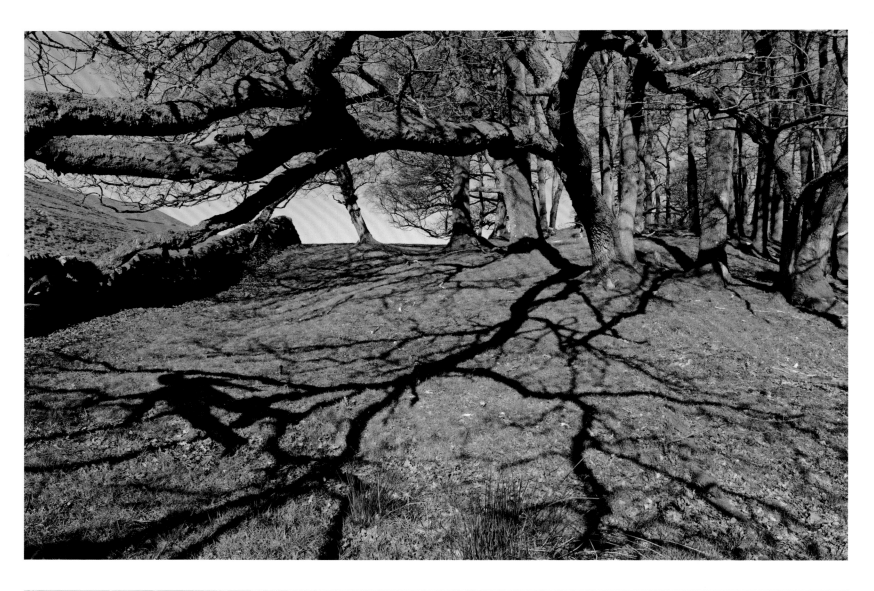

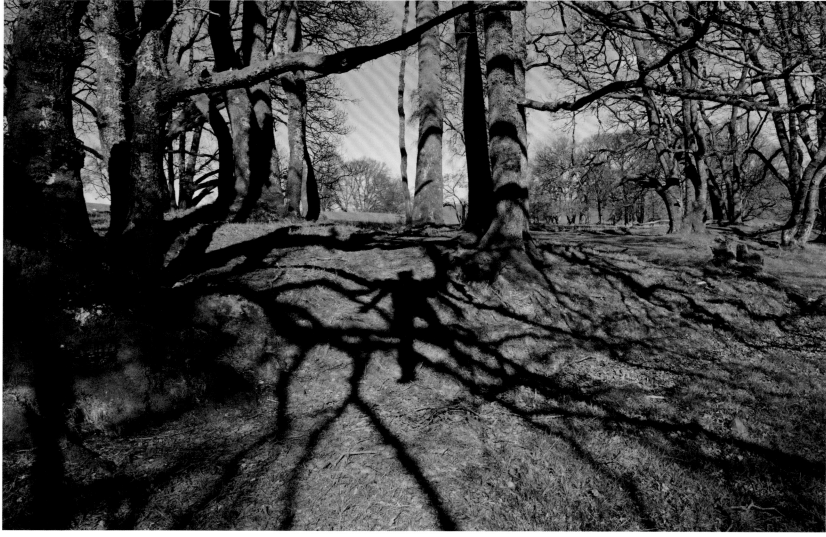

LAID ACROSS OAK BOUGHS TO MAKE SHADOWS ON THE GROUND BELOW. DUMFRIESSHIRE, SCOTLAND. 19 APRIL 2014

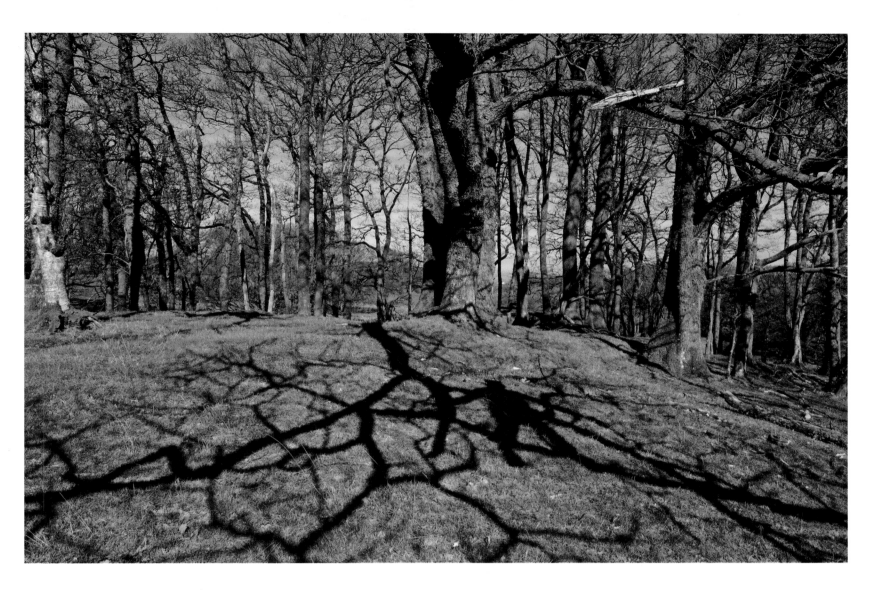
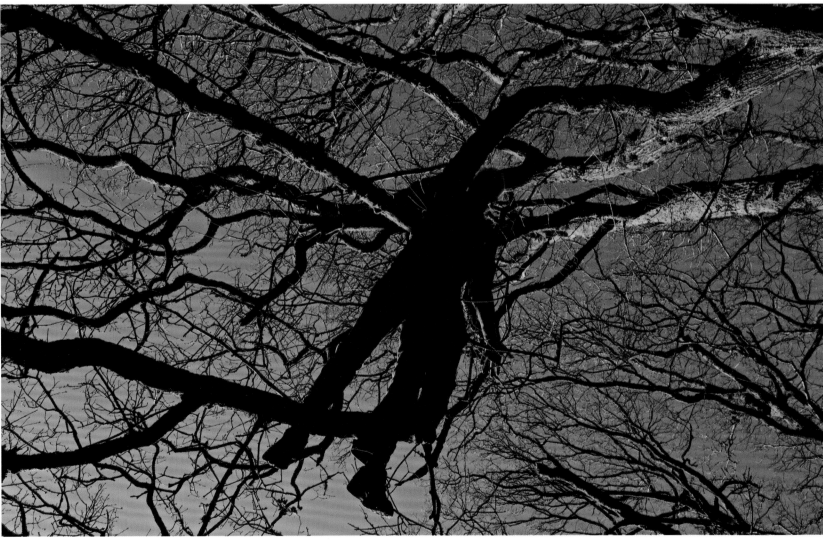

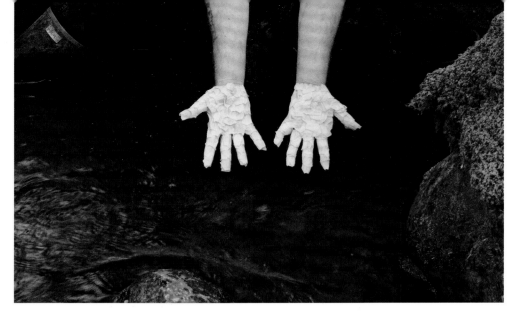
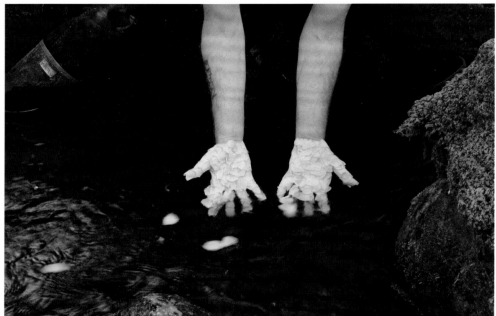
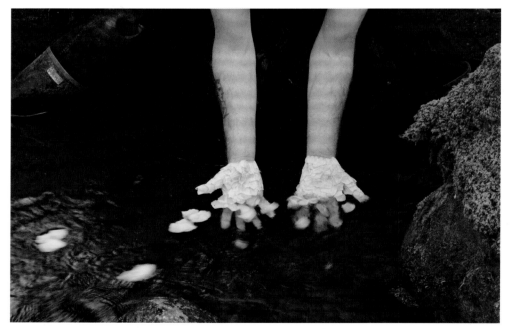
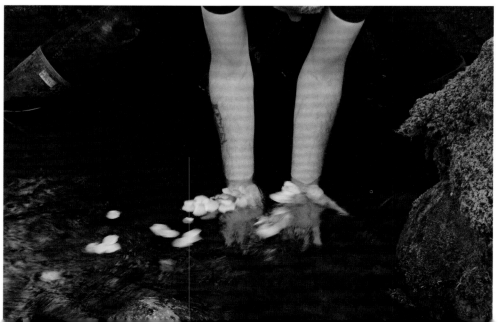

POPPY PETALS AND ELM LEAVES. LEFT HAND WRAPPED
BY ME. RIGHT HAND BY MY DAUGHTER.
FOR ANDREW CAUSEY.
DUMFRIESSHIRE, SCOTLAND. 14 MAY 2014

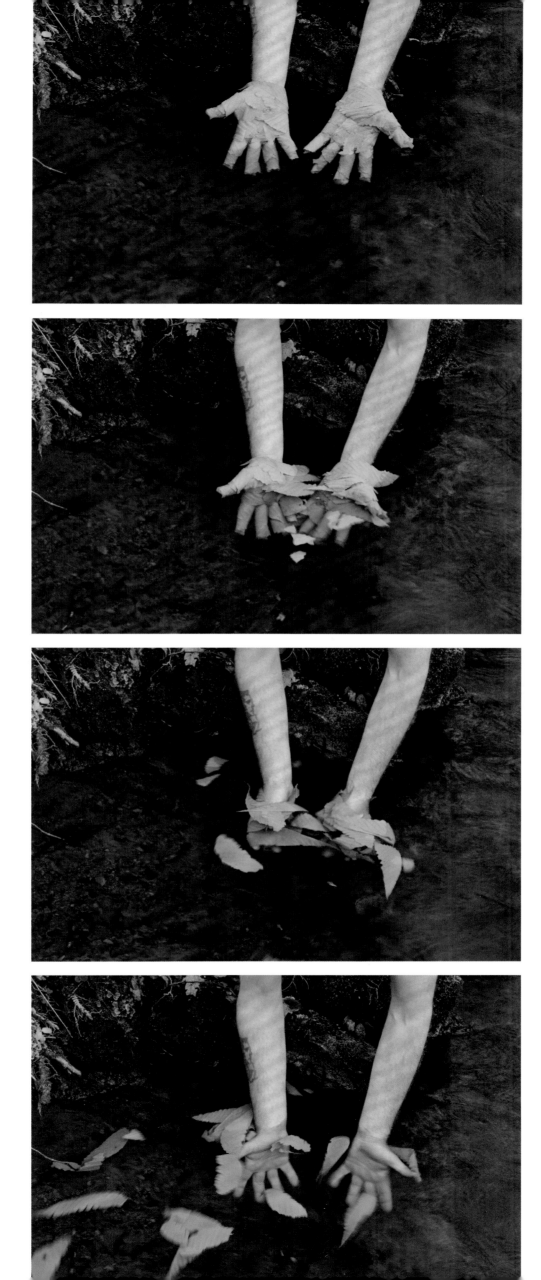

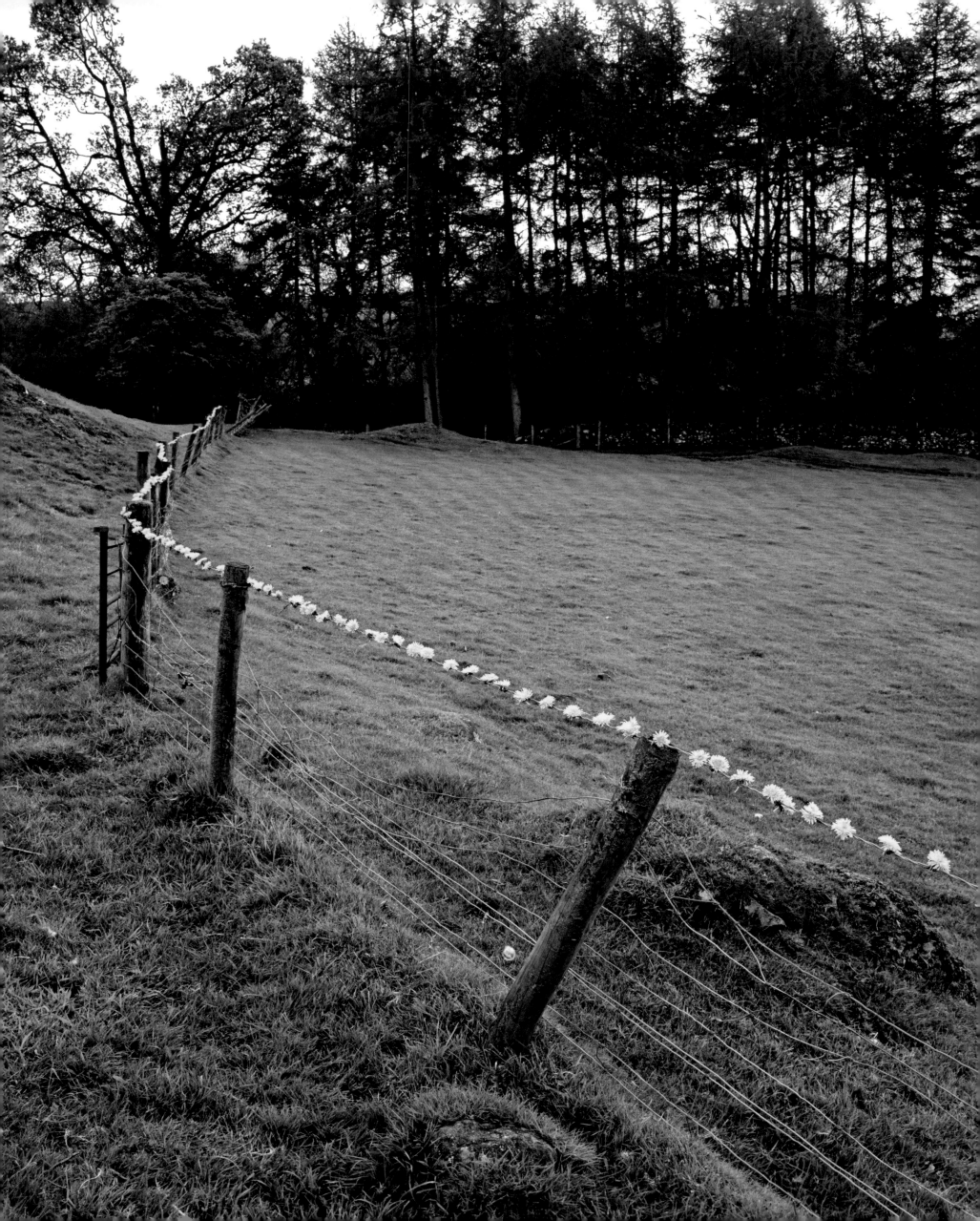

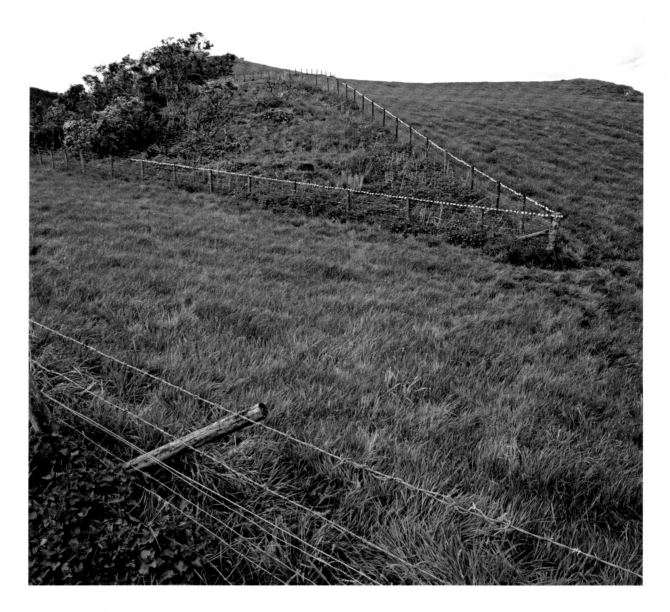

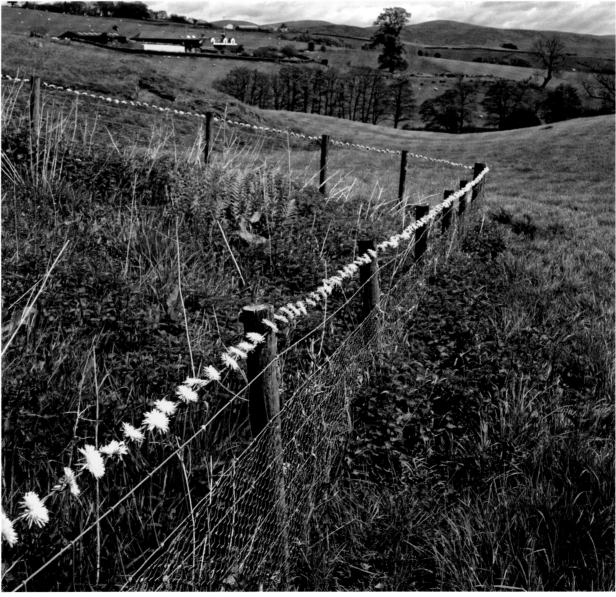

TWO DANDELION LINES. HELD TO THE BARBS OF BARBED WIRE FENCES.
DUMFRIESSHIRE, SCOTLAND. 13, 15 MAY 2014

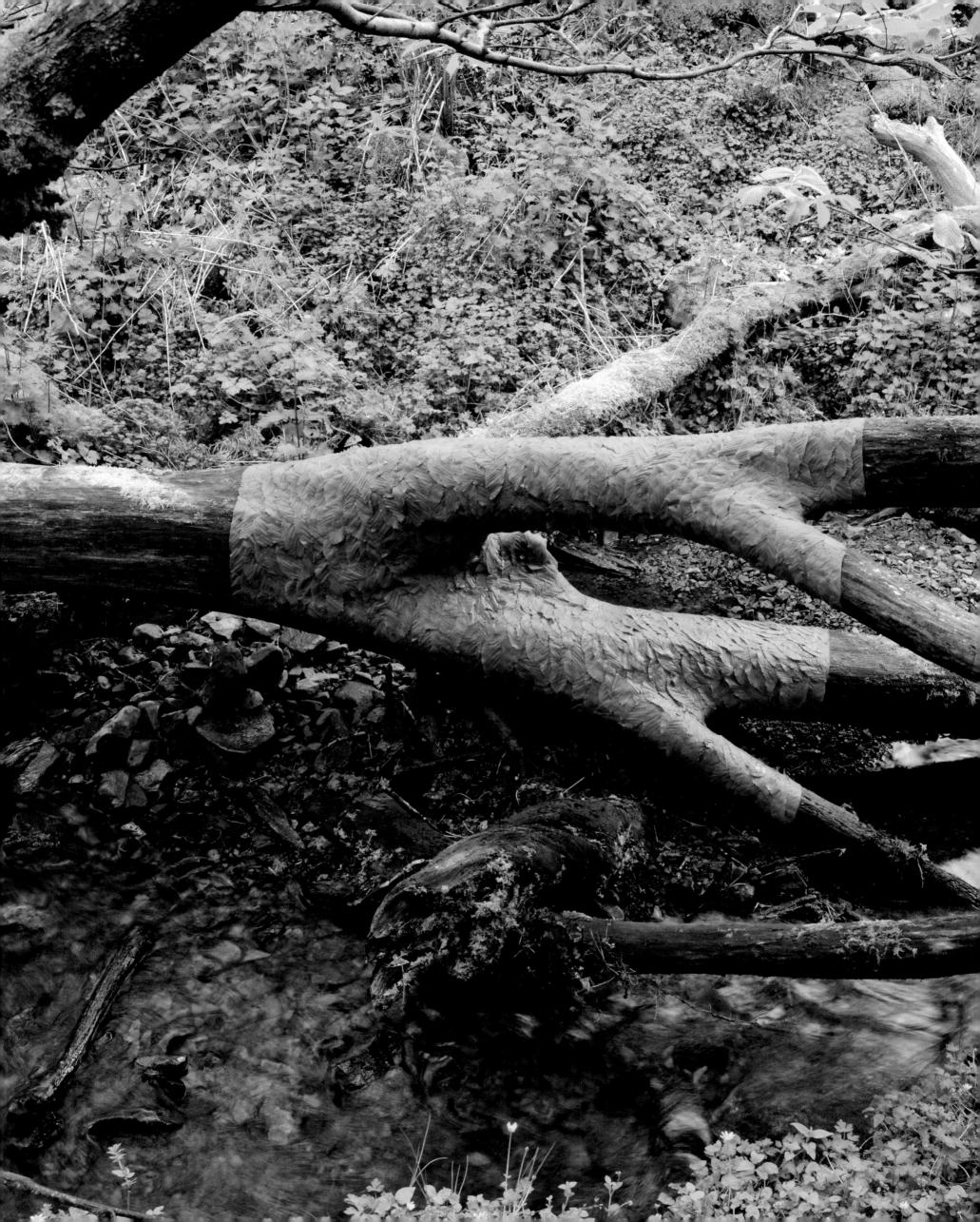

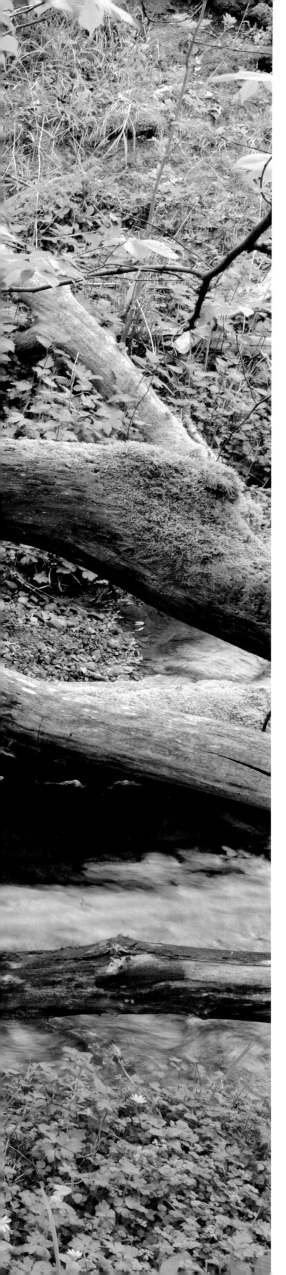
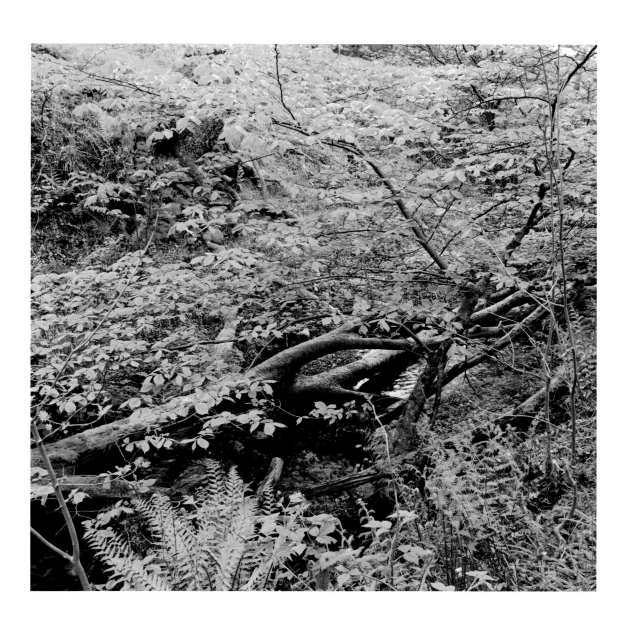

FRESH SPRING-GREEN ELM LEAVES. LAID AROUND A FALLEN ELM TREE. HELD WITH WATER. DUMFRIESSHIRE, SCOTLAND. 16 MAY 2014

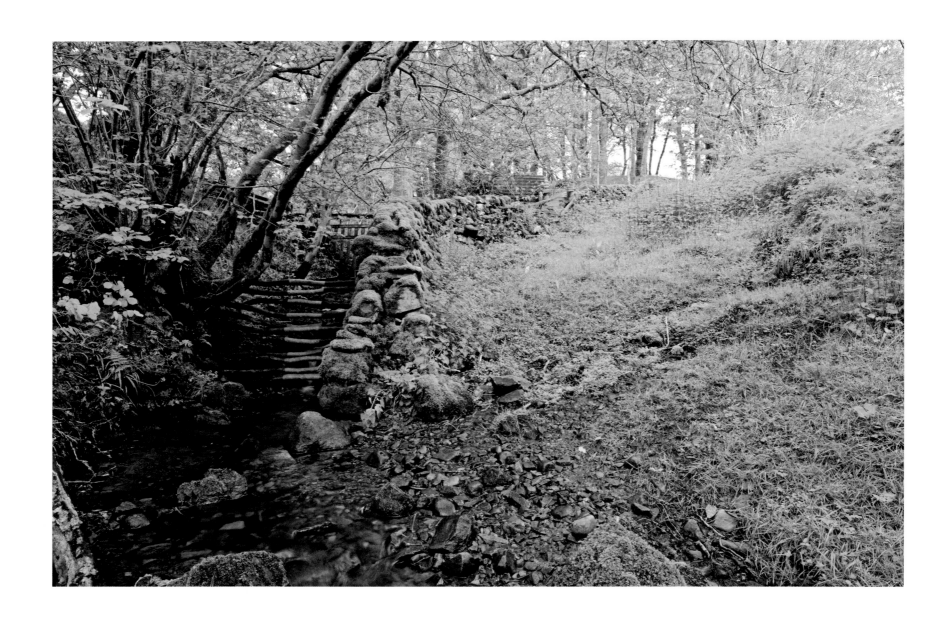

WET ELM LEAVES WRAPPED AROUND ELM BRANCHES. WEDGED BETWEEN WALL AND BANK. DUMFRIESSHIRE, SCOTLAND. 21 MAY 2005

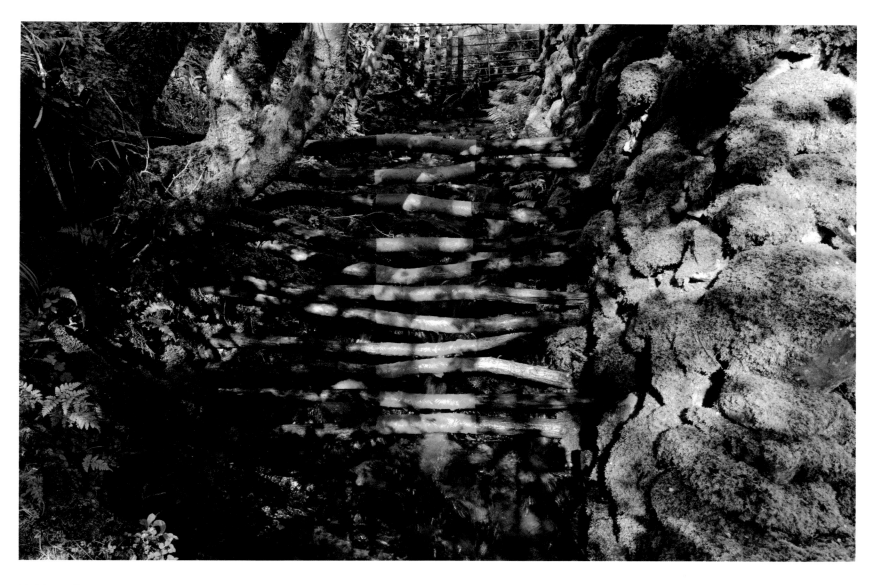

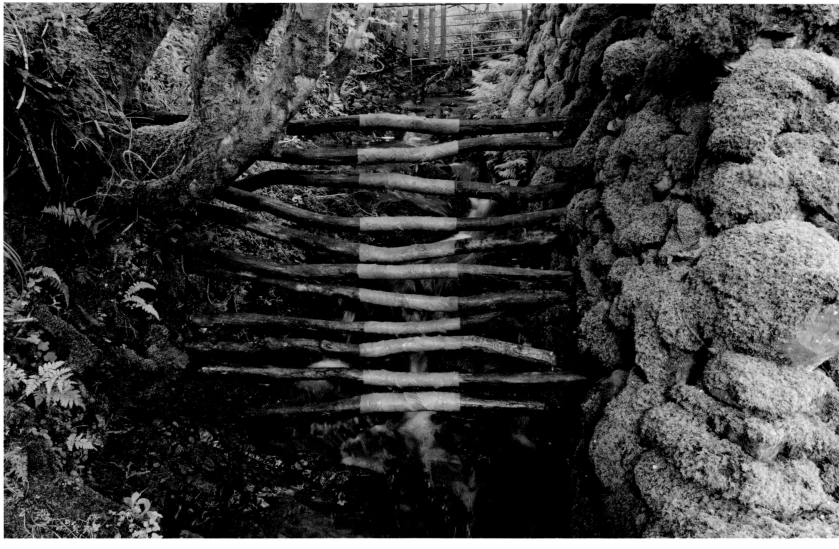

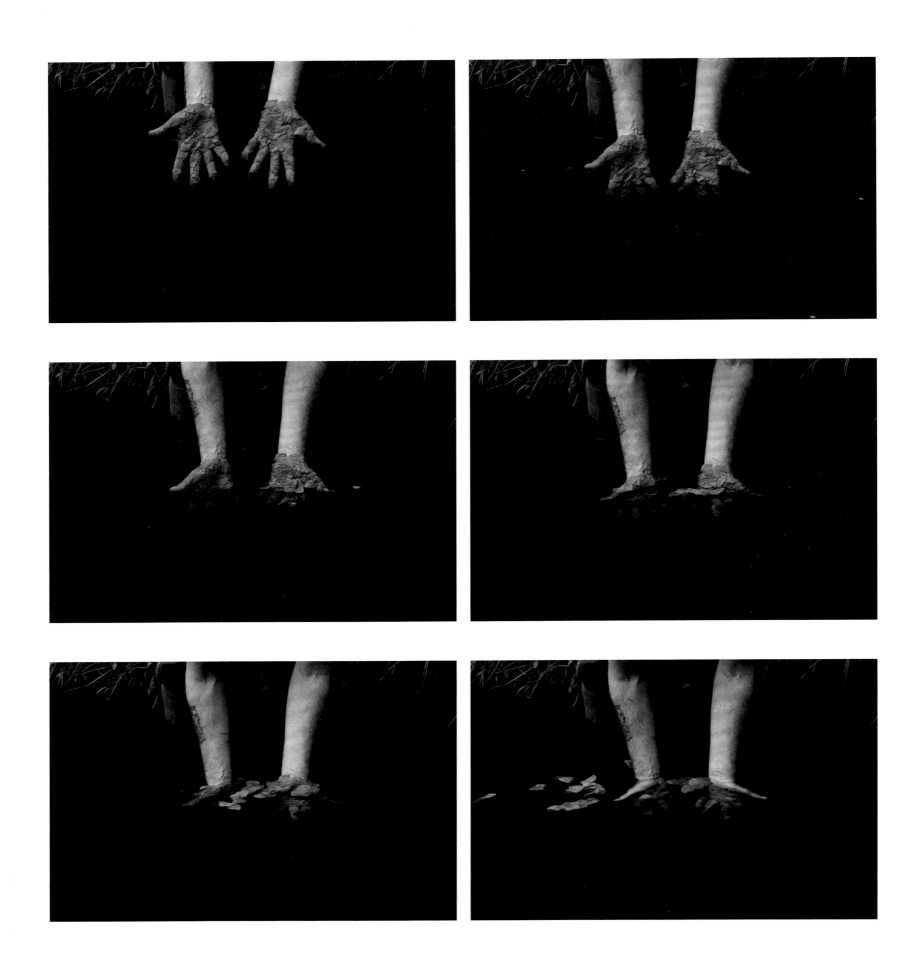

POPPY PETALS. LEFT HAND WRAPPED BY ME. RIGHT HAND BY MY DAUGHTER. WASHED OFF IN TOWNHEAD BURN, DUMFRIESSHIRE. 11 JUNE 2014.
REPEATED THE FOLLOWING DAY IN THE MIDDLE OF RIVER SARK, THE BORDER BETWEEN SCOTLAND AND ENGLAND. 12 JUNE 2014

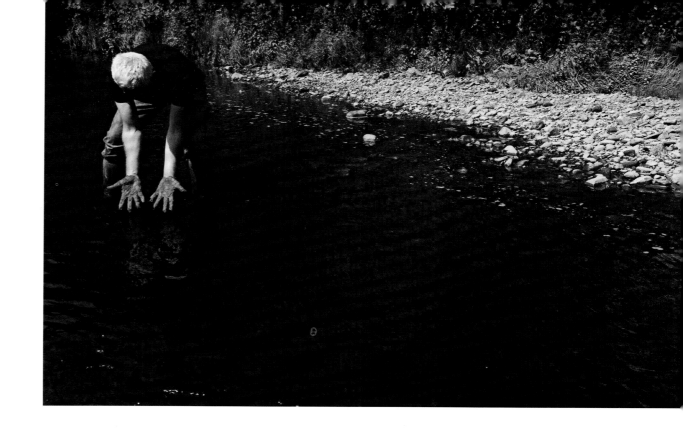

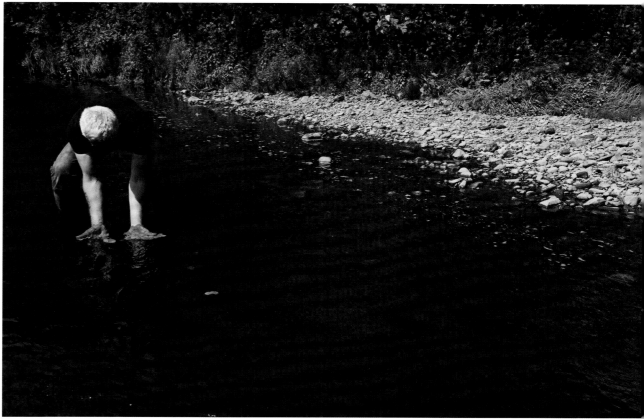

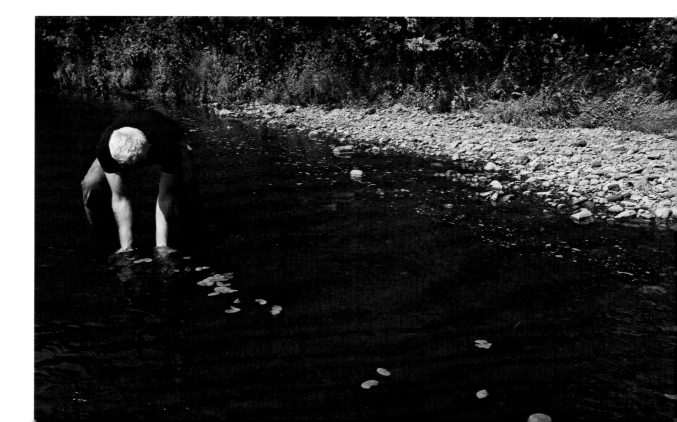

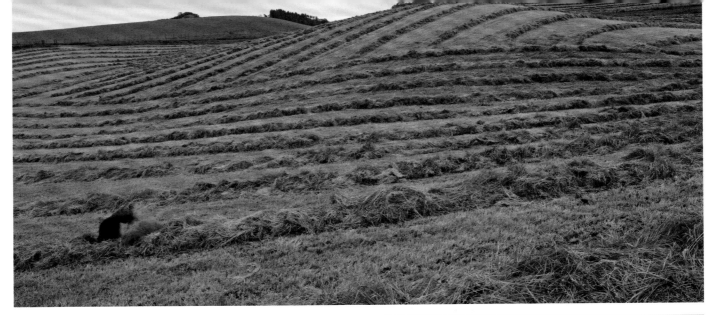

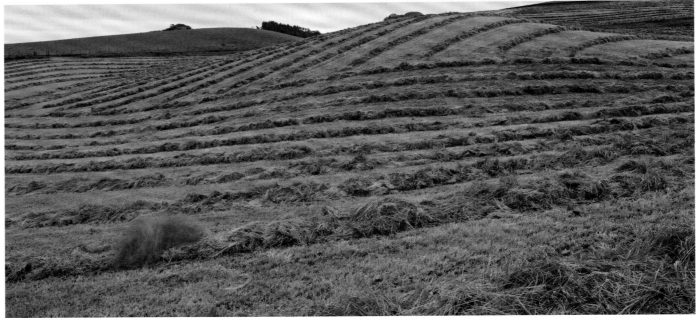

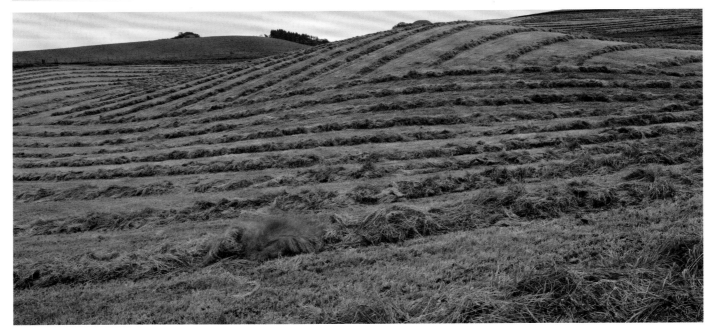

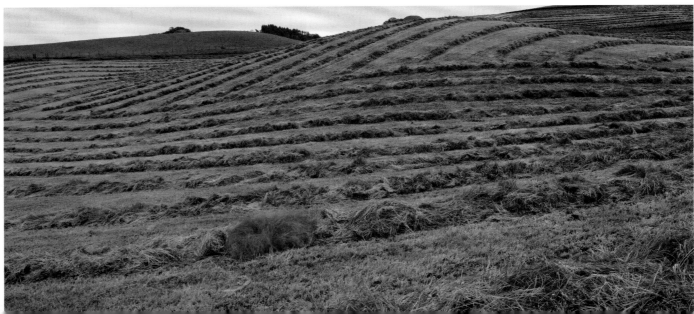

CRAWL THROUGH DAMP, HEAVY,
DENSE, FRESHLY MOWN GRASS.
DUMFRIESSHIRE, SCOTLAND.
12 JUNE 2014

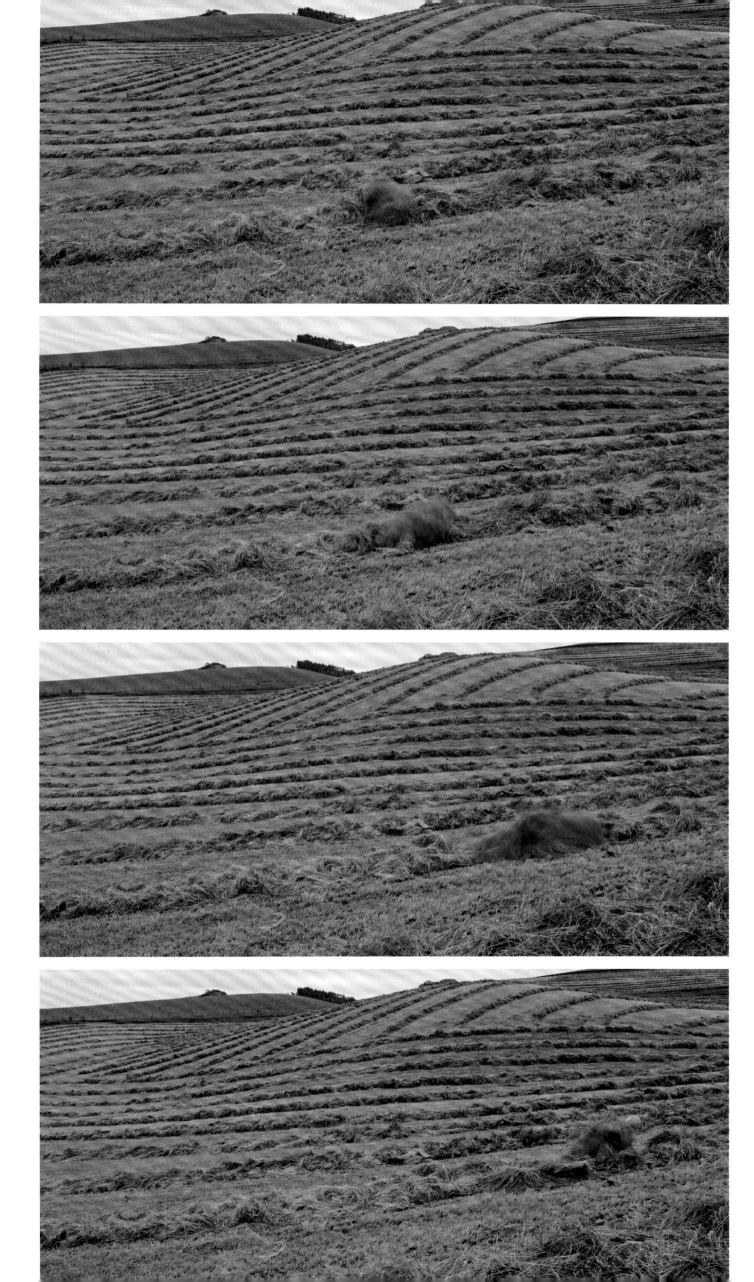

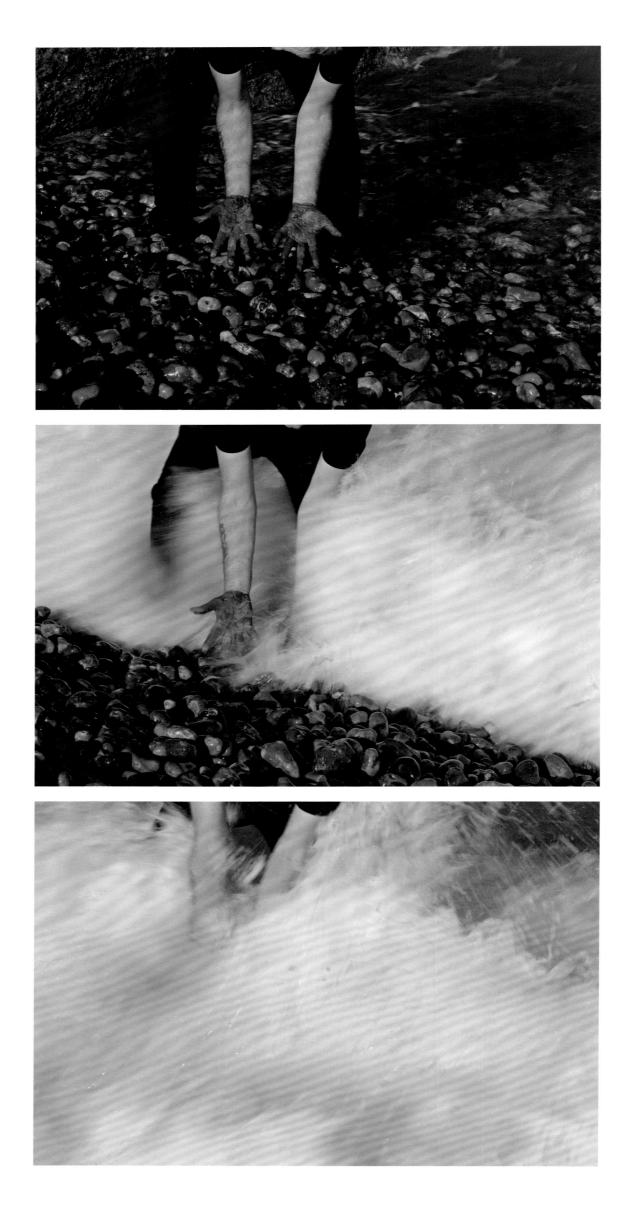

WINDY. SHELTERED BY HARBOUR WALL. POPPY PETALS. LEFT HAND WRAPPED BY ME. RIGHT BY MY SON. WASHED OFF BY A WAVE. FOLKESTONE HARBOUR, ENGLAND. 17 JUNE 2014

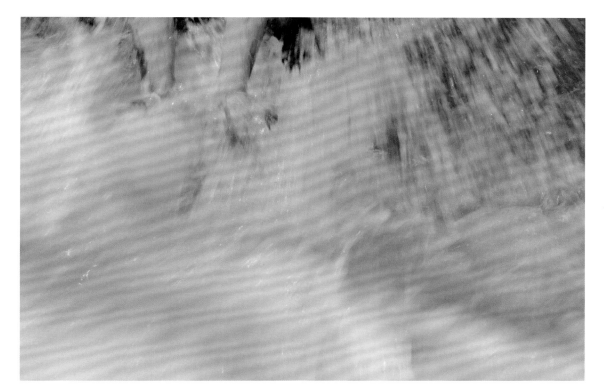

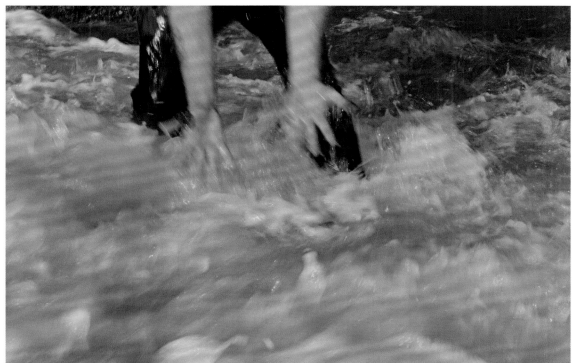

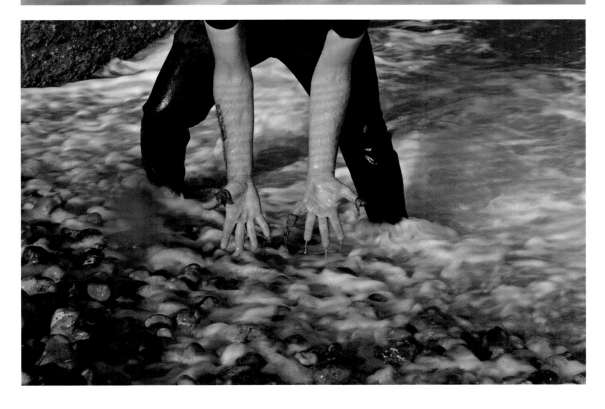

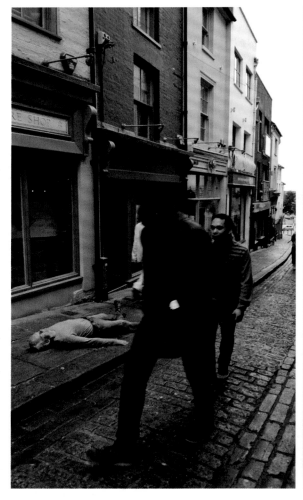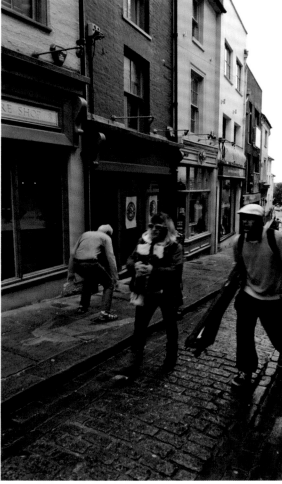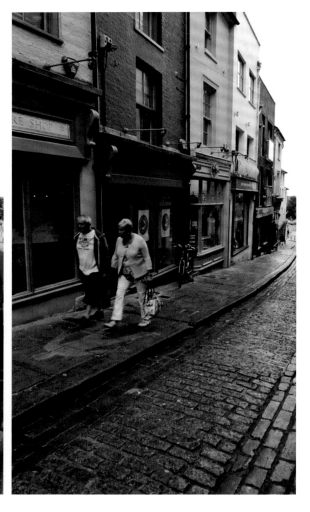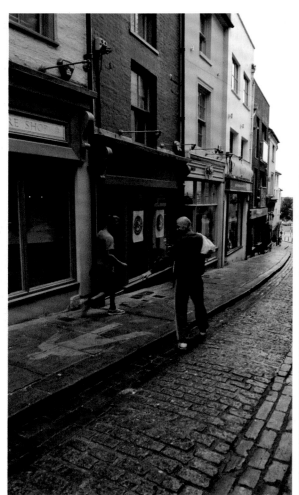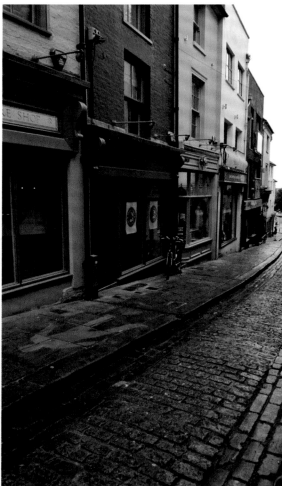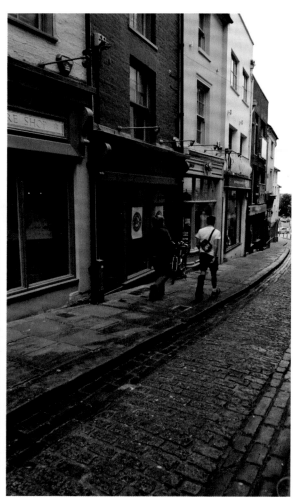

RAIN SHADOW. HIGH STREET, FOLKESTONE, ENGLAND. 19 JUNE 2014

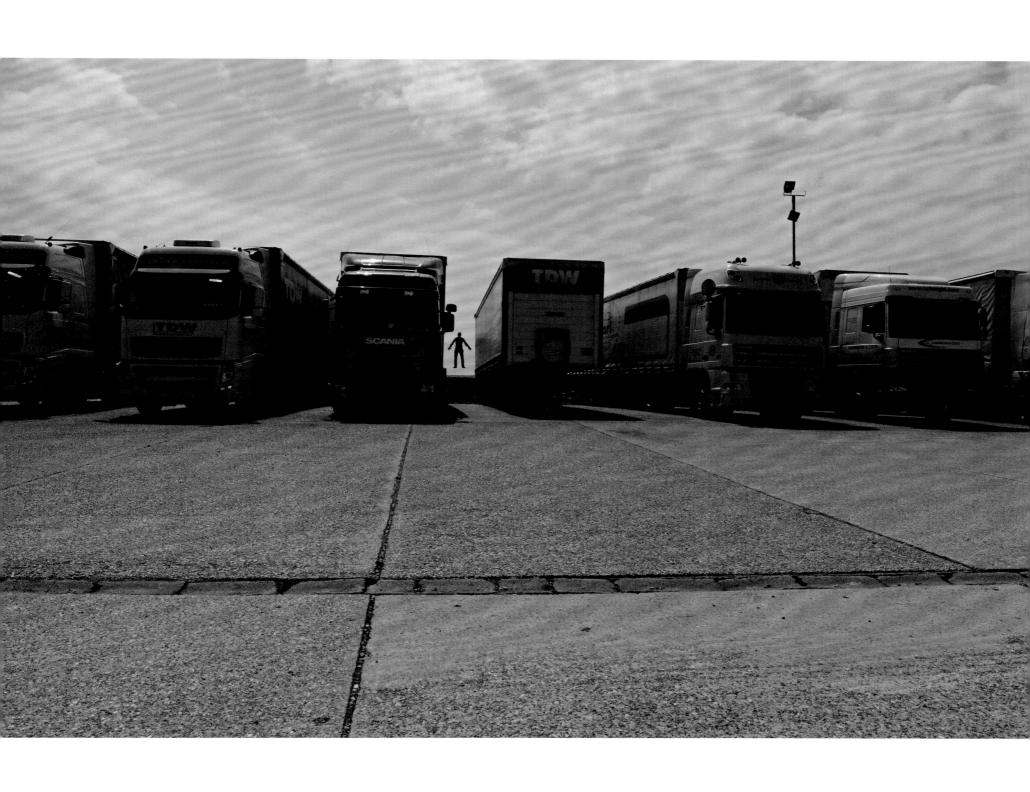

STANDING STILL ON A FENCE. BETWEEN PARKING LOT AND BEACH. FOLKESTONE, ENGLAND. 21 JUNE 2014

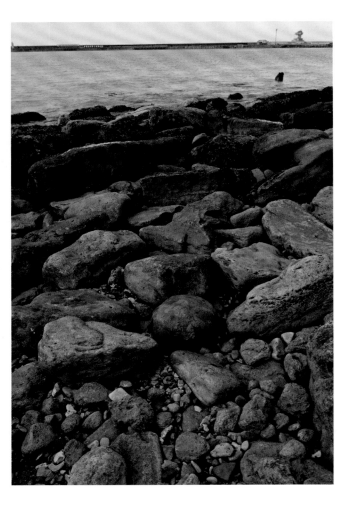 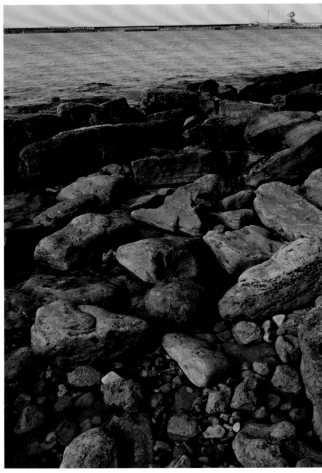 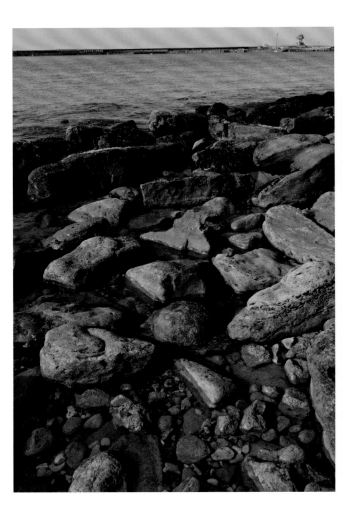

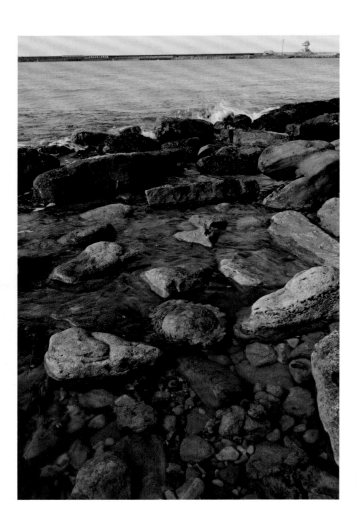 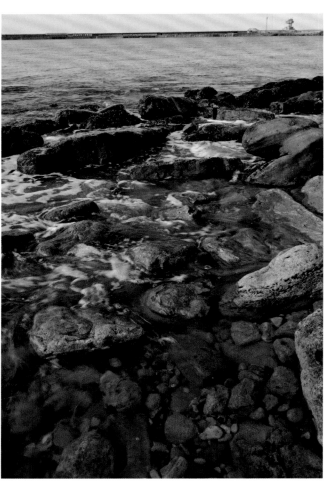 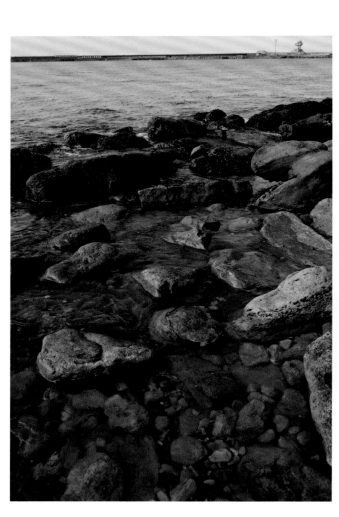

OUT EARLY TO WORK. AHEAD OF THE INCOMING TIDE. STONE LOCATED AND POPPIES COLLECTED THE DAY BEFORE. OVERLOOKING THE HARBOUR. FOLKESTONE, ENGLAND. 23 JUNE 2014

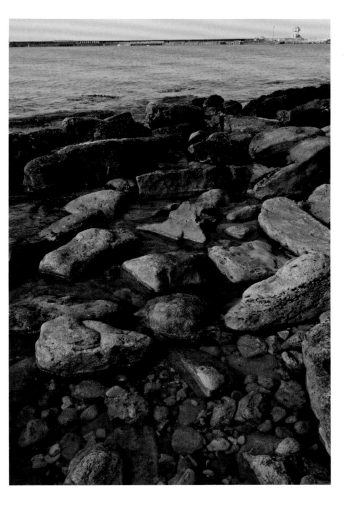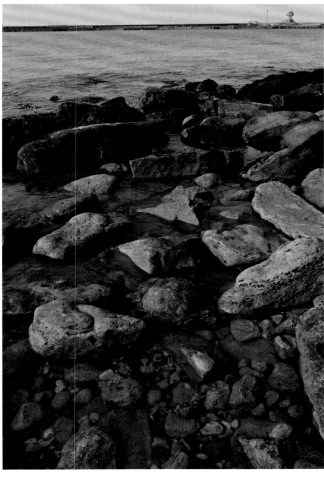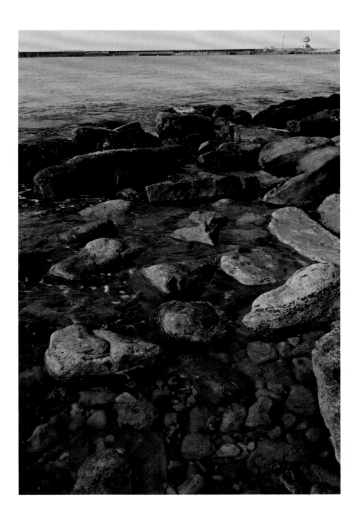
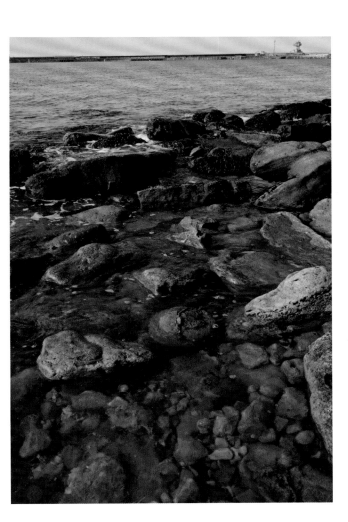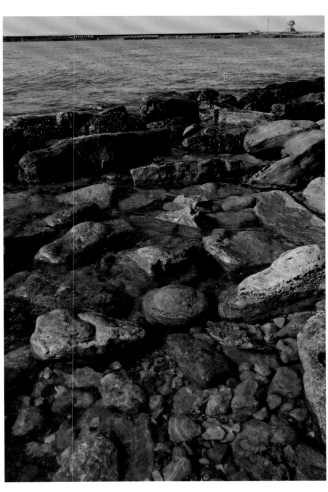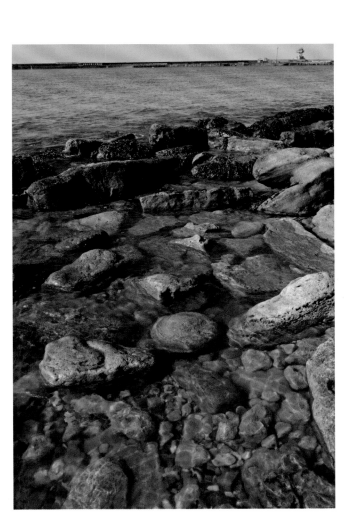

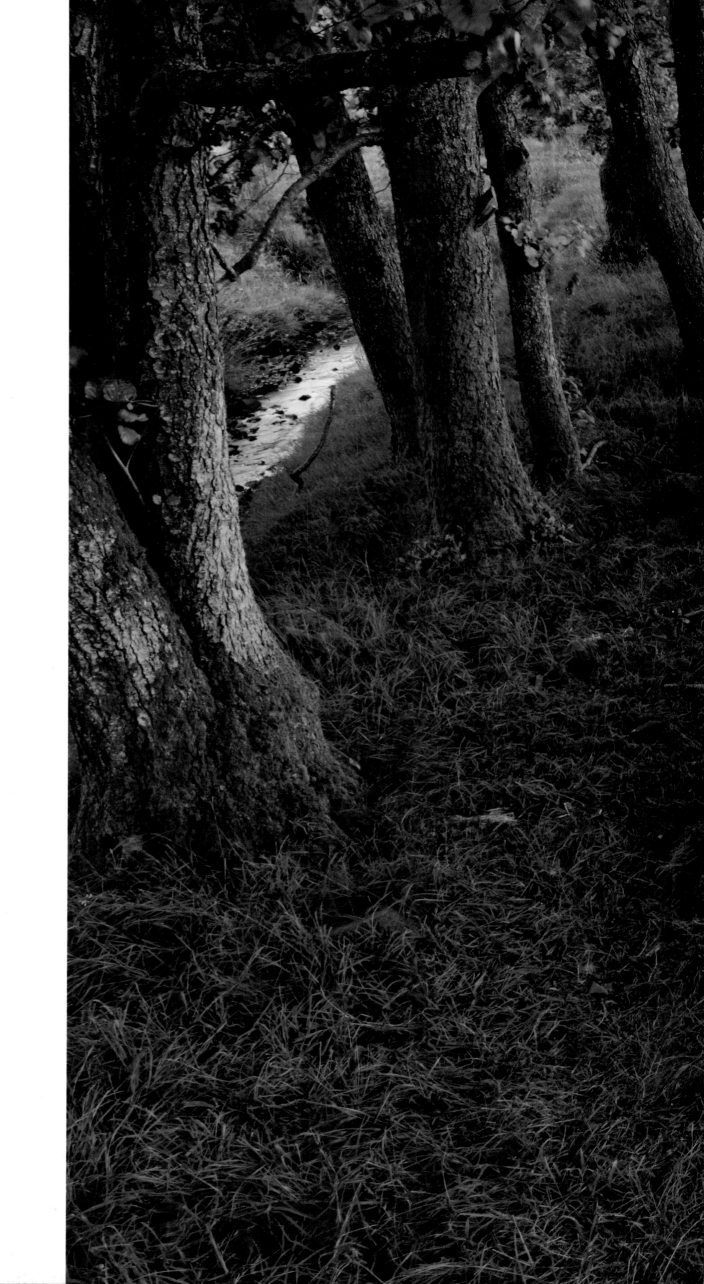

WOOD WALL. DUMFRIESSHIRE, SCOTLAND. 2 JULY 2014

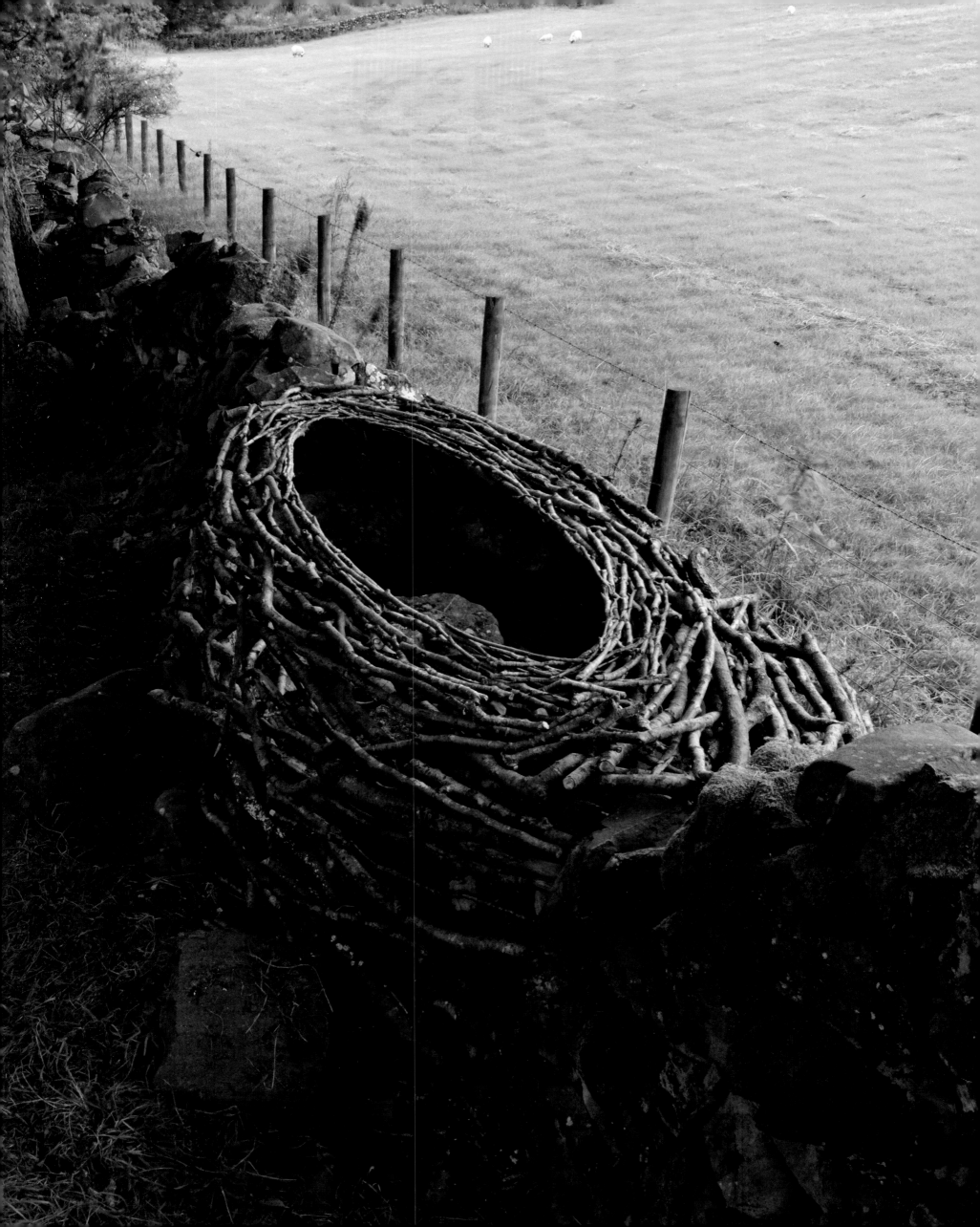

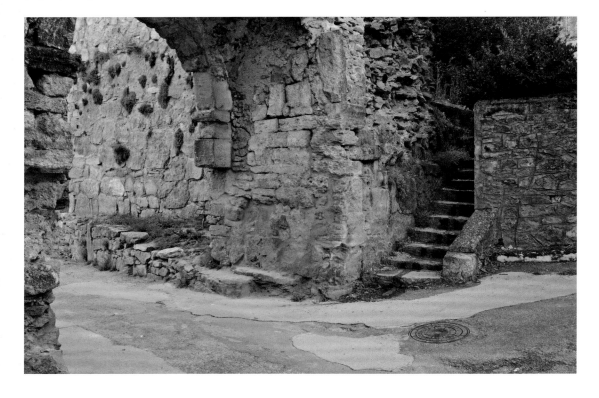

POPPIES. IN FLOWER AFTER RECENT HEAVY RAINS. COLLECTED FROM FIELDS. LAID ON STEPS. HELD WITH WATER. CAÑETE, SPAIN. 7 JULY 2014

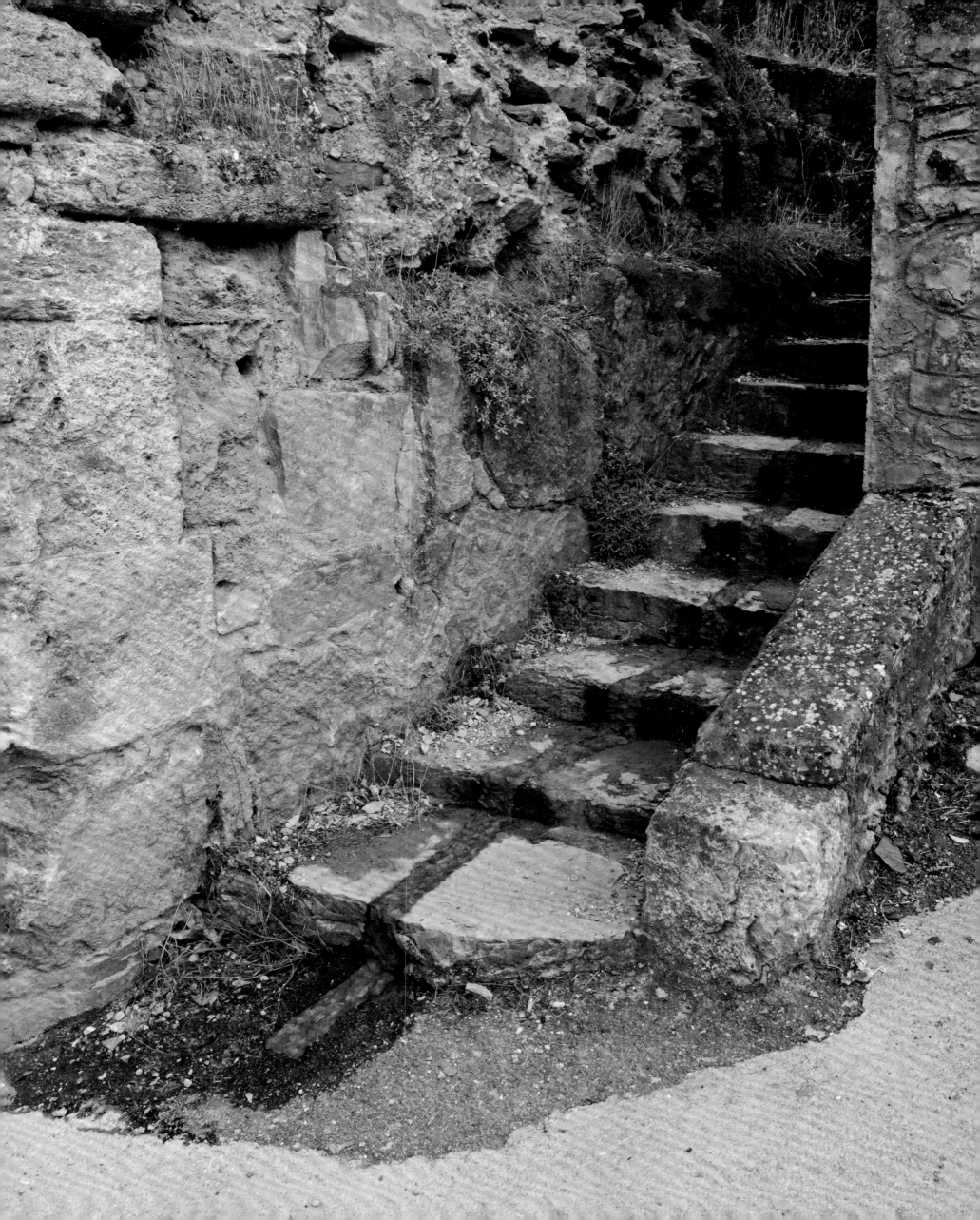

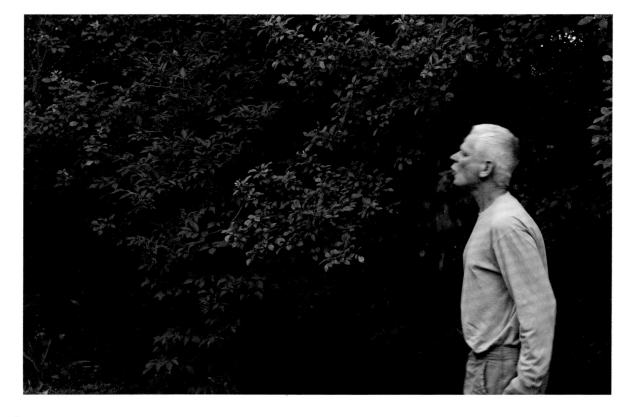

SPITTING POPPIES. CAÑETE, SPAIN. 16 JULY 2014

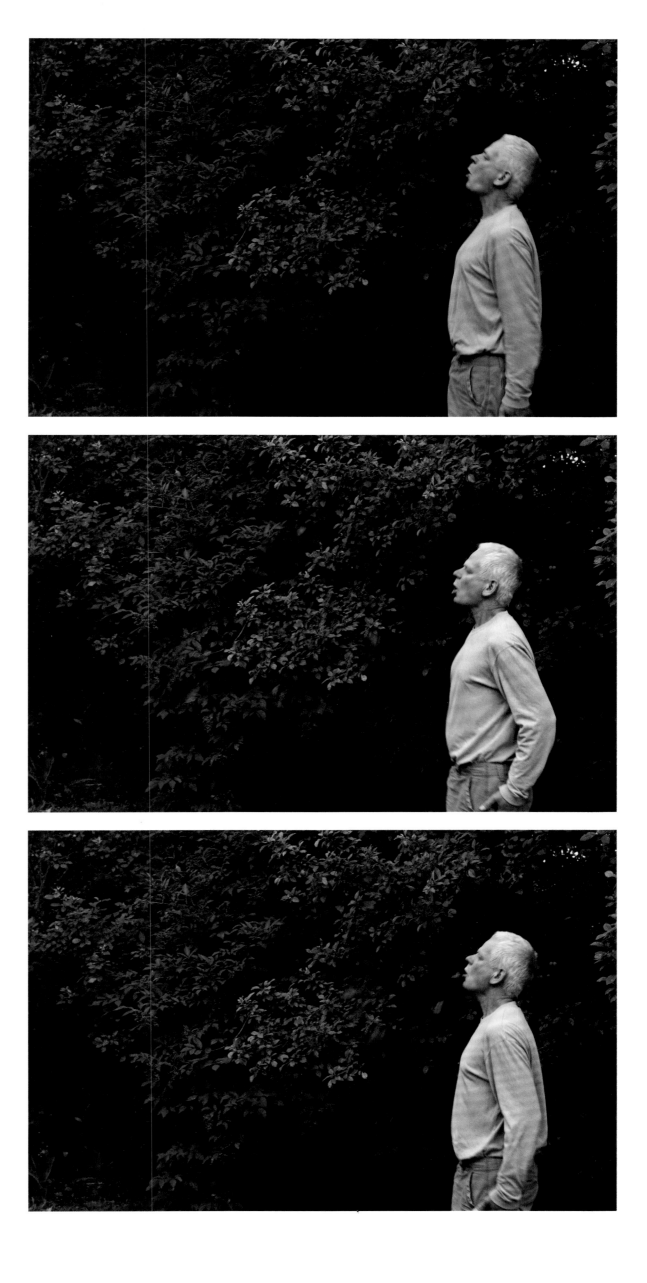

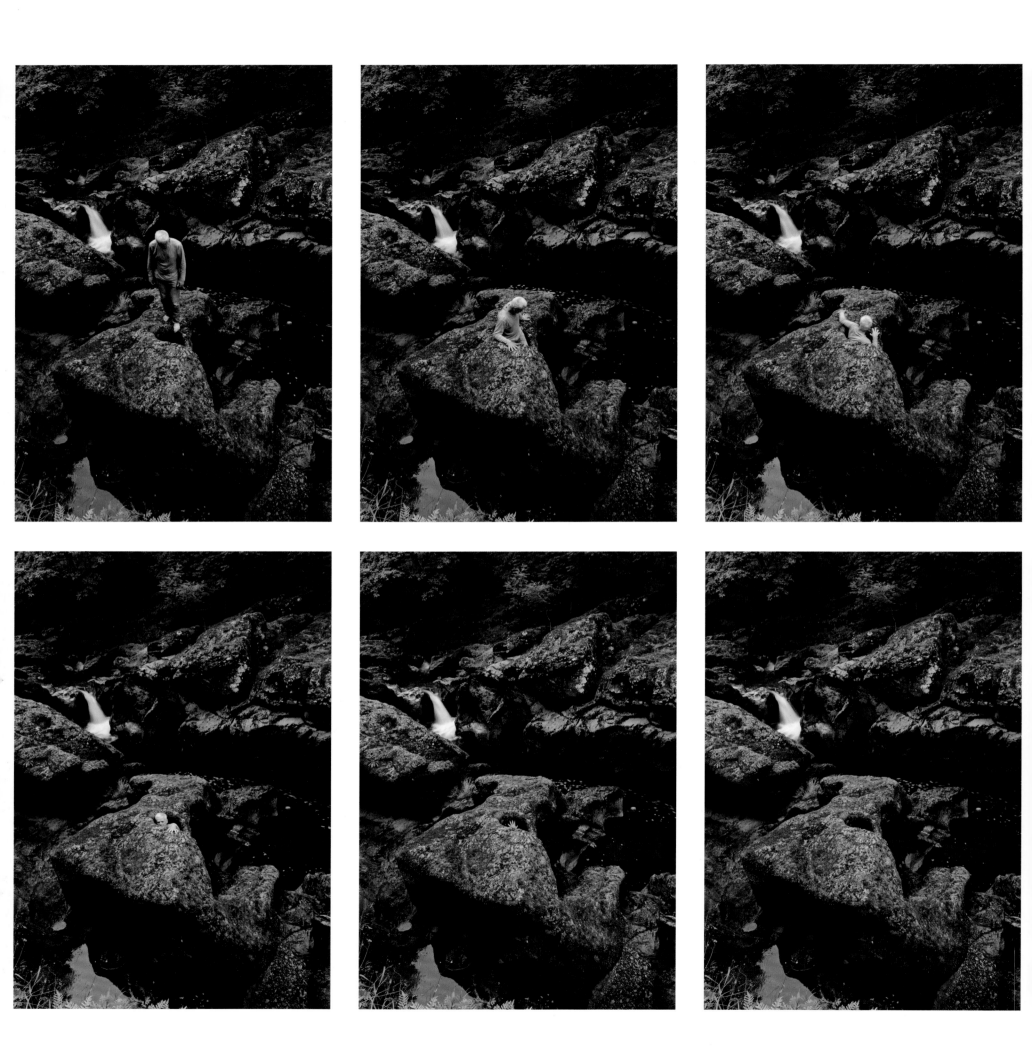

ENTERING STONES. DUMFRIESSHIRE, SCOTLAND. 29 JULY 2014

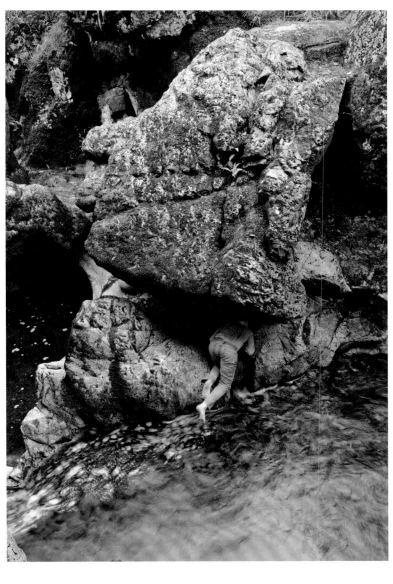
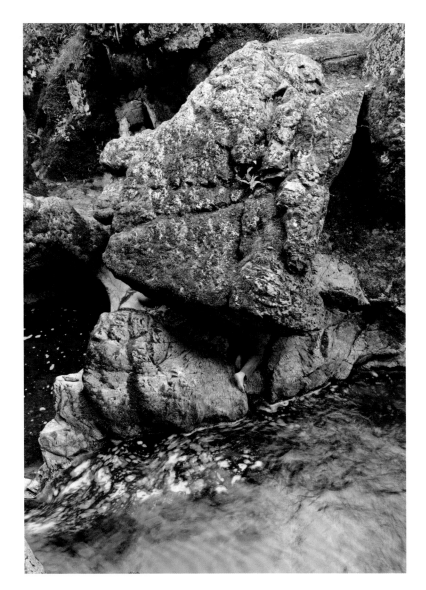
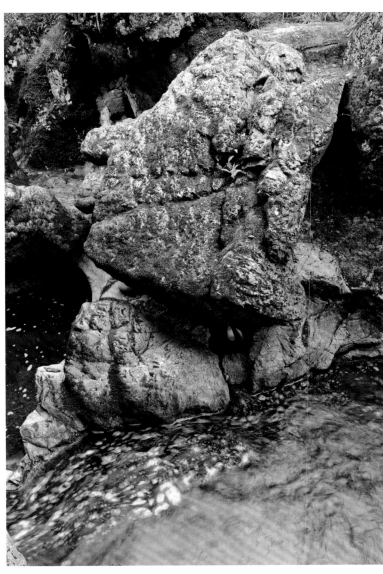
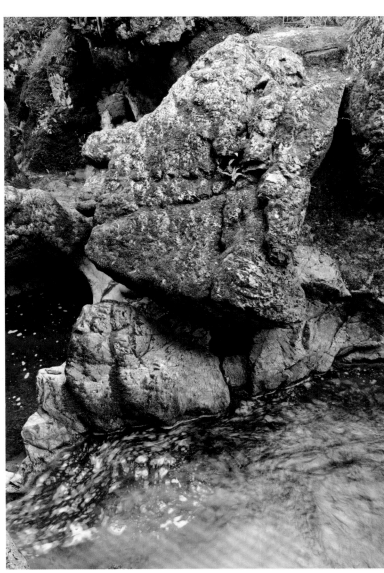

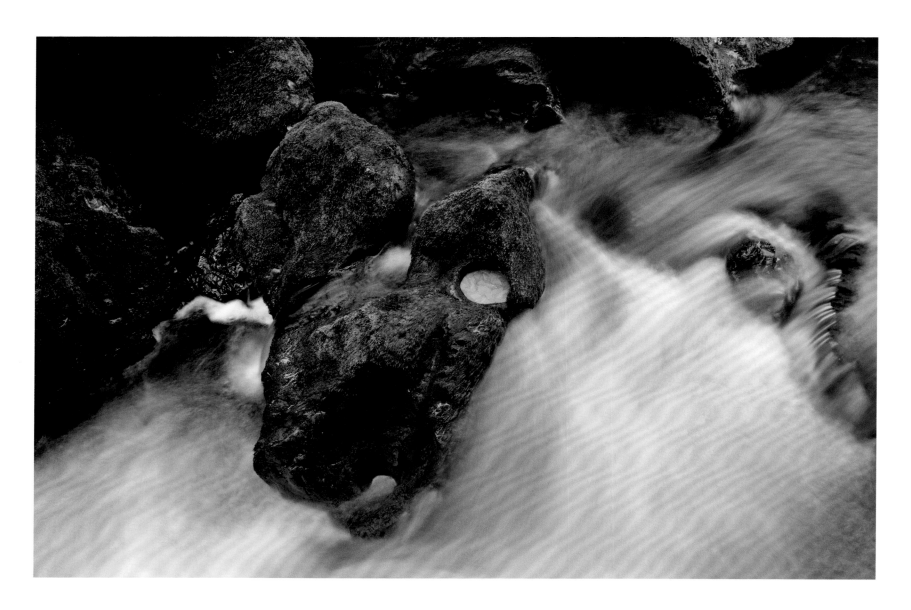

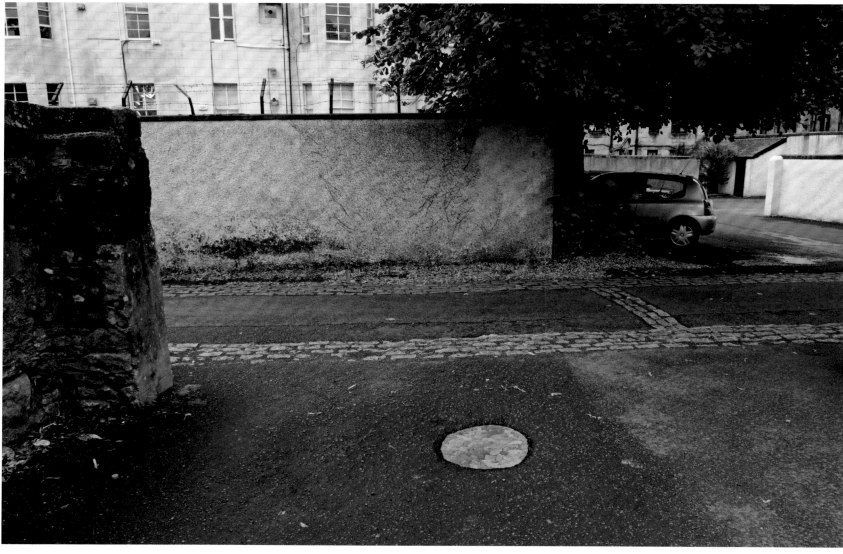

TWO POOLS. GREEN LEAVES. ELM IN DUMFRIESSHIRE, SCOTLAND. 31 JULY 2014. COLTSFOOT IN GLASGOW, SCOTLAND. 1 AUGUST 2014

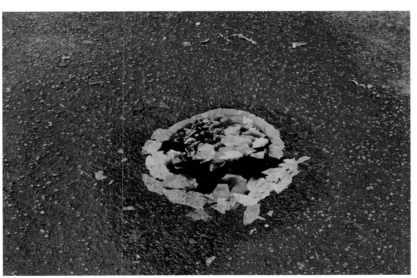

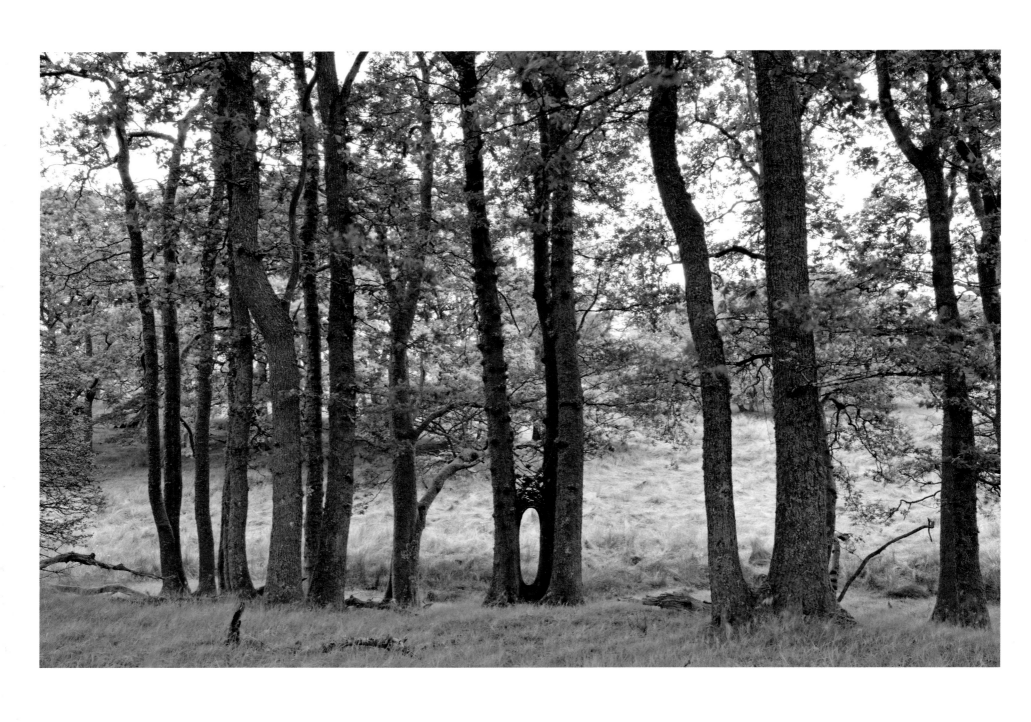

OAK BRANCHES, MUD AND LEAVES. WORKED INTO THE SPACE BETWEEN TWO TRUNKS OF AN OAK TREE. DUMFRIESSHIRE, SCOTLAND. 4 AUGUST 2014

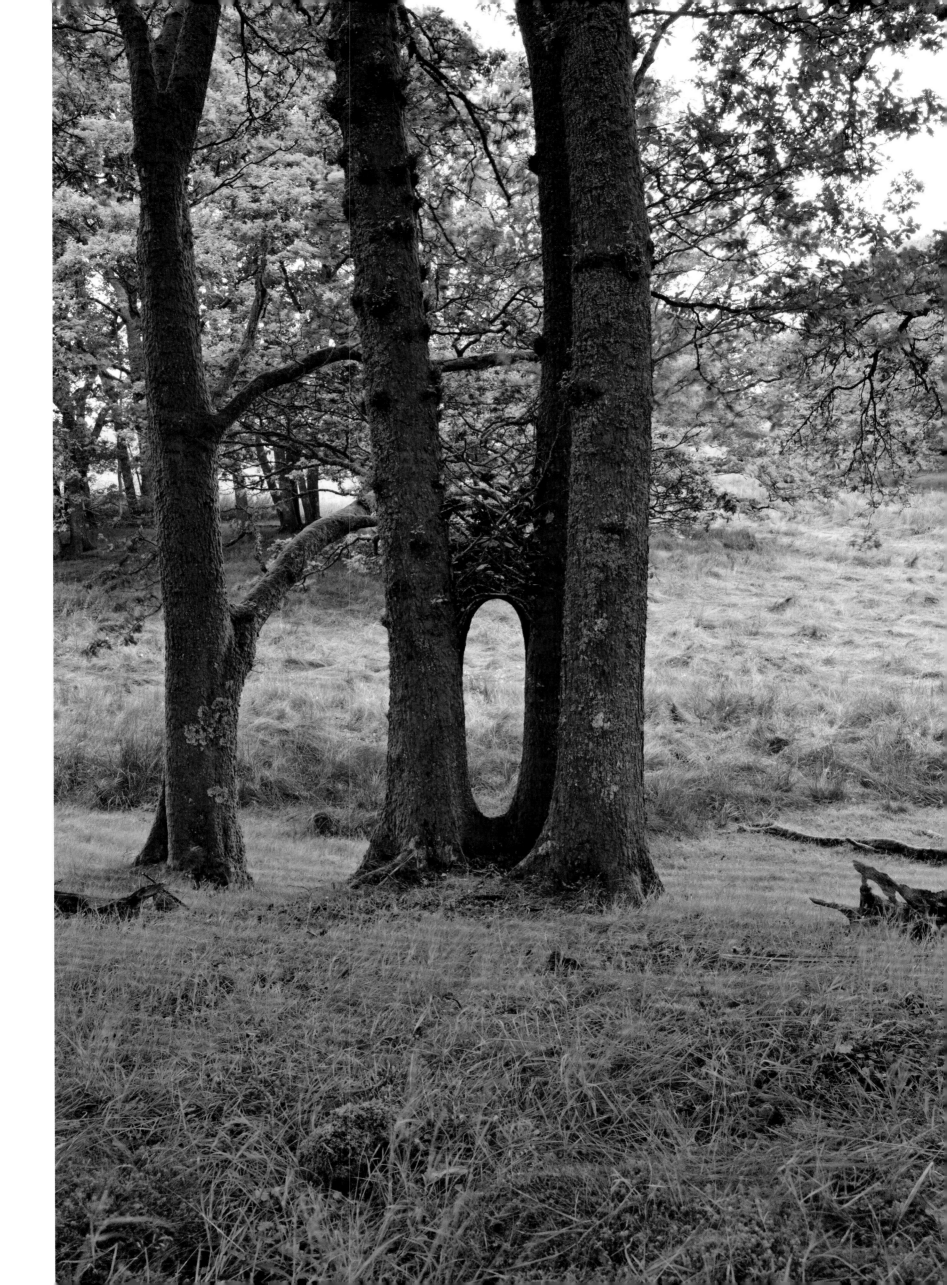

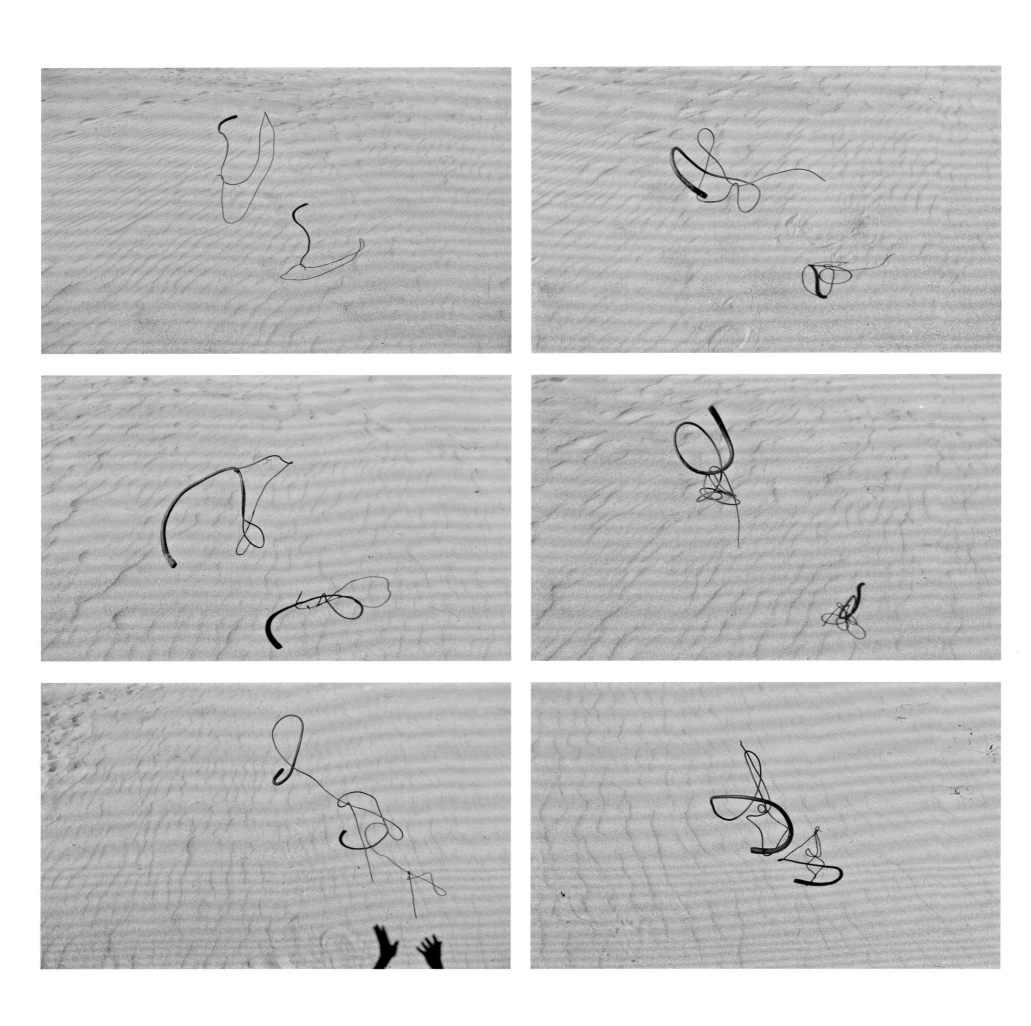

KELP. SHADOW. SAND. AÑO NUEVO, CALIFORNIA. 17 AUGUST 2014

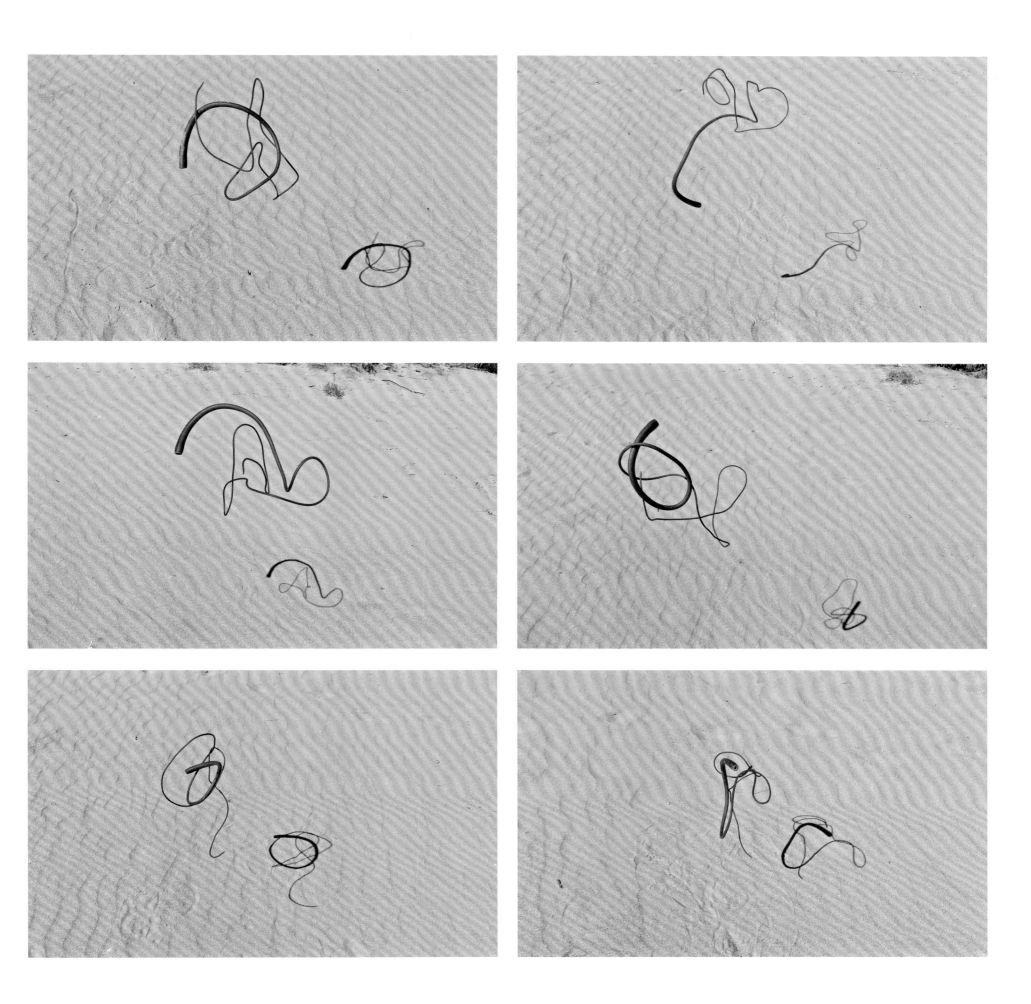

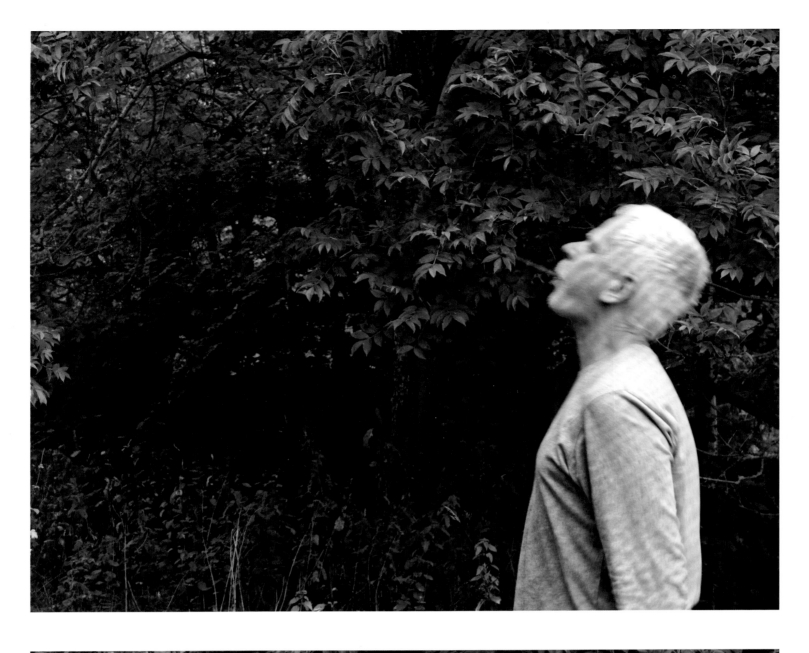

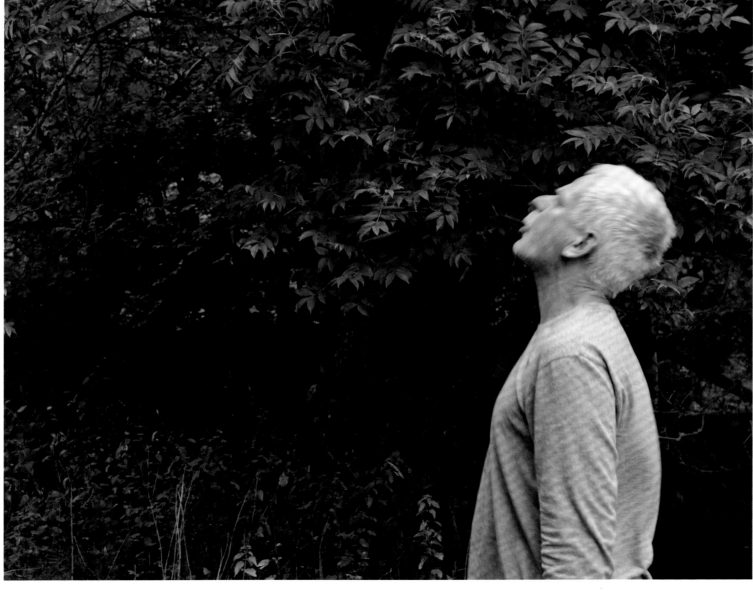

SPITTING BERRIES.
DUMFRIESSHIRE, SCOTLAND.
31 AUGUST 2014

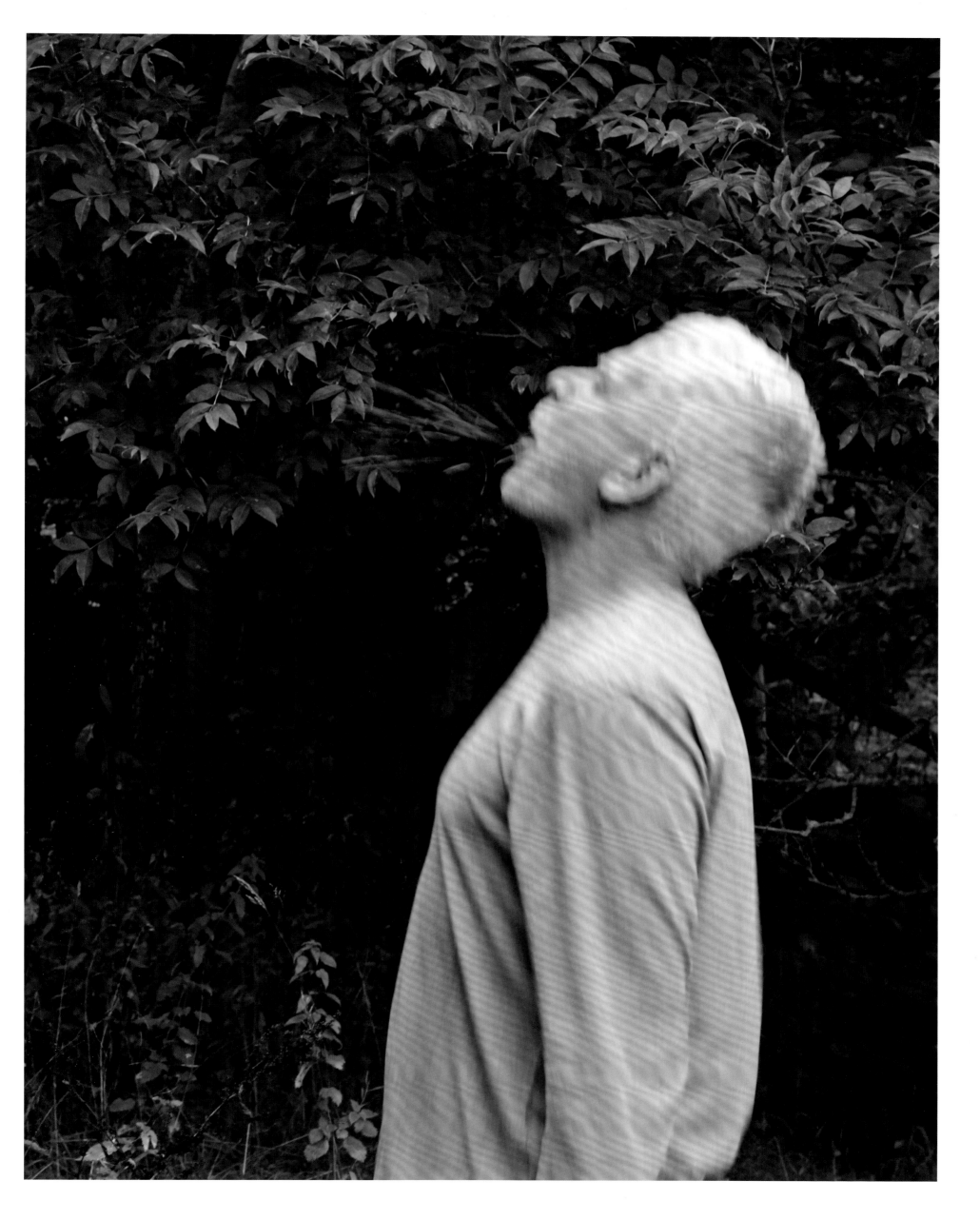

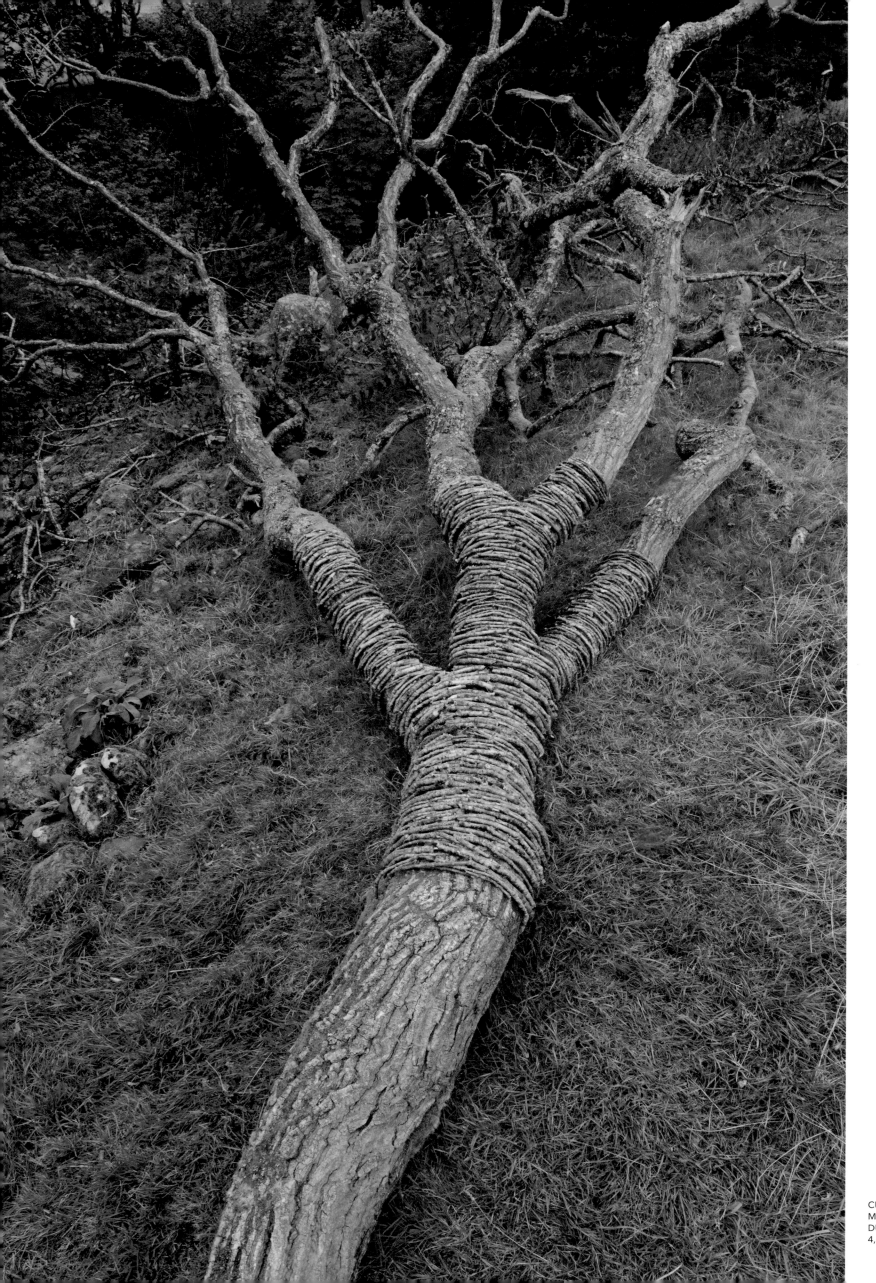

CURVED BRANCHES AND
MUD ON FALLEN BOUGH.
DUMFRIESSHIRE, SCOTLAND.
4, 5 SEPTEMBER 2014

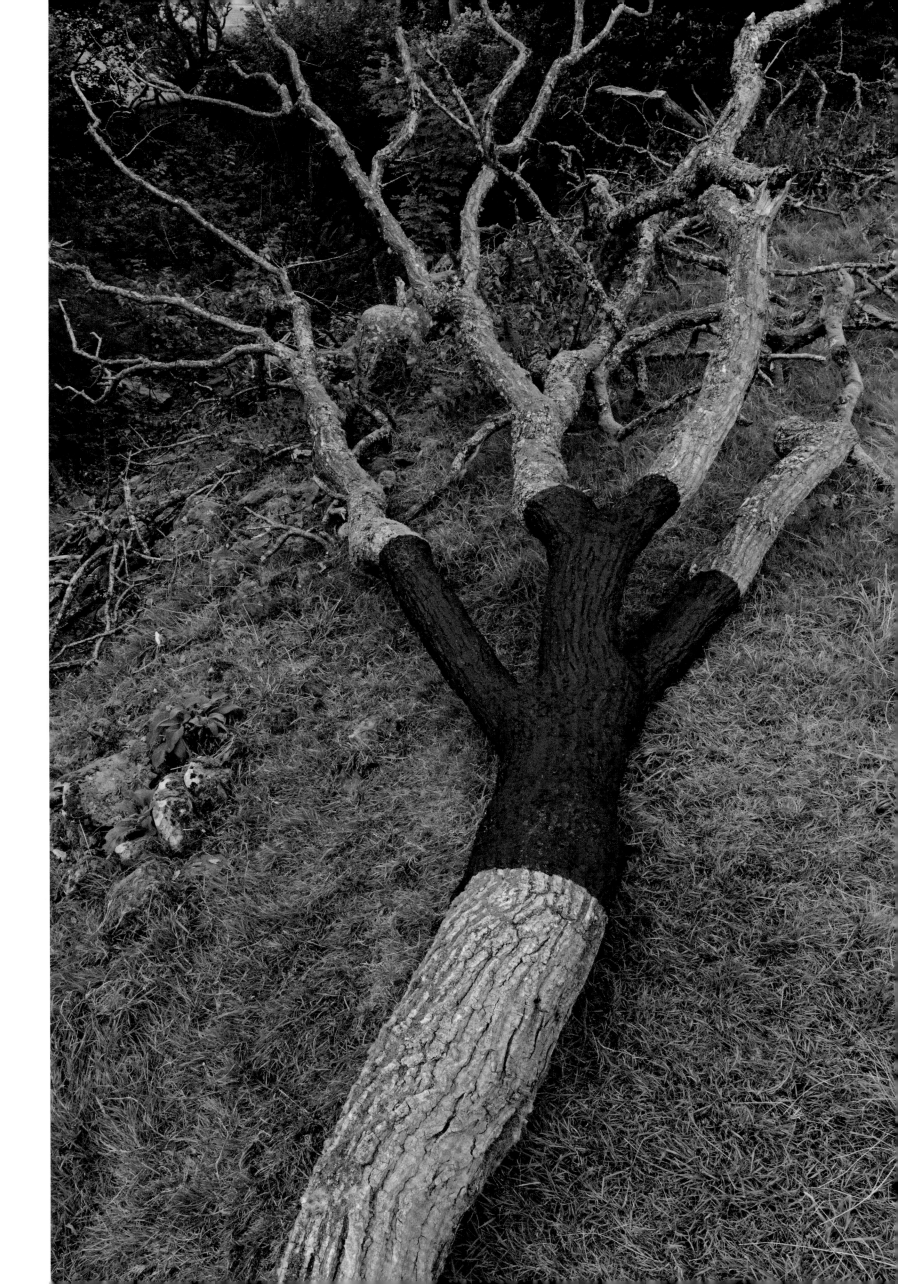

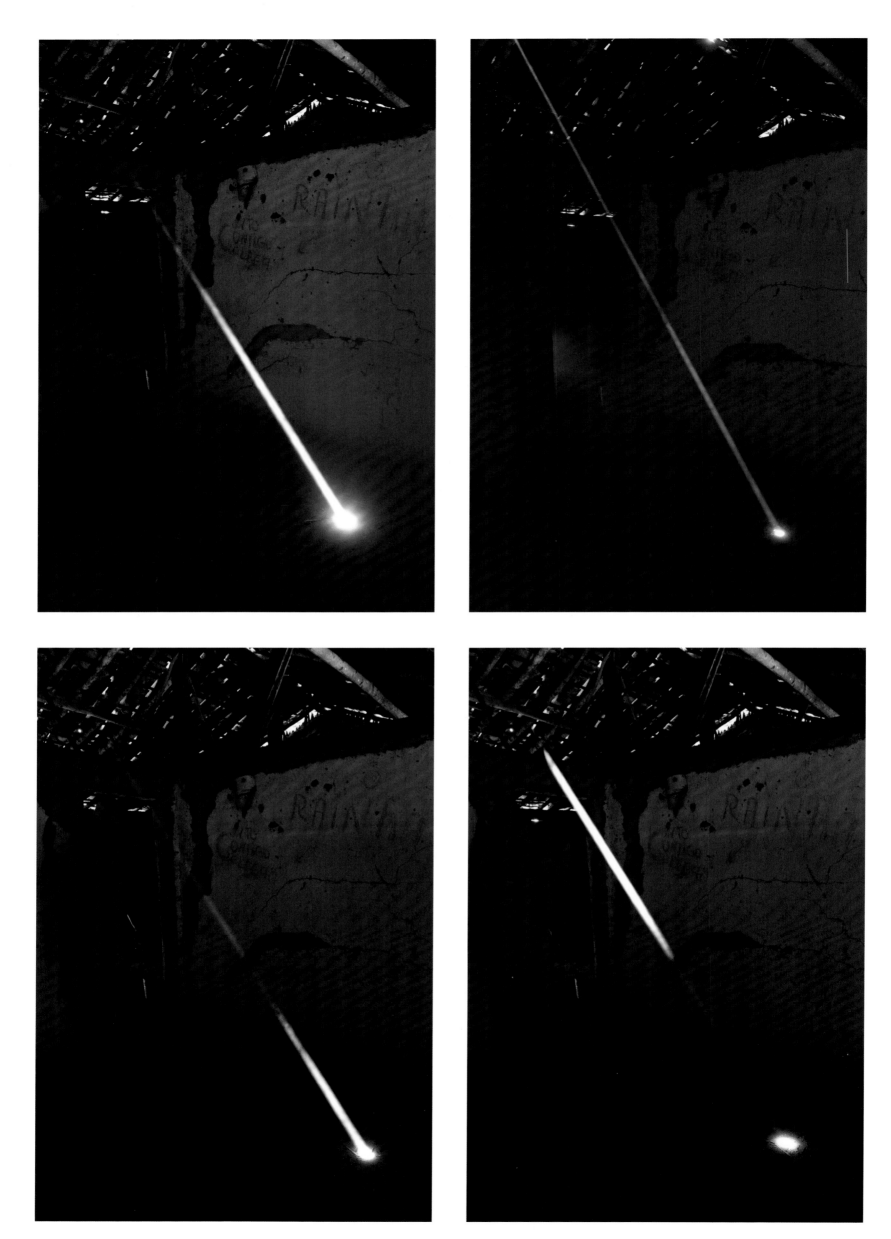

DUST. SWEPT AND THROWN TO REVEAL A SHAFT OF LIGHT. IBITIPOCA, BRAZIL. 12 SEPTEMBER 2014

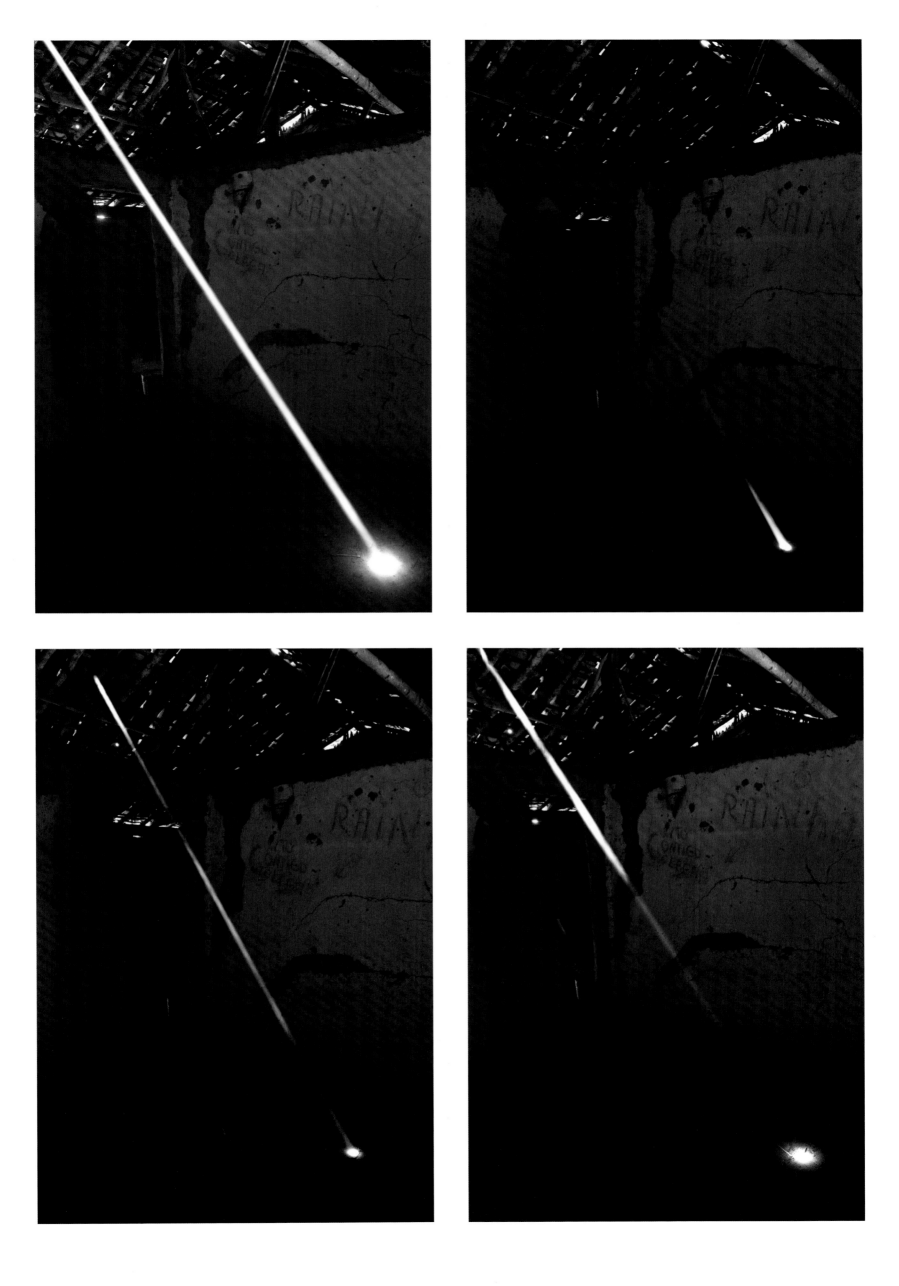

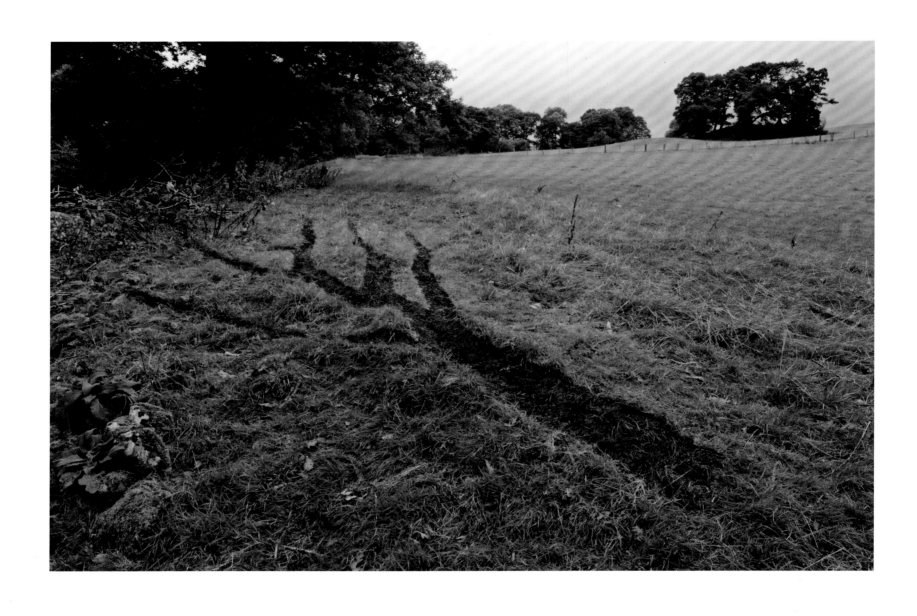

RETURNED TO FIND FALLEN OAK BOUGH HAD BEEN CUT UP AND TAKEN AWAY. MUD PAINTED ON TO THE GROUND WHERE IT HAD LAIN. DUMFRIESSHIRE, SCOTLAND. 25 SEPTEMBER 2014

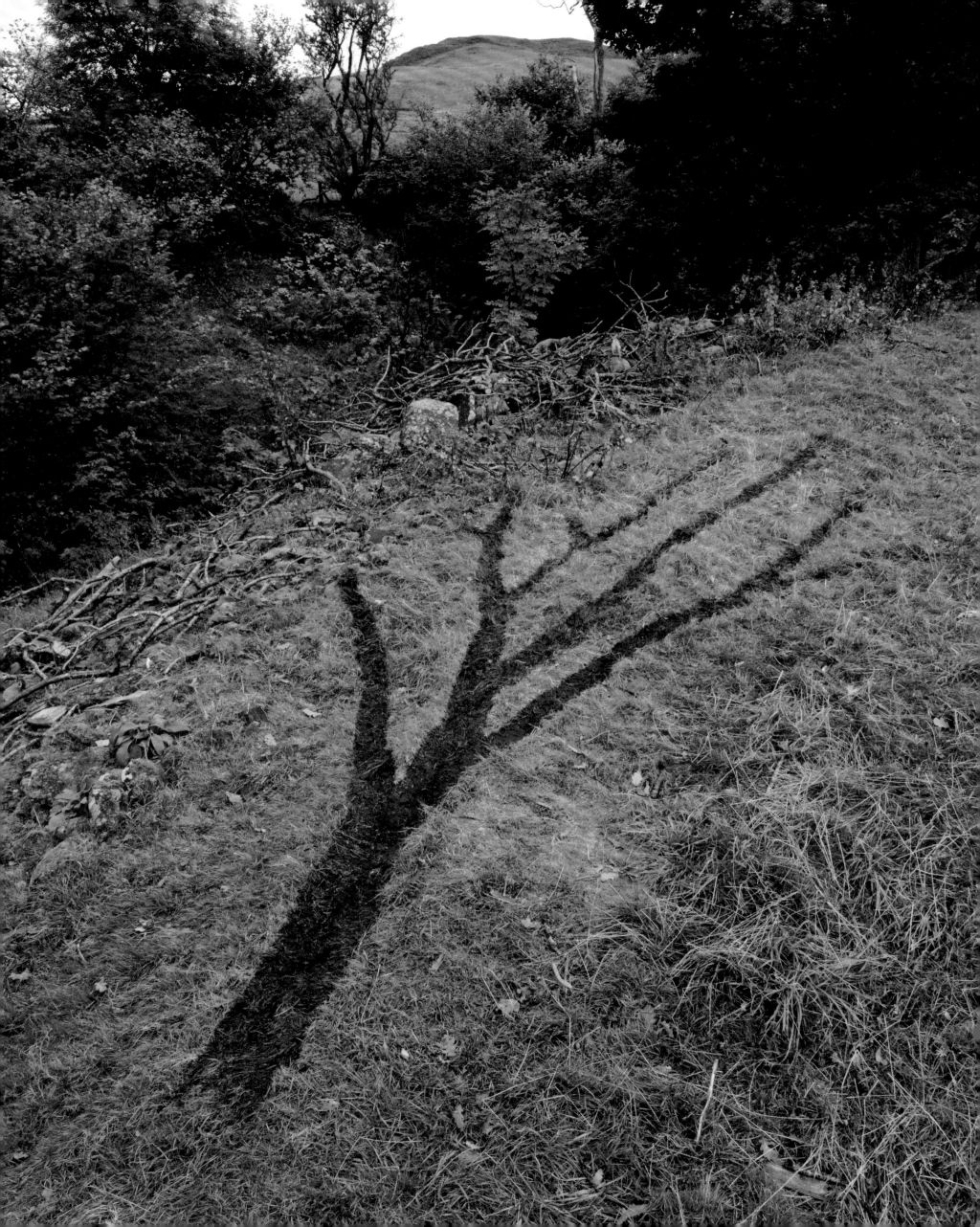

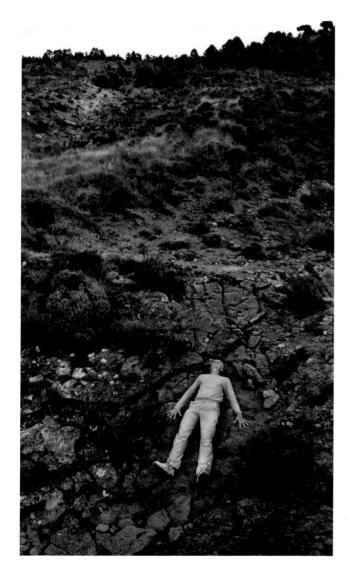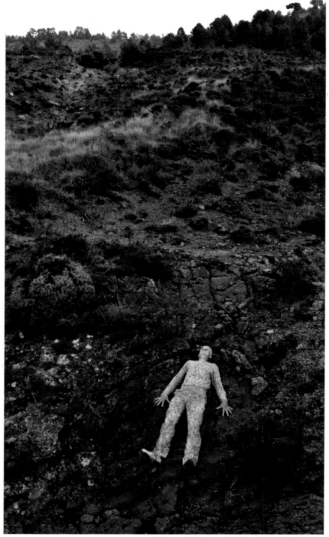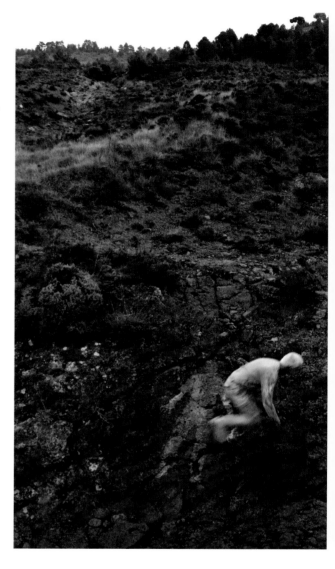

RAIN SHADOW. CUENCA, SPAIN. 6 OCTOBER 2014

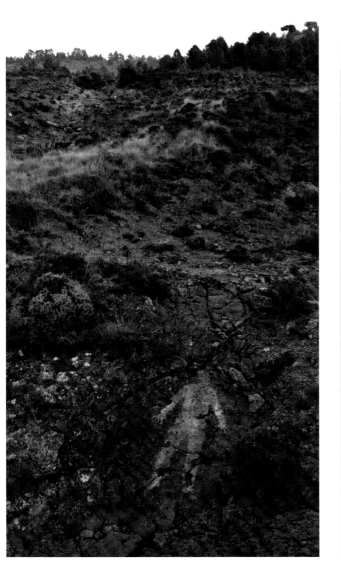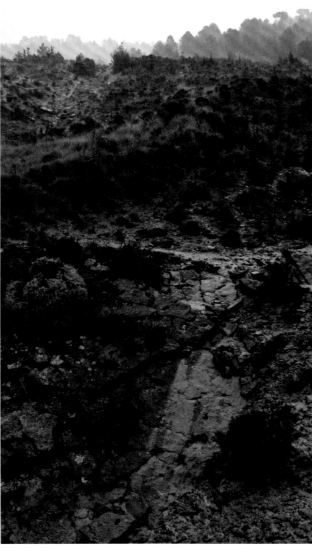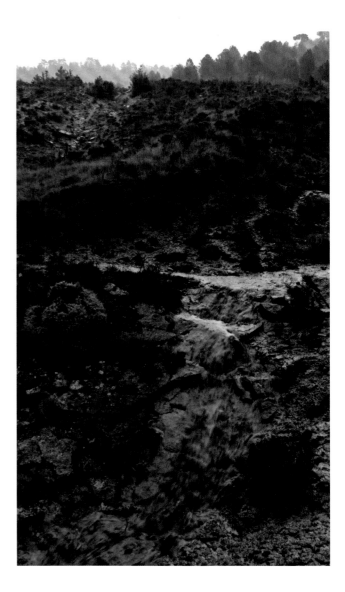

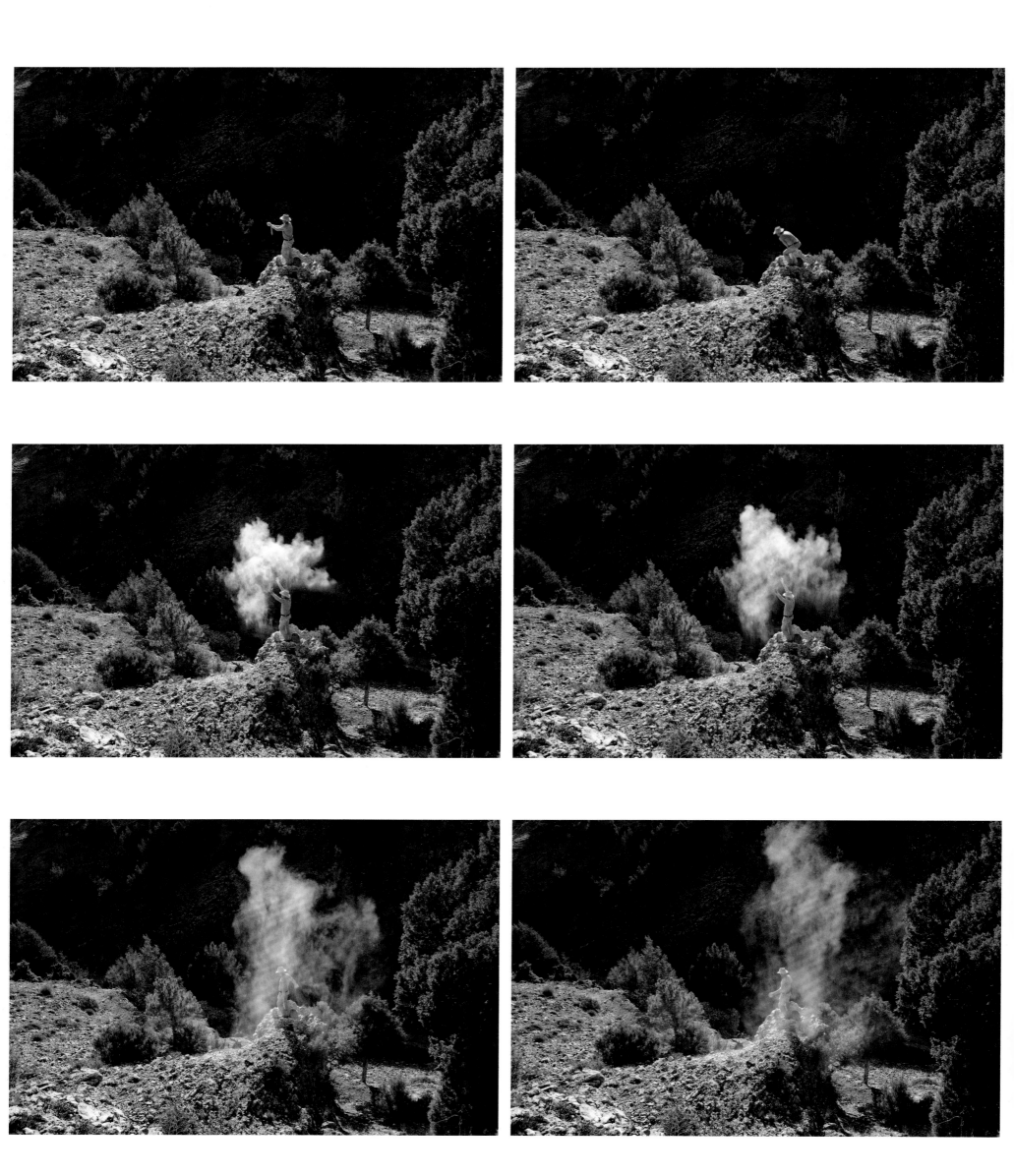

LIMESTONE DUST. BY-PRODUCT OF 'SLEEPING STONES'. CUENCA, SPAIN. 7 OCTOBER 2014

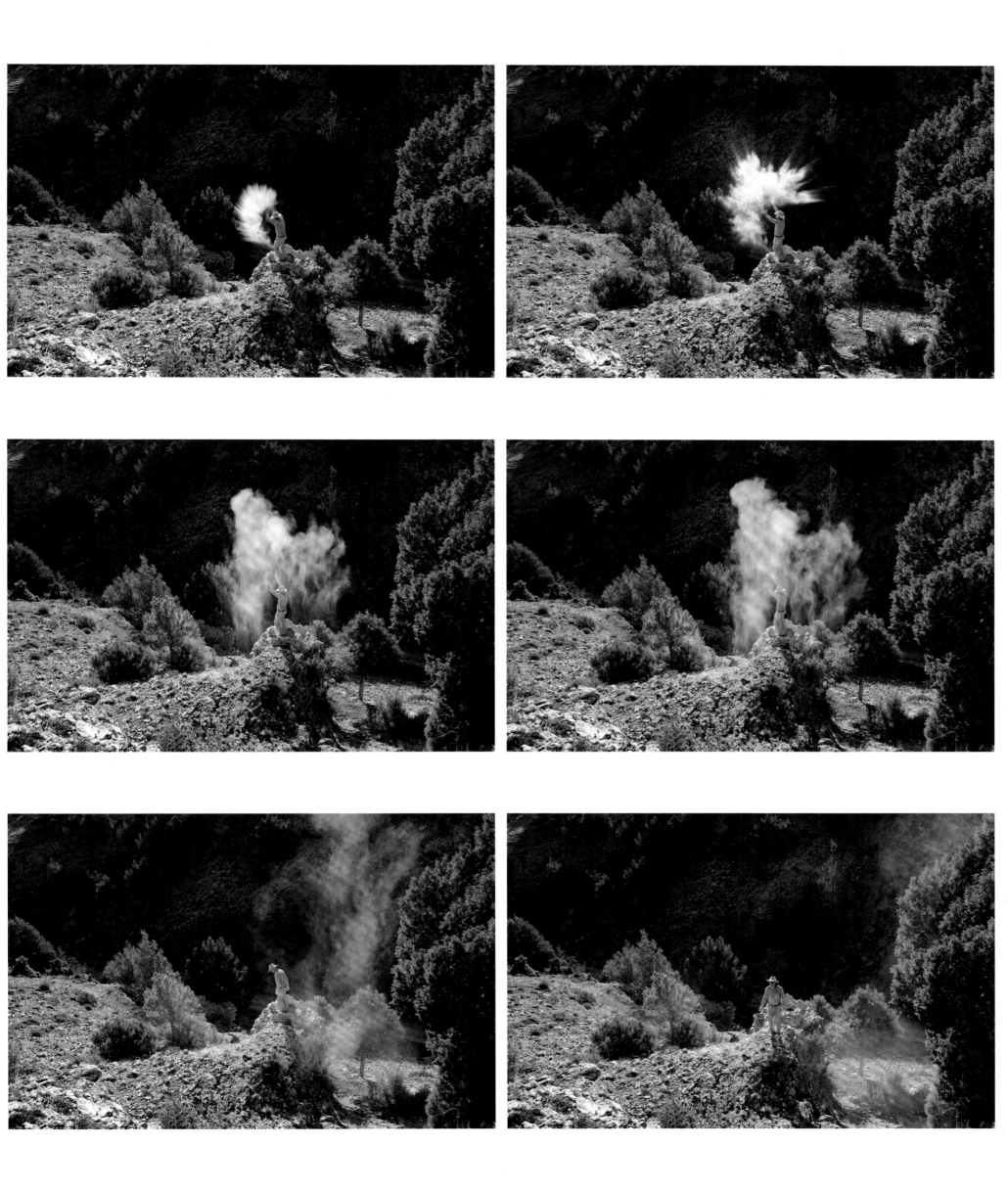

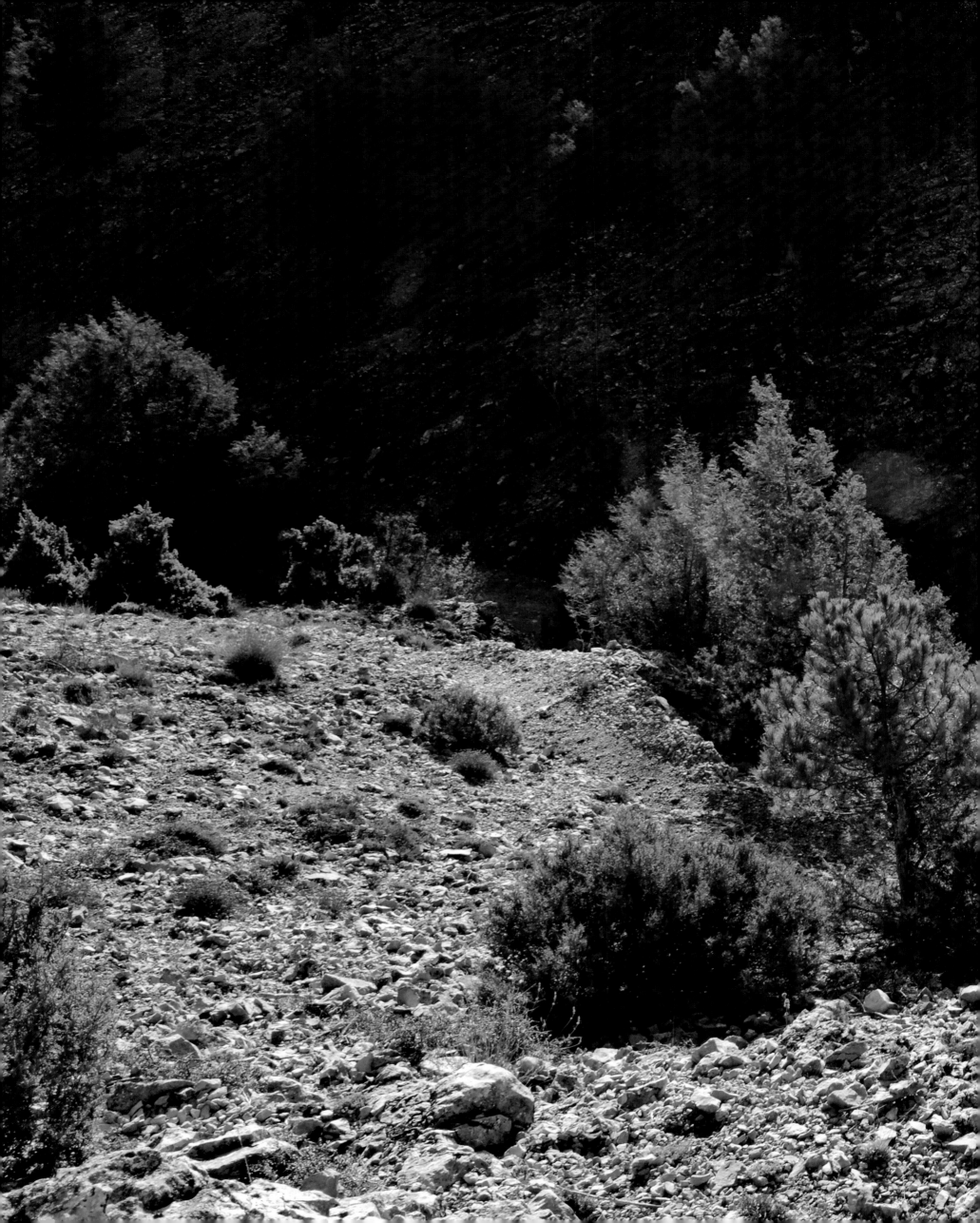

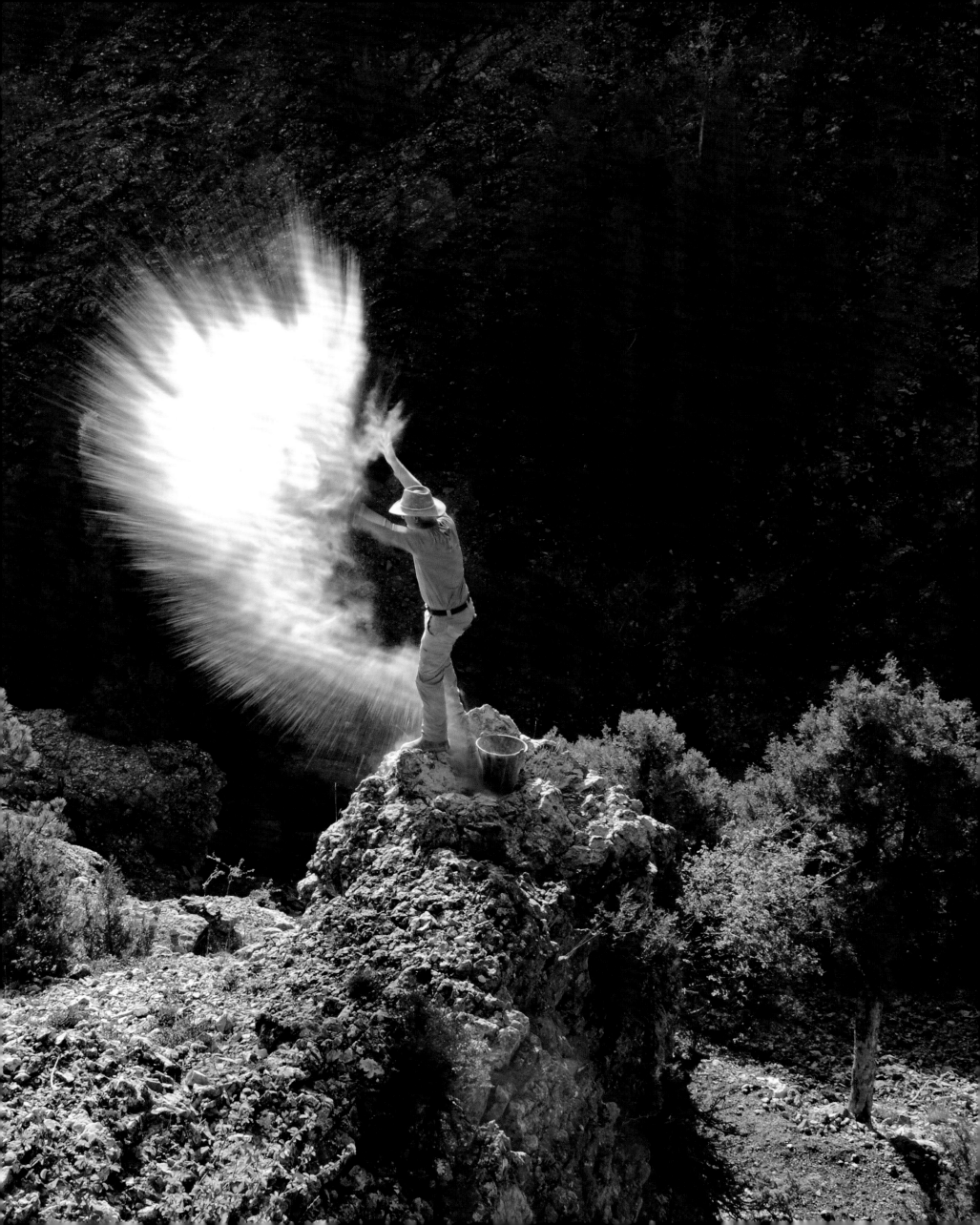

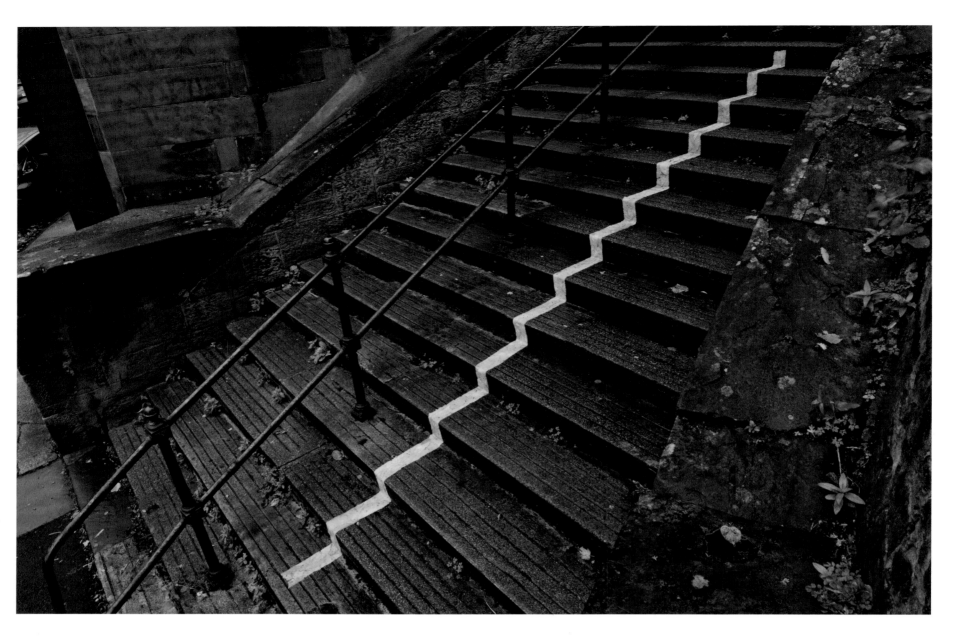

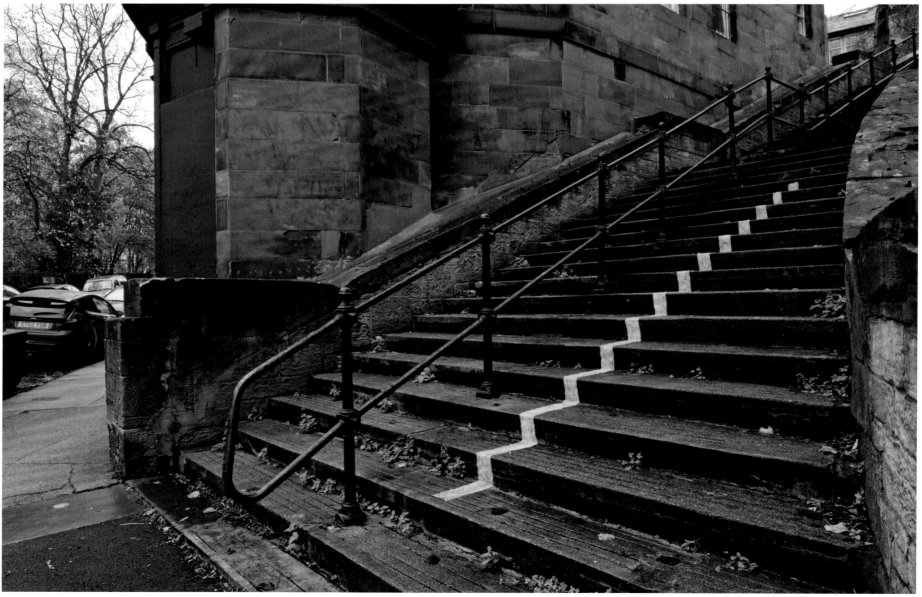

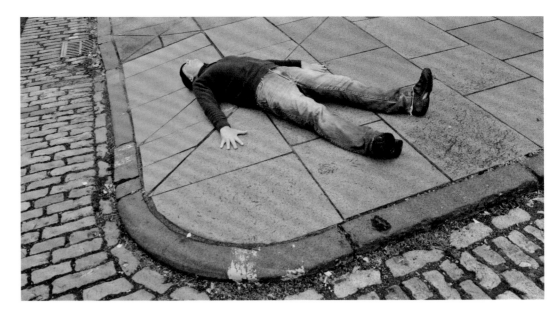

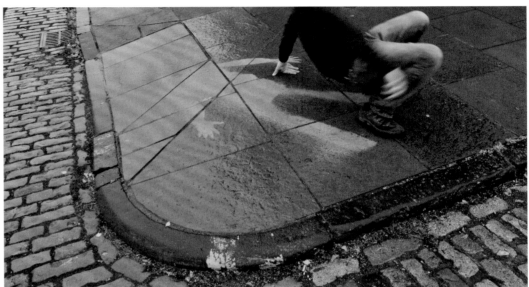

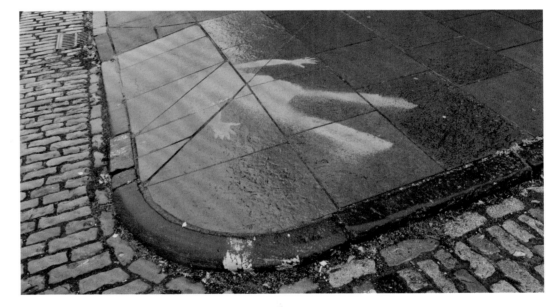

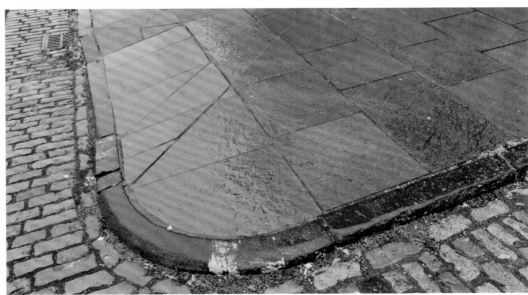

ELM LEAVES HELD TO 'SIXTY STEPS' WITH WATER.
RAIN SHADOW.
GLASGOW, SCOTLAND. 23 OCTOBER 2014

STRONG WINDS. COLD RAIN (TURNING TO SNOW). POLICE AND SECURITY FENDED OFF BY LIZ BOWER FROM GALERIE LELONG. INDIANAPOLIS, INDIANA. 31 OCTOBER 2014

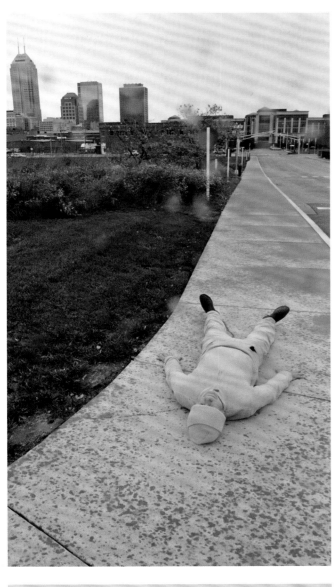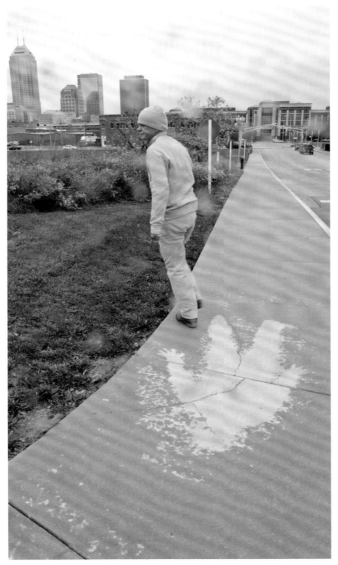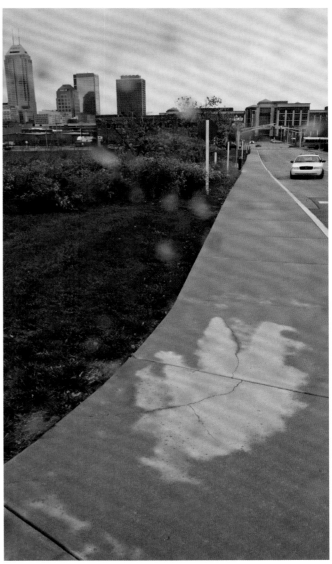
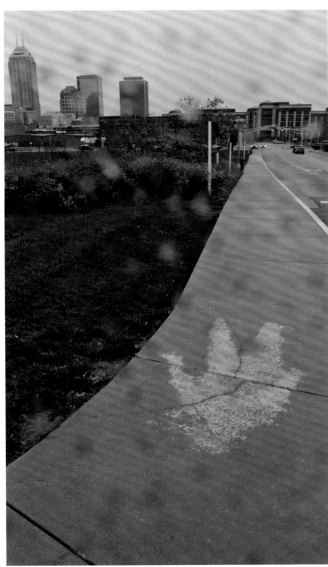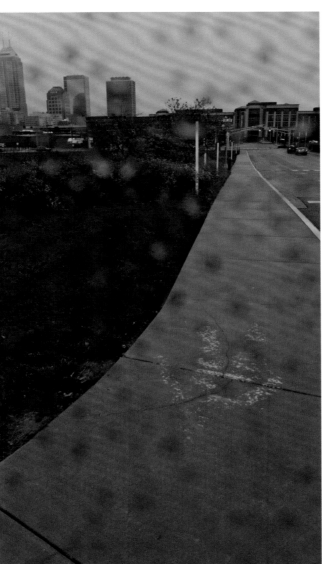

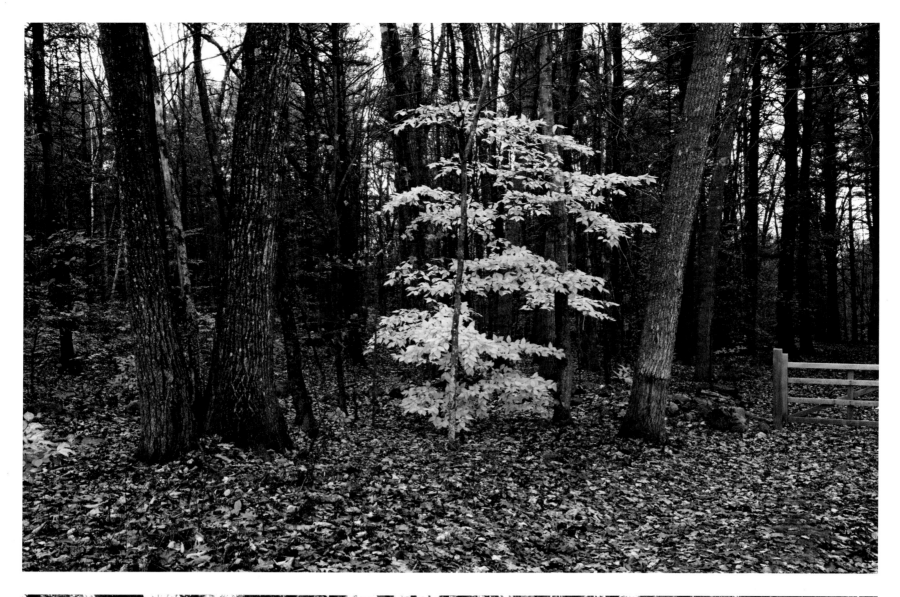

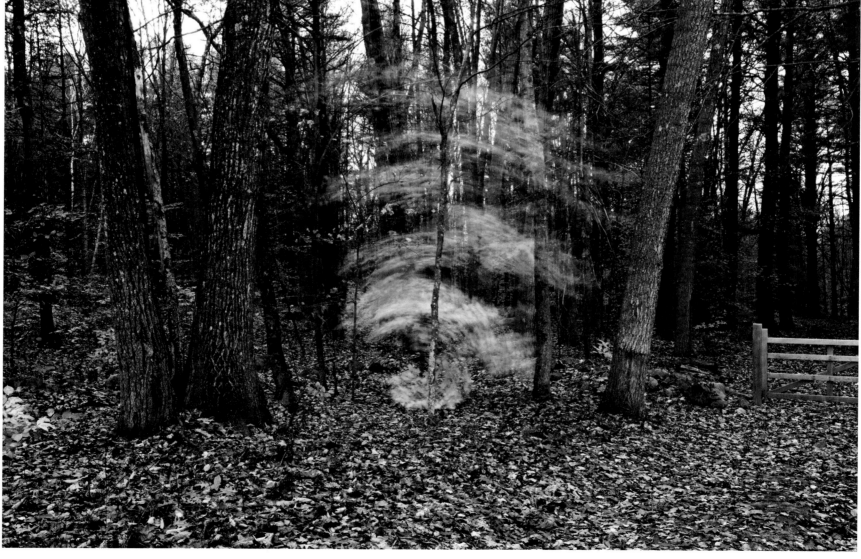

CLIMBED INTO AND GENTLY SWAYED BEECH AND WINTERBERRY TREES. DUSK. KENSINGTON, NEW HAMPSHIRE. 9, 11 NOVEMBER 2014

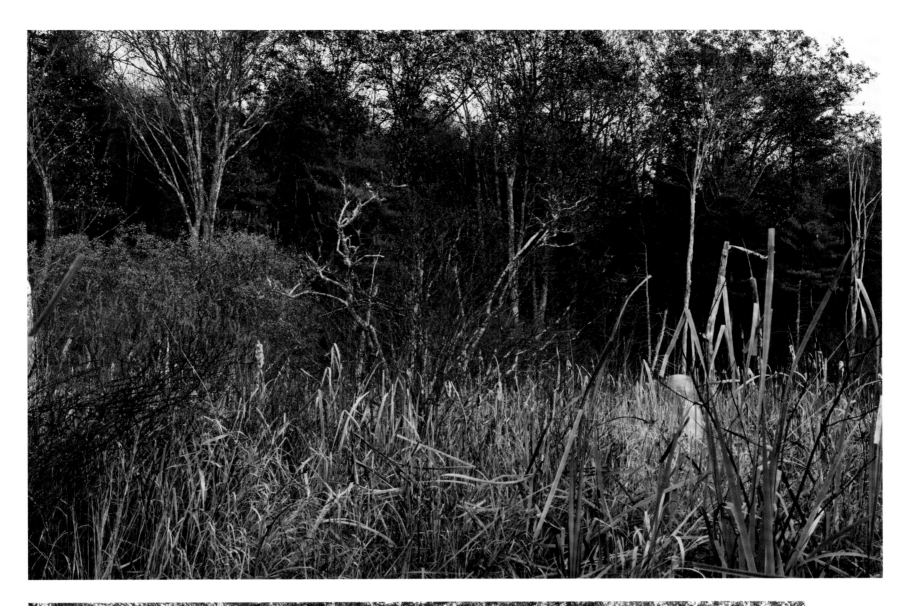

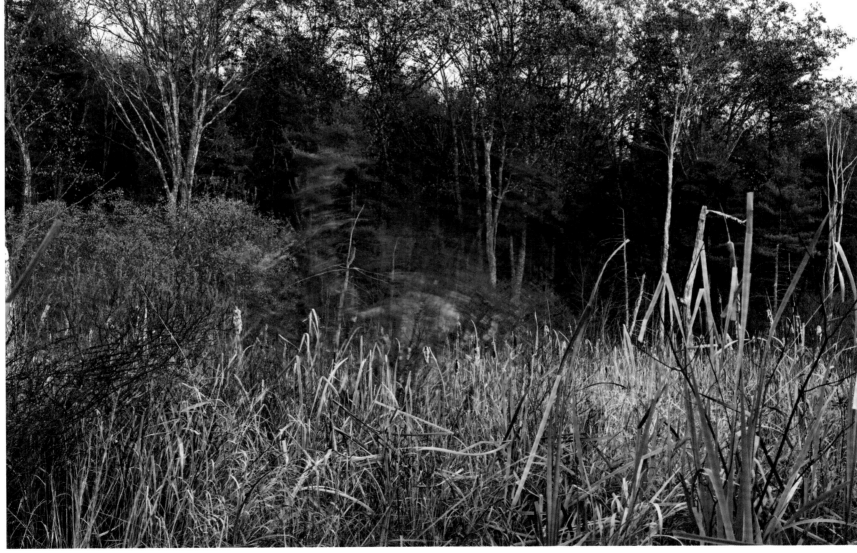

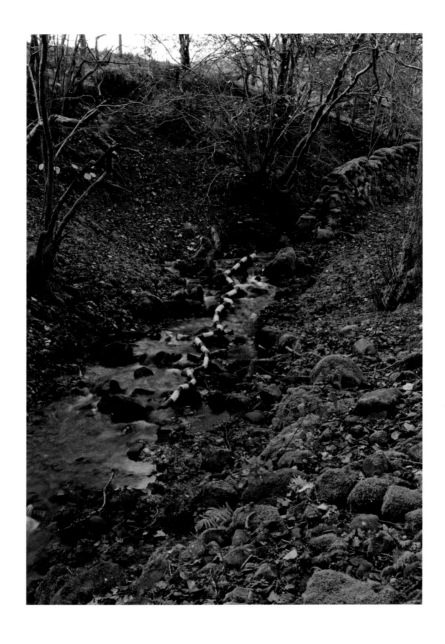

ELM LEAVES WRAPPED AROUND ELM BRANCHES. DUMFRIESSHIRE, SCOTLAND. 18 NOVEMBER 2014

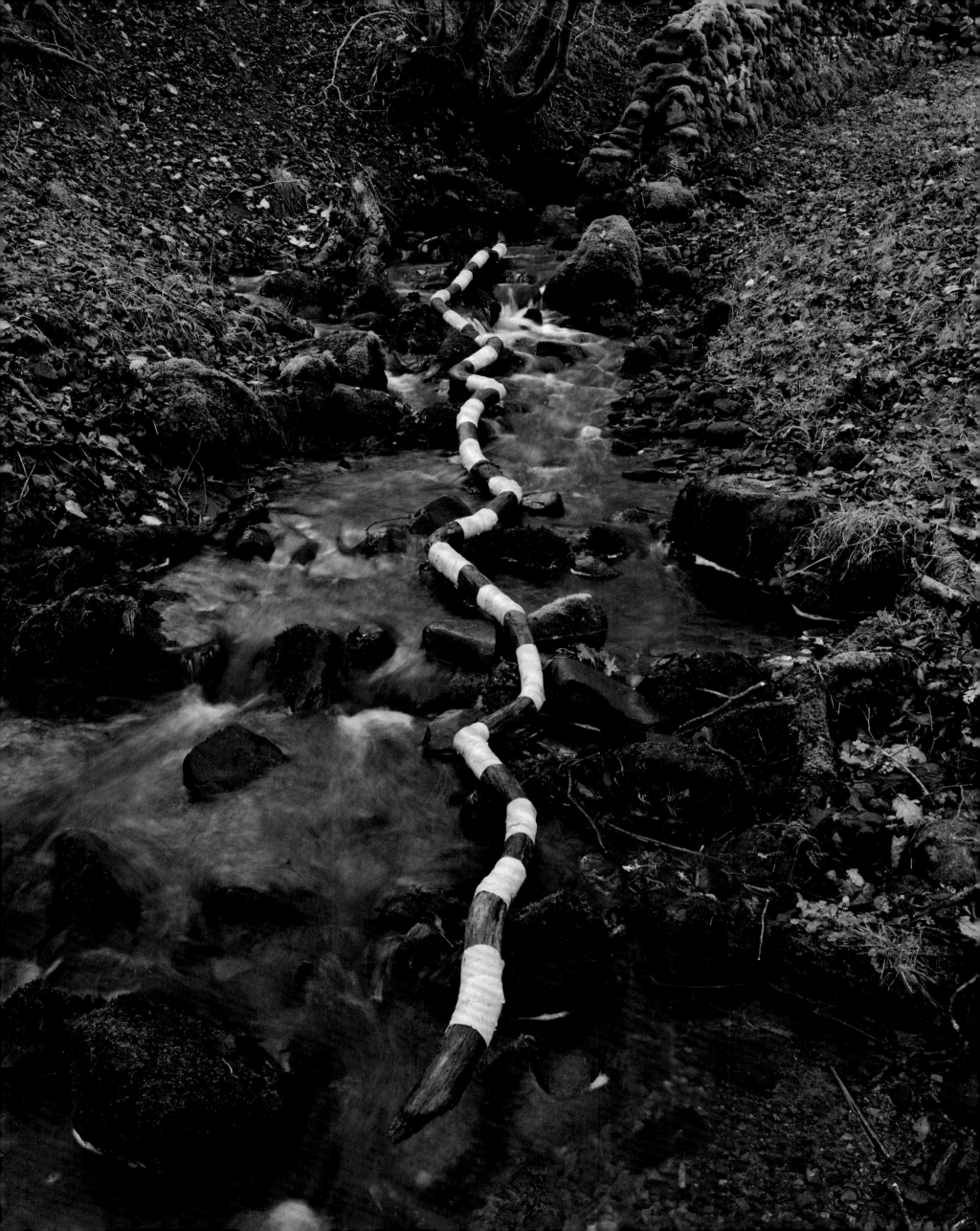

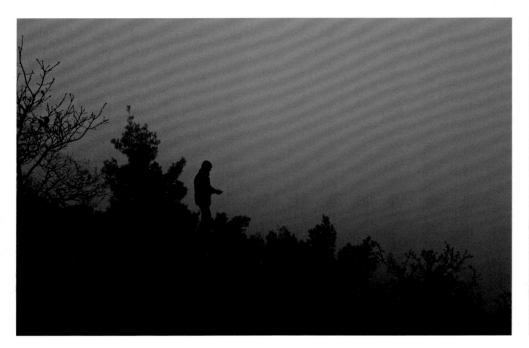
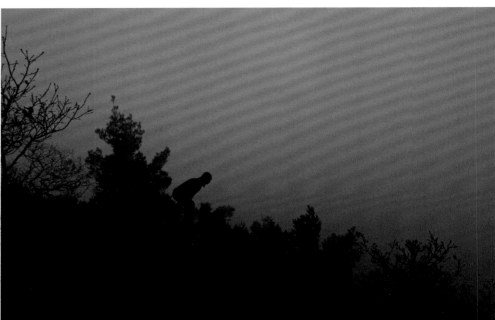
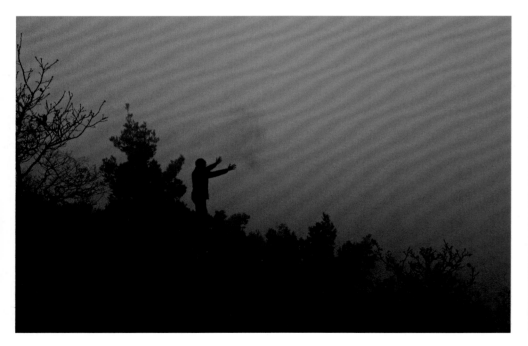
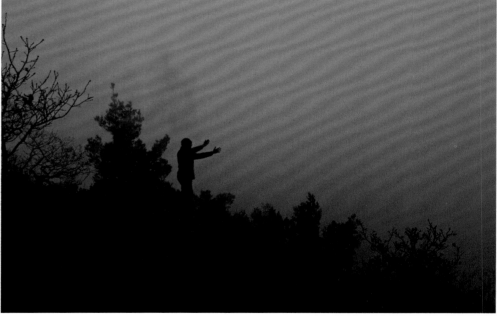

FOR MY FATHER. NORTH YORKSHIRE MOORS, ENGLAND. 22 NOVEMBER 2014

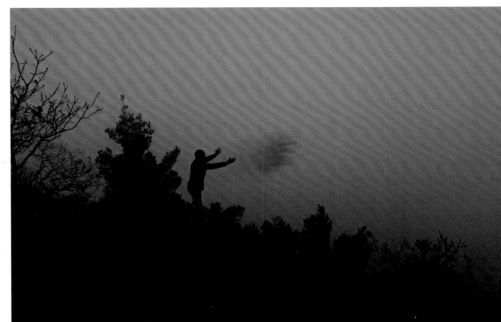
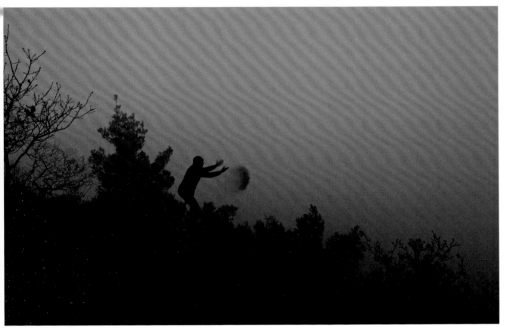
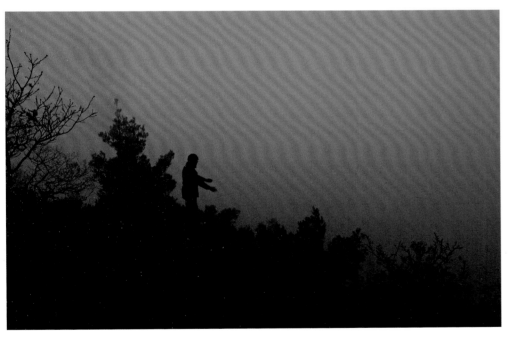
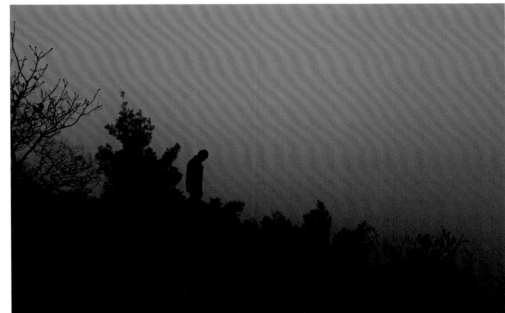

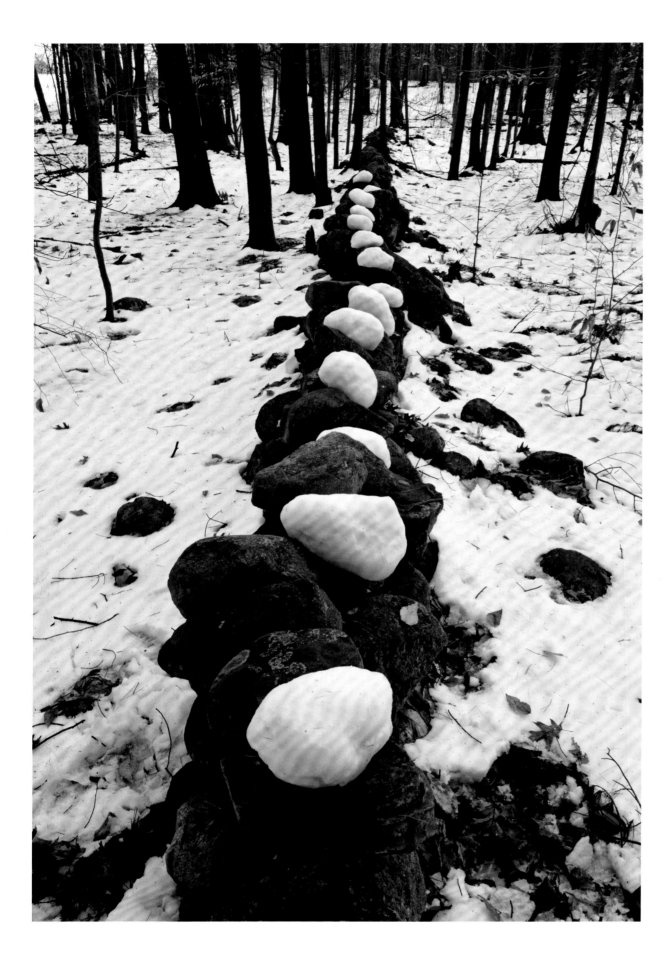

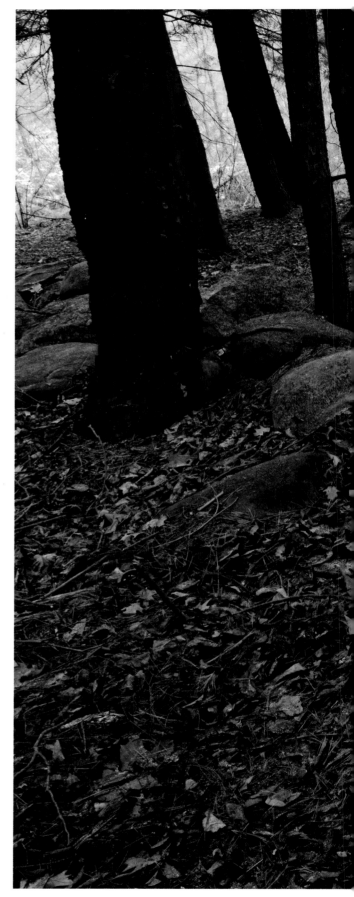

SNOW STONES. KENSINGTON, NEW HAMPSHIRE. 1 DECEMBER 2014

WALL. BOULDER. ICE. KENSINGTON, NEW HAMPSHIRE. 5 DECEMBER 2014

(OVERLEAF) BRANCHES STACKED AROUND THE HARDLY VISIBLE, RUSTED STRANDS OF AN OLD BARBED WIRE FENCE. KENSINGTON, NEW HAMPSHIRE. 7 DECEMBER 2014

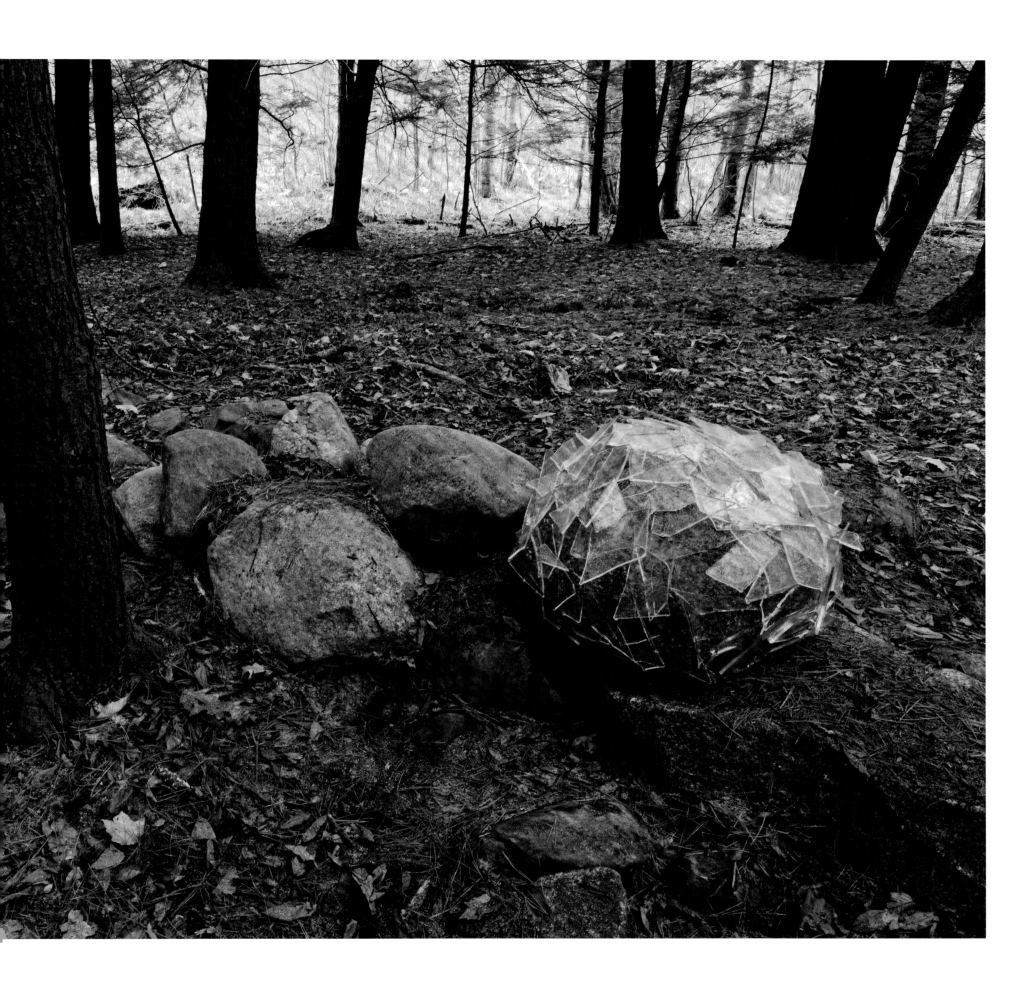

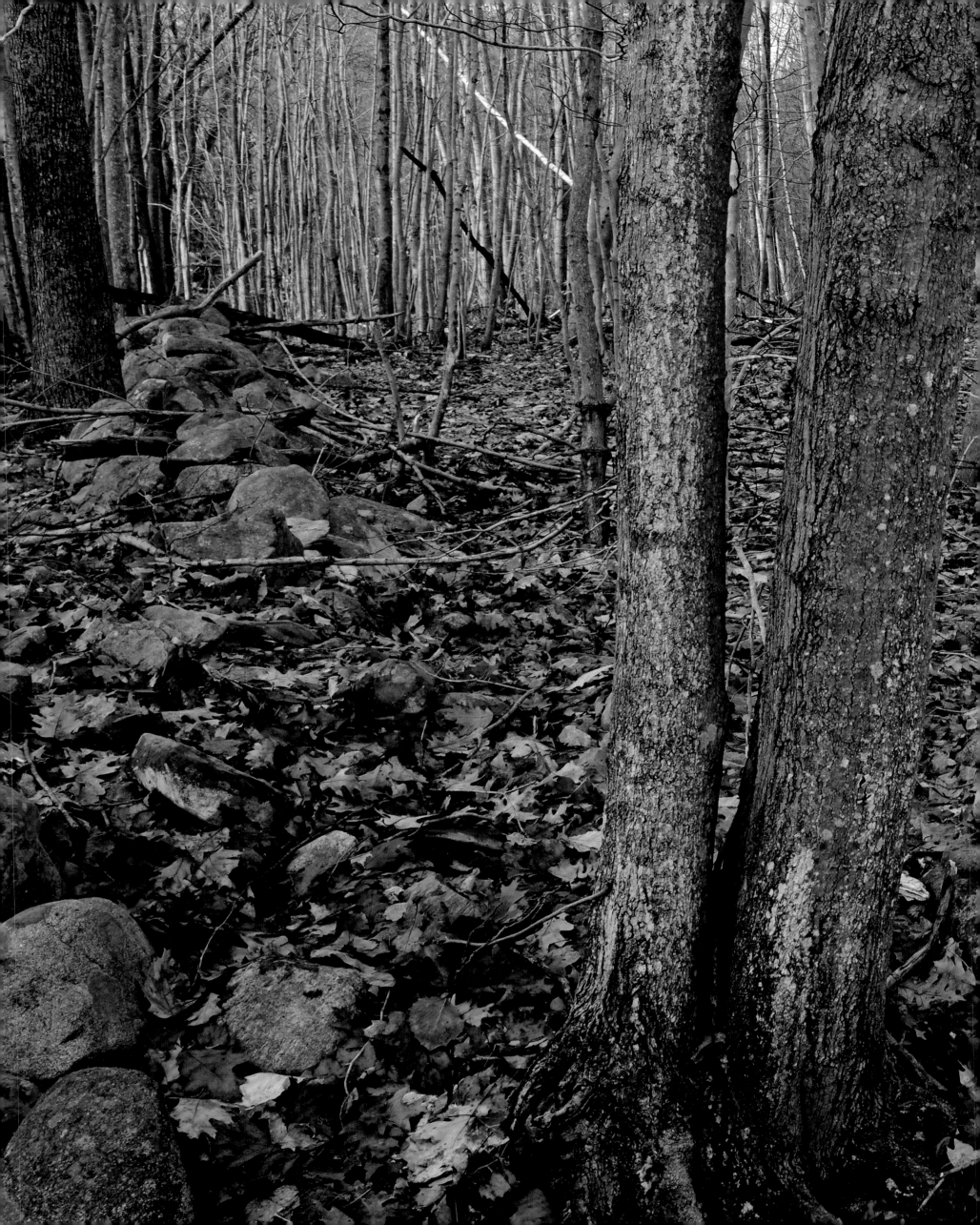

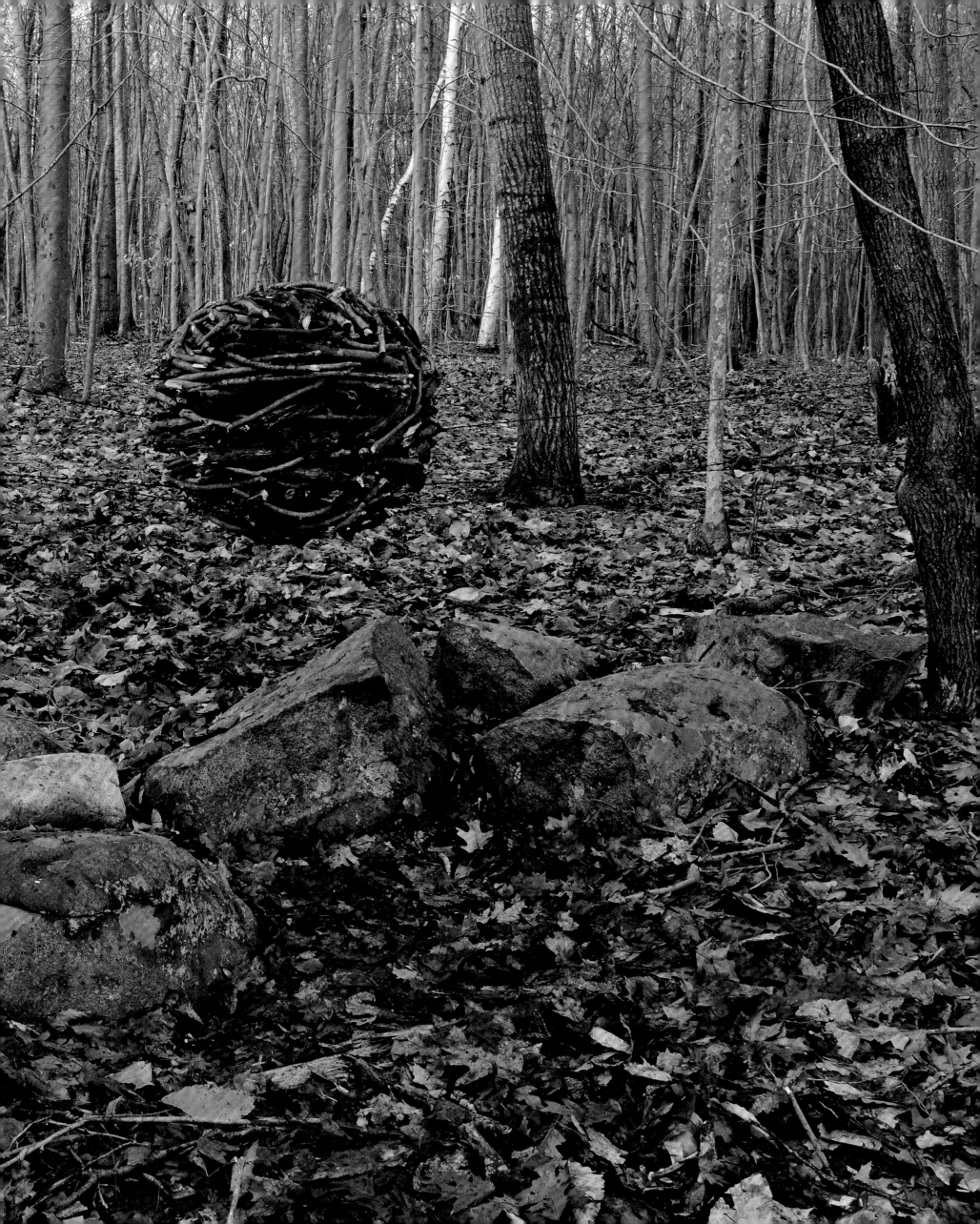

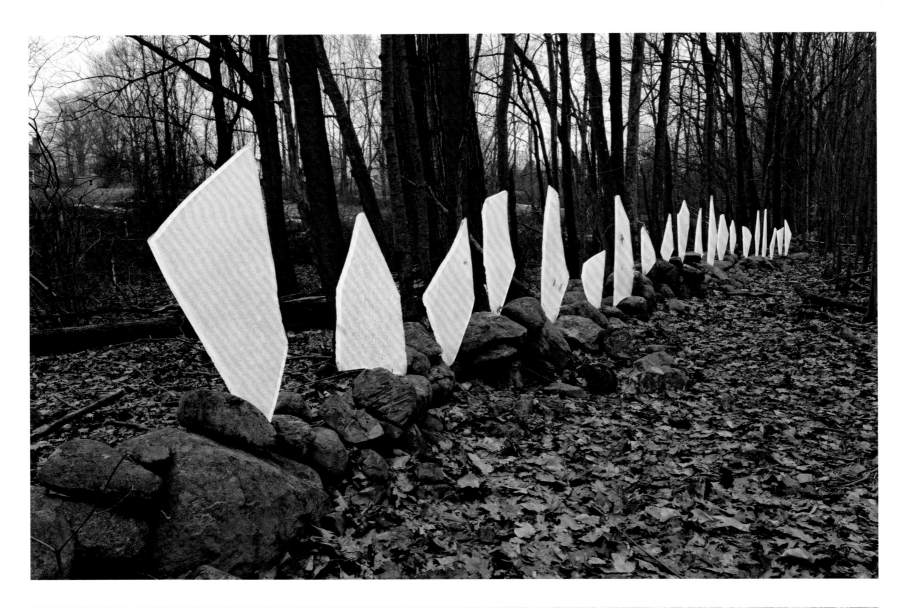

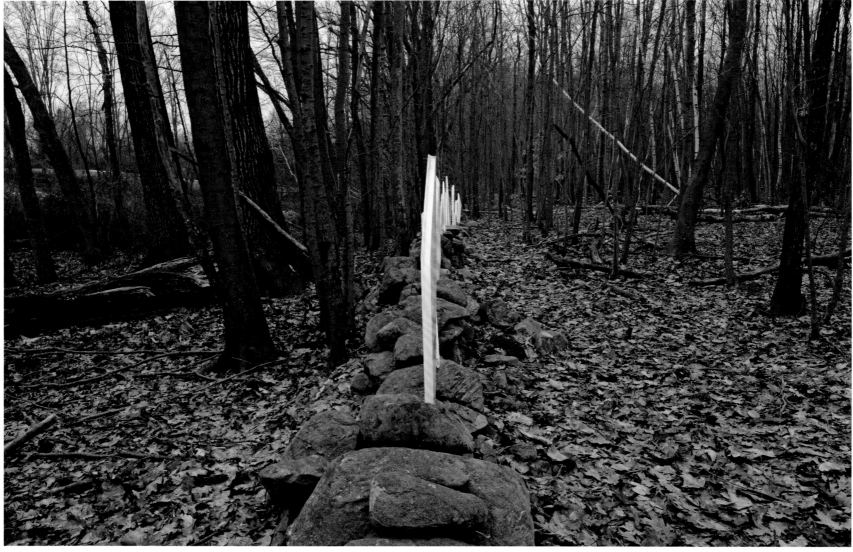

SHEETS OF ICE. CARRIED FROM NEARBY POND. STOOD ON END. FROZEN TO STONE WALL. KENSINGTON, NEW HAMPSHIRE. 8 DECEMBER 2014

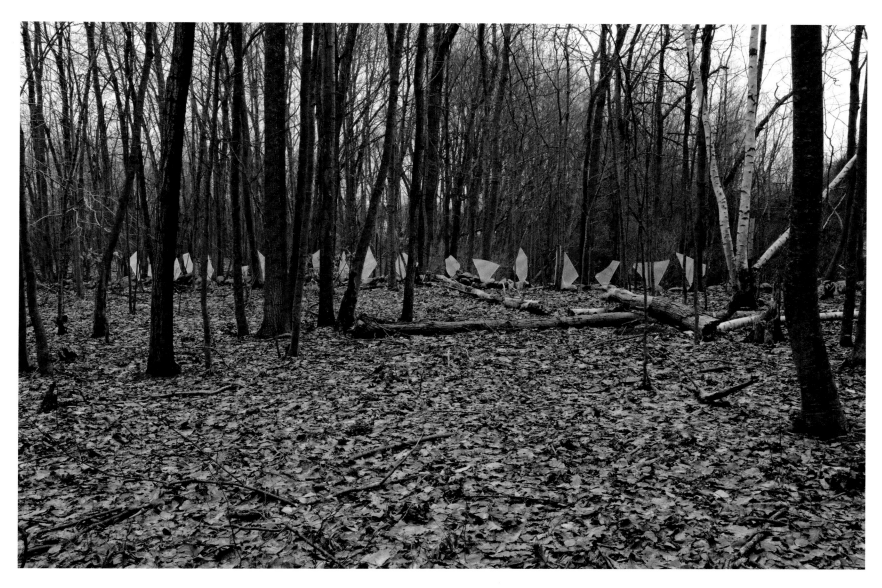

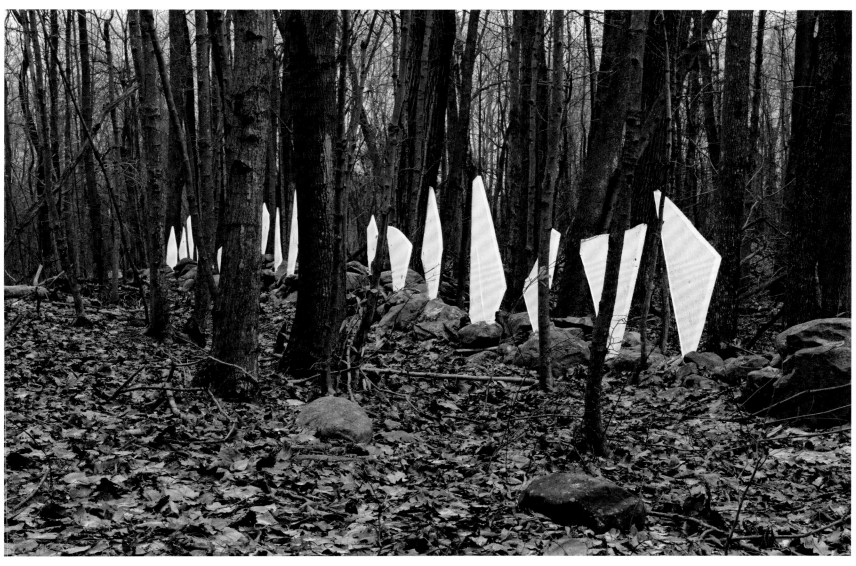

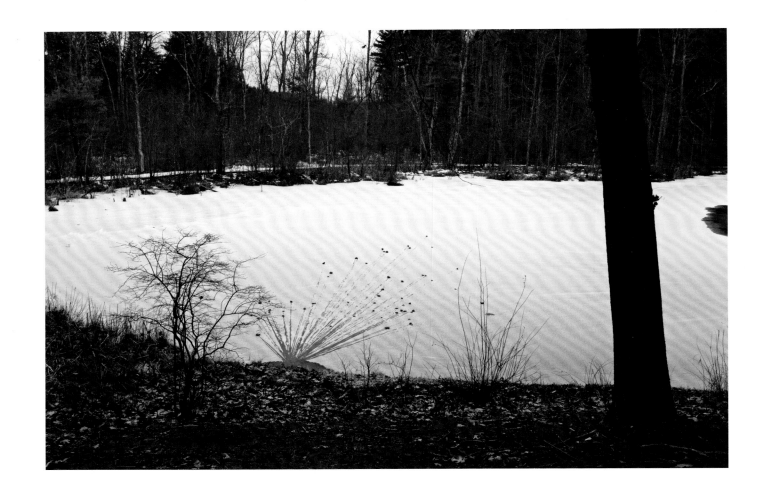

STONES. DIPPED IN WATER THEN SLID ACROSS FROZEN, SNOW-DUSTED LAKE. KENSINGTON, NEW HAMPSHIRE. 8 DECEMBER 2014

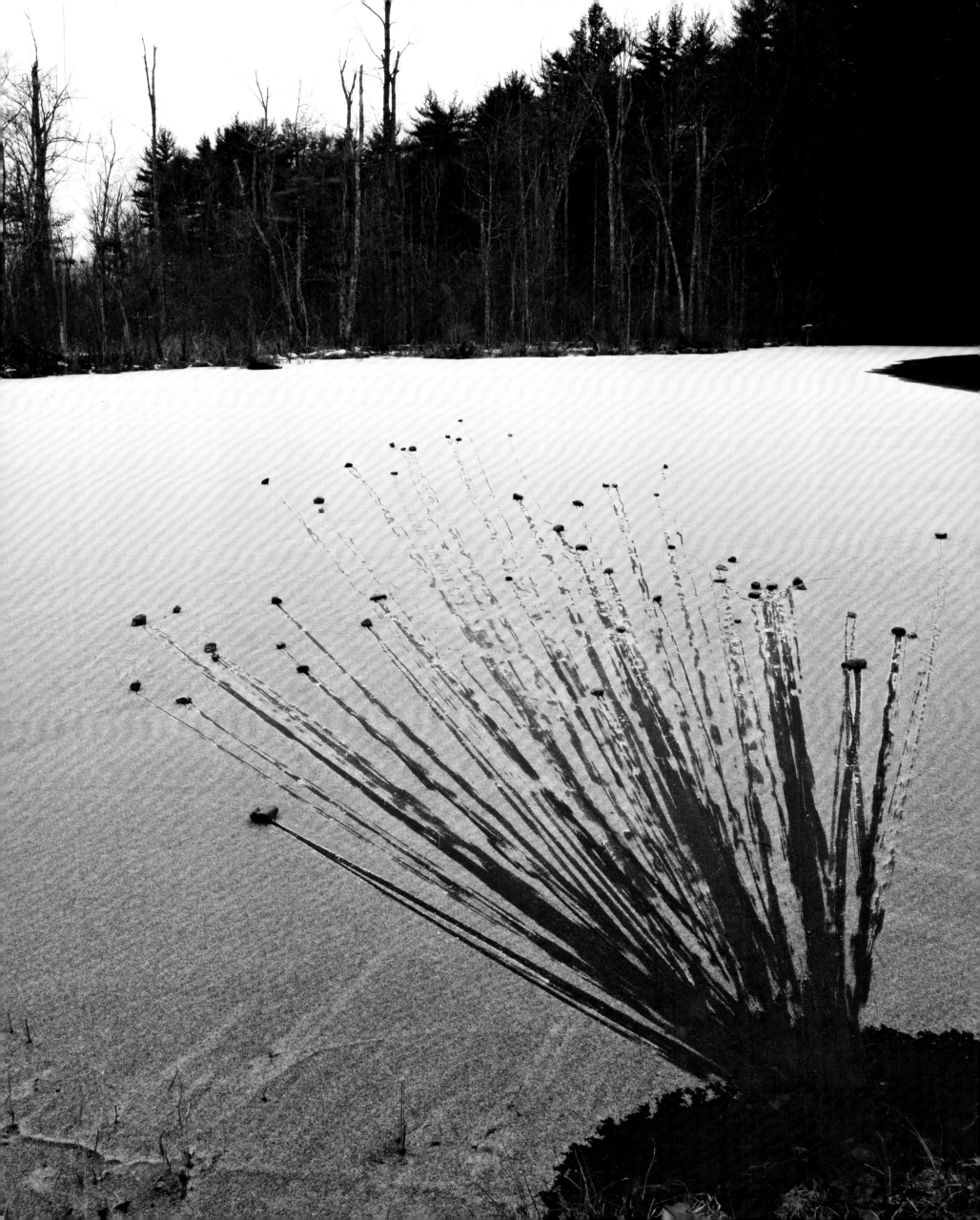

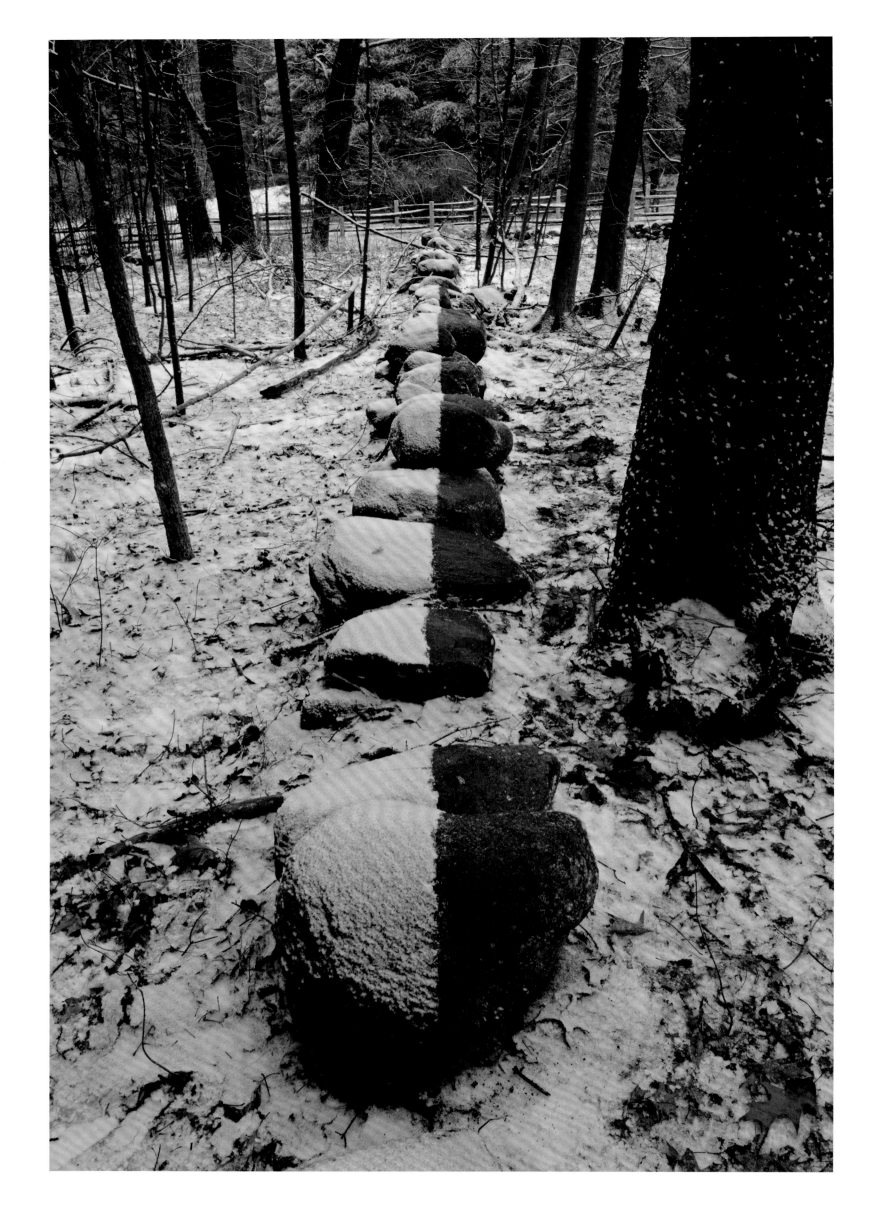

WALL ENCRUSTED WITH SNOW ICE. CHIPPED OFF TO DIVIDE SNOW AND STONE. KENSINGTON, NEW HAMPSHIRE. 9 DECEMBER 2014

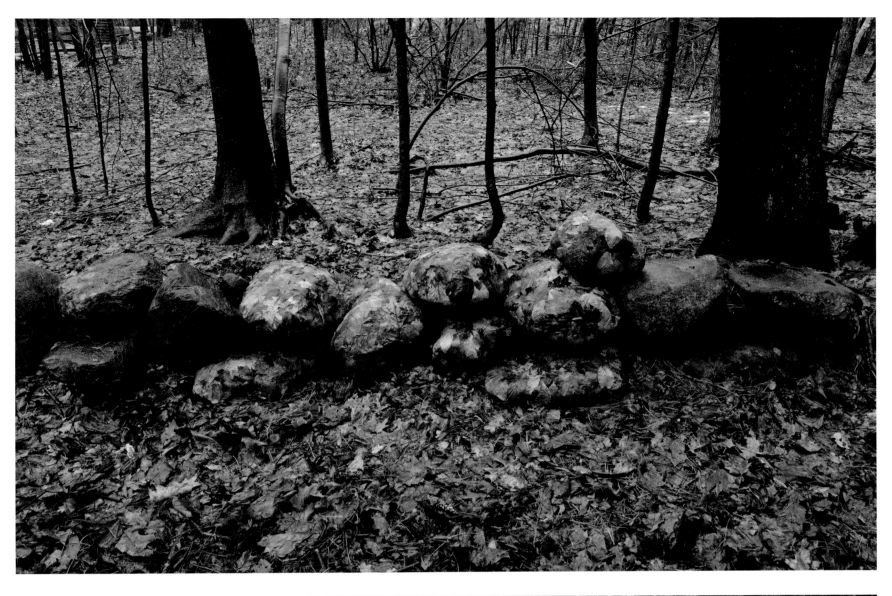

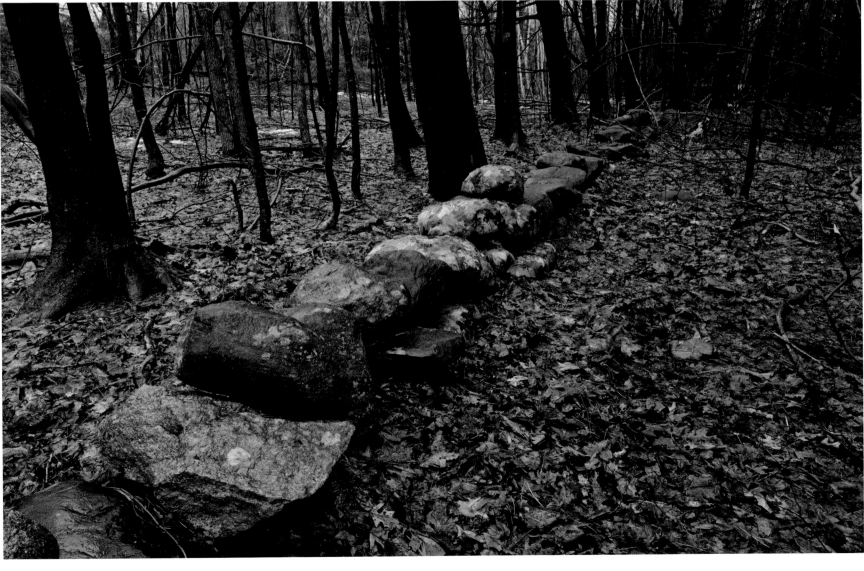

WET LEAVES WRAPPED AROUND WET WALL STONES. KENSINGTON, NEW HAMPSHIRE. 10 DECEMBER 2014

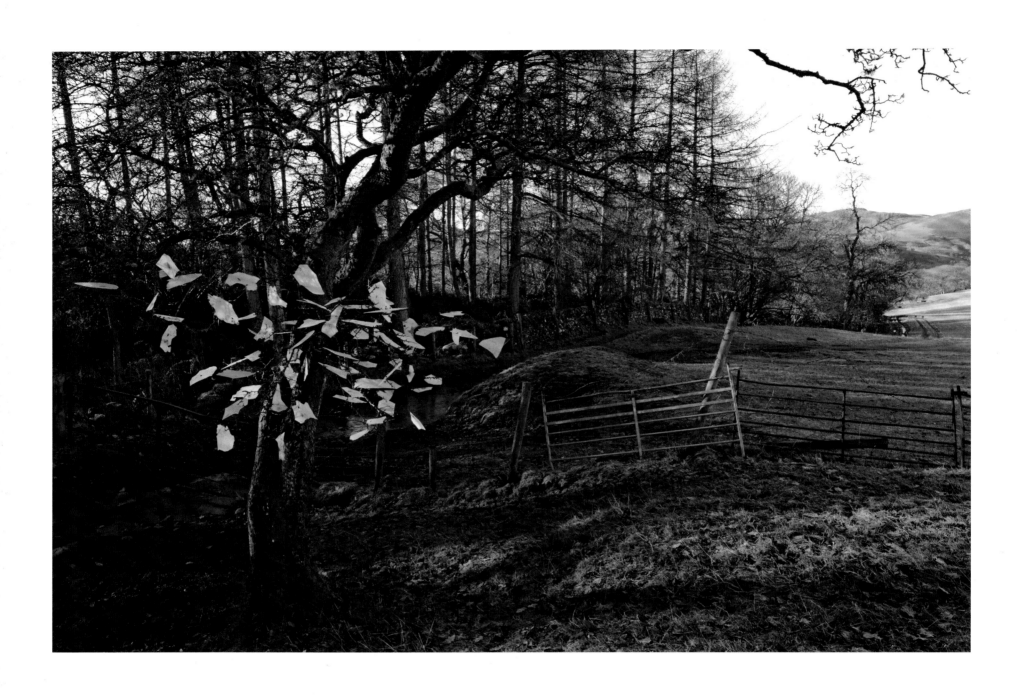

DRY ICE. COLLECTED FROM POOL THAT FROZE THEN DRAINED AWAY. LAID IN A HAWTHORN TREE. NO WIND. DUMFRIESSHIRE, SCOTLAND. 28 DECEMBER 2014

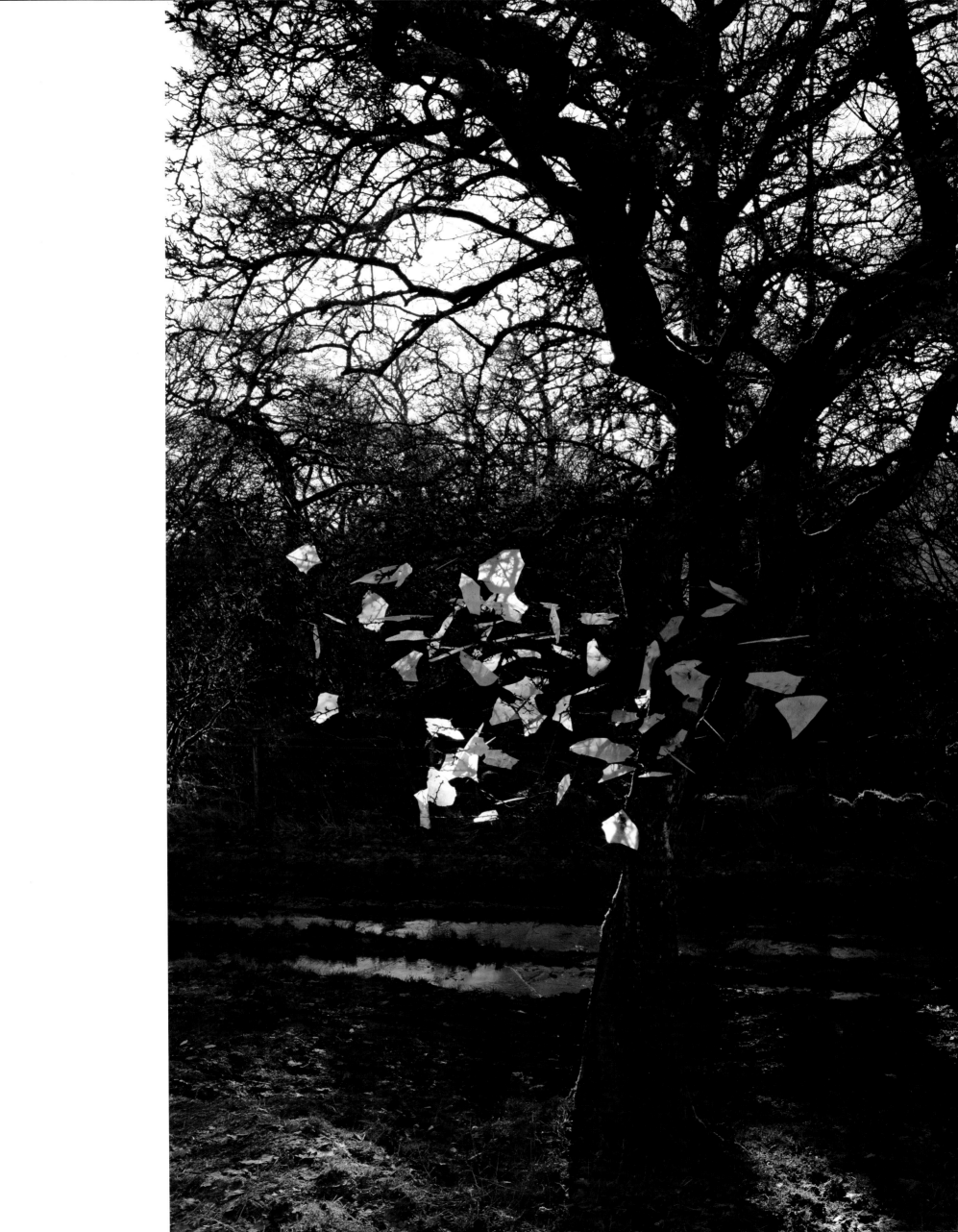

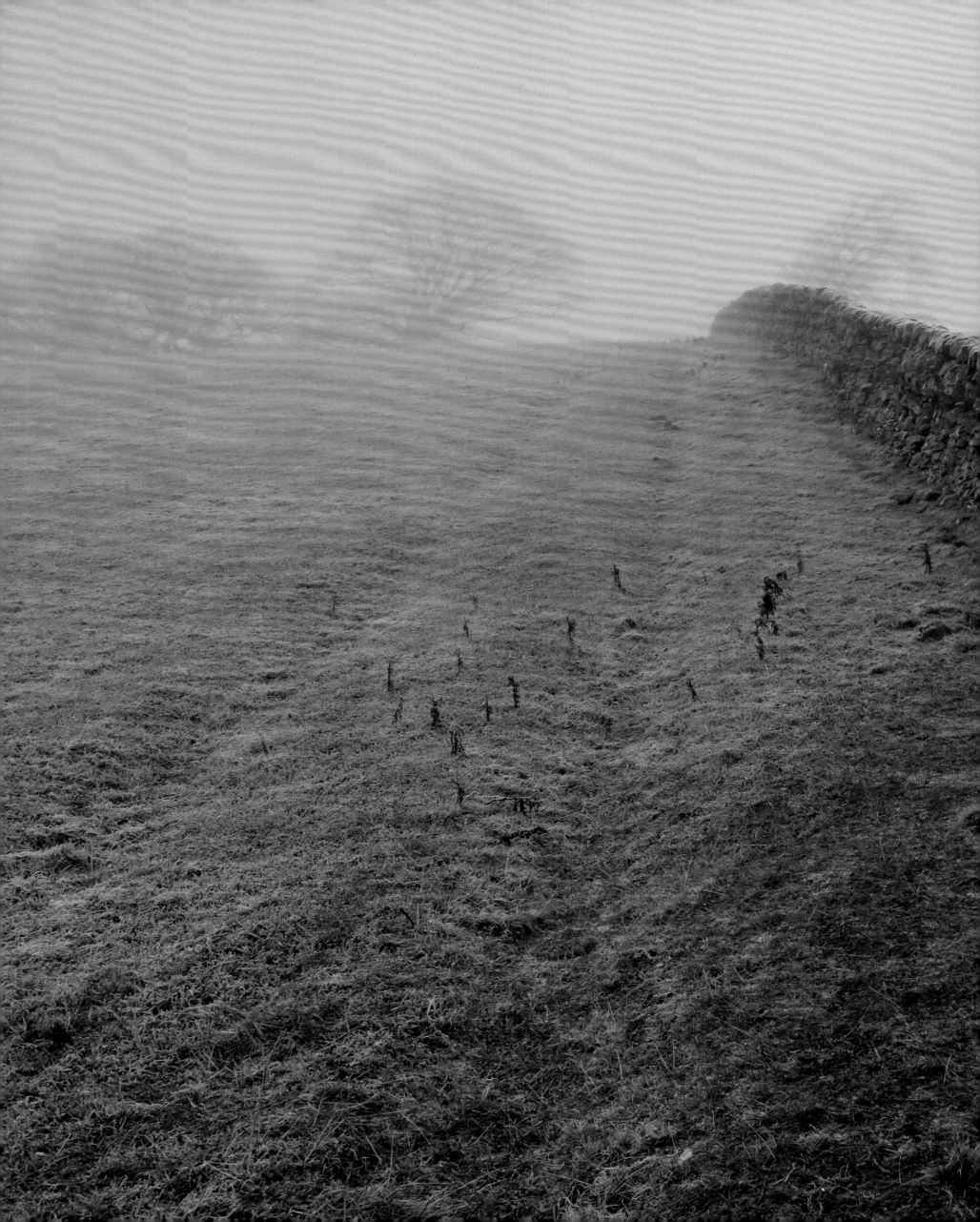

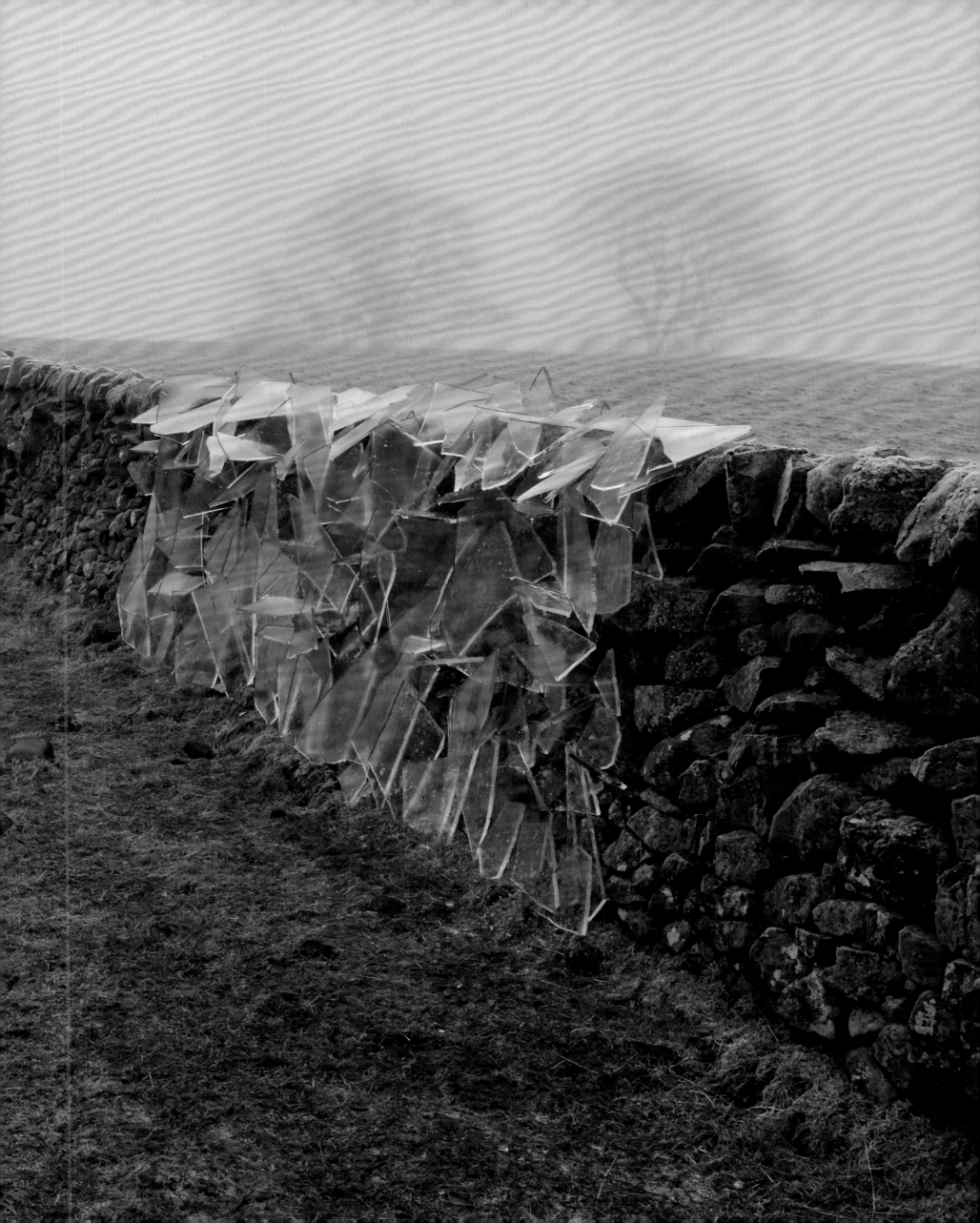

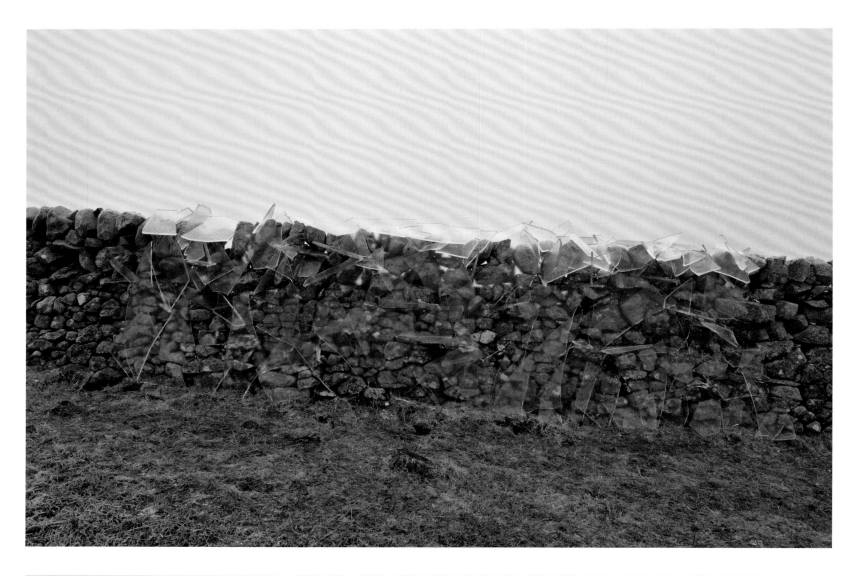

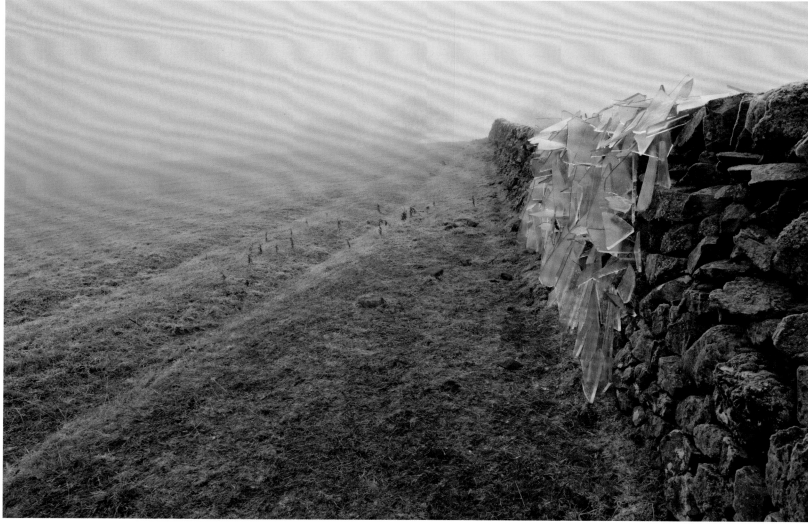

ICE. FROZEN TO WALL. FALLING OFF. PIECE BY PIECE. THE FOLLOWING DAY. DUMFRIESSHIRE, SCOTLAND. 29 DECEMBER 2014

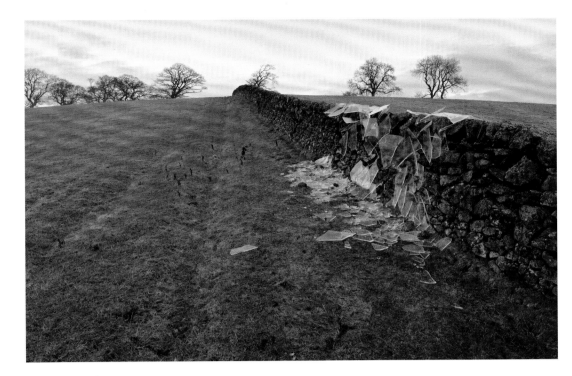

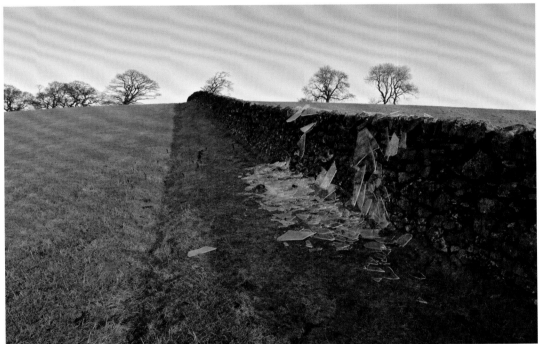

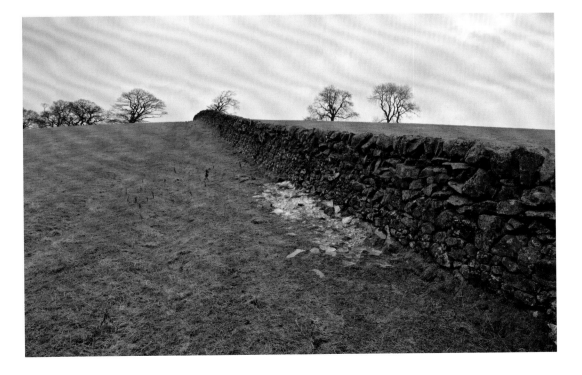

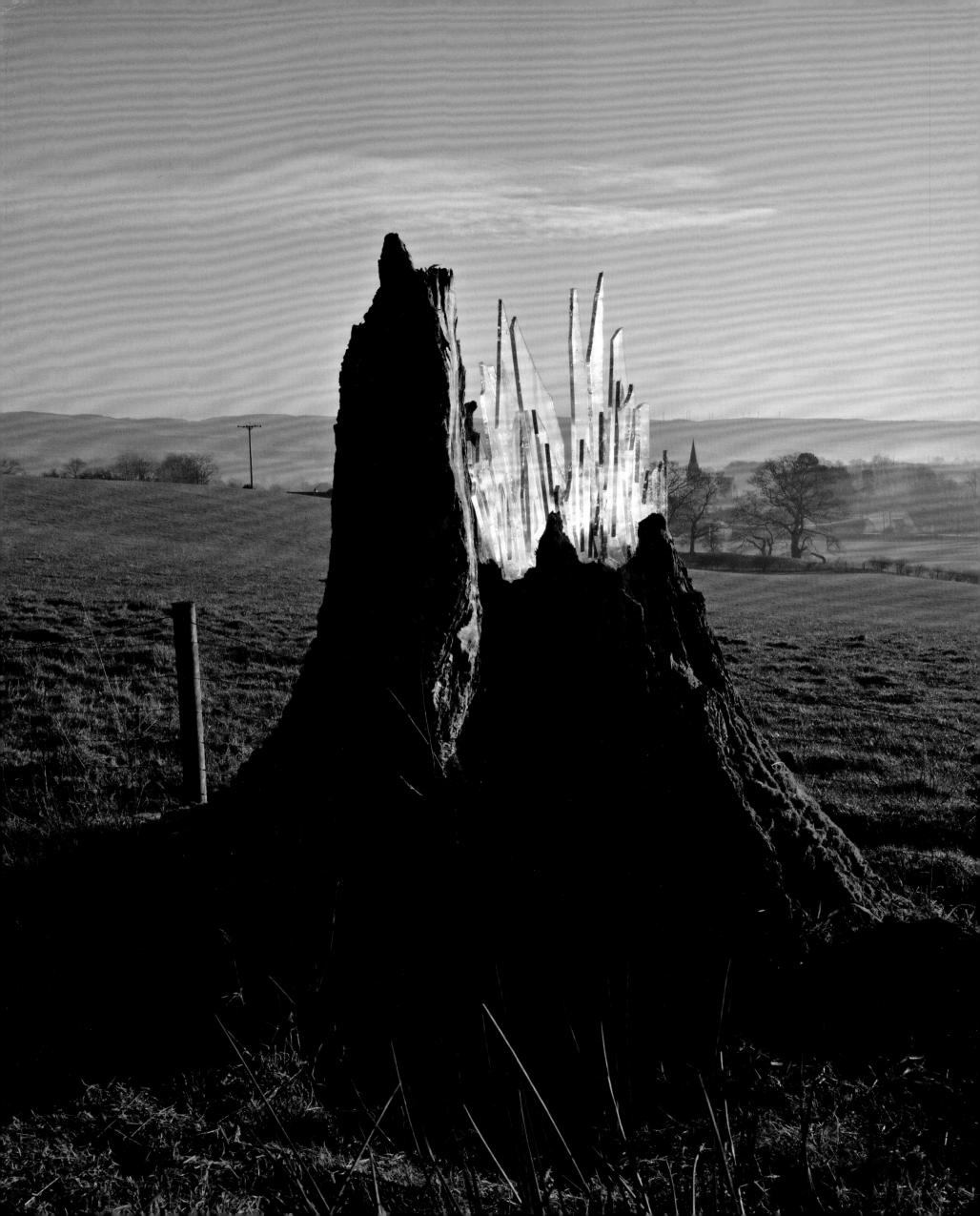

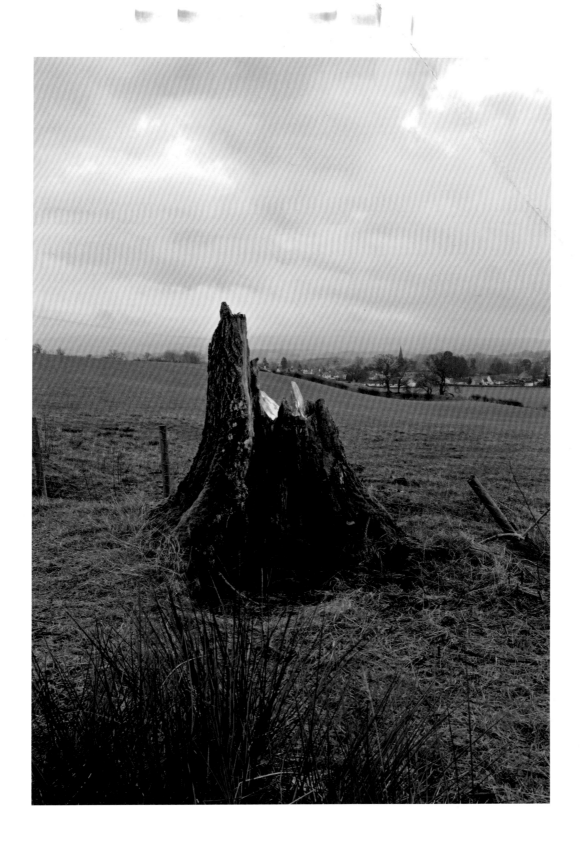

ICE. REMAINS OF AN ASH TREE. DUMFRIESSHIRE, SCOTLAND. 30 DECEMBER 2014

ACKNOWLEDGEMENTS

My thanks to Tina Fiske, who has made me think more deeply about the way I make books, and to Eric Himmel, editor in chief at Abrams, who, throughout the eight years since my last publication, quietly let me know he was ready to publish whenever I was. The scale of this book and its partner publication, *Projects*, due to be published in 2016, is evidence of Abrams' commitment to my work.

I am sometimes helped with the taking of photographs, collecting of materials, and, occasionally, in the making of the work itself. Usually helpers are enlisted at short notice and tend to be whoever is close at hand.

On home ground Holly Goldsworthy, Eric Sawden, John Goldsworthy, Shirley Singh, Richard Wall, James Goldsworthy, Thomas Goldsworthy, Anna Goldsworthy and Tina Fiske have most often assisted me.

Also on home ground I wish to thank the farmers and landowners in whose fields and woods I most often work, in particular: Andrew Morton, Bill Barbour, Sinclair Barbour, John Barbour, John Fawcett, Malcolm Fawcett, Jim Campbell, Buccleuch Estates and Capenoch Estates.

I would also like to acknowledge the support of Galerie Lelong, New York; Haines Gallery, San Francisco; Slowtrack, Madrid; and Galerie Lelong, Paris.

Andy Goldsworthy, 2015

Design and layouts: Andy Goldsworthy and Tim Jones

Scans and colour corrections: Charlie Meecham and Holly Goldsworthy

Production: Anet Sirna-Bruder

Camera assistant credits:

Liz Bower: 342, 343
Jacob Ehrenberg: 66, 67, 100, 101, 108, 109, 110, 111
Tina Fiske: 44, 45, 324, 325
Catherine Galloway: 118, 119
Nicolette Goff: 308
Anna Goldsworthy: 61, 292, 293
Holly Goldsworthy: 222, 223, 226, 227, 228, 229, 232, 233, 258, 259, 271, 274, 275, 278, 280, 281, 282, 283, 294, 295, 302, 303, 316, 317, 318, 319, 326, 327, 330, 331, 334, 335, 336, 337, 338, 339, 341
James Goldsworthy: 181, 184, 188, 189, 250, 251
John Goldsworthy: 166, 167, 194
Thomas Goldsworthy: 54, 55, 161, 306, 307, 309
Michael Meyers: 242, 243
Tricia Paik: 146, 147

Stills from video: 62, 63, 64, 65, 100, 101, 110, 111, 112, 113, 114, 115, 116, 117, 148, 149, 182, 183, 308, 334, 335, 343

Library of Congress Control Number: 2014959355

ISBN: 978-1-4197-1779-6

Printed and bound in Italy
10 9 8 7 6 5 4 3 2 1

Abrams books are available at special discounts when purchased in quantity for premiums and promotions as well as fundraising or educational use. Special editions can also be created to specification. For details, contact specialsales@abramsbooks.com or the address below.

THE ART OF BOOKS SINCE 1949

115 West 18th Street
New York, NY 10011
www.abramsbooks.com